Teach Yourself

VISUALLY™

Adobe® Photoshop® Lightroom® 2

Visual

by Lynette Kent

WILEY

Wiley Publishing, Inc.

Teach Yourself VISUALLY™ Adobe® Photoshop® Lightroom® 2

Published by
Wiley Publishing, Inc.
10475 Crosspoint Boulevard
Indianapolis, IN 46256

www.wiley.com

Published simultaneously in Canada

Library of Congress Control Number: 2008935267

ISBN: 978-0-470-26435-5

Manufactured in the United States of America

10 9 8 7 6 5 4 3 2 1

Trademark Acknowledgments

Contact Us

For general information on our other products and services please contact our Customer Care Department within the U.S. at 800-762-2974, outside the U.S. at 317-572-3993, or fax 317-572-4002.

For technical support please visit www.wiley.com/techsupport.

Wiley Publishing, Inc.

Sales

Contact Wiley
at (800) 762-2974 or
fax (317) 572-4002.

Praise for Visual Books

"Like a lot of other people, I understand things best when I see them visually. Your books really make learning easy and life more fun."

John T. Frey (Cadillac, MI)

"I have quite a few of your Visual books and have been very pleased with all of them. I love the way the lessons are presented!"

Mary Jane Newman (Yorba Linda, CA)

"I just purchased my third Visual book (my first two are dog-eared now!), and, once again, your product has surpassed my expectations.

Tracey Moore (Memphis, TN)

"I am an avid fan of your Visual books. If I need to learn anything, I just buy one of your books and learn the topic in no time. Wonders! I have even trained my friends to give me Visual books as gifts."

Illona Bergstrom (Aventura, FL)

"Thank you for making it so clear. I appreciate it. I will buy many more Visual books."

J.P. Sangdong (North York, Ontario, Canada)

"I have several books from the Visual series and have always found them to be valuable resources."

Stephen P. Miller (Ballston Spa, NY)

"Thank you for the wonderful books you produce. It wasn't until I was an adult that I discovered how I learn – visually. Nothing compares to Visual books. I love the simple layout. I can just grab a book and use it at my computer, lesson by lesson. And I understand the material! You really know the way I think and learn. Thanks so much!"

Stacey Han (Avondale, AZ)

"I absolutely admire your company's work. Your books are terrific. The format is perfect, especially for visual learners like me. Keep them coming!"

Frederick A. Taylor, Jr. (New Port Richey, FL)

"I have several of your Visual books and they are the best I have ever used."

Stanley Clark (Crawfordville, FL)

"I bought my first Teach Yourself VISUALLY book last month. Wow. Now I want to learn everything in this easy format!"

Tom Vial (New York, NY)

"Thank you, thank you, thank you...for making it so easy for me to break into this high-tech world. I now own four of your books. I recommend them to anyone who is a beginner like myself."

Gay O'Donnell (Calgary, Alberta, Canada)

"I write to extend my thanks and appreciation for your books. They are clear, easy to follow, and straight to the point. Keep up the good work! I bought several of your books and they are just right! No regrets! I will always buy your books because they are the best."

Seward Kollie (Dakar, Senegal)

"Compliments to the chef!! Your books are extraordinary! Or, simply put, extra-ordinary, meaning way above the rest! THANK YOU THANK YOU THANK YOU! I buy them for friends, family, and colleagues."

Christine J. Manfrin (Castle Rock, CO)

"What fantastic teaching books you have produced! Congratulations to you and your staff. You deserve the Nobel Prize in Education in the Software category. Thanks for helping me understand computers."

Bruno Tonon (Melbourne, Australia)

"Over time, I have bought a number of your 'Read Less - Learn More' books. For me, they are THE way to learn anything easily. I learn easiest using your method of teaching."

José A. Mazón (Cuba, NY)

"I am an avid purchaser and reader of the Visual series, and they are the greatest computer books I've seen. The Visual books are perfect for people like myself who enjoy the computer, but want to know how to use it more efficiently. Your books have definitely given me a greater understanding of my computer, and have taught me to use it more effectively. Thank you very much for the hard work, effort, and dedication that you put into this series."

Alex Diaz (Las Vegas, NV)

Credits

Project Editor
Sarah Hellert

Sr. Acquisitions Editor
Jody Lefevere

Copy Editor
Scott Tullis

Technical Editor
Chris Bucher

Editorial Manager
Robyn Siesky

Business Manager
Amy Knies

Sr. Marketing Manager
Sandy Smith

Editorial Assistant
Laura Sinise

Manufacturing
Allan Conley
Linda Cook
Paul Gilchrist
Jennifer Guynn

Book Design
Kathie Rickard

Production Coordinator
Erin Smith

Layout
Andrea Hornberger

Screen Artist
Jill A. Proll

Illustrators
Ronda David-Burroughs
Cheryl Grubbs
Shane Johnson

Proofreader
Lynda D'Arcangelo
Betty Kish

Quality Control
David Faust

Indexer
Johnna VanHoose Dinse

Special Help
Tobin Wilkerson

Vice President and Executive Group Publisher
Richard Swadley

Vice President and Publisher
Barry Pruett

Composition Director
Debbie Stailey

About the Author

Lynette Kent (Huntington Beach, CA) studied art and French at Stanford University. After completing her master's degree, she taught at both the high school and community college level. A fervent Mac user since 1987 and unconventional computer person, she now teaches and writes books and magazine articles on digital imaging and photography, and often presents computer graphics hardware and software at trade shows. She enjoys photography as well as painting with traditional watercolors, and often combines both arts using the computer. Her books include *Teach Yourself VISUALLY Mac OS X Leopard*, *Adobe Photoshop CS3: Top 100 Simplified Tips & Tricks*, and *Teach Yourself VISUALLY Digital Photography*, 3rd Edition. Lynette is also one of the leaders of the Adobe Technology Exchange of Southern California, a professional organization for photographers, graphic designers, and fine artists.

Author's Acknowledgments

Special thanks go out to acquisitions editor Jody Lefevere for asking me to write this book; to project editor Sarah Hellert for her literal and meticulous unscrambling of chapters; to copy editor Scott Tullis for making sure the text was understandable and legible; and to tech editor Chris Bucher for overseeing the accuracy of the steps and technical terminology. Thank you to the graphics department for handling all the variances I kept asking for. I particularly want to thank George Jardine of Adobe for his time-consuming and thoughtful answers to my often confusing questions on organization and file naming. His insight truly helped me find ways to help my readers understand the Lightroom concept. Thanks also go to Colin Smith for his direct help on various topics. And of course thanks go to the Adobe team for always being so responsive to all the questions from the beta testers.

Table of Contents

 chapter 1 Introducing Photoshop Lightroom

Understanding Lightroom . 4

Understanding Lightroom's Structure . 6

Using the Lightroom Interface . 8

Open Lightroom and Click the Modules . 10

Enlarge the Central Viewing Area . 12

Create a Practice Lightroom Catalog . 14

Locate the Practice Lightroom Catalog . 16

Remove the Photos from the Practice Catalog . 18

chapter 2 Getting Your Photos into Photoshop Lightroom

Understanding Lightroom Catalogs and Image Storage . 22

An Overview of Lightroom's Import Process . 24

Understanding File Formats . 26

Import Photos at Their Current Location . 28

Import Photos from a Memory Card . 30

Import Photos and Change Format to DNG . 32

Be Consistent with File Names . 34

Import Photos and Change Names . 36

Rename Photos after Importing . 37

Understanding Lightroom's Naming Template Presets . 38

Create Your Own Naming Template Preset . 40

Create a New Catalog . 44

Import Photos from an Existing Catalog . 46

Automate the Import Process . 48

Back Up During Import . 50

Build a Lightroom Library with External Drives . 52

Combine a Travel Catalog with Your Main Lightroom Library . 56

chapter 3

Viewing and Organizing Your Photos

Locate the Parts of the Library Module. 60

Change the Library Views . 64

Using a Second Window . 66

Adjust the Lights . 70

Change the Display of the Side Panel Sections. 71

Change Your Library View Options . 72

Customize the Library Toolbar. 74

Rename a Group of Photos . 76

Tag Your Photos for Easier Sorting . 78

Filter Your Photos . 80

Organize Your Photos with Folders. 82

Synchronize Folders That Have Changed . 84

Group Your Photos into Collections . 86

Create a Smart Collection . 88

Group Collections into a Collection Set . 90

Make a Quick Collection . 92

Convert a Quick Collection to a Permanent Collection . 94

Add Keywords to Your Photos. 96

Add Keywords with the Painter Tool. 98

Create Custom Keyword Sets and Hierarchical Lists . 100

Create an Image Stack . 102

Remove or Delete Photos from Lightroom. 104

Table of Contents

chapter **4** **Personalizing Lightroom**

Understanding Lightroom Presets . 108

Set the Essential Lightroom Preferences . 110

Customize the Catalog Settings . 114

Quickly Change Your Lightroom View . 116

Understanding Metadata . 118

Apply Metadata in the Library Module . 120

Synchronize Metadata between Photos . 122

Create a Copyright Metadata Preset . 124

Design a Personal Identity Plate . 126

Modify the Module Buttons . 128

Create a Graphical Identity Plate . 130

chapter **5** **Setting the Stage for Digital Photo Developing**

Focus on Your Monitor . 134

Understanding Monitor Calibration Options . 136

Calibrate and Profile Your Monitor . 138

chapter 6 Using the Library Module for Quick Developing

Understanding the Histogram . 144

Alter the Photo with a Preset . 146

Crop Your Photo with a Preset. 147

Make a Quick Change to Grayscale. 148

Quickly Select a Different White Balance . 149

Fine Tune the White Balance Setting. 150

Modify an Auto Tone Change . 152

Understanding Library Module Clarity and Vibrance Tools. 154

Improve the Photo with Clarity and Vibrance. 155

Synchronize a Quick Develop Setting for Multiple Images . 156

Create Virtual Copies to Compare Edits . 158

chapter 7 Exploring the Develop Module

Locate the Parts of the Develop Module. 162

Change the Develop Module Interface . 164

Try the Develop Module Shortcuts . 166

Using the Develop Module Presets . 168

Compare Images in the Develop Module . 170

Using the Image History and Snapshot. 172

Rotate a Photo in the Develop Module . 176

Copy and Paste Edits from One Photo to Another. 177

Using the Histogram Features in the Develop Module . 178

Straighten Images . 180

Recompose Your Photo with a Crop . 182

Creatively Crop an Image for Effect. 184

Repair Dust Spots and Other Imperfections . 186

Remove Red Eye . 188

Table of Contents

chapter 8 — Image Processing in the Develop Module

Adjust the White Balance . 192

Modify the Basic Exposure . 196

Make Precise Changes with the Tonal Adjustments Tools . 198

Improve the Photo with Clarity, Vibrance, and Saturation . 200

Make Controlled Tone Curve Adjustments . 202

Explore the HSL/Color/Grayscale Tools . 206

Adjust Individual Color Ranges . 208

Creatively Convert a Color Image to Black and White . 210

Tone an Image . 212

Brush On a Localized Adjustment . 214

Add a Localized Graduated Filter . 218

Reduce Digital Noise in the Image . 220

Decrease Chromatic Aberration . 222

Improve Details with Sharpening . 224

Add a Lens Vignette for Effect . 226

Save Your Settings as a Custom Preset . 228

Understanding the Camera Calibration Feature . 230

Using the Camera Calibration Pane . 232

chapter 9 — Making Slideshows Look Professional with Lightroom

Locate the Parts of the Slideshow Module . 236

Play an Impromptu Slideshow . 238

Create a Basic Slideshow with a Slideshow Template . 240

Customize an Existing Lightroom Slideshow Template . 242

Add Customized Text Overlays to a Slideshow . 246

Save a Custom Slideshow Template . 248

Export a Slideshow to PDF . 249

chapter 10

Printing from Photoshop Lightroom

Locating the Parts of the Print Module . 252

Using a Lightroom Template to Prepare One Photo to Print . 254

Print a Contact Sheet . 256

Add Overlay Text or Graphics to Prints . 258

Customize and Save an Existing Lightroom Print Template . 262

Prepare a Picture Package for Printing . 266

Create a Custom Picture Package . 268

Understanding the Color Management Options . 270

chapter 11

Creating Web Galleries with Your Photos

Locating the Parts of the Web Module . 274

Using a Template to Create a Web Gallery . 278

Customize a Web Gallery Template . 280

Managing Your Custom Web Gallery Templates . 284

Export Your Web Gallery . 286

Upload Your Web Gallery to a Web Site . 288

chapter 12

Using Photoshop or Elements with Lightroom

Understanding the Differences between Lightroom and Bridge 292

Understanding the Differences between Lightroom and Photoshop or Elements 294

Set Lightroom's Preferences for the External Editors . 296

Take a Raw or DNG File from Lightroom to Photoshop and Back 298

Take an Image from Lightroom to Photoshop or Elements and Back 300

Go from Lightroom to Photoshop to Create a Panorama . 302

Table of Contents

chapter **13** **Exporting Photos for Multiple Uses**

Understanding the Lightroom Export Feature . 306

Explore the Export Dialog Box Settings . 308

Create an Export Preset to Attach Photos to Your E-mail. 310

chapter 14

Best Practices for Memory Cards and Storage

Understanding Memory Cards and Memory Card Readers 316

Using Memory Cards Correctly ... 318

Differentiating between Storage, Backups, and Archives 320

Understanding External Hard Drives.. 322

Defining Multidrive and RAID Systems .. 324

Protecting Your Hard Drives... 325

Understanding Travel Essentials with a Digital Camera.......................... 326

Using an Online Storage System ... 328

How to use this book

Do you look at the pictures in a book or newspaper before anything else on a page? Would you rather see an image instead of read about how to do something? Search no further. This book is for you. Opening *Teach Yourself VISUALLY Adobe Photoshop Lightroom 2* allows you to read less and learn more about the Lightroom.

Who Needs This Book

This book is for a reader who has never used this particular technology or software application. It is also for more computer literate individuals who want to expand their knowledge of the different features that Lightroom has to offer.

Book Organization

Teach Yourself VISUALLY Adobe Photoshop Lightroom 2 has 14 chapters.

Chapter 1, **Introducing Photoshop Lightroom**, introduces the Lightroom organization and interface and helps you locate the tools you will use. It also steps you through creating a practice catalog to get familiar with the Lightroom concept.

In Chapter 2, **Getting Your Photos into Photoshop Lightroom**, you learn about the Lightroom Import process. It includes a variety of different import scenarios so you can bring photos into Lightroom from a memory card, an external drive, or the current drive and more.

Chapter 3, **Viewing and Organizing Your Photos**, guides you through different ways of viewing your photos onscreen and the many ways to sort and group your images. You can add keywords, colored tags star ratings, and more to customize your photo collection.

Chapter 4, **Personalizing Lightroom**, gives you an overview of the Lightroom preferences and ways to customize the application so it works for you.

Chapter 5, **Setting the Stage for Digital Photo Developing**, explains the basics of color calibration and profiling and why this is an essential part of digital photo editing. It includes a step-by-step task on how to calibrate and profile your monitor.

Chapter 6, **Using the Library Module for Quick Developing**, teaches you some easy tools to edit photos using the basic Lightroom adjustments.

Chapter 7, **Exploring the Develop Module**, introduces you to the main photo editing tools in Lightroom, and teaches the location of all the tools. It covers cropping and straightening, as well as red-eye and dust repair.

Chapter 8, **Image Processing in the Develop Module**, teaches the basics of the white balance and tonal adjustment tools, sharpening, and vignetting. The tasks also show how to use the localized adjustment tools for making specific rather than global changes.

Chapter 9, **Making Slideshows Look Professional with Lightroom**, guides you through the quick and easy of building a simple yet personalized slideshow of your images.

Chapter 10, **Printing from Photoshop Lightroom**, gives an overview of the print module tools and teaches some of the many ways to send your photos to a printer directly from Lightroom.

Chapter 11, **Creating Web Galleries with Your Photos**, explains how to put your images on the web in a gallery style of your own design.

Chapter 12, **Using Photoshop or Elements with Lightroom**, explains the differences between Lightroom and these two photo editing tools, and when and how to use them in conjunction with Lightroom.

In Chapter 13, **Exporting Photos for Multiple Uses**, you learn Lightroom's method and reasons for exporting from the application.

Chapter 14, **Best Practices for Memory Cards and Storage**, includes valuable explanations and information about the many ways to keep your digital photo files when you are working on them and for archiving them. This chapter is a basic overview of the hardware options currently available for the safekeeping of your images.

Chapter Organization

This book consists of sections, all listed in the book's table of contents. A *section* is a set of steps that show you how to complete a specific computer task.

Each section, usually contained on two facing pages, has an introduction to the task at hand, a set of full-color screen shots and steps that walk you through the task, and a set of tips. This format allows you to quickly look at a topic of interest and learn it instantly.

Chapters group together three or more sections with a common theme. A chapter may also contain pages that give you the background information needed to understand the sections in a chapter.

What You Need to Use This Book

To install Lightroom, you need a Macintosh PowerPC G4 or G5 or Intel Based Mac, with system 10.4 or 10.5, or

an Intel Pentium 4 processor with Windows XP service Pack 2 or Windows Vista, plus a minimum of 768 MB or RAM, at least 1 GB of available hard disk space, a monitor with a screen resolution of 1024 x 768 or greater, and a CD-ROM drive.

To perform the tasks in this book, you need digital photos on a computer, an external hard drive, or on a memory card with a card reader. At least one external hard drive is recommended, as is a Wacom tablet and pen.

Using the Mouse

This book uses the following conventions to describe the actions you perform when using the mouse:

Click

Press your left mouse button once. You generally click your mouse on something to select something on the screen.

Double-click

Press your left mouse button twice. Double-clicking something on the computer screen generally opens whatever item you have double-clicked.

Right-click

Press your right mouse button. When you right-click anything on the computer screen, the program displays a shortcut menu containing commands specific to the selected item.

Click and Drag, and Release the Mouse

Move your mouse pointer and hover it over an item on the screen. Press and hold down the left mouse button. Now, move the mouse to where you want to place the item and then release the button. You use this method to move an item from one area of the computer screen to another.

The Conventions in This Book

A number of typographic and layout styles have been used throughout *Teach Yourself VISUALLY Adobe Photoshop Lightroom 2* to distinguish different types of information.

Bold

Bold type represents the names of commands and options that you interact with. Bold type also indicates text and numbers that you must type into a dialog box or window.

Italics

Italic words introduce a new term and are followed by a definition.

Numbered Steps

You must perform the instructions in numbered steps in order to successfully complete a section and achieve the final results.

Bulleted Steps

These steps point out various optional features. You do not have to perform these steps; they simply give additional information about a feature.

Indented Text

Indented text tells you what the program does in response to you following a numbered step. For example, if you click a certain menu command, a dialog box may appear, or a window may open. Indented text may also tell you what the final result is when you follow a set of numbered steps.

Notes

Notes give additional information. They may describe special conditions that may occur during an operation. They may warn you of a situation that you want to avoid, for example the loss of data. A note may also cross reference a related area of the book. A cross reference may guide you to another chapter, or another section with the current chapter.

Icons and buttons

Icons and buttons are graphical representations within the text. They show you exactly what you need to click to perform a step.

 You can easily identify the tips in any section by looking for the TIPS icon. Tips offer additional information, including tips, hints, and tricks. You can use the tip information to go beyond what you have learned in the steps.

Operating System Difference

The screenshots in this book were taken on a Macintosh computer. Some dialog boxes show OK on a PC where the Macintosh dialog boxes show Create. Preferences are listed under the Edit menu on a PC instead of under the Lightroom menu on a Mac. Everything functions the same way on both systems.

CHAPTER 1

Introducing Photoshop Lightroom

Adobe designed Photoshop Lightroom to help professional photographers manage and edit large numbers of images in a simplified photographic workflow. Lightroom's streamlined interface and modular approach also allow photographers of all skill levels to use this new digital darkroom to organize, edit, and display their photos.

Understanding Lightroom4

Understanding Lightroom's Structure..............6

Using the Lightroom Interface8

Open Lightroom and Click the Modules10

Enlarge the Central Viewing Area12

Create a Practice Lightroom Catalog14

Locate the Practice Lightroom Catalog16

**Remove the Photos from the
 Practice Catalog**..18

Understanding Lightroom

Adobe Photoshop Lightroom is a virtual darkroom and includes a digital version of traditional photographic darkroom tools. You can use Lightroom to import your photos from the camera's memory into the computer and view, rename, and sort them in a variety of ways. You can then use Lightroom to enhance the colors and tone, crop, and more without ever changing the original image. In addition, Lightroom helps you design the style of print layouts and create slide shows and Web galleries to display your photos.

Lightroom Is Perfect for All Photographers

Adobe designed Photoshop Lightroom for professional photographers so they could spend more time with the camera and less time working with their photos on the computer. By simplifying the way the pros work with their images, Lightroom also makes it easier for all types of photographers to organize, edit, and show their photos.

Lightroom Is a Database

Like any other database, Lightroom enables you to organize a large collection of images and information about those images to help you find specific ones quickly and easily. Lightroom automatically enters information about each photo when it is imported. You add information to the database as you rate, sort, and enhance each image.

Lightroom Is an Organizational Tool

Lightroom enables you to view all your photos on a digital light table, scrolling through your entire photo collection at once. You can select individual images or groups of images, assign ratings, separate them into folders, or reorganize them into special collections, all so you can find your photos quickly. The viewing options enable you to easily compare two or more images or view an image at full size or a variety of sizes.

Lightroom Is a Digital Photo Developing Tool and a Photo Editing Tool

Lightroom replaces the chemicals and enlarger of the traditional darkroom with digital developing tools. You can adjust colors and tone, crop and straighten, even convert color to grayscale with immediate visual results. All changes are non destructive, meaning Lightroom never changes the actual pixels in the photo. Instead, it adds the changes you make to the database, like a set of instructions on how you want the image to appear. You can always revert to the original photo file.

Lightroom Is for Presenting Your Photos

You can use Lightroom to set up your print options for any number of photos, or quickly create and play a slide show with a musical background. You can even use Lightroom to create a Web Gallery, ready to upload to a Web site. Lightroom includes a number of templates for all types of presentations, and also enables you to create your own custom layouts.

Lightroom Is Designed to Work with Photoshop or Photoshop Elements

Lightroom does not replace Photoshop or Photoshop Elements. You can use Lightroom alone or in conjunction with one of these applications. You can import, organize, and edit images in Lightroom and then seamlessly adjust them further using Photoshop or Elements for pixel-level enhancements, before bringing the photos back into Lightroom to reorganize, print, or create a slide show or a Web gallery.

Understanding Lightroom's Structure

Lightroom is intended to streamline the digital photographic workflow of downloading the images from a camera and sorting, developing, and sharing them. Lightroom includes many options to accommodate the organizational requirements of all types of photographers. This flexibility can also be confusing to the new user. Understanding Lightroom's structure before you import your photos, and planning where you will store them and the catalog, are important first steps.

The Lightroom Catalog

A Lightroom catalog of photo files functions like a card catalog of books from a public library. The catalog contains specific information about each image and where it is located.

Your Photo Collection

Your entire image collection corresponds to the public library building itself. It includes all your photos, like the building stores the books. The individual photo files may not necessarily be in the same building as the catalog. When you are in Lightroom's Library module, you can view all the images in your photo collection.

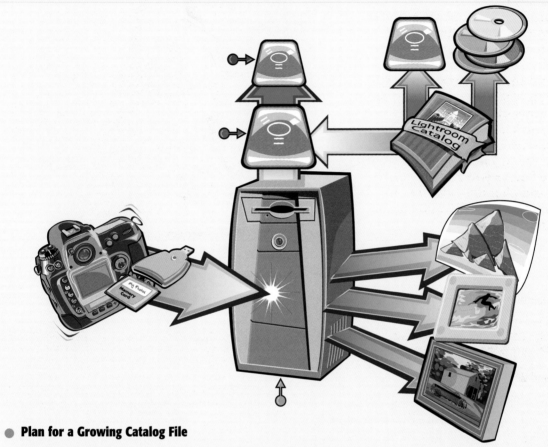

Plan for a Growing Catalog File

Your photo collection requires more storage space as you take and import more digital photos. The size of both the Lightroom Catalog Previews.lrdata file and the Lightroom Catalog.lrcat file also get larger as you import more photos into Lightroom.

Use Additional Internal or External Hard Drives

You can store your photo files as well as the Lightroom catalog and previews on an external hard drive. See Chapter 2 to create a Lightroom catalog in a location other than your computer's main hard drive. See Chapter 14 for information on hard drives.

Back Up Your Photo Files and Lightroom Catalog

You should also plan to back up your digital photo files and your Lightroom catalog regularly. Because hard drives have a limited lifespan, you should maintain a complete backup or duplicate of your photo files on at least one, preferably two separate hard drives. You can copy the files manually or you can use automated back-up software, such as Intego's Personal Back Up for Mac or NTI Shadow for either Mac or PC. You can also make an archive duplicate of your photo files by burning the files to DVD media.

Using the Lightroom Interface

The Lightroom interface is designed to help you focus on your photos at all times, from the general layout, which remains constant throughout the various stages in your photo processing, to the neutral gray and black color scheme, which prevents distracting influences in color perception. Although it may appear daunting at first, Lightroom's interface is very logical and intuitive.

● **Lightroom main menu bar**

The Lightroom main menu bar, as for any other application, includes all the menu options for the open window.

● **Top panel**

The top panel includes the Identity Plate on the left and the Module Picker on the right. The Identity Plate is used for customizing your Lightroom interface, and the Module Picker enables you to change the tools depending on the editing tasks.

● **Central viewing area**

The central content area is for viewing your images. Depending on the module you are in, your photos will appear in Grid Mode with thumbnails in a grid layout, in Loupe mode with one image, or you will see a preview of your print, slide show, or Web gallery page layout.

● **Toolbar**

The Lightroom toolbar displays different types of tools depending on the module you have selected.

● **Left panel**

The left panel contains the tools that relate to viewing content for the open module, such as the folder hierarchy, collections, history, presets, and templates.

● **Right panel**

The right panel contains the organizing and editing tools for the open module, such as key words, image processing, and customizing templates.

● **Filmstrip**

The Filmstrip is constant and shows the thumbnails of the images of the selected folder or collection so you can access the images from any module.

A Consistent Interface

Although the contents and tools of the individual panels change as you click through the different modules, the panel arrangement and overall interface remain constant throughout.

A Customizable Interface

You can modify the general layout, as shown in the tasks in this chapter, to focus on the central viewing area by hiding the left panel, the right panel, or both. You can also hide any of the other panels to expand the main viewing area. The central viewing area is the only panel you cannot hide. The surrounding panels and the options and tools for the central viewing area differ from module to module.

A Platform Independent Interface

Lightroom's interface appears the same whether you use a Macintosh or a Windows computer. The only differences are those related to the operating system itself. For example, Lightroom's preferences are located under the Lightroom menu on a Mac and under the Edit menu on a PC; the menu bar is at the top of the main screen on a Mac and under the application title bar on a PC.

Open Lightroom and Click the Modules

Lightroom's main interface automatically fills your screen area. Despite the seemingly complex main window, Lightroom is a very logical tool for organizing and developing digital photographs. Lightroom's modular design guides you through the steps for digital photo processing and still remains flexible. You can quickly become familiar with the Lightroom interface and photo developing tools by clicking the modules.

Open Lightroom and Click the Modules

① Launch Lightroom.

The first time you open Lightroom, six welcome screens appear in succession.

② Click **Next** to view each welcome screen.

③ Click **Finish** to close the welcome screens.

The main Lightroom window appears with the Library module highlighted.

④ Click **Develop** in the top panel.

The Develop module panels and toolbar appear.

⑤ Scroll down to see more of the Develop module's right panel.

⑥ Click **Slideshow** in the top panel.

The Slideshow module panels and toolbar appear.

⑦ Scroll down to see more of the Slideshow module's left and right panels.

⑧ Click **Print** and **Web** in the top panel to explore those modules' panels.

⑨ Click **Library** in the top panel to return to the main Library module.

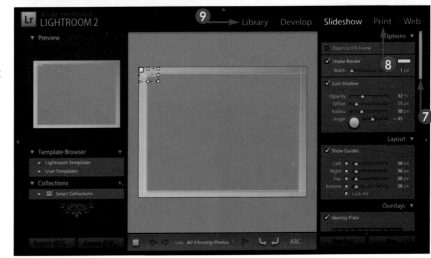

How can I reopen the welcome screens?

When you first install and launch Lightroom, the Five Rules welcome screens appear. You can reopen these at any time if you forgot to read them. Click **Help** in the main menu bar and click **The Five Rules**. When using Lightroom, always remember rule number five — Enjoy.

Why are there two listings for help under the Help menu?

Help for the Lightroom application in general is always at the top of the list under the Help menu. Each module also lists a targeted help selection for that module, along with the specific shortcuts for that particular module, so you can quickly find a topic or a shortcut for that module without having to read through the Help for the entire application.

Enlarge the Central Viewing Area

Lightroom enables you to temporarily hide and show the various panels so you can make the central viewing area larger to focus on your photos. You can hide one or all the panels at one time. You can also make some panels *sticky* or more permanent while others reappear only when you want them to.

① Click the left panel triangle (◀) in the Library module.

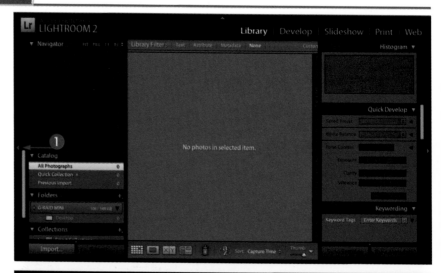

The left panel disappears and the solid triangle changes to a dotted triangle (◀ changes to ◼).

② Position the cursor over the dotted triangle (◼).

The left panel reappears temporarily. The triangle remains dotted.

Note: When you click the triangle again, it turns solid.

③ Repeat Steps **1** and **2** with each of the other three triangles — top, right, and bottom (▲, ▶, and ▼).

The top panel, right panel, and the Filmstrip disappear individually, and the central viewing area adjusts to fill the majority of your screen.

TIPS

Is there a keyboard shortcut to hide and show the panels?

Yes. Press F7 to hide and show the left panel and press F8 to hide and show the right panel. Press Tab to alternately hide and show the side panels. Press F5 to hide and show the top panel. Press F6 to hide and show the Filmstrip and Filmstrip toolbar.

Are there keyboard shortcuts to hide and show the toolbar or all the panels at once?

Yes. Press T to hide and show the toolbar. Press Shift + Tab to hide and show all the panels.

Create a Practice Lightroom Catalog

Unlike software applications that focus on one image or one project at a time, Lightroom builds a continually expanding library of your photos. Understanding where Lightroom stores the photo and data files is essential to creating a logical database of images. You can create a practice catalog with several images and then view the location and file types before you start building your photo library and Lightroom database.

Create a Practice Lightroom Catalog

① Start with two digital photos on your hard drive, or click and drag two image files from a memory card or optical media.

② Launch Lightroom.

③ Click **Import**.

Note: You can also click and drag the digital photo files onto the Lightroom icon to launch the application.

The Import Photos or Lightroom Catalog dialog box appears.

④ Navigate to the practice images on your hard drive.

⑤ ⌘+click (Ctrl+click) individual images to select them or click a folder of images.

⑥ Click **Choose**.

The Import Photos dialog box appears.

⑦ Click **Show Preview** (☐ changes to ☑).

● The dialog box expands to show thumbnails of the selected images.

⑧ Click **Import** to import the photos into Lightroom.

Note: For this practice catalog, you should leave all the other default settings as they are.

The photos are imported into the Lightroom database and catalog.

● Lightroom shows a progress bar on the top left of the screen as it imports the photos.

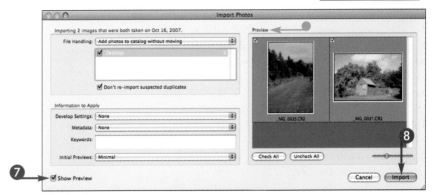

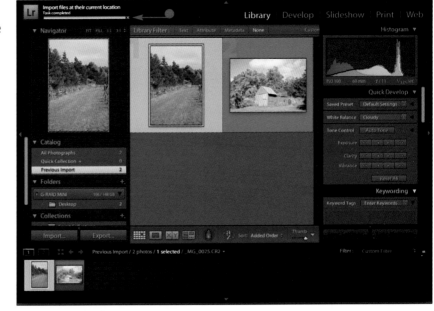

Do I have to import all the photos in the folder?

No. You can change the size of the thumbnail previews using the slider to better view the photos and decide if there are some you do not want to import. By default, all the images are selected. You can individually uncheck those you do not want to import or click **Uncheck All** and then reselect only the photos you want to import. This is particularly useful when you import a large group of images and an image is completely blank or is obviously out of focus.

Locate the Practice Lightroom Catalog

In the previous task, two photos were imported into the Lightroom catalog. The photo files themselves were not moved. Instead Lightroom created a record or link referencing the photo files at their original location. This record is stored in the Lightroom catalog, along with a file of previews of the images. Learning where Lightroom places these data files is key to using Lightroom effectively.

Locate the Practice Lightroom Catalog

1 Click **Lightroom**.

2 Click **Catalog Settings**.

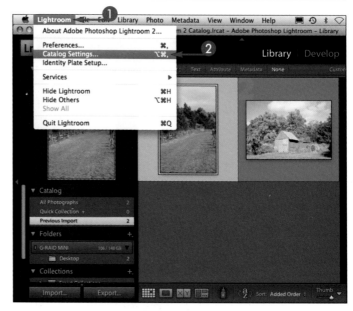

The Catalog Settings dialog box appears.

3 Click **General** if it is not already selected.

4 Click **Show**.

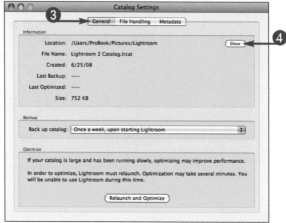

The Pictures folder opens.

Note: *On a PC, the My Pictures folder opens.*

⑤ Double-click the Lightroom folder inside the Pictures folder.

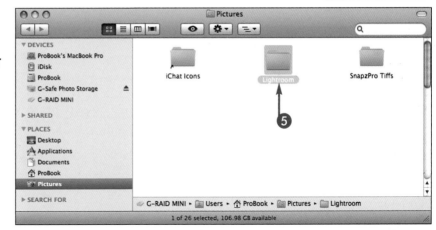

The Lightroom folder opens and displays three files.

● Lightroom Catalog Previews.lrdata stores the photo previews. It is created automatically when you import photos.

● Lightroom Catalog.lrcat stores the practice catalog. It is created when you first launch Lightroom.

● Lightroom Catalog.lrcat.lock is a temporary file while the application is open.

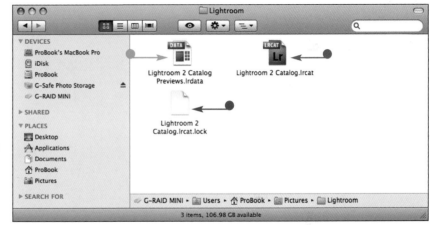

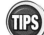

Where does Lightroom save the changes I make to my photos?

All the changes you make to both the organization of your photos and the tonal or other digital developing changes are added as data to the Lightroom catalog file Lightroom 2 Catalog.lrcat.

After I import these two photos, where are the photos stored?

Your original photo files in this exercise are still located on the hard drive where they were. The catalog only contains a reference link to the images, information on how they were taken, and instructions regarding any edits you make. You can choose to copy or move the photos to a different location using the options in the Import dialog box. See Chapter 2 for the different importing options for copying or moving the photo files themselves.

Remove the Photos from the Practice Catalog

You imported two photos into a catalog to see how and where Lightroom creates a catalog and a reference to the images. You can remove these photos from the Lightroom catalog in several ways. Removing photos from a catalog only removes the data about the photos from the catalog. It does not automatically delete the photo files themselves from your hard drive.

Remove the Photos from the Practice Catalog

REMOVE THE PHOTOS WITH A KEYSTROKE

1 In the central viewing area or in the Filmstrip, `Shift`+click the two images to be removed from the catalog.

2 Press `Delete` (`Backspace`).

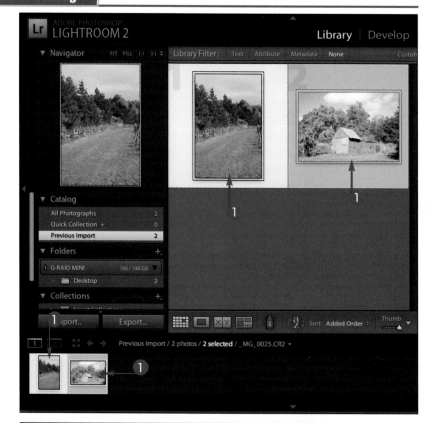

A dialog box appears.

3 Click **Remove**.

The photos are removed from the catalog, but the photo files are still in their original location.

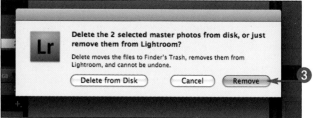

chapter 1

REMOVE THE PHOTOS USING THE MENU

1 In the central viewing area or in the Filmstrip, Shift+click the two images to be removed from the catalog.

2 Click **Photo**.

3 Click **Remove Photos from Catalog**.

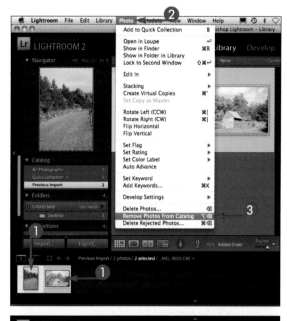

The photos are removed from the catalog, but the photo files are still in their original location.

TIP

Can I delete the practice catalog instead?

Yes, if you are comfortable deleting files from your computer. With the Lightroom application closed, double-click your hard drive to view its contents. Navigate to the Pictures (My Pictures) folder. Select the Lightroom folder and put it in the trash. The next time you launch Lightroom, a completely new Lightroom catalog will be created. If you delete only the two files Lightroom Catalog Previews.lrdata and Lightroom Catalog.lrcat, the next time you launch Lightroom, a dialog box appears asking you to find the catalog or create a new one. See Chapter 2 to understand the options for creating a new catalog or a second catalog.

Getting Your Photos into Photoshop Lightroom

With photographers taking more photos digitally than with traditional film cameras, sorting photos and finding a particular image from so many files with the cryptic names that the cameras apply can be difficult. One of the purposes of Lightroom is to streamline the management of large numbers of photos by importing them into a structured filing system and cataloging them in a logical manner. You can import photos in various ways depending on the photo library structure you build. You can also store your photo library on external hard drives, giving you added storage space while keeping your catalog organized.

Understanding Lightroom Catalogs and Image Storage22

An Overview of Lightroom's Import Process24

Understanding File Formats26

Import Photos at Their Current Location28

Import Photos from a Memory Card30

Import Photos and Change Format to DNG ..32

Be Consistent with File Names34

Import Photos and Change Names36

Rename Photos after Importing37

Understanding Lightroom's Naming Template Presets38

Create Your Own Naming Template Preset40

Create a New Catalog44

Import Photos from an Existing Catalog46

Automate the Import Process48

Back Up During Import50

Build a Lightroom Library with External Drives ...52

Combine a Travel Catalog with Your Main Lightroom Library ...56

Understanding Lightroom Catalogs and Image Storage

Lightroom differs from other image-editing applications. Instead of applying changes directly to a photo file, Lightroom writes the adjustments you make into a data file and links the data file to the photo file. All this information is kept in a Lightroom *catalog*. The images themselves are stored separately. To be most effective, you need an organizational system for storing Lightroom catalogs and the photo files.

Organization and Customization

The user's Picture folder on the internal hard drive is Lightroom's default location for storing the catalog, the previews, and the photo files. You can choose to store these together or separately on the internal drive, on external drives, or combinations of each depending on the size of your drives and the photo library you plan to build.

The Library Concept

Lightroom maintains a catalog with information about all the photos, similar to a card catalog at a public library. It also creates and keeps a file of previews of each photo, like a book catalog with tiny pictures of the book covers. The photo files themselves, like the books at the public library, can be housed in a different physical location.

The Lightroom Catalog and Other Necessary Files

When you import images into Lightroom, two database files are automatically created. One is called *catalogname*.lrcat and keeps the data about the images including the metadata, rating keywords, collections, and image location. The other is called *catalogname* Previews.lrdata and contains a database of the image previews. These two files should be kept together.

Photo Files

The images themselves can be left in their current location, moved, or copied to another location during the import process. Depending on your storage configuration, you might first copy these files directly from the memory cards to a folder in the final location and then import them into Lightroom, or you might copy them during import directly to the new storage location.

Catalog Backup File

Lightroom can automatically create a duplicate or *backup catalog* in a separate location. In the Catalog Settings Preferences under the General tab, you can set Lightroom to schedule a backup of the catalog, preferably every time Lightroom starts. When next launched, Lightroom creates a duplicate of the *catalogname*.lrcat file and places it in a new dated folder in the location you specify.

An Overview of Lightroom's Import Process

When Lightroom imports photos, it records all the data about the photos, including a link to the storage location, in a catalog. You decide where the actual photo files will be stored using the options in the Import dialog box. You can also select what file format to save the photos in, how to name them, and even add information to make searching easier.

Location of the Source Images

Lightroom can import photo files directly from memory cards or removable media such as CDs or DVDs, as well as from other separate hard drives and digital photo viewers where you copied your photos when traveling.

The Import Location

When importing, you can leave the photo files at their current location if they are already on the intended storage drive or make a complete duplicate of the files by selecting one of the copy options in the import dialog box. You can even choose to move the files from one location to a new one during the import process.

The Import Process

Understanding the import process is the key to using Lightroom. With other image editing applications, you *open* an image to view and edit it. However, because Lightroom functions both as a database and an image editor, the images must be *imported* rather than just opened.

Rename or Move Imported Photos

The photo files for your imported images can be located in different locations, not just on one hard drive. Because Lightroom catalogs the files and includes a reference to their location and name, you should use Lightroom and not the Finder (Explorer in Windows) to rename or move any photo files after they have been imported.

● Become a Photo Library Architect

A first step is to design your photo library, planning where the images will be stored and how you will name the files and folders. When you do so, you can create a more efficient photo filing system and take full advantage of digital search capabilities. The design depends on your available storage space and back-up plan, as well as your own sorting requirements.

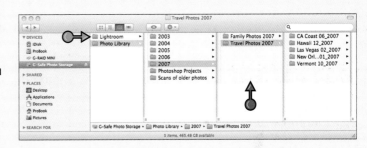

● Set Up Folders and File Names in Advance

You can set up and name folders at the storage location in advance to make the import process more logical. In Lightroom's Library module, you can create a naming template or system for naming your photos. You can then choose to apply the new file names when Lightroom imports the photos or later when you edit them.

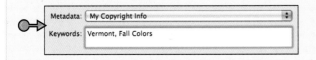

● Add Keywords and Metadata During Import

The options in the Import dialog box enable you to add settings, keywords, and other pertinent information to a whole set of photos during the import process. You can add more detailed metadata later when viewing your photos in the Library module. See Chapter 3 for more about the Library module.

Understanding File Formats

A file format, designated by a 3- or 4-character code after the file name, tells the computer what type of information is encoded in the file. Photographic images have various file formats depending on the source. Lightroom can process most photographic file formats including most camera manufacturers' proprietary RAW files, DNG, JPEG, TIFF, and PSD.

File Formats

The list that follows defines various file formats.

RAW

A RAW file is the most direct representation of what the camera sensor captures. The data in a RAW file, such as white balance, sharpening, and color, is not processed or compressed in the camera. RAW files are truly your digital negatives.

JPEG

A JPEG is the most commonly used photographic file format. To produce a JPEG file, the camera processes and compresses the data captured by the image sensor. Some image data is lost during compression, which can cause unwanted *artifacts*, or white pixels, when the JPEG is enlarged.

TIFF

A TIFF or TIF file is used for various applications from image editing to document imaging. A TIFF can be a large file and can include multiple layers.

PSD

A PSD is the standard file format produced by Photoshop and Photoshop Elements. A PSD is also a large, uncompressed file and can include multiple layers.

XMP

XMP is a metadata file that you can embed or attach as a sidecar file into a manufacturer's RAW photo file. An XMP sidecar file travels with the photo file and includes information such as exposure, image size, copyright, and any edits you make to the photo in Lightroom.

DNG

DNG is a RAW format developed by Adobe as an open standard for camera files and is available to all camera manufacturers. Lightroom includes a DNG converter to change a manufacturer's proprietary RAW file into a DNG. A DNG has lossless compression, meaning no data is deleted during the processing. Any edits in Lightroom are written into the DNG file.

Differences between JPEG, RAW, and DNG

Most digital cameras can create JPEGs and sometimes TIFFs. Advanced cameras can also write a manufacturer's proprietary camera RAW format, such as NEF or CR2. Some cameras can produce DNGs, a more universal RAW file format. The manufacturer's RAW files require specific software to convert the file in the computer; however, RAW files give the photographer more options for editing the photos.

The Advantages of RAW

Shooting JPEGs is faster than shooting RAW files. However, when shooting JPEGs the camera processor applies *lossy* compression, a type of compression that discards, or loses, some of the pixel data as the camera records and processes the photo. By contrast, a RAW file contains the complete, unprocessed pixel data as captured by a camera sensor. The RAW file format allows the photographer to manipulate the actual data to improve colors, tone, and more during image editing.

The Advantages of DNG

The digital photo industry is quickly evolving. Each camera manufacturer has its proprietary RAW format, and all may not be supported later on. Although you can save photos in the RAW file format, converting these to DNGs in Lightroom and archiving the DNG photo files instead avoids obsolescence or compatibility problems in the future and offers additional advantages. DNGs use lossless compression, thereby reducing file size 10 to 40 percent compared to RAW files. With DNG files, metadata can be written directly into the file structure, eliminating the need for XMP sidecar files as with RAW files. Finally, the previews stored with DNGs are updated to represent the edit settings you have applied to the photo.

Import Photos at Their Current Location

You probably have folders of photos on your computer or another hard drive. If you already have an organized photo folder system in place, you can import the existing folders or individual photos into Lightroom and leave the files in their current location, making the import very quick. Lightroom creates a link to the files so it can manage the images in the catalog.

Import Photos at Their Current Location

① Launch Lightroom.

② Click **Import** to start the import process.

Note: *Optionally, click* **File** *and then click* **Import Photos from Disk**.

The Import Photos or Lightroom Catalog dialog box appears.

③ Navigate to the folder or individual photos.

④ Click the folder to select it.

Note: *Optionally,* ⌘ *+click (* **Ctrl** *+click) the individual photo files to select them.*

⑤ Click **Choose**.

The Import Photos dialog box appears.

6 Click **Show Preview** to view the previews of the photos (☐ changes to ☑).

● Click to deselect any photos you do not want to import (☑ changes to ☐).

7 Click **Import**.

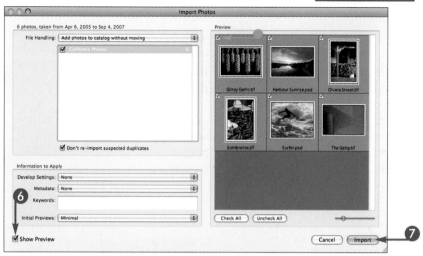

The photos are imported to the catalog, leaving the files at their original location.

8 Click the **Thumbnails** slider (▲) and drag to the right to see larger thumbnails.

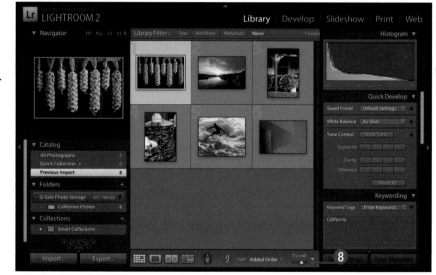

TIPS

Is there a disadvantage to showing the previews before importing my photos?

Showing previews takes time. If you import hundreds of photos at once, you can uncheck **Show Preview** in the Import photos dialog box. Once you click the **Show Preview** check box, it remains checked even after you close the Lightroom application until you uncheck it.

Where does Lightroom save the catalog?

The default location for the Lightroom catalog on a Mac is in the Pictures folder of the user's home folder, and in the My Pictures folder inside the My Computer folder on a PC.

Import Photos from a Memory Card

When you transfer photos from a memory card to your computer, you should copy the photos to a new location and import them into the Lightroom catalog. You have many options in the Lightroom Import dialog box when you move or copy photos from one location to another.

Import Photos from a Memory Card

① Launch Lightroom.

② Insert a memory card with photos into a card reader connected to your computer.

The Import Photos from *Your Memory Card Reader* dialog box appears.

③ Click **Choose** to select the location to copy the files.

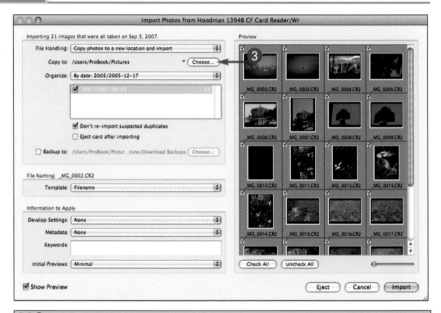

The Choose Folder dialog box appears with the Pictures (My Pictures) folder selected by default.

④ Navigate to your photo storage location on your selected hard drive.

⑤ Click **Choose**.

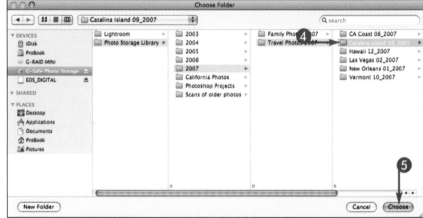

Lightroom returns to the Import Photos dialog box.

6 Click the **Organize** :.

7 Click **Into one folder**.

Note: *Optionally, you can import the photos by their existing folders or into folders designated by the date the photos were taken.*

8 Click to uncheck any photos in the Preview panel you do not want to import at this time (☑ changes to ☐).

9 Type keywords that relate to the whole series of photos.

10 Click **Import**.

Lightroom copies the photos to the designated folder in the new location and enters the data into the catalog.

● A descriptive progress bar appears in the top left corner.

● Any keywords appear in the Keyword List on the right panel.

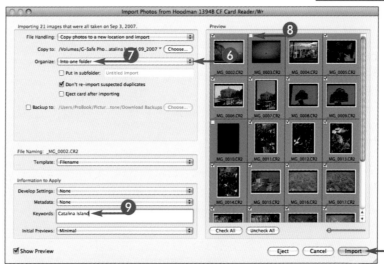

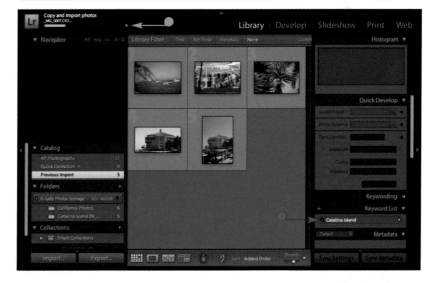

Import Photos and Change Format to DNG

RAW files offer more creative control for editing; however, they must be converted in the computer either by the camera manufacturer's software or by digital imaging software such as Lightroom or Photoshop. With the digital imaging industry constantly changing, some camera-specific RAW files may prove to be a challenge to open in the future, depending on both software updates and changes in computer operating systems. You can convert your RAW files to Adobe's DNG open-standard RAW files, for archiving and to ensure you will always be able to open them.

Import Photos and Change Format to DNG

1 Launch Lightroom.

2 Insert a memory card with photos into a card reader connected to your computer.

The Import Photos from *Your Memory Card Reader* dialog box appears.

3 Click the **File Handling** [⬍].

4 Click **Copy photos as Digital Negative (DNG) and import**.

5 Click **Choose** to select the location to copy the files.

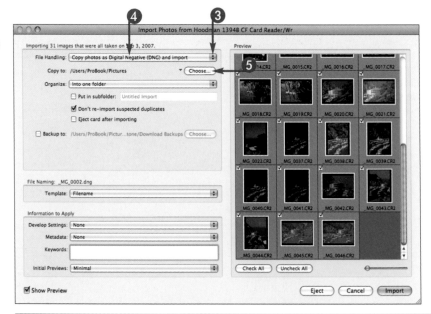

The Choose Folder dialog box appears.

6 Navigate to a folder to import the DNG files.

● Click **New Folder** to create and name a folder in which to store the DNGs.

7 Click **Choose**.

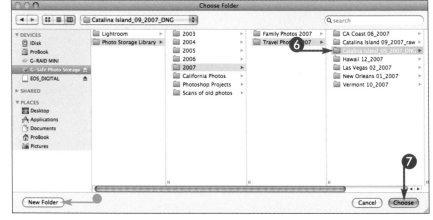

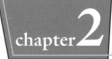

8 In the Import Photos dialog box, click the **Organize** ⬙.

9 Click **Into one folder**.

10 Click **Don't re-import suspected duplicates** (☐ changes to ☑).

11 Click **Eject card after importing** (☐ changes to ☑).

12 Type some keywords applicable to all the photos to be imported.

13 Click the **Initial Previews** ⬙.

14 Click **Standard**.

Note: Importing with Standard rather than Minimal previews selected takes longer. However, once imported, Lightroom will have previews that match the minimum requirement for working in the Library. You can import with Minimal previews and then let Lightroom render the larger previews all at once before you work with your photos.

15 Click **Import**.

The photos are imported into the Lightroom database and cataloged and the photo files are copied as DNGs to the new folder.

TIPS

Why did another dialog box appear as I was importing?

Lightroom did not re-import any photos it had already imported (●) into the catalog because you checked the box next to **Don't re-import suspected duplicates** in Step 10. Click **OK** to continue or click **Show in Library** to verify their existing location.

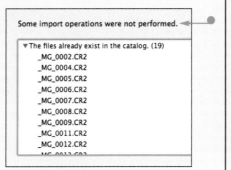

Why does storing a DNG instead of a camera manufacturer's RAW file save space?

Not only does the DNG start out slightly smaller in file size than a camera RAW file because it uses lossless compression, it also writes the data of the changes you make when editing the file, such as white balance or color settings, directly into the file instead of having to create a sidecar XMP file.

Be Consistent with File Names

Each digital camera manufacturer applies a name and sequential number to your photos as you shoot. Finding a specific photo named MG0022.CR2 or DSCN0340.JPG can be difficult. You can change the file names to something that is relevant to the photo or date taken using Lightroom. It is essential that you be consistent with your photo file names to take advantage of Lightroom's cataloging benefits, and to find your photos quickly in the future.

Rename at Different Times

You can rename a group of images all at once as you import them, or rename the files when they are in the Lightroom catalog using the Library module. You can also rename the files when you export them. See Chapter 3 for more about the Library module.

Rename or Renumber

You can add specific information for a location or add a date designation, leaving the existing camera-applied file number. You can also rename the images completely, giving them a distinct name and sequence number.

Rename Consistently

Whether you rename or not, you should keep all stored versions of a photo file, from RAW to DNG or JPEG, with the same name for a consistent and organized catalog.

Rename Logically

You can create a name that includes the location, event, or included subjects and then add a sequence number for a particular set of images. You should not have a file name longer than 31 characters, so that other applications, such as Bridge, can access the file.

Special Renaming Situations

Although renaming files is not absolutely required for a Lightroom catalog, you must rename the files in two instances to avoid data collisions if different photo files have identical file names. First, if you changed the numbering in the camera from continuous to auto reset, each time you insert an empty memory card, the camera assigns files names staring with 0001. Second, if you shoot with two cameras of the same brand, separate images from each camera will have duplicated names and numbers.

Import Photos and Change Names

You can change the camera-applied name of photo files as you import the data into the Lightroom catalog if you select copy, move, or copy as DNG in the File Handling section of the import dialog box. You cannot change the file names when you import if you choose to import photos at their current location.

Import Photos and Change Names

① Launch Lightroom.

② Insert a memory card with photos into a card reader connected to your computer.

The Import Photos from *Your Memory Card Reader* dialog box appears.

③ Click the **Template** ⬍ in the File Naming section.

④ Click **Custom Name**.

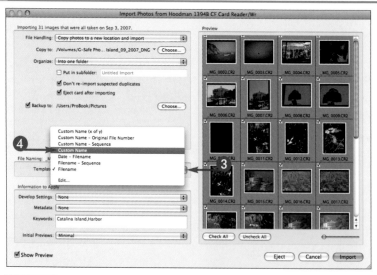

A Custom Text box opens.

⑤ Type a name for all the files, such as Catalina.

⑥ Click **Import**.

The files are imported and renamed as Catalina.CR2, Catalina-1.CR2, Catalina-3.CR2.

The files are automatically numbered sequentially as imported.

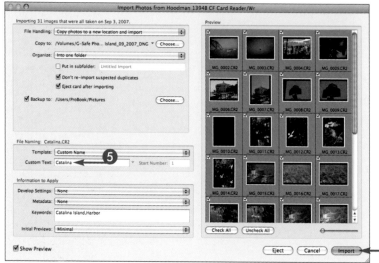

Rename Photos after Importing

The Library module enables you to rename one photo file or a group of files after you import them into the Lightroom catalog. Renaming after importing does not copy or move the files to a new location.

Rename Photos after Importing

1. Open Lightroom and click the Library module.

2. Shift +click a series of photo thumbnails to select them.

Note: Optionally, ⌘ +click (Ctrl +click) individual photo files to select them.

3. Click **Library**.

4. Click **Rename Photos**.

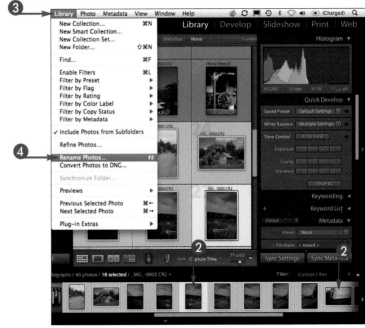

The Rename (number of photos) Photos dialog box appears.

5. Click the **File Naming** ⬦.

6. Click **Custom Name**.

7. Type the custom name in the text box.

8. Click **OK**.

● The files are renamed as in the previous task.

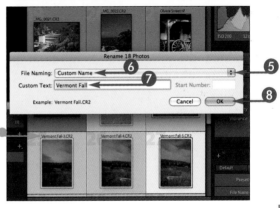

Understanding Lightroom's Naming Template Presets

When you rename photos, you can also select Edit from the File Naming drop-down menu in the Rename Photos dialog box. You can edit Lightroom's naming template presets to create your own custom template. Using the Filename Template Editor, you build your naming template preset using blue placeholders called *tokens* for the information to be inserted in the new file name. You can save your custom filename template as a preset and use it for consistency with all import, renaming, and export operations.

Lightroom Filename Template Presets

Custom Name. Names the photos using your text.

Custom Name (x of y). Applies your text, followed by sequential numbers in relation to the total number of photos being imported at that one time, as in 1 of 10. The next time you use that naming template it restarts as in 1 of 7, 2 of 7.

Custom Name – Original File Number. Applies your text followed by the photos' original number.

Custom Name – Sequence. Applies your text followed by sequential numbers starting with the number you specify at each import session.

Date – Filename. Applies the creation date, followed by the photos' current file names.

Filename. Applies the current file names.

Filename – Sequence. Applies the photos' current file names, followed by sequential numbers starting with the number you specify.

Lightroom Filename Tokens to Insert for Custom Template Presets

Image Name Tokens

Filename. Includes the existing filename.

Filename number suffix. Includes the existing number suffix, such as 0019.CR2.

Folder name. Adds the name of the enclosing folder to the filename.

Original filename. Adds the original filename from the camera.

Original number suffix. Includes the original number suffix from the camera.

Copy name. Only numbers the photos starting with no number, then 1, and so on.

Sequence and Date Tokens

Sequence # (1) – Sequence # (00001). Adds a sequential number starting with the number you specify at the time of import or renaming.

Image # (1) – Image # (00001). Adds a sequence number for the files imported or renamed at one time and is cumulative across imports, as in 2-1, referring to the second photo of the first import session, or 5-10 as the fifth photo of the tenth import or renaming session.

Total # (1) – Total # (00001). Adds the total number of files imported or renamed at one time, as in 5-1, referring to the first photo of 5 total imported, and 10-3 being the third of 10 on the next import.

Date. Adds the day, date, or time the photo was taken using the EXIF information embedded in the photo file. You can use Lightroom's date tokens or combine several individual date tokens to create a custom date-naming template.

Metadata Tokens

Metadata tokens. Available only in the Filename Template Editor for renaming or exporting photos, metadata tokens add camera model or other detailed information.

Custom Tokens

Custom Text tokens let you write out specific information such as a location or project or person's name.

Additional Import Token

When you access the Filename Template Editor from the Import Photos dialog box, the token options are slightly different and include the Import # token: **Import # (1) – Import # (00001)**. This token adds the number of times you use the Import feature and is cumulative across imports: 5-2 is the fifth import session, second photo; 5-3 is the fifth import session, third photo.

Create Your Own Naming Template Preset

You can create your own naming template preset and use it for all your imports. Adding a Custom Text token, you can change the name of a set of photo files to correspond with the location of the shots, the name of a person, or any project name. Adding Date tokens automatically adds the date or time each shot was taken.

Create Your Own Naming Template Preset

1. Click a photo in the Library module to select it.

2. Click **Library**.

3. Click **Rename Photo**.

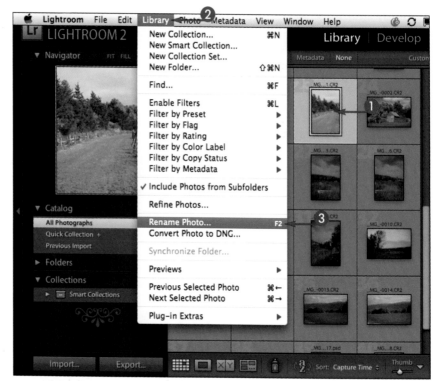

The Rename Photo dialog box appears.

4. Click the **File Naming** [⬍].

5. Click **Edit**.

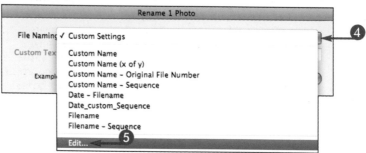

The Filename Template Editor appears.

6️⃣ Click in the text box, which shows the Filename token.

7️⃣ Press Delete (Backspace).

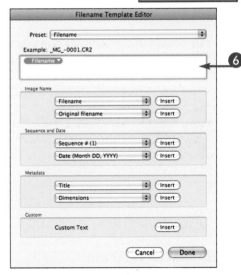

● The Filename token is removed and the Preset is renamed Filename (edited).

Note: *The following steps show one option for creating a naming template preset. You can customize your own template by selecting different options.*

8️⃣ In this example, click the Date 🔃.

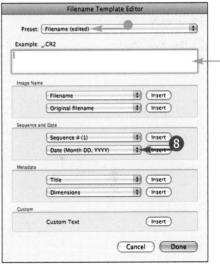

Can I add as many tokens as I want for my filename template?

No. A complete file name should be no longer than 31 characters, including the file type extension. You can count the characters in the example file name that appears above the text box with the tokens in it.

Do I have to create separate templates for importing and exporting?

No. Once you create a File Naming Template and save it as a preset, it appears listed in the File Naming drop-down menu in the Import, Rename, and Export dialog boxes.

continued

Create Your Own Naming Template Preset (continued)

You can create a completely new template preset for file naming, or you can start with any of Lightroom's existing template presets and add tokens where you want different options to appear. You can separate the tokens with underscores or hyphens, or run the tokens together in one string.

The example in this task uses one selected photo to access the Filename Template Editor but does not actually rename that photo.

Create Your Own Naming Template Preset *(continued)*

⑨ Select **Date (YYYY)** from the list that appears.

● A Date token is automatically placed in the text box.

Note: *If the Date token is not placed in the text box automatically, click **Insert** by the Date option.*

⑩ Click in the text box to deselect the Date token.

⑪ Press `Shift`+`-` to place an underscore after the Date token.

⑫ Click **Insert** in the Custom Text field.

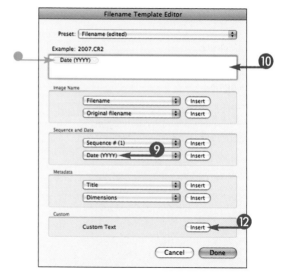

● A Custom Text token in placed after the underscore in the text box.

Note: *The token is a place-holder. When you select your filename template preset for renaming, importing or exporting, a text box will appear for typing the custom text.*

⑬ Repeat Steps **10** and **11** deselecting the Custom Text token and adding an underscore.

⑭ Click the **Sequence** 🔽.

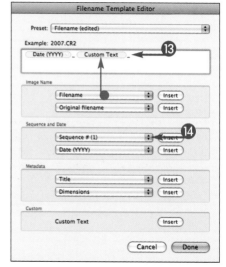

⑮ Select **Sequence # (0001)**.

● A Sequence # (0001) is inserted into the text box.

⑯ Click the **Preset** ⬙.

⑰ Select **Save Current Settings as New Preset**.

⑱ In the New Preset dialog box, type a name for the new file-naming template preset.

⑲ Click **Create**.

● The new Preset with your custom name appears in the Filename Template Editor.

⑳ Click **Done**.

㉑ Click **Cancel** in the Rename 1 Photo dialog box.

*Note: Optionally, you can click **OK** in the Rename 1 Photo dialog box to rename the one selected photo. Your new Filename Template Preset has been saved for future use.*

From now on, when you import, rename, or export images, your custom template preset appears in the File Naming drop-down menu. After selecting your custom template preset, you can type any custom text, such as a location, in the Custom Text field that appears in the Rename, Import, or Export dialog boxes.

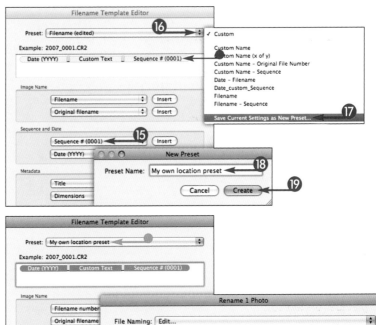

I use two cameras but I want to keep the original file names. Can I still avoid data collisions when I import?

Yes. You can create a custom filename template to distinguish photos taken with the two camera bodies and still preserve the original file names. Create a file name template with a Metadata token for Serial Number and a token for Filename. Lightroom adds each camera's serial number to the corresponding file name and adds the original file number. You can also use a Make token if you have two different brands of camera bodies, or a Model token if the models are different.

Create a New Catalog

The first time you launch Lightroom, it automatically creates a catalog in the user's Pictures (My Pictures) folder, the default location. You can create a new catalog in two different ways depending on whether Lightroom is open or closed.

Create a New Catalog

CREATE A NEW CATALOG WITH LIGHTROOM CLOSED

① Press and hold the **Option** (**Alt**) key as you launch the Lightroom application.

The Adobe Photoshop Lightroom – Select Catalog dialog box appears.

② Click **Create New Catalog**.

The Create Folder with New Catalog dialog box appears.

③ Navigate to and click the name of the storage location for the new catalog.

Note: *Optionally, click* ***New Folder*** *and name the folder.*

④ Type a name for the new catalog in the Save As text box.

⑤ Click **Create**.

Lightroom launches and opens the new catalog.

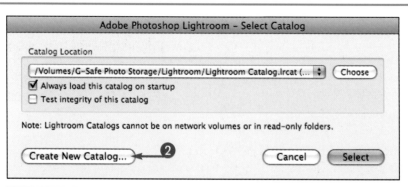

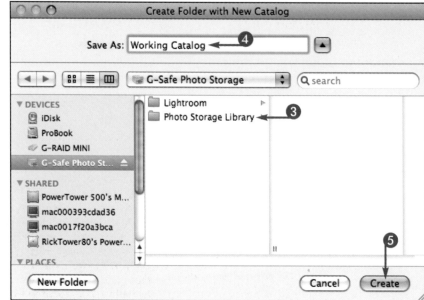

CREATE A NEW CATALOG WITH LIGHTROOM OPEN

1 In the Library module, click **File**.

2 Click **New Catalog**.

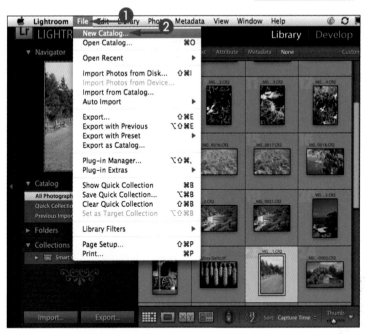

A Create Folder with New Catalog dialog box appears.

Note: *Optionally, click the down arrow (▼ changes to ▲) to expand the dialog box.*

3 Navigate to and click the name of the storage location for the catalog.

4 Type a name for the new catalog in the text box.

5 Click **Create**.

Lightroom relaunches and then opens the new catalog.

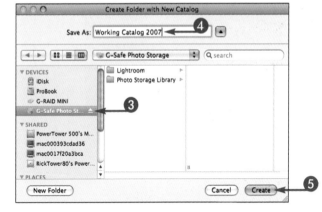

 TIPS

Can I make Lightroom always open my new catalog by default?

Yes. In the Select Catalog dialog box, check **Always load this catalog on startup** (☐ changes to ☑).

Can I open multiple catalogs at one time?

No. Although you can store multiple catalogs, such as a travel catalog, a family photo catalog, and a work projects catalog, Lightroom can recognize only one open catalog at a time. To switch to another catalog, click **File** and select **Open Catalog**. Lightroom closes and then relaunches with the other catalog. Multiple catalogs can share and display the same images from one storage location.

Import Photos from an Existing Catalog

You may have already created a Lightroom catalog and need to import specific photos or a group of photos to another catalog. You can have multiple catalogs, each with their own Catalog.lrcat file and Previews.lrdata file. You can also consolidate all your catalogs into one by importing the photos to a new or separate catalog.

Import Photos from an Existing Catalog

① Open Lightroom with a new or different catalog.

② Click **File**.

③ Click **Import from Catalog**.

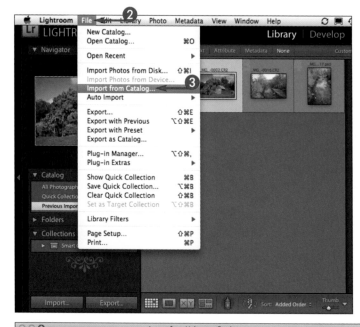

The Import from Lightroom Catalog dialog box appears.

④ Navigate to and click to select the catalog from which to import.

⑤ Click **Choose**.

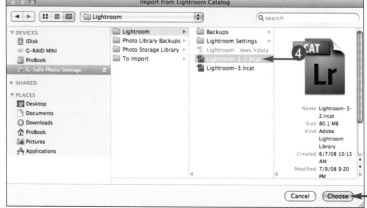

The Import from Catalog dialog box appears with the existing catalog's name in quotation marks.

6 Click **Show Preview** (☐ changes to ☑).

7 Click to uncheck **All Folders** (☑ changes to ☐).

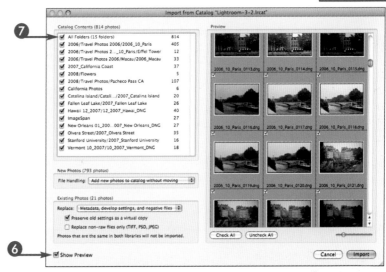

8 Click an individual folder of images from the existing catalog (☐ changes to ☑).

9 Click the **File Handling** ⊞ and select **Add new photos to catalog without moving**.

Note: *Optionally, in the Preview area, click to deselect any individual photos you do not want in this new catalog.*

10 Click **Import**.

The selected photos are imported into the new catalog without moving the photo files from their current storage location.

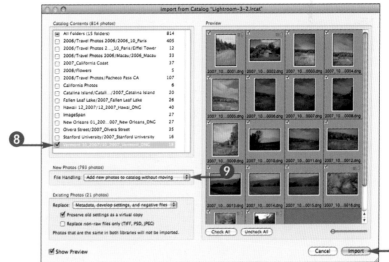

TIP

What are the different Replace options in the Existing Photos section?

Lightroom analyzes both catalogs before it opens the dialog box. If any photos are already in the catalog, the existing photos display an alert (●). You can choose (●) to replace nothing, replace the metadata and develop settings, or replace the photo files as well. You can also save a copy of the older settings with a virtual copy (●) of the photo to preserve your previous work to the files.

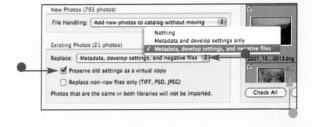

Automate the Import Process

By default, Lightroom automatically launches the Import dialog box whenever a memory card is detected. Many photographers find this action disruptive and turn the option off in the Preferences. Instead, they use the Auto Import feature and set Lightroom to automatically import photos placed in a specific *watched* folder.

You can also use the watched folder for shooting tethered, with the camera connected directly to the computer, without using a memory card.

Automate the Import Process

1. Create a new empty folder in a convenient location such as the desktop.

2. Name the folder Photos to Import.

Note: You can name your watched folder anything that fits your naming system.

3. Click **File**.

4. Click **Auto Import**.

5. Click **Auto Import Settings**.

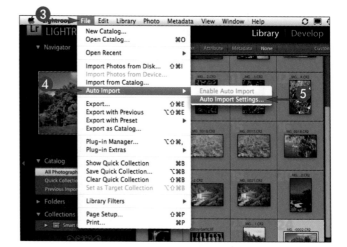

The Auto Import Settings dialog box appears.

6. Click **Choose** in the Watched Folder section.

● The Auto-Import from Folder dialog box appears.

7. Navigate to and select the Photos to Import folder you created in Step 1.

8. Click **Choose**.

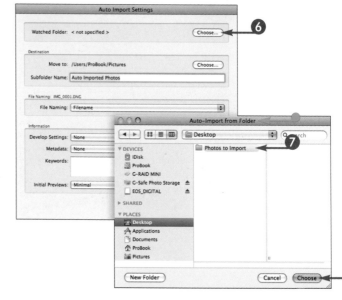

● The Photos to Import folder is listed as your Watched Folder in the Auto Import Settings dialog box.

9 Click **Choose** in the Destination section.

● The Choose Folder dialog box appears.

10 Navigate to and select a location to store the imported photos folder.

Note: The default location is the Pictures (My Pictures) folder on your main hard drive.

11 Click **Choose**.

● The Auto Import dialog box now shows both the name and location of your Watched Folder and the destination of the Auto Imported Photos subfolder.

12 Click **OK**.

13 Click **File**.

14 Click **Auto Import**.

15 Click **Enable Auto Import**.

The Auto Import feature is now activated and Lightroom automatically imports any photos placed in the watched folder into the Imported Photos folder.

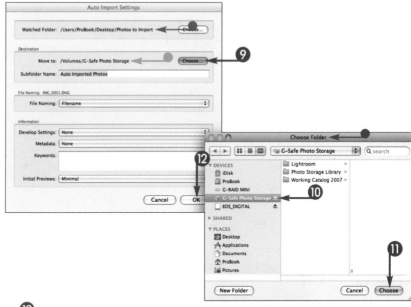

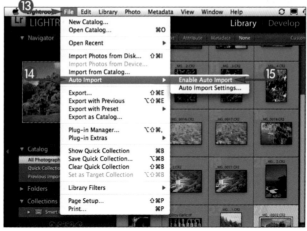

How can I stop Lightroom from automatically opening the import dialog box when I connect a memory card?

Click **Lightroom** and then click **Preferences** (click **File** and then click **Preferences** in Windows) to open Lightroom's preferences. Click the **Import** tab and click **Show import dialog when a memory card is detected** (☐ changes to ☑).

What do I need to shoot directly from the camera into the computer without using a memory card?

Connect your camera to the computer using the USB cable that came with the camera. You also need software to go between your camera and Lightroom. Canon includes the Canon EOS Viewer free with their cameras. You can purchase other manufacturers' software, such as Nikon's Camera Control Pro 2, if it is not included. Set the camera software to download images to the watched folder you create in Lightroom.

Back Up During Import

You can set Lightroom to automatically make a backup of the files as you import them. This is particularly important when you import images from a memory card or other removable media that you plan to reformat and reuse to continue shooting.

The last chapter of this book examines a variety of backup hardware options.

Back Up During Import to the Same Drive

When you are working in the field during a photo trip and have only a laptop for photo storage, you can have Lightroom back up the photo files to a separate location and folder on your hard drive.

Back Up During Import to an External Hard Drive

You can set Lightroom to import and store the photo files on your main storage drive and back up the files at the same time to a separate external hard drive. This duplicate is more secure than two separate folders on one hard drive in case of hard drive failure.

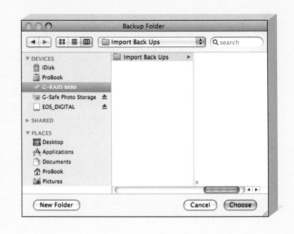

Set an Automatic Backup in the Import Dialog Box

Click **Backup to** (☐ changes to ☑) in the Import Photos dialog box and click **Choose**, and then select the location for the backup folder in the dialog box that appears. When you click **Import** in the Import Photos dialog box, the backup process becomes automatic and simultaneous.

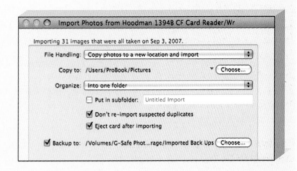

Back Up Folder Name

When Lightroom backs up the files during import, it creates a backup folder named by the date of the import. All the backed-up photos on April 6, 2008, even from multiple import sessions or photos taken in 2007, will be in the Imported on April 6, 2008 folder.

More Backups

You can back up photo files automatically only if you are copying or moving photos. When you import photos at their current location, the automatic backup option is not available. You should always maintain at least two copies of all your valuable photo files on separate devices. You should also keep a backup copy of the Lightroom catalog to save any editing changes you make in Lightroom to the photos.

Build a Lightroom Library with External Drives

The user's Picture folder on the internal hard drive is Lightroom's default location for storing the catalog, previews, and photos. You can instead use larger external hard drives to store your entire photo library and another separate drive to store the backup of the photo files.

In this scenario, the photos are on a Digital Foci Picture Viewer and need to be copied and imported into Lightroom. The same scenario could be used for copying and importing from any type of travel hard drive or any other media with photos.

Build a Lightroom Library with External Drives

① Turn on the picture viewer and connect it to the computer with the USB cable.

● The Picture Porter Elite appears as an external drive named HARDDISK, on the desktop.

② Double-click the main external photo storage drive.

③ Create a new folder called **To Import**.

● You can create and name a specific folder to store the copied files within the To Import folder.

④ Double-click the picture viewer drive.

⑤ Navigate to the photos on the viewer.

⑥ Click ⌘+Ⓐ to select all the individual photos.

⑦ Click and drag the photos into the To Import folder, or the specific named folder inside.

The photos are manually copied to the main external storage drive.

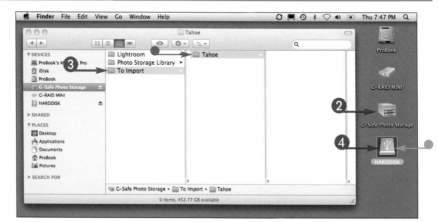

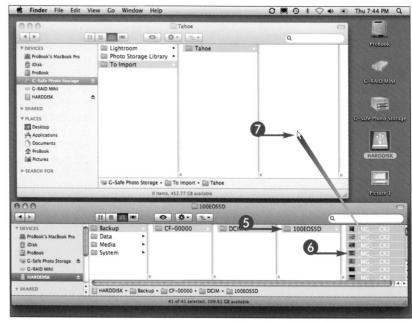

8 Launch Lightroom.

Lightroom opens in the Library module.

9 Click **Import**.

● The Import Photos or Lightroom Catalog dialog box appears.

10 Navigate to and click the **To Import** folder or select the specific folder if you created one in Step **3**.

11 Click **Choose**.

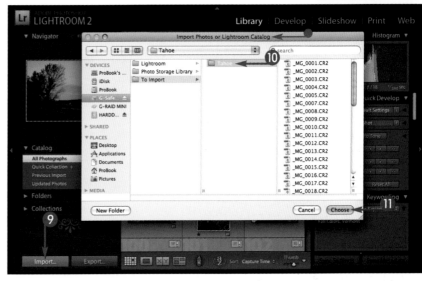

The Import Photos dialog box appears.

12 Click **File Handling** and click **Copy photos as Digital Negative (DNG) and add to catalog**.

13 Click **Choose**.

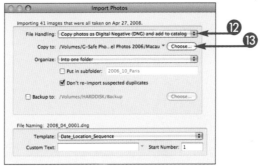

 TIPS

Are there other advantages to using external drives to store the catalog and photos?

Yes. As your photo collection gets larger, Lightroom's catalog and preview files also increase in size. External hard drives provide more storage room. In addition, having the catalogs and the images stored on external drives makes the photo collection portable. If your main computer were to malfunction, you could easily access your files on another computer.

Can I burn the backup to DVD media?

Yes. You can create a backup folder on your main or any hard drive. In the Import Photos dialog box, click **Backup to** (changes to ☑), click **Choose**, and choose that folder. After the import process is finished, you can burn that folder to DVD media. You have to calculate the size of the folders to burn by how many megabytes or gigabytes can fit on the type of DVD media you use.

continued

Depending on the organization of your photo library and your storage space, you can either keep or delete the files you initially copied to your storage drive. If you plan to keep both the DNG and the original files, you may want to keep the original file names so both sets of photos match. You can always rename the photos in the Library module later.

Build a Lightroom Library with External Drives (continued)

The Choose Folder dialog box appears.

⑭ Navigate to the folder on the storage hard drive.

⑮ Click **Choose**.

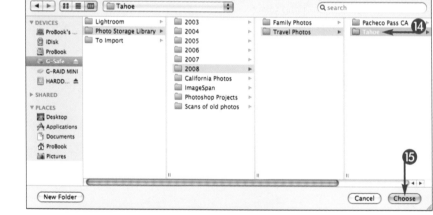

⑯ In the Import Photos dialog box, click the **Organize** and click **Into one folder**.

⑰ Click **Backup to** (☐ changes to ☑).

⑱ Click **Choose**.

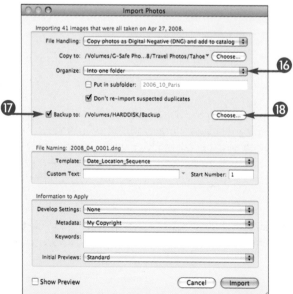

The Backup Folder dialog box appears.

19 Navigate to a separate location to store the photo backups.

20 Click **Choose**.

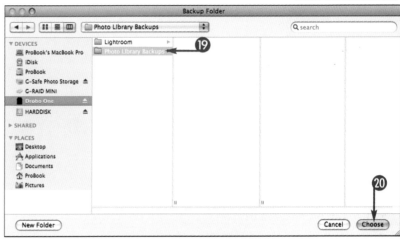

21 In the Import Photos dialog box, click the **Template** and select your naming template preset.

22 Add any additional information.

Note: See earlier tasks in this chapter for more information about naming templates.

23 Click **Import**.

You have now built the foundation for your Photo Library storage on external hard drives.

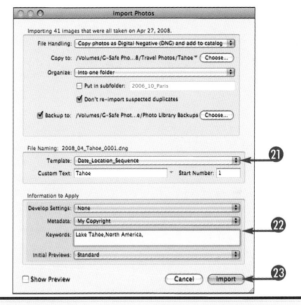

What is the difference between the Back up catalog option in the Catalog Settings dialog box and the back up in the Import Photos dialog box?

• *Back up catalog* in the Catalog Settings dialog box tells Lightroom how often to make a copy of your catalog database. When you launch Lightroom and the backup dialog box appears, you can select a storage location for the backup catalog.
 This backup contains all the edits and metadata, and provides security and preserves any editing or sorting work you have done to your photos, if your main catalog is ever lost or corrupted.

• Selecting *Backup to* in the Import Photos dialog box has Lightroom make a duplicate set of the photo files you import and lets you specify a location to store the files.
 This backup maintains a second copy of your original unedited images.

Combine a Travel Catalog with Your Main Lightroom Library

If you use Lightroom to import photos and create a catalog on a laptop during a trip, you can easily add the travel catalog data to your main Lightroom catalog and copy the images to your main storage library when you return.

In this scenario, both the catalog and photo files are on a travel laptop. The laptop's catalog needs to be imported into the main Lightroom catalog on a desktop computer and the photo files need to be copied and stored on the main computer's storage drive.

Combine a Travel Catalog with Your Main Lightroom Library

① Open the Travel Catalog in Lightroom on the laptop.

② In the Library module, press ⌘+A (Ctrl+A) to select all the photos in the catalog.

③ Click **File**.

④ Click **Export as Catalog**.

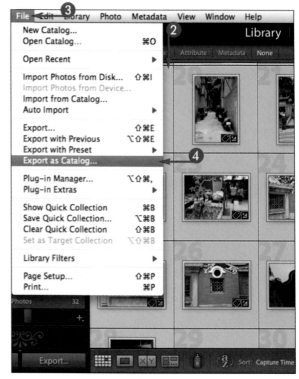

The Export as Catalog dialog box appears.

⑤ Click in the text box and type a name for the exported catalog folder.

⑥ Click the **Where** 🔽 and select a destination for the catalog folder.

Note: *This task uses a separate external hard drive to make the transfer. You can export to any external media, or export to another location on the laptop and use Ethernet or Wi-Fi to connect the computers and make the transfer in Steps 12 to 17. You can also connect a Mac laptop in Target Disk mode with a FireWire cable.*

⑦ Click **Export negative files** (☐ changes to ☑).

⑧ Click **Include available previews** (☐ changes to ☑).

⑨ Click **Export Catalog**.

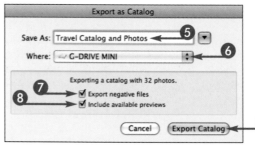

Lightroom exports the catalog and photos to the selected location.

⑩ Quit Lightroom and eject the external drive from the laptop. Connect the external drive to your desktop computer.

⑪ Launch your main Lightroom catalog on the desktop computer.

⑫ Click **File**.

⑬ Click **Import from Catalog**.

● The Import from Lightroom Catalog dialog box appears.

⑭ Navigate to the external drive with the exported travel catalog.

⑮ Click **Choose**.

The Import from Catalog "*catalogname*.lrcat" dialog box appears.

⑯ Click the **File Handling** and select **Copy new photos to a new location and import**.

⑰ Click **Choose** and navigate to the new storage location for the photo files.

Note: *Optionally, click **Put in subfolder** and type a name in the text box.*

⑱ Click **Import**.

Note: *If a box appears regarding a naming template, click **OK**.*

Lightroom imports the catalog data into the main catalog and puts the photo files (also called negatives) in the new storage location.

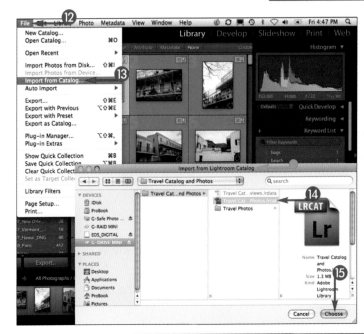

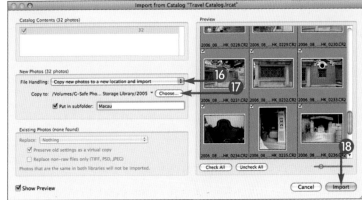

What files does Lightroom export with these settings?

Lightroom exports a copy of the database *catalogname*.lrcat (●), along with the *catalogname Previews*.lrdata file (●) and a folder with the original photos files (●). If you export RAW files, be sure to check **Automatically write changes into XMP** in the Metadata tab of the Catalog Settings preferences. That way any edits you have already made are exported with and attached to the photo files.

CHAPTER 3

Viewing and Organizing Your Photos

The Library is the default module for Lightroom. The Library module functions like a giant light table for viewing all the photos in your catalog, and in addition gives you powerful tools to rate, sort, compare, and organize your images. It is also the central hub for all of Lightroom's modules.

Locate the Parts of the Library Module........60

Change the Library Views64

Using a Second Window66

Adjust the Lights ...70

Change the Display of the Side
 Panel Sections ..71

Change Your Library View Options72

Customize the Library Toolbar74

Rename a Group of Photos...............................76

Tag Your Photos for Easier Sorting78

Filter Your Photos ...80

Organize Your Photos with Folders82

Synchronize Folders That Have Changed84

Group Your Photos into Collections86

Create a Smart Collection88

Group Collections into a Collection Set........90

Make a Quick Collection92

Convert a Quick Collection to a
 Permanent Collection94

Add Keywords to Your Photos96

Add Keywords with the Painter Tool98

Create Custom Keyword Sets and
 Hierarchical Lists...100

Create an Image Stack102

Remove or Delete Photos from
 Lightroom ...104

Locate the Parts of the Library Module

The Library module is where you import, sort, rate, organize, compare, select, delete, export, and rename the photos in your Lightroom catalog. It is the key to handling large numbers of photos. Getting familiar with the parts and functions of the Library module makes handling all your digital images more fluid and intuitive.

● **Library central viewing area**

The Grid view

The grid default view displays all the photos in the selected catalog, folder, or collection.

Scroll bar

Click and drag the scroll bar to scroll through the thumbnails.

● **Library Module Top Filter bar**

The Top Filter bar expands so that you can filter and sort your photos using different parameters, such as the date a photo was shot, camera or lens used, location text, or any custom filters you apply. The parameters, from the left:

Text

Text filters let you sort using any combination of words applied to the photos, such as file names and metadata.

Attribute

Sorting attributes include pick or reject flags, star ratings, and color labels.

Metadata

Metadata filters let you filter by date, camera or lens used, or labels.

● **Custom filters**

Custom filters can be created and saved using any combination of settings.

● **Library Module toolbar**

You can add tools to the toolbar as you need them. The tools, from the left:

View mode buttons

Click to view in Grid, Loupe, Compare, or Survey modes.

Painter tool

Apply keywords with the tool.

Reverse sort order

Select sort parameters

Change thumbnail size

You can add other tools for flagging, rating, and labeling; navigating through the photos; starting an impromptu slide show; and viewing the file name.

● **Filmstrip and Filmstrip tools**

The Filmstrip appears in every module. The Filmstrip includes, from the left:

Thumbnails of the images in the selected folder

● **Main and second window buttons**

● **Grid view button**

● **Navigation buttons**

● **Photo location**

● **Filter menu and on/off switch**

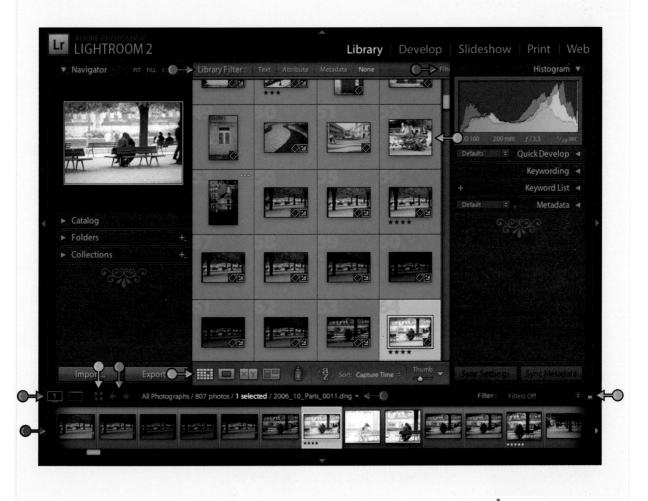

continued

The Library module acts as a central hub for the rest of the application. Lightroom always opens in the Library module, and you will constantly jump back to this initial module as you import, sort, and enhance your photos.

● **Library Module left panel**

● **Navigator section**

The Navigator displays the selected photo. Click to select the quick Zoom level for the Loupe view.

Catalog section

Click **All Photographs** to view all photos in the entire catalog. Click **Quick Collection** to view only the Quick Collection. Click **Previous Import** to view only the last images imported.

● **Folders section**

The Folders section shows all the folders in the Lightroom catalog and their various locations, even on separate hard drives. If necessary, click ◼ to open the location and click a folder to view only the photos in that folder.

Collections section

The Collections section shows groups of photos independent of their individual folders. A folder icon with a star (▨) indicates a *Smart Collection*. A folder icon (▨) indicates a named collection. A file box icon (▨) indicates a *Collection Set*.

● **Import and Export buttons**

The Import button enables you to quickly import new photos from various sources and the Export button takes you to the various export options in the Export dialog box.

● **Library Module right panel**

Histogram

The Library Histogram shows a graphical representation of the color and tonal values in the selected image.

Quick Develop section

In the Quick Develop section, you can apply general photo corrections and presets to one or multiple images.

Keywording section

In the Keywording section, you can create and assign keyword tags and group the words into Keyword sets.

Keyword List section

In the Keyword List section, you can view and group your existing keywords hierarchically.

Metadata section

The Metadata section displays the data automatically included by the camera or added by the photographer.

● **Panel end marks**

The panel end marks are used to show there are no more options in the panel. You can customize these ornaments in the Lightroom Preferences.

● **Sync Settings and Sync Metadata buttons**

The Sync Settings and Sync Metadata buttons are activated when two or more photos are selected and are used to synchronize the edits or metadata applied to one photo with the other selected photos.

● **Scroll bars**

The scroll bars let you access the various sections of the panels when they are expanded.

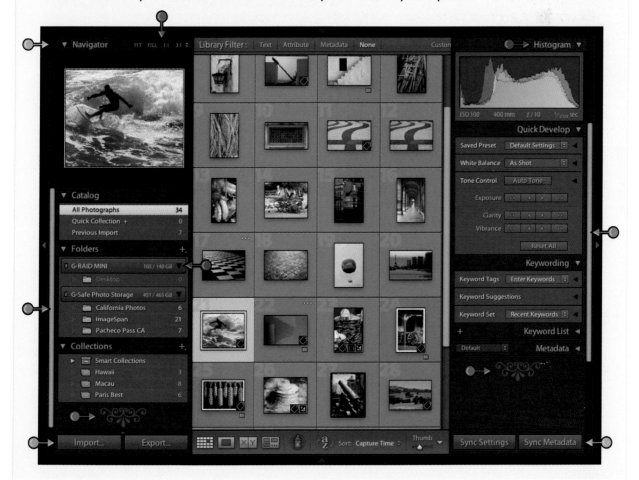

Lightroom's Library module enables you to view your photos in a variety of ways. Not only can you make the viewing area larger (see Chapter 1), you can also choose to view images in a variety of ways: in a grid, one image enlarged, two images as a comparison, multiple images, and so on.

Change the Library Views

1 Open Lightroom.

Lightroom opens by default in the Library Grid view with one image showing in the Navigator contents of the left panel.

2 Click **Loupe View** (▢).

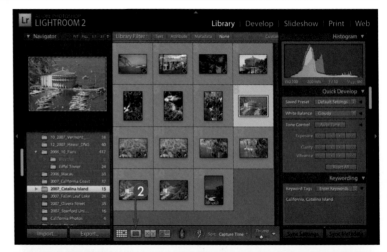

The central viewing area changes to the Loupe view mode and displays the selected photo to fit.

3 ⌘+click (Ctrl+click) any other photo in the filmstrip to select it while keeping the first photo selected.

4 Click **Compare View** (▥).

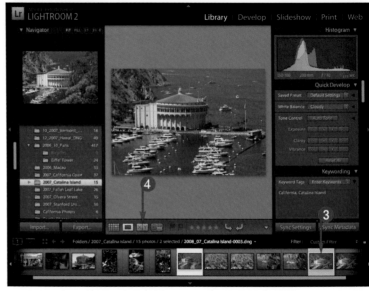

The central viewing area changes to the Compare view mode and displays the two photos.

5 Press **Tab**.

The side panels are hidden, making the photos in the central viewing area larger.

6 ⌘+click (**Ctrl**+click) additional photos in the filmstrip to select them while keeping the first two photos selected.

7 Click **Survey View** (▦).

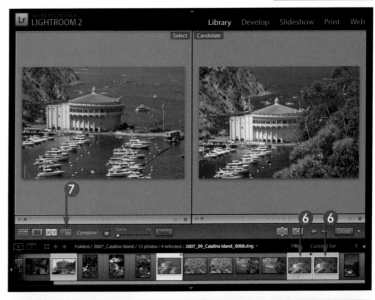

The central viewing area changes to the Survey view mode and displays the selected photos.

● The first selected photo is indicated by a brighter white border.

8 ⌘+click (**Ctrl**+click) any of the photos to remove it from the viewing area.

Note: *Optionally, click* **Remove Photo** *(▢) to remove a photo from the viewing area.*

The viewing area dynamically adjusts to the remaining photos.

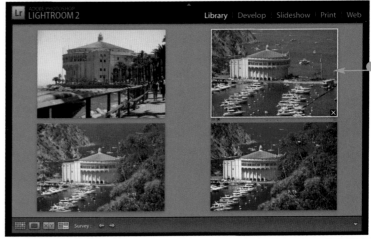

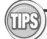

TIPS

When my cursor rolls over the left or right side, the panels reappear temporarily. Can I change this and still make my central area large?

Pressing **Tab** toggles on and off the side panels. You can manually make one side appear and stay open by clicking ◼ or ◼ on that side.

Is there any other way to change the behavior of the side panels?

Yes. **Control**+click (right-click) either ◀ or ▮ by the left panel to get a menu. Click **Auto Hide** (●).

✓ Auto Hide & Show
Auto Hide ◀——●
Manual

Sync with Opposite Panel

From now on, the left panel reappears only when you click ◀ or when you toggle both panels on by pressing **Tab**. Repeat the steps on the right to see that panel's behavior or click **Sync with opposite panel** to make both sides respond to the same setting.

Using a Second Window

Lightroom includes a second window viewing option. You can use this window on a second monitor or just as a second window on one large monitor. The second window offers three different modes, Normal, Live, and Locked, and makes it easy to click through images in the Grid view in one window while viewing each image enlarged in the Loupe view at the same time.

Using a Second Window

① Open the Library module in the Grid view mode.

② Click **Second Window** (▭).

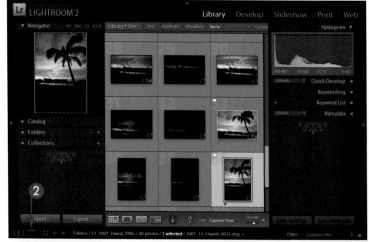

● The second window appears with the selected photo in the Loupe view.

Note: *Optionally, click and drag the bottom right corner of the second window to enlarge it and move it to a second monitor if you have one.*

③ Position the cursor over another image in the Filmstrip but do not click.

● The other image appears in the Navigator panel.

④ Click another image either in the Filmstrip or the Grid view of the main window to select it.

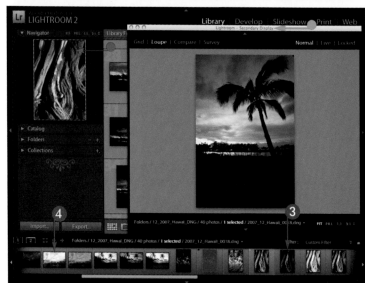

66

The image in the second window changes to match the one selected in the first window.

⑤ Click **Live** in the second window.

⑥ Position the cursor over the other images in the Filmstrip or the Grid view of the main window, but do not click.

The second window shows the live Loupe view of the images as you move over them.

⑦ Click **Locked** in the second window.

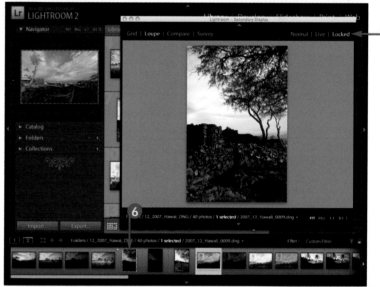

TIPS

Is there a way to enlarge the image in Loupe view in the second window?

Yes. Click **Loupe** in the second window. The cursor appears as a magnifying glass (🔍). The photo zooms to the zoom default you have selected in the main window, such as 1:1. Click again and it returns to the view you have selected, such as Fit.

Can I change the background color of just the second window?

Yes. You can Control+click (right-click) the gray background and select another gray, white, or black. The background color changes for the second window only.

continued ➡ 67

The second window is also useful when presenting photos to clients. With the second window in Loupe view on another monitor, you can go through your catalog of images while showing the client only the photos you push to the second monitor.

Using a Second Window (continued)

The second window locks the Loupe view of the originally selected photo.

8 Position the cursor over the other images in the Filmstrip or the Grid view of the main window, but do not click.

The second window remains locked on the originally selected photo, but the Navigator displays the photos as you move the cursor over other thumbnails.

9 Click another photo in the grid or Filmstrip on the main window.

The second window still displays the locked Loupe view of the originally selected photo.

10 Press Option + Return (Alt + Enter).

The photo selected in the main window is pushed to the Loupe view of the locked second window.

11 ⌘+click (Ctrl+click) a second photo in the Filmstrip or Grid of the main window.

12 Click **Compare** in the second window.

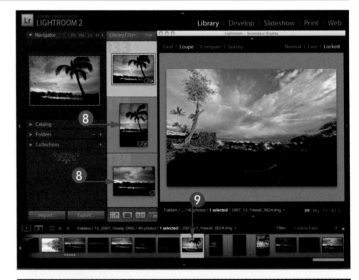

The second window shows an enlarged view of both photos in the Compare mode.

⑬ ⌘+click (Ctrl+click) additional photos in the Filmstrip or grid.

⑭ Click **Survey** in the second window.

The second window shows an enlarged view of the selected photos in the Survey mode.

⑮ Click a photo to be removed from the survey.

The photo appears with ✕ in the corner.

⑯ Click ✕ to remove the photo from the Survey mode view.

 TIPS

Can I use the second window to display the Grid view also?

Yes. You can use either Grid or Loupe views on either the main or second window.

Can I use another module with the second window open?

Yes. For example, you can view either the Grid or Loupe view on the second window and work on the image in the Develop module on the main window.

Adjust the Lights

Lightroom was created to let you focus on your photos as you view and organize them. You can dim the areas surrounding a selected photo or turn the surrounding area completely black in any of the modules to get a better view of an image.

1. Click a photo to select it.

2. Press **E** to go to Loupe view.

3. Press **L**.

 The surrounding areas dim.

4. Press **L** a second time.

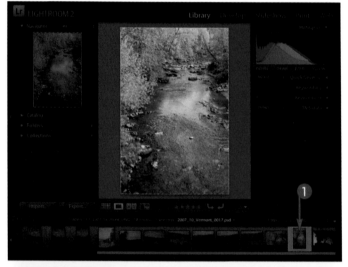

 The surrounding areas turn black.

5. Press **L** a third time.

 The screen returns to the normal view.

Change the Display of the Side Panel Sections

Depending on the size of your monitor, you must scroll to see all the options in each separate section on the side panels. You can arrange the side panels with only one section open at a time and use the sections more effectively.

Change the Display of the Side Panel Sections

1 In the left panel, ⌘+click (Ctrl+click) the **Catalog** ▼.

All the left panel contents sections, except for the Navigator, close at once (▼ changes to ▶).

2 In the right panel ⌘+click (Ctrl+click) the **Quick Develop** ▼.

All the right panel contents sections close at once (▼ changes to ◀).

3 Click any ▶ or ◀ to open only that side panel section.

Change Your Library View Options

You can view your photos in many different ways in Lightroom. You can customize the View Options for the Library module to show different sized cells and information in the Grid view and different overlay information in the Loupe view.

① Press **Tab** to hide the side panels.

② Click **View**.

③ Click **View Options**.

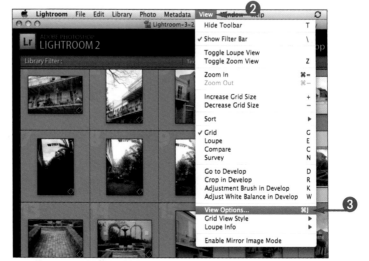

The Library View Options dialog box appears.

Note: *The selections listed in the steps are suggestions for setting preferences. You can change the preferences to fit your projects.*

④ Click the **Compact Cells** 🔹 and select **Expanded Cells** in the menu that appears.

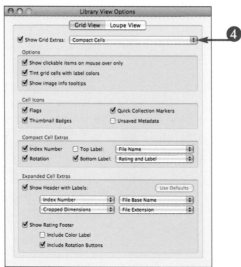

● The grid cells expand in the Grid view.

⑤ Under Cell Icons, click **Thumbnail Badges** (☑ changes to ☐).

● The thumbnail badges are removed from the grid cells.

⑥ Click an **Expanded Cell Extras** ◆ and select **F-Stop**.

● The F-Stop appears in the cell header.

⑦ Click **Loupe View**.

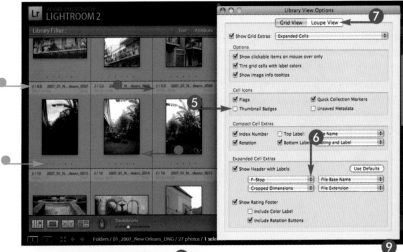

● The viewing area changes to Loupe view.

⑧ Click **Show Info Overlay** (☐ changes to ☑).

● The photo info appears over the photo.

⑨ Click the **Show Info Overlay** ◆ and select **Info 2**.

⑩ Click a **Loupe Info 2** ◆ and select **Exposure and ISO**.

● The Exposure and ISO appear as an overlay.

⑪ Click ◉ to close the dialog box.

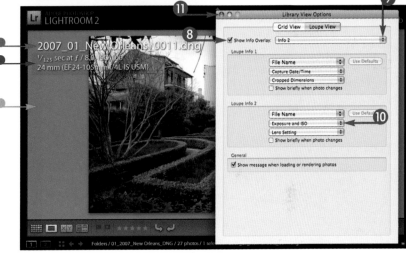

Can I turn off all the added information and view just the photos in a grid?

Yes. In the Grid View tab of the Library View Options, click **Show Grid Extras** (☑ changes to ☐).

How can I set the Loupe view Info Overlay to appear and then click it off?

In the Loupe view, press ⓘ once to view the Overlay for Info 1. Press ⓘ a second time to view Info 2. Press ⓘ a third time to turn the Info Overlay off.

Customize the Library Toolbar

The tools available in Lightroom's toolbar vary with each module. In the Library module, the toolbar has tools for changing the view modes plus tools for adding rating tags, a thumbnail size slider, navigational and rotational tools, and more. You can add tools to the toolbar as you need them.

ADD TOOLS TO THE TOOLBAR

Note: Your toolbar may already have some tools on it. The following steps are for illustration purposes. You can select any of the options to fit your projects.

① Click **Grid View** (▦).

The view mode changes to Grid view.

② Press `Tab`.

The side panels hide, revealing a full-sized toolbar.

Note: All the tools may not be visible in the toolbar with the two side panels showing.

③ Click ▾.

④ Click **Rating**.

● Five stars are added to the toolbar.

⑤ Repeat Step **3** and choose other tools to add to the toolbar.

REMOVE TOOLS FROM THE TOOLBAR

① Click .

② Click any of the checked tools to remove them from the toolbar.

The tools disappear from the toolbar.

③ Repeat Steps **1** and **2** to remove any other tools.

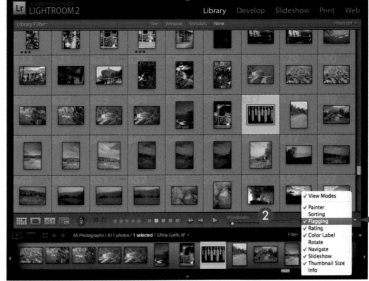

TIPS

Why can I not see the toolbar?

The toolbar can be hidden to enlarge the viewing area. Press ⊤ to toggle it on and off.

Why did the tools I added to the toolbar disappear when I went to Loupe view?

The toolbar tools are specific to each module and set for each view mode independently. You can set up the ones you want while in the Loupe view following the steps in this task.

Rename a Group of Photos

If you imported photos already on your hard drive and selected Import Photos at Their Current Location, the existing file names were not changed. You can easily rename a group of photos already in Lightroom in the Library module.

See Chapter 2 for more about importing photos.

Rename a Group of Photos

1 Click a folder or collection previously imported from the disk.

2 Press ⌘+A (Ctrl+A) to select all the photos.

3 Click **Library**.

4 Click **Rename Photos**.

Note: Optionally, press F2.

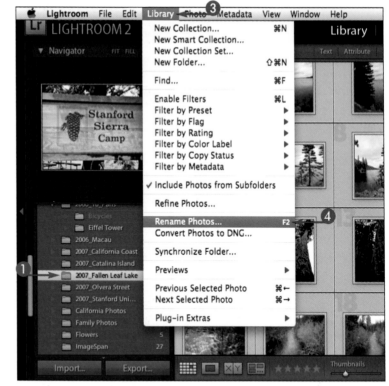

The Rename *number* Photos dialog box appears.

5 Click the **File Naming** ⬦.

6 Click a Lightroom preset or a custom preset if you created one.

⑦ Depending on the preset, you can enter custom text and/or a start number.

⑧ Click **OK**.

● The photo files are automatically and sequentially renamed.

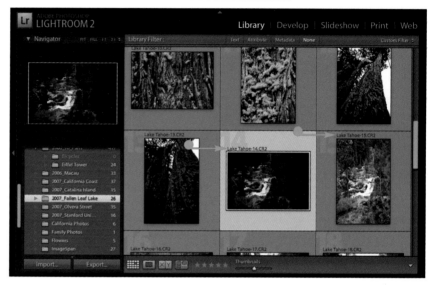

After deleting some photos, my sequence numbers now have gaps. Can I rename the photos with this technique?

Yes. However, be aware that if you imported photos and converted to DNG and you saved a separate set of original files, the DNG numbers will no longer match the numbers of the original files you saved. See Chapter 2 for more about DNG.

When is the best time to rename photos?

Some photographers rename on import and others once they have sorted and deleted the rejected photos. Still others rename when they export the files. (See Chapter 13 for more about exporting.) However you name your files, your naming system must be consistent to take advantage of Lightroom's organizational features.

Tag Your Photos for Easier Sorting

Lightroom includes three different types of rating tags you can add to help organize your photos. Some photographers only mark the good photos and others include a complete ranking system. You can tag photos in either the Grid or Loupe view with one to five stars, one to five colors, or flag them as rejected or accepted.

Tag Your Photos for Easier Sorting

APPLY TAGS

① Open Lightroom in the Library module.

② Click a photo to select it.

③ Click the fourth star (★) in the toolbar.

Note: Optionally, press 4 to add four stars.

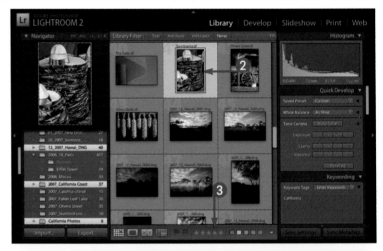

● Four stars are applied to the thumbnail of the photo.

④ Click another photo to select it.

⑤ Click a flag (■ or ■) in the toolbar.

Note: Optionally, press P for accepted or X for rejected.

● The accepted or rejected flag tag appears on the photo.

The photo is dimmed in the grid if the photo is tagged rejected.

6 ⌘+click (Ctrl+click) a number of photos to select them.

7 Click a color label (■) in the toolbar.

Note: Optionally, press 6 to add the red color label.

● The red color label is added to the selected photos.

*Note: The borders of the thumbnails with color labels turn the color of the label if the **Tint grid cells with label colors** check box is checked in the Library View Options under Grid View.*

REMOVE TAGS

1 Double-click the first star under the thumbnail to remove a rating.

2 Click the flag on the thumbnail to remove it.

3 Click the color label on the thumbnail and click **None** in the menu that appears.

Note: Optionally, click a thumbnail to select it and click the red label (■) to remove the color label.

What are the keyboard shortcuts for ratings?

Keystroke	Action	Keystroke	Action
p	Accepted flag	5	5 Star
x	Rejected flag	[Decrease star rating
u	Remove flag]	Increase star rating
0	No star	6	Red label
1	1 Star	7	Yellow label
2	2 Star	8	Green label
3	3 Star	9	Blue label
4	4 Star		

Filter Your Photos

Filtering helps you find specific photos by limiting the photos in the viewing area to those that fit specific criteria. The Filter bar above the Grid view displays all the possible ways to filter your photos. The filters are additive and can be customized.

You can also access filters in the Filmstrip, which is persistent across all the modules so you can filter your photos even when developing or outputting them.

Filter Your Photos

① Click **Catalog**.

② Click **All Photographs**.

③ Press **T** to hide the toolbar.

④ Press **Shift** + **Tab**.

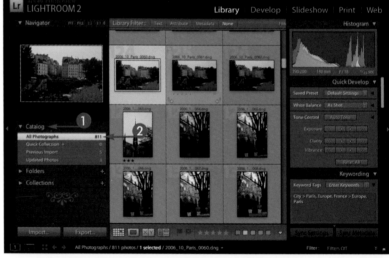

All the panels hide so you can see the full Filter bar.

*Note: Optionally, click the **Any Searchable Field** or the **Contains** to restrict the search more.*

⑤ Click **Text** in the Filter bar.

The Text search options bar appears.

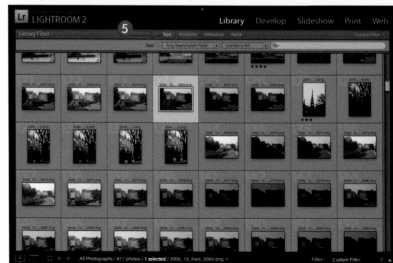

⑥ Type a word in the text box.

The Grid view shows only the photos that match the Text criteria.

⑦ Click **Attribute**.

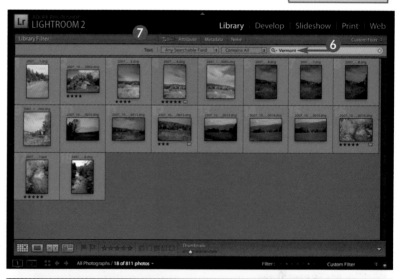

The Attribute search options appear.

⑧ Click any of the Attribute options to apply them.

Note: *Optionally, click **Metadata** and select any metadata options for filtering the photos.*

The Grid view displays only the photos that meet all the criteria set in the Filter bar.

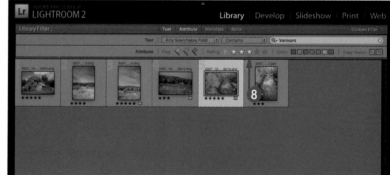

TIPS

Can I sort my photos and still see all of them in the Grid view?

Yes. You can sort your photos in the grid by name, applied rating or flag, or by capture time or a number of other sorting options. Add the Sort tool to the toolbar as described in the "Customize the Library Toolbar" task, and then click ⬍ to select the sort order.

Are there any other keyboard shortcuts for either filtering or tagging photos?

Yes. Press ⟍ to toggle the top Filter bar on and off. When you use the keyboard shortcuts, pressing ① to ⑤ for star ratings or ⑥ to ⑨ for color labels, you can press and hold Shift to advance the photos automatically as you apply the rating or color, or click Caps lock to automatically advance each photo after rating or labeling.

Organize Your Photos with Folders

Folders are Lightroom's first level of organization. You can create new folders and subfolders, rename folders, and move images between folders in Lightroom to get your photos organized. When you create folders or move images between folders using Lightroom, the same changes automatically appear in the folder hierarchy on the photo storage drive.

CREATE A SUBFOLDER

1 In the Folders section of the Library module, click the name of a folder.

2 Click the plus sign (**+**).

3 Click **Add Subfolder** in the menu.

A Create Folder dialog box appears.

4 Type the name for the subfolder in the text box.

Note: *Optionally, if you had already selected the photos to use in the subfolder, click **Include selected photos** (☐ changes to ☑).*

5 Click **Create**.

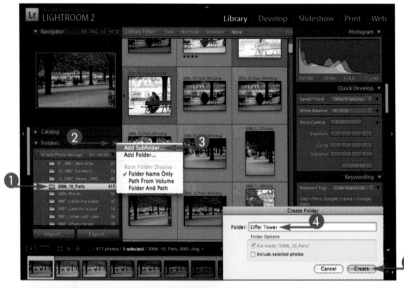

The subfolder is listed under the previously selected folder.

6 Click the parent folder to view the photos in the grid.

7 ⌘+click (Ctrl+click) or Shift+click the photos to move to the subfolder.

8 Click and drag the selected folders to the subfolder.

Note: *Click directly on a photo and not the frame to click and drag a group of photos into the subfolder.*

9 Click **Move** in the warning dialog box that appears.

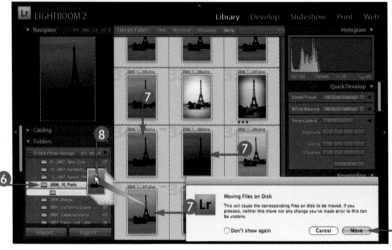

● The photos are shown in the subfolder.

VIEW THE SUBFOLDER ON THE STORAGE DRIVE

① `Control`+click (right-click) the subfolder.

② Click **Show in Finder** (**Show in Explorer**).

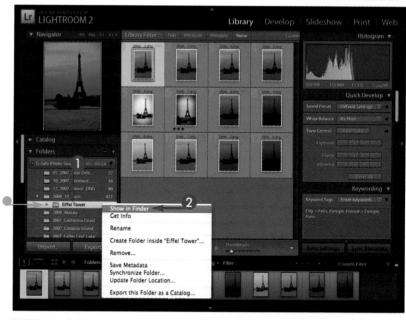

● The Finder (Explorer) window appears showing the location of the parent folder.

③ Scroll down if necessary to see the new subfolder inside the parent folder.

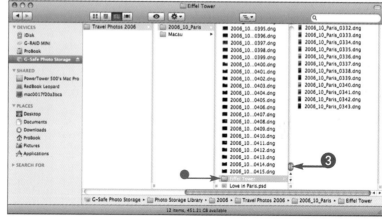

How do I rename a subfolder?

To rename a subfolder, double-click the folder name, type the new name in the text box, and press `Return` (`Enter`). You can also ⌘+click (`Ctrl`+click) the folder and click **Rename**. Type the new name in the Rename Folder dialog box that appears and click **Save**.

How do I delete a folder?

If the folder has no images in it, you can delete the folder by clicking the folder to select it and clicking the minus sign (−). If the folder contains photos, a warning box appears saying the photos will be removed from Lightroom's catalog but both the folder and photos will remain in the storage location.

Synchronize Folders That Have Changed

Moving images between folders or creating subfolders in Lightroom automatically changes the folder structure on your hard drive. However, if you make changes to a folder on your hard drive — for example, if you drag-copy files from a memory card directly to a folder on your system, or even create a subfolder on the hard drive — you must synchronize the folder to bring the photos into Lightroom's catalog.

Synchronize Folders That Have Changed

① In the Folders section of the Library module, click the name of a folder you added images to directly on the hard drive.

② **Control**+click (right-click) the folder name.

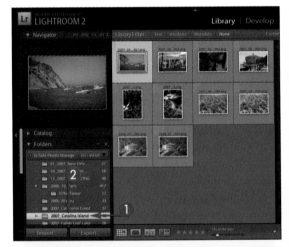

A menu appears.

③ Click **Synchronize Folder**.

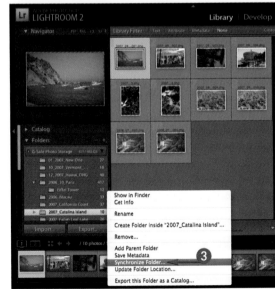

The Synchronize Folder dialog box appears with the name of the folder in quotation marks.

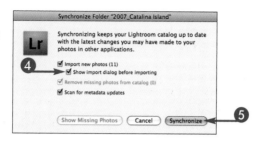

④ Click **Show import dialog before importing** (☐ changes to ☑) if it is not already selected.

⑤ Click **Synchronize**.

The Import Photos dialog box appears.

● The File Handling is automatically set to **Add photos to catalog without moving** and the folder is highlighted in the box.

● You can add keywords in the text box.

⑥ Click **Don't re-import suspected duplicates** (☐ changes to ☑) if it is not already selected.

● You can click the **Develop Settings** ⬧ to add settings to all the imported images.

⑦ Click the **Initial Previews** ⬧ to change the Preview size.

⑧ Click **Import**.

The photos are imported and added to the selected folder.

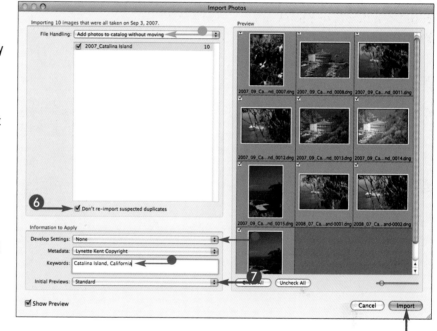

 TIPS

Is there another way to access the Synchronize Folder command?

Yes. First select the folder. In the menu bar, click **Library** and click **Synchronize Folder**. Then follow Steps **4** to **8** as in the task.

Do I have to start over and re-import some photos I accidentally removed from a folder?

No. As long as you did not delete the photos from the hard drive, the photo files are still in the folder structure on your system or hard drive. You can quickly bring them back by using the Synchronize Folder command as in the task.

Group Your Photos into Collections

Lightroom's collections are a powerful way of organizing photos regardless of where they are on your hard drive or the folder in which they reside. Lightroom offers several ways of working with collections. You can have named collections or Smart Collections, or group multiple collections in Collection Sets. Collections are an extremely flexible method of organizing your photos in Lightroom.

Group Your Photos into Collections

CREATE A COLLECTION OF PHOTOS

1 ⌘+click (Ctrl+click) multiple photos to group into a collection.

2 Click the **Collections** ➕.

3 Click **Create Collection**.

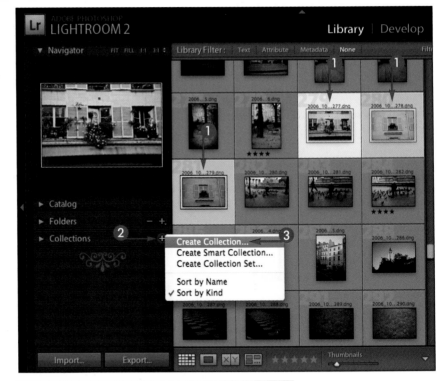

The Create Collection dialog box appears.

4 Type a name for the collection in the text box.

5 Click **Create**.

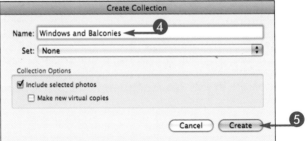

● A collection is created with the selected photos and appears in the Collection section.

ADD TO AN EXISTING COLLECTION

1 Click the **Catalog** ▶ to view the all the photos in the grid.

*Note: Optionally, click the **Folders** ▶ and click a specific folder to view only those photos in the grid.*

2 ⌘+click (Ctrl+click) more photos to add to the collection.

3 Click and drag the selected photos to the newly created collection.

The selected photos are added to the collection.

REMOVE A PHOTO FROM AN EXISTING COLLECTION

1 Click the **Collections** ▶.

2 Click the name of the collection to view only those photos in the grid.

3 Click a photo to select it.

4 Press Delete (Backspace) to remove the photo from the collection.

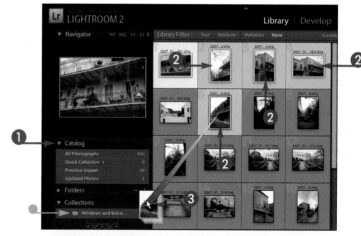

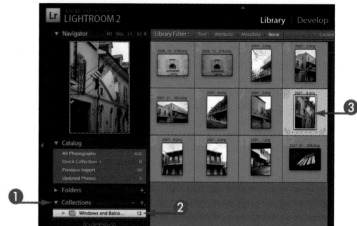

TIPS

If I create a collection of photos in my catalog, are the photos physically moved on my system or hard drive as with folders?

No. Unlike folders, collections keep a reference or a pointer only to the actual photo file. The photos remain in the same location and folder regardless of the collection in which they are included.

Can photos be in multiple collections at one time?

Yes. You can have a collection of photos with balconies from Paris and New Orleans and another collection with street scenes of Paris. The photos of the Paris balconies can be in both collections, and no files are duplicated on the hard drive.

Create a Smart Collection

In version 2, Lightroom added Smart Collections for refining and sorting images. A Smart Collection monitors all the photos in your Lightroom catalog and adds photos to the collection based on the customized criteria you set. You can create a Smart Collection to help you keep your photo catalog organized.

① Click the **Collections** ➕.

② Click **Create Smart Collection**.

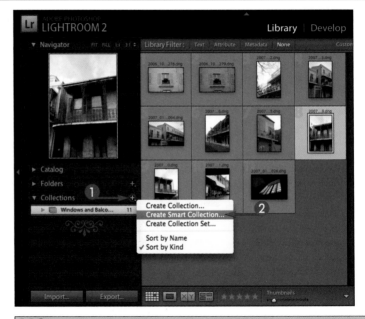

A Create Smart Collection dialog box appears.

③ Type a name in the text box.

Note: *You can use any one or multiple parameters for a Smart Collection.*

④ Click ⬍.

⑤ Click **is**.

⑥ Click the fourth dot.

The dots change to stars.

⑦ Click the plus sign (➕).

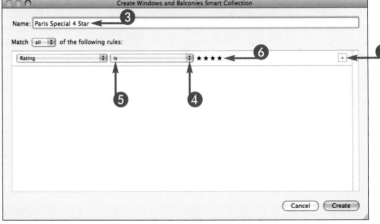

Another set of parameter options appear.

8 Click the second [↕].

9 Click **Keywords**.

10 Type some keywords in the text box.

11 Repeat Steps **7** and **8** to add more specific parameters.

12 Click **Create**.

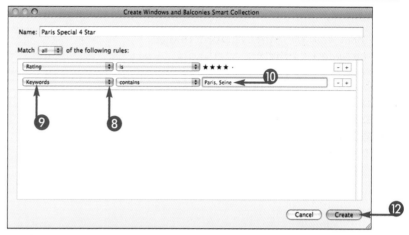

● A Smart Collection appears in the Collections section.

● All the photos in the catalog that match the criteria are displayed in the grid.

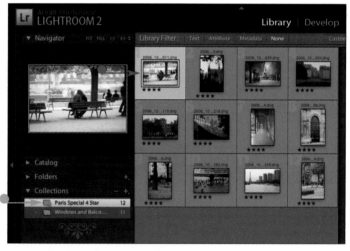

TIPS

Why did one of my photos disappear from the Smart Collection when I changed the photo's rating?

Smart Collections are interactive and change when you change the parameters of the included photos. For example, if you set a rating of five stars for a Smart Collection and then reduce a particular photo's rating from five to three stars, the photo is automatically removed from the Smart Collection.

Can I rename a Smart Collection without affecting the photos in it?

Yes. You can rename a Smart Collection by Control +clicking (right-clicking) the Smart Collection's name. Click **Rename** in the list of options. Type a name in the text box of the Rename Smart Collection dialog box that appears and click **Rename**. The Smart Collection is renamed and the collection is left intact.

Group Collections into a Collection Set

Using Collection Sets is a powerful and systematic way to organize your images. You can create customized sets to group similar or related collections. You can also create the sets and the included collections first and then drag-copy photos into them. Because collections are visible in all the output modules — Print, Slide Show, and Web — you can group photos you want to work with for each module.

① Click the **Collections** ⊞.

② Click **Create Collection Set**.

● A Create Collection Set dialog box appears.

③ Type a name for the Collection Set.

④ Click **Create**.

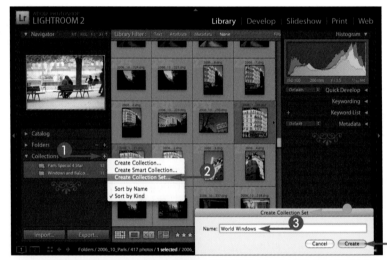

● A new folder with the Collection Set name appears in the Collections section.

⑤ Click the **Collections** ⊞.

⑥ Click **Create Collection**.

⑦ Type a name for the collection in the text box that appears.

⑧ Click the **Set** ⊡.

⑨ Click the name of the Collection Set to store the new collection.

⑩ Click **Create**.

⑪ Repeat Steps **5** to **9** to create multiple collections in a Collection Set.

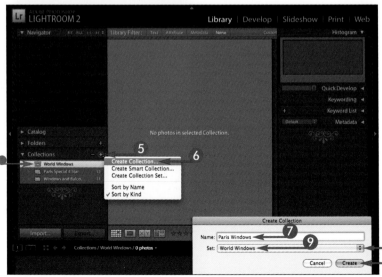

● The new collections are named and placed in the appropriate Collection Set.

⑫ Click any folder in the Folders section.

⑬ ⌘+click (Ctrl+click) any images to be put into a collection.

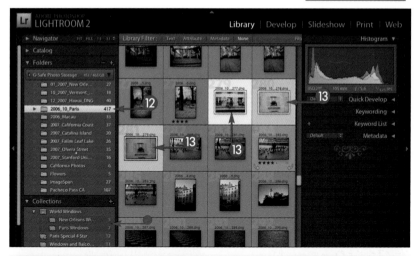

⑭ Click and drag the images to a collection inside the Collection Set.

Note: *You can also create collections by first selecting photos as the task "Group Your Photos into Collections" and then dragging the collection into the Collection Set.*

The grouped photos are now visible in the grid as grouped in each collection.

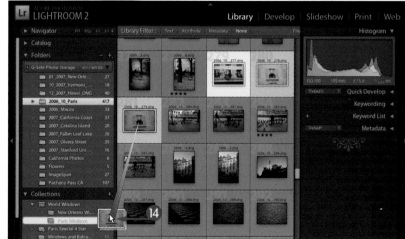

TIPS

Can I view the contents of several collections at one time?

Yes. Like folders you can ⌘+click (Ctrl +click) multiple collections to view the combined images in the grid. You can also view the contents of a complete Collection Set at one time by clicking the set's name.

Can I move a collection from one Collection Set to another?

Yes. You can click and drag collections from one set into another in the Collections section of the left Library module panel. You can also click and drag photo files from one collection to another, which shows the photo thumbnail in both collections without having to duplicate the photo file.

Make a Quick Collection

A Quick Collection is a quick way to temporarily group photos as you make decisions. Lightroom's Quick Collection feature is under the Catalog section instead of the Collections section because you do not name or save a Quick Collection and you can have only one Quick Collection at a time. You make the Quick Collection from the Grid view in the Library module.

Make a Quick Collection

USE THE QUICK COLLECTION CIRCLES TO ADD QUICK COLLECTION

1 Open the Catalog or any individual folders in the Grid view.

Note: Optionally, press F8 to hide the right panel.

2 Position the cursor over a photo to add to a Quick Collection.

3 Click the Quick Collection circle (○) that appears as the cursor moves over the photo.

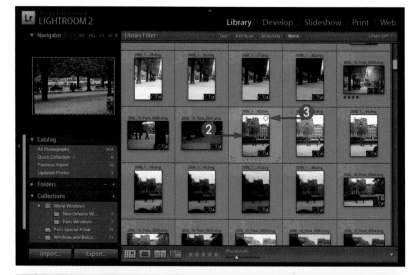

● The photo is automatically added to the Quick Collection and ○ turns gray.

4 ⌘+click (Ctrl+click) multiple photos to add to the Quick Collection.

5 Click ○ on one of the selected photos.

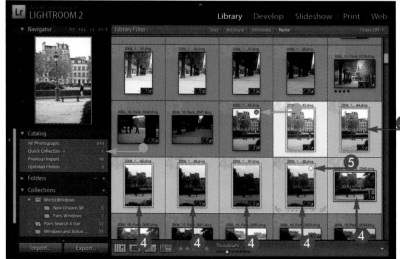

● All the selected photos are added to the Quick Collection.

USE A KEYSTROKE TO ADD PHOTOS TO ADD QUICK COLLECTION

1 Click a photo to select it or ⌘+click (Ctrl+click) other photos to add to the Quick Collection.

2 Press B.

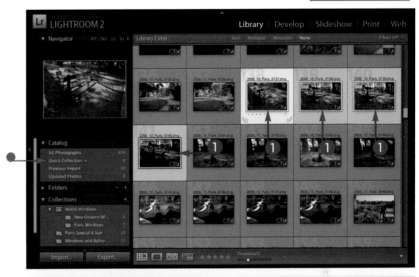

● All the selected photos are added to the Quick Collection.

3 Click the Quick Collection to view only the included photos.

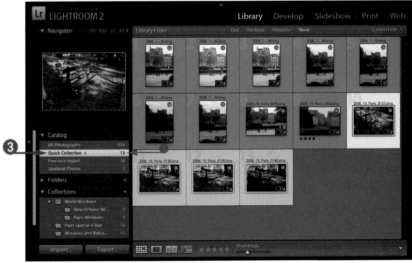

TIPS

Why do I not see the Quick Collection circle as I position the mouse over my photos in the Grid?
Click **View** in the menu bar, click **Grid View Style**, and click **Show Badges**. The Show Badges option must be checked for the Quick Collection circle to appear.

If a Quick Collection is temporary, what happens to the Quick Collection when I quit Lightroom?
A Quick Collection remains available even after quitting and restarting Lightroom.

Convert a Quick Collection to a Permanent Collection

You can use the Quick Collection to gather photos from any of your folders, and add or delete images from the Quick Collection to finalize a grouping. You can then convert one or all the photos in a Quick Collection into a permanent named collection to create a more organized and usable catalog.

CONVERT SOME PHOTOS FROM A QUICK COLLECTION TO A PERMANENT COLLECTION

1 Click the Quick Collection in the Catalog section.

2 ⌘+click (Ctrl+click) any photos to use in a new named collection.

3 Click the **Collections** ➕.

4 Click **Create Collection**.

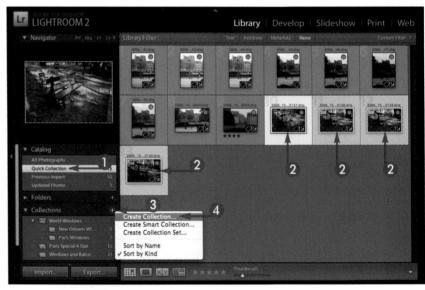

The Create Collection dialog box appears.

5 Type a name for the new collection in the text box.

Note: Optionally, click the **Set** ⬆ to put the new collection in an existing set.

6 Click **Include selected photos** (☐ changes to ☑).

7 Click **Create**.

The selected photos are added to the new collection.

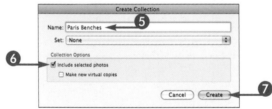

CONVERT AN ENTIRE QUICK COLLECTION TO A PERMANENT COLLECTION

1 Control +click (right-click) **Quick Collection** in the Catalog section.

2 Click **Save Quick Collection**.

The Save Quick Collection dialog box appears.

3 Type a name for the new named collection.

4 Click **Clear Quick Collection After Saving** (☐ changes to ☑) if it is not already checked.

5 Click **Save**.

● The Quick Collection is converted to a named collection.

● The photos are removed from the Quick Collection.

6 Click the new named collection to view the photos in the grid.

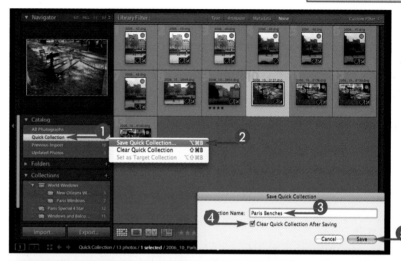

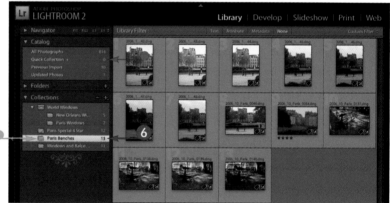

TIPS

How do I remove the photos in the Quick Collection?
You can delete one photo at a time from a Quick Collection by clicking the ⊙. You can also Control +click (right-click) one or multiple selected photos in the Quick Collection and click **Remove from Quick Collection**. To remove all the photos at once, you can Control +click (right-click) the words **Quick Collection** in the Catalog section and click **Clear Quick Collection** (●) from the menu that appears.

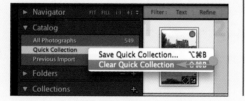

Are the files duplicated when I convert but do not clear a Quick Collection?
No. Collections only make references to the photo files. They never move any files from their current locations. Even if you do not clear the Quick Collection when converting it and the photos appear both in the Quick and named Collection, there is no duplication of the files.

Add Keywords to Your Photos

On the right panel in the Library module are two sections relating to keywords. *Keywords* are words or phrases that relate to the content of the photo. You can add keywords for sorting and organizing to make finding specific photos easy even as your catalog of images increases in size.

ADD A NEW KEYWORD TO ONE OR MULTIPLE PHOTOS

1 Click one thumbnail or ⌘+click (Ctrl+click) multiple thumbnails in the grid.

2 Click the **Keywording** ◀.

3 Click ◀ to open the Keyword Tags section.

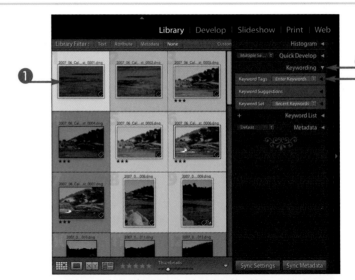

The keywords currently assigned to the thumbnails are listed in the Keywording pane.

4 Click here to add a new keyword.

5 Type a new keyword in the text field that appears.

6 Press Return (Enter) to apply the keyword to the selected photos.

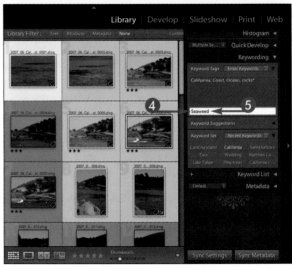

ADD AN EXISTING KEYWORD TO ONE OR MULTIPLE PHOTOS

1 Click a thumbnail or ⌘+click (Ctrl+click) multiple photos in the grid.

● The existing keywords appear in the Keywording pane.

2 Click in the text box.

3 Start typing a keyword.

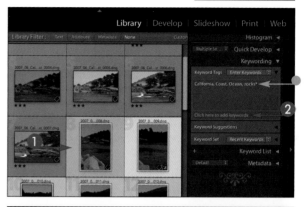

● A list of previously added keywords appears.

4 Click a word to select it.

5 Press Return (Enter) to apply that keyword to all the selected photos.

Note: *Optionally, click the* **Keyword Suggestions** ◄ *to view a list of keywords already used in your catalog of photos, and click to select one or more.*

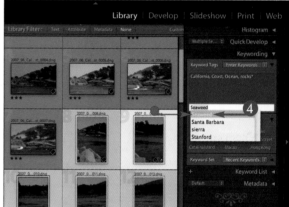

TIPS

Why is there an asterisk in the Keyword pane after one of the keywords?

If you select multiple thumbnails and some have different keywords assigned, the keywords that apply to some but not all of the photos display an asterisk. You can reassign a keyword with an asterisk to the entire group of selected photos by deleting the asterisk in the text in the Keyword pane.

I added keywords as I imported photos. Why should I add more keywords?

The keywords you added upon import (●) have to be general and relate to all the photos in the import group. By adding more specific keywords to target certain images, you will be able to sort your photos far more efficiently with Lightroom's filters and find specific photos much more quickly.

Add Keywords with the Painter Tool

You can quickly apply one or more keywords to photos using the Painter tool found in the toolbar. You can click the Painter tool on any thumbnails in the grid, and the keyword or words you select are quickly assigned. You can also erase keywords using the Painter tool just as easily.

Add Keywords with the Painter Tool

Note: *Optionally, press* F7 *to hide the left panel.*

① Click in the toolbar.

② Click **Painter** in the list that appears.

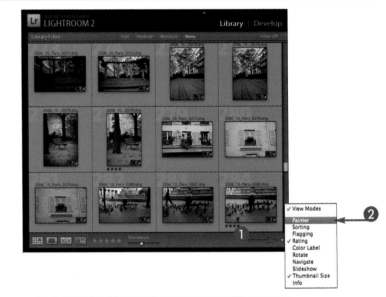

The Painter tool appears in the toolbar.

③ Click the **Painter** tool (🎨).

Note: *The Painter tool floats and becomes the cursor when you position it over thumbnails.*

④ Click in the toolbar text field that appears.

⑤ Type one keyword in the text field.

Note: Optionally, type more keywords separated by commas.

⑥ Move the Painter Tool cursor (🖰) over the grid.

⑦ Click the thumbnail to assign the keyword.

⑧ Repeat Steps **6** and **7** to assign the same keywords to other thumbnails.

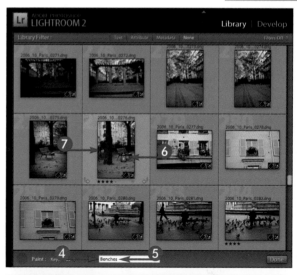

● Each time you click, text appears telling you the keyword was assigned.

⑨ Click **Done** in the toolbar to return the Painter tool and stop applying the keyword.

● You can also click in the circle (⬤) on the toolbar to return the Painter tool.

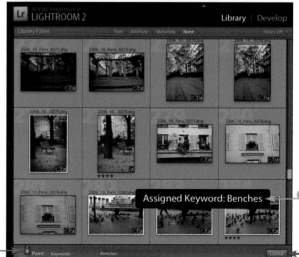

TIPS

The Painter icon changed after I applied it to a thumbnail. What does that mean?

After assigning the keyword, the Painter icon changes to an eraser (🖊). The cursor appears as 🖰 over any thumbnail without that keyword and as 🖊 over any thumbnail with that keyword assigned. Click any thumbnail using the eraser (🖊) to remove the keyword.

Can the Painter tool be used to apply other attributes?

Yes. You can apply keywords as well as other criteria using the Painter tool. Click the **Painter** tool (🖰). **Keywords** appears as the Painter selection in the toolbar. Click 🔽. Click another option in the list that appears.

Paint : Keywords ✓ Label / Flag / Rating / Metadata / Settings / Rotation

Create Custom Keyword Sets and Hierarchical Lists

You can group your keywords in customized keyword sets and also in a hierarchical list. Lightroom includes some general keyword sets to get you started. You can customize these or create your own sets and save them. You can assign keywords as a set and by dragging and dropping the thumbnails on a word or set in the keyword list.

Create Custom Keyword Sets and Hierarchical Lists

CREATE CUSTOM KEYWORD SETS

① Click the **Keyword Set** ◄.

② Click ▐.

③ Click **Edit Set**.

The Edit Keyword Set dialog box appears with previously used keywords.

④ Type keywords to use in a custom set.

⑤ Click the **Preset** ▐.

⑥ Click **Save Current Settings as New Preset**.

⑦ Type a name in the New Preset text box that appears.

⑧ Click **Create**.

The Preset name changes in the Edit Keyword Set dialog box.

⑨ Click **Change** to save the new keyword set.

The new set is listed in the Keyword Set list.

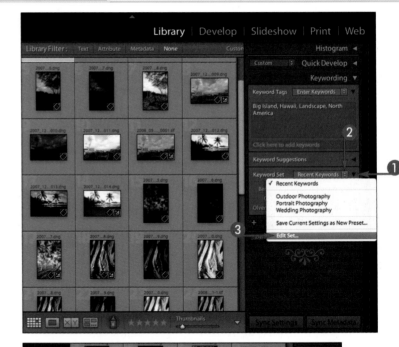

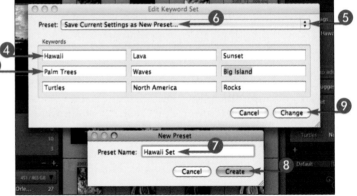

ORGANIZE YOUR KEYWORDS IN A HIERARCHICAL LIST

Note: Optionally, press F6 to hide the Filmstrip and F twice to go to Full Screen view mode.

1 Click the **Keyword List** ◄ to open the keyword list.

2 Click and drag a keyword to another keyword to act as a parent keyword.

The parent keyword is highlighted.

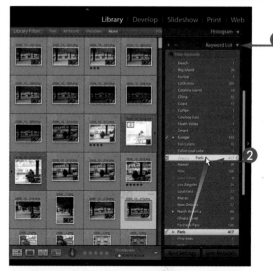

● The keyword is grouped hierarchically under the parent keyword.

3 Repeat Step **2** to create a more concise hierarchical keyword list.

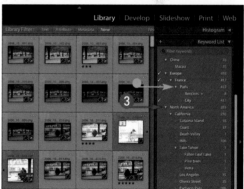

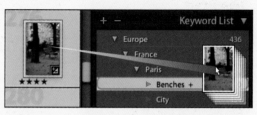

TIPS

How does Lightroom suggest keywords?

Lightroom lists the keywords you assign and suggests keywords applied to other photos having close capture times or the same keyword already assigned to them. For example, if you assign the keyword *city* to several photos that also have the keyword *benches* applied to them, when you apply *city* to another thumbnail, Lightroom may also suggest *benches*.

Is there a fast way to assign keywords to a group of thumbnails?

Yes. You can ⌘+click (Ctrl+click) any number of thumbnails in the grid and drag the thumbnails as a group over a keyword in the list. You can also click the keyword and drag it over one of the selected thumbnails to assign the keyword to all the selected photos. You can even apply multiple words at once by dragging the lowest word in the hierarchy that you want to assign.

Create an Image Stack

Image stacks are useful for organizing photos that are similar in content or shot around the same time. By stacking two or more photos, you can streamline the grid and also view more images at one time. Stacking is also convenient when you shoot multiple photos for merging to HDR or creating a panorama in Photoshop.

CREATE A STACK OF IMAGES

1. In the Grid view, ⌘+click (Ctrl+click) any images to stack.

2. Control+click (right-click) one of the selected thumbnails.

Note: *You must click the image thumbnail and not the frame.*

3. Click **Stacking** in the menu that appears.

4. Click **Group into Stack** in the submenu.

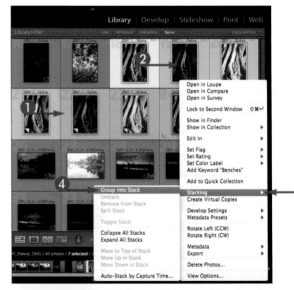

● The selected photos are stacked together and the top thumbnail displays the number of photos in the stack.

● The frame around the photo shows both a right and a left handle.

CHANGE THE ORDER OF THE STACKED IMAGES

1. Click the right handle on a thumbnail stack to expand the stack.

● You can also click the stack number to expand the stack.

 The stack expands and each photo displays a number as the cursor moves over it.

2. Click a different thumbnail from the stack and drag it to the left of the first thumbnail in the stack.

Note: *Optionally, press* `Shift` + `[` *to move the selected photo up in the stack. Repeat if necessary to make the selected photo first in the stack.*

3. Click the left handle on the thumbnail to collapse the stack.

● You can also click the stack number of the first photo to collapse the stack.

 The selected photo now appears on the front of the stack.

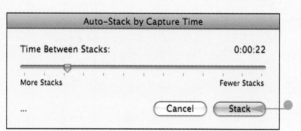

What does Auto-Stack by Capture Time in the Stacking submenu refer to?
The Auto-Stacking feature enables you to group together photos that were shot within a short time frame. Press `⌘`+`A` (`Ctrl`+`A`) to select all the images in a folder. `Control`+click (right-click) one of the selected thumbnails. Click **Stacking** and click **Auto-Stack by Capture Time**. In the dialog box that appears, specify the length of time between shots to limit the stacks and click **Stack** (●). Lightroom automatically creates the stacks according to the time between the shots.

Is there another way to access the Stacking menu?
Yes. With the photo thumbnails selected in the grid, click **Photo**, click **Stacking**, and click **Group into Stack**.

Remove or Delete Photos from Lightroom

You may have imported images that are totally dark or totally white or just out of focus, and you want to remove these photos from Lightroom. You can remove the photos from the Lightroom catalog or completely delete the photo files from the drive on which they are stored. Deleting the photo files decreases the size of your photo collection on your storage drives.

Remove or Delete Photos from Lightroom

REMOVE PHOTOS FROM THE CATALOG

1 Click a photo to be removed.

Note: *Optionally, ⌘+click (Ctrl +click) multiple photos to be removed.*

2 Click **Photo**.

3 Click **Remove Photos from Catalog**.

Note: *Optionally, press Option + Delete (Alt + Backspace).*

The photo is automatically removed from Lightroom's catalog.

DELETE PHOTOS FROM LIGHTROOM AND THE HARD DRIVE

1 Click to select a photo to be removed.

Note: *Optionally, ⌘+click (Ctrl +click) multiple photos to be removed.*

2 Click **Photo**.

3 Click **Delete Photo**.

Note: *Optionally, press Delete (Backspace).*

A warning dialog box appears.

4 Click **Delete from Disk** to move the photo files to the trash.

1 Delete photos flagged as rejected.

Note: *See the task "Customize the Library Toolbar" to flag photos.*

2 Click **Photo**.

3 Click **Delete Rejected Photos**.

Optional: Press ⌘ *+* Delete *(* Ctrl *+* Backspace *).*

Only the flagged photos appear in the grid and a warning dialog box appears.

4 Click **Delete from Disk** to completely delete the photos from Lightroom and the hard drive.

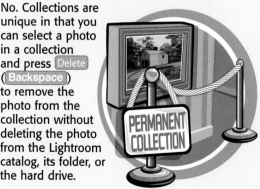

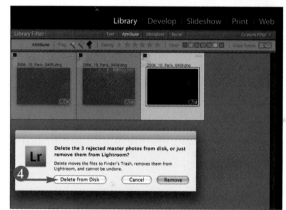

TIPS

How do I remove a photo from a stack and does removing it from a stack also remove it from the catalog?

When you remove a photo from a stack, the photo remains in the catalog and on the drive. To remove a photo from a stack, click the right handle to expand the stack. Control +click (right-click) the photo to be removed, click **Stacking**, and click **Remove from Stack**.

Does a photo I delete from a collection get removed from the hard drive as well?

No. Collections are unique in that you can select a photo in a collection and press Delete (Backspace) to remove the photo from the collection without deleting the photo from the Lightroom catalog, its folder, or the hard drive.

Personalizing Lightroom

Lightroom's structure enables each photographer to customize many of the settings for his or her own specific needs. From the overall look of the interface to individual photo developing settings, you can personalize Lightroom and customize it for your use.

Understanding Lightroom Presets108

Set the Essential Lightroom Preferences110

Customize the Catalog Settings114

Quickly Change Your Lightroom View116

Understanding Metadata118

Apply Metadata in the Library Module120

Synchronize Metadata between Photos122

Create a Copyright Metadata Preset124

Design a Personal Identity Plate126

Modify the Module Buttons128

Create a Graphical Identity Plate130

Understanding Lightroom Presets

Lightroom includes presets, or special files with predetermined settings, in all the five modules. You can find presets for naming, sorting, and editing in the Library and Develop modules. You can find similar preset files, called templates, in the Output modules. Presets are designed to help you get the most out of your photos and maximize the power of Lightroom.

Preferences and Presets

Lightroom's preferences help you customize the application as a whole, while Lightroom's presets are specific to each module. The Preferences dialog box includes a tab for setting the general handling of presets and for resetting all the presets to the default settings.

Why Use Presets?

The intent of Lightroom's presets is to save the photographer time when sorting and editing the photo collection, so he can spend more time with the camera and less time with the computer. Presets allow you to reapply the same settings or effects to multiple photos without having to re-create them.

Lightroom Default Presets

Lightroom includes a number of presets for many aspects of the application. You can use the default presets as they are designed, or you can use these as a starting point to enhance an image with your own custom enhancements. You can also use the default presets as a base for creating your own custom presets.

Custom Presets

You can create and save custom presets or templates in all the modules. Once you create a preset or design a template, whether it is for naming photos, enhancing the colors and tone, or for printing, slide shows, or Web galleries, you can save the preset and name it. The next time you need to apply those settings or use the template, your custom preset is listed as one of the options.

Third-Party Presets

You can use presets designed by third parties. You can purchase Lightroom presets, particularly presets for editing and toning images. Other Web sites include free downloads of custom designed Lightroom presets.

Installing Presets

Presets or templates you purchase or download must be installed into Lightroom. Copy the third-party files on your hard drive and open Lightroom. In the Develop module click the **Presets** ▶; in the Slideshow, Print, or Web modules, click the **Template Browser** ▶. Control +click (right-click) on **User Presets** or **User Templates**, and select **Import** to find and load the files.

Set the Essential Lightroom Preferences

Although you can use Lightroom without changing any preferences, many photographers prefer customizing some of the ways Lightroom appears or functions. You can select and set preferences to customize Lightroom for your individual use and to make you more efficient with your photo projects.

Set the Essential Lightroom Preferences

Note: The selections listed in the steps are suggestions for setting preferences. You can change the preferences to fit your projects.

1 Click **Lightroom** (click **Edit**).

2 Click **Preferences**.

The Preferences dialog box appears.

3 Click **General**.

4 Click **Automatically check for updates** (☐ changes to ☑).

5 Click the **When starting up use this catalog** ⬍.

6 Click **Prompt me when starting Lightroom**.

7 Click the **When finished importing photos play** ⬍.

8 Click a system sound to play when Lightroom completes the import process.

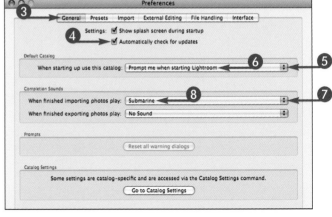

 chapter 4

⑨ Click **Presets**.

The Presets preferences appear in the dialog box.

⑩ Click **Apply auto grayscale mix when converting to grayscale** (☑ changes to ☐).

⑪ Click **Store Presets with catalog** (☐ changes to ☑).

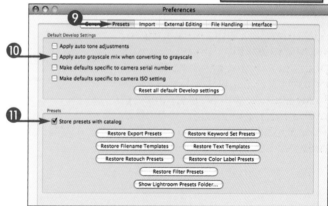

⑫ Click **Import**.

The Import preferences appear in the dialog box.

⑬ Click **Ignore camera-generated folder names when naming folders** (☐ changes to ☑).

⑭ Click the **Image Conversion Method** 🔽.

⑮ Click **Preserve Raw Image** to maximize the amount of data preserved in the original raw file when importing into the DNG format.

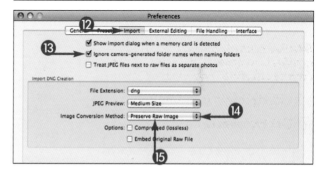

 TIPS

Why should I select Prompt me when starting Lightroom as in Step 6?

Many photographers maintain multiple catalogs, either because of a very large volume of images in their collection or to separate projects. Having Lightroom prompt you to select a specific catalog (●) as it launches ensures that the application opens the way you intended.

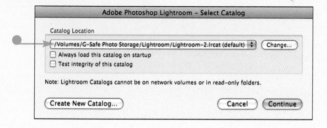

What is the benefit of storing the presets with the catalog?

When you copy catalogs from one computer to another with the presets stored with the catalog — for example, from your desktop machine to your travel laptop — the same presets are available on both systems so you can work consistently with your images. Leaving the box unchecked stores the presets on the local machine and makes those presets available to all catalogs on that one computer.

Compared to most applications, Lightroom has relatively few preferences options. Some are essential for the way you work. Others, such as the Panel End Marks and Panel Font Size, enable you to customize the visual appearance of the interface itself. Learning how to configure specific preferences helps you get the most out of Lightroom.

Set the Essential Lightroom Preferences *(continued)*

⑯ Click **External Editing**.

Note: Lightroom automatically sets Photoshop CS3 as the external editor if that program is installed on the computer.

⑰ Click the **Color Space** ⬦.

⑱ Click **ProPhoto RGB**.

⑲ Click the **Bit Depth** ⬦.

⑳ Click **16 bits/component**.

㉑ Click the **Compression** ⬦.

㉒ Click **None**.

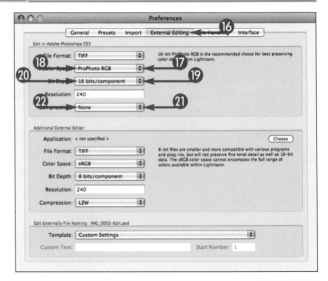

㉓ Click **File Handling**.

㉔ Click the **Treat the following characters as illegal** ⬦.

㉕ Click the list of symbols.

㉖ Click the **Replace illegal file name characters with** ⬦.

㉗ Click **Underscores**.

㉘ Click the **When a file name has a space** ⬦.

㉙ Click **Replace With An Underscore**.

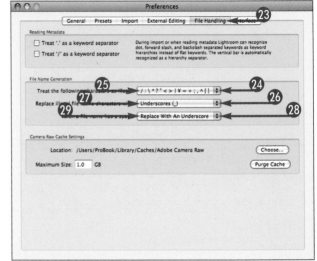

③⓪ Click **Interface**.

③① Click the **Panel End Mark** 🔽.

③② Click **Fleur**.

③③ Click **Zoom clicked point to center** (□ changes to ☑).

③④ Click 🔘 (click **OK**).

The Preferences dialog box closes.

③⑤ ⌘+click (Ctrl+click) the **Catalog** ▼.

● The left panel sections close, showing the Fleur-styled panel end mark.

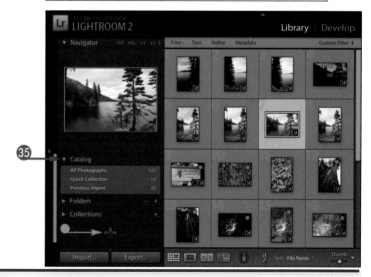

Why is medium gray the best background fill color?

Because you are making decisions about your photos by what you see on the screen, you want to view the images without any influence from surrounding colors. Medium gray does not affect the color or contrast of a photo. Black increases the visual contrast in a photo, and white makes the colors and contrast appear less pronounced.

Why select ProPhoto RGB and not Adobe RGB for the color space in Adobe Photoshop?

If you shoot in RAW, you want to preserve the most color information possible throughout the photo processing. By editing your photos in ProPhoto RGB, which is a larger color space than Adobe RGB, you do not downgrade the colors your camera sensor captured. Also, maintaining the 16-bit setting when moving from Lightroom to Photoshop preserves the most data in the file.

Customize the Catalog Settings

Catalog settings determine where the catalog is stored on your computer, the size and quality of the Lightroom previews you use for editing your photos, and metadata options. You can also set Lightroom to automatically back up the catalog data as an added safety measure.

Customize the Catalog Settings

Note: The selections listed in the steps are suggestions for catalog settings. You can change the settings to fit your hardware and projects.

① Click **Lightroom** (click **Edit**).

② Click **Catalog Settings**.

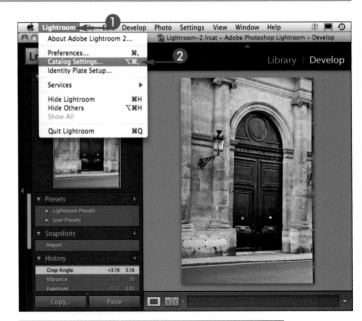

The Catalog Settings dialog box appears.

③ Click **General**.

④ Click the **Back up catalog** [↕].

⑤ Click **Every time Lightroom starts**.

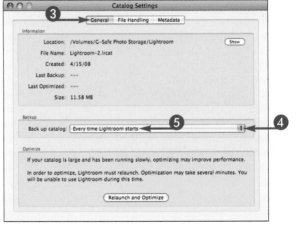

6 Click **File Handling**.

The File Handling options appear.

7 Click the **Automatically Discard 1:1 Previews** :.

8 Click **Never**.

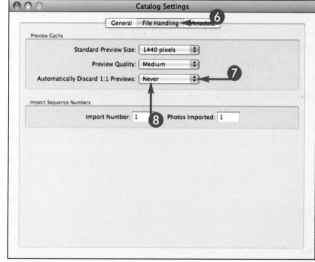

9 Click **Metadata**.

10 Click **Automatically write changes into XMP** (☐ changes to ☑).

Note: *Lightroom cannot write data changes into a manufacturer's camera raw file. When you write the changes to XMP, Lightroom saves the data in a sidecar file so applications such as Bridge and Photoshop can see the edits you have already applied to the image.*

11 Click 🔘 (click **OK**) to save and close the Catalog Settings.

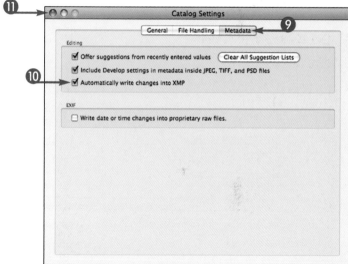

TIPS

Why would I want to discard the 1:1 previews?

Lightroom generates 1:1 previews when you work on an image. Ideally you would want to keep the full size previews available to save rendering time when you open the photo. The larger previews take up more space. So if you are finished working on some images, you might want to discard the large previews to save disk space.

Why are there several options for standard preview size?

The standard preview size is the maximum dimensions for the rendered preview in Lightroom. Select a size that is in line with your monitor's resolution. If you have a high-resolution display, a large preview size gives you a better view of the photos.

Quickly Change Your Lightroom View

Lightroom is designed to let you focus on your photographs. You can change the Lightroom interface by hiding or showing any of the different panels as described in Chapter 3. You can also quickly view your photo with no distractions and in any module as you work, by changing from a normal Lightroom interface to a full screen view with one keystroke.

Quickly Change Your Lightroom View

1 In the Library module, click **Loupe View** (☐) to see a Loupe view of a photo.

2 Press `Shift` + `Tab`.

All the panels disappear and the image fills the space.

3 Press `F` twice.

First the title bar disappears and then the menu bar disappears. The Lightroom interface fills the entire screen.

④ Press L.

The lights dim and the photo appears as large as possible surrounded by an 80% gray border.

⑤ Press L twice to return to normal lights.

⑥ Press Shift + Tab to return all the panels.

TIP

What are the keyboard shortcuts for screen view options?

F	Toggle through Screen Modes
⌘+Shift+F (Ctrl+Shift+F)	Full Screen and Hide Panels
L	Toggle through Lights Dim, Lights Out, and Normal
Tab	Toggle Side Panels
Shift+Tab	Toggle All Panels
F5	Toggle Module Picker On and Off
F6	Toggle Filmstrip On and Off
F7	Toggle Left Module Panels On and Off
F8	Toggle Right Module Panels On and Off
T	Toggle Toolbar On and Off

Understanding Metadata

Metadata is data about data. *Metadata* in Lightroom refers to all the data that accompanies a digital photo file. It includes EXIF metadata and IPTC metadata. Lightroom also lets the photographer add a variety of descriptive information to the files for easier sorting and organizing in a catalog.

EXIF Metadata

EXIF metadata is the technical information automatically embedded in the digital file by the camera and generally describes all the camera settings such as ISO, exposure, and file type, as well as the camera and lens model used to capture the image. The specific EXIF metadata applied depends on the camera manufacturer and model.

IPTC Metadata

IPTC metadata is a standard format established by the International Press Telecommunication Council for attaching specific information about a photograph originally intended for use by the press. You can follow the specifications for IPTC fields to add information about the photo category, subject code, and more.

Applying Metadata

Lightroom's Metadata section includes EXIF and IPTC information, as well as general data such as ratings, contact, and copyright information, to help you identify your images. You can apply metadata when you import and when you organize photos in the Library module. You can also create sets with specific metadata and save them as templates.

Metadata in the Catalog

The metadata for each image, along with the previews and keywords, is written into the catalog. You can edit the metadata for a photo even when the actual photo is not on an attached drive, which allows you to organize your image archive on any computer on which you have the Lightroom catalog.

Save Metadata with the Photo Files

In order to export images or to edit them in Photoshop or another application, you must set Lightroom to save the metadata with the file so the external application, such as Bridge or Photoshop, is aware of the changes already applied. For DNG photo files, Lightroom writes the metadata directly in the file. For camera RAW files, you must set the Metadata preferences in the Catalog Settings to automatically write changes into XMP to link the XMP sidecar file to the RAW file.

Apply Metadata in the Library Module

You can modify or add specific metadata for one photo or a group of photos in the Library module. The Metadata pane in the right Library panel includes fields for rating stars, labels, titles, scene location, and more. You can add as much detail as you want to any photo.

① In the Library module, click a photo to select it.

② Click the **Histogram** ▼ to close the Histogram pane.

③ Click the **Metadata** ◀ in the right panel.

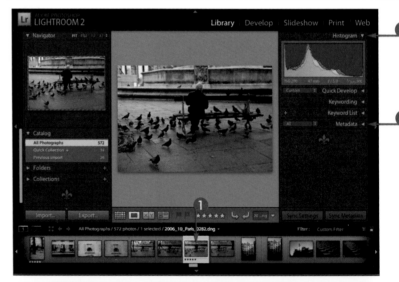

The Metadata section opens.

④ Click in the Title field.

⑤ Type a title for the photo.

⑥ Click in the Caption field.

⑦ Type a caption for the photo.

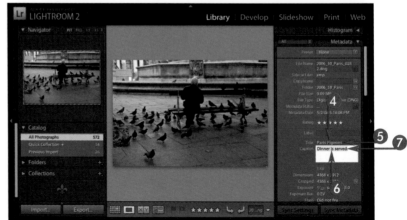

8 Click and drag the scroll bar to view more Metadata fields.

9 Click in the Creator field and type your name.

10 Click in the Website field and type your site name.

Note: *Optionally, enter relevant information into any other field.*

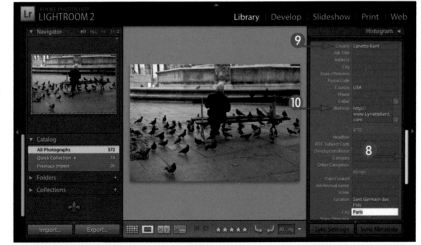

11 Click and drag the scroll bar to the bottom of the Metadata pane.

12 Click the **Copyright Status**.

13 Click **Copyrighted**.

14 Click in the Copyright field.

15 Type your copyright information.

Any metadata you add is applied to the selected photo.

Note: *If you ⌘+click (Ctrl+click) individual photos in the Filmstrip or the grid to select them, any information you add in the Metadata pane is applied to all the selected photos at once.*

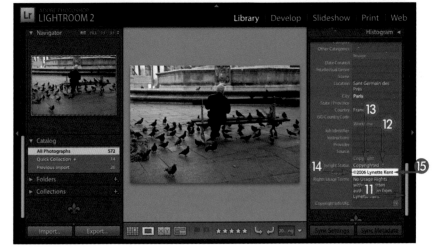

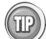

Can I change the EXIF metadata?

You cannot change EXIF metadata for a photo with one exception. You can change the recorded capture time. If the date and time of the camera was not properly set or if the shot was taken in a different time zone, you can correct the data by selecting **Metadata** and then **Edit Capture Time**. In the dialog box that appears, set the correct date and time (●) and click **Change**.

Synchronize Metadata between Photos

You can add metadata to one photo and then selectively synchronize this information from the selected image file to a group of selected images. Synchronizing is different from applying the metadata to multiple photos because you can select specific data from the master image file to be synchronized to the other photos.

① Click a photo in the Library module to select it.

② Click the **Metadata** ◀.

The Metadata pane expands.

③ Repeat any of the steps from the previous task to enter metadata.

④ ⌘+click (Ctrl+click) other photos in the Filmstrip or in the grid.

⑤ Click **Sync Metadata**.

The Synchronize Metadata dialog box appears.

⑥ Deselect any metadata or categories that do not apply to all the selected photos (☑ changes to ☐).

Note: *Optionally, click any metadata and type the information to be added to any empty fields that apply to all the selected photos.*

⑦ Click **Synchronize**.

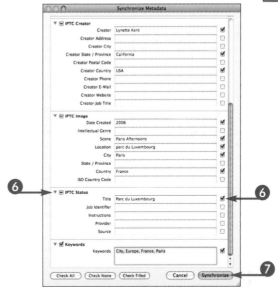

Note: *If a warning dialog box appears, click* ***Don't Save*** *to synchronize the metadata for all the selected photos and not set the selections as a new preset.*

The selected metadata is applied to all the selected photos.

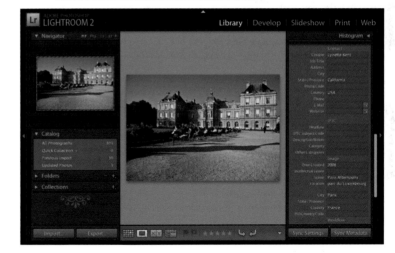

How do I type the copyright symbol?

On a Mac, press `Option` + `G` to create the copyright symbol. On a PC, press `Ctrl` + `Alt` + `C` or press `Alt` +0169 on the numeric keypad.

What is the benefit of taking the time to add all that metadata?

Lightroom's database engine is one of the main advantages of the application. Lightroom searches the database quickly by using the metadata information that is linked or embedded in the photo files. Once you apply metadata you can easily search to more quickly find the images you need.

Create a Copyright Metadata Preset

You can create various metadata presets to apply the same specific information to images without having to enter the data over and over. A copyright metadata preset is particularly useful to quickly apply your name and copyright to images when importing or as you categorize them in the Library module.

① In the Library module, click **Metadata**.

② Click **Edit Metadata Presets**.

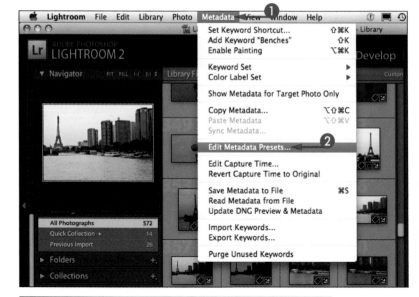

The Edit Metadata Presets dialog box appears.

③ Click the **Preset** 🔽.

④ Click **Save Current Settings as New Preset**.

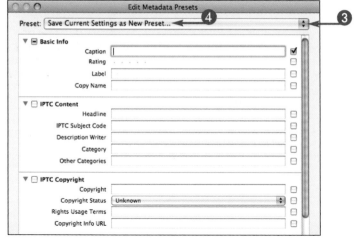

A New Preset dialog box appears.

⑤ Type a name for your copyright into the field.

⑥ Click **Create**.

⑦ Click **IPTC Copyright** (☐ changes to ☑).

⑧ Click in the **Copyright** field and type your copyright.

⑨ Click the **Copyright Status** ▤.

⑩ Click **Copyrighted**.

⑪ Click in the **Rights Usage Terms** field and type the usage rights you want to use.

⑫ Click **IPTC Creator** (☐ changes to ☑).

⑬ Click in each of the fields and type any information you want to include.

⑭ Click **Done**.

The copyright metadata preset is now available.

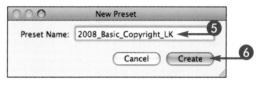

Are there more ways to create and access the metadata presets?

Metadata presets can be created and even edited during the import process or directly from the menu bar as in the task above. You can also apply, edit, or create new metadata presets in the Metadata panel by clicking the **Presets** ▤ and selecting a preset to change or selecting **Edit Presets**.

How can I remove or delete a metadata preset?

You can delete a metadata preset in the Edit Metadata Presets dialog box. With a preset selected in the dialog box, click the **Preset** ▤. Click **Delete preset** *"the name of the preset"* (●).

Design a Personal Identity Plate

You can personalize the Lightroom interface by changing the top panel, which includes both the identity plate and the module buttons. Because Lightroom is intended to help the photographer catalog, edit, and present photos to clients, you can create a personal identity plate with your name or company logo to appear not only on the Lightroom interface but also on the final output, such as a Web gallery or print page.

① Click **Lightroom** (click **Edit**).

② Click **Identity Plate Setup**.

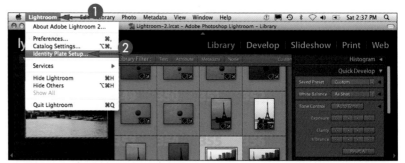

The Identity Plate Editor appears.

③ Click **Enable Identity Plate** (☐ changes to ☑).

● Lightroom automatically picks up the login name and places it in the top left corner of the interface.

④ Click **Use a styled text identity plate** (○ changes to ⦿).

⑤ Click and drag across the existing login name.

⑥ Type your name.

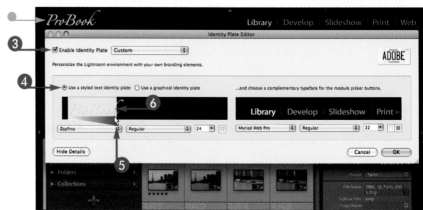

⑦ Click the **Font** 🔁 to select a font.

⑧ Click the **Font Family** 🔁 to select a font family.

⑨ Click the **Size** 🔽 to select a size.

⑩ Click the color box (▣) to change the color.

⑪ Click the **Enable Identity Plate** 🔁.

⑫ Click **Save As** from the menu that appears.

● The Save Identity Plate As dialog box appears.

⑬ Type a name for the identity plate in the field.

⑭ Click **Save**.

● The custom identity plate name now appears as a selection in the Identity Plate Editor pull-down menu.

⑮ Click **OK** to close the Identity Plate Editor.

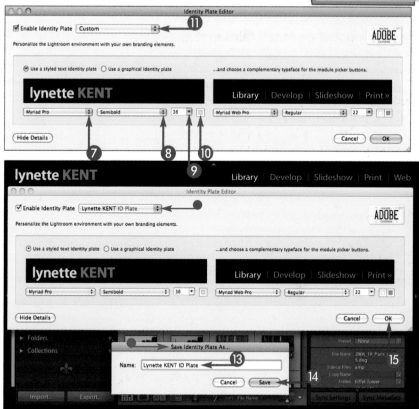

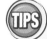

TIPS

Can I have more than one custom identity plate to use at different times?

Yes. You can create multiple identity plates both with text and with graphics. You can create one identity plate for each client or project. Save and name the identity plates you create in the Identity Plate Editor and they will all appear in the pull-down menu for quick and easy interface changes.

Where else can I use the identity plate other than the basic Lightroom Interface?

The output modules — Slideshow, Print, and Web — each include an option to add your identity plate to the finished files. You can also set the Scale and Opacity of the identity plate as it appears on the slide shows, prints, or Web galleries.

Modify the Module Buttons

If you show your photos to clients or friends using your computer, you may want to unify the look of the Lightroom interface by customizing the module buttons. Also, if your custom identity plate is wide, you may want to adjust the size of the module buttons to fit the available space in the top panel.

① Click **Lightroom** (click **Edit**).

② Click **Identity Plate Setup**.

The Identity Plate Editor appears.

③ Click the **Font** 🔽 to select a font for the module buttons.

④ Click the **Font Family** 🔽 to select a font family.

⑤ Click the **Size** 🔽 to select a font size.

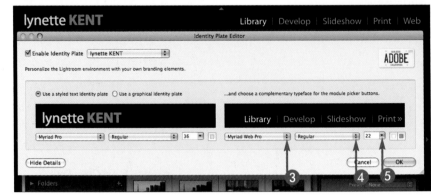

- The changes to the font are shown in the sample and are immediately reflected in the top panel module buttons.

6 Click the left box (▭) to change the active color.

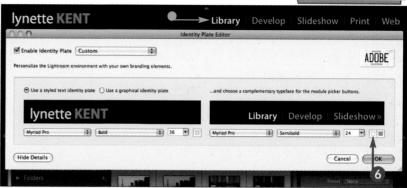

- The color picker appears.

7 Click in the color picker to select the active color.

8 Click the right box (▭) to change the base color.

9 Repeat Step **7** to select the base color.

10 Click **OK**.

- The module buttons appear in the colors you chose.

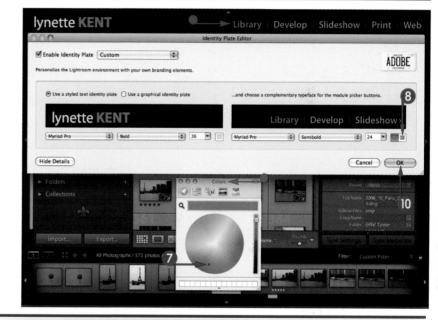

 TIPS

Can I make an identity plate to use as an overlay when printing proof contact sheets?

Yes. Create an identity plate as in the previous task using the word PROOF in white. Save it as a custom identity plate. In the Print module, click **Identity Plate** in the Overlays pane. Click and drag the **Opacity** and **Scale** sliders to fit your image. Click the rotation degree and set the angle (●). Click **Render on every image** to have the word PROOF on each photo on the contact sheet.

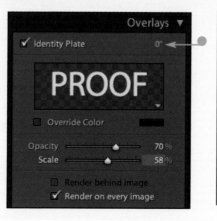

When I change the Identity Plate in the Overlay selection does the top panel identity plate change as well?

No. When you select a specific identity plate as an overlay in one of the output modules, the main identity plate in the top panel remains with your original selection.

Create a Graphical Identity Plate

Using Photoshop or Photoshop Elements, you can add your logo or create any graphic file to save and use as an identity plate. You can even include tiny photo thumbnails by reducing the size of the photos and adding these as layers in your design. The process is very similar in both Photoshop and Photoshop Elements.

① Launch Photoshop or Photoshop Elements.

② Click **File** and select **New**.

Note: Optionally, type a name in the Name field.

③ Type **57** pixels in the height field.

Note: Lightroom requires a maximum height of 60 pixels high at 72 ppi for the identity plate.

④ Set the width to approximately one half the width of your largest monitor screen.

⑤ Set the resolution to **72** ppi.

Note: This resolution is not for printing.

⑥ Click the **Background Contents** ▣ and select **Transparent**.

⑦ Click **OK**.

A new document appears.

Note: You can use type, copy and paste your pre-designed logo, add photo thumbnails, or create any art for your identity plate. The following are suggestions for a gradient identity plate.

⑧ Click the foreground color to select a color.

⑨ Click the **Gradient** tool (▣).

⑩ Click the gradient picker and select the Foreground to Transparent option.

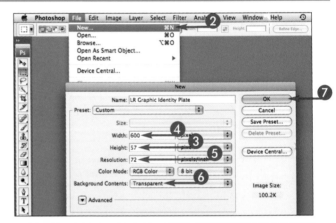

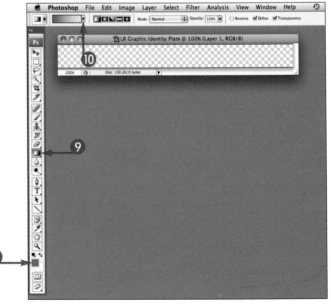

⑪ Click and drag in the image to create a gradient fading to transparent.

⑫ Click the foreground color to select white.

⑬ Click the **Type** tool (T).

⑭ Select the font, font family, and size.

⑮ Click in the document and type your text.

⑯ Click **Layer**.

⑰ Click **Flatten Image**.

⑱ Click **File** and select **Save**. Name the custom identity plate in the Save As dialog box, and save it in the Lightroom folder on your hard drive or a convenient location.

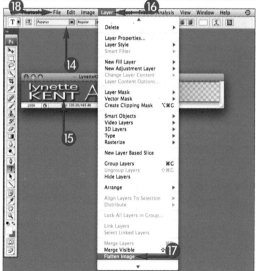

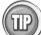
TIP

How do I place my graphical Identity plate into Lightroom?

Follow the steps in the Design a Personal Identity Plate task to open the Identity Plate Editor. Click **Enable Identity Plate** (☐ changes to ☑). Click **Use a graphical identity plate** (○ changes to ◉). Click **Locate File** and navigate to the file you just created. Your design automatically appears in the Editor and in the top panel in Lightroom.

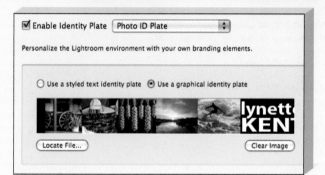

CHAPTER

5

Setting the Stage for Digital Photo Developing

Lightroom helps you develop your photos in the digital darkroom. Lightroom's interface lets you focus directly on the image as you work, just as you would in a traditional darkroom. Because you edit the images based solely on what you see on the screen, a good quality and well-calibrated monitor is the most important tool for processing photographs with Lightroom.

Focus on Your Monitor.......................................134

**Understanding Monitor Calibration
 Options ...136**

Calibrate and Profile Your Monitor..............138

Focus on Your Monitor

Everything starts with your monitor. Your camera captures the data and your monitor displays it as a photograph. You make decisions on the quality of the photo and make adjustments to the colors and tone based on the colors and tone you see on the monitor. If your monitor displays inaccurate colors, your images cannot be viewed accurately.

Quality of Monitor

Because you cannot enhance what you cannot see correctly, the monitor is the most important piece of computer hardware for judging and editing photos. Unlike a TV, you sit very close to the monitor to analyze details and colors. Use a high-quality monitor with sharp details, uniform brightness, and image stability to help you see the image clearly and avoid eyestrain.

Monitor Calibration and Profiling

All monitors require regular calibration and profiling. Each monitor is different from every other one, including the same model and brand, and each interacts differently with your computer's specific video card. Even a brand-new monitor straight out of the box must be calibrated and have a profile created to more closely display the colors and tone captured by your camera.

Monitor Calibration Defined

Monitor calibration refers to the measurement by an external hardware device of the colors a particular monitor displays as compared to an established ICC, International Color Consortium, standard for those colors.

Monitor Profiling Defined

Profiling software analyzes the colors recorded by the measurement device and creates a data file or set of instructions called a *profile*. Your computer's graphics card then uses the new profile to adjust the monitor so it displays the colors closer to the ICC standards.

More Viewing Considerations

The area surrounding the monitor should be free of bright colors and lights that reflect in the screen or cause glare, both when you calibrate your monitor and view your photos. Even the viewer's clothing should be as neutral in color as possible, because what you are wearing reflects directly in the monitor and can affect your visual perception.

Understanding Monitor Calibration Options

Although the operating system generally includes a software monitor calibration option and Adobe Photoshop includes the Gamma application, these visually controlled monitor calibration options are totally subjective and depend on the color sense of the user. The best and most accurate way to calibrate and profile a monitor is using an external hardware device and its specific software.

Software-Only-Based Monitor Calibration

Using the operating system to calibrate your monitor and create a profile is better than no calibration at all. However, the results vary with the color sense of the user. This software asks you make adjustments according to what you see on the screen. It cannot actually measure how your monitor is emitting the light.

Hardware-Based Monitor Calibration

Using a hardware device, your monitor can be more accurately calibrated. A *colorimeter* measures the colors shown on the monitor. A *spectrophotometer* has more options and can also measure the colors produced by other devices, including a printer; you can also use the spectrophotometer to create color profiles for your particular printer using specific papers and inks.

Hardware Calibration Devices

Various vendors including Datacolor and X-Rite make monitor calibrating hardware and profiling software such as the Spyder3, hueyPRO, i1Display, ColorMunki, and i1Photo. The entry-level devices include basic measurement and profiling software, and the more advanced units include profile editing plus digital camera and scanner profiling.

hueyPRO Colorimeter

Designed for all types of monitors, both CRT and LCD, the Pantone X-Rite hueyPRO colorimeter offers basic monitor calibration and profiling software and also measures the ambient light levels around the monitor, adjusting the display in response to changing room brightness.

ColorMunki

X-Rite's ColorMunki Photo is a spectrophotometer specifically designed for the digital photographer. The ColorMunki measures the ambient light levels and can calibrate your monitor, printer, or even a projector.

Calibrate and Profile Your Monitor

Using a device such as the ColorMunki makes monitor calibration and profiling very quick. Using the easy mode, you select the display type, set the device on the screen, and follow the on-screen steps. You can also use the advanced mode to specifically regulate the brightness and contrast settings and other settings for your specific monitor.

Calibrate and Profile Your Monitor

Note: *The following steps show how to use the ColorMunki Photo in advanced mode. Most other devices use similar steps.*

CALIBRATE THE MEASURING DEVICE

① With the device software installed, launch the ColorMunki application.

② Click **Profile My Display**.

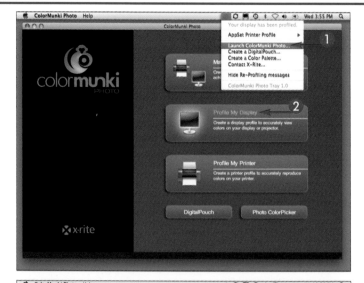

③ Click your monitor type (🔘 changes to 🔘).

④ Click **Advanced** (🔘 changes to 🔘).

⑤ Click the **Target White Point for display** 🔽 and click **D65 (default)**.

⑥ Click **Next**.

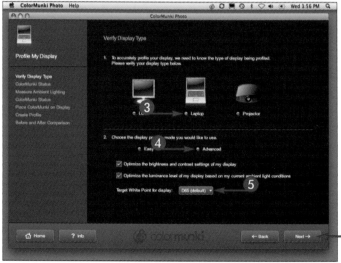

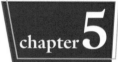

7 Connect the device with the USB cable if necessary.

8 Rotate the dial to the calibrate device setting.

9 Click the button on the device to calibrate it.

10 Click **Next**.

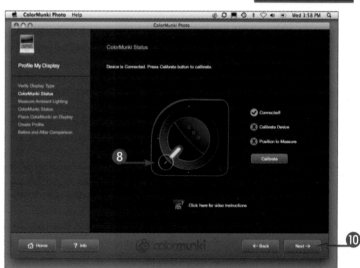

MEASURE THE AMBIENT LIGHTING

1 Place the ColorMunki next to the monitor.

2 Click **Measure**.

3 When the green check mark appears, click **Next**.

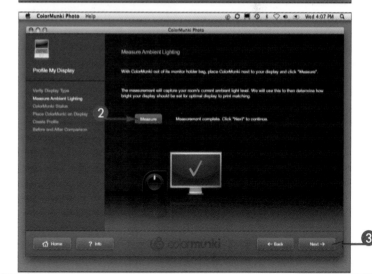

TIPS

What is the best color temperature to use for my monitor for viewing photographs?
6500K (or D65) (see Step 5) is considered a good choice. Video cards and monitors are often preset to 9300K, which gives a bluish tint to everything. 5000K approximates sunlight and is the color of lighting in art galleries; however, it often produces dingy, yellowish white colors on monitors. For LCDs, use the native white point if possible to display the widest color range on this type of monitor.

What Gamma setting should I use?
A monitor's *gamma* refers to the contrast in the midtones it produces. If possible, use the monitor's native gamma, which allows for the maximum range of colors your system can display. For most monitors the native gamma is 2.2.

continued

Calibrate and Profile Your Monitor *(continued)*

Color temperature describes the color of light in terms of the temperature of the light source. The color temperature of the display changes the appearance of the image. At 9300K the light appears more bluish-green. At 5000K and below, the light appears more yellow-red.

White point for a monitor combines the color temperature of the light source with the intensity of the brightest white the monitor can reproduce.

Calibrate and Profile Your Monitor *(continued)*

MEASURE AND CALIBRATE YOUR MONITOR

① Turn the device dial to the measure position with the beam pointing up.

② Click **Next**.

 A yellow box appears in the application window.

③ Place the ColorMunki in its holder and place it directly over the yellow box on the screen, hanging the lanyard off the back of the monitor.

④ Click **Next**.

 The Contrast setting box appears.

⑤ Follow the instructions to adjust the contrast on your display if possible.

⑥ Click **Next**.

 The Contrast Adjustment box appears.

⑦ Follow the instructions to adjust the contrast until the green check mark appears.

⑧ Click **Next**.

⑨ Repeat Steps **7** and **8** to adjust the Brightness.

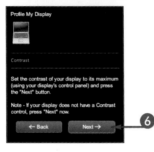

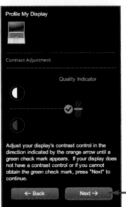

The monitor displays a series of full-colored screens as the device measures all the colors.

Another screen appears showing the profile complete.

⑩ Click the **Remind me to re-profile this display every** ▼ and select **week**.

⑪ Click **Next**.

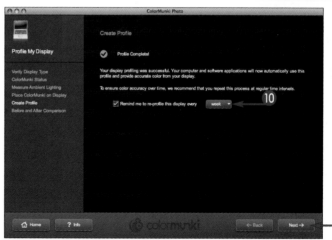

A Before and After Comparison screen appears.

⑫ Click the **Before** button and then the **After** button to compare the results.

⑬ Click **Next** to complete the process.

TIPS

What do the black and white levels refer to?

Black levels correspond to the monitor's brightness, and white levels correspond to the contrast values. The calibration software guides you and displays a green check mark when the optimum levels are set. In general, the brightness should be set so almost black is just distinguishable from pure black. The contrast should be set so that fine details are not blown out.

How often do I have to calibrate and profile my monitor?

You should calibrate and profile more frequently as the monitor ages. Consider calibrating and re-profiling once a week for photographic use depending on the age of your monitor. LCDs generally retain their color fidelity longer than CRTs, which are considered old after 3 years. However, even an older monitor's color display can be somewhat revived or improved by calibration and profiling.

CHAPTER

6

Using the Library Module for Quick Developing

The Library module not only contains all the tools for organizing, categorizing, and sorting your photos, it also includes some quick develop tools. You can use these tools to easily judge the editing possibilities and quality of your photos without going into the full Develop module.

Understanding the Histogram144

Alter the Photo with a Preset.......................146

Crop Your Photo with a Preset......................147

Make a Quick Change to Grayscale148

**Quickly Select a Different White
Balance** ...149

Fine Tune the White Balance Setting150

Modify an Auto Tone Change........................152

**Understanding Library Module Clarity
and Vibrance Tools**154

**Improve the Photo with Clarity
and Vibrance** ...155

**Synchronize a Quick Develop Setting
for Multiple Images**156

Create Virtual Copies to Compare Edits158

Understanding the Histogram

Lightroom includes a histogram in both the Library and Develop modules. In the Library module, the histogram functions as a guide to viewing and enhancing your photos. In the Develop module, the histogram functions as both a guide and a tool to help you adjust overall tones in your images. Understanding what the histogram shows is essential to editing photos.

What Is a Histogram?

A *histogram*, whether on the back of your camera or in Lightroom or Photoshop, is a graph that displays the overall distribution of tonal levels in the image, from the darkest to the lightest levels. The histogram acts as a guide, showing the kind of exposure and the amount of contrast, and can help you determine which adjustments to use to best improve your photo. Each photo is different, and the histogram of a good image does not necessarily spread completely across the graph.

Dynamic Range

Dynamic range describes the ratio between the measurable intensity of the darkest and the lightest areas that can be seen by the human eye, captured by a camera sensor, displayed on a monitor, or printed by a printer, and each specific device has its own dynamic range. A camera sensor can capture greater dynamic range than what a monitor can display or a printer can print.

Tonal Range

Tonal range and dynamic range are related. The histogram is a graph of all the tones in the image, ranging from the darkest on the left to the lightest on the right. The tonal range is the region on the histogram where most of the brightness values appear.

Clipping

Clipping occurs when areas of the image have no shadow or highlight detail and are either totally black or totally white. Clipped areas appear in the histogram as areas going up and off the right or left side of the chart. The Develop module's histogram includes a preview function so you can see exactly the areas in the photo that are clipped.

Contrast

Contrast is the difference in the extremes of brightness between the light and dark areas in a photo. A high-contrast image shows deeper shadows and brighter highlights than a low-contrast image. The histogram for a high-contrast image has wider mountain peaks than those in the histogram of a low-contrast image. A photo can have areas of both high and low contrast.

Alter the Photo with a Preset

The Quick Develop options in the right panel of the Library module include a number of presets you can use to easily change the look of your photograph with one click. These presets are a quick way to see how an ordinary image might be improved.

① In the Library module, click a photo in the grid or the Filmstrip.

② Click **Loupe View** (▣).

Note: Alternately, press **E**.

Note: Click **F7** to hide the left panel.

③ Click the **Quick Develop** ◄.

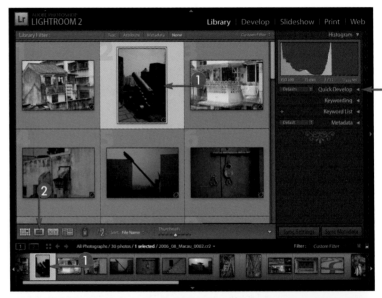

The Quick Develop pane expands.

④ Click the **Saved Preset** ▣.

⑤ Click a preset.

The settings, Creative Antique in this example, are applied to the image.

⑥ Repeat Step **5** to try any of the other presets.

Note: If you click multiple presets in the order in which they are listed, the effects are compounded.

Crop Your Photo with a Preset

You can crop photos in the Library module using the Quick Develop crop ratios. You can use any of the preset crop ratios listed or you can enter a custom crop ratio. The preset crop ratios always crop the photo from the center.

Crop Your Photo with a Preset

① Repeat Steps **1** to **3** from the previous task.

Note: *Optionally, click* **F** *twice to see the full screen.*

② Click the **Crop Ratio** ▣.

③ Click a preset ratio.

The image is cropped from the center to the preset crop ratio.

Note: *Optionally, in Step 3, click* **Enter Custom**.

The Enter Custom Aspect Ratio dialog box appears.

④ Type the desired ratio in each box.

⑤ Click **OK**.

The new crop ratio is saved and appears in the Crop Ratio menu.

Make a Quick Change to Grayscale

In addition to selecting a Black and White preset, you can quickly change a color photo to grayscale by applying a grayscale treatment in the Library module. You can quickly see if the grayscale image has more impact than the color photo.

Make a Quick Change to Grayscale

1 Repeat Steps **1** to **3** from the "Alter the Photo with a Preset" task.

2 Click the **Treatment** ⊟.

3 Click **Grayscale**.

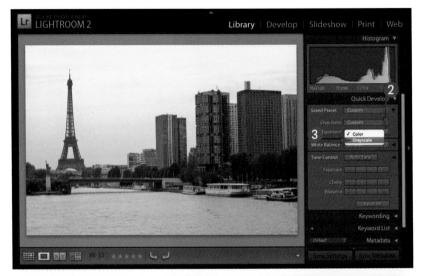

The color photo appears in grayscale.

4 Click **Reset All**.

The photo reverts to the original settings.

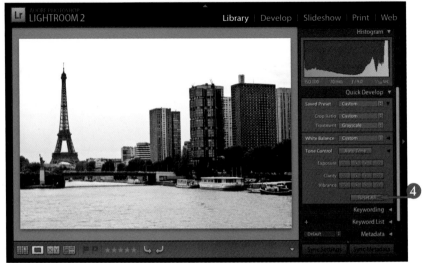

Quickly Select a Different White Balance

Whether you used the automatic white balance of the camera or set a custom one, you can select a different white balance in Lightroom to quickly see how it will alter your photo. You can easily compare the various options and also use this comparison as a learning tool to improve your photography in general.

Quickly Select a Different White Balance

① Repeat Steps **1** to **3** from the "Alter the Photo with a Preset" task.

② Click the **White Balance** .

③ Click a different white balance from the menu.

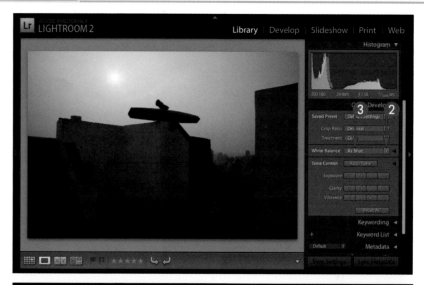

The new white balance is applied to the photo.

④ Repeat Step **3** until you find a setting you like for that photo.

Note: If you import JPGs rather than RAW photos, your choices are Auto, As Shot, and Custom.

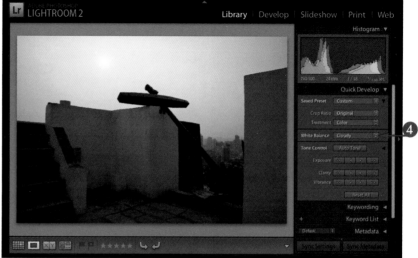

Fine Tune the White Balance Setting

An incorrect white balance setting in a camera can produce a color cast, giving the photo an overall blue, orange, or green appearance. You can make refined adjustments to the Temperature and Tint of the white balance, especially for RAW files while in the Library module.

Fine Tune the White Balance Setting

CHANGE THE WHITE BALANCE SETTINGS

1 Repeat Steps **1** to **3** from the "Alter the Photo with a Preset" task.

2 Click the **White Balance** .

3 Click a different white balance from the menu.

4 Click the **White Balance** .

The White Balance pane expands.

5 Click the **Temperature** or to make the photo cooler, or or to make the photo warmer.

Note: The and make a much greater correction with one click than and .

⑥ Click the **Tint** [▷▷] or [▷] to add more magenta to the tint, or [◁◁] or [◁] to add more green to the tint.

REVERT THE WHITE BALANCE SETTINGS

① Click the **White Balance** [⊟].

② Click **As Shot**.

● Click **Reset All** to revert all the settings in the Quick Develop pane.

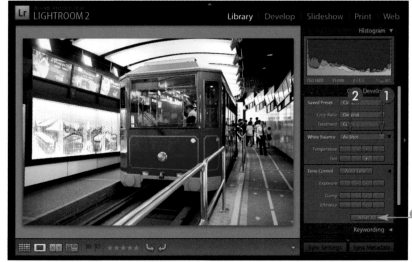

Why is there a color cast in my photo?
All light sources have different color temperatures, which can lead to these color casts. Although the human eye sees white as white under varying lighting conditions, the camera sees the color of the light reflected from the white item. Digital cameras include a number of presets you can use to set a white balance based on the color temperature of the light source, and advanced cameras include a custom option.

How do I set the Custom White Balance on my camera?
Take a full-frame photo of a known reference card, such as the ColorChecker card from xrite.com or a WhiBal card from rawworkflow.com, in the same lighting as your subject. You can also use an ExpoDisc from expodisc.com, as a custom lens filter, and take a photo to capture the incident light in the scene. You then set that photo as the custom white balance according to the individual camera manufacturer's instructions.

Modify an Auto Tone Change

The Auto Tone setting in the Quick Develop pane tries to correct the exposure by extending the dynamic range of the image without clipping the highlights or shadows. Depending on the image, Auto Tone may make the photo appear overexposed. You can then refine the Auto Tone setting using the rest of the tools in the expanded Tone Control section.

① In the Library module, click a photo in the grid or the Filmstrip.

② Click 🔳 to go to Loupe view.

Note: *Alternately, press* E *.*

Note: *Click* F7 *to hide the left panel.*

③ Click the **Quick Develop** ◀.

The Quick Develop pane expands.

④ Click **Auto Tone**.

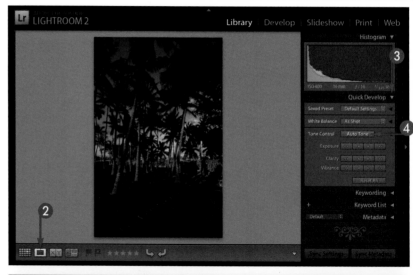

The image changes.

⑤ Click the **Tone Control** ◀.

 chapter 6

The Tone Control pane expands.

6 Click the **Exposure** [◀◀] or [◀] to decrease the exposure.

● Click the **Exposure** [▶▶] or [▶] to increase the exposure.

7 Click the **Recovery** [▶▶] or [▶] to recover lost highlights.

8 Click the **Fill Light** [▶▶] or [▶] to lighten the darkest shadow areas.

9 Click the **Blacks** [▶▶] or [▶] to increase the depth of the dark areas.

TIPS

What do the Recovery and Fill Light options do?

Clicking the right **Recovery** arrows ([▶▶] and [▶]) helps bring back details in the highlights without blocking up the shadow areas. Clicking the right **Fill Light** arrows ([▶▶] and [▶]) adds light to the shadow areas without lightening the entire image. Using too much Fill Light adds noise to the dark areas.

What kind of change is made to the exposure by clicking the single or double arrows?

Clicking the single arrows ([◀] and [▶]) decreases or increases the exposure by 1/3 exposure stop. Clicking the double arrows ([◀◀] and [▶▶]) decreases or increases the exposure by 1 full exposure stop. For the other controls, the single arrows increase the values by 5 steps and the double arrows by 20 steps.

The lower portion of the Tone Control pane includes adjustments that mainly affect the midtones in the photo. Adding Brightness increases the brightness of the image. Increasing Contrast darkens the middle-to-dark areas and lightens the middle-to-light areas. Although Clarity is related to Contrast, and Vibrance is similar to Saturation, they differ in the way they affect the image.

Clarity

Clarity is an adaptive midtone contrast adjustment, which should be applied when zoomed in at 100%. Clarity increases the contrast by carefully sharpening mainly the midtones and helps give the image a dramatic look. It even seems to minimize the noise that would be visible with standard digital sharpening. Using the Clarity tool, you can add contrast in a subtle way to improve your photo.

Vibrance

Increasing Vibrance, like increasing Saturation, intensifies the colors in the image. However, although Saturation adjusts the intensity of all the colors of the image, Vibrance affects the less-saturated colors and minimizes any effect on the more saturated areas in the photo. Vibrance also helps avoid oversaturated skin tones.

Improve the Photo with Clarity and Vibrance

You can best adjust your photo by using all the tone controls in the Quick Develop pane. Change the White Balance first and then adjust the tone controls in the order in which they appear. You can always readjust them after setting the Clarity and Vibrance. The Clarity is best adjusted when viewing the image at 100% or greater.

Improve the Photo with Clarity and Vibrance

1. Click ◄ to open the Tone Control pane.

Note: Press F7 to hide the left panel.

2. Press Z to zoom to 100%.

3. Click the **Clarity** ▶▶ or ▶ to increase the clarity.

4. Repeat Step **3** until you see white fringes, referred to as *halos*, on the edges of contrasting areas.

5. Click the **Clarity** ◄ until the halos just disappear.

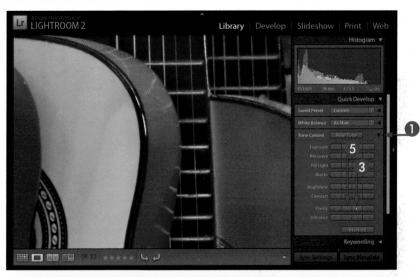

6. Click the **Vibrance** ▶▶ or ▶ to increase the vibrance of the midtones.

7. Press Z to fit the photo in the view.

8. Repeat Step **6** as needed until the image looks pleasing.

Note: To reset just the Clarity or just the Vibrance back to zero, click the word **Clarity** or the word **Vibrance**. To reset the photo to the original, click **Reset All**.

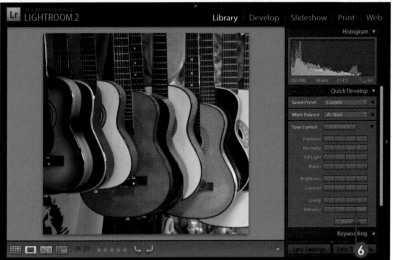

Synchronize a Quick Develop Setting for Multiple Images

You can apply changes to multiple photos at once by first selecting them in the Grid mode, and then clicking the settings in the Quick Develop pane. You can also make changes to one photo and then select others and synchronize the settings across the other images.

Synchronize a Quick Develop Setting for Multiple Images

① Click one photo in the grid to select it.

Note: *Press* F7 *to hide the left panel.*

② Make changes to the photo using the settings in the Quick Develop pane.

③ ⌘+click (Ctrl+click) other photos in the Filmstrip or grid to select them.

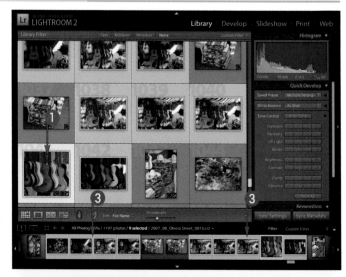

④ Press E to make sure the photo in the Loupe view is the base photo.

⑤ Press G to return to the Grid mode.

⑥ Click **Sync Settings**.

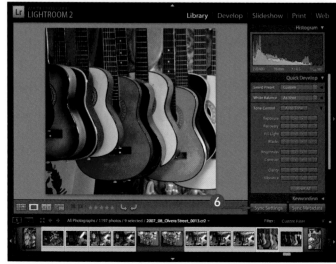

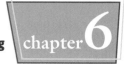
The Synchronize Settings dialog box appears.

⑦ Click the check boxes of any settings you do not want to apply to all the selected photos (☐ changes to ☑).

⑧ Click **Synchronize**.

The selected Quick Develop settings are applied to all the images.

Note: To remove the settings from all but the base photo, press ⌘+Z (Ctrl+Z).

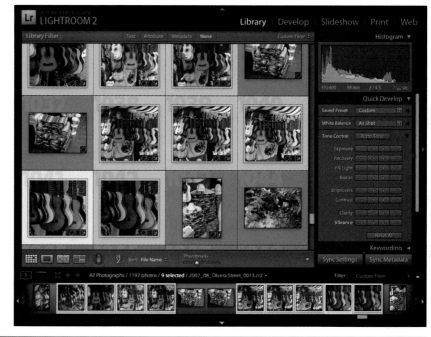

TIPS

With multiple images selected, how do I know which photo's settings will be applied to the others?

Settings are copied from the base photo, the first image you selected. This is the *most selected* photo with the brightest outline area in the Filmstrip or grid. The most selected photo appears in the viewing area in the Loupe view. Press E to go to Loupe view to check. Press G to return to the Grid view.

Why does the Quick Develop pane not include Sharpening and Saturation settings?

Actually it does. You can change the Sharpening and Saturation in the Quick Develop pane by pressing the Option (Alt) key. The Clarity and Vibrance options change to Sharpening and Saturation.

Create Virtual Copies to Compare Edits

You can compare several versions of the same image with different edits applied by creating virtual copies in the Library module. Virtual copies are not copies of the photo but rather a second set of data instructions for viewing the image. You can create virtual copies before applying any develop settings and use the Survey mode to compare all the variations.

Create Virtual Copies to Compare Edits

① Click a photo to select it.

② Click **Photo**.

③ Click **Create Virtual Copy**.

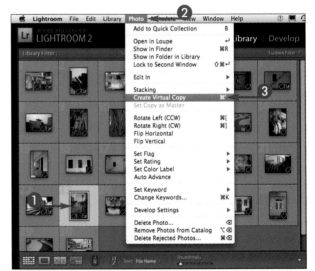

Lightroom makes a virtual copy and stacks it with the master photo.

● The master photo shows the number of photos in the stack.

● The virtual copy appears with a page-turn icon on the lower left corner of the photo.

④ Click the master photo.

⑤ Repeat Steps **2** and **3** to create another virtual copy.

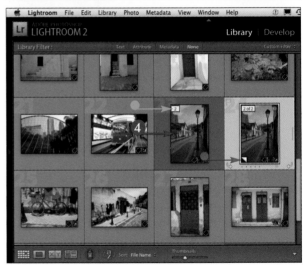

6 Click the first virtual copy.

7 Click the **Saved Preset** ⬚.

8 Click **BW High Contrast**.

9 Click the second virtual copy.

10 Click the **Saved Preset** ⬚.

11 Click **Creative – Sepia**.

12 ⌘+click (Ctrl+click) the three photos to select them.

13 Click **Survey View** (▦).

The master photo and two virtual copies with different adjustments appear in the Survey view.

 TIPS

Does a virtual copy take up more room on my hard drive?

Virtual copies are not duplicate files, so they do not take up more room on your hard drive. You can make as many virtual copies of one master photo as you want.

What else should I know about virtual copies?

- When you export a virtual copy it becomes a separate file.
- You can set the virtual copy to be the master photo by clicking **Photo** and selecting **Set Copy as Master**.
- You can create virtual copies in any module by Control+clicking (right-clicking) the photo in the Filmstrip and selecting **Create Virtual Copy**.

159

CHAPTER 7

Exploring the Develop Module

Although Lightroom's Library module includes some limited image editing functions, the Develop module acts as a full digital darkroom. In this module you can crop and straighten images, edit exposure and tone, improve colors, enhance the contrast, add vignettes and sharpening, and more.

Locate the Parts of the Develop Module....162

Change the Develop Module Interface164

Try the Develop Module Shortcuts166

Using the Develop Module Presets168

Compare Images in the Develop Module....170

Using the Image History and Snapshots172

Rotate a Photo in the Develop Module176

Copy and Paste Edits from One Photo
 to Another...177

Using the Histogram Features in the
 Develop Module ...178

Straighten Images ..180

Recompose Your Photo with a Crop............182

Creatively Crop an Image for Effect184

Repair Dust Spots and Other
 Imperfections..186

Remove Red Eye ...188

Locate the Parts of the Develop Module

The Develop module is used for processing photos. As with a traditional darkroom, you work on your images in the Develop module to create the best negative from your shots. Learning where to find the tools and how to use them is essential to convenient digital photo editing.

● **Develop Module left panel**

Navigator section

The Navigator provides a preview of the image with presets applied and offers specific zooming options

Presets Section

All the Lightroom default presets are listed along with any presets you create and name.

Snapshots section

You can create any number of snapshots to save a specific set of applied steps.

History section

History lists all the recorded edits you have applied.

● **Copy and Paste buttons**

You can copy and paste Develop settings from one photo to another.

● **Develop Module central viewing area (Loupe view)**

The main viewing area shows a large single image or a Before and After view for edit comparisons.

● **Develop Module toolbar**

The toolbar includes the view mode options and any of the flagging, rating, labeling, navigating, slide show, and zoom tools you add to it.

● **Develop Module right panel**

Histogram

The Develop histogram shows a graphical representation of the color and tonal values in the selected image. You can adjust the tones in the image by clicking and dragging directly on different areas of the histogram. You can adjust the Blacks, the Fill Light, the Exposure, and the Recovery as you move the cursor from left to right over the histogram.

● **Adjustment tools**

Clicking any tool icon expands the section to reveal the controls for specific area editing. From the left:

> Crop tool (⬛)
> Spot Removal tool (⬛)
> Red Eye Correction tool (◉)
> Graduated Filter (⬛)
> Adjustment Brush (▬▬)

Basic Adjustments section

The Basic section expands to change the white balance, exposure, and more tonal controls.

Tone Curve section

You can adjust the tonal curve three ways: by moving the descriptive sliders, by clicking and dragging on the curve itself, or by clicking and dragging directly on the image using the Target Adjustment tool.

HSL/Color/Grayscale section

The section expands for three different types of color adjustments, or you can view all three at once by clicking **All**.

Split Toning section

Enables separate controls over the tones in the highlights and shadows.

Detail section

Includes a 100% sectional view and three details adjustments including Sharpening, Noise Reduction, and Chromatic Aberration

Vignettes section

Enables you to add, alter, or remove a vignette on the photo.

Camera Calibration section

Allows you to change the default color response for the specific camera you used or import a custom calibration.

● Previous and Reset buttons

You can go back to the previous settings applied or reset the photo back to its original. With multiple photos selected, the Previous button changes to the Sync button for synchronizing settings across multiple images.

● Filmstrip

The Filmstrip displays all the photos in the folder.

● Filmstrip toolbar

The toolbar lets you open a second window, return to the Library grid, and sort by a filter.

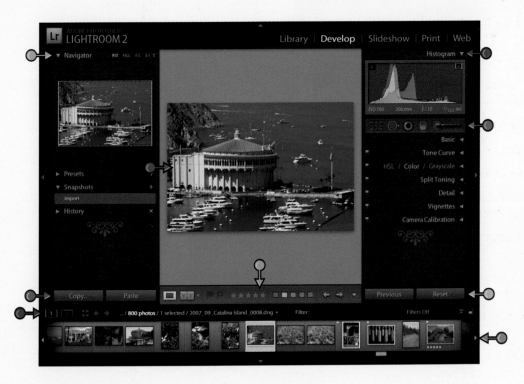

Change the Develop Module Interface

You can change the Develop module's interface to make the viewing area larger and use a second window on another monitor as shown for the Library module in Chapters 1 and 3. You can also increase the viewing area by hiding or minimizing the Filmstrip. Adding tools to the toolbar offers more customization options.

Change the Develop Module Interface

① Press **F** to hide the Lightroom window title bar.

② Press **F** again to hide the Lightroom menu bar.

③ Press **F5** to hide the Lightroom module picker bar.

The interface expands.

④ Click the line between the toolbar and Filmstrip tools.

⑤ Drag down until the Filmstrip is as small as possible.

The interface expands.

⑥ Click the toolbar ▼.

⑦ Click any of the tools, such as **Navigate**, to add it to the toolbar.

⑧ Repeat Step **7** to add more tools to the toolbar.

● The tools are added to the toolbar.

Note: *Depending on how many tools you added, some tools may not be visible with both the left and right panels open.*

⑨ Press F7 to hide the left panel to see more tools.

Can I hide the Filmstrip instead of minimizing it?

Yes. You can press F6 to hide the Filmstrip and Filmstrip toolbar. Minimizing the Filmstrip first gives you more space when you toggle it open and still gives you access to the Filmstrip toolbar tools, such as the Second Window tool or the name of the file.

Can I hide the toolbar?

Yes. You can alternately press T to hide and show the toolbar. The toolbar's Before and After View mode icon () is useful for quickly changing the view modes to see a Before and After view of your edited image as you work.

Try the Develop Module Shortcuts

You can modify the Develop module interface to fit each individual project. As you learn more keystroke shortcuts, you can hide the toolbar and still use all of the tools to navigate through images, add ratings and color labels, zoom into the photo to see more details, compare Before and After views, or start an impromptu slide show.

Try the Develop Module Shortcuts

① Press **T** to hide the toolbar.

② Press **F6** to hide the Filmstrip and Filmstrip toolbar.

● The main viewing area appears as large as possible with the two side panels visible.

③ Press **⌘**+**→** (**Ctrl**+**→**).

● The next photo appears in the main viewing area.

④ Repeat Step 3 to advance to the next image.

⑤ Press **⌘**+**←** (**Ctrl**+**←**) to go to the previous image.

⑥ Press **4**.

● A rating of 4 stars is added to the photo.

Note: Optionally, press **6** to add a red color label to the photo.

⑦ Press **⌘**+**+** (**Ctrl**+**+**).

● The image zooms in to the next size and Fill in the Navigator pane is highlighted.

Note: Optionally, you can click Fit, Fill, 1:1, or any of the zoom levels in the Navigator pane to zoom in or out of the image.

⑧ Repeat Step **7** to zoom in further.

⑨ Press ⌘+ **-** (**Ctrl**+ **-**) to zoom back out one step at a time.

⑩ Press **Option**+ **Y** (**Alt**+ **Y**).

● The main viewing area changes to Before and After view up and down.

*Note: You can view the Before and After images left and right by pressing **Y**.*

*Note: Optionally, press ⌘ + **Return** (**Ctrl** + **Enter**) to start an impromptu slide show of the images currently in the Filmstrip.*

TIPS

Where can I find a complete list of the Develop module keyboard shortcuts?

The keyboard shortcuts for each module can be quickly accessed by clicking **Help** in the top menu and selecting **Develop Module** (or another module name) **Shortcuts**. You can also use the keyboard shortcut ⌘+ **/** (**Ctrl** + **/**) to open the module's keyboard shortcut list.

How can I compare the Before and After views as large as possible on one monitor?

You can press **Y** to go to the Before and After view left and right, or press **Option** + **Y** (**Alt** + **Y**) to view Before and After up and down, and then press **T** to hide the toolbar. Press **Shift** + **Tab** to hide all the panels. Press **T** and **Shift** + **Tab** to bring back all the panels and toolbar, and press **D** to return to the Loupe view.

Using the Develop Module Presets

Lightroom's *presets* are a group of settings you can use to give photos a specific look. You can preview the effects on your photo before applying the preset. You can also create your own presets, save them to use again on other photos, and export them to a different computer. You can then import your own custom presets from the other computer, or you can import third-party presets into your copy of Lightroom.

You can find presets to import on the Internet from vendors such as Kubotaimagetools.com.

Using the Develop Module Presets

PREVIEW AND APPLY A LIGHTROOM PRESET

Note: Optionally, press F8 *to hide the right panel.*

① Click the **Navigator** ▶ to open the Navigator if necessary.

② Click the **Presets** ▶ to expand the pane.

③ Position the cursor over each preset in the list.

● The effects appear in the Navigator.

④ Click a preset, such as **Creative - Aged Photo**.

● The effects of the preset are applied to the photo in the main viewing area.

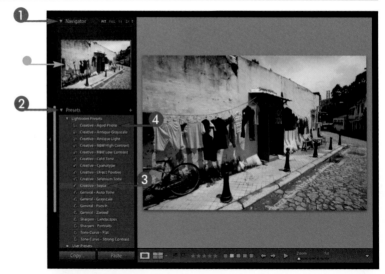

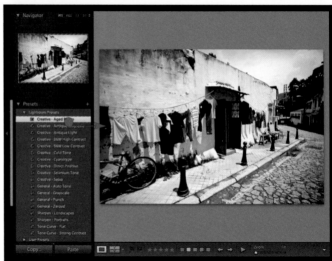

IMPORT A PRESET

① **Control** +click (right-click) **User Presets** in the Presets pane.

② Click **Import** in the menu that appears.

● An Import Preset dialog box appears.

③ Navigate to the location where you downloaded the presets.

④ Click or ⌘+click to select the *preset-name*.lrtemplate files.

⑤ Click **Import**.

● The imported presets are listed under the User Presets.

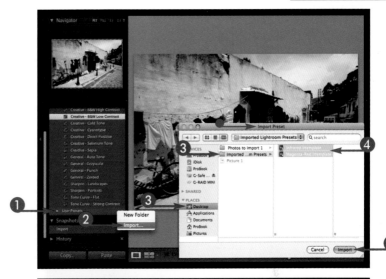

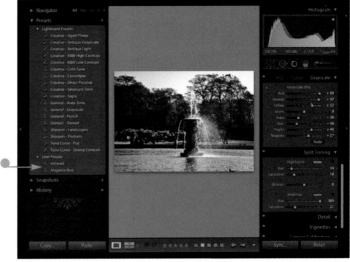

TIPS

What happens if I have multiple photos selected in the Filmstrip?

If you click a preset with multiple images selected, the settings are applied to all the selected photos.

How do I delete a preset from the list?

To delete any user preset, click the name of the preset in the list and click the minus sign (−). You can also **Control** +click (right-click) the name of the user preset and put it into a new folder, or delete, rename, update, or export the preset (●).

Compare Images in the Develop Module

In the Develop module, you can compare the effects of the changes you make to an image using the editing tools, and see the same photo in Before and After views. This is different from the Compare mode or Survey mode in the Library module, where you can compare two or more separate photos.

Compare Images in the Develop Module

① Click a photo in the Filmstrip to select it.

② Press F8 to hide the right panel.

③ Click a Lightroom preset such as **Creative - Direct Positive**.

The photo in the main viewing area changes.

④ Click **Before and After / Left and Right** (▭▭).

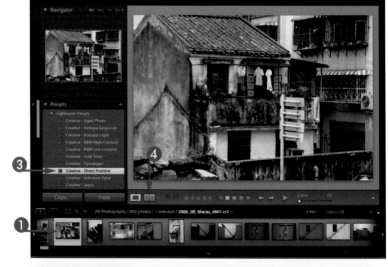

The Before and After views appear side by side.

⑤ Click ▼.

⑥ Click **Before/After Left/Right Split**.

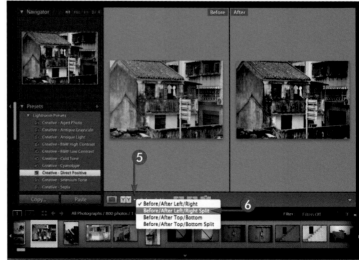

The Before and After views are combined into one image split in half.

7 Repeat Step **5**.

8 Click **Before/After Top/Bottom**.

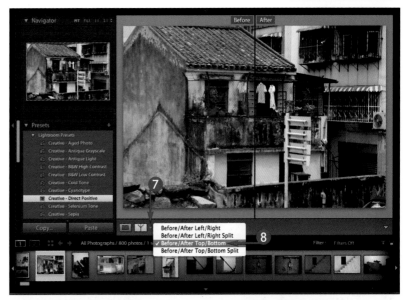

The Before and After views appear one above the other.

9 Click another Lightroom preset such as **Creative - B&W High Contrast**.

● The After view shows the new preset applied.

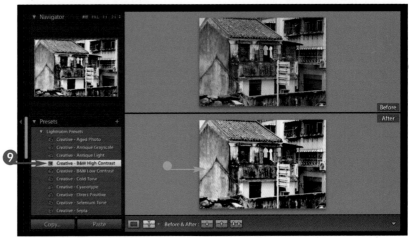

 TIPS

What do the other three Before and After icons do?

Clicking the first one copies the Before settings to the After image. Clicking the second one copies the After settings to the Before image. Clicking the third one swaps the two settings.

Is there a keystroke to viewing the Before and After views?

Yes. To see the two images side by side, press Y or Option+Y (Alt+Y). You can also toggle the Before and After views in Loupe view by pressing \.

Using the Image History and Snapshots

Lightroom's History and Snapshots options let you experiment with your photos without making duplicates or virtual copies, while preserving all your edits. History lists all the steps you did on an image including the previous and new values from the applied sliders. Snapshots let you freeze a specific editing state. You can take snapshots of different history states so you can create variations of an image starting from the settings in those snapshots.

Using the Image History and Snapshots

Note: These steps illustrate how to use the History and Snapshots features rather than how to edit a photo.

① Click an image in the Filmstrip.

② Click any number of presets to apply them as in a previous task, or make edits using any of the right panel sliders.

③ Click the **History ▶**.

● All the steps appear in the History list.

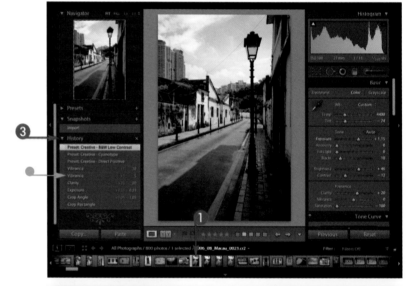

④ Position the cursor over the each history state.

● The effects of that setting are visible in the Navigator panel.

⑤ Click another history state.

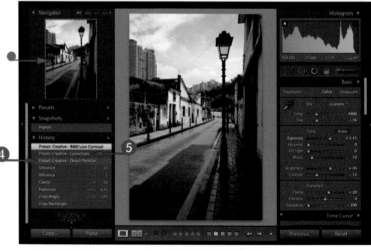

- The photo in the main viewing area shows the effects of the earlier settings.

6 Click the **Create Snapshot** plus sign (➕).

A text box appears.

7 Type a descriptive name for the snapshot.

*Note: Optionally, you can type **A** and a descriptive name for the first snapshot. You can then type **B** before the second snapshot name and so on so that the snapshots are listed alphabetically in the order they were taken.*

8 Click the top history state in the list.

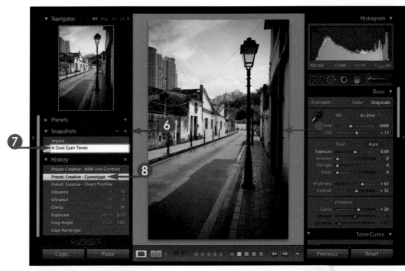

- That history state is applied to the photo in the main viewing area.

9 Repeat Steps **6** and **7** to create a second snapshot.

*Note: Optionally, type **B** and a descriptive name for the second snapshot.*

10 Click more presets or make edits using any of the right panel sliders.

11 Repeat Steps **6** and **7** to create a third snapshot.

*Note: Optionally, type **C** with the third snapshot name.*

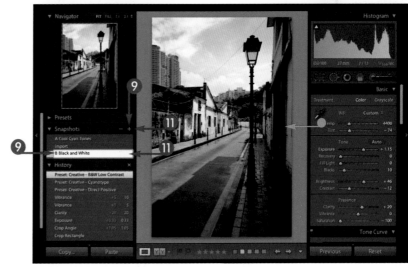

 TIPS

Why do you suggest using a letter before each snapshot name?

Snapshots are listed alphabetically rather than sequentially. Adding **A** for the first snapshot, **B** for the second, and so on allows you to easily see the order of the snapshots you take.

Are the edits I make to the photo in the Library module recorded in the history?

Yes. Both the Library module edits and Develop module edits are recorded as history states, and appear chronologically in the list of steps in the History pane of the Develop module.

continued

Lightroom's history is not lost when you close Lightroom. The History list is written into the DNG or embedded into the XMP file for the photo. You lose the history states only if you click an earlier state and then make more changes. The previous editing steps forward from that history state are erased and overwritten by the new changes you make.

Using the Image History and Snapshots *(continued)*

12 Position the cursor over a snapshot to see the effect in the Navigator panel.

13 Click an early history state to apply it.

14 Click additional presets or make other edits using any of the right panel sliders.

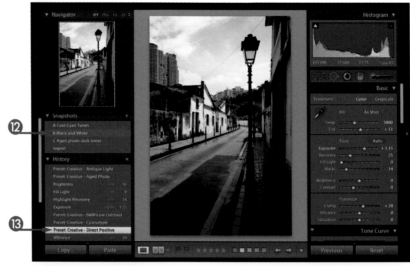

● The changes are applied to the photo.

● New states replace the previous ones listed above the history state selected in Step **13**.

15 Repeat Steps **6** and **7** to create another snapshot.

16 Click the **Clear History** button (❎).

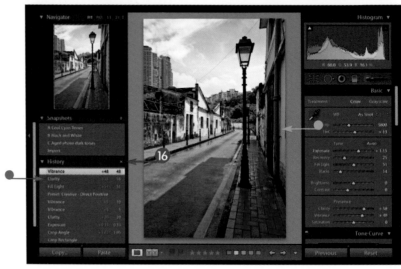

● The History list is cleared.

⑰ Click a different snapshot to apply it.

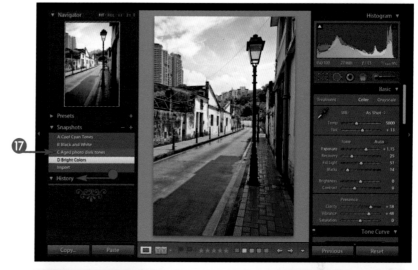

● The snapshot is listed as a history state.

⑱ Click the **Snapshot** minus sign (■).

The selected snapshot is deleted from the Snapshots list.

Note: *Snapshots are deleted one at a time. History states are all deleted at once.*

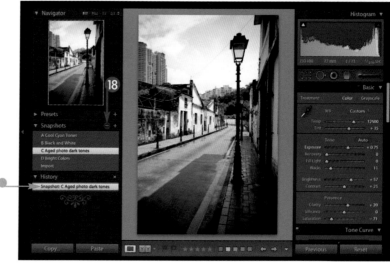

TIPS

If the History list is embedded with my DNG file or into the XMP file, does it increase the size of the file?

Yes, slightly. As the list gets long, you can create snapshots of the states you want to keep and clear the History list by clicking the **History Clear All** button (⊠).

Can I still undo steps using the Undo keyboard shortcut?

Yes. You can press ⌘+Z (Ctrl+Z) to undo step by step and ⌘+Shift+Z (Ctrl+Shift +Z) to restore the steps one by one.

Rotate a Photo in the Develop Module

You can rotate a photo in the Develop module using the menu bar or using a keystroke.

To rotate multiple selected photos at one time, you must change to the Library module and click the rotation arrows on the photos in Grid mode or use the rotation arrows in the Library mode toolbar for the Loupe view.

Rotate a Photo in the Develop Module

① Click a photo in the Filmstrip to select it.

② Click **Photo**.

③ Click **Rotate Left (CCW)**.

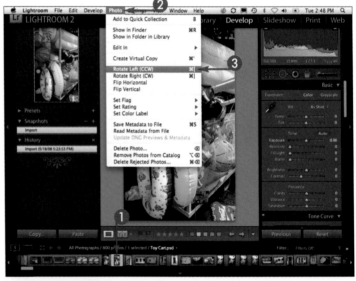

The photo rotates in the selected direction.

④ Press ⌘+] (Ctrl+]) to rotate the photo back (clockwise).

Note: Pressing ⌘+ [(Ctrl+ [) rotates the photo counterclockwise.

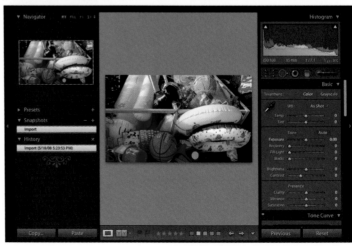

Copy and Paste Edits from One Photo to Another

You can edit a photo in either or both the Library and the Develop modules and then quickly apply the same adjustments to another photo using the Copy and Paste buttons in the Develop module. You can apply all the changes or select which edits to apply.

Copy and Paste Edits from One Photo to Another

① Click a photo in the Filmstrip to select it.

② Make tonal changes, edit the aspect ratio or crop the photo, and add a preset.

③ Click **Copy**.

The Copy Settings dialog box appears.

④ Click any of the settings to deselect them.

Note: Optionally, click **Check None** to deselect all the settings and then click only the ones to apply.

⑤ Click **Copy**.

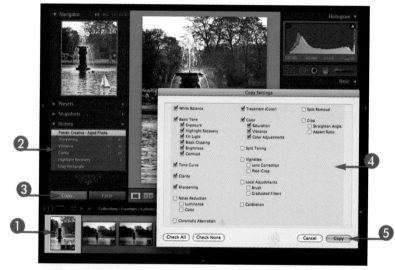

⑥ Click another photo in the Filmstrip.

⑦ Click **Paste**.

● The selected edits are applied to the second photo.

Note: You can press Option and click the **Copy** button to bypass the Copy Settings dialog box. Any of the settings selected in a previous copy operation will be applied to the second photo.

Note: Optionally, you can click ⌘ + Shift + C (Ctrl + Shift + C) to copy the settings and ⌘ + Shift + V (Ctrl + Shift + V) to paste them.

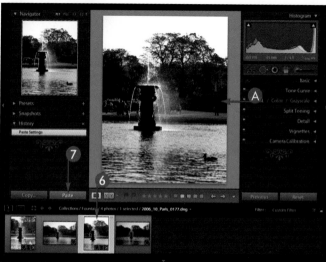

Using the Histogram Features in the Develop Module

The histogram in both the Library module and the Develop module represents the range of color and tonal values in the selected photo. However, the Develop module's histogram is a functional tool you can use to adjust the tones in the image. This histogram also includes warning triangles indicating clipped values, or areas with no detail, and displays these in the image with red and blue.

Using the Histogram Features in the Develop Module

Note: *The steps to creating the best negative depend on the photo and the subject matter. The following steps are to illustrate the use of the histogram.*

1. Click a photo in the Filmstrip.

2. Click the **Histogram** ◀.

3. Click the **Basic** ◀.

 Both panes in the right panel expand.

4. Position the cursor over the left ▲.

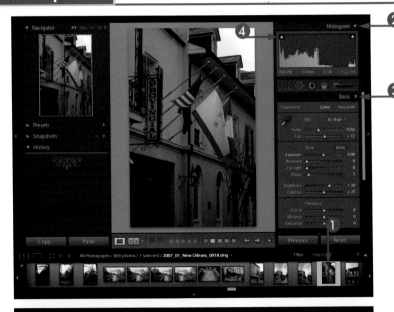

● The 100% black shadow areas with no detail are colored in blue.

5. Position the cursor over the right ▲.

● The 100% white highlight areas with no detail are colored in red.

Note: *Optionally, click both ▲ triangles to show the warning colors as you make adjustments.*

6. Click in the far right of the histogram and drag to the left.

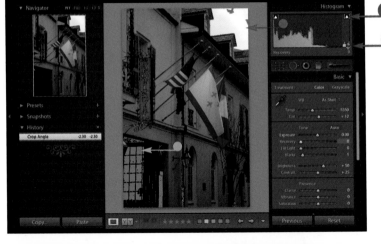

- The histogram moves away from the right and the red warning areas diminish. The Recovery ⬛ moves to the right accordingly.

7 Click in the area at the far left of the histogram and drag to the right.

- The histogram moves away from the right and the blue warning areas diminish. The Blacks ⬛ moves to the left accordingly.

8 Click in the Fill Light area in the histogram and drag to the right.

- The histogram spreads to the right and the Fill Light ⬛ increases accordingly.

9 Depending on the photo, click in the Exposure area in the histogram and drag in one direction or the other as needed.

- The histogram and Exposure ⬛ change to match.

Note: *Sometimes clipping is necessary, as in the case of specular highlights, the kind that reflect off a shiny surface, and for the darkest shadows to create better contrast.*

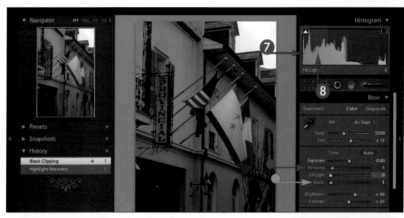
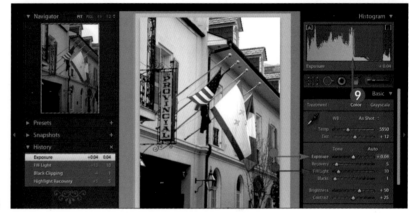

 TIPS

Is there a way to recognize which sliders move when I click in the histogram?

The Basic panel's sliders correlate to specific areas in the histogram. As you click and drag directly in the histogram in these areas, the affected adjustment appears below. You adjust for blacks on the far left, fill light (●), exposure in the central

areas, and highlight recovery on the far right. The corresponding sliders move accordingly in the Basic panel.

Is there a way to see the clipped areas without leaving the warning triangles on?

Yes. If you press and hold the Option (Alt) key as you move the **Recovery** ⬛, the image is displayed in Threshold mode and turns black. The clipped highlights appear as posterized bright areas. Similarly, if you press and hold the Option (Alt) key as you move the **Blacks** ⬛, the clipped shadows appear as posterized blacks against a totally white image.

Straighten Images

The first step in editing a photo is often to straighten a crooked horizon. The Develop module offers three ways to straighten an image. Using the Angle tool directly on the photo is the most direct method. You can also move the Angle slider, or you can rotate the photo directly with the superimposed grid to straighten the image.

Straighten Images

① Click a photo in the Filmstrip.

② Click the **Crop Overlay** tool (▦).

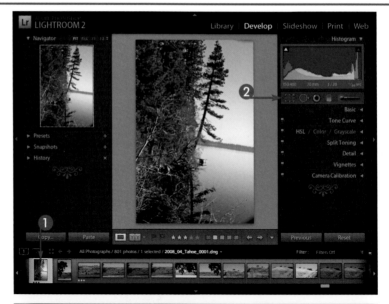

● The Crop and Straighten tools are added to the right panel.

● A grid overlay appears on the image.

③ Click the **Straighten** tool (▱).

● The cursor changes to the Straighten tool (▭).

④ Click and drag in the photo along the horizon line and release the mouse.

Note: *If the horizon line is not visible in the photo, you can click and drag along any line that should be horizontal or any edge that should be vertical.*

The photo is automatically straightened.

The crop marquee is set to include all the areas of the image that fit inside using the original aspect ratio.

⑤ Press Return (Enter) or double-click in the image to set the crop.

TIPS

Can I rotate the photo itself instead of clicking and dragging in the photo?

Yes. Click the **Crop Overlay** tool (▦) to activate the Crop and Straighten tools. Press O until you see the Grid overlay. Position the cursor just outside the crop marquee (▸ changes to ↻). Slowly move in one direction or the other, trying to line up the horizon or a vertical line in the photo with the lines in the grid. Press Return (Enter). The photo is straightened and cropped to fit.

How do I use the slider to straighten an image?

Click the **Crop Overlay** tool (▦) to activate the Crop and Straighten tools. Press O until you see the Grid overlay. Focus on the image as you click and drag the **Angle** ◭ until the horizon or a vertical line in the photo lines up with the lines in the grid.

Recompose Your Photo with a Crop

The Crop tool in the Develop module lets you crop to any dimensions to fit your image or crop to a specific aspect ratio. You can revert the photo to its original dimensions at any time. You can quickly access the Crop tool in the Develop module from any other module by pressing ⬚.

Recompose Your Photo with a Crop

① Repeat Steps **1** and **2** in the previous task to apply the crop overlay on a photo.

② Press F7 to hide the left panel.

③ Press O until the crop guide overlay appears in thirds.

④ Click and drag the edges of the crop marquee to change the composition of the photo.

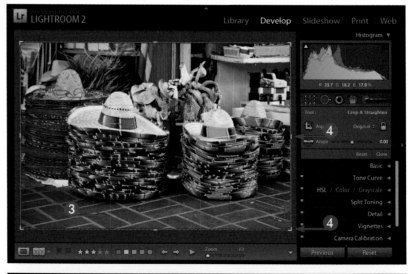

The crop marquee changes the look of the image.

⑤ Click the bottom right corner of the crop marquee and drag to the left.

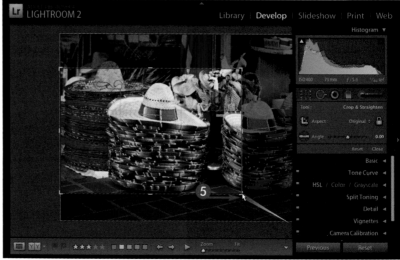

The horizontal aspect ratio changes to a vertical aspect ratio.

⑥ Click in the image and drag.

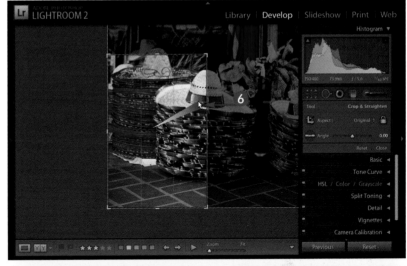

The image moves inside the crop marquee.

⑦ Press Return (Enter) or double-click in the image to apply the crop.

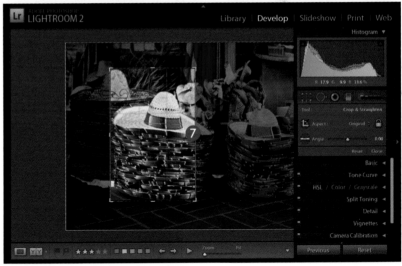

How can I return to the original photo dimensions?

You can click **Reset** in the Crop and Straighten pane. Be careful not to click the Reset button at the bottom of the right panel because this would reset the image completely, removing all the edits you have made.

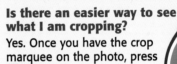

Is there an easier way to see what I am cropping?

Yes. Once you have the crop marquee on the photo, press L to dim the lights. You can continue to click and drag the crop marquee until the photo fits your composition.

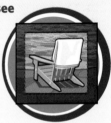

Creatively Crop an Image for Effect

You can crop with a different preset fixed aspect ratio by selecting from a menu, or you can create your own aspect ratio and save it. You can even crop without any preset and adjust the size to fit your subject matter. You can also use the different overlay styles as a compositional guide.

Creatively Crop an Image for Effect

CREATE A NEW CROP RATIO

1. With a photo selected, click the **Crop Overlay** tool ().

2. Press F7 to hide the left panel.

3. Click the **Original** .

4. Click **Enter Custom** in the menu that appears.

Note: You can also click any of the preset aspect ratios.

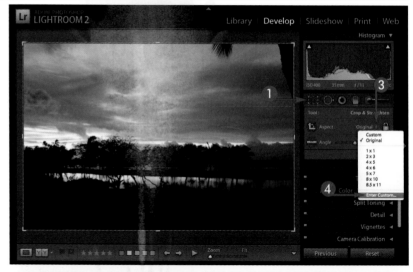

The Enter Custom Aspect Ratio dialog box appears.

5. Click in the boxes and type your dimensions.

6. Click **OK**.

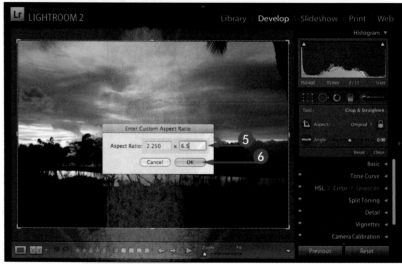

- The custom aspect ratio is listed in the Crop and Straighten tool pane.

- The image displays the new crop ratio.

7 Click and drag in the image or on the crop marquee to adjust the composition.

8 Press **Return** (**Enter**) or double-click in the image to set the crop.

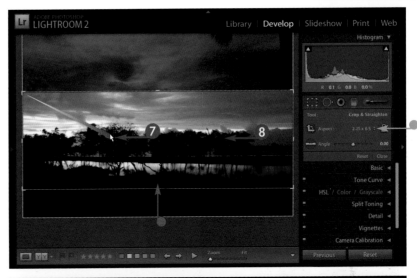

CROP WITHOUT A SET ASPECT RATIO

1 Repeat Steps **1** and **2**.

2 Click the **Aspect Ratio** lock (🔓 changes to 🔒).

3 Click the **Crop Frame** tool (🔲).

4 Click and drag in the photo to freely crop the image to match the subject matter.

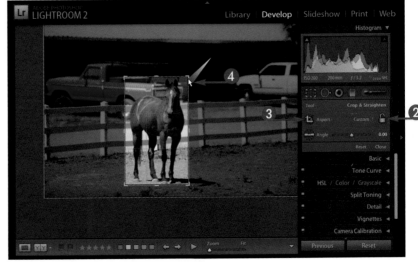

TIPS

Why are there other styles of crop overlays?

The overlays are guides for improving the composition of the photo. For example, you can use the Thirds overlay to apply the traditional rule of thirds and place the subject at the intersections of the lines, or guide the viewer's eye into the photo using the Golden Spiral overlay.

How do I access the other styles of overlay guides?

Once you activate the crop overlay by pressing **R** or clicking the **Crop Overlay** tool (🔲), you can cycle through the different styles of overlays by pressing **O**. You can also click **View** in the menu bar, click **Crop Guide Overlay**, and select the name of the guide overlay you want. You can alter the direction of the overlay lines in the Golden Spiral and Triangle overlays by pressing **Shift**+**O**.

Repair Dust Spots and Other Imperfections

Digital camera sensors attract dust that appears as spots on photos. Lightroom's Spot Removal tool can repair dust spots and other blemishes in an image. If the spot is due to camera sensor dust, it will probably reappear in the same area on multiple photos. You can fix one photo and then have Lightroom synchronize that spot repair with other selected photos.

Repair Dust Spots and Other Imperfections

REMOVE DUST SPOTS

1 Click a photo in the Filmstrip to select it.

2 Click **1:1** in the Navigator to zoom to 100%.

Note: *Optionally, press* `Spacebar` *and click to zoom to 100%.*

3 Press `Home`.

Note: *If you are using a laptop or your keyboard does not have a* `Home` *key, press* `Fn` + `←` *instead.*

● The preview section moves to the top left corner in the Navigator.

4 Press `Page down`.

Note: *If you are using a laptop or your keyboard does not have a* `Page down` *key, press* `Fn` + `↓` *instead.*

● The preview section moves to the next section in the Navigator.

Note: *Pressing* `Page down` *shifts the preview area from the top left down, back up to the top, and down again to the bottom right.*

5 Repeat Step **4** until you see dust spots or blemishes.

6 Click the **Spot Removal** tool (⬛).

● The Spot Removal pane expands.

7 Click **Heal**.

8 Position the cursor over the spot to remove.

9 Press □ to reduce or □ to enlarge the circle until it is slightly larger than the spot.

10 Click once, and two circles appear.

11 Click and drag the second circle to a clean area nearby.

The spot is healed.

12 Repeat Steps 4 to 11 to scan and repair other spots.

Note: *Click a healing circle and press* Delete *(* Backspace *) to delete it and the edit.*

REMOVE THE SAME SPOTS ON MULTIPLE IMAGES

13 Click **Copy**.

14 In the Copy Settings dialog box, click **Check None**.

15 Click **Spot Removal** (□ changes to ☑).

16 Click **Copy**.

17 Click other photos taken from the same shooting position.

18 Click **Paste**.

The same spots in all the selected photos are healed.

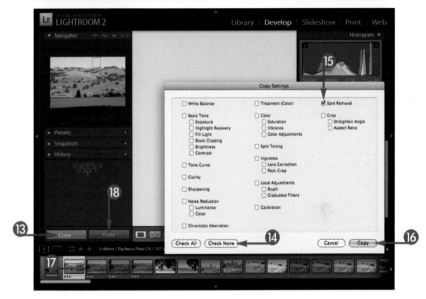

TIPS

Once I copy the spot repairs, can I change the area used for the repair?
Yes. The healing circles are editable whenever the Spot Removal tool is selected. With the photo selected, click the **Spot Removal** tool (⊙) to activate the healing circles. Click and drag the repair location to a different area of the photo and release the mouse.

What is the difference between the Clone function and the Heal function?
In Clone mode, the Spot Removal tool clones, or copies, the pixels from one area to another. In Heal mode, the tool samples the color and texture of the repair location to blend the area being repaired. The Heal mode blend can distort an edge near the area being repaired. When this happens, try using the tool in Clone mode.

Remove Red Eye

Using any camera with an integrated flash or even a separate flash unit mounted close to the lens can produce the red-eye effect in your subject. Lightroom provides an easy to use Red Eye Correction tool in the Develop module so you do not have to go to another image editor to correct the image.

Remove Red Eye

① With the photo selected, click **1:1** in the Navigator pane or press **Spacebar** and click to zoom to 100%.

② Click the **Red Eye Removal** tool (▣).

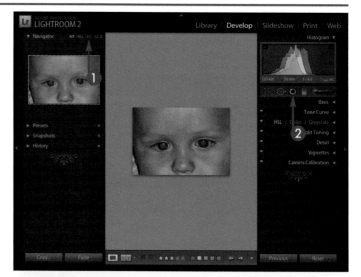

The tool turns red and the tool pane expands.

③ Position the cursor over one eye.

The cursor changes shape.

④ Click and drag from the center of one eye outward.

⑤ Release the mouse.

The pupil is desaturated.

6 Click the edge of the correction circle and drag to adjust the pupil size.

The cursor changes to 🕂.

Note: *Optionally, click and drag the **Pupil Size** in the Red Eye Correction pane in the right panel.*

7 Position the cursor over the other eye.

8 Click to apply the same size correction or click and drag to fit the other eye.

The second eye is desaturated.

9 Click and drag the **Darken** 🔹 as needed to adjust the color of the pupil.

The darkness increases for the second pupil.

10 Repeat Step **9** for the first eye.

11 Click the **Switch** (🔳) to turn off the correction.

12 Repeat Step **11** to turn the correction back on.

TIPS

How can I remove a red eye correction if I made a mistake?

You can click the correction circle over the eye and press `Delete` (`Backspace`). To remove all corrections in one image, click **Reset** under the Red Eye Correction pane. Do not click the **Reset** button at the bottom of the right panel because that resets all previous edits to the photo.

Does this tool work with the yellow-to-white eyes that appear with photos of animals?

No. This tool only corrects the red eye phenomenon. You need to use Photoshop or Photoshop Elements to properly correct the flash effect on an animal's eyes.

CHAPTER 8

Image Processing in the Develop Module

The photo processing tools in the Develop module are sophisticated and powerful. However, because Lightroom makes it easy to see the effect on your photo as you edit, and because all changes are always nondestructive, you can safely retouch and edit photos to make the best digital negative from your original photo file or give an image a unique look.

Adjust the White Balance192

Modify the Basic Exposure196

Make Precise Changes with the Tonal Adjustments Tools198

Improve the Photo with Clarity, Vibrance, and Saturation ...200

Make Controlled Tone Curve Adjustments ...202

Explore the HSL/Color/Grayscale Tools ..206

Adjust Individual Color Ranges208

Creatively Convert a Color Image to Black and White ...210

Tone an Image ..212

Brush On a Localized Adjustment214

Add a Localized Graduated Filter218

Reduce Digital Noise in the Image220

Decrease Chromatic Aberration222

Improve Details with Sharpening224

Add a Lens Vignette for Effect226

Save Your Settings as a Custom Preset228

Understanding the Camera Calibration Feature ..230

Using the Camera Calibration Pane232

Adjust the White Balance

Whether you use the auto white balance of the digital camera or set a custom white balance, you may need to adjust the colors of your photo to eliminate color casts and make neutral areas really neutral. Lightroom's Develop module includes three tools for adjusting the white balance in a photo: the white balance presets, the white balance selector tool, and temperature and tint sliders.

Adjust the White Balance

USE THE WHITE BALANCE PRESETS

① Click a photo in the Filmstrip to open it.

② Press D to go to the Develop module if necessary.

③ Click the **Basic** ◄ to expand the pane.

④ Click the **WB** ⬝.

⑤ Click a white balance from the menu.

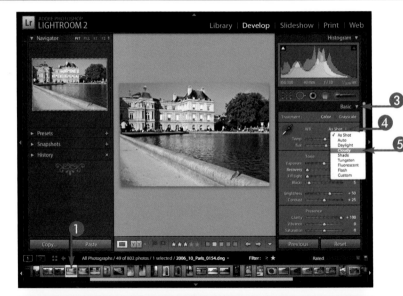

● The color in the image changes accordingly.

● The selected preset is listed in the White Balance pane.

● The histogram changes.

⑥ Repeat Steps **4** and **5** to view the results of other presets.

⑦ Press L to dim the lights so you can see the results of the white balance adjustments against a dim or black background.

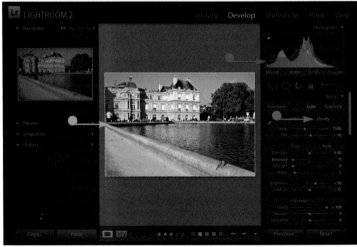

USE THE WHITE BALANCE SELECTOR

1 Repeat Steps **1** to **3**.

2 Click the **White Balance Selector** (🖊).

3 Position the cursor over the photo.

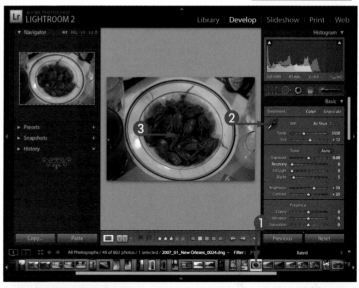

● The cursor changes to the White Balance Selector tool (🖊).

4 Move the tool around the image.

● The target area displays the range of colors under the tool.

● The Navigator displays the different white balance changes in real time.

5 Click an area that should be a neutral color, such as medium gray or white.

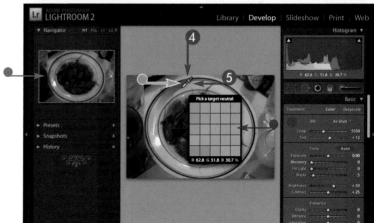

TIPS

Why do some of my photos have color casts?

Each type of light has a color temperature. Although your eyes automatically compensate for lighting conditions and adjust so you see white objects as white, the camera sees the color of the light reflected by an object. You may have a yellow-orange cast in incandescent (tungsten) lighting and a greenish-blue cast in fluorescent lighting.

Is there a difference with JPEG and RAW files for white balance adjustment?

When using JPEGs in Lightroom, you are limited to three white balance presets (●). Also, because the camera writes the color temperature directly into the file for JPEGs, changing the white balance on a JPEG may introduce distorted or white pixels, called *artifacts*. With RAW files, the color temperature is written only into the metadata, making the RAW file more easily adjusted and customized with more presets (●).

continued

193

Adjust the White Balance *(continued)*

You can use a preset or use the White Balance Selector tool to establish a more neutral white balance or remove the color cast. You can then use the Temperature and Tint sliders to refine the white balance setting or even introduce a creative color cast for effect.

Adjust the White Balance *(continued)*

● The color in the image changes and the white balance shows Custom.

⑥ Click 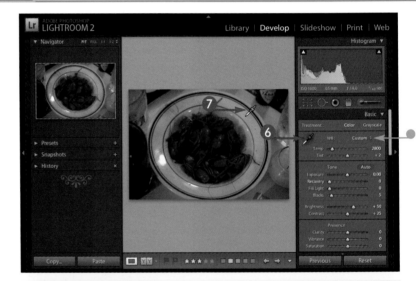.

⑦ Position the tool over the neutral area in the photo without clicking.

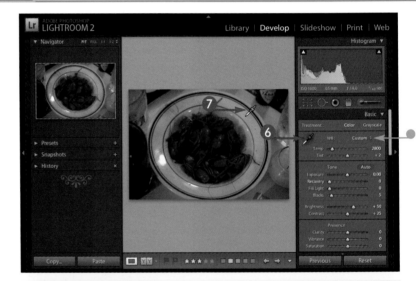

● The target area displays the RGB values.

Note: *Look for close RGB numbers. An absolutely neutral color has identical RGB values.*

⑧ Click in the White Balance Selector's circle in the right panel to return the tool and complete the adjustment.

Note: *Optionally, you can click a different area in the photo to change the white balance setting again. Each time you click in the photo with the tool, the White Balance Selector automatically returns to the panel.*

USE THE TEMPERATURE AND TINT CONTROLS

1️⃣ Repeat Steps 1 to 7 from either of the previous white balance adjustment subsections.

2️⃣ Click and drag the **Temperature** 🔲 to the left.

The colors appear blue or cooler.

Note: *Optionally, click and drag the **Temperature** 🔲 to the right to warm or make the photo more yellow.*

3️⃣ Click and drag the **Tint** slider to the right.

The image takes on a magenta tint.

Note: *Optionally, click and drag the **Tint** 🔲 to the left to add a green tint.*

4️⃣ Double-click the **Temperature** and **Tint** sliders to reset them to their default setting.

What is the difference between the white balance adjustments in the Develop module and the white balance adjustments in the Library module?

The white balance adjustments, like all the edits in the Develop module, are much more precise than those in the Library module, and offer more flexibility as well as more tools to refine the adjustment.

Is there a more precise way to select a neutral color in the photo?

Yes. Take the first photo of a series with the same lighting conditions including a spectrally neutral white-balance reference card, such as a WhiBal card (www.WhiBal.com) or a GretagMacBeth ColorChecker (www.xrite.com), in the shot. In Lightroom, set the white balance by clicking the card in the photo using the White Balance Selector. You can then click **Copy** to use the white balance setting from that photo. Click **Paste** to apply it to other selected photos.

Modify the Basic Exposure

Adjusting the tonal values in the image is the next step to improving your image. Even with a properly exposed image, you may want to make creative adjustments to the photo. You can try the Auto setting or use the individual sliders directly to fine-tune the values starting with the Exposure setting. View the preview image as large as possible and always watch the histogram as a guide.

Exposure

Modify the Basic Exposure

1 Click a photo in the Filmstrip.

2 Press ⌘+Shift+F (Ctrl+ Shift+F) to go to full-screen mode.

3 Press T to hide the toolbar.

4 Press F8 to view the right panel.

5 Click the **Basic** ◀.

6 Click **Auto**.

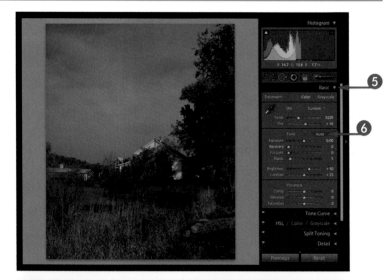

● The preview image changes, as does the histogram.

7 If the Auto setting does not help the photo, press ⌘+Z (Ctrl+Z) to go back to the previous setting, and then continue with Step **9**.

8 If the Auto setting improves the photo, continue with Step **9** or any of the following tonal adjustment tasks.

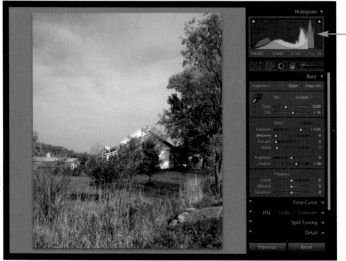

9 Click and drag the **Exposure**
to the right to increase the
exposure and lighten the image,
or to the left to decrease the
exposure and darken the image.

Note: *Optionally, click the number for the
Exposure value and type a specific setting.*

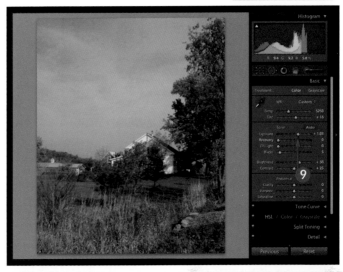

The Exposure values change in
the right panel and the image
adjusts accordingly. The
histogram also reflects the
changes.

Note: *You are adjusting the tones based on what
you see in the preview window on your monitor.
Make sure your monitor is calibrated and profiled
as described in Chapter 5.*

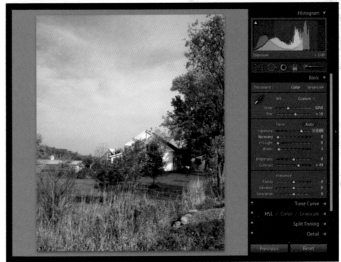

TIPS

**It appears that clicking Auto changes more than
just the Exposure value.**

Yes. The Auto feature
resets the Exposure,
Blacks, Brightness,
and Contrast. Both
the Recovery and
Fill Light values are
set to 0.

**To what do the
Exposure values
correspond?**

The numerical values
for exposure in the
Tone adjustments
are approximately
equivalent to the
camera's f-stops. An exposure
increase of +2 is similar to increasing the
camera's aperture by two stops.

Make Precise Changes with the Tonal Adjustments Tools

You can adjust a photo to diminish or remove *clipped highlights* and lighten *clipped shadows* while still maintaining sufficient contrast. Clipped highlights are areas with no data, and they appear completely white in the photo. When you print a photo with clipped highlights, no ink is placed on the paper in those areas, making the print appear incomplete. Clipped shadows are areas that are black and print as solid black areas on the paper. Some clipped shadows are necessary to maintain contrast, depending on the aesthetics of the image and the subject matter.

Make Precise Changes with the Tonal Adjustments Tools

① Click the **Histogram** ◀.

② Click the **Basic** ◀.

③ Click both clipping warning triangles (▲).

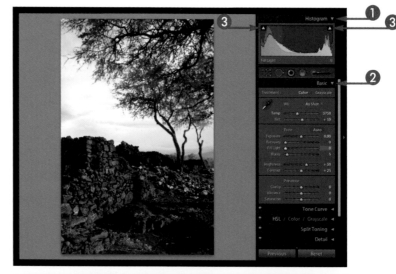

The clipped highlights are marked in red and the areas of total black are marked in blue.

④ Click and slowly drag the **Recovery** ▲ to the right to reduce the areas marked in red.

Note: *Move the sliders slowly for more precise control, just far enough to reduce or remove the clipped areas.*

⑤ Click and slowly drag the **Fill Light** ▲ to the right to increase the light in the shadows.

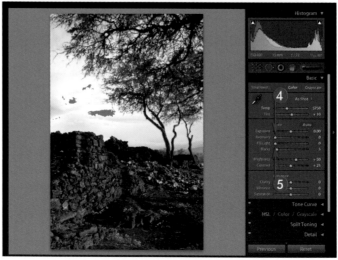

The image tones adjust accordingly and the extreme ends of the histogram move away from the edges.

6 Click both clipping warning triangles () to turn off the warning colors.

7 Click and drag the **Blacks** to increase the areas that become black and visually enhance the contrast in the image.

8 Click and drag the **Brightness** if necessary to increase or decrease the overall brightness.

9 Click and drag the **Contrast** to increase the overall contrast.

Both the image and the histogram reflect the changes.

10 Double-click or Option+click (Alt+click) the word **Tone** to reset all the tonal changes to their original settings.

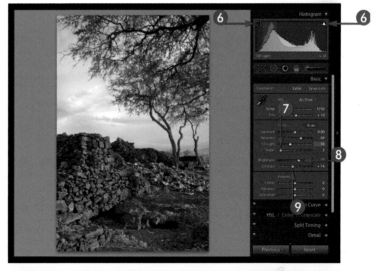

TIP

What tonal ranges are affected by each of the Tone sliders?
- Lightroom's Recovery slider recovers clipped highlights by slightly darkening the areas with little or no detail, and without affecting the rest of the image.
- The Fill Light slider opens up shadow areas to reveal more detail while minimizing the effect on the highlights.
- The Blacks slider darkens or even clips the darkest shadow areas to enhance the contrast.
- The Brightness slider lightens or darkens the images by redistributing the values in the midtones, minimizing any clipping in the highlights or shadows.
- The Contrast slider increases or decreases the overall contrast mainly in the midtones in the image without changing the extreme highlights or shadows.

Improve the Photo with Clarity, Vibrance, and Saturation

You can use the Clarity adjustment under the Presence pane to subtly increase the contrast in the midtones. The Vibrance slider lets you increase the intensity of the less saturated colors. Because clarity effectively adds mild sharpening, this adjustment should be applied when viewing your photo at 100%.

Vibrance also improves skin tones better than the Saturation setting, which saturates all the colors in the image.

Improve the Photo with Clarity, Vibrance, and Saturation

① Follow the steps in the previous tasks to adjust the white balance and tone in the Basic pane.

② Click **1:1** in the Navigator to view the image at 100%.

Note: Optionally, press ⌘ + + (Ctrl + +) to zoom in until you are viewing at 100%.

③ Click and drag the **Clarity** ◨ slowly to the right.

The midtone contrast is increased and the edges are slightly sharpened.

④ Click **Fit** in the Navigator to view the full image.

5 Press F7 to hide the left panel and enlarge the viewing area.

6 Click and drag the **Vibrance** [icon] slowly to the right.

7 Click the **Saturation** value in the Presence pane and type **1** or **2** to increase the overall saturation slightly.

8 Press T if necessary to view the toolbar.

9 Click **Before/After Left/Right** ([icon]) once to view the images left and right, or twice to view the images top and bottom.

The Before and After views are shown one above the other.

10 Click and drag the **Vibrance** and **Saturation** sliders to adjust the settings.

Note: Optionally, click and drag any of the tone sliders to adjust the previous settings.

Note: The Clarity and Vibrance adjustments can be very subtle enhancements, even viewed at 100%. Adjusting the saturation causes more dramatic shifts in color.

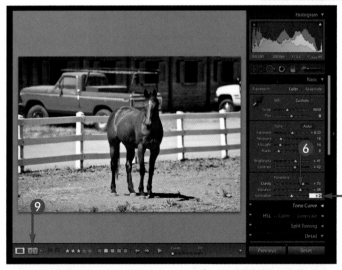

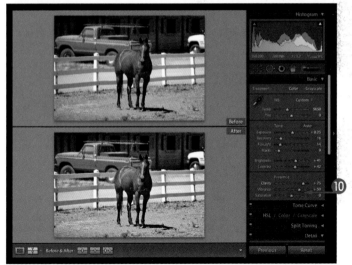

TIPS

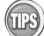

How can I reset just one slider to its original position?

You can reset just one slider in the group by either double-clicking the slider's name, such as **Clarity**, or by double-clicking the slider ([icon]).

Do these adjustments affect the previous edits I made?

Lightroom's adjustment tools are organized in a logical order to help you redistribute the tonal values in an image while preserving the widest tonal range possible; however, changing one setting may affect a previous edit, so you may need to readjust a setting as you continue improving a photo.

Make Controlled Tone Curve Adjustments

Lightroom's tone curve provides advanced adjustments similar to Curves in Photoshop and Adobe Camera Raw but with more intuitive controls. You can refine the adjustments made in the Basic pane by changing the tone curve three different ways: clicking and dragging directly on the curve, moving the sliders, and using the Targeted Adjustment tool on the photo. You can also limit the range of tones you adjust.

Tonal adjustments depend on your image and your aesthetic vision.

Make Controlled Tone Curve Adjustments

Note: *This task demonstrates only where to find and how to use the tools.*

DIRECTLY ADJUST THE TONE CURVE

1 Arrange Lightroom's interface as in a previous task to show a large viewing area and the right panel.

2 Click the **Tone Curve** ◀.

3 Click the curve in the bottom left area of the graph representing the shadows, and drag down.

The curve bends and darkest shadows in the photo get darker.

4 Repeat Step **5** on other areas in the graph to increase or decrease the highlights on the top right of the graph, or the midtones, the darks and lights, in the center of the graph.

Note: *Optionally, with the cursor over an area on the curve, use* ⬆ *and* ⬇ *to move the curve.*

USE THE TONE CURVE SLIDERS

1 Click the **Lights** and drag to the right.

The light midtones are lightened.

2 Repeat Step **1** on the other sliders.

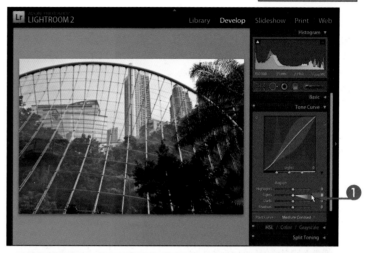

● The tones in the areas affected by the specific sliders are lightened or darkened accordingly.

Note: *Darks and Lights affect the middle regions representing the midtones on the curve. Highlights and Shadows affect the outer edges of the tonal range.*

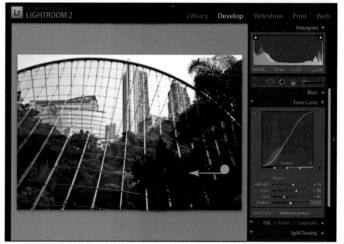

TIPS

What is the ghosted region that appears on the curve when I move a point?

This grayed area (●) indicates the limits in which the current slider can affect the curve and the tones in that range. Unlike curves in other applications, Lightroom's tone curve restricts the maximum changes you can make and protects the user from ruining a photo. You can use the grayed area as a guide for improving the tones in your image.

How can I reset the tone curve adjustments?

You can reset the curve many ways. Double-click the word **Region** to reset all the sliders. Also, Option +clicking (Alt +clicking) the word *Region* changes it to *Reset Region*, and then clicking **Reset Region** resets all the sliders. You can Control +click (right-click) directly in the graph area and click one of the reset options in the contextual menu that appears. Double-click a slider's name or the slider (●) to reset that individual slider.

continued

The tone curve is more precise than the Brightness and Contrast sliders in the Basic pane. Using the Targeted Adjustment tool to click directly on areas of the image gives you more control over which areas are changed. You can also use the sliders at the base of the graph to limit the areas, or range of tones, affected by each region slider. For example, moving the right slider under the graph more to the right limits the effect of the Highlights slider to the brightest areas of the image.

Make Controlled Tone Curve Adjustments *(continued)*

USE THE TARGETED ADJUSTMENT TOOL

1 Click the **Targeted Adjustment** tool (⊙).

● The cursor changes to the Targeted Adjustment tool (☖).

2 Click and drag up or down directly on the photo.

3 Move the cursor to another area.

4 Click and drag up or down depending on the image.

● The values in the area under the tool change, as do the curve and the sliders in the right panel.

5 Click ⊙ to stop using the tool and return it to the Tone Curve pane.

CHANGE THE AREAS AFFECTED BY THE REGION SLIDERS

① Click the rightmost ◆ at the base of the graph.

② Drag it slightly to the right.

③ Click and drag the **Highlights** ◆ to the right.

Only the lightest highlights are affected.

④ Repeat Steps **1** to **3** to limit the changes to other tonal regions on the curve.

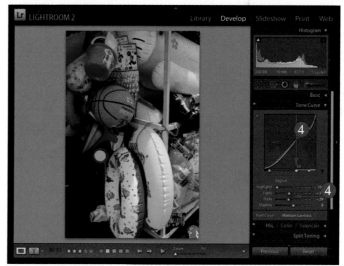

TIPS

What does the Point Curve arrow change?

Clicking the **Point Curve** ⬚ (●) offers three options. Medium Contrast is the default Point Curve setting. Linear creates a perfectly straight line and shows no curves adjustments, and Strong Contrast boosts the contrast in the photo. The setting you choose changes the curve but not the region sliders. If you import a photo and its metadata previously edited with the Adobe Camera Raw curve, the Point Curve option shows Custom, and the curve itself displays the custom edits.

Is there an easy way to see the effect of the tonal adjustment?

Yes. You can click the **Tone Curve** ⬚ to switch the Tone Curve effects on and off. You can use similar on/off switches to preview the effect of the changes for other adjustments in the right panel.

Explore the HSL/Color/ Grayscale Tools

The HSL/Color/Grayscale pane of the right panel is a powerful three-part color adjustment tool. You can view each section of the Hue Saturation and Luminance pane separately, or all at once if your monitor size allows. The Color and Grayscale sections each let you target specific color values to control every area of the image.

HSL Tools

The Hue sliders (●) change only the specific color associated with each of the eight sliders. The Saturation sliders change the vividness of the selected color. You can saturate or desaturate specific colors individually. The Luminance sliders change the brightness of each color individually. You can selectively brighten or darken one or more colors.

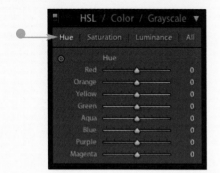

Viewing the HSL tools

You can click **Hue**, or **Saturation**, or **Luminance** to view only those sliders, or you can click **All** (●) to view all three HSL tools at once. When they are all displayed in the pane, you can click one of the HSL names once to reduce the sliders back to just that specific group.

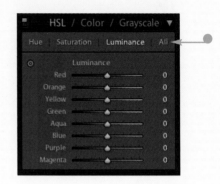

Color

You can click **Color** to selectively adjust the hue, saturation, and luminance of one specific color. Click any one of the eight color boxes (●) at the top of the pane to adjust the corresponding sliders. Click **All** to view all the colors grouped by color.

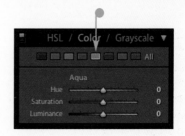

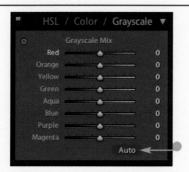

Grayscale

The Grayscale section is a grayscale mixer for controlled conversions from color to black and white. Clicking **Grayscale** automatically displays a black-and-white preview, although the photo remains an RGB image. Click **Auto** (●) as a starting point. Use the sliders to fine-tune the conversion by brightening or darkening specific color areas to creatively affect the grayscale tones.

Using the HSL/Color/Grayscale Adjustment Tools

You can use the sliders to apply each adjustment or click and drag directly in the image using the **Targeted Adjustment** tool (⊙). Reset individual sliders (●) by double-clicking the slider's name or ◢. You can reset any group of sliders by Option +clicking (Alt +clicking) the name of the group. Click the ◾ to view the effects of your edits.

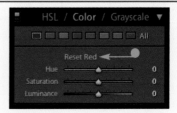

Adjust Individual Color Ranges

You can selectively adjust individual colors by hue, by saturation, or by the overall brightness of the color. For example, if an object or an area appears too dull or too vivid, you can adjust the sliders for the specific color. You can also use these tools creatively, changing the existing colors or the intensity to give a photo a totally different look.

Adjust Individual Color Ranges

ADJUST THE HUE, SATURATION, AND LUMINANCE WITH THE TARGETED ADJUSTMENT TOOL

1. Arrange Lightroom's interface to show a large viewing area and the right panel.

2. Click the **HSL/Color/Grayscale** ◀ in the right panel.

 The pane expands.

3. Click **All** to display all three sets of sliders for Hue, Saturation, and Luminance.

4. Click the **Targeted Adjustment** tool (⦿) in the Hue section (▶ changes to ◉).

5. Move the cursor over a colored area and drag up or down to adjust the hue.

 The hue changes in the image and the corresponding sliders in the Hue pane move to one side or the other.

6. Repeat Step **5** by clicking and dragging in a different colored area.

 - You can also click the Targeted Adjustment tool in the Saturation and Luminance sections and click and drag in the colored areas to adjust the color's saturation and luminance.

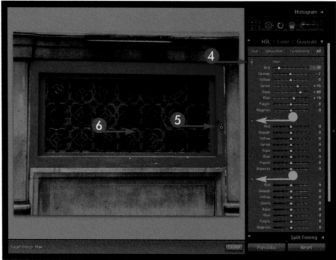

ADJUST THE COLORS WITH THE COLOR PANE SLIDERS

① With another photo selected, click **Color** in the HSL pane.

The Color pane expands.

Note: *Clicking **All** expands the Color pane to display all the color boxes at once.*

② Click a color box to select it.

③ Click and drag each slider to adjust the Hue, Saturation and Luminance for that color to change the image.

The characteristics of the selected color in the image change accordingly.

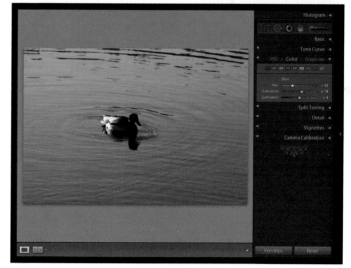

TIP

Why is there both an HSL and a Color pane? Do the Color pane tools produce the same effect as the tools in the HSL pane?

Yes. The adjustments you make using the tools in the Color pane affect the photo the same way the adjustments you make using the tools in the HSL pane. The two sets of tools are organized differently so you can work the way you prefer. In the Color pane, you click the color box of the color you want to modify, and then adjust the hue, the saturation, and the luminance of that color. In the HSL pane, all the sliders for hue are grouped together, as are the sliders for saturation and luminance for each color. In both panes, you can view just one group or click **All** to view all the sliders and colors at once.

Creatively Convert a Color Image to Black and White

Although you can apply a preset in either the Library or Develop module to convert a color photo to black and white, the Grayscale pane of the right panel offers more options for creating a unique black-and-white photo. You can also specifically control the individual tones in the final image with the sliders or the Targeted Adjustment tool.

① Arrange Lightroom's interface to show a large viewing area and the right panel.

② Click **Grayscale** in the right panel.

Note: You can also start with a preset and then use the Grayscale pane to make custom adjustments.

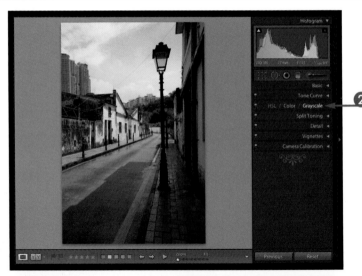

The Grayscale pane opens and the photo automatically appears black and white in the main viewing area.

③ Click and drag any of the sliders to adjust the grayscale tones.

● The tones in the image vary and the Grayscale Mix sliders adjust.

④ Click and drag the **Blue** ◐ to the left.

Note: The selection of sliders and the direction to move them depends on your photo.

The levels of gray in the sky and other blue areas increase.

⑤ Click ◉.

The cursor changes to the Targeted Adjustment tool (◉).

⑥ Position the cursor over a specific area in the photo.

⑦ Click and drag in the image.

The areas in the color image below change, creating different grayscale values.

⑧ Click ◉ to return the tool to the Grayscale pane.

TIPS

Why did all the tools disappear from the toolbar below the main viewing area when I clicked the Targeted Adjustment tool?

When you use the **Targeted Adjustment** tool (◉), the toolbar options change. You can click **Done** in the toolbar to stop using the Targeted Adjustment tool. The previous toolbar tools reappear. You can also quickly switch back to another adjustment pane by clicking the **Target Group** ▣ and selecting **Tone Curve**, **Hue**, **Saturation**, or **Luminance**.

How can I revert my grayscale photo to a color image?

You can click **HSL** or **Color** to return to a color image, click **Color** in the Basic pane, or use the History pane in the left panel to step backwards. If you Option +click (Alt +click) **Grayscale Mix**, the photo returns to the default grayscale and enables the Auto button. Clicking **Auto** applies a grayscale mix that distributes the gray tones as much as possible for that image.

Tone an Image

Whether you tone black-and-white images or color photos, Lightroom opens more creative possibilities with the Split Toning pane in the Develop module. You can simply tint a photo or even simulate the chemical cross processing techniques used with film in a traditional darkroom. You can also give the image a unique tone for a different effect.

Tone an Image

① Repeat the steps in the previous task to create a custom black-and-white photo.

Note: Optionally, apply the steps in this task starting with a color photo.

② Click the **Split Toning** ◀.

③ Click and drag the **Highlights Saturation** ◆ to 50.

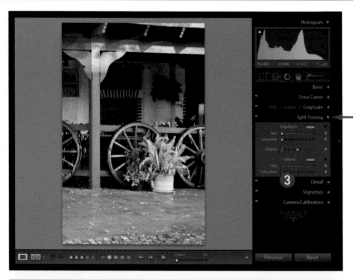

The photo appears tinted.

④ Click and drag the **Highlights Hue** ◆ to the right to select a tone color.

Note: Try using warm tones for highlights and cooler tones for shadows.

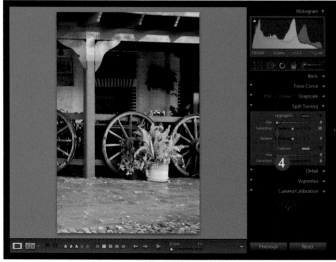

The tint color changes.

⑤ Click and drag the **Shadows Hue** ⬥ to the right to select a tone color.

⑥ Click and drag the **Shadows Saturation** ⬥ to 50.

⑦ Click and drag the **Balance** ⬥ to the left to increase the effect of the Shadows color.

⑧ Click and drag the **Balance** ⬥ to the right to increase the effect of the Highlights color.

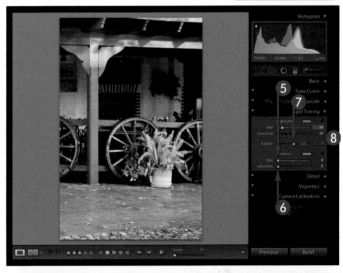

The balance of highlights and shadows colors changes as you move the slider.

⑨ Click and drag both **Saturation** sliders to get the final effect.

Note: *Optionally, continue to adjust the sliders in any order. Go back and forth until your photo has the look you want. You can also open any of the other panes to continue editing the tones.*

TIPS

Why should I start with the Saturation sliders?

When Saturation is set to zero, the hue changes have no effect on the image. If you press and hold Option (Alt) as you change the hues, Lightroom displays the effect of full saturation so you can see which areas of the photo will be toned.

How can I use the color squares in the Split Toning pane?

Clicking the color square in the Split Toning pane opens the color selector. You can click and drag (●) in the selector to find the toning color you want, and the main viewing area previews the color applied to the photo.

Brush On a Localized Adjustment

Lightroom includes an Adjustment Brush tool so you can paint specific areas of the image and effectively dodge, burn, saturate, desaturate, adjust exposure, and more. You can set options for two different brushes, labeled A and B, and paint with each brush for different edits. You can also click New to create new brush settings for either brush and then brush on the new adjustments on any area.

Brush On a Localized Adjustment

ADJUST A LARGE BACKGROUND AREA0

1. Click the **Adjustment Brush** ().

 The Adjustment Brush tool pane opens.

2. Click the **Effect** and select **Exposure**.

3. Click and drag the **Amount** .

4. Position the cursor over the image, but do not click.

● The cursor appears here.

5. Click and drag the **Size**, **Feather**, and **Flow** sliders to adjust the size of brush A.

6. If necessary, click **Auto Mask** (changes to).

Note: *Auto Mask prevents adjustments from being brushed on certain areas. The tool separates edges it sees as different from the area selected with the adjustment pin. By deselecting or turning off the Auto Mask feature in a photo with irregular edges such as trees against a large sky, you can brush on the adjustment more uniformly, and then erase areas from the adjustment, as in the steps that follow, to create a smoother look.*

7 Click the area to edit in the image.

The clicked area is marked by a local adjustment pin ().

8 Click and drag over the area to be adjusted using the cursor as a paint brush.

● The exposure in the painted area is changed.

● Once you apply a brush, a mask is created and the Mask mode changes to Edit, indicating the selected mask can be changed.

9 Repeat Step **5** to make the brush smaller.

10 Repeat Step **8** to continue painting more areas.

11 Position the cursor over .

The painted areas appear as a red mask and show over-painted areas.

12 Press Option (Alt).

continued 215

TIPS

How can I see the areas to erase if the red mask disappears when I move the cursor away from the Adjustment pin?
You can click 🔲 to show all the sliders. Then exaggerate the Exposure Effect by moving the ◆ completely to the left, which darkens all the painted areas so you can see where you need to erase. Alternatively, you can click the color box when viewing all the sliders and selecting a bright color for the painted areas. When you finish painting and erasing, click in the color box again and change it back to white to remove the tint.

Is the Local Adjustment tool only good for adjusting landscape photographs?
No. The Adjustment Brush is particularly useful to soften skin in a portrait. Click the Adjustment Brush tool to expand the tool pane. Click the **Effect** ⊟ and select **Soften Skin.** Paint over the skin areas avoiding the eyes, nostrils, and lips. The Skin Softening Effect softens the skin by modifying both the Clarity and Sharpness adjustments.

Brush On a Localized Adjustment *(continued)*

Because you are actually creating a mask when you use the Adjustment Brush, you can edit any adjustments after they are applied by changing the parameters. You can also use localized adjustments to add focus or other creative elements by desaturating some parts of the photo and leaving just some areas colored.

The cursor changes to ✛.

⑬ Click and drag, holding Option (Alt) to paint over any areas to remove the mask.

⑭ Click and drag to the left or right directly on the Adjustment pin (◉) to increase or decrease the exposure in the brushed areas.

Note: *Optionally, click and drag the **Amount*** 🔘 *to adjust the Exposure.*

⑮ Click 🔳 to show all the Effect sliders.

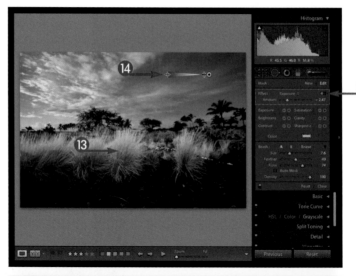

All the Effects sliders appear.

⑯ Click and drag any of the sliders to adjust the settings for the painted areas.

⑰ Click **New**.

⑱ Repeat all the steps to apply a new set of adjustments to another area.

Note: *Optionally, click any Adjustment pin (◉) and press* Delete *(*Delete *or* Backspace*) to delete the adjustment and the pin.*

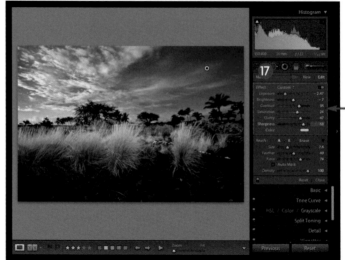

USE THE AUTO MASK FOR CREATIVE LOCALIZED ADJUSTMENTS

1 Repeat Steps **1** to **5** in the first part of this task.

2 Click **Auto Mask** (☐ changes to ☑).

3 Click the area to edit in the image.

4 Click and drag over the area to be adjusted using the cursor as a paint brush.

Note: It is important to keep the center of the brush ring on the outside edge of the area to be preserved.

5 Readjust the **Size**, **Feather**, and **Flow** sliders of the brush as you paint closer to edges.

6 Click ☐ to show all the Effect sliders, if necessary.

7 Click and drag the **Saturation** ◧ to the left.

The painted areas appear grayscale.

8 Click and drag the other **Effect** sliders to alter the photo.

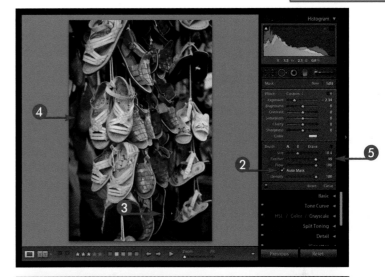

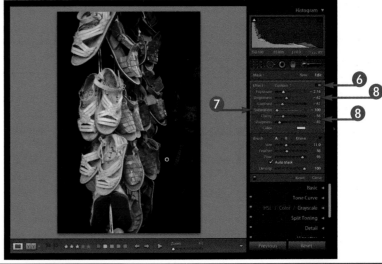

TIPS

Why do I get little halos around some areas as I apply the brush?

With Auto Mask checked, the Adjustment Brush looks for contrast edges and tries to paint around them. Click **AutoMask** to uncheck it and turn it off (☑ changes to ☐) as you paint to cover these areas.

What do the Brush controls mean?

- Feather creates soft-edged transitions between brushed areas and the surrounding pixels.
- Flow controls the amount of the adjustment.
- Auto Mask limits the brush strokes to areas of similar color.
- Density controls the amount of transparency in the brushstrokes.
- A and B keep the options of two separate brushes until you change them. Click **A** to set one brush and click **B** to set a second style. Press / to change brushes.

Add a Localized Graduated Filter

You can use the Graduated Filter tool to apply adjustments as a uniform gradient across a region in an image. You can add a sunset effect to a landscape or add light at an angle. Like the Adjustment Brush tool, the Graduated Filter requires some practice and experimentation. Both localized adjustment tools let you push your own creative boundaries.

Add a Localized Graduated Filter

① Click the **Graduated Filter** tool (▣).

The Graduated Filter tool pane opens.

② Click the **Effect** ▤ and select **Saturation**.

③ Click and drag the **Amount** ◆ to 100.

④ Position the cursor (✛) over the image.

⑤ Click and drag from the bottom of the image upward.

Note: Optionally, press Shift to constrain the angle, making the gradient blend in a straight perpendicular or vertical line.

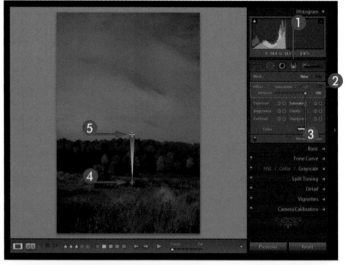

- The Local Adjustment pin (◉) appears, indicating the center of the effect.

- Parallel lines indicate the high and low extents of the gradient.

- The Mask mode changes to Edit.

⑥ Click ◉ to move the center of the adjustment.

⑦ Click and drag the top or bottom line to change the range of the adjustment.

⑧ Click ▣ to show all Effect sliders.

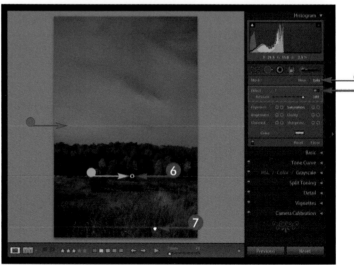

⑨ Click and drag the other **Effect** sliders to edit the adjustment.

⑩ Click **New**.

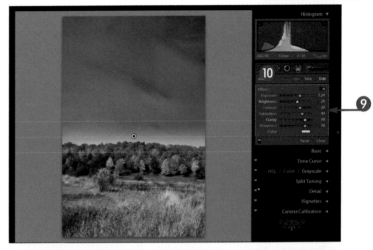

⑪ Repeat Steps **2** to **9** to add another Graduated Filter adjustment.

⑫ Press H to toggle on and off the ⊙ pins and view the image without the Adjustment pins.

⑬ Click to select a ⊙ pin.

⑭ Click and drag the **Effect** sliders to edit the parameters of the adjustment.

⑮ Click the **Graduated Filter** tool to stop using it.

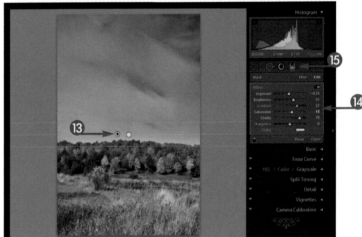

TIPS

Can I apply a Graduated Filter and then use the Adjustment Brush to change specific areas?

Yes. Although the Adjustment Brush cannot edit a Graduated Filter adjustment, you can apply multiple adjustments one on top of the other, so you can selectively change a section of the photo that already has a graduated adjustment applied.

Can I create a preset of my own settings for an Adjustment Brush or a Graduated Filter?

Yes. You can save presets for both types of localized adjustment tools. Apply the effects you want and click the **Effect** ⊙. Select **Save Current Settings As New Preset** (⊙). Type a name in the Preset Name dialog box and click **Create**. Your preset now appears in the Effect menu. The saved settings include all the adjustment effects and the values for either tool, but not the Size, Feather, and Flow of the Adjustment Brush tool.

Reduce Digital Noise in the Image

Digital noise refers to the extraneous pixels that may be visible in a photo viewed at full resolution and can be both Luminance noise, which makes an image look grainy, and Color noise, which adds specks of different color mostly in shaded areas. All digital cameras produce some noise; however, the smaller the camera sensor the greater the chance of noise in the image.

Noise Reduction and Sharpening are interconnected tools: Changing one setting affects the results of the other.

Reduce Digital Noise in the Image

1 Click the **Detail ◀**.

Note: *The default color noise reduction value of 25 is automatically applied but may not be correct for your photo.*

2 Click **Detail Zoom Area** (⊞).

● The cursor (➘) changes to +.

3 Move the cursor over the image to change the area displayed at 1:1 in the detail panel.

Note: *Optionally, press* ⌘ + + *(* Ctrl + + *) to view the image at 1:1 in the main viewing area.*

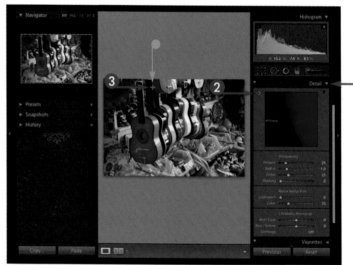

4 Click and drag the **Color** ◆ completely to the left.

● The noise appears more obvious.

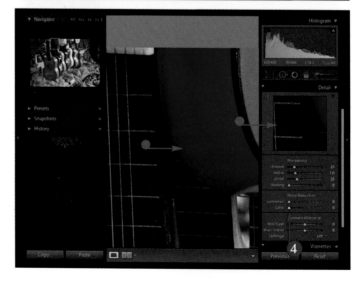

5 Click and drag the **Color** slowly to the right just until the noise almost disappears.

● The amount of noise is reduced.

6 Click and drag the **Luminance** slowly to the right, just until the grainy appearance is diminished.

● The noise becomes much less apparent.

7 Click and drag in the main preview image to check the image detail in other areas.

TIPS

What causes digital noise?

All digital cameras produce some electronic noise when they convert the light into electrical signals to record the color values. However, certain camera settings, such as underexposure or higher ISO settings, for example ISO 800 or higher depending on the camera, as well as the use of the Fill Light or Exposure sliders in Lightroom can all contribute to and increase the effect of digital noise.

Can I just move the Color slider to 100% to remove the noise?

No. Lightroom reduces digital noise by blurring or softening the image slightly. If you move the sliders to 100% you soften the image detail and give your photo an artificial look.

Decrease Chromatic Aberration

Chromatic aberrations are visually distorted pixels similar to digital noise and can appear as colored fringes on high-contrast edges, especially at the outside borders of the photo. Many newer lenses designed for digital cameras already reduce the effect, which comes from the different colored wavelengths of the light passing through the glass of the lens. Chromatic aberrations tend to be more visible with wide-angle lenses.

Decrease Chromatic Aberration

1 Click the **Detail** ◄.

2 Click ⬚.

3 Position the cursor over the image.

4 Press ⌘+➕ (Ctrl+➕) to zoom in at least to 1:1.

5 Click a high-contrast edge.

● The edge appears in the detail view.

6 Click the **Navigator** ⬚ and click **2:1** for a larger view.

7 Click and drag the **Red/Cyan** ⬚.

● The colored edges start to disappear.

⑧ Click and drag the **Blue/Yellow** ◆ to refine the adjustment.

● The colored edges are removed or reduced.

Note: *Optionally for images with specular highlights from light reflecting off a shiny surface, such as metal or water, and that display additional fringing around edges, click the* **Defringe** ◆ *and select* **Highlight Edges** *or* **All Edges**. *Be sure to check the effect of the correction on the rest of the photo and not just the highlighted edges.*

TIPS

What causes chromatic aberration?

Chromatic aberration appears as colored fringing and is most often a result of the different colored wavelengths of the light being focused at different positions as they pass through the glass of the lens before reaching the sensor. Special types of glass in newer lenses optimized for digital cameras can reduce the distortion.

Where should I look for the colored fringes in my photo?

Chromatic aberration tends to appear more towards the outside edges of the image, particularly with wider-angle lenses, and appears most on sharp-contrast edges. It is most noticeable against a light sky or an even colored area.

Improve Details with Sharpening

Once you have made the large area adjustments to your photo and reduced the noise if necessary, you can apply sharpening using the Detail pane in the Develop module. By default most cameras apply sharpening to JPEGs but not to RAW files. Lightroom automatically applies a little sharpening to all RAW images calculated as part of the camera default.

When you add sharpening, you may need to readjust the settings you used when reducing digital noise, because these tools are related.

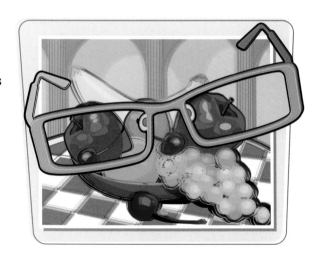

1 Press ⌘+= (Ctrl+=) to zoom in to 1:1.

2 Click the **Detail** ◀.

3 Click the **Sharpening** ◀.

The Detail preview opens.

4 Click ⊕.

5 Position the cursor over the image and click.

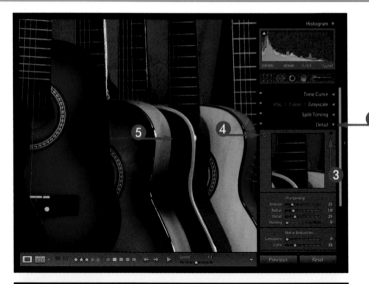

● Detail preview shows a 1:1 view of the selected section.

6 Leave the **Radius** ◙ at the default setting of 1, meaning sharpen one pixel to either side of an edge.

7 Click and drag the **Amount** ◙ all the way to the right.

● The sharpening is at maximum and distorted or white pixels called artifacts now appear in the photo.

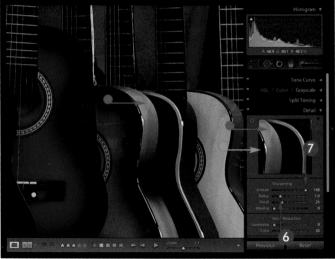

⑧ Click and drag the **Amount** ◨ slowly to the left until the artifacts are no longer visible.

The amount of sharpening and artifacts is reduced.

Note: *The sharpening amount makes edges brighter or darker to give the appearance of sharpness.*

⑨ Click and drag the **Detail** ◨ slowly to the right, again to obtain the maximum sharpness with the fewest artifacts.

Note: *Detail determines how many edges are sharpened.*

⑩ Click and drag the **Masking** ◨ slowly to the right to increase the sharpness until you still see sharp edges but also minimized noise in the solid color areas.

Note: *Masking hides or masks sharpening from certain areas of the photos, restricting it to edges.*

Note: *Try to balance sharper edges with no added noise in the continuous-tone areas.*

Note: *Optionally, Option +click (Alt +click) the word **Sharpening** to reset all the sliders.*

TIPS

How can I know what is being sharpened?

Press Option (Alt) as you click and drag the **Radius** or **Detail** sliders to show how far and which edges are sharpened (●). The preview shows black edges against a white background. Press Option (Alt) as you click and drag the **Masking** slider. Black areas in the preview are masked and not sharpened.

What is the difference between sharpening in the Library and Develop modules and sharpening in the Print module?

As you work on your images in Lightroom, you sharpen photos at two points in the process. You need to sharpen images as you work on them in the Library or Develop modules to compensate for the camera's conversion process from light on the sensor into pixels. When you prepare a photo for printing, you need to add specific sharpening for the type of printer used, because the printing process, both inkjet and offset press, introduces some softness.

Add a Lens Vignette for Effect

Vignettes can be a technical problem or an artistic addition. *Vignetting* is a darkening in the corners of a photo. The Vignettes pane in Lightroom's Develop module includes two sets of tools: One for removing or applying a vignette to the original image, the other for applying a vignette after cropping the photo.

① Click the **Vignettes** ◄.

② Click and drag the **Post-Crop Amount** 🔘 to the left to darken the corners.

Note: *To remove an undesirable lens vignette from an original uncropped photo, click and drag the **Amount** 🔘 of the Lens Correction pane to the right.*

The corners of the image darken.

③ Click and drag the **Midpoint** 🔘 to the left.

The darkened areas expand toward the center of the photo.

④ Click and drag the **Roundness** ▣ to the left for a more oval effect.

Note: *To create a more circular effect, click and drag the* **Roundness** ▣ *to the right.*

⑤ Click and drag the **Feather** ▣ to the right to soften the transition between the vignette and the center of the photo.

Note: *To create a hard-edged darkened area around the center of the image, click and drag the* **Feather** ▣ *to the left.*

TIPS

What causes camera-induced vignetting?

Lens vignetting occurs when more light reaches the center than the edges of the digital sensor. It can happen when the lens is not optimized for the digital camera or with some wide-angle lenses and/or wide open apertures.

Why are vignettes applied to a good photo?

Adding a darkened vignette can give an image a dark, moody look. It can also help focus the viewer's eye on the central subject of the image. You can also apply a light-colored vignette to imitate old-style portraits.

Save Your Settings as a Custom Preset

Once you have created a special effect, you can apply it to other images by copying and pasting, as shown in Chapter 7, or synchronize the adjustments to multiple photos, as shown in Chapter 6. You can also save your settings as a custom preset. Your new preset will appear in the Presets pane in the Develop module and the Quick Develop pane in the Library module under Saved Presets.

Save Your Settings as a Custom Preset

CREATE A NEW CUSTOM PRESET

Note: When you create a preset, the included settings are based on the current settings of the selected photo.

① Make adjustments to a photo using any combination of the Develop module tools.

② Click the **Presets** ➕.

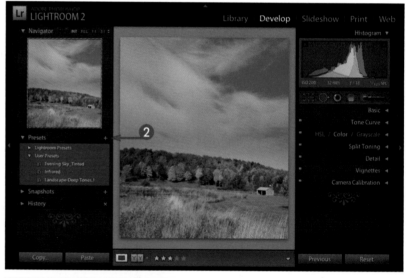

The New Develop Preset dialog box appears.

③ Type a name in the Preset Name text box.

④ Click any individual checked setting to deselect it (☑ changes to ☐).

Note: Optionally, click **Check None** and then click only the settings you want to use.

⑤ Click **Create**.

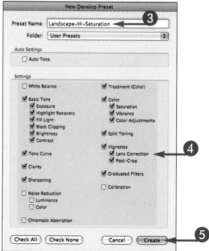

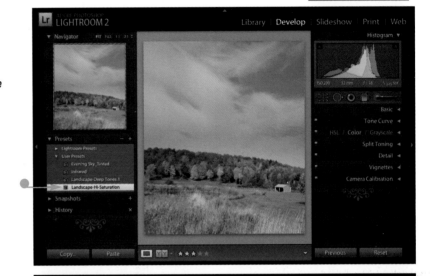

● Your custom preset appears in the User Presets under the Presets pane.

Note: To delete a custom preset, Control +click (right-click) the preset in the Presets pane and click **Delete** from the menu that appears. You cannot delete the default Lightroom presets.

UPDATE A CUSTOM PRESET

1 Make adjustments to a photo using any Lightroom tools.

2 Position the cursor over the preset to update.

● The Navigator preview displays the preset's current effect.

3 Control +click (right-click) the preset in the Presets pane.

A menu appears.

4 Click **Update with Current Settings**.

The custom preset's settings are updated to those of the selected photo.

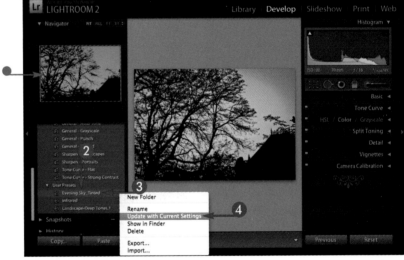

TIPS

Is there a way to manage a long list of custom presets?

Yes. You can create your own folders inside the User Presets folder to group your presets. Control +click (right-click) the User Presets in the Presets pane. Click **New Folder** from the menu. Type a name for the folder in the New Folder dialog box that appears and click **Create**. Your folder (●) appears in the list under User Presets. Click and drag any custom presets into this folder in the Presets pane.

Can I export a custom preset to use on another computer?

Yes. You can Control +click (right-click) a preset and select **Export** to use it on another computer or **Import** to bring different presets into Lightroom. You can also purchase predesigned presets such as those from KubotaImageTools.com and import them.

When you import RAW photos, Lightroom applies the Adobe Camera Raw (ACR) conversion for the camera model you used. You can select different settings created by Adobe and even fine-tune any of the settings using the sliders in the Camera Calibration pane. You can save your customized settings as a new camera specific preset for your particular camera.

Calibration Features

Camera Calibration Profiles

Camera Sensor Variations

ColorChecker

Develop Preset

Updated Default Settings

Creative Uses

Camera Calibration Pane Built-In Profiles

Thomas Knoll and Adobe measured the color response of many models of cameras under specific lighting conditions to create custom profiles. As long as your camera model is included in the ACR profiles, your photos automatically appear in Lightroom with that profile applied. Lightroom includes different versions of ACR and other profiles corresponding to custom settings of your specific camera model.

Camera Sensor Variations

Because digital sensors can vary from camera to camera of the same model, you can use the Camera Calibration sliders for the Tint in the Shadows, and the Hue and Saturation of the Red, Green and Blue Primary colors, to define and adjust the way Lightroom translates the color from your particular camera.

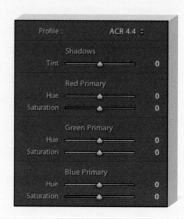

Third-Party Software

You can shoot a 24-patch GretagMacbeth ColorChecker Chart (http://www.xrite.com) and use the sliders to create your own profile or, for more accuracy and advanced photographers, use your shot of the ColorChecker with Photoshop and a third-party ACR Calibrator software script (http://fors.net/chromoholics).

Create a Develop Preset

You can create a new preset (●) from the settings, selecting just the calibration settings in the New Develop Preset dialog box, and then apply your camera-specific calibration preset to all photos from that camera upon import.

Update the Default Settings

You can also update Lightroom's default camera calibration settings with your own adjustments by clicking **Develop** in the top menu and clicking **Set Default Settings**. Click **Update to Current Settings** (●) in the warning box.

Using the Camera Calibration Pane

You can change the look of a photo shot in the RAW file format by selecting a different profile in the Camera Calibration pane. Changing the profile changes the tones and appearance of the photo because the profile describes how Lightroom should display the image. You can also use the sliders in the Camera Calibration pane to alter your image with creative color adjustments.

The adjustments shown in this task are subjective and depend on your photo and the look you want to achieve.

Using the Camera Calibration Pane

① Click a photo in the filmstrip to select it.

② Click the **Camera Calibration** ◀ to expand the pane.

③ Click the **Profile** ▪.

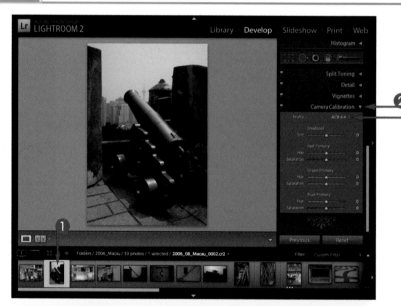

The list of Adobe Camera Raw profiles appears.

④ Click a different profile in the menu to apply it.

Note: *The menu may list different profiles depending on the camera you used for the photograph.*

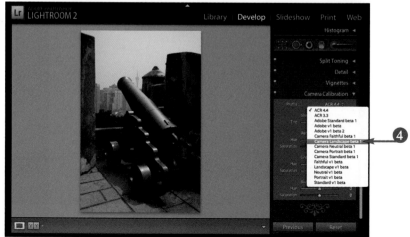

The colors and tone in the image change.

Note: *Depending on the photo and the profile, the changes may not be very strong.*

5 Click and drag the **Shadows Tint** to the right for a more magenta tint or to the left for a greener tint.

6 Click and drag the **Red Primary Hue** to the right to lighten the red values.

7 Click and drag the **Red Primary Saturation** to the right to increase the saturation of the red values.

The colors and tone in the image change more.

8 Repeat Steps **6** and **7** for the **Green** and **Blue Primary Hue** and **Saturation** sliders to adjust the photo to create a specific look.

Note: *Optionally, scroll up to the Basic pane and lower the **Saturation**.*

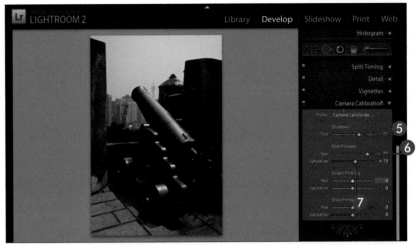

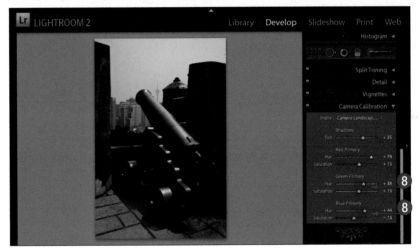

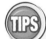

What kind of Camera Raw profiles does Adobe include with Lightroom?

The profiles that ship with Lightroom include general Adobe Camera Raw profiles as well as specific sets specifically created for many of the digital cameras on the market. Adobe constantly adds to and updates the list. New camera profiles are added to your version of Lightroom when you download updates. Be sure to set the general Lightroom preferences to **Automatically check for updates**.

Do I need to create my own Camera Calibration profile if my camera model is included in the ACR profiles that ship with Lightroom?

No. Although each individual camera's sensor varies from every other sensor in the same camera make and model, Adobe created the profiles with multiple measurements. The variations for images from your specific camera may not be very noticeable.

Making Slideshows Look Professional with Lightroom

Slideshows are a great way to share your photos. You can create a quick slideshow just to review your own photo collections or create customized slideshows to show clients. The Slideshow module in Lightroom includes standard slideshow templates and many options for customizing and creating a professional-looking slideshow.

Locate the Parts of the Slideshow Module ..236

Play an Impromptu Slideshow238

Create a Basic Slideshow with a Slideshow Template240

Customize an Existing Lightroom Slideshow Template242

Add Customized Text Overlays to a Slideshow ...246

Save a Custom Slideshow Template248

Export a Slideshow to PDF249

Locate the Parts of the Slideshow Module

As with the other Lightroom modules, getting to know the parts of the Slideshow module is the key to creating slideshows quickly and effectively. Like the other modules, the Slideshow module includes predesigned templates you can use or modify, and the option to save your own custom templates to use over and over again. The Filmstrip and Filmstrip tools on the bottom of the screen are the same in all the modules.

Slideshow Slide Editor viewing area

The Slide Editor displays the highlighted photo in the Collection using the currently selected slideshow template or design.

Slideshow Module toolbar

The toolbar includes the controls for navigating, playing, and adding text to your slides. From the left:

Click to go to first slide.

Click to go to previous slide.

Click to go to next slide.

Click to select photos for slideshow.

Click to launch a preview of the slideshow.

Click directly on the text overlay on the slide and click here to rotate it counter-clockwise.

Click directly on the text overlay on the slide and click here to rotate it clockwise.

Click to add text to a slide.

The Custom Text field appears here when Add Custom Text is clicked.

Slideshow Module left panel

Slideshow Preview

The Preview displays the first selected photo in the Filmstrip.

Slideshow Template Browser

The Template Browser lists all the preset slideshow templates and any custom templates you create and save. Position the cursor over a template to view the preset slideshow layout in the Preview window.

Slideshow Collections pane

The Collections pane shows your photo collections from which you can more easily build the slideshow.

Export buttons

You can export your slideshow as JPEG files or as a PDF.

Slideshow Module right Panel

The right panel contains all the options for customizing your slideshow.

Options pane

You can select a style and modify the slide appearance, including that of fill frame slides, and add borders and cast shadows.

Layout pane

You can choose to show the guides in the design.

Overlays pane

You can select and modify the information to display on the slides and to add drop shadows to text added in the toolbar.

Backdrop pane

You can select and modify the background slide color, add an image as a background, and give the slide a gradient color wash.

Titles pane

You can add an intro and ending screen and also add your identity plate to these screens.

Playback pane

You can add music for playing the slideshow in Lightroom, change the duration of the slides and the fades, select a fade color, and have the slideshow repeat or even display in a random order.

● Preview button

Click to view a preview in the main viewing area of how the slide will appear with the selected settings.

● Play button

Click to start the slideshow with the selected settings in full screen mode.

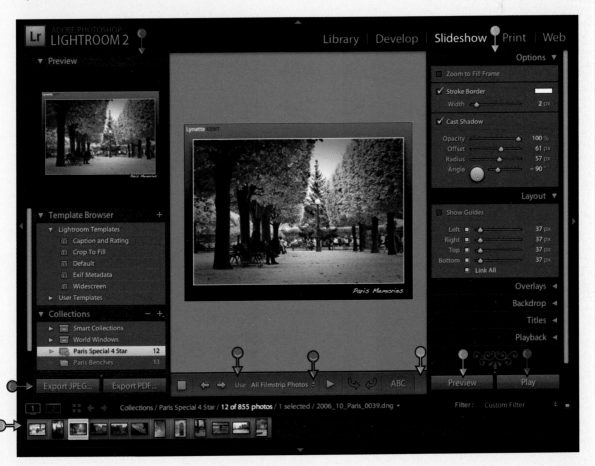

Play an Impromptu Slideshow

You can actually play a quick impromptu slideshow of any selected images in any of the modules. Seeing your images in full screen with a black background is a convenient way to review a newly imported group of photos, or to quickly see a collection of the images with which you have been working.

Play an Impromptu Slideshow

① In any module, ⌘+click (Ctrl+click) multiple photos in the Filmstrip.

② Press ⌘+Return (Ctrl+Enter).

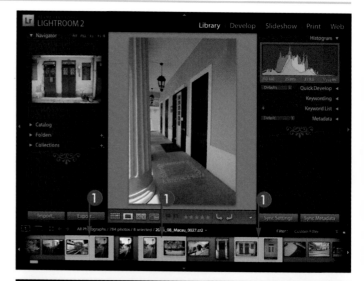

The impromptu slideshow begins showing the selected photos.

③ With the slideshow playing, press ← to go back to the previous slide.

The previous slide appears and
the slideshow continues.

Note: *Optionally, press* → *to advance to the
next slide to advance the slideshow more quickly.*

④ Press **Spacebar** to pause the
slideshow.

⑤ Press **Spacebar** to resume the
slideshow.

⑥ Press **Esc**.

The slideshow quits and
Lightroom returns to the previous
module.

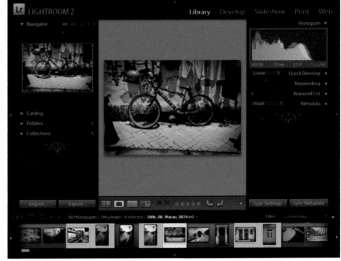

TIPS

**Can I change the background
settings for the impromptu
slideshow?**

Yes. The impromptu
slideshow automatically
applies the settings currently
selected in the Slideshow
module. Make sure you have
your favorite slideshow options
selected in the Slideshow module ahead of time.

**Is there another way to start
an impromptu slideshow?**

Yes. In any module you can
click Window from the top
menu and click **Impromptu
Slideshow**. You can also
start a slideshow in the
Library or Develop modules
by clicking **Play** (▶) in the
toolbar.

Create a Basic Slideshow with a Slideshow Template

Lightroom's Slideshow templates include a number of predesigned slide styles you can use to quickly build your own slideshow using any of the photos in your catalog. By grouping your images in a collection in the Library module first, you can easily add or remove images from the slideshow and rearrange their display order so the slideshow plays the way you intend.

① In the Library module, click a collection of photos.

Note: See Chapter 3 to create a collection.

② Click **Slideshow** in the module picker.

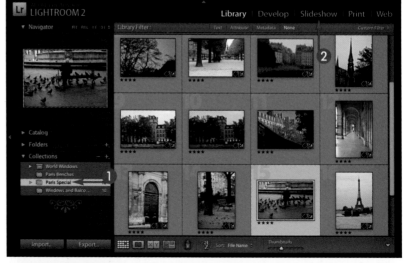

● The slideshow module opens with the collection selected.

● The Slide Editor displays the first slide with the default template or the last selected template applied.

③ Position the cursor over each of the Lightroom templates to view the slide in the Preview pane.

④ Click another template.

The Slide Editor view displays the slide in the different template.

⑤ Click ■ to go to the first slide.

⑥ Click ▶ to preview the slideshow.

The slideshow begins in the Slide Editor pane.

⑦ Click ▮▮ to pause the slideshow.

⑧ Click ⬅ to go to the previous slide.

⑨ Click ➡ to go to the next slide.

⑩ Press Esc to stop the slideshow.

TIPS

Can I use a Smart Collection to create a slideshow?

Yes. However, you cannot change the order of the photos in the Filmstrip for a Smart Collection. You can convert the Smart Collection to a named collection in the Library module, and then in the Slideshow module you can easily change the order of the slides as you preview the slideshow.

Can I preview the slideshow in full screen?

Yes. Click **Play** at the bottom of the right panel. You can pause the slideshow by pressing Spacebar, and stop the slideshow by pressing Esc.

Customize an Existing Lightroom Slideshow Template

The right panel of the Slideshow module includes all the tools you need to completely customize the look of your slideshow. You can change the color of the background, add a border and drop shadow, add a soundtrack, and more by clicking any of the options in the right panel. You can then save your customized template as a new template to use for another collection.

Customize an Existing Lightroom Slideshow Template

① Repeat Steps **1** and **2** from the previous task.

② Click the **Layout** ◄.

③ Click the **Backdrop** ◄.

④ Click **Show Guides** (☐ changes to ☑).

⑤ Click **Link All** to link all the guides

Note: Link All is selected when the boxes appear white.

⑥ Click and drag the guides in the Slide Editor to readjust the image size.

⑦ Click **Background Color** if it is not already checked (☐ changes to ☑).

⑧ Click the **Background Color** box (▭).

The Background Color selector appears.

⑨ Click in the color range or on a sample color.

● The color of the slide background changes.

🔟 Click the Background Color selector **Close** button (⊗).

⓫ Click **Color Wash** (▢ changes to ☑).

⓬ Click the **Color Wash** box (▭).

⓭ Repeat Steps **9** and **10** when the Color Wash selector appears to select a wash color.

⓮ Click and drag the **Angle** ◉ to change the angle of the wash.

⓯ Click **Show Guides** to deselect it. (☑ changes to ▢).

⓰ Press Shift + Tab to view the layout full screen.

The new slide layout fills the screen.

⓱ Press Shift + Tab to return to the full Slideshow interface.

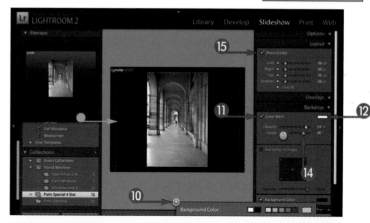

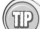 **TIP**

When and how do I use the Cast Shadow option?

You can add a Cast Shadow (●) to the photo to make the image stand out more against the slide background. You must use a light colored background so the shadow effect is visible. Use the four Cast Shadow sliders to customize the shadow. Increasing the opacity of the shadow makes the image stand out more. The Offset ◉ changes the distance the shadow is offset from the image. Increasing the Radius setting increases the blur of the shadow, and the Angle setting changes the direction the shadow is cast.

continued 243

Customize an Existing Lightroom Slideshow Template *(continued)*

You can customize not only the background color and stroke border, you can also include or even change your identity plate and where it appears on the slides. You can even add an introductory title frame and an ending frame to the slideshow.

⑱ Click the **Options** ◄ to expand the pane.

⑲ Click **Stroke Border** (☐ changes to ☑).

Note: *Optionally, click the [] to select a different stroke color.*

⑳ Click and drag the **Width** ▲ to increase the border.

㉑ Click the **Options** ▼ to collapse the pane.

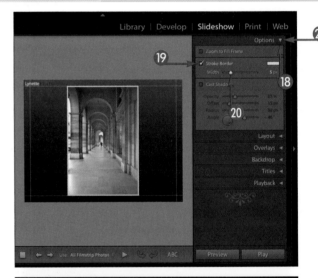

㉒ Click the **Titles** ◄ to expand the pane.

㉓ Click **Ending Screen** (☐ changes to ☑).

The Slide Editor preview fills with black temporarily.

㉔ Click **Add Identity Plate** (☐ changes to ☑).

㉕ Click and drag the **Scale** ▲ to adjust the size of the identity plate in the closing screen.

Note: *Optionally, click Override Color (☐ changes to ☑) to change the identity plate for the ending screen.*

The Slide Editor preview displays the closing screen temporarily.

㉖ Click the **Titles** ▼ to collapse the pane.

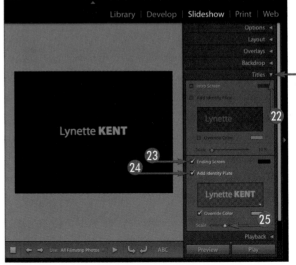

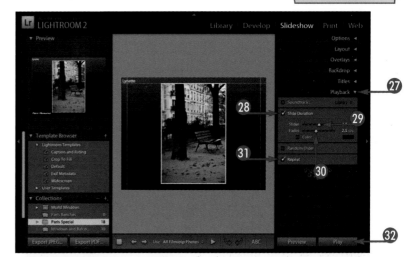

27 Click the **Playback** ◀.

*Note: Optionally, click **Soundtrack** (☐ changes to ☑) and click the ⇕ to select a music source and music.*

28 Click **Slide Duration** (☐ changes to ☑).

29 Click and drag the **Slides** ⬟ to set the duration of each slide on screen.

30 Click and drag the **Fades** ⬟ to set the amount of time each slide fades in and out.

31 Click **Repeat** to have the slideshow repeat continuously (☐ changes to ☑).

32 Click **Play**.

The slideshow plays in full screen mode.

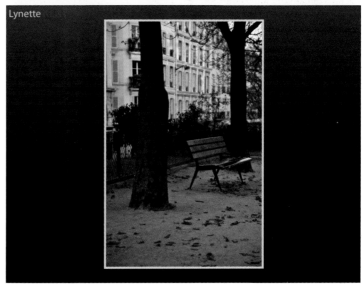

Lynette

TIPS

How do I add a soundtrack to my slideshow?
You can add any music file in your iTunes playlist or in a folder or your hard drive (PC). In the Playback pane, click **Soundtrack**. Click the **Library** (Mac) or **Music** ⇕ to select the music file.

Can I remove the identity plate from each of the slides?
Yes. In the Overlays pane, click **Identity plate** (☑ changes to ☐). The identity plate is immediately removed from the slides.

Add Customized Text Overlays to a Slideshow

You can place a slideshow title on each slide by adding text overlays. Lightroom puts the text overlays on the bottom left corner by default; however, you can move the text to any area you prefer. You can select all the attributes of the text including the font and type face, and opacity. You can even add shadows to the text overlay to make it stand out from the image.

① Press F7 to hide the left panel and make the toolbar wider.

② Click the **Overlays** ◄ to expand the pane.

③ Click **Text Overlays** (☐ changes to ☑).

④ Click **Add text to slide** (ABC) in the toolbar.

● The Custom Text box appears.

⑤ Click in the custom text box and type your overlay text.

⑥ Press Return (Enter).

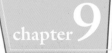

- The text appears in the bottom left corner of the slide.

7 Click the **Font** and select a font from the list that appears.

8 Click the **Face** and select a type-face from the list that appears.

The Text changes style on the slide.

9 Click and drag on a handle of the text bounding box to adjust the size.

10 Click and drag the box to reposition the text.

- The Text moves on the slide.

11 Click and drag the **Opacity** in the Text Overlays pane to the left to fade the text.

- You can click the **Text Overlays** color box (▭) to select a different color for the text overlay.

Your custom text overlay now appears on every slide.

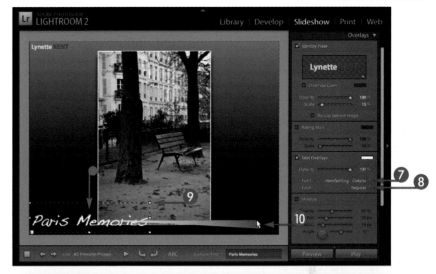

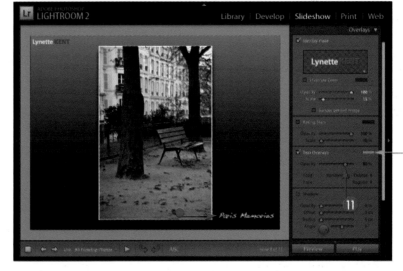

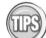

Is the Shadow option in the Overlays pane different from the Cast Shadow in the Options pane?
Both Shadow and the Cast Shadow have the same options for adjustment and include sliders for Opacity, Offset, Radius, and Angle. The Shadow option in the Overlays pane only adds a shadow to the letters in the text overlay and you cannot select the Shadow option unless the Text Overlays is selected. The Cast Shadow is applied to the frame of the photo on the slide.

Are there multiple ways of changing the angle of the shadow?
Yes. You can click and drag the **Angle** , click and drag directly on the number of degrees, or click on the number and type the specific degree angle you want. You can also click and drag in the circle to change the direction of the shadow.

Save a Custom Slideshow Template

Once you have customized a slideshow, you can save the settings as your own custom template. You can make and name as many templates as you want and save them to use for different types of presentations.

① With your custom slideshow still open, click **Slideshow**.

② Click **New Template**.

Note: Optionally, click the plus sign (➕) in the Template Browser pane in the left panel.

The New Template dialog box appears.

③ Type a name in the field.

④ Click **Create**.

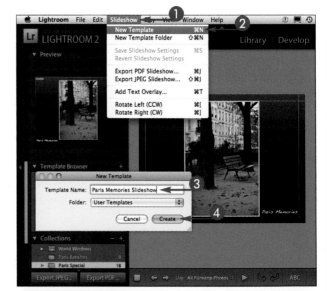

● The new template is placed in the User Templates and appears in the Template Browser.

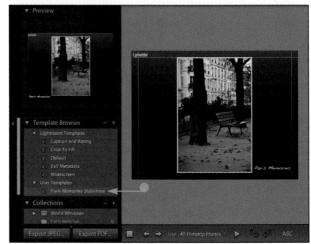

Export a Slideshow to PDF

You can play your slideshow in the Slideshow module, or you can export the slideshow as a PDF. You adjust the Quality settings according to how the Slideshow will be used. Select the highest quality setting, a large screen size, and full screen playback to burn the slideshow to DVD media as a portfolio presentation, for example. Select a lower quality setting, such as 60 percent, and/or a smaller size, if you plan to attach the slideshow to e-mail.

Export a Slideshow to PDF

① With your slideshow open, click **Export PDF**.

● You can also export the slides as individual JPEGs by clicking **Export JPEG**.

Note: *Although the soundtrack does not export with the slideshow, you can add a soundtrack later using Acrobat Professional.*

② Type a name for the slideshow in the text box.

③ Click **Automatically show full screen** (☐ changes to ☑).

Note: *Optionally, click the **Common sizes** ⊕ to select a different screen size.*

④ Click the **Where** ⊕ and select a location to save the PDF Slideshow from the menu that appears.

Note: *Optionally, click the **Where** ⊕ to open a Finder window and navigate to a location to save the PDF Slideshow.*

⑤ Click **Export**.

● Lightroom exports the slideshow as a PDF and displays a progress bar in the upper left corner.

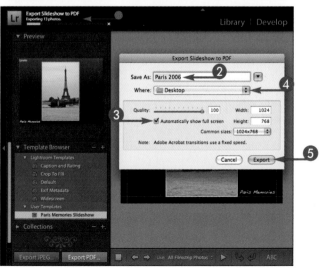

CHAPTER
10

Printing from Photoshop Lightroom

Lightroom's Print module is like a page layout program for photographers. The individual settings for layout, color control, and specific printer media are all easily accessible and visually uncomplicated. And like the other output modules, the Print module includes layout templates and customization options to help you print what you want and decide how you want it to look.

Locating the Parts of the Print Module......252

**Using a Lightroom Template to Prepare
 One Photo to Print254**

Print a Contact Sheet ..256

Add Overlay Text or Graphics to Prints258

**Customize and Save an Existing
 Lightroom Print Template262**

Prepare a Picture Package for Printing266

Create a Custom Picture Package268

**Understanding the Color Management
 Options ...270**

Locating the Parts of the Print Module

The Lightroom interface includes all the tools you need to design, lay out, and prepare your images for print. As with the other output modules, the left panel includes the templates and photo collections, and the right panel contains all the tools for customization. The center section shows you a layout of the actual pages you are designing. The Filmstrip and Filmstrip tools on the bottom of the screen are the same in all the modules.

● **Print Module main viewing panel**

The main viewing panel shows the photos in the selected layout.

● **Print Module toolbar**

The toolbar includes the navigation and photo selection controls. From the left:

Click here (▣) to show the first page.

Click here (◀) to go to previous page.

Click here (▶) to go to next page.

Click the **Selected Photos** ▣ to select the group of photos to use.

● **Print Module left panel**

Preview

The preview displays the Print layout style.

Template Browser

The Template Browser lists the Lightroom templates and custom user templates. Position the cursor over a template to view the print layout in the Preview window.

Collections

Select the photos to print from the Collections pane.

● **Page Setup button**

Click to set the paper size and orientation for custom presets.

● **Print Settings button**

Click to set the specific printer model options to add to custom presets.

● **Print Module right panel**

The right panel contains all the options for customizing your print layout design.

Layout Engine pane

The Layout Engine pane lists the options for the main layout.

Image Settings pane

The Image Settings set the options for the photos in the layout.

Layout pane

You can set the page margins and cell size and spacing.

Guides pane

You can set the nonprinting rulers and guides and image dimensions.

Overlays pane

Add information to appear on the prints. You can: add and edit your identity plate; add page-specific information; and add photo-specific information such as a title or copyright.

Print Job pane

You can select the specifics of the print job, including the print resolution, amount of sharpening, and color management preferences.

● Print One button

Click to print just one set of prints to the selected printer.

● Print button

Click to set the specific printer options before printing.

● Print Module Filmstrip

The Filmstrip remains consistent throughout all the modules.

Using a Lightroom Template to Prepare One Photo to Print

Lightroom's Print Template Browser makes it easy to experiment with different page layouts. You can quickly see how your page will look with one or multiples of one photo using the different templates and one photo selected.

The Page Setup and Print settings you use will depend on your specific printer.

Using a Lightroom Template to Prepare One Photo to Print

① Click a collection in the Print module.

② Click a specific photo in the Filmstrip.

③ Click the **Page Setup** button to open the Page Setup dialog box.

④ Select the settings for your printer model, paper size, and page orientation.

⑤ Click **OK** to close the dialog box.

⑥ Click the **Print Settings** button to open the Print dialog box.

⑦ When the dialog box appears, set the paper selection, color management, and other settings on your printer; click **Save** to save the settings and close the dialog box.

⑧ Click the **Template Browser** ▶.

⑨ Click the **Lightroom Templates** ◀.

⑩ Click a different template, such as **2-Up Greeting Card**.

● The main viewing area changes to show the photo in the Greeting Card layout template.

⑪ Click the **Layout Engine** ◀.

⑫ Click **Contact Sheet/Grid** if it is not already selected.

⑬ Click the **Image Settings** ◀.

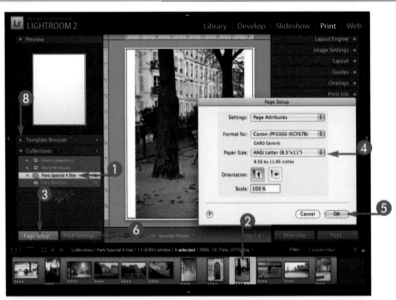

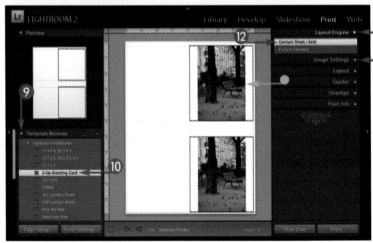

The Image Settings pane expands.

⑭ Click **Zoom to Fill** (▣ changes to ☑).

● The photos fill the frames of the greeting cards.

⑮ Click **Repeat One Photo per Page** if it is not already selected (▣ changes to ☑).

⑯ Click and drag in one photo to reposition the image.

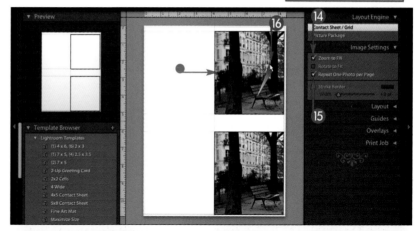

● Both photos are repositioned inside the greeting card template.

⑰ Click **Stroke Border** (▣ changes to ☑).

⑱ Click and drag the **Width** ◉ to adjust the border size.

⑲ Click **Print One**.

● Lightroom sends one print to the selected printer and displays a progress bar.

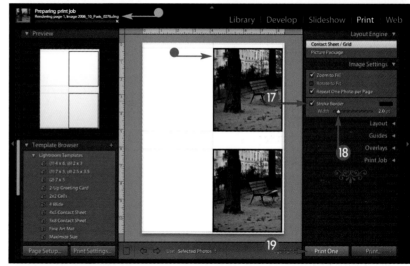

How do I change the stroke color?

Click in the color rectangle next to Stroke Border. Click anywhere in the color box that appears. To open more color options, click and drag in the color slider (●).

What is the difference between Print One and Print?

When you click **Print One**, Lightroom prepares the image, sends it to the selected printer, and the image is printed. When you click **Print**, the Print dialog box opens so you can select the specific printer and the settings you want to apply.

Print a Contact Sheet

Using the Contact Sheet/Grid layout engine, you can quickly print a contact sheet of a collection or a selection of images. You can select different contact sheet templates and adjust the settings and the information to be displayed on each photo.

When you first open the Print module, the Info Overlay appears at the top left corner of the page to be printed. Press [I] to turn off the Info Overlay which is on by default.

Print a Contact Sheet

① Click a collection in the Print module.

● The collection of photos appears in the Filmstrip, and the first photo appears in the main viewing area.

② Click the **Layout Engine** ◄.

③ Click **Contact Sheet/Grid**.

④ Click the **Template Browser** ►.

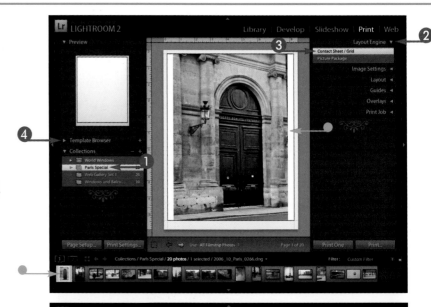

The Template Browser opens.

⑤ Click the **Lightroom Templates** ◄.

⑥ Click **4x5 Contact Sheet**.

⑦ Press [A] to select all the photos in the collection.

● The main viewing area displays a contact sheet of all the images in the collection.

⑧ Click the **Overlays** ◄.

The Overlays pane expands.

9 Click **Photo Info** (■ changes to ✓).

10 Click the **Photo Info** ⊟ and select **Sequence**.

● The image sequence numbers appear on the contact sheet.

11 Click the **Font Size** ⊟ and select a larger font size.

The sequence numbers print larger on the contact sheet.

 TIPS

Is there a quick way to add photos to a collection from the Print module?

You can easily return to the Library module to add photos to a collection by double-clicking the name of the collection in the Collections pane in the Print module. Click and drag the photos to be added to the collection from a folder or other collection. To return to the Print module, click **Print** in the module picker or click ⌘+**Option** +**4** (**Ctrl**+**Alt**+**4**).

Can I change the order in which the photos are printed in the contact sheet?

Yes. Click the white border of one photo in the Filmstrip to deselect the other photos. Click and drag any photo in the Filmstrip to a different position. Then press **A** to reselect all the photos, and the photos appear in the new order on the Contact Sheet.

Add Overlay Text or Graphics to Prints

As shown in the previous task, you can add information about the photos, such as image sequence number, a caption, or the camera equipment used, to a print layout. Using the Overlays pane in the right Print module, you can also add your identity plate or another graphic or text, such as a copyright watermark to prints.

ADD YOUR IDENTITY PLATE TO A PRINT

1 Repeat Steps **1** to **4** in the previous task.

2 Click **Fine Art Matte** in the Template Browser.

Note: You can select a different template.

3 Click the **Overlays** ◀.

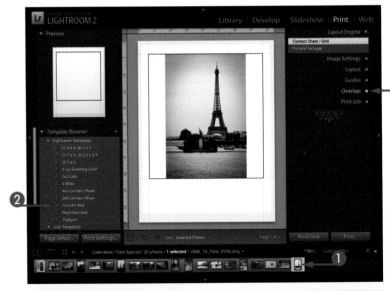

The Overlays pane expands.

Note: Optionally, press F7 *to close the left panel and expand the main viewing area.*

4 Click **Identity Plate** (■ changes to ✓).

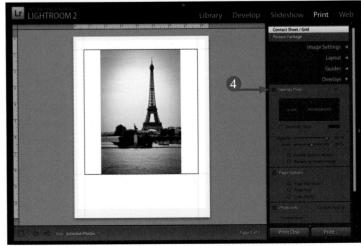

- The currently selected identity plate appears on the page.

⑤ Click and drag the Scale slider to adjust the size.

- You can also click and drag the selection handles to adjust the size.

⑥ Click the identity plate to drag it to a different position on the page.

⑦ Click **Override Color** (☐ changes to ☑).

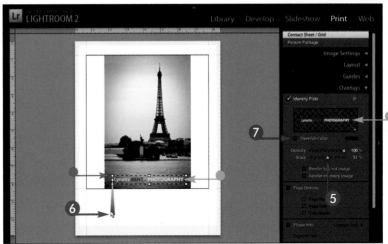

- The identity plate text now appears in black in the new position on the page.

⑧ Click in the color rectangle next to Override Color.

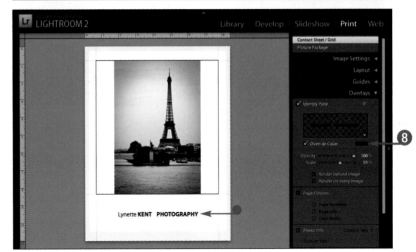

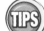

Can I add both an identity plate and photo information to the same print layout?

Yes, depending on the layout engine used. Contact sheets and grids can have both an identity plate and photo information, as well as page numbers, page information, and crop marks. Picture packages can have only an identity plate or a graphic identity design applied but can show the Cut Guides.

Can I resize a graphic identity plate to fill the area below my photo?

The graphical identity plate image is limited to 57 pixels high, so the graphic would be very pixilated if you stretch it to fit a printed page. You can, however, resize a regular or text-based identity plate.

You can use the same Overlay pane to apply a watermark on prints. You can add a copyright or the word *proof* as a watermark when you first print the photos and submit them to clients for approval. You can fade the watermark and even rotate it to fit across the page.

Add Overlay Text or Graphics to Prints *(continued)*

● The Override Color selector appears.

⑨ Click and drag the color slider to change the colors.

⑩ Click in the main color selector to change the text color.

⑪ Press `Return` (`Enter`) to apply the color.

ADD A WATERMARK AS AN OVERLAY

① Repeat Steps **1** to **4** above.

● The Fine Art Matte template displays the currently selected identity plate.

② Click in the Identity Plate box or click the ▾.

③ Click **Edit** in the menu that appears.

The Identity Plate Editor appears.

④ Click **Use a styled text identity plate** (⦿ changes to ○).

⑤ Click in the text box.

⑥ Press ⌘+`A` (`Ctrl`+`A`) to select all the text.

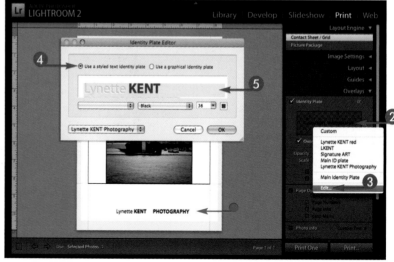

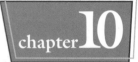

7 Type your text, such as **PROOF**, or your copyright.

8 Click the Identity Plate color box ().

9 Click a light gray in the color picker that appears.

10 Click the **Custom** ⬦.

11 Type a name for the custom identity plate.

12 Click **Save**.

13 Click **OK** In the Identity Plate Editor.

● PROOF or your copyright appears on the page.

● Click **Override Color** to deselect if it is still checked from the previous task (☑ changes to ▣).

14 Click and drag the text over the photo.

15 Click and drag the **Opacity** slider to lower the visibility.

● Click the **Rotate Identity Plate** (0°) and select a rotation amount.

Note: Optionally, you can also click and drag the **Scale** ◮ to change the size of the word Proof, or click **Render on every image** so the word proof appears on every photo.

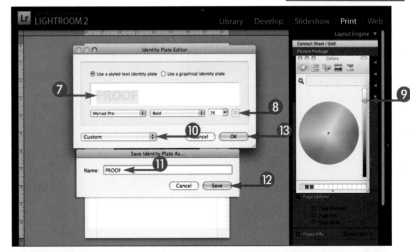

TIPS

How do I deselect all the photos in the Filmstrip, to select only one?

To select all the photos, you press ⌘+A. To deselect them all, press ⌘+D. To deselect them and select only one, click in the frame around the photo, not in the image, in the Filmstrip. The rest of the photos will be deselected, leaving only the one you clicked.

Will the black line I see around my photo in the main viewing area be visible in the print?

The outside black line is only a guide. Set your print layout and then uncheck all the options in the Guides pane to view the page as it will print. You can add a stroked border to the photo that will show in the print. Use the Image Settings pane, click **Stroke Border** (▣ changes to ☑), and select the stroke width and color.

Customize and Save an Existing Lightroom Print Template

Starting with one of Lightroom's print templates, you can easily customize the image as it appears in the layout to create a custom template. You can save your customized template so you can use it again with different images the next time you print.

Customize and Save an Existing Lightroom Print Template

① Click a collection in the Print module.

② Click the **Template Browser** ▶ to open the Template Browser pane.

③ Click a template such as **4 Wide**.

Note: You can select any of the templates and change them the same way.

④ Click **Zoom to Fill** under the Image Settings pane (□ changes to ☑).

⑤ ⌘+click (Ctrl+click) four portrait (vertical) photos in the Filmstrip.

● The photos appear in the template in the main viewing panel.

⑥ Click **Page Setup** in the left panel.

The Page Setup dialog box appears.

⑦ Click an Orientation icon, **Landscape** (▢) in this example.

⑧ Click **OK**.

Note: You can select specific settings for your printer and save them with the template by clicking the left panel **Print Settings** button.

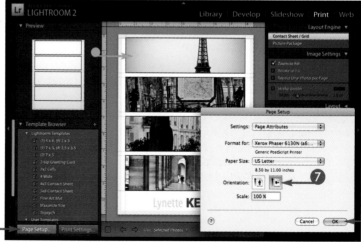

The page appears in landscape orientation.

Note: The 4 Wide template automatically fills the cells.

9 Click and drag in each cell to adjust the photo.

10 Click the **Image Settings** ◀ to expand the pane.

11 Click **Stroke Border** (■ changes to ✓).

12 Click and drag the **Width** slider to resize the stroke.

13 Press F7 to hide the left panel.

14 Click the **Layout** ◀.

The Layout pane expands.

15 Click and drag any of the margin sliders to change the margins.

Note: You can also click directly on the margin measurements and type a new margin setting.

16 Repeat Step **15** for the Cell Spacing and Cell Size options.

17 Option +click (Alt +click) the **Overlays** ◀ to open the Overlays pane and close the Layout pane.

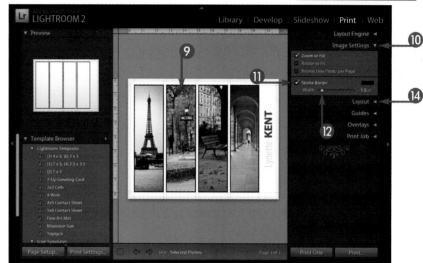

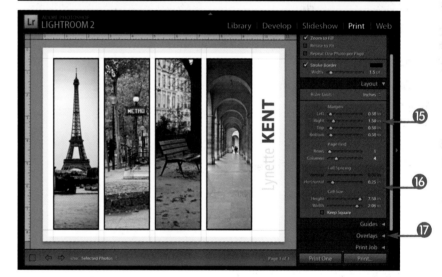

What happens if I change the Rows and Columns under Page Grid?

The results depend on whether you are using a portrait or landscape page orientation. Increasing the number of rows adds more image cells horizontally on the page. Increasing the number of columns adds more cells vertically to the page. You can then select more photos from the Filmstrip to use in the added cells.

Can I make the individual cells different sizes?

Not in the 4 wide template design. To create a template of different sized cells, you need to create a custom picture package as in the next pages of this task.

Customize and Save an Existing Lightroom Print Template *(continued)*

Not only can you set the parameters for the page of your custom layout, you can also specify the specific printer, paper type, and printer settings to use with this custom template. Once saved, you can quickly apply the template to any group of images in a selected collection.

Customize and Save an Existing Lightroom Print Template *(continued)*

Note: The identity plate is selected because it is part of the 4 Wide template.

● You can click in the Identity Plate pane and select a different identity plate or follow the steps in the previous task, "Add Overlay Text or Graphics to Prints," to change the text.

⑱ **Option**+click (**Alt**+click) the **Print Job** ◀ to open the Print Job pane and close the Overlays pane.

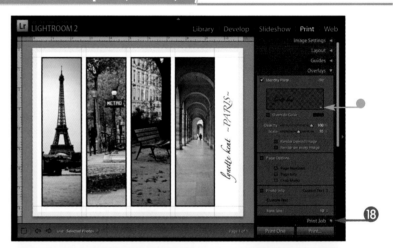

⑲ Click the **Print Sharpening** ▪.

⑳ Click the level of sharpening for your intended use.

㉑ Click the **Media Type** ▪.

㉒ Click the paper surface.

● You can click the Color Management **Profile** ▪, click **Other**, and select a paper profile from the list for your selected printer.

● You can click the **Rendering Intent** ▪ and select **Relative** or **Perceptual**.

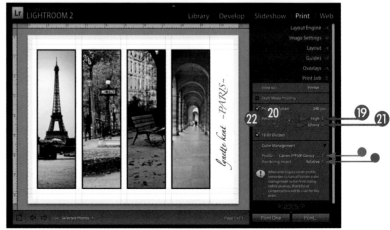

㉓ Click **Print**.

㉔ Click **New Template**.

The New Template dialog box appears.

㉕ Type a name in the dialog box.

㉖ Click **Create**.

㉗ Press F7 to make the left panel reappear.

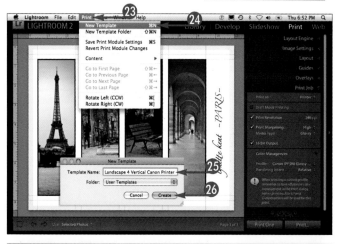

● Your custom template is listed under User Templates in the Print module left panel.

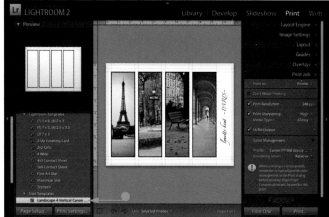

TIPS

What is the Print to arrow used for?

When you click the **Print to** ⬚, you can select **JPEG file** and set the File Resolution, Print Sharpening, File Dimensions, and Color Management options to save the template or output the complete page as a JPEG file.

Can I create a template with three perfectly square images?

Yes. In the Layout pane, set the Columns to 3 and click **Keep Square in the Cell Size** (⬚ changes to ☑). Adjust the margins, and then click and drag the **Cell Size Height** slider to adjust the size of the square cells.

The Picture Package option in the Print module includes layouts for multiple prints of the same photo on one page. You can easily select a template, make any modifications in the right panel, and select multiple images in the Filmstrip. Lightroom creates a complete page of each of the selected photos and sends them to the selected printer.

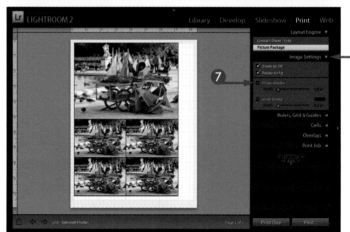

Prepare a Picture Package for Printing

① Click a collection in the Print module.

② Click the **Template Browser** ◄ to expand the Template Browser pane.

③ Click a template, **(1) 7 x 5, (4) 2.5 x 3.5** in this example.

④ Press F7 to hide the left panel.

⑤ Click a photo in the Filmstrip.

The photo fills all the cells in the main viewing area.

⑥ Click the **Image Settings** ◄ to expand the pane.

⑦ Click **Photo Border** (■ changes to ✔).

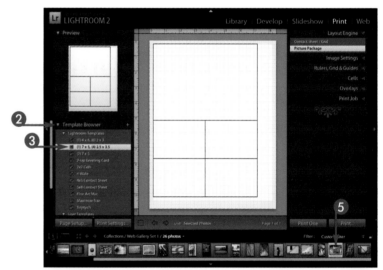

8 Click and drag the **Width** slider to increase the white photo border around each image.

● You can also click the number and type a specific size photo border.

9 Click **Inner Stroke** (■ changes to ✓).

10 Click and drag the **Width** slider to increase the stroke.

● You can click the number and type a specific size stroke.

11 Click the **Rulers, Grid & Guides** ◄ to expand the pane.

12 Click **Grid** to deselect it (✓ changes to ■).

● The grid is hidden so you can see the print and the cut lines.

 TIPS

Do I need to resize my images for printing?

No. You set the parameters of the page you want to print in the Layout pane and determine the print resolution in the Print Job pane. Lightroom automatically samples the image up or down to produce a print with the correct number of pixels for the dimensions you selected.

Will the grid print if I leave the box checked?

No. The markings on the page that are controlled with the Rulers, Grid & Guides pane are only for your reference and do not print.

Create a Custom Picture Package

You can start with a blank page to create a custom picture package layout, and save your design as a new template. You can include varied sizes of picture cells, and Lightroom lays them out to best fit the page. If additional pages are needed to fit the photo cells, Lightroom automatically increases the page count.

Create a Custom Picture Package

1 Click a collection in the Print module.

2 Click the **Layout Engine** ◄ to expand the pane.

3 Click **Picture Package**.

Note: *The last Picture Package template selected appears in the main viewing area.*

4 Click the **Cells** ◄ to expand the pane.

5 Click **Clear Layout**.

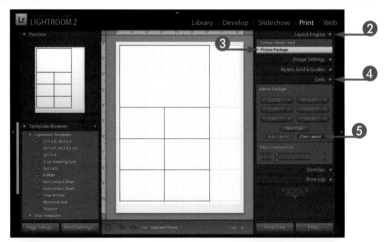

The main viewing area cells disappear.

6 Click any of the preset cell sizes.

The cells are automatically placed and rotated to fit the page.

7 Click and drag the cell handles to adjust the size.

● You can also click the Adjust Selected Cell Height and Width numbers to adjust them.

8 Option +click (Alt +click) and drag any cell to duplicate it.

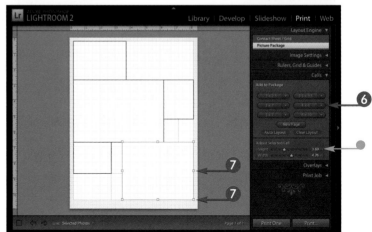

The layout adjusts to fit the number of cells and sizes.

9 Click a photo in the Filmstrip.

The photo fills each cell.

10 Click the warning symbol (⚠) to reveal any overlapping cells.

11 Click and drag the overlapping cells to reposition them.

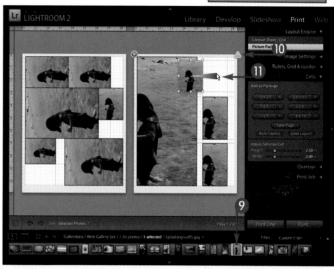

12 ⌘+click (Ctrl+click) and drag in the cells to reposition the photos within any cells with different aspect ratios.

Note: Optionally, repeat any of the steps in previous tasks to add photo border or strokes, or change margins and cell spacing.

13 Repeat Steps **23** to **26** of the "Customize and Save an Existing Lightroom Print Template" task to save and name the new picture package template.

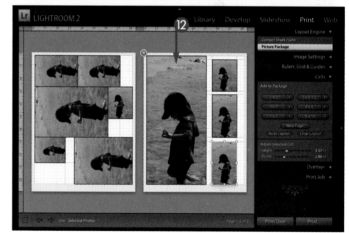

TIPS

How do I remove a page or a cell?

To remove a page, position the cursor over the page and (●) click the close button (⊗). To remove a cell, click the cell (●) and press Delete (Backspace).

Why does the page bleed area appear asymmetrical?

Each type of printer requires a different amount of bleed along the edges. Lightroom's Page Bleed displays the amount of bleed the selected printer requires and adjusts the margins accordingly so your image prints centered.

Understanding the Color Management Options

You select the printer model in the Print dialog box by clicking the Print Settings button. You then set the Color Management options in the Print Job pane to have the printer or Lightroom control the color.

Using Color Managed by Printer

Managed by Printer (●) is the default setting for the Color Management Profile. Using this setting with a newer printer model can produce reasonable prints, especially for draft mode printing or contact sheets. You must always set the Media Type in the Print Settings dialog box to match the paper used.

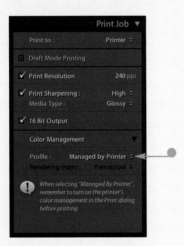

Using Lightroom to Manage the Print Color

For high-quality prints, having Lightroom manage the color can produce a more color-correct print. Click the **Profile** and select a profile (●) from the list that appears. These profiles include custom profiles you create using a ColorMunki or i1Photo spectrophotometer for your specific printer and paper type, any generic profiles that come with the printer driver, or any profiles you downloaded for specific papers you purchased from various paper companies.

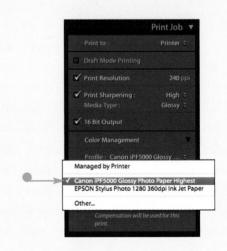

Settings for Printer Driver Color Control

When you select a specific profile and have Lightroom manage the color, you must turn off the printer's color controls by selecting **No Color Adjustment** (⦿) in the Color Management Controls.

When you let the printer manage the color, you must set the Color Management controls in the printer driver's Print dialog box to **ColorSync** (⦿) for Mac or **ICM Color Management** for PC.

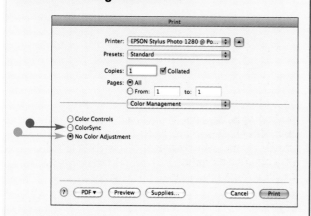

Rendering Intent

ProPhoto, Lightroom's working color space, has a wider color gamut, or range, than a printer can print. When you select a custom profile, you set the rendering intent (⦿) for printing those colors that are out of the printable range.

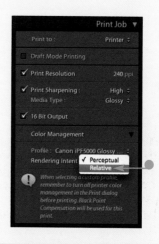

Perceptual Rendering Intent

Selecting **Perceptual** makes the printer shift out-of-gamut colors to printable colors, and in doing so, slightly shifts in-gamut colors to maintain the visual or perceptual relationships among all the colors in the image.

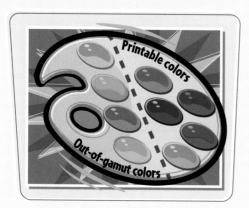

Relative Rendering Intent

Selecting **Relative** forces the printer to print the in-gamut colors as they are, and shifts only the out-of-gamut colors to the closest relative color it can print.

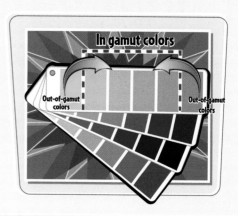

Creating Web Galleries with Your Photos

Lightroom makes it easy for you to design, build, and upload professional-looking photo galleries without knowing any Web page technology. You can use the Web gallery like an online lightbox to show images to a client for proofing, or share specific collections or even your entire portfolio on the Web.

Locating the Parts of the Web Module274

Using a Template to Create a Web Gallery ..278

Customize a Web Gallery Template280

Managing Your Custom Web Gallery Templates284

Export Your Web Gallery286

Upload Your Web Gallery to a Web Site288

Locating the Parts of the Web Module

Getting to know the parts of Lightroom's Web module and how the editing tools function makes creating a custom Web gallery very easy. As with the other Lightroom modules, all the tools you need are available in the main interface, without having to hunt through hidden menus. The center section displays your photo gallery as it will appear on your Web page and automatically updates the design as you make changes.

● **Web Module Main Gallery panel**

The Main Gallery displays the selected Web gallery template design including the selected photos, title options, and gallery navigation as it will appear on the Web site.

● **Web Module left panel**

● **Preview**

The Preview displays the selected Web gallery template style. Position the cursor over a template to view the preset Web gallery layout in the Preview window.

● **Template Browser**

The Template Browser lists all the preset Web gallery templates and any custom user templates you create and save.

● **Collections pane**

The Collections pane shows your photo collections from which you can easily build Web galleries.

● **Preview in Browser button**

You can preview your Web gallery creation in Web browsers such as Safari or Internet Explorer.

● **Scroll bar**

Click and drag to view expanded options panes.

Web Gallery toolbar

The toolbar includes the controls for navigating and selecting the photos to be used in the Web gallery. From the left:

Click here (▣) to go to first page of Web gallery.

Click to go to previous photo (◀).

Click to go to next photo (▶).

Click here (▣) to select photos to use for Web gallery.

● Name of Gallery style in use.

The Preview area at the top of the left panel displays a preview of the different templates in the Template Browser. You can look at your current Web gallery in the center section and see a different style of gallery design in the Preview pane. The side panels include preset templates as well as customization options. The Filmstrip and Filmstrip tools on the bottom of the screen are the same in all the modules.

● **Web Module right panel**

The right panel contains all the options for customizing your Web gallery design.

● **Engine pane**

You can select a style of Web gallery. You can also purchase or download other custom Web gallery styles.

● **Site Info pane**

You can enter the information to be displayed in the particular Web gallery design and select an Identity plate.

● **Color Palette pane**

You can use the color palette to change the text, background, and function colors to customize your Web gallery.

● **Appearance pane**

You can customize the look of the photo borders and pages specific to the selected Web gallery template.

● **Image Info pane**

You can add labels to the photos and customize them to suit your design.

● **Output Settings pane**

You can change the size of the display image, add any metadata and a copyright watermark to the display, and specify the sharpening to be applied.

● **Upload Settings pane**

You can enter the settings to upload the Web gallery directly to an FTP server from within Lightroom.

● **Export and Upload buttons**

You can click the Export button to export your designed Web gallery to save it on your hard drive.

You can click the Upload button to upload the Web gallery directly to your FTP server.

Using a Template to Create a Web Gallery

Lightroom's Web module includes a number of predesigned Web gallery styles you can use to quickly build a Web gallery page with any of the photos in your catalog. By grouping your images in a Collection in the Library module first, you can easily add or remove images from the Web gallery and rearrange their display order.

Using a Template to Create a Web Gallery

Note: *Create a collection of photos using the Library module first as shown in Chapter 3.*

① Click the **Web** module.

② Click the **Collections** ▶ to open the Collections pane.

③ Click a Collection.

● The photos in the collection appear in the Filmstrip.

④ Press the **Template Browser** ▶.

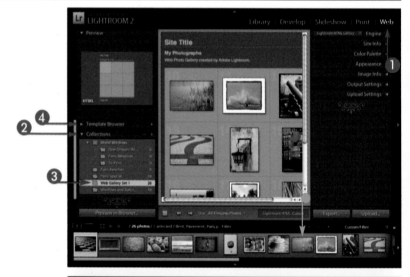

The Template Browser pane opens.

Note: *Press F6 to hide the Filmstrip if necessary to see both the Preview pane and the Template Browser pane or use the scroll bar to see all the included templates.*

⑤ Position the cursor over a template design in the list.

● The Preview pane displays a sample of the Web gallery design.

⑥ Click a template, such as **Midnight**.

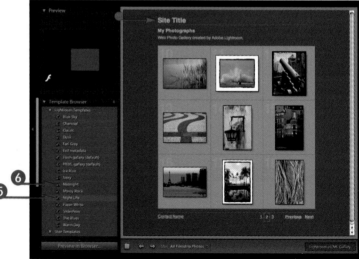

Note: The following steps show the options for an HTML Web gallery. Some options in the right panel will be different if you select a Flash Web gallery.

● The Main Gallery panel shows the collection as a styled Web gallery.

⑦ Click **Next** to view the next page layout.

The next set of images appears in the Web gallery design.

Note: Press F6 to show the Filmstrip if necessary.

⑧ Click and drag a photo in the Filmstrip to a different location.

● The display order in the Web gallery changes accordingly.

What are the advantages of creating a collection before designing my Web gallery?
By grouping your photos into a collection, you can make adjustments across all the photos, or add or remove photos from the Web gallery. In addition, you can rearrange the display order in the Filmstrip without returning to the Library module.

What is the difference between an HTML gallery and a Flash gallery?
HTML gallery pages are directly compatible with most browsers. Flash gallery pages require the viewer to have the Adobe Flash Player plug-in installed. However, a Flash gallery can be more interesting because it can include slide shows with transitions as well as animations and special effects. The type of gallery you have selected is shown by the logo in the Preview pane and listed in the toolbar below the main gallery panel.

Customize a Web Gallery Template

You can completely customize any basic Web gallery in Lightroom with a few simple clicks. Start by selecting a type of site, either Flash Gallery or HTML, and then selecting a template with a layout that appears close to your desired design. Use the right-panel tools to personalize the template for your Web gallery.

The example in this task shows the options for a Flash gallery. If you select an HTML gallery, some options in the right panel will be different.

Customize a Web Gallery Template

1. Follow the steps in the previous task to create a basic Web gallery.

2. Press F7 to close the left panel.

3. Press F twice to clear the top panel.

4. Click the **Site Info** ◀.

 The Site Info pane opens.

5. Click **Site Title**.

 The text appears highlighted.

6. Type a title for your custom site.

7. Press Enter.

● The new site title appears on the Gallery Preview.

8. Click **Collection Title**.

9. Type a new title for the Collection.

10. Repeat Steps 8 and 9 for each of the other Site Info fields.

Note: You can also click directly on any title in the Gallery Preview and type new information. Press Return (Enter) to apply it.

11. Click the **Color Palette** ◀.

The Color Palette pane opens.

⑫ Click the **Header Text** color box.

The Lightroom Color Picker appears.

⑬ Click and drag in the slider.

The color field changes.

⑭ Click in the color field to select a Header Text color.

● Optionally, you can type RGB values by clicking the number by R, G, or B, and typing a new value. Press Return (Enter) to apply the color.

⑮ Click 🞨 to close the Color Picker.

● The header text is shown in the new color.

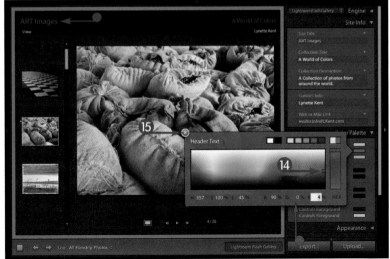

 TIPS

How is my e-mail shown on the final site?

The custom Web page displays either your e-mail address or a Web site address as an active link. Users can click your e-mail address on the Web page to automatically launch their default mail application and send you an e-mail, or they can click the Web site address to go directly to the site you list.

Why are there little triangles by each field?

Lightroom keeps a list of all the site field entries you have made. You can click these triangles (●) to open a menu and quickly select the text you applied to a previous Web gallery.

continued ⮕

The various site customization options, particularly in the Color Palette and the Appearance panes, are different for HTML and Flash Web Galleries. HTML Web Galleries include a grid of images and you can change borders, colors, and the number of images in the grid. Flash Galleries include scrolling, pagination, and slide show options. Other options appear the same for both styles.

Customize a Web Gallery Template *(continued)*

16 Click the **Appearance** ◄.

17 Click the **Layout** ▤.

18 Click **Scrolling**.

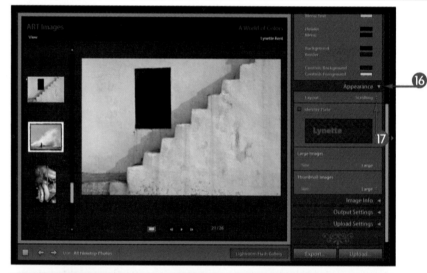

● The Gallery Preview layout changes.

19 Click **Identity Plate** (▣ changes to ☑).

20 Click in the identity plate to open a menu of existing identity plates.

21 Click a different identity plate from the menu.

● The new identity plate appears.

22 Click the **Large Images Size** ▤.

23 Click a different image size.

24 Repeat Steps **22** and **23** for the Thumbnail Images option.

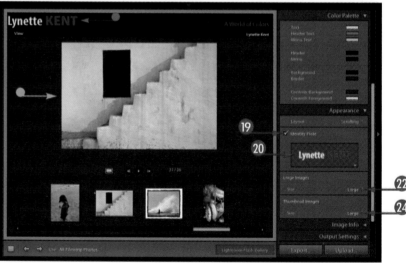

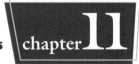

- The Gallery Preview changes accordingly.

㉕ Click the **Image Info** ◀.

㉖ Click **Title** (▣ changes to ☑).

㉗ Click the **Title** ⬍.

㉘ Click a different title to show such as **Filename**.

- The file name appears under the image in the Web gallery.

Note: Optionally, repeat Steps 26 to 28 for the Caption option.

㉙ Click the **Output Settings** ◀.

㉚ Click and drag the Quality slider.

㉛ Click **Add Copyright Watermark** (▣ changes to ☑).

- Your copyright appears on the large image.

㉜ Click **Sharpening** (▣ changes to ☑).

㉝ Click the **Sharpening** ⬍.

㉞ Click a different amount of output sharpening.

Your changes to the Web gallery page automatically appear in the main gallery panel.

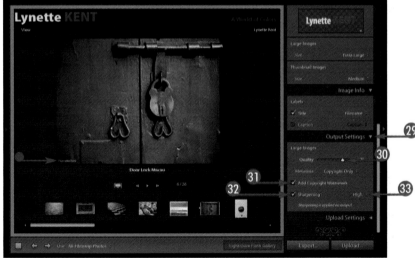

Why should I use anything less than 100 percent Quality in the Output Settings?

The higher the quality, the larger the file size and the slower your images load on the viewer's screen. You can experiment with your own browser to judge the best output settings.

Why does my copyright not appear on the image when I click Add Copyright Watermark?

Lightroom displays the copyright from the metadata of the image. You should create a copyright in the Metadata panel of the Library module as in Chapter 4.

Managing Your Custom Web Gallery Templates

You should always save your custom Web gallery template immediately after creating it so you can reuse it for a different collection of images, or use it as a base for a different custom design. If you click another preset before saving your custom design, your customized layout is no longer available. When you no longer use a custom Web gallery template you created, you can easily delete it from the list.

Managing Your Custom Web Gallery Templates

SAVE AND PREVIEW A CUSTOM WEB GALLERY TEMPLATE

1. With your custom Web gallery design open, click the **Template Browser** ▶.

 The Template Browser pane opens.

2. Click the plus sign (➕).

 The New Template dialog box appears.

3. Type a name for your custom Web gallery design.

4. Click **Create**.

 ● The User Templates pane opens and lists your custom design.

5. Click **Preview in Browser**.

 Your Web browser launches and displays a functioning version of your Web gallery.

6. Click any of the buttons or scroll bar to test the gallery.

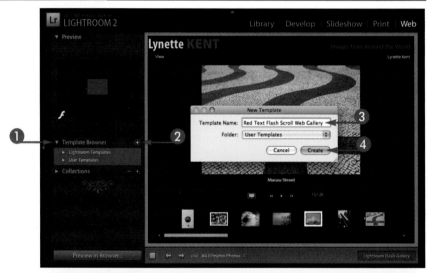

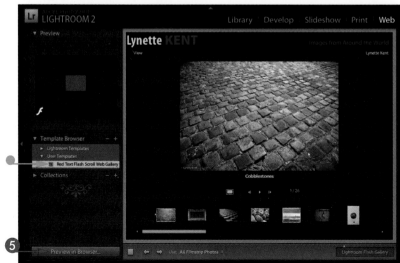

DELETE A CUSTOM WEB GALLERY TEMPLATE

1 Click the **Template Browser** ▶.

The Template Browser pane opens.

2 Click the **User Templates** ▶.

Your custom templates appear in a list.

3 Click the custom template you want to delete.

4 Click the minus sign (▬).

The custom template listing is removed.

The custom template design remains in the Main Gallery preview; however, it is no longer saved.

TIPS

Can I delete the existing Lightroom Web templates?

No. You cannot delete these templates, so you always have a base design available to customize. Starting from one of Lightroom's layout templates makes creating a custom Web gallery much easier.

Are there other predesigned Web Galleries available?

Yes. You can purchase and download custom Lightroom Web gallery designs from various vendors, such as SlideShowPro.net, and install the plug-in files according to their instructions.

Export Your Web Gallery

You can export any Web gallery you make and save a copy on your computer's hard drive. You can then view your Web gallery with clients or friends directly from the computer without an Internet connection. You can also burn the Web gallery files onto CD or DVD media for archiving and to share the Web gallery on another computer.

EXPORT YOUR WEB GALLERY

1. Click your custom Web gallery in the User Templates pane.

2. Click **Export**.

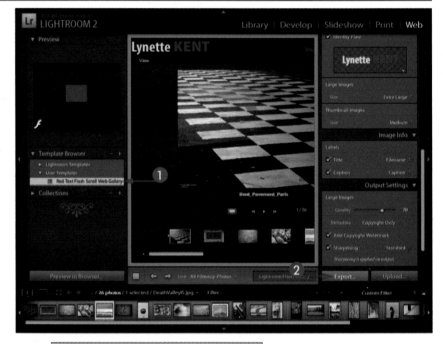

The Save Web Gallery dialog box appears.

3. Click in the Save As field and type a name for the Web gallery.

4. Navigate to and click a location to save the Gallery on a hard drive.

5. Click **Save**.

● Lightroom automatically creates a folder with the name of your Web gallery and creates the files necessary to open it in a Web browser.

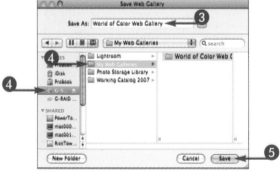

TEST YOUR EXPORTED WEB GALLERY IN A BROWSER

1 Navigate to the location where you saved the Web gallery.

2 Double-click the index.html file.

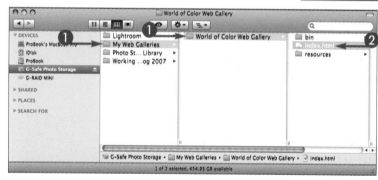

Your Web browser launches and displays your Web gallery and photos.

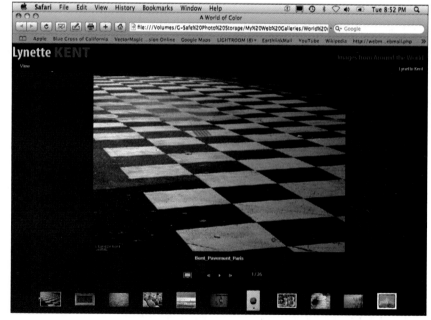

 TIPS

Should I change the color space of the photos I am using for a Web gallery to sRGB in Lightroom's Preferences dialog box?

No. Lightroom's Web module automatically converts the image previews to sRGB as it builds the Web gallery. sRGB is the correct color space for Web output, where most of your viewers will be looking at your images with uncalibrated monitors. Lightroom's default color space is ProPhoto RGB, which is best for editing RAW photo files.

What files should I burn to CD or DVD media for sharing with friends or clients?

You should select the entire Web gallery folder that was created by Lightroom. You can, however, make it easier for your viewers to launch the site by first selecting and making an alias (shortcut) of the index.html file in the

folder. Rename the alias *Begin* (●) or *Start Here*. Clicking this file launches the browser and Web gallery.

Upload Your Web Gallery to a Web Site

You can upload your exported Web gallery using various File Transfer Protocol (FTP) applications. However, you can upload the files directly from within the Web module and Lightroom uploads the files in the background so you can work on other images. Either way, you need specific information including the server URL, your User ID, and password.

Upload Your Web Gallery to a Web Site

1 Click the **Upload Settings** ◄.

The Upload Settings pane expands.

2 Click the **FTP Server** ▣.

3 Click **Edit**.

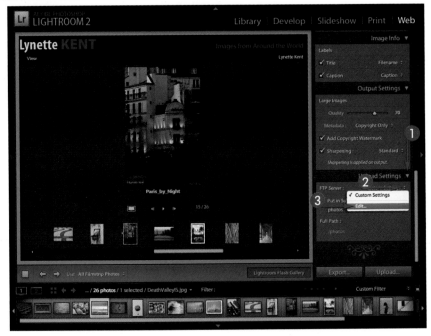

The Configure FTP File Transfer dialog box appears.

4 Type your server name in the Server field.

5 Type your username and password in the appropriate fields.

6 Type the name of the folder location where you will upload the Web gallery folder.

Note: Optionally, click **Browse** to find the correct server path.

7 Click the **Preset** ▣.

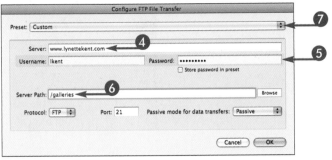

8 Click **Save Current Settings as New Preset**.

The New Preset dialog box appears.

9 Type a name for the new preset for your FTP server.

10 Click **Create**.

11 Click **OK** in the Configure FTP File Transfer dialog box.

● Your FTP server preset appears in the Upload Settings pane.

12 Click **Put in Subfolder** (changes to).

13 Type a name for this subfolder.

Note: The subfolder's name appears as part of the URL for your Web gallery so short, descriptive names can help with Web navigation.

14 Click **Upload**.

Lightroom automatically uploads the Web gallery to your Web site.

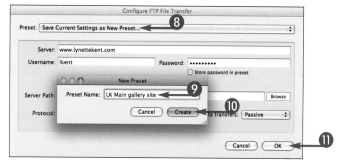

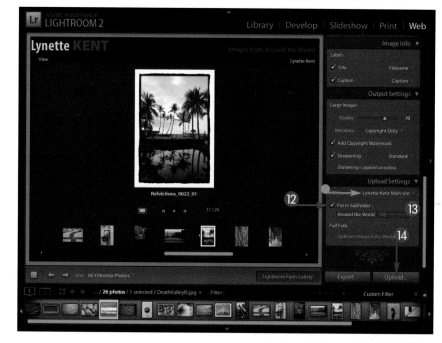

TIPS

Where can I find the information including the server name, my username, and the server path?

If your Internet account includes server space or if you pay a provider for site hosting, your Internet service provider will supply you with this information.

Should I click Store password in preset?

If you are the only person with access to the computer, you can store the password in the preset. Otherwise, anyone using your computer could upload altered items on your site without having to enter a password.

Using Photoshop or Elements with Lightroom

Adobe designed Lightroom as a tool for the digital photographer. Lightroom is not a replacement for Photoshop, the professional image-editing application, nor the consumer version, Photoshop Elements. Instead, Lightroom combined with Photoshop CS3 or even Elements creates a more complete solution for creating digital photographic images.

Understanding the Differences between Lightroom and Bridge292

Understanding the Differences between Lightroom and Photoshop or Elements 294

Set Lightroom's Preferences for the External Editors ...296

Take a Raw or DNG File from Lightroom to Photoshop and Back298

Take an Image from Lightroom to Photoshop or Elements and Back300

Go from Lightroom to Photoshop to Create a Panorama ...302

Understanding the Differences between Lightroom and Bridge

Adobe Lightroom and Adobe Bridge differ in the way they see and store data about images. Both are powerful image-viewing applications and both enable you to affect the files you see. You can use one or both depending on what you do with your files.

Bridge Connects Multiple Applications

Bridge helps photographers, fine artists, and all types of designers look through their files and use them with various applications. Bridge is the tool that connects all the applications in Adobe's Creative Suite.

Lightroom Guides Photographers

Lightroom is specifically geared to photographers to help them manage and process large numbers of images. Lightroom offers flexible file management and can be customized to fit the individual photographer's needs.

Bridge Is an Image Browser

Bridge is a very powerful image browser. By definition, an image browser enables you to see the digital photos on your main hard drive and any connected drives. In addition, Bridge also allows you to rename, convert file formats, and batch process your images.

Lightroom Functions as a Database

Lightroom can see farther than Bridge. Acting as a database, Lightroom lets you view, sort, organize, and apply settings to images on your connected drives as well as images stored on other currently disconnected drives.

Advantages of Lightroom

Lightroom is perfect for the traveling photographer. Once you import photos into a Lightroom catalog on your laptop, you can use the computer without the storage drives and still sort, organize, develop, and adjust your images. Because Lightroom is database driven, it accesses metadata more quickly, making searches faster. Lightroom also stores data for virtual copies, collections, and various template designs, making everything you do with your photos faster and easier.

Understanding the Differences between Lightroom and Photoshop or Elements

Photoshop has been the standard for image editing since it first appeared in early 1990. Elements was introduced as a consumer version of Photoshop in 2001. Lightroom offers a digital darkroom for all types of photographers, providing traditional photographic tools within a digital application.

Individual Photo Editors

Photoshop and Elements are pixel-level editors. You use them to work on one image at a time, adjusting the color, tone, and the pixels that make up the image. Both are also excellent for creating composites or blending of multiple photos into one creation.

Volume Photo Organization and Enhancement

With Lightroom, you can manage large numbers of photos at one time. You can easily apply the same edits such as white balance, tonal corrections, or black-and-white conversions, across a number of images, as well as add metadata such as copyright and keywords. Finally, Lightroom helps you show and share your images through slide shows, print, and the Web.

Permanent Pixel-Based Editing

Photoshop and Elements both change the pixels in the image. Once the image is saved, the changes are permanent. To create several versions of an image, such as a photo in original color, grayscale, and split tone, you must create three separate files.

Nondestructive Editing

Lightroom adds edits to the data, or the information describing the photo. Lightroom never changes the actual pixels in the image, and the original file can be viewed any time. You can create virtual copies to view any number of renditions of the same original without increasing the actual number of images or the storage requirements for the photo.

Lightroom Works with Photoshop or Elements

Lightroom enables you to seamlessly send any photo to Photoshop or Elements for editing, and then return the final image to the Lightroom catalog. Although Photoshop has many more options for enhancing photos than Elements, you can use either application to retouch individual photos, remove parts of images, and merge or combine images into one creation.

Set Lightroom's Preferences for the External Editors

You can specify the external photo-editing application you want to use with Lightroom in the preferences. Lightroom automatically recognizes the version of Photoshop on your system, and you can set both a first and a second image editor in the dialog box.

Set Lightroom's Preferences for the External Editors

SET THE MAIN EXTERNAL EDITING APPLICATION

1 Click **Lightroom** (click **Edit**).

2 Click **Preferences**.

The Preferences dialog box appears.

3 Click the **External Editing** tab.

Note: *If Photoshop is installed on your computer, it appears as the default external editor.*

4 Click any of the arrows () to change the default options.

5 Click to close and save the preferences.

SET THE SECONDARY EXTERNAL EDITING APPLICATION

1 Click **Choose**.

The Applications folder appears.

② Navigate to another image editor.

③ Click **Choose**.

● The second editor application appears as the Additional External Editor.

Note: You can select the same editor again with different options and save it as a special Preset. For example, you may want to edit strictly for e-mail or Internet viewing in sRGB color space and at a lower resolution.

④ Click any of the arrows (⬍) to change the options.

⑤ Click ⊙ to close and save the preferences.

TIPS

How do I determine which color space settings to select?

The settings depend on your external editor and what you will do with the edited photo. Adobe includes a descriptive paragraph with each selection in the dialog box to help you. The ProPhoto color space and 16 bit gives you the greatest color range and tonal details to work with in Photoshop.

Should I create a custom naming template for external editing?

Not necessarily. If you rename your photos on import or once they are in a catalog, you can leave this part of the dialog box blank. The file names remain the same as the original with "-Edit" added so you can more easily identify the edited image with the originals.

Take a Raw or DNG File from Lightroom to Photoshop and Back

You can take any Raw or DNG photo from Lightroom to Photoshop and continue editing. You can apply any changes to the photo such as filters or cloning. When you save the file, the edited photo automatically appears in the Lightroom grid next to the original.

Take a Raw or DNG File from Lightroom to Photoshop and Back

① Click a photo in either the Library or the Develop module.

② Click **Photo**.

③ Click **Edit In**.

④ Click **Edit in Adobe Photoshop CS3**.

Note: *Lightroom recognizes the latest version of Photoshop CS on your system.*

Photoshop launches and the photo appears in the active window.

Note: *The effect in this task is only an example. You can use any Photoshop tools, effects, or filters, as well as the Type tool.*

⑤ Click ⌘+Control+H (⎻) to hide Lightroom.

⑥ Click the **Type** tool (T).

⑦ Click a font, size, and color in the options bar.

⑧ Click in the photo and type the text.

Note: *Optionally, add any layer styles to the text.*

⑨ Click **File**.

⑩ Click **Save**.

⑪ Switch back to Lightroom.

On a Mac, click the Lightroom icon in the Dock to bring Lightroom back.

On a PC, click Lightroom in the taskbar.

● The edited file appears next to the original in the Library grid and the Filmstrip.

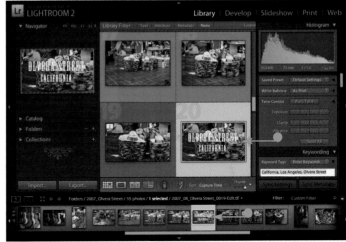

TIPS

Where is the file saved when I open the photo in Photoshop and save it after making changes?

When you edit a photo with Photoshop and save it, the changes are applied, a new file is created, and the photo is automatically imported into the Lightroom catalog. The new file is placed in the same location as the original on the storage drive.

Can I rename the edited file in Photoshop?

Yes, you can rename the file by clicking **Save As**. However, when you save the file with a new name, Lightroom does not automatically import it for you. You have to click **Import** and select the file to add this edited file to your catalog.

Take an Image from Lightroom to Photoshop or Elements and Back

You can take any image from Lightroom and go directly to Photoshop or Elements to edit or make a Photoshop Elements creation. If the file is a PSD, TIFF, or JPEG, you can edit the original file, edit a copy with no Lightroom adjustments, or edit a copy with the Lightroom adjustments visible.

Photoshop Elements Creations include easy steps for designing photo books, photo calendars, and photo collages.

Take an Image from Lightroom to Photoshop or Elements and Back

① Click a photo in either the Library or the Develop module.

② Click **Photo**.

③ Click **Edit In**.

④ Click **Edit in Adobe Photoshop Elements**.

The Edit Photo with Adobe Photoshop Elements dialog box appears.

Note: *In Photoshop, the Edit Photo in Photoshop CS3 (or the installed version of Photoshop CS) dialog box appears.*

⑤ Click **Edit a Copy with Lightroom Adjustments** (○ changes to ◉).

The Copy File Options are now available.

⑥ Make any changes to the file options depending on what you plan to do with the file.

Note: *Some filters, particularly in Elements, cannot be applied to 16-bit images.*

⑦ Click **Stack with original** (☐ changes to ☑).

Note: *Stack with original makes the externally edited copy appear in Lightroom's Filmstrip and Grid grouped with the original photo, making your catalog organized and the images easy to compare.*

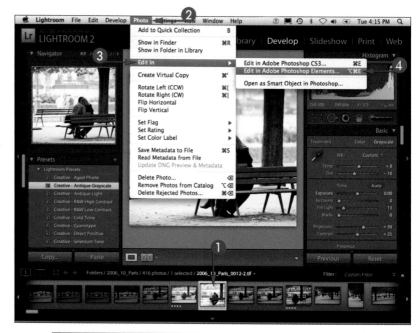

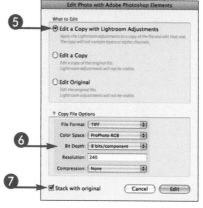

● Elements launches and the photo appears in the active window.

⑧ Click **Edit**.

⑨ Click **Effects**.

⑩ Double-click an effect, such as **Colored Pencil**.

Make any changes in the Colored Pencil dialog box that appears and click **OK** to apply it.

Note: *You can also click **Create** in Elements to make a creation or select any tools in Photoshop or Elements to apply them.*

⑪ Press ⌘+S (Ctrl+S) to save.

The edited copy is saved to the same location as the original.

⑫ Press ⌘+Control+H (➖) to hide Elements.

● The edited file appears next to the original in the Library grid and the Filmstrip.

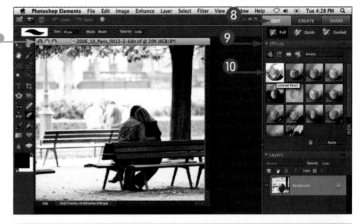

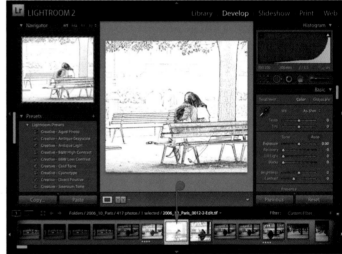

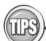

What happens is if I make a photo collage in Elements with the photo from Lightroom?

Unlike a photo, which you can edit in Elements and click **Save** to have the edited photo appear in Lightroom, you must click **Save As** for a photo collage or any other Elements creation and give the creation a new name. You must also import the creation into Lightroom to have Lightroom manage it in the catalog.

What are the differences between the What to Edit options in the Edit Photo dialog box?

Click **Edit a Copy with Lightroom Adjustments** to further edit a photo in Photoshop or Elements with the Lightroom adjustments visible in the external editor. Click **Edit a Copy** to create and edit a separate copy of the original file without any Lightroom adjustments applied. Click **Edit Original** to directly edit the original file in Photoshop or Elements, without any Lightroom adjustments applied and without adding a separate file to the Lightroom catalog and photo storage.

Go from Lightroom to Photoshop to Create a Panorama

You can easily create a panorama from multiple photos using Photoshop CS3. You can preview and select the images to use in Lightroom and then send them directly to Photoshop. The panorama is automatically saved back to the Lightroom catalog.

Shooting the individual photos in portrait orientation and using a tripod to level the horizon makes creating panoramas much easier.

Go from Lightroom to Photoshop to Create a Panorama

① Shift+click a series of photos in the Grid of the Library module.

② Click **Photo**.

③ Click **Edit in**.

④ Click **Merge to Panorama in Photoshop**.

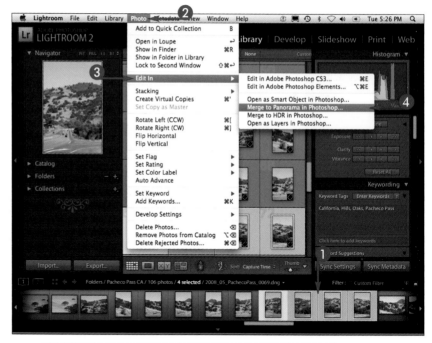

Photoshop launches and the Photomerge dialog box appears with the selected files listed.

⑤ Click **Auto** (○ changes to ◉).

Note: *Click any of the other layout options depending on your images.*

⑥ Click **OK**.

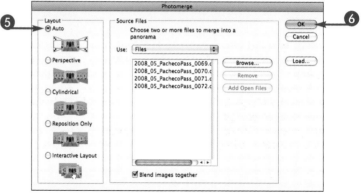

Photoshop merges the files, aligning and blending the layers.

Note: *Optionally, make any adjustments to the panorama using Photoshop tools.*

7 Click the **Crop** tool (⬚).

8 Click and drag in the image to eliminate blank edges.

9 Press **Return** (**Enter**) to apply the crop.

10 Press ⌘+**S** (**Ctrl**+**S**) to save the panorama file.

11 Press ⌘+**Control**+**H** (➖) to hide Photoshop.

● The panorama file appears next to the original files used in the merge in the Library Filmstrip.

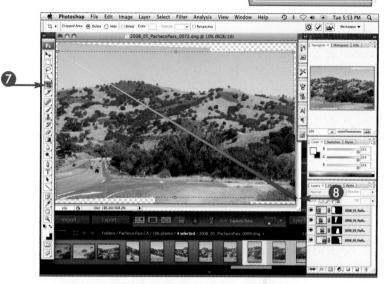

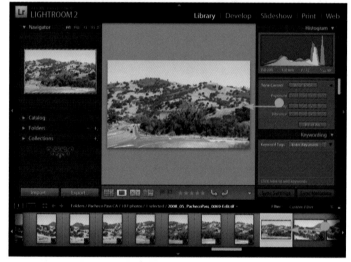

TIPS

Can I use Merge to HDR in Photoshop the same way to create a High Dynamic Range photo?

Yes. **Shift**+click to select a series of photos taken at different exposures. Then click **Photo**, click **Edit In**, and click **Merge to HDR in Photoshop** to automatically open the selected images in Photoshop with the Merge to HDR command activated. With Merge to HDR, you can create a separate image with a broader range of tones than the camera could capture in one photo.

What are Open as Smart Object in Photoshop and Open as Layers in Photoshop used for?

When you open a Lightroom file as a Smart Object, you can transform or add styles and still edit the Camera Raw settings, giving you more flexibility with your enhancements. Opening multiple photos as layers in photos enables you to use the Auto Align feature in Photoshop to easily create the best composite of a group of photos.

CHAPTER 13

Exporting Photos for Multiple Uses

Lightroom never actually changes the pixels in your photos. Instead, it writes a set of instructions in the data corresponding to the enhancements you make to the photo as it appears on your monitor. If you want to use the photo file with a different application or on another computer, you need to export the edited image and make sure the changes you made in Lightroom are still visible when you open the image with another photo editor.

**Understanding the Lightroom
Export Feature**..**306**

Explore the Export Dialog Box Settings......308

**Create an Export Preset to Attach
Photos to Your E-mail**..................................**310**

Lightroom's Export function is similar to the Save As function in other applications in that you select different options depending on what you intend to do with the exported photos. The Library module includes a general Export button; however, you can export from any module using keyboard shortcuts or the File menu. You can also use the Export buttons in the Slideshow and Web modules for specific export tasks.

You can export one image at a time, export a group of photos, or even export a complete catalog.

EXPORT FROM ANY MODULE

● **Export**

You can click **Export** from the File menu to open the Export dialog box, where you select settings, such as destination folder and file names, for the exported files. You can also press ⌘+Shift+E (Ctrl+Shift+E) to open the Export dialog box.

● **Export with Previous**

You can click **Export with Previous** from the File menu to export one or multiple images and bypass the Export dialog box. The photos are exported with the existing settings in the export dialog box. You can also press ⌘+Option+Shift+E (Ctrl+Alt+Shift+E) to export with previous settings.

● **Export with Preset**

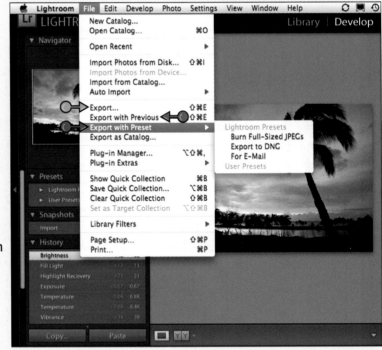

Clicking **Export with Preset** under the File menu also bypasses the Export dialog box and automatically exports the photos using specific settings, including Burn Full-Sized JPEGs, Export to DNG, or For E-Mail. You can also select any custom export presets, or Photoshop action droplets you placed into the Export Actions folder.

EXPORT FROM ANY MODULE (CONTINUED)

● Export as Catalog

Clicking **Export as Catalog** under the File menu exports the Lightroom catalog, complete with the previews and the original photo files, called *digital negatives*, to a new location. For example, you can export a catalog from a travel laptop after a trip and save it to an external drive. You can then import the travel catalog and synchronize it with the catalog on your main computer.

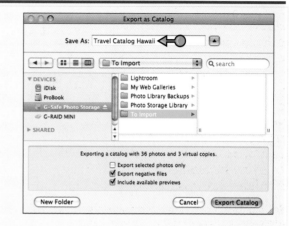

EXPORT USING THE MODULE-SPECIFIC EXPORT BUTTONS

● Use the Library Module Export Button

The Library module includes an export button in the left panel to export one or multiple selected photos. Click the **Export** button to open the Export dialog box.

● Use the Slideshow Export Buttons

The Slideshow module includes export buttons to save the slideshow as either individual JPEGs or as a complete PDF.

● Use the Web Module Export Button

The Web module includes an export button to save a completed Web Gallery in a new folder.

Explore the Export Dialog Box Settings

Lightroom's Export dialog box is the key to automating your photo projects. Because Lightroom does not save photos with your edits, you must export them to attach to e-mail or write to other media. You can set the Export dialog box options, and then all the files you select and export using Export with Previous are exported with those same settings.

Explore the Export Dialog Box Settings

Note: *The settings in this task are for exporting images to a folder of JPEGs sized to print on a consumer-level inkjet printer.*

1. With one or more files selected in the Filmstrip, click **File**.

2. Click **Export**.

The Export dialog box appears.

3. Click the **Export Location** ▶.

4. Click **Choose** and navigate to a location to save your exported files.

- You can click **Put in Subfolder** (☐ changes to ☑) and type a name in the text box.

5. Click the **File Naming** ▶.

6. Click the **Template** ▮ and click a template.

- If you select Custom Text, click in the Custom Text box and type a name for the files.

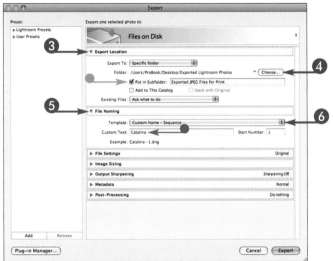

7 Click the **File Settings** ▶.

8 Click the **Format** and click **JPEG**.

9 Click the **Color Space** and click **AdobeRGB (1998)**.

● Optional: Click and drag the **Quality** slider.

10 Click the **Image Sizing** ▶.

11 Click **Resize to Fit** (☐ changes to ☑).

12 Type **10** in each box.

13 Click the and click **in.**

14 Click the **Output Sharpening** ▶.

15 Click the **Sharpen For** and click a paper type, such as **Matte Paper** or **Glossy Paper**.

16 Click the **Post-Processing** ▶.

17 Click the **After Export** and click **Show in Finder**.

18 Click **Export**.

Lightroom displays a progress bar in the upper left corner and opens the Finder (Windows Explorer) showing the folder with the exported image.

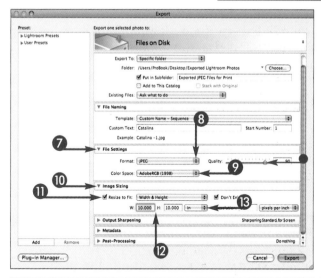

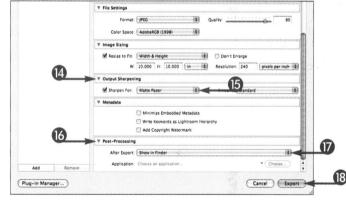

TIPS

Are there keyboard shortcuts to using the Export commands?

Yes, but only for the Export and Export with Previous commands. You can open the Export dialog box by pressing ⌘+Shift+E (Ctrl+Shift+E) with or without a photo selected. To use the Export with Previous command, ⌘+Shift+Option+E (Ctrl+Shift+Alt+E), you must first select one or more photos.

Why should I put 10 in both the width and height for 8 by 10 photos?

Lightroom sizes the photos according to their current aspect ratio. If you type **10** in both the width and height, a landscape (horizontal) photo is sized to 10 inches wide, and a portrait (vertical) photo is sized to 10 inches high for exporting. When you click **Don't Enlarge** (☐ changes to ☑) in the Image Sizing section, Lightroom also limits the size to the maximum pixel dimensions of the original file. It will not *interpolate* or make up pixels to increase the size of the exported photo.

Create an Export Preset to Attach Photos to Your E-mail

You can create a custom Export preset to automatically launch your particular e-mail application and attach selected photos, resized and saved as JPEGs with the optimum settings for e-mail attachments. You can create as many presets as you want for various exporting projects to make all your exporting tasks seamless.

Create an Export Preset to Attach Photos to Your E-mail

① In any module, click a photo in the Filmstrip to select it.

② Click **File**.

③ Click **Export**.

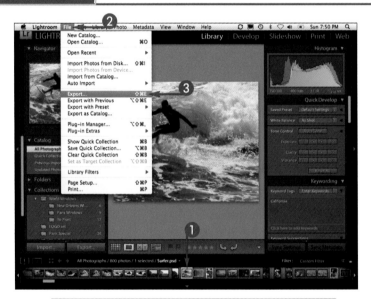

The Export dialog box appears.

④ Click the **Lightroom Presets** ▶.

⑤ Click **For E-Mail**.

The settings in the dialog box change to the optimum settings for attaching a photo to an e-mail.

Note: *You can change any of these settings to fit the type of file you want to send.*

⑥ Click and drag the scroll bar to view the Post-Processing settings.

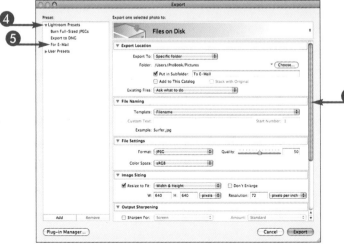

You can also start with one of Lightroom's export presets and modify the options to fit your projects. Be sure to click Add in the Export dialog box and save the customized preset with a new name so your individual settings are saved for future exports.

Create an Export Preset to Attach Photos to Your E-mail *(continued)*

⑩ Click **File**.

⑪ Click **New Finder Window**.

Note: *You can also* Control *+click the Mail application in the Dock, and select **Show in Finder**.*

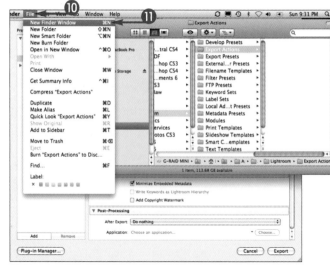

A second finder window appears.

⑫ Click **Applications**.

⑬ Click **Mail** or your Mail application.

⑭ Press ⌘+ Option and click and drag the Mail application icon into the Export Actions folder.

● An alias for your Mail application appears in the Export Actions folder.

⑮ Click 🔘 to close each Finder window.

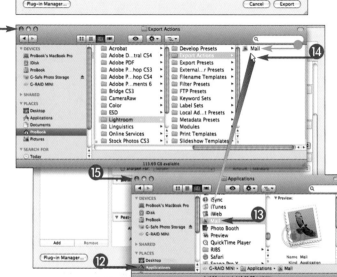

⑯ Click the **After Export** ▣.

⑰ Click **Mail** or your e-mail application.

⑱ Click **Add**.

● A New Preset dialog box appears.

⑲ Click in the Preset Name box and type a name for the preset.

⑳ Click **Create**.

● The new preset is listed and is saved as a user preset.

㉑ Click **Export**.

Your e-mail application launches and opens a new e-mail with the file as an attachment.

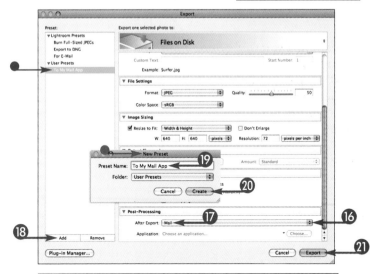

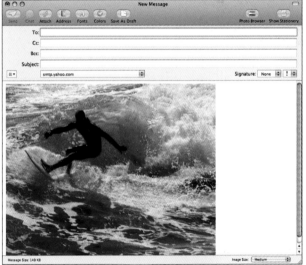

TIPS

Is the preset still saved if I click Cancel?

Yes. You can click **Cancel** instead of Export to return to the Lightroom interface. When you next click **File** and then **Export with Preset** in the menu, your custom e-mail preset (●) appears as a selection in the menu.

Lightroom Presets
Burn Full-Sized JPEGs
Export to DNG
For E-Mail
User Presets
To My Mail App ◀

Can Lightroom run a Photoshop action?

Yes, indirectly. In Photoshop you can create a *droplet* of an action by clicking the **File** menu, clicking **Automate** and then **Create Droplet**. Then in Lightroom, open the Preferences dialog box and click the **Presets** tab. Click **Show Lightroom Presets Folder** and locate the **Export Actions** folder. Click and drag the action droplet you created into the Export Actions folder. The next time you click **Export with Preset**, your action droplet appears in the menu.

CHAPTER 14

Best Practices for Memory Cards and Storage

From the moment you click the shutter through the final print or display, your photos reside on memory cards and computer hard drives. Understanding the different options and how best to use these devices to avoid potential problems is as important as knowing how to use your camera.

Understanding Memory Cards and Memory Card Readers316

Using Memory Cards Correctly318

Differentiating between Storage, Backups, and Archives320

Understanding External Hard Drives322

Defining Multidrive and RAID Systems324

Protecting Your Hard Drives325

Understanding Travel Essentials with a Digital Camera326

Using an Online Storage System328

Understanding Memory Cards and Memory Card Readers

Photographers spend a lot of time and money selecting and preparing the camera and lenses. Digital cameras capture the photo data and store it on a memory card. The quality of the card as well as its proper use are very important factors for the security of your photo files.

ABCs of Memory Cards

Each different digital camera uses a specific type of memory card, which can include Secure Digital (SD), CompactFlash (CF), x-D Picture Card (x-D), and Memory Stick (MS). Each type of card also comes in different speeds and size in megabytes or gigabytes of storage capacity.

Fake Memory Cards Warning

Relabeled and repackaged memory cards exist in the marketplace. Not only is the quality inferior, the cards may have a lower capacity than the labeled size, as well as an incorrect partition, increasing the likelihood of card corruption. Always purchase memory cards from known stores or reputable online vendors.
A good camera is useless without a good quality memory card.

UDMA Memory Cards

UDMA cards (Ultra Direct Memory Access) cards, such as the Hoodman RAW UDMA card or Delkin Pro UDMA card, can write and transfer data significantly more quickly than standard memory cards when paired with UDMA-enabled cameras or card readers. Although only newer cameras utilize the UDMA protocol, you can use a UDMA memory card in non-UDMA cameras.

Use Memory Card Readers and Adapters

Using a card reader to download your files from the card to the computer is more convenient and safer than connecting the camera directly to the computer with a cable. Downloading your photos using a card reader is not only faster, it frees the camera to continue shooting with a different card during the transfer of the photos, may reduce the wear and tear on the camera terminals, and saves the camera batteries for shooting.

Types of Memory Card Readers

A card reader connects to your computer either by USB or FireWire and enables the inserted memory card to appear as an external device on the computer. UDMA-enabled card readers significantly reduce transfer time with UDMA cards. You can purchase single memory card readers with one slot for a specific type of memory card, multicard readers that accept several different types of cards, and even multislot readers to download up to four memory cards at once.

Using Memory Cards Correctly

Memory cards themselves are fairly rugged; however, they are electronic devices and are susceptible to corruption. Purchasing brand name cards from reputable resellers is the first step in protecting your photo files. You can avoid most problems and data loss by following simple guidelines for using and connecting memory cards.

Memory Card Size Selection

The type of media card you use depends on your camera manufacturer. You can select the size of your memory cards by the largest RAW or Large JPEG file size your camera creates, such that you can shoot between 75 and 100 shots on one card. In general, having multiple smaller capacity cards rather than one larger card for each project or trip provides a measure of safety in case a memory card is defective or corrupted.

Format and Reformat the Card in the Camera

Each camera has its own system and file structure. Always format a new card in the specific camera you are using. To format a card, insert it and turn on the camera settings to Format. When asked if you want to erase all the data on the card, click *Yes* to format the card. And always reformat the card in your camera before each use. Do not delete the photos with the computer to clear the card.

Insert and Remove Cards Safely

Always turn off the camera before inserting or removing a memory card. Never remove a card from a card reader or disconnect the cable while transferring files. Never force a card into the reader or camera slot.

Shoot Sequentially without Checking Images on a Computer

It is generally best to avoid taking a partially filled card out of the camera to check the files on a computer and then reinserting the card in the camera to continue taking photos. Also, do not take a partially filled card out of one camera and put it into another camera. You risk losing your photos and corrupting the card.

Avoid Filling Up a Memory Card

It is generally safer to leave some space, about two shots, at the end of each card. Some memory cards may get corrupted if they are trying to write a last file and there is not enough space.

Never Delete Photos in Camera at the End of a Card

Although you can generally delete files in the camera as you shoot, you should never delete the last files when a card is almost filled to make room for more shots. A full or almost full card is more fragile and susceptible to data loss.

Differentiating between Storage, Backups, and Archives

The number of files you create with digital photography expands very quickly. Lightroom keeps the catalog organized; however, you need a method of storing all those photos. And because the images exist in an electronic environment, you also need a backup, as well as an archive of your finalized images. Understanding the differences between these terms, often used synonymously, helps you establish a strategy so your files are always available and safe.

Storage

Storage generally refers to permanent mass data storage, such as the computer's internal hard drive where you download and save files to keep them readily available. RAM memory is a form of internal data storage, however, it is volatile and forgets what it had stored when the computer shuts down.

Storage Drive

A storage drive includes any hard drive or other device that keeps your files available so you can access them anytime. Using a large external storage hard drive works well with Lightroom to hold a growing photo library that might not fit on your internal hard drive. External storage can also include optical media, flash drives, and network drives.

Backup

A *backup* is a cumulative and regularly updated duplicate of your current files, saved on a separate hard drive, network, or other device, and used to restore the original files in case of file corruption, loss, or drive failure. Backups often include multiple versions of edited files. When you create a backup, you do not remove the files from the original location.

Backup Software

Backup software automates the process of copying your files and photos from your storage drive to the backup device, and simplifies restoration of the files if your main storage fails. Intego's Backup for Mac and NTI Shadow 3 for PC and Mac work in the background and automatically duplicate your most important files or all your files at the intervals your specify.

Archive

An *archive* consists of the finalized photos comprising a photographer's body of work. You can archive your finished photos, financial files, or other documents that need to be saved for future printing or record keeping. You do not edit archived data and the information does not need to be accessed regularly. Archives are stored on external drives or DVDs, and should generally be kept in separate locations, for example in a safety deposit box and in an office or home safe.

Understanding External Hard Drives

Hard drives come in different physical sizes, different capacities, different connection types, and different configurations. They include single drives, photo-specific copying and photo-viewing devices, and various RAID (Redundant Array of Independent Disks) options. Understanding how to select and use these hardware devices with Lightroom and your photo files can make a big difference in the security and longevity of your images.

Hard Drive Options

External drives can be used for storage or archives, and are perfect for backups. The rotational speed, 5400 or 7200 RPM, describes how fast the data is read, written, and retrieved from the drive. Some options include single drives such as the G-Drive or G-Drive-Q, and RAID-type hardware systems such as the G-Safe (g-technology.com), and the Drobo system (www.drobo.com), which automatically place the data on multiple hard drives.

Cables and Connections

The most common hard drive connections are USB2, FireWire 400, and FireWire 800. Generally, USB is more available because of its lower cost, yet FireWire handles data transfers more efficiently and is better when you need to constantly access the drive. eSata connections are newer, and currently not as many computers include an external eSata port.

Travel Hard Drives

Although the small format external drives can be used anywhere, they are particularly useful when traveling with a laptop. Small drives can have large capacities and are bus powered, taking their power from the laptop and eliminating the need for an external power supply. Some such as the G-Drive mini include a protective carrying case.

Multipurpose Picture Viewer

A picture viewer is a portable, battery-operated hard drive with a built-in viewing screen. You can download photos from a memory card directly to a picture viewer without using a computer. Some picture viewers, such as the Picture Porter Elite (www.digitalfoci.com), also function as an MP3 player and a voice recorder, and can even connect to a television to both record videos from the TV or display a slide show of your images with a sound track.

Photo-Centric Travel Hard Drive

Other portable photo storage devices combine a memory card reader and a portable hard drive without a viewing screen, making them essential photographic travel tools with or without a computer. Devices such as the Photo Safe II from Digital Foci (www.digitalfoci.com) can act as a memory card reader to transfer files to and from the computer, as well as copy and store your photos from the memory card.

Defining Multidrive and RAID Systems

As your photo collection grows, so will your collection of storage and external drives. Multidrive systems or a RAID, Redundant Array of Independent Drives, offers more options for accessible storage, particularly for very large collections of photos and data. The different types of RAIDs are used for different purposes.

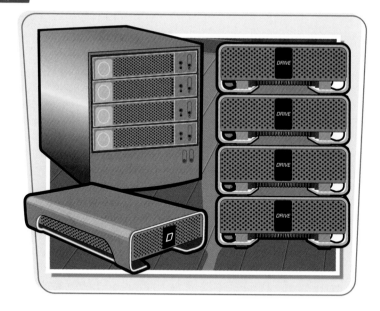

Striped and Mirrored Raid

A RAID is a grouped set of drives controlled by software or preferably hardware that appears as a single volume on your computer. Striped RAID (RAID 0) is used for faster reading and writing of data rather than data protection, as each drive copies parts of the data at the same time. Mirrored RAID (RAID 1) copies a mirror image of the first drive onto a second drive, creating a redundant system. If one drive fails, you can replace it and the RAID automatically rebuilds the new drive to mirror the existing drive.

Drobo-Managed Storage or Backup System

The Drobo from Data Robotics (www.drobo.com) is a special proprietary type of storage device using multiple drives in an automated and expandable system. You can replace a drive if it fails or add larger capacity hard drives as your storage needs grow, and the Drobo manages the data, moving files to the new drives. Rather than mirror images of one another, the Drobo unit efficiently maintains all the data across all the drives.

Protecting Your Hard Drives

You rely on these drives to store or restore your important files and photos. Hard drives, both internal and external, can eventually fail, which is why you must always have a backup. However, following a few guidelines, including not bumping or turning the drive upside down when it is running, can improve the reliability of your storage and backup system.

Heat and the Hard Drive

Hard drives get hot as they spin to access data. The type of enclosure is crucial to preserving your data and the reliability of the drive. A metal enclosure can dissipate heat better than a plastic one, and drives with metal enclosures plus a built-in heat sync or a fan, as in the G-Tech and Drobo units, remain cooler and generally work longer.

Keeping Power Consistent

Surges, spikes, and sudden loss of power can damage any hard drive. Always connect your computer and external drives to a UPS, an uninterruptible power supply, such as the Belkin UPS with AVR (www.belkin.com) for voltage regulation. To power a laptop or charge any unit when traveling, use a small surge suppressor to at least avoid the surges and spikes that pass through the electrical lines.

Understanding Travel Essentials with a Digital Camera

In addition to the camera, you should travel with multiple memory cards, spare camera batteries or the battery charger, and a mini surge suppressor. You should also have two separate forms of photo storage to make copies of your photos while traveling.

Traveling with a Laptop

If you travel with a laptop, you can download photos from memory cards to the laptop's hard drive. You should also carry a card reader to transfer the photos as well as some type of external travel hard drive to store duplicates. Make sure the travel drive is bus-powered, protected in a case, and that you carry the appropriate USB or FireWire cable.

Mini Travel Hard Drive

You can connect a card reader and a travel drive to the laptop and copy the contents of the memory cards to both the internal and external drive. If you import photos directly using Lightroom you can set the preferences to automatically back up the images to the external drive upon import. Lightroom then creates two sets of photo files, one on the internal drive and one on the external hard drive. See Chapter 2 for the steps to import and back up your photo files.

Multipurpose Travel Drive

Using a picture viewer such as the Picture Porter Elite, you can copy the photos from the memory cards and also copy them to the laptop, creating two separate copies of your photos. You can also preview the photos anytime on the viewer without starting up the laptop, and even view them on a television.

Photo-Storage Travel Hard Drive

You can travel with a drive such as the Photo Safe II and use it as both a card reader to copy the photos from the memory cards to the laptop's hard drive, and as an external drive for downloading and storing a duplicate set of images. Such a unit can be recharged with a power adapter or directly from the computer using the USB cable.

Traveling without a Laptop

In this electronic universe you need to have a backup, even when on the road. If you travel without a laptop, consider using a picture viewer and a second photo storage device, such as the Photo Safe II. Carrying two such multipurpose travel hard drives is more economical and practical than purchasing as many gigabytes of memory cards, and you will always have duplicate sets of photos.

Using an Online Storage System

Even if you regularly back up your photos, catalogs, and other files to separate hard drives, you can still lose files in case of corruption, a natural disaster, or theft. A fire could destroy your main files and your backups. Adding an online storage system to your backup strategy increases your level of security and can save you time after such a disaster.

What Is Online Storage?

Online storage from companies such as Mozy is a service that enables you to use the Internet to back up remotely to a server somewhere else, creating insurance for your valuable files. Using a high-speed Internet connection and the software from the service, you can back up and store your entire hard drive or just specific folders to the service's large online drives.

Monthly Fees

Although such a service used to be quite costly and complicated, some companies such as Mozy (www.mozy.com), for both Macs and PCs, and Fabrik (www.fabrik.com), for PCs, have established simple-to-use and unlimited online storage, for less than $5.00 a month, and even offer a free account limited to 2GB of storage, which is enough to back up many text and financial documents.

Backup Application

To use the online service, you first download and install a small company-specific application (). You then select the files and folders on your computer to back up, and set a time and interval for the backups. The initial backup can take a long time depending on the size of the files you selected. After that, the application works constantly in the background checking for files that are changed or added.

Security

Your files are encrypted during the back-up process and again while in storage. You use a secured password to access your data on the servers.

Restoring Your Files

After any loss, accidental deletion, or corruption, you can click to select the files to restore using the service's back-up application. You can also restore using the Web by logging in and selecting the files to be downloaded, and even opt to have the restore files mailed to you on DVD for a fee.

Index

A

ACR (Adobe Camera Raw), 230
Adobe RGB, *versus* ProPhoto RGB, 113
altering photos with presets, 146
ambient lighting, measuring, 139
applying metadata, 119
archives, 321
Attribute filters, 60
Auto Mask, localized adjustments, 217
Auto Tone, change, 152–153

B

background, fill color, 113
backups
 catalog, 7
 import and, 50–51
 location, 23
 overview, 321
 photo files, 7
 software, 321
black and white levels of monitor, 140
black and white photos, converting to from color, 210–211
black line surrounding photo to print, 261
Bridge, Lightroom comparison, 292–293

C

calibrating camera, 230–231
calibrating monitor
 definition, 135
 frequency, 140
 hardware-based, 136
 measuring device, 138–139
 need for, 134
 software only, 136
camera
 calibration, 230–231
 connecting via cable, 31
 traveling with, 326–327
 white balance, 151
Camera Calibration pane, 232–233
camera-induced vignetting, 227
Cast Shadow, slideshows, 243
catalog
 backups, 7
 creating, 44–45
 deleting, 19
 growth, 7
 locating, 16–17
 metadata, 119
 photo collection, 6
 practice, 14–15
 presets and, 111
 removing photos, 18–19, 104
 saving, location, 29
 settings, 114–115
Catalog section, Library module, 62
CDs, burning, 287
central content area, image viewing, 8
central viewing area, enlarging, 12–13
CF (CompactFlash) memory card, 316
chromatic aberration, 222–223
clarity, 200
Clarity tool, Tone Control pane, 154
clipped highlights, removing, 198
clipped shadows, lightening, 198
clipping in histogram, 145
Collection Sets, group collections in, 90–91
collections
 adding photos from Print module, 257
 adding to existing, 87
 creating, 86
 deleting photo, 105
 moving between Collection Sets, 91
 naming, 86
 photos in multiple, 87
 Quick Collections, 92–93
 removing photos from, 87
 Smart Collections, 88–89
 viewing multiple, 91
 Web module, 278–279
Collections section, Library module, 62
color
 adjusting individual, 208–209
 color pane sliders, 209
 converting to black and white, 210–211
 hue, 207–208
 luminance, 207–208
 reverting to from grayscale, 211
 saturation, 207–208
 stroke color, 255
color casts in photos, 151, 193
Color Management, 270–271
Color noise, 220
Color slider, digital noise, 221
color space settings, 297
color temperature for monitor, 139–140
colorimeter, 136–137
ColorMunki spectrophotometer, 137
Compact Cells, 72
Compare view, 64
contact proof sheets, identity plate, 129
contact sheets, 256–257

contrast
> Clarity tool, 154
> histogram, 145
copying edits between photos, 177
copying photos, virtual copies, 158–159
copyright symbol
> adding to Web page, 283
> exporting files and, 311
> metadata preset, 124–125
> typing, 123
Crop tool, 182–183
cropping photos
> crop ratio, 184–185
> for effect, 184–185
> presets and, 147
> recompose photos, 182–183
Custom filters, 60

D

data files, edits, 22
Develop module, 10–11
> adjustment tools, 162
> Basic section, 162
> Before/After views, 170–171
> Camera Calibration section, 163
> central viewing area, 162
> comparing images, 170–171
> Copy button, 162
> Detail section, 163
> Filmstrip, 163
> Filmstrip toolbar, 163
> histogram, 162, 178–179
> History section, 162
> HSL/Color/Grayscale section, 163
> interface changes, 164–165
> Navigator section, 162
> Paste button, 162
> presets, 168–169
> Presets section, 162
> Previous button, 163
> Reset button, 163
> rotating photos, 176
> sharpening in, 225
> shortcuts, 166–167
> Snapshots section, 162
> Split Toning section, 163
> Tone Curve section, 162
> toolbar, 162
> Vignettes section, 163
> white balance, 195
digital light table, viewing photos on, 5

digital noise, 220–221
DNG files
> advantages, 27
> changing to, 32–33
> moving between Lightroom and Photoshop, 298–299
> size, 33
downloading directly from camera, 31
Drobo storage/backup system, 324
DVDs, burning, 287
dynamic range of histogram, 144

E

e-mail
> photo attachments, 310–313
> Web pages, 281
editing photos
> copying edits between, 177
> data files, 22
> red eye removal, 188–189
> repairing, 186–187
> saving changes, location, 17
editors, external, 296–297
Elements
> Lightroom and, 5
> Lightroom comparison, 294–295
> moving images to/from Lightroom, 300–301
enlarging central viewing area, 12–13
EXIF metadata, 118, 121
Expanded Cell Extras, F-Stop, 73
Expanded Cells, 72
Export button, Library module, 62
exporting
> Export buttons and, 307
> from modules, 306–307
> photo attachments to e-mail, 310–313
> presets, 229
> slideshows to PDF, 249
> Web Gallery, 286
exposure
> arrows, 153
> Auto feature, 197
> modify basic, 196–197
> as overlay, 73
> values, 197
external editors, preferences, 296–297
external hard drives, 52–55, 322–323

F

F-Stop, Expanded Cell Extras, 73
Fabrik online storage, 328
fake memory cards, 316

Index

file formats, 26–27
file growth, 7
file names
 naming practices, 34–35
 naming template presets, 40–43
 setup, 25
 template resets, 38–39
Fill Light, shadow areas, 153
Filmstrip
 deselecting photos, 261
 hide/show, 13, 165
 Library module, 61
 multiple photos selected, 169
 thumbnails, 8
Filmstrip tools, Library module, 61
Filter menu, Library module, 61
filtering photos, 80–81
Flash gallery, HTML gallery comparison, 279
folders
 deleting, 83
 Pictures, 17
 setup, 25
 subfolders, 82–83
 synchronizing, 84–85
Folders section, Library module, 62
fonts, module buttons, 128–129
formatting memory card, 318

G

gamma setting for monitor, 139
Graduated Filter tool, 218–219
graphical identity plates, 130–131
grayscale
 changing, 148
 previewing, 207
 reverting images to color, 211
Grid view
 expanded grid cells, 73
 Library module, 60
 second window, 69
 sort photos, 81
Grid view button, Library module, 61
groups, renaming, 76–77

H

hard drives
 deleting photos, 104
 external, 7, 322–323
 heat and, 325
 multidrive systems, 324–325
 picture viewers, 323
 power, 325
 RAID, 324–325
 travel, 323, 326–327
hardware-based monitor calibration, 136–137
hide/show
 Filmstrip, 13
 Library module toolbar, 75
 menu bar, 164
 panels, 13
 picker bar, 164
 title bar, 164
 toolbar, 13, 165
hierarchical keyword lists, 101
High Dynamic Range, 303
highlights, clipped, 198
histogram
 clipped area, warning triangles, 179
 clipping, 145
 contrast, 145
 Develop module, 178–179
 dynamic range, 144
 sliders, 179
 tonal range, 145
Histogram, Library module, 62
History, 172–175
HSL tools, 206
HSL/Color/Grayscale tools, 206
HTML gallery, Flash gallery comparison, 279
Hue sliders, 206

I

Identity Plate, interface and, 8
Identity Plate Editor, 126–127
identity plates
 contact proof sheets, 129
 create, 126–127
 graphical, 130–131
 slides, 245
image stack, 102–103
importing
 automating process, 48–49
 backups and, 50–51
 downloading directly from camera, 31
 from existing catalog, 46–47
 keywords, 25
 metadata, 25
 move photos, 25
 photos, current location, 28–29
 photos, location, 17
 photos, from memory card, 30–31
 photos, selected, 15

presets, 169
RAW files and convert to DNG, 32–33
renaming, 36
renaming after, 37
renaming photos, 25
source images location, 24
Import button, Library module, 62
interface
 central viewing area, 8
 consistency, 9
 customizable, 9
 Filmstrip, 8
 left panel, 8
 main menu bar, 8
 platform independence, 9
 right panel, 8
 Toolbar, 8
 top panel, 8
IPTC metadata, 118
ISO, as overlay, 73

J

JPEG files
 description, 26
 printing, 265
 save as, 265
 white balance and, 193

K

keyboard shortcuts
 Develop module, 166–167
 exporting and, 309
 filter photos, 81
 tag photos, 81
 views, 117
Keyword List section, Library module, 62
Keywording section, Library module, 62
keywords
 adding to photos, 96–97
 custom keyword sets, 100–101
 hierarchical lists, 101
 Painter tool and, 98–99
 Smart Collections, 89
 suggested, 101
 thumbnails, 101

L

Library, items saved in, 22
Library module, 10–11
 Catalog section, 62
 Change thumbnail size, 60

Collections section, 62
enlarging central viewing area, 12–13
Export button, 62
Filmstrip, 61
Filmstrip tools, 61
Filter menu, 61
Folders section, 62
Grid view, 60
Grid view button, 61
Histogram, 62
Import button, 62
Keyword List section, 62
Keywording section, 62
Main button, 61
metadata and, 120–121
Metadata section, 63
navigation buttons, 61
Navigator section, 62
Painter tool, 60
Panel end marks, 63
photo locations, 61
Quick Develop section, 62
scroll bar, 60, 63
second window button, 61
Select sort parameters, 60
sharpening in, 225
Survey view, 65
Sync Metadata, 63
Sync settings, 63
toolbar, 60, 74–75
Top Filter bar, 60
View mode, 60
View Options, 72–73
views, 64–65
white balance, 195
Lightroom
 Bridge comparison, 292–293
 as database, 4, 293
 Elements comparison, 294–295
 moving DNG files to Photoshop and back, 298–299
 moving images to/from Photoshop or Elements, 300–301
 moving RAW files to Photoshop and back, 298–299
 open, 10–11
 as organizational tool, 5
 Photoshop actions, 313
 Photoshop and, 5
 Photoshop comparison, 294–295
 Photoshop Elements and, 5
 prompt when starting, 111
 as virtual darkroom, 4
localized adjustments, 216–217

Index

Loupe view, 64, 67
 lighting, 70
 selecting, 116
 Show Info Overlay, 73
 toolbar tools, 75
Luminance noise, 220
Luminance sliders, 206

M

Main button, Library module, 61
main menu bar, 8
measuring ambient lighting, 139
memory cards
 adapters, 317
 CF (CompactFlash), 316
 fake, 316
 filling up, 319
 formatting, 318
 full, 319
 import from, 30–31
 inserting, 319
 MS (Memory Stick), 316
 readers, 317
 removing, 319
 SD (Secure Digital), 316
 shooting sequentially, 319
 sizes, 318
 UDMA (Ultra Direct Memory Access), 317
 x-D (x-D Picture Card), 316
menu bar, hide/show, 164
metadata
 applying, 119
 benefits, 123
 catalog and, 119
 copyright symbol, 124–125
 EXIF, 118
 IPTC, 118
 Library module and, 120–121
 presets, 124–125
 saving with photo files, 119
 synchronizing between photos, 122–123
Metadata filters, 60
Metadata pane, 122
Metadata section, Library module, 63
mirrored RAID, 324
module buttons, modify, 128–129
Module Picker, tools and, 8
modules
 Develop, 10–11
 exporting from, 306–307
 Library module, 10–11

 Print, 11
 Slideshow, 11
 Web, 11
monitor
 black and white levels, 140
 calibration, 134–136
 color temperature, 139–140
 colorimeter, 136
 environment surrounding, 135
 gamma setting, 139
 profiling, 134–135
 quality, 134
 spectrophotometer, 136
 white point, 140
Mozy online storage, 328
MS (Memory Stick) memory card, 316
multidrive systems, 324–325

N

name collections, 86
name files, 34–35
navigation buttons, Library module, 61
Navigator section, Library module, 62
neutral color, selecting, 195
NTI Shadow, 7

O

online storage, 328–329
open Lightroom, 10–11
open, welcome screens, 11
output settings, Web module, 283

P

Painter tool
 keywords and, 98–99
 Library module, 60
Panel end marks, Library module, 63
panels, hide/show, 9, 13
panoramas, 302–303
password, Web Gallery and, 289
PDF files, exporting slideshows to, 249
personal identity plates, 126–127
photo collages, 301
photo collection, catalog and, 6
photo files
 backups, 7
 location, 23
photo locations, Library module, 61
photos
 copying edits between, 177
 deleting from hard drive, 104
 filtering, 80–81

group rename, 76–77
import selected photos, 15
keywords, 96–97
removing from catalog, 104
repairing, 186–187
saving metadata with, 119
sizing, 309
straightening images, 180–181
tagging for sorting, 78–79
viewing in grid, 73
Photoshop
 actions in Lightroom, 313
 Lightroom and, 5
 Lightroom comparison, 294–295
 moving DNG files to and from, 298–299
 moving images to/from Lightroom, 300–301
 moving RAW files to and from, 298–299
 Open as Layers, 303
 panoramas, 302–303
 renaming edited files, 299
Photoshop Lightroom. *See* Lightroom
picker bar, hide/show, 164
Picture folder
 catalog, 22
 photo files, 22
 previews, 22
picture packages
 bleed area, 269
 custom, 268–269
 printing, 266–267
 removing pages/cells, 269
Picture Porter Elite, as external drive, 52, 323
picture viewers, 323
Pictures folder, 17
playing slideshows, impromptu, 238–239
Plug-in Manager, 311
Point Curve arrow, tone curve, 205
practice catalog, 14–15
preferences
 external editors, 296–297
 Preferences dialog box, 110–111
 presets and, 108
 setting, 110–113
presentations, 5
presets
 altering photos with, 146
 cropping with, 147
 custom, 109, 228–229
 default, 109
 deleting from list, 169
 Develop module, 168–169
 Export, e-mail attachments and, 310–313

exporting, 229
importing, 169
installing, 109
metadata, 124–125
preferences and, 108
reasons for, 108
storing with catalog, 111
third-party, 109
white balance, 192
Print module, 11
 adding photos to collections, 257
 Collections pane, 252
 Filmstrip, 253
 Guides pane, 252
 Image Settings pane, 252
 Layout Engine pane, 252
 Layout pane, 252
 Overlays pane, 252
 Page Setup button, 252
 previewing, 252
 Print button, 253
 Print Job pane, 253
 Print One button, 253
 Print Settings button, 252
 sharpening in, 225
 Template Browser, 252
 toolbar, 252
Print One, 255
print templates, 262–265
printing
 adding identity plate, 258
 black line surrounding photo, 261
 contact sheets, 256–257
 JPEG files, 265
 options, 5
 overlay graphics and, 258–261
 overlay text and, 258–261
 picture packages, 266–267
 resizing images, 267
 templates and, 254–255
 watermark as overlay, 260
profile monitor, 134–135, 138–139
prompt when starting Lightroom, 111
ProPhoto RGB, *versus* Adobe RGB, 113
PSD files, 27
publishing Web Gallery, 288–289

Q

Quick Collections
 convert to permanent, 94–95
 create, 92–93
 remove photos, 95

Index

Quick Develop pane, 146, 156–157
Quick Develop section, Library module, 62

R

RAID (Redundant Array of Independent Drives), 324–325
RAW files
 advantages, 27
 converting to DNG, 32–33
 description, 26
 moving between Lightroom and Photoshop, 298–299
 size, 33
 white balance, 193
Recovery, highlights, 153
red eye removal, 188–189
remove photos, from catalog, 18–19
renaming
 after importing, 37
 groups of photos, 76–77
 imported photos, 25
 subfolders, 83
repair photos, 186–187
Reverse sort order, Library module, 60
right panel, 8
rotate photos in Develop module, 176

S

saturation
 adjusting, 201
 Vibrance and, 154
Saturation sliders, 206
scroll bar, Library module, 60, 63
SD (Secure Digital) memory card, 316
second window button, Library module, 61
second window viewing, 66–69
Select sort parameters, Library module, 60
shadows
 Cast Shadow, slideshows, 243
 clipped, 198
sharpening
 details and, 224
 Develop module, 225
 Library module, 225
 Print module, 225
side panels
 arranging, 71
 behaior, 65
Slideshow module
 Backdrop pane, 237
 Collections pane, 236
 export buttons, 236
 introduction, 11

 Layout pane, 236
 Options pane, 236
 Overlays pane, 236
 Play button, 237
 Playback pane, 237
 preview, 236
 Preview button, 237
 Slide Editor, 236
 Template Browser, 236
 Titles pane, 237
 toolbar, 236
slideshows
 Cast Shadow option, 243
 exporting to PDF, 249
 identity plate on slides, 245
 playing impromptu, 238–239
 previewing in full screen, 241
 Smart Collections, 241
 soundtracks, 245
 templates, 240–241
 templates, customizing, 242–245
 templates, saving custom, 248
 text overlays, 246–247
Smart Collections
 creating, 88–89
 keywords, 89
 slideshows, 241
Smart Object (Photoshop), 303
Snapshots, 173–175
software-only-based monitor calibration, 136
sorting photos
 Grid view, 81
 tagging, 78–79
soundtrack to slideshows, 245
spectrophotometer, 136–137
Split Toning pane, 212–213
Spot Removal tool, 186–187
storage
 growth, 7
 online, 328–329
 overview, 320
storage drives, 83, 320
straighten images, 180–181
striped RAID, 324
subfolders, 82–83
Survey view, 65
Sync Metadata, Library module, 63
Sync settings, Library module, 63
synchronizing
 folders, 84–85
 metadata between photos, 122–123

T

tagging photos for sorting, 78–79
Targeted Adjustment tool
 hue, 208
 luminance, 208
 resetting sliders, 207
 saturation, 208
 tone curve, 204
 toolbar, 211
temperature, white balance, 194–195
templates
 creating, Web Gallery, 278–279
 custom, Web Gallery, 280–283
 deleting, 285
 external editors and, 297
 printing and, 254–255
 saving, Web Gallery, 284–285
 slideshows, 240–241
 slideshows, custom, 242–245
 slideshows, saving custom, 248
Text filters, 60
text overlays, slideshows, 246–247
third-party presets, 109
thumbnails, keywords, 101
TIFF files, 26
tint, white balance, 194–195
tinting photos, 212–213
title bar, hide/show, 164
tonal adjustments tools, 198–199
tonal range of histogram, 145
Tone Control pane, 154–155
tone curve
 adjusting directly, 202
 effects, viewing, 205
 ghosted region when moving point, 203
 resetting adjustments, 203
 sliders, 203
 Targeted Adjustment tool, 204
Tone sliders, 199
toning images, 212–213
toolbars
 hide/show, 13, 165
 Library module, 60, 74–75
 modules, 8
 Print module, 252
 Slideshow module, 236
 Web Gallery, 275
Top Filter bar, Library module, 60
top panel, 8
travel catalog, main library and, 56–57
travel hard drives, 323, 326–327
triangles on screen, 281

U

UDMA (Ultra Direct Memory Access) memory cards, 317
uploading, Web Gallery, 288–289

V

vibrance, 201
Vibrance, Tone Control pane, 154
View mode, Library module, 60
View Options, Library module, 72–73
views, 116–117
vignettes, 226–227
virtual copies, compare edits, 158–159
virtual darkroom, Lightroom as, 4

W

watermarks
 adding to Web page, 283
 description, 260
 exporting files and, 311
Web Gallery
 exporting, 286
 introduction, 5
 password, 289
 template creation, 280–283
 templates, 278–279
 templates, deleting, 285
 templates, previewing, 284
 templates, saving, 284–285
 testing in browser, 287
 toolbar, 275
 uploading, 288–289
Web module, 11
 Appearance pane, 276
 collections, 278–279
 Collections pane, 274, 278–279
 Color Palette pane, 276
 Engine pane, 276
 Export button, 277
 Image Info pane, 276
 Main Gallery, 274
 Output Settings pane, 276, 283
 Preview, 274
 Preview in Browser button, 274
 scroll bar, 274
 Site Info pane, 276
 Template Browser, 274, 278–279
 Upload button, 277
 Upload Settings pane, 277
Web pages, e-mail, 281
welcome screen, 11

Index

white balance
 adjust, 192–195
 camera, 151
 change, 149
 color casts and, 193
 Develop module, 195
 JPEG files, 193
 Library module, 195
 presets and, 192
 RAW files, 193
 selector, 193
 setting changes, 150–151
 temperature, 194–195
 tint, 194–195
white point for monitor, 140

X–Y–Z

x-D (x-D Picture Card) memory card, 316
XMP files, 27

Maria

Merriam A. Bass

Eugenia Price
June 22, 1916–May 28, 1996

First Novel in the Florida Trilogy

Maria

Eugenia Price

EUGENIA PRICE COMMEMORATIVE EDITION

Printed in the United States of America

13 12 11 10 09 08 07 5 6 7 8 9 10 11

Library of Congress Cataloging-in-Publication Data

Price, Eugenia.
 Maria / Eugenia Price.—Eugenia Price commemorative ed.
 p. cm.—(First novel in the Florida trilogy)
 ISBN 1-57736-152-0 (alk. paper)
 1. Evans, Maria, 1729 or 30–1792 Fiction. 2. Saint Augustine (Fla.)—
History—Revolution, 1775–1783 Fiction. 3. Florida—History—English
colony, 1763–1784 Fiction. 4. Florida—History—Spanish colony,
1784–1821 Fiction. 5. Women—Florida Fiction. I. Title II. Series: Price,
Eugenia. Florida trilogy ; 1st novel.

PS3566.R47 M34 1999
813' .54—dc21 99-23553
 CIP

Cover design: Gary Bozeman

Cover art: Background map of northeast Florida, circa 1764, compli-
ments of the St. Augustine Historical Society; cameo inset from the first
edition dust jacket, copyright 1977, Eugenia Price (J. B. Lippincott
Company, Philadelphia & New York)

Turner Publishing Company

200 4th Avenue North • Suite 950
Nashville, Tennessee 37219

445 Park Avenue • 9th Floor
New York, NY 10022
www.turnerpublishing.com

For Nancy Goshorn

Aileen Rains

Mar 2013

Publisher's Foreword

Eugenia Price first discovered St. Simons Island, Georgia, in 1961 while on a book tour with her longtime friend and fellow author Joyce Blackburn. There she became aware of the nineteenth-century dramatic saga of an Episcopal minister, Anson Dodge, and the tragic death of his beloved Ellen on their wedding trip. His passion for his bride, which inspired him to erect the beautiful Christ Church, Frederica, in 1884 as a memorial, was so moving that Price wrote her first novel based on that story.

For Price, historical fiction was a genre that enabled her to write the lives of those long-deceased St. Simons residents into history and to see her titles make the *New York Times* bestseller lists repeatedly.

Fourteen major novels were published with Georgia and Florida history serving as the backdrop. The faith that Price naturally wrote into the lives of her characters made the books popular with the established readers of her nonfiction and inspirational works.

In total, forty titles were published resulting in a combined fifty million copies in eighteen languages. Countless trade hardcover, softcover, large print, mass market, book club, audio tape, and other forms of the books were released.

The Eugenia Price Commemorative Edition from Turner Publishing is part of an ongoing program to release new editions of her works. This title, *Maria,* introduces the reader to the celebrated Florida Trilogy which is based on the lives of historical characters in

northeast Florida and the St. Augustine area. Also being published at this time is *Lighthouse*, the first volume in the classic *St. Simons Trilogy* which ends with her first novel, *The Beloved Invader*.

The resiliency of Price's writings, her faith-filled characters, and the timelessness of these historical themes await a host of new readers. It is our hope that many of her loyal followers will introduce others to Eugenia Price through these new editions.

Part One

1

In spite of the heat, pride of appearance forced Maria to wear her husband's military watch cape. The sun in St. Augustine was unremitting. Even the breeze, nearly a wind, sent gusts of heavy heat over her strong, slender body, whipping the folds of the cape as she walked. She could taste the salt air and smell the fishy water of Matanzas Bay.

All but two of the six petticoats she was allowed to pack in Charles Town more than a year ago had long since been worn out or torn for bandages in Havana during the weeks of fighting against the Spaniards. Maria Evans Fenwick, along with her best friend, Ann Cameron, and the four other Charles Town women permitted to go to war with their British husbands, had shredded their own clothing to dress the wounds of the soldiers they nursed.

The remaining outer petticoat which she wore now, faded blue and frayed, was ripped all the way up one side—caught on a nail while she was boarding the convoy ship, *Renown,* the day they sailed from Havana some two weeks ago. Sailing also on the *Renown* to the strange Florida land were her sick husband, Sergeant David Fenwick, and the other soldiers still too ill from fever or dysentery to care for themselves. The healthy members of four companies of David's British Royal First Regiment of Foot—the Royals—were so pathetically few in number that they could all be transported to St. Augustine in the two small schooners which followed the *Renown.* Well over half, more from fever than from battle wounds, had died. The mood aboard all

three ships had been glum. Britain had won the battle for Havana, but there had been little heart or time to revel in the victory. Only a few, Maria and David among them, had found places to settle in Cuba. Then, early in July of this year, 1763, abrupt orders came for all British soldiers of occupation to abandon Havana and occupy St. Augustine, long the seat of Spanish power in Florida. The reaction was one of shock, disbelief, and resentment. In Paris, far from the scene of battle, an agreement had been made between Spain and England, and the exhausted, dispirited troops were uprooted and shipped out.

As the *Renown* had reached the dangerous St. Augustine bar yesterday, not one needle or piece of thread could be found among the six women aboard. Maria's outer petticoat was unmended, and her last bodice was rust-stained and washed so thin that it no longer gave proper support to her full, high breasts. She wore her only shift today, too, because during the long hours of last night, in an attempt to keep cool packs on David's head in the oppressive heat of the old Spanish fort where they were billeted, she had torn up her one extra shift. So, to hide her shabby clothing, she wore his watch cape today. It became her, she knew, and Maria Evans Fenwick had no intention of showing herself a ragamuffin on her first day in St. Augustine.

On the April morning well over two months ago, when Captain John Hedges had informed the troops in Havana that Cuba, for which the British had fought so hard, was to be traded back to Spain in exchange for Florida, Maria had suspected that David would be sent there with the occupation forces, in spite of his lingering weakness from fever contracted just before the British victory. Too many had died in Cuba for a man obviously recuperating to be discharged.

To most women, her mission today would be unnerving; a lone British woman hunting a house in a crumbling, foreign town filled with Spanish residents in turmoil because the King of Spain had sacrificed their long-inhabited province in order to regain Cuba. There was no reason to expect favors or kindness from these perplexed, troubled people; still, Maria was not unnerved. She was tired but, by sheer will, she had taken hold of today, and hope was not so hard to come by as it had been on the voyage over. The reason? David, who had filled her horizon since her first sight of him two years ago, seemed a bit more

like his old, cheerful self this morning, after a fair night's rest on the wooden sleeping shelf at the fort, where he lay beside the other ill men housed in the makeshift infirmary. Oh, he was thin—thin and pale—and needed the healing rays of the sun to restore color to his cheeks, the strength to his arms, and the laughter to his eyes, but he could walk now, and early this morning she had helped him out onto the fort's ramparts, where their Charles Town friend, Private James Cameron, had promised to see to him.

Captain John Hedges, in command of the four companies of British soldiers just landed in St. Augustine, had warned Maria that a good vacant property would be hard to find. There were only about three hundred houses, and the Spanish still had eighteen months in which to evacuate the city, according to the terms of the Treaty of Paris; but Captain Hedges had freely given permission to move David from the fort, if she could locate quarters. Hedges even took time to go over a sketchy map with her so that she would have some idea at least where she walked. It would be impossible to get lost, he assured her, since there were only four main north and south streets, bisected by lanes that led to and from the shores of Matanzas Bay on the east. The incredibly small, foreign-feeling town was less than a mile long and only a quarter of a mile wide.

Maria read anger, bewilderment, and downright terror in the faces of the people who hurried past her. She and David would have to learn to live among these fear-ridden Catholics until the heartless Spanish monarch found a place for his subjects. The thought filled her with both pity and dread. George III, their own benevolent young monarch, would never treat Englishmen in such a heartless manner.

She paused, leaned against a crumbling garden wall, and emptied sand from her slippers. So far, she had passed only two houses which appeared vacant. Both near the Plaza at the heart of town, but both too large for the Fenwicks' means. The heat was nauseating. She longed for shade, a moment of rest, but she kept walking toward the less barren south end of town, where Ann Cameron, James' wife and Maria's best friend, had said she might find a place more suited to her needs. How Ann knew this, Maria could not imagine, but Ann thrived on relaying news, true or false,

and Maria, usually not interested in either gossip or hearsay, needed anything Ann could tell her just now. Her obsession with getting David out of the wretched fort before another night fell would keep her searching, and by now, the location mattered less and less. Yesterday, within an hour after the elaborate state ceremonies held on their arrival, the British command had changed the name of the massive, flaking, dirty-white fort from Castillo de San Marcos to Fort St. Mark, but nothing could change or cleanse the stinking, foul air of the stone-walled infirmary where she and David spent last night.

Her husband's regiment had been shipped out from the South Carolina colony so soon after their wedding that Maria had wondered if she would ever be alone with him again. After all, most of their one year of married life had been lived in crowded quarters aboard ship. She had had her fill of the hardships and complainings of other people, although back in Charles Town, once David received his orders, there had been no thought but to find a way to go to war with him. Even the heartbreak of leaving her father had not changed that. She had received permission more easily than the other wives because her years of experience as one of Charles Town's leading midwives guaranteed her usefulness to the troops as a nurse. After the fighting ended, there still had been no privacy in Havana. Along with the other married couples, she and David had been billeted in a dank, rat-infested Havana barn. But that was behind them. Here in St. Augustine Maria meant, somehow, to get away from everyone—to be alone with David.

In the back of her mind was also the determination to persuade David one day to leave the military altogether. This was certainly not the time to bring it up, but his brush with death from fever had been too chillingly close. She could not live without him. Even though her Lutheran father had instilled in her a horror of suicide, when David had been so near death two months ago in Cuba, she had thought of following him. Now she had made up her mind to find a way, once his term of duty ended, of persuading him to become a planter, or perhaps a carpenter like her father, who declared that David could do anything he wanted with his hands. Her own dreams tilted toward life as a planter's wife. There would be British land grants aplenty in the new colony—but all that must wait. A house, a small, reasonable

house in fair repair, was the goal of the moment. A house in which they could spend their first night, in a long and bitter year, alone.

She passed a stand of cabbage palms rattling in the wind, buoyed every step of the way by the cheerful smile David had managed for her this morning—at last. She could handle any hardship so long as he smiled. Now he seemed closer, less the ill, nearly silent stranger she'd nursed all these weeks.

Maria searched a while along the Bay front, then cut over to what the Spaniards called The Street That Leads to the Land Gate, fairly sure of the name because the narrow thoroughfare passed Government House on the Plaza. Most homes were still occupied and most were in disrepair, the plastered outer walls cracked and weather-stained, the high walls enclosing the gardens, vine-split and decaying. But the town would not look this way for long. St. Augustine was His Majesty's city now. The British flag flew above the newly named Fort St. Mark; Acting Spanish Governor Felieú had turned over the reins of government to Captain Hedges until such time as England sent a governor for Florida. Given time, British proficiency and order would change the drab little foreign city. At present, most of the Spanish garrison appeared to be still here, and the looks on the drawn, hostile faces of the citizens showed them fiercely clinging in these final days to the place where their families had lived for nearly two hundred years. In spite of her British upbringing, she felt a fresh surge of pity toward them, but walked along with her proud, dark head high, her wide shoulders erect, her handsome body swinging gracefully beneath the folds of the watch cape. Dry, dusty, quaint St. Augustine was her city now. She was going to like it and conquer it.

From the brief stay in Havana, she knew that few Spanish houses had chimneys. On a chill night the Spanish came by what heat they enjoyed huddled about open braziers. Well, if the house she found had no chimney, David could build one. She remembered their first winter's night before a roaring log fire in her father's house in Charles Town just before David had been ordered to Havana. Strange thinking of that now, her back wet with perspiration, her eyes squinting against the glare of white sun. She turned off The Street

That Leads to the Land Gate and walked east on what must be St. Francis Street, according to Captain Hedges' directions. In spite of the bulk of the Catholic monastery at the Bay end of the street, she rather liked the quiet, tree-filled neighborhood.

For a long time she stood looking at a double-storied, balconied house on the opposite side of the street. Too expensive for them now, but certainly they would buy a good house of their own some day— she would see to that. A place even finer than this one, with a walled garden and an orange grove.

Slowly she crossed a sandy lane, smiling to herself. Thirty-three might seem middle-aged to some. Not to Maria. I'm a young, strong woman, she thought. There will be time for everything—everything I dream of being and doing and having. As David would say, "The good gentle folk, the best fairies will see to that, because you are you, love." She found his simple, native faith in his best fairies disarming, but Maria's source of magic was herself.

Feeling she could not bear the cape a minute longer, she removed it, draped it over her arm and pretended to saunter along nonchalantly with one hand on her hip—in reality, holding together the torn sections of her full outer petticoat. She looked as good as most women she'd passed—better. Except for the uniformed Spanish officials entering and leaving Government House on the Plaza, few citizens appeared at all prosperous. Petticoats and shifts worn by the Spanish women were made of once gaudy colors, but now the clothes were threadbare and faded. Some were filthy; at least, by her standards.

She did not care for the flat-topped, one-storied Spanish houses and wondered if Spaniards just didn't mind that water stood puddled above their heads on a rainy day. Then she noticed baked clay pipes protruding from the coquina walls near the flat roofs and smiled at her British sense of superiority. Water drained through these pipes, of course. But there was a foreign, unfinished look about the flat-roofed houses which offended her taste, and she hoped limited funds would not force her to settle for one.

Then she saw it—nestled on the north side of St. Francis Street—in its own small grove of orange and palm trees, as though

house and trees had grown together through the years of their lives. Not a large place, only one-storied, but not too small. And with a steep, thatched hip roof. A cottage much like others she had seen in St. Augustine, yet with an air of its own and, wonder of wonders, glazed sash windows! Built of coquina stone plastered over, its plaster was only a little cracked. She knocked and then, on impulse, tried the heavy wooden street door. Locked. She laid one hand on the sheltering garden wall and peered through the spindle gate. The lot was enormous! Surprisingly so for a fairly small, single house. Shade trees clustered close to the building, where Maria could read to David as he dozed, but out beyond the trees was a large weedy garden in which he could putter in the sun. She tried the garden gate. It, too, was locked. A chicken squawked nearby, but the place seemed to be vacant.

She looked about her. There was not a soul in sight. Shielding her eyes against the sun, she peered again through the gate. A privy and one outbuilding stood at the rear, and a well. The cottage had no chimney, but never mind that for now. In time, they could put on a shingled roof and add a fireplace chimney and maybe another for her kitchen. Maria would hate cooking in a typical Spanish kitchen of the kind she'd seen in Cuba, where the housewife's face and arms were streaked from smoke that refused most days to drift out through holes in the kitchen ceiling.

Determined to inquire of the first person she met if the house were for sale, she strolled toward the Bay, to the north-south waterfront street, La Marina—Marine Street—at that end of the city. But even if she saw someone, how would she inquire? Would anyone speak English? Fearing robbery, she had not worn her mother's gold watch, but the sun was overhead now, it must be after eleven o'clock. David would be growing restless without her.

Torn between delight in the St. Francis Street house and anxiety as to how she would ever find out about it, she stood at the corner across from the monastery and looked out over the glistening waters of Matanzas Bay. What houses there were on Marine Street stood only on the leeward side, with a view across the Bay of a rather large island and a watch tower. Most of the Marine Street houses, and

there were few, were run-down and deserted. Anyway, she had found the house she wanted. Whatever the interior arrangement of the St. Francis Street cottage, she knew, as a carpenter's daughter knows, that it was well built and could bear additions in the future, even a second story.

Her mind still on the St. Francis Street cottage, she stepped through the sagging, open gate in the wall of a little flat-topped building on Marine Street and peered into its gaping windows. There were few glazed windows in the whole town. The Spanish were either very poor or very careless, or didn't mind flies. Inside the cramped rooms, she could see large brown bugs similar to those she'd battled in Cuba scurrying over remnants of food. Dried meat scraps littered the filthy floors, and there were half-eaten crusts of bread along the stone counter in the smoke-blackened kitchen. A twisted strand of dried, dusty onions hung from a rafter, and in the shadows of one corner, she could distinguish a pile of old garments. Surely this family had left hurriedly.

The empty, sorrowful little place repulsed her. She turned to look again at the water. David, in spite of the ugly house, would probably like living here with the view. He had grown up in County Mayo, fishing for brown trout in the wide waters of Lough Mask. She smiled again to herself. For him, if it turned out that they had no other choice, she would work her fingers to the bone to fix up even this little hut. Her impatience grew. Except for a few fagged children shouting Spanish phrases at her from the beach, Marine Street, too, was deserted.

She crossed the bare yard to the other side of the dilapidated structure to glance in at the remaining two rooms. In the rough plastered walls were deep niches, stripped of their heathen religious figurines. How could one rid any house of such dark superstitions? Maria laughed a little. They could, of course. She and David could do anything.

"Good morning to you, ma'am." She had heard no footsteps, but behind her, a man's soft, whispery voice spoke in English.

Maria turned to face a somewhat frail gentleman of medium height in a spotless linen waistcoat and shirt and carrying a satchel.

He doffed his tricorn and bowed. "Allow me to introduce myself. I'm Jesse Fish, a St. Augustine resident. Anastasia Island, to be exact." He gestured toward the island across the Bay. "I was wondering if I might be of assistance."

As Maria introduced herself and stated her mission, she studied the narrow, sharp-boned face, the penetrating brown, almost black eyes. "I didn't realize any British civilians were here yet," she said. "I wasn't aware that anyone other than the military had come."

Fish's smile was thin, but kind. "I am English, but I haven't just arrived. It's been my pleasure to live in St. Augustine since 1736. You see, I came as a boy from the New York colony to learn the Spanish language and customs. When I had learned enough—at twenty—I became the official representative of the Walton mercantile firm which had sent me, and have conducted the business ever since."

"Then, you're leaving with the Spanish?"

"Not at all. My work goes on. I like my plantation on Anastasia. My company is British. The firm will remain, at least this year, but I intend to stay on."

Maria frowned. "You—you were welcome here all these years with the Spanish? As an Englishman?"

"Indeed, yes." His smile was puzzling. Almost too genteel. "I can see you think all Spaniards hate all Englishmen. Most do, I believe. But I'll wager you'll learn a bit more about the virtues of accommodation if you remain in St. Augustine." The dark eyes twinkled. "Trade makes possible a multitude of accommodations, you know."

Maria was thinking too hard to respond. She did not feel particularly uncomfortable with this man, and if he'd lived here twenty-seven years, he must know every house in the city. He *was* a gentleman and he spoke English.

"My husband is recovering from Havana fever, Mr. Fish," she began firmly. "I hate the thought of leaving him in that hideous dungeon the Spanish call a fort for another night. It's no fit place for a man in good health. I want to buy a house—now. I have the money."

"Well, I'm afraid it's a mite early. Legal arrangements for sales have not been completed."

"But the governments have already changed hands."

"True, but His Spanish Majesty intends to see to it that his St. Augustine subjects are financially protected. The Royal auditor, Don Josef Elixio de la Puente, will be back from Cuba, I hope, before too long—to handle the sale of the people's properties for them. To see to it that they get fair treatment. If all goes well, I—uh—will be assisting him. A few properties are quite valuable. All are valuable to those forced to evacuate."

Maria laughed. "Not this one. I'd guess no one valued it much. Look at those shutters, ripped right off their hinges."

"And just last night, too," Fish said evenly, "but not by the poor family who had to leave. By the newly arrived British soldiers—for firewood at the fort. In one night they seemed intent upon tearing up a good part of our town, in fact. I hate to think what it will look like after they've been here a month!"

"Of course, the Spanish government with any show of courtesy would have had wood on hand for our soldiers. For cooking at least." Maria's voice was flat with sarcasm. "They've known for a month that we were coming."

Her manner did not ruffle him. "It's been a sudden transition, ma'am," he said. "Governor Felieú tried, but all contingencies could not have been anticipated."

Maria did not like an Englishman speaking in defense of the enemy. But she needed Mr. Fish. Suddenly remembering her torn outer petticoat, she flung the cape around her shoulders and asked in a haughty voice, "If we can't buy a house, can we rent one?"

"Yes," Fish said. "Some are for rent."

"I know the one I want, providing the rental is within reason," she said. "It's right around the corner on St. Francis Street. A cottage. Not in what one would call excellent condition, of course. My husband would have to do an enormous amount of work on it." She exaggerated with a clear conscience. After all, it was up to her to strike a suitable bargain.

"Yes, I know the place. But it's in remarkably good condition compared to other St. Augustine houses. It even has paned windows.

Just vacated three weeks ago by one of our more careful families, the Gonzáleses, among the first to go. It so happens their property is in my hands to rent for them."

Maria's growing excitement almost betrayed what she hoped was a cautious, businesslike manner. Surprisingly, she was beginning to feel a strange interest in Jesse Fish, in spite of the fact that he had lived most of his life among the Spanish. Her manner had not intimidated him one bit, and she respected that in anyone. She could feel her heart quicken but said in a controlled voice, "Are you certain we're speaking of the same property, Mr. Fish?"

"Only one-storied house vacant on St. Francis Street. It's the same one, all right. Thatched hip roof?"

"Yes. How much rent?"

He bowed again. "For you, a modest fee, ma'am. I'm sure the Gonzáles family would want to rent it to someone who would look after the property."

"I'll take it," Maria blurted. Then she laughed, feeling her face color. "I know I should see it first, but my husband is still quite ill— I've been away from him all morning. Would you think me too foolish if I said I want him to see inside it with me the first time?"

He only smiled, but her cool manner had vanished. She was going to rent a house from him. She needed his help now; and if she were to make the right contacts for her profession later on, who was more likely to have them than one so closely connected through his work with both governments? She had tried to be wary of Jesse Fish, but she didn't honestly feel that way.

She reached into the roomy pocket tied around her waist. "How much do I owe you, sir? I must get back to my husband."

Fish held up a hand. "Nothing now, Mrs. Fenwick. It will be my pleasure, if I may, to drop by later this afternoon. You've enough problems to handle, moving a sick husband. He and I can settle then. That is, if he's able."

"I think he's strong enough. I'd like him to meet you." She paused. "Do you have any idea what your kindness means to me on my first day here, Mr. Fish?"

"Perhaps I do. Perhaps not. By the way, in their haste to flee the British, the Gonzáles family left their furniture in place. Took only their clothing and religious treasures."

Her heart leaped. "The house is *furnished?*"

"I am to dispose of the furnishings, too, should you like them."

"Whether I like them or not, I need them!"

"Of course, you'll find the place a bit dusty, but Tomás Gonzáles took care of his home. It would require but a few minutes to show you the house now."

"No. No, thank you. I know I want it and I *must go.* I'll have to arrange for rations. Oh, and transportation. You see, Sergeant Fenwick isn't strong enough to walk all this way. I'll have to find horses or a cart—some means of getting him here. But would you be kind enough to unlock the house on your way past?" She laughed at herself. "I'm thinking of things in bunches, am I not?"

"I doubt it would be safe to leave it unlocked, with the British troops in town." He reached into the satchel and handed her a heavy key. "Wouldn't you like to have your husband unlock your new front door for the first time?"

Maria held the key, beaming, for some reason not at all embarrassed to show emotion with this stranger. "I—I wouldn't have believed a businessman such as you would also be a romantic, Mr. Fish. Thank you."

"I know at least what it is to be lonely," he said, his voice still even. "I have no one." Then, "I'm sure I can help you with the problem of getting your husband here, too."

Maria could only stare at him.

"One of the eight Spaniards chosen to stay on—my longtime, trusted friend, Don Luciano de Herrera—should be back in the city by now and with some Spanish horses he's been commissioned to round up—to sell, if possible, to the British."

"But—I don't want to have to *buy* a horse, sir!"

"I wasn't thinking of you doing so . . . Captain Hedges should know of Luciano's whereabouts. When you find him, tell him I said to rent you two good mounts for your ride down here."

When she had thanked Fish warmly again and watched him walk away around the corner out of sight, Maria hurried up Marine Street in the direction of the fort. She ran halfway to the Plaza, and then, dizzy from the heat, she made herself slow to a rapid walk; then, with effort, to a measured stride. She needed time to think.

2

For all the years of her life, even as a child, something had forced Maria to stop and test whatever made her sad or afraid, or even extremely glad. She was glad now, excited, and in spite of her eagerness to tell David about the house, she felt the need to test her own inner responses to what she'd done.

Ever since her mother's death when she was eight, especially because of the added responsibilities of her childhood, she had fled at certain times—happy or solemn or frightening times—down, down into the deep and private place within her. A place which to her young mind—indeed, to her adult mind now, in the heat of the strange Florida city—was a safe and sheltered refuge, a garden all her own, shadowy and green. No flowers bloomed in her secret garden; only thick-layered greens grew there, bright and dark—soft moss and fern, green leaves and tangled vines, embracing cheerful, hidden glooms where she could withdraw and think. A place where the very roots of her being reached for an awareness beyond explanation, her inner garden had been the sheltered source of her strength even during the horror in Havana when she thought David might die. She needed that strength now.

She needed it for the painful, perhaps even dangerous task of moving her husband in this strangling heat, she told herself as Maria Evans—not Maria Fenwick. It gave her immense joy to share David's surname, but when she paused to retreat to her innermost being, as now, she still thought of herself—especially to command her own attention—as Maria Evans. At the moment, her attention kept wandering to David. Was he all right? Had James Cameron helped him back inside, out of the hot sun, as he'd promised? She was turning and reaching toward her green and secret place for some assurance that she'd done the right thing by renting a house sight unseen from a stranger, but her concentration was broken into by thoughts of the man she loved more than her own life. In these thoughts, she seemed to be experiencing a renewal of the freeing sense of adventure which had begun upon her first sight of Sergeant David Fenwick that rainy summer afternoon two years ago, when he had arrived to take up quarters in her father's workshop to the rear of their Queen Street home in Charles Town. From the start, even before she'd met David, an unfamiliar recklessness had possessed her.

"I dread his coming, daughter," Richard Evans had said in his quiet, solemn way. "I don't intend to behave in the disloyal fashion of those New York colonists, refusing to billet soldiers on their property, but even without your mother, Maria, I've found a kind of happiness here in our house with you. I pray this Sergeant Fenwick will turn out to be a gentleman. At least, one we can tolerate."

Ever since that terrible July day in 1738 when her mother had died in the smallpox epidemic, just past her own eighth birthday, Maria had been comforting her father. As to whether billeting a soldier would be tolerable, she had only laughed at his anxiety. "We think alike, Papa, but not always. I don't dread the sergeant's coming one bit. The man can't be out fighting the Cherokees all the time. He'll be a help to you. That's part of the bargain, you know. Any soldier billeted on the property of a Charles Town citizen works. We'll do fine—or he'll get a sharp piece of my mind."

Maria had been away on an errand when David Fenwick got there, and all of life had changed the instant she entered the tiny, paneled parlor of the Queen Street house, her shopping basket on her arm, and found her father and the sergeant deep in conversation. Right now, in her mind's eye she could see him as he had been at that moment—lithe, vital, golden. She had never been able to remember that her father had introduced them. He had, of course, but when the beautiful young man sprang to his feet smiling, the shadowy house had filled so suddenly with his light that Maria, all but blinded by it, could only stand and look—aware instantly that she wanted this man's arms around her.

"Are you sure I even acknowledged Papa's introduction, David?" she had asked a hundred times since. "I'm seldom at a loss for words. I was at that moment, wasn't I?"

"And how would I be knowing what you said, love?" David inevitably replied, always as eager as she to relive that first shining moment. "Wasn't I as love-struck as you? And have I ever recovered? I have not. I never shall. I shudder, my Maria, to think you might not have fallen as much in love with me on that first sight as I with you."

And then, for all the months of their married life, until his sickness from the fever in Havana, she would often do exactly what she had longed to do on their first meeting—rush into those strong arms to be held and reassured. He still loved her the same, even in his weakness, and with care, he would be well again—perhaps soon, as his smile this morning had seemed to tell her. The pale, drawn face would glow again under the crown of tawny curls, and the green eyes would laugh as the two of them sat together in their rented house, touching, talking, dreaming, wondering aloud about poor Papa alone back in Charles Town. David and Papa had developed a mutual attachment as close as a devoted daughter could wish. She could never have endured the agony of leaving Papa for any man on earth but David Fenwick.

Distantly related to the prominent English Fenwicks of Charles Town, his great-grandfather had, for love of an Irish girl,

left England for the wide valleys and blue-green hills of County Mayo in Ireland. David's speech and ways and sense of play were still more Irish than English. Maria was captivated by his light brogue and relished his unfailing humor. She laughed again and again at the same "reharsal of a rale oul' tale" when the lilting voice dipped into the magic of a deep country accent to spin a story that, he vowed, matched the most skillful Irish shanachie reciting before a charmed audience in a wake house, or on the banks of a lough in summer.

Maria had not been his only charmed audience. Her father, too, listened to David's tales, had laughed the freest laugh that she could remember in all the years since her mother died. It had seemed yet another tragedy for the aging, kindly man to lose the companionship of both his daughter and his newfound son. But Richard Evans had borne the loss more bravely than had either Maria or David. Often during one of David's spells from the fever, memories of her father's loneliness would stab him until, as the fever soared, he sobbed from weakness. She had cradled his head in her arms in her effort to soothe him. She kept up her own spirits on the voyage to St. Augustine by assuring David that, now that they were to live in a British colony nearer to South Carolina, Richard Evans would surely join them. She found solace in the thought, but always with reservation. She knew how much her father loved every foot of timber in the Queen Street house which he had built for her mother with his own skillful hands, how firmly memories held him there.

Eager as she was to get back to the fort to tell David, as excited as she was about her blind transaction with Jesse Fish, she closed her eyes for a painful moment against the thought of her father living alone day after empty day, cooking his own meals in characteristic, uncomplaining silence.

For all of her thirty-three years, Maria had adored her father, and since her mother's death had devoted her enormous energy to a continuing, untiring effort to assuage his loneliness. She had been contented, even stimulated, as a single woman pursuing her chosen

profession as midwife, happier caring for her father, she knew, than were many of her friends with husbands.

Maria's high spirits were her mother's, but her mind worked with her father's thoughtful deliberation. Physically vigorous and striking, outwardly she was her mother's child—the deep-set violet eyes, the straight nose; she held her head in the same proud manner—but inside she was her father's daughter, independent in judgment and determined to succeed at whatever she undertook. That confident determination had been enough to keep her happy until David Fenwick changed everything. He had come into her life loving her as she loved him, and now, in St. Augustine, a whole new world would open.

She walked faster. David was stronger today. The nightmare in Havana was behind them. She was free to plan again and dream. "The only woman in all the world who can dream practical dreams," David once teased. Soon he would feel up to teasing her again. One fine day he would be full of laughter, and his arms would grow hard and able to hold her. She would work at her profession and make a name for herself, and David could be proud of her when they were once more in decent English society.

In a year of married life, Maria had shown no sign of giving him a child. It haunted her at times, but her way was to put the whole thought aside by seeing to it that, until she did have a child, David would find her enough.

She was aware of her professional accomplishments and of her good fortune in having a husband who praised them freely. Her growing stature as one of Charles Town's most sought-after midwives had in no way threatened this happy-natured man. At thirty-four, he was content to be nothing grander than a good soldier—a sergeant able to command the respect of his men—and to leave ambition to Maria. As loyal as he was to his regiment, David's profession was *living*. He had taught her, an only child, how to play at nearly everything they undertook, and Maria found it all good. Not that she believed—as David swore he did—in all the antics of David's gentle folk, the wee red men—"Lochrie Men,

a little taller than leprechauns, whose long beards glow in the dark." The certain earth remained under Maria's feet, but she had learned to pretend, and the enchantment and vitality David brought to her added light to her days, a light she meant never to let grow dim.

David seemed equally captivated by her common sense and ambition. During the rough voyage from Havana, on one of his better days, he had even suggested her urging talkative Ann Cameron to spread the word that Maria's skills as a midwife would now be available to the British women who would surely accompany their husbands to the new English colony of Florida once the Spanish left. It would take little urging. Ann's favorite pastime was any endeavor that involved word of mouth.

In her own opinion, Maria was far above average where her profession was concerned. It had been necessary for her to learn patience with nature, to be sure, and she prided herself on knowing when and when not to force a birth. The learning had not been easy, but she had studied every available book, had gone often as a young girl to assist one of Charles Town's aging black midwives, and knew that, more than most, she used her mind as well as her hands. She considered herself a female physician, born to the work. A new city offered new stimulus. What she had not yet learned, she would master here.

Past the Plaza on her way back to the fort, Maria carried herself so lightly and her expectations were so heady that she unconsciously smiled into the anxious faces of the Spanish people who hurried in and out of their ramshackle houses. She could see signs that a few more families were already packing. She wanted the hapless Spanish people out of the city for good, yet her pity for them as she walked along was real.

Back in respectable, protestant Charles Town, she had been taught, as had all her friends, to fear Spanish Catholics who lived on the Florida land next to the new colony of Georgia—land His British Majesty needed for the protection of his other colonies. She had lived most of her life with a vague fear of a Spanish attack on

Charles Town. Until today, she supposed, she hadn't even thought of Spaniards as human beings; she knew only that Spain and Spaniards had struggled to hold on to the province of Florida against many attempted invasions earlier in the century from the colonies of both Georgia and South Carolina. But today she saw the Spaniards as people like herself and David and Papa; and people, in her opinion, never really have a hand in the doings of any government. Men and women and children of all countries simply believed, because they had been taught to believe, that their monarch was benevolent and had their best interests at heart. Spaniards were pawns, obviously, of an evil king.

Amazed and rather pleased, she realized that she had enjoyed her search in the strange foreign city; that she'd even enjoyed being alone again after such a long period of nursing the ill and wounded. There had been an unexpected relief in being by herself where no one knew her. Because she was the most capable nurse of the lot, according to the regimental surgeon, for more than six months since she and David had waved goodbye to her father at the Charles Town wharf, she'd known precious few minutes alone. Perhaps, now that David was better and the fighting over, she would once more find time to explore the varied levels of her own inner world, the green deeps of the familiar place where her own true intent came unmistakably clear. Even David could not penetrate—did not know about—this mystery of her secret self. This place of utter certainty. No one was there except Maria Evans, when she could quiet herself enough. She supposed her father would call what she did at these times praying. To her, it was taking depth soundings which confirmed or refuted impulsive decisions such as the one just made—to have rented a house she had never seen inside, for a rental she had not settled—to be calm about the intuitive feeling of trust and affinity she felt for the gentle, enigmatic Englishman, Jesse Fish.

She crossed the drawbridge over the sluggish moat at the fort. No doubts gave her pause; she'd done the right thing, no matter how daring. Mr. Fish was going to be trustworthy. He had to be.

3

*T*he stench from the fort's stone-floored *necesarias,* cleaned only by the tides, assaulted Maria as soon as the British guard, with a broad smile and a salute, waved her across the drawbridge. Mingled smells of excrement, mildew, and dried urine sickened her. She would find Jesse Fish's Spanish friend, Herrera, as soon as possible so that David would not have to stay in this foul place through the heat of the day, but before anything else, she had to be sure that he was all right.

It was well past noon. She trusted that James Cameron had helped David back into the shadowy infirmary. Deciding to look there first, she raced across the fort's plaza and stopped at the entrance to the dim, high-ceilinged cell to give her sun-blinded eyes a chance to adjust.

Then she saw him, sprawled motionless on his back, his quiet hands whiter than the white face under a two weeks' growth of beard. His eyes were closed. Maria jerked off the watch cape, tossed it in a heap on the floor, and bent over him.

"David? I've come back—and with the most glorious news!"

The smile came even before he opened his eyes. "You were gone for a week."

"No. Just all morning."

"My strength goes when you go, Maria."

"Nonsense. Did you hear me say I have glorious news?"

He nodded.

"I've found a house for us! A good house, with furniture—and we can move in this afternoon." She took his hand. "Did you hear? This afternoon!"

The smile twisted into a pained frown as he gripped her hand and forearm, pulling himself up onto one elbow. "You crazy girl, how can I go anywhere—this afternoon?" His eyes squeezed shut. Tears trickled down his cheeks. The anger of a strong man at his own helplessness reddened his face. "I can't even walk without help."

No matter that seven other groaning men lay beside him on the long shelf, she gathered him into her arms, reached for the still damp cloth with which she had bathed his head in the night—once her linen shift—and tore off a piece so that he could wipe his brow. Then she held his head between her hands and looked straight into his face, waiting for what he would say.

"I—want to feel like myself again, Maria. I want so much to be glad with you. I—*am* glad about the house."

"I know you are. And it's all right," she said, her voice low and encouraging. "Our voyage was long and rough. It's bound to have exhausted you. To say nothing of the effort you made getting all the way up to the ramparts this morning and back down again. Did James Cameron help you back, my darling? I'm sure he did. He promised faithfully to keep an eye on you." Maria was prattling. Except for Ann Cameron, she disliked prattling women. So did David.

His head sank back onto the wooden shelf. "Yes," he said on a long sigh. "James helped me. He's a good fellow. Said he and Ann were not permitted to stay together last night. They can't as long as we're in this hole. You were let stay with me because I'm still a weakling who needs—nursing!"

"You need nursing only because you're not your usual strong self yet, dearest. But time and all my loving care will fix that—time and love and quiet and sunshine and the best food I can scrounge from this still Spanish town. And blessed privacy. We're going to be alone tonight—in our very own house!"

"Aw, Maria, don't try so hard."

"I'm not trying; I'm loving you. And don't tell me that doesn't mean as much to you as it means to me, because I won't listen!"

He lifted his head and looked at her, his face drawn. "Can you find a way to get me there? If you've really found a house in this godforsaken place, can—even you—get me there?"

"Yes! Your best County Mayo magic—all the gentle folk—are working for us. If I could have endured waiting a few more minutes to see you, I'd have had our transportation arranged." She kissed his

forehead. "I couldn't wait. But I do have a plan, a way to get you there. All you have to do is lie here and rest while I'm gone." She got to her feet.

"Now, just a minute. What about money? Did you buy this house?"

"No, I rented it."

She described the cottage as best she could and went into some detail concerning Jesse Fish, but she avoided any mention of Herrera, the Spaniard with the horses. After all, David had nearly lost his life in a bitter siege where every Spaniard was his enemy. Time enough later to tell him how she'd arranged their transportation.

"Do you trust this man, Fish?"

"Yes."

David smiled. "Then, so do I. After all, he's a British subject. Not a Spaniard. Undoubtedly he's all right. I wouldn't worry."

Maria gave him another quick kiss. "I'm not worried! But I am in a hurry, Sergeant. Will you wait for me?"

"If you'll kiss me again."

"I will—just once, though. I simply cannot stay here making love to my husband all day. I've got to find Captain Hedges."

It was only a half lie. She would have to ask how to locate Herrera's house.

By luck, she caught up with the stocky, graying captain striding across the grounds toward his quarters, and called to him above the racket made by a handful of soldiers moving supplies in a broken-down cart. He turned half annoyed until he recognized her.

He doffed his officer's hat and bowed cordially. "Ah, Mrs. Fenwick, what may I do for you?"

"I'll be brief, Captain. I know your mind must be riddled with problems today."

"Eh? Yes, riddled is right. Although I must say these Spaniards appear to be trying to make a peaceful transition. How is Sergeant Fenwick?"

"Stronger, I believe. He slept some last night. I see flashes of the old David."

"That is good news. We need him."

"Captain Hedges, I've found a house we can rent. I intend to get him out of here this afternoon."

"Splendid! He'll get well far quicker away from this dripping dungeon. Can he walk?"

"Not more than a few steps without help—or stopping to rest. The house is nearly a mile away. We'll need horses. At least one horse. Do you know a Spaniard named Herrera?"

Hedges' eyes widened. "Now, how is it possible you've heard so soon about Don Luciano de Herrera, Mrs. Fenwick?"

"I rented our house from a Mr. Jesse Fish, who told me I might get horses from his friend Herrera."

The captain chuckled, rubbing his square chin. "You are a remarkable woman—most remarkable! I'm in command of the province and learned of these two important citizens only this morning! You'd make a good spy, I swear it. The truth is, I've just come from Herrera's house. Clever man. A Spaniard of the Spaniards. He's been ordered by Havana to remain—among other reasons, I'm sure, for the purpose of striking a good deal on the horses the Spanish people are forced to leave behind."

"Mr. Fish told me. Do you think I could see him right away?"

"I left him only moments ago at his father's house on the east side of The Street That Leads to the Land Gate. We've got to rename these foreign streets! Anyway, the place is just north of the Square. I—uh—refuse to call it the Plaza. You can't miss the house. It's a good one. The first two-storied residence with a balcony. The back lot at the moment filled with horses."

"Thank you, Captain. I'll go right now."

"Wait. A word of warning. Herrera's just bested me—I refused his outrageous prices. Gave him time to rethink matters. I daresay he won't. He has the only available animals."

"Is Luciano de Herrera young or old? How will I know him? Does he speak English?"

"Yes, fluently. He's not old. A bachelor, I understand. I'd judge in his late twenties." The captain smiled. "He'll be the handsomest man in sight. That is, if an English lady is disposed to find anything hand-some in a Spaniard at this point in history. Clean-shaven, black hair,

black, flashing eyes. Be on your guard when you bargain. Sergeant Fenwick, thanks to his bravery, has a generous share of money from the fighting in Havana, but it won't last forever. Uh—perhaps I'd better accompany you."

"No, thank you, Captain. I think I'd like to try it alone."

Maria didn't remember that she had left the watch cape in a heap on the infirmary floor until she had run most of the way down the narrow street toward Herrera's house. Too late now. She would simply make the most of the torn outer petticoat. A woman with a hand on her hip could be forbidding.

A Spaniard of the Spaniards, Captain Hedges had called Luciano de Herrera. That could mean any of a number of things. In front of the somewhat pretentious house, she stopped long enough to tuck loose strands of dark hair out of sight, she hoped, beneath her mob-cap. It would be helpful to have the added bravado of a well-groomed appearance, but that was impossible. She would depend on her wits.

She rang the ornate bell that hung from the arched entrance to the side loggia and waited. Alongside the others, the Herrera house was quite beautiful, its outer walls newly painted a soft ocher, the plastered coquina stone in good condition. No sign of impermanence here. The Herrera family could afford to keep their house in good repair. They were not only obviously influential; they were not going to leave.

While she was jerking the bell a second time, a lithe, dark young man stepped up beside her, smiling, a thin cigar between startlingly white teeth.

"It's a handsome bell, isn't it, señorita?"

He removed the cigar and looked at her in such a direct and congenial way that Maria was at a loss for words.

"*Buenas tardes,*" he said, bowing.

"How do you do, sir? You startled me."

"I am so sorry, but how could you have heard me over the clang of that bell? You have a strong arm, señorita."

Maria returned the disarming smile. "You must be Don Luciano de Herrera."

"*Sí*. How do you know my name? I do not know yours."

Maria was relieved. He did speak English well, though with a heavy accent. "Captain Hedges described you. Your friend, Mr. Jesse Fish, said you might help me."

Herrera laughed. "How I would like to know the manner of British Captain Hedges' description of me—and how like *mi amigo,* Jesse Fish, to do me this honor." He bowed again. "Will you come inside my father's house, señorita?"

"No, thank you. I'm very rushed for time. But first, I'm no señorita. I'm a—happily—married woman. My name is Maria Fenwick. My husband, recovering from fever, is British Sergeant David Fenwick. Sir, I need two horses."

"Ah! Then you have come to the right man." He touched her hand, the one not clutching her skirt ever so lightly. "But—*por favor,* will you please to call me Don Luciano and no longer 'sir'?"

She should have been insulted by his touch, but his manner was too open and natural for her to feel insulted. "No, thank you. I fear we British are a more formal lot."

He shrugged, not the least offended. "So I observe. Now, to the horses. Some I have are fine mounts. Others? Not so good. Sway-backed. Or a little lame. Not much lame. Only a little."

Inwardly, Maria was responding so wholeheartedly to his surprising warmth and honesty that she annoyed herself. Captain Hedges had warned her to be on guard. Herrera's eyes did flash, but to her they were good eyes, and she noticed that he looked directly at her with every word he spoke.

"I'll need the horses for only a few hours. You see, I've rented a house. From your friend, Mr. Fish."

"To be expected."

She decided to ignore whatever he might have meant by that. "My husband is unable to walk all the way from the fort to St. Francis Street. If you care to rent only one horse, I can walk alongside. I have to get him there—today."

"For your husband, then, you will need a gentle beast, no?"

"Oh, yes. He's still very weak. How much, sir, to rent one horse for, say, three or four hours? I'll need to see that my husband is comfortable

before I can return it. But I promise to do so as soon as possible."

Maria had a feeling Herrera was not even listening. He made no attempt to respond, but stood shaking his head from side to side, a small, suddenly sorrowful smile on his dark face.

"Did you understand what I said, sir?"

"*Sí*. I understand." He sighed. "It is sad to know of your husband's illness, but I would gladly be ill for the remainder of my life if I could have such tender care . . . from such a lady."

For a moment, Maria could think of nothing to say. Somehow, the man had aroused her concern for him; she sensed that his sorrow was more real than his gallantry. Or was this a trick to prevent her from driving a hard bargain?

"I apologize, señora, to speak so freely from my heart at our first meeting. You see, one day soon, I will be only one of a handful of Spaniards left in the city in which my great-great-grandmother was born. Already, three shiploads have gone. You have found me in a time of heartbreak."

"I've seen the faces of your people today in the streets," she said softly, and dropped the pretense of concealing her torn garment. She no longer felt like standing arrogantly with a hand on her hip. "It all must be very hard for you."

The smile flashed back across his striking features. "But I am rude to burden you. So, two horses—two gentle horses—you will have, and I myself will bring them to you at the Castillo. You will only tell me the time when you will have made your husband ready to travel."

"How much money, sir?"

The sad, somewhat injured expression returned. "No money, señora. You and your husband will owe me nothing beyond a small return of kindness now and then when my people have gone."

"I'm most grateful to you. If you could have the horses at Fort St. Mark in about two hours, I feel sure we'll be ready. I promise to return them no later than seven o'clock. And"—she extended her hand—"my husband and I will try to be your friends."

"*Gracias*. I know the small house of Fish on St. Francis Street. The Gonzáles house. For such an offer of friendship, I myself will

come there at six o'clock to get the horses. Now, you are happy by the arrangement?"

"Oh, yes, thank you!"

"Do not thank me, señora. Only invite me one day into your home to meet this Sergeant Fenwick for whom you care so much."

4

Within the hour, Maria had packed their few belongings in two bundles and tied them with ropes. David, clean-shaven, sat exhausted on the sleeping shelf in the fort's infirmary.

"Don't be long," he said. "I feel the worse for being so helpless. Is James Cameron gathering our rations?"

"No. He's doing guard duty. But Ann's racing from one supply room to another. She's beside herself that we've found a house."

"It's good of Ann to help."

"If I know her, she's talked the quartermaster into extra food for us." Maria leaned down and took his face in both her hands. "Don't worry about a thing, David. Just wait for me. The man with the horses will be here soon and I'll come back for you. Be quiet and rest. We're going to be fine. Just fine."

Carrying a bundle in each hand by its rope she walked out of the shadowy infirmary into the dazzling sunlight, and her spirits lifted at what she saw. Across the fort's plaza came Luciano de Herrera, riding a black horse and leading two others. From the other direction, Ann Cameron hurried toward her at a good clip, arms full of provisions. All her plans were working. There would be no need to make David wait.

"Look, Maria," Ann called, "Beans. This bag's full of potatoes—and, there's salt, flour, onions, salt meat, almost a full loaf of sugar, and I don't know how much lard!" She put down some of the provisions.

"You must have convinced him we were moving to another country to get all this!"

"The same as. From what you say, it's going to be a long walk for you, carrying provisions every day. Too long for poor David to ride now, do you think?"

"No. He's going to make it fine. And look—here come our horses, right on schedule."

Ann all but dropped the bag of potatoes. "Is *that* your Spaniard?"

"It certainly is." Maria waved. "But why in the world has he brought three horses?"

Ann, her eyes wide, could only stare, as Herrera returned Maria's wave.

"It's such a short walk from here to his house," Maria went on, "it's ridiculous for him to ride back."

"I couldn't care a whit if he'd brought six," Ann breathed. "I declare, he's the best-looking man I've ever seen! I'm glad James is on duty. This way I can look and look and look."

"Fiddle," Maria said. "I need James' help with David."

"Why not ask *him?*"

"You know perfectly well what David thinks of Spaniards. I don't want him upset, that's why. Besides, I'm under enough obligation as it is."

"*Buenas tardes,*" Herrera called, dismounting. "I bring one horse for me to ride to St. Francis Street."

Maria set down her bundles, frowning. "But—"

"You do not understand my *inglés?*" His smile included Ann, who beamed back. "One is for me to ride. Do you not think you will need help once you reach St. Francis Street and the house of Tomás Gonzáles? A man to help and an extra horse to pack your bundles?"

"Perhaps. But—I hate imposing."

Ann nudged her with an elbow. Maria introduced them, then explained, "Mrs. Cameron and her husband have to stay here until they, too, find a house."

Herrera bowed to Ann and took the bag of potatoes. "If I can be of service to you then, Señora Cameron, do not hesitate to call on me."

Ann curtsied, for once too flabbergasted to speak. Her round, pert face was red as a beet. Evidently Luciano de Herrera could not make an ordinary statement without having a decided effect upon women. Ann's instant infatuation, of course, did not mean that David would like him.

"Today, Señora Fenwick, I am at *your* service. Your husband, he is ready? You will allow me to assist him onto his horse?"

The sun was blinding, but Maria could hear thunder. She bit her lip. David was so painfully embarrassed by his weakness even before his own comrades, would he permit this suave, handsome Spaniard's help? But thunder meant that it could rain soon. She decided quickly. "All right. Yes, I'd be grateful if you gave my husband a hand . . . he's waiting through that doorway, Don Luciano."

"Ah! Don Luciano. *Muy bien. Gracias.* You have obliged me with my Christian name." He handed her the reins of all three horses. "You will hold these? Your husband and I will return *en un momento* and I will pack your possessions."

When he had disappeared into the shadows of the infirmary, Maria sighed. "I'm taking a chance, Ann. And I should *not* have called him Don Luciano!"

"Do you think David will come with him? Oh, Maria, I don't believe I'd dare send a Spaniard to help my James, now that I think about it. I'm sure I wouldn't dare."

Dark, low clouds began moving across the Bay, and the thunder rolled nearer.

"Beggars can't be choosers, Ann. It's going to storm, too—I'll need Herrera to get us there and inside the house as soon as possible. Anyway, I've promised him our friendship. He seems lonely."

"I'll wager not for women friends! I declare, Maria Fenwick, he's the best-looking man I've ever laid eyes on."

"You said that." Maria gentled Herrera's spirited mount. "His looks don't matter. He's been generous—so far, at least. And David needs his help. It's as simple as that."

Only a light drizzle fell during the first part of the slow, nerve-racking ride. Then the sky, so bright an hour ago, lowered with thunderheads, and wind whipped the trees and the gray waters of the Bay. Halfway down the last long block, on Marine Street by the beach, the sky opened, and all three riders were drenched.

Surely some words had passed between them as Don Luciano led David from the infirmary, but Maria could not be sure. David, who sat his horse grimly, his face pinched, his thin, pale hands gripping the reins, had said not one word in her presence to their benefactor. Until the downpour began, Maria carried on a determinedly pleasant conversation, but her concern for David made the ride seem endless.

The Spaniard appeared not to notice David's silence even now, as he gently helped him dismount beside the little St. Francis Street cottage. Then, steadying him, Don Luciano spoke quietly, encouragingly: "*Bueno,* Sergeant. You will do well just to lean your weight against me. See? My arm will support you."

When they reached the house, still without a word and at Maria's insistence, David took the key, unlocked the heavy door, pushed it open, and all but collapsed in Herrera's arms. Maria, hauling wet bundles behind her, hurried after them. She glanced around the two low-ceilinged, whitewashed main rooms, then spotted the plain wooden Spanish bed in an alcove to the rear of the second room.

"There, Don Luciano. Help him to the bed, please!"

Herrera, half carrying David, eased him carefully onto the faded red coverlet as though he were a sick child.

Too worried to notice the shadowy rooms in any detail as she opened windows, Maria did see that the house was furnished adequately—a few chairs, an old wooden high-backed bench, a small dining table.

"You will need water," Herrera said. "I will fetch it. The Gonzáles well is a sweet one."

When he had gone out to the backyard, Maria leaned down and kissed David. "Don't frown so. It's all right now. We're here."

His eyes were closed. He said nothing.

"I'll get you out of these wet clothes just as soon as Don Luciano is gone," she said as she began to pull off his shoes and gaiters.

"David, I do hope you'll have strength enough to thank him." She felt his stockinged feet for dampness, then asked tentatively, "Are you—so silent because of the weakness?"

A slow smile came briefly to his face, eyes still closed. "Don't worry, Maria. I'll thank him."

"I knew the ride here would be hard for you, but David, I have to know. Are you so quiet because of the weakness? Or is it because he's Spanish?"

He opened his eyes. "In a word, Maria—both."

She untied a soggy bundle of clothing and found a pair of dry hose well inside, stripped off the others, and began pulling on the dry ones. "We're here, darling! In our own place. Can you believe it?"

"When *he's* gone, I'll believe it."

She could hear the chain, then the wooden buckets, clatter against the stone rim of the well out back. Peeping from the window behind David's bed, she saw Herrera disappear through a rear doorway into another room—probably her kitchen—with water. The kitchen must be inside. She would have to cook like a poor Spanish woman, breathing her own smoke. Oh, well. Herrera reappeared in the yard with an ax, strode toward the small woodpile, selected a dry knot of pine from underneath, and began to split off slender splinters for her cooking fire, sheltering them from the rain with his body.

"Why don't you join him, Maria? I can smell your curiosity."

David's voice puzzled her. It was weak, of course, but as well as she'd thought she understood its every nuance, she honestly couldn't tell now whether he was amused or bothered by Herrera's help.

She sat down on the bed beside him. "You'll be chopping our wood in no time," she said, smoothing back the damp curls from his forehead.

"You bet I will! And it won't be as hard as hearing him chop it, either."

She was no longer puzzled; he was bothered.

"I've built up the fire in your kitchen stove, señora," Herrera said, appearing in the other of the two main rooms. "And now there is water, too. What can I do further for you?"

"I don't see how you could do more. And you got so wet doing it! I don't know how my husband and I will repay your kindness."

Herrera laughed softly, uselessly brushing at his wet clothes. "With friendship, as I said."

Maria glanced at David. His eyes were closed again, and he lay quite motionless.

"Do not worry that he is not yet able to talk," Herrera whispered. "The ride in such a storm was long for a sick man."

Slowly, David opened his eyes and turned his head so that he looked directly at Herrera. Then, with a hint of his old charm—in a voice that puzzled Maria all over again—he said, "I . . . am grateful to you, sir. My wife and I both thank you."

Herrera moved swiftly to the bed and laid his hand on David's shoulder. "I wish you good health, Sergeant."

"A vain wish, sir. I'm no good anymore," David said. "The ride almost did me in. But that was only part of the reason for my silence." The tired eyes almost smiled. "I'm . . . just not accustomed to thanking Spaniards. I've been killing them, you know, for quite some time."

"*Sí*, Sergeant," Herrera laughed. "I understand you." He held out his hand to David. "Now, I will go. Your wife will want you in dry clothing, if there is such to be found."

David hesitated a moment, then shook his hand. "No," he said, his voice surprisingly firm. "Don't go yet. I have more to say. I—I've—been sorting out my thoughts a bit. I want to say that—I learned something as we rode along."

Maria watched his face closely.

Looking straight at Herrera, David went on, "I realized how much my wife and I will need friends here. You see, I'm married, sir, to the most remarkable woman on the face of God's earth. She could be nothing else and put up with me as she's done all these weeks. I—haven't been easy. I'm still not." With effort, he raised himself on one elbow. "What I'm saying is that I hope you'll help spread the word in St. Augustine that Mrs. Fenwick is not only a remarkable woman, she's also a skillful midwife."

"David!"

"I can tell you're a man of influence, Herrera. Overheard you talking on the way here about being one of the few Spaniards staying on. You must stand high in the esteem of both governments. You'll oblige me by letting it be known that my wife is a fine female physician."

"David, please stop talking now—and rest! You must excuse my husband, Don Luciano. He's terribly prejudiced."

"Nonsense," David said. "The truth is I'm—*not* getting well. My wife cannot stay around this house day in and day out watching me waste away. It'll be the death of her. She needs her own work to do. She'll need money."

Maria stared at him.

Herrera said, "I understand, Sergeant."

A soft knock at the street door caused Maria to jump to her feet. That would be Jesse Fish about the rent money, and David had already talked too much.

"Allow me," Herrera said quickly.

From the street door in the adjoining room, Maria could hear him conversing in Spanish with another man.

In a moment Herrera closed the door softly and returned to the bed alcove. "It is Don Jesse Fish. He will come again tomorrow. As will I." He turned and looked straight at David. "I will remember your request, Sergeant Fenwick, but"—the smile flashed—"we will not permit you to 'waste away.' You will grow well and strong again soon. I am at your service, *amigo*. And yours, *señora*."

He bowed and let himself out the door, and while the sound of horses faded down the sandy lane, Maria put her arms around David. "What made you say such a thing, about not getting well?"

"I'm *not*," he whispered hoarsely. "I—almost fainted—twice on the ride here!"

"But in all the weeks you've been ill—far more ill than you are now—you've never once said a word about not getting well! David— what made you say it now?"

"I don't know, except halfway here on that horse, I felt it was true. I'm so—weak, Maria. I'm not a man anymore! 'Tis true you'll have to live somehow when I'm gone."

A frightened, anxious wife was the last thing he needed, so she kissed him, then began to unbutton his damp shirt.

Maria seldom had to fight tears. She was fighting them now as she rummaged in first one and then another of their soggy bundles. Finally she found a nightshirt, removed his breeches and shirt, and pulled the dry garment down over his head. He let her work as would a small boy, not exactly happy with what she was doing, but because he had no choice. With the one linen towel she'd salvaged, she began drying his hair.

He said nothing during the vigorous procedure, but she felt his shoulders shake, and the more she rubbed the more fearful she became that he had gone into one of his weeping spells.

She stopped, towel in hand, to look at his face. He was laughing! Not his merriest laugh, but laughter just the same. "David Fenwick! You're more than I can handle sometimes. What's so funny? You've just scared me half out of my wits talking about not getting well, and now—" She hugged him again. "Oh, I'm relieved you're laughing, dearest, but—what's so funny?"

He touched her. "You are—funny and beautiful and strong and determined and wise—and mine."

"But, David—a moment ago you thought you were dying!"

As though he hadn't heard her at all, he asked in an almost lilting voice, "Don't you think it's dark in here, love? Since your Spaniard started a fire in the kitchen, how about lighting a lamp from it? The better for me to look at your face. I don't like you in shadow."

In the kitchen she stood for a moment struggling to adjust. The quixotic transformation took her off balance. Such swift changes had never stopped surprising her, but this one was too quick. Almost without seeing, her troubled gaze took in the small, low-ceilinged, sooty room that would be her kitchen. The typical stone counter stove stood along one wall, and above it, spaces in the thatched roof let in the rain, which was still coming down. She felt like weeping. Her body ached with fatigue, and hearing David speak of death for whatever reason had drained away what energy she had left. Was he delirious again? Was the fever recurring?

She selected a lighted stick of pine and carried it carefully back to where he lay, eyes wide open, studying the ceiling above his bed as calmly as though he had just stretched out for a rest. Even in the half-light, she was certain that his face showed more color. More than a hint of the clean, rosy glow which had kept her wanting to touch him every moment since her first sight of him. Still, she wanted to cry.

On the small table in the front room, she found a lamp with oil in its saucer, pinched off the burned wick, and touched it with the flaming splinter. The shadow of the high wooden bed leaped up and bent across the board ceiling.

"There, now. Is that better, David?" She brought the lamp to the bedside and placed it on the floor.

"Move it out just a bit," he ordered gently. "You're still in shadow."

She moved the lamp, then buried her face in her hands and burst into tears.

"Maria! Oh, Maria, come here!" He turned her toward him on the bed, pulled her hands from her eyes, took off her mobcap, and held her face against his shoulder. "Love, love." He spoke softly, his hand smoothing, caressing her dark hair as it spilled down over her shoulders. "At the behest of all the wee red men in the glen, I would not hurt ya, Maria." He lapsed tenderly into the Irish country speech that never failed to melt her heart. "Y'er worn to a frazzle carin' for me, love. What harm is it that ya spill a few tears for a change? Yer husband might even find strength for a bit of comfort."

He held her in his arms, and for the first time since he had fallen ill, she allowed herself to cry. The arms about her were not strong, but they were gentle. She could count on his silence, not because she'd cried often, but because she had never known him to speak in any tender moment when silence was more eloquent. After a while her sobs lessened, but she kept her head on his shoulder. The rain was coming down harder now, sweeping across the thatched roof, and an uneven succession of musical drops leaked through and plinked on the loose boards laid across the rafters to form their ceiling. She could feel the tenseness leave her body. The taut control which had kept her functioning eased, even though a knot of fear remained because of

what David had said about dying. What on earth made him say such a thing? Slowly she lifted her head to look at him.

"David—don't tease. Tell me the truth. You did frighten me when Don Luciano was here. Now look at you! Do you suddenly feel stronger? Or are you pretending?"

He grinned sheepishly. "To be honest, wife, I—uh—I don't want to tell you."

"But why?"

"For fear I'll sound the fool. On that horse, Maria—in the devil's own downpour—I swear to you, I felt that I was not going to live."

"But now, David? How is it now?"

His green eyes grew misty in the lamplight. "I know I sound like a madman and I don't understand the change myself that came over me—all in a minute or so—but I wouldn't give you tuppence for the idea of dyin' now, Mrs. Fenwick."

"Thank you! Oh, David, thank you!"

"Don't thank me, love. I'm as puzzled as you are. It had to be God and the wee red men that did it—who worked the miracle. They led you to a true enchanted castle when they led you to this little hut. 'Tis filled with healing! I swear, I feel some better under this"—he looked up—"dripping roof. Thatch, is it?"

"Yes, David, yes—it's thatch. And who cares if it drips?" She caught his hands. "Who cares about anything, except that you're better? You're better and at last, at long, long last, we're alone. Only us, can you believe it?"

He jumped. "No! I don't believe it—and neither will you! Look at the beast—slap it, Maria! On my foot."

The biggest palm beetle Maria had ever seen scurried across his foot and up his leg. She slapped twice but only stunned it, so that in a split second it had scurried over the creases in David's nightshirt and sat waving its antenna on his bare chest.

He whacked hard—pummeling himself until she shouted, "Stop! It's gone—you're not hitting the beetle at all. It's vanished into the headboard!"

David sank back on the pillows laughing. "Now, which fairies d'ye think kicked that thing down on us out of the thatch?"

Before Maria could answer, something hit the back of her neck and she leaped to her feet, batting a second beetle right onto David's bare chest. Clap! Her hand closed over it and she sat motionless, laughing too, now, in spite of the insect trapped under her hand. "They're so quick, I'm afraid to let it go—what'll I do, David?"

"Don't squash it—they stink. Toss it out the open window."

She threw the wriggling bug out, then sat back down beside him. His face grew suddenly solemn. "How I thank you, Maria."

"For trapping the beetle?"

"For all you've done—to care for me. For all you've been. Thank you for having such a low, singin' voice and deep woods eyes. I don't deserve you, Maria. No man does."

She sat up. "The playtime ends when you begin to talk nonsense about not deserving me!" With no warning, she wanted to cry again. "Not I nor any other woman deserves *you,* David. Not even the tip of your little finger—least of all your beauty, inside and out. Are you hungry?"

"I think I'm starving."

"That's the best news yet!" She hoped her voice was cheerful, that she wasn't going to burst into tears again. "Your quartermaster sent both beans and potatoes. Which kind of soup shall I make?"

"Potato. But, wait—listen. Do you hear what I hear?"

"Just the rain leaking through on our rickety ceiling."

"Tune your ears, love. There's a talking tree outside!"

She was too near tears again to play at his Irish game. "It's only a palm tree rattling its fronds in the wind. I'd better build up my kitchen fire before you faint from hunger."

"Aye," he said, in no hurry. "We mustn't waste the grandiose Spaniard's kindling, but listen. 'Tis a true talking tree, and in a day or so—maybe even tomorrow, if the rain stops—I'll feel up to doing a bit of inspectin'. Wouldn't surprise me if we also have our very own gentle bush—a tree planted by God through a bird or a squirrel—a tree not touched by the hand of man. A talking tree and a gentle bush to boot, Maria."

"Will you keep up those expectations while I'm all the way out in the kitchen making supper?"

"That I will, and more—the expectation of sleeping this night beside my wife—in a bed. You see, love, we're going to have no more sadness at all here. We'll be only happy." He grinned—and yawned. "Every single one of us. You, me—and every beetle in the thatch above our heads!"

Maria put the pot of soup ingredients over the fire hole, and for nearly two hours, the rain still coming down, she worked at cleaning the primitive little kitchen. On her knees, she scrubbed the old stone floor with a worn palmetto brush found in the woodshed. She felt quieter now; the weeping was passed. Her decision about the house still felt exactly right, and judging by the almost miraculous change in David, it had been. The little house was going to do just fine. He'd slept deeply for all the time she'd been cooking and scrubbing—no nightmares, no twisting and groaning. These moments alone, her soup simmering in Señora Gonzáles' big iron kettle, were resting her inside. The soup smelled good.

Maria was hungry, too.

5

Every other day, Maria walked to Fort St. Mark for their military rations. The quartermaster was more than generous in their allotments, but when she could carry something extra, she stopped to bargain in sign language with a Spanish family for a mess of pole beans, a head of cabbage; occasionally she bought a fish at the market on the Plaza, now called the Square. Once she even surprised David with a fine melon, ripe and ready to eat.

During those first blessed days in their house, he had experienced no more weak spells and spent much time in their garden behind its protective stone wall, planning what he would grow once he could use a spade again. The remainder of the time, he dozed in the shade of the orange grove. Over and over he vowed to Maria that he was going to be one man who suffered no recurrence of the fever. He confided that he'd found not only the talking tree in the garden—a palm, as Maria had guessed—but his gentle bush, too—planted, he was certain, by a wild creature, not a man. The gentle bush was a fat little wide-spreading fig tree that grew against their house, and laughingly, he assured her that the gentle bush gave him the good feeling about getting well. He'd done no other work yet, but he had carefully loosened the sandy soil around the fig, and he watered it almost every evening when the sun went down. She wondered if his time alone with his talking tree and his gentle bush might be much the same as her own private times in her green and secret place?

She scrubbed every inch of the cottage. The windows shone, except for pollen streaks which had been there too long to erase. Little by little, as David felt up to it, they were going to patch four broken shutters, repair the hinges, and shingle the roof so that when winter came, they could close up the little house, light logs in the fireplace David would have built by then, and settle in for long, cozy evenings. She had even painted their privy a soft, pretty blue inside and out, had made herself a new bodice and two shifts, and had cut out two top petticoats—all within the first week.

She was convinced that being in their own home was healing him. He slept soundly at night and more often than not was still sleeping when she got up a little after dawn to add fat pine splinters to the embers in her primitive cooking stove. The morning moments alone were peaceful for her. Standing at the kitchen window waiting for the pine to flare so that she could lay in oak, she would watch the trees grow green in the spreading sunrise. Then, while hard wood caught, she would slip back into bed beside him and think.

These times that she had to herself became important for planning ahead. Little could be done about the Spanish furniture, which,

though simple and not expensive, was heavy and dark for her taste. But she was determined to do all she could to make the house comfortable, to give it a good British feeling of home.

For the past three mornings, a temporarily buried idea had begun to surface. She was not ready to act on it yet. There was no hurry. Barring a miracle, David would not be able to return to active duty for two or three months, according to the military surgeon. It was still just the end of July, and his present term of duty would not be up until December, but more and more, she wanted him out of the military once and for all. At her kitchen window or lying beside him, she would test the idea, giving her love for him a chance to guide her, to force her to be certain that her desire was not motivated only by her own ambitions for their future. The last thing she ever wanted was to run ahead of her husband. Being careful not to run ahead of one's husband did not seem a difficult restraint for Ann Cameron, nor would it for most women, she supposed. But Maria, well aware that she had a mind of her own, knew above everything else that, where David was concerned, it must always be gentled by love. The love would always be there; the one absolute around which she could safely permit her own ambitions to circle. What to her might seem practical and right could be all wrong and cruel if it would in any way hurt David, or diminish his self-respect.

The recurring idea was centered on him, heaven knew, but the more she dwelt on it, the more convinced she became that it was good generally—good for her, for their financial future, and for David himself. The delicate part of it would be her timing. Her natural impulse was to begin at once to convince him—and that was the last thing she should do, of course. He had never entertained a single thought, she was sure, of any life for himself outside the military. A mere hint from her now—at any time—that he might consider asking for a discharge would come as a shock. His devotion to the King, to Captain Hedges, and to his regiment was total. So was her desire to have him out of the army forever. That needed no more thought. He had come too close to death in Havana, once when a cannonball blew apart, killing the man next to him, and again when

the fever had struck. True, everyone lived with the specter of death, but David must be in the safest possible work—because he was David, her own life.

This morning, he stirred earlier in the bed beside her, and as was his habit, now that they could sleep together, he pulled her onto his shoulder and settled for another snooze before really coming awake. She had tended to her stove, and now David himself filled her thoughts. Not very well-directed thoughts this morning, but fleeting and lovely, like stars or twinkling jewels tossed at random across the surface of her mind. Happiness thoughts, lighted by the bright and continuing wonder that David loved her. He'd be awake in a moment, ready for another day of playing his garden games and finding ways to make her laugh. A doggedly loyal—but quite unmilitary—man, really. She gave a brief nod to the idea that David should apply for a land grant *now*. Soldiers were eligible for grants within the city limits, she'd learned from Captain Hedges, and by December, when his present term of duty was ended, there was a chance that David would value his new grant so much he might well consider her suggestion that he leave the army, as farfetched and wild as the plan would undoubtedly seem to him when she first shared it. As a civilian, he could apply for a large grant of land anywhere in East Florida and become a prosperous planter.

The thought was indeed brief—he was stirring again, kissing her hair, making comfortable, intimate, familiar noises into the pillow. Her plan faded.

Walking briskly past the Square the next day, on July 31, Maria heard Don Luciano call out to her. There was an urgency about his voice. She waited.

"I am fortunate to find you, señora," he said. "There is news which concerns Sergeant Fenwick. I planned to visit him this afternoon, but perhaps it is better that he learn the news from you."

"I am trying to protect him these days, unless, of course, it's good news. In which case, it might be well for you to tell him yourself, Don Luciano."

"You are a woman of tact. But do not worry. Sergeant Fenwick and I will be friends—truly friends, any day now. He is a disarmingly honest and straightforward man. I like him." He grew more serious. "The news may be good or it may be bad. Your Captain Hedges is no longer in command here."

"*What?*"

He pointed to a schooner lying at anchor across the bar. "That is the ship which will this afternoon take the captain to London."

Maria was staring at him, a deep frown creasing her high forehead. "What in heaven's name has happened?"

"The vessel brought to St. Augustine the new British officer in charge. Major Francis Ogilvie, who brought with him his Ninth Regiment of Foot."

"Oh, this *will* upset my husband! Not that we don't need more soldiers, but Sergeant Fenwick is so attached to Captain Hedges. So am I. He's been more than kind." She looked at him a moment. "You're frowning too, Don Luciano. Does the change in command also concern you?"

"His Excellency, Acting Governor Felieú—every Spaniard here of influence—found Captain Hedges most agreeable. It does indeed concern me, but that is not the end of the news, señora. Your husband's regiment is to be drafted into the Ninth. There is to be no more representation of the Royal First in the province." He reached for her bundle of rations. "Allow me to help, señora. I can see that you are shaken by my unfortunate announcement. I will walk along to your house."

"No. No, thank you. I—prefer to go alone. I'll need time to think this through. To think how to tell my husband . . . surely the draft will not take place at once!"

"It has already begun. One rebellious man is in the stocks now. He pointed across the Square. "Over there—by the guardhouse. The man is there because he objected noisily to leaving his old regiment."

"Who is it, do you know?"

"I do not know his name."

She straightened her shoulders. "Well, thank you, but you must excuse me now. I want to be sure no one else breaks this dreadful news to my husband."

He bowed. "If you have any doubts as to the truth of my information, señora, I suggest you cross the Square to see for yourself that one of the Royals is in stocks."

Shifting her bundle, she extended her free hand. "I have no doubts about anything you tell me, but I may go anyway. It's sure to be someone we know. My husband will ask."

When Maria reached home, she found David cutting weeds in their garden with the old scythe he'd spent part of yesterday afternoon sharpening.

"Dearest, you've cut so much in the short time I've been gone!"

"And you warned me not to do but a bit at a time. I know, love." Beaming with pride, he wiped his brow with his forearm. "But you forget I'm skillful. A lot of weeds fall with very few swings of the blade." He leaned the scythe against a tree, sat down in a shady spot, and patted the ground beside him. "Have a seat, Mrs. Fenwick. One day soon I'll make garden chairs, but for now, I've cleared a spot under our finest orange tree—just for you."

She sat down and was immediately in his arms.

"Tell me now," he said contentedly, after a long kiss, "was my quartermaster generous with us today? I'm hungry. Did you see Captain Hedges?"

"Captain Hedges wasn't there."

"Oh? At Government House pacifying the Spanish governor for one thing or another, I suppose."

"David, Captain Hedges is leaving today—for London."

He sat up, his face stricken.

"He's aboard his ship now, waiting for the tide. A new commander is here—already in charge. A Major Francis Ogilvie. It's all been very sudden."

"I'd say so," he said hoarsely. "Otherwise, I feel certain Captain Hedges would have sent word to me." His voice was halting, flat, his mind trying to grasp the news. "Maybe I'm presumptuous to think that, but it isn't like him at all to take his leave—without a word, is it? Why, his appreciation for your work as a nurse in Havana would have—" He broke off. "Maria, who told you this?"

"I met Don Luciano on my way home."

He moaned. "My friend, the too pleasant Spaniard. I wouldn't trust that man not to lie—or to repeat gossip if it would be of use to him."

"He's an important man in the city, and his information is correct."

His face drawn and white, David got up and began to pace the yard. "I know my orders from the company surgeon are not to leave our place, but I've got to talk to someone in the regiment. How would Herrera know for certain about a change in command?"

"I haven't told you everything. Major Ogilvie's Ninth Regiment arrived with him as reinforcements."

He stopped pacing. "Well, we needed them."

"Please sit back down."

"I can't."

"Dearest, the Royals here are to be drafted into the Ninth. There is no longer a Company of the Royal First Regiment of Foot in St. Augustine."

He stopped again and glared down at her. "That's just not true! I don't believe a word of it! Your Spaniard can't be right on that, Maria."

"He is right," she said as gently as she knew how. "I have proof. He told me one of our men was in the stocks because he objected loudly to leaving his regiment. I walked across the Square to see for myself. The man was there. It was James Cameron."

For a long time, David said nothing, but stood staring at the ground, the muscles in the clean, strong angle of his jaw jerking angrily.

"David, oh, David—I'm so sorry!"

He turned his back. "Don't be—careful with me. I won't have it! I won't have my regiment swallowed up in a strange one, either, do you hear? Herrera's lying. Even if you saw Cameron in the stocks— it's some trick of the Spanish governor to demoralize us!"

"You're talking nonsense, but go on—if it helps."

"It's beyond what a man can believe that His Majesty would ever permit one company of his Royal First Regiment—one of the main reasons Britain was victorious in Cuba to—to—" He stopped, shoulders sagging, then turned around and gave her a look that tore her heart. "I'm raving. I know it . . . if you *saw* James Cameron—with

your own eyes—then I'm raving. But, Maria—why James, in the name of God? James of all people!"

"Evidently he was as enraged as you are. I wasn't permitted to speak much to him. I had to walk back and forth in front of the stocks, looking the other way, tossing questions over my shoulder. James told me he'd lost his head—shouted at Ogilvie. He hates the man already. I guess he let him know it."

David choked out a bitter half laugh. "Quiet, submissive James Cameron," he muttered. "Well, if he flew off the handle like that, it's not so surprising that—that the blow felled me, eh?"

"No, David. That's why I made sure no one else brought you word."

He picked up his scythe and let it fall to the ground. Then he squared his shoulders, turned, and hurried toward the house.

"Leave me alone, please," he called back.

Maria started to follow anyway and got as far as the door; then she returned slowly to the garden, forcing herself to obey him. He undoubtedly did need to be alone for a while. Unwatched.

Not knowing what else to do, she picked up the heavy scythe and finished cutting the weeds, raked them into a pile in one corner by the stone wall, and sat down under the orange tree.

Heartache for David was like death for her. She had watched him suffer so physically that the thought of him suffering now in his spirit was almost more than she could endure. She longed desperately to help, but by some means she would force herself to wait. He was not insensitive; he would not keep her waiting any longer than he had to.

She sat staring at the stubby, wide-branched fig tree growing crookedly against the side of the house. The tree David called his gentle bush. "Help him, gentle bush," she breathed. "Help him—because I can't."

And then the thought struck: Why not? Why wouldn't this be exactly the right, the hopeful time to persuade him to leave the army altogether? To ask for a discharge when his term of duty was up in December might be far easier for him than to become a part of a new regiment under a commanding officer whom even James Cameron despised. Besides, the government needed settlers as well as soldiers.

She started for the house, then stopped herself once more. Her own impetuous spirit must he controlled. The summer silence of the garden was broken into by a sudden burst of song from their pet mockingbird—so loud, it had to be very nearby. At any other time—and if David were with her—they would have laughed. She looked around for the bird, tamer than most, hoping the raucous spurt of music had not jarred David, alone inside the house. The bird sang again, the same ear-splitting phrase repeated four or five times, and then she saw it, perched on the topmost twig of the fig tree.

After a while, David appeared at the back door, plainly looking around for the bird.

"There it is," she said. "On top of your gentle bush."

He only half grinned and came directly to where she sat under the orange tree. "I love you, Maria," he said simply. "And I thank you—*and* our mocker."

He dropped down beside her, and for a time they just listened to the bird. When it unmistakably chortled something that sounded exactly like *hee-haw,* David sighed and smiled.

"Mockingbirds love figs," he said. "An ancestor of that noisy scoundrel probably planted our gentle bush." He took a deep breath. "I'm all right now, Maria. I won't object to being drafted into the Ninth. Such action must be known to His Majesty. He's my monarch. I'm sorry I acted like a spoiled lad."

"You did not. You just acted human." She took his hand. "Wonderfully, completely human." Then, "David?"

"Hmm?"

"I had a thought—a moment ago."

"Oh?"

"I'd enjoy so much being married to a landowner. Maybe even a big landowner."

"Instead of me? Can't say I blame you."

"No—to you as a landowner!"

He responded with his infectious laugh, the one she had never been able to take for granted.

"I'm serious, David. Soldiers are eligible for grants. The colony desperately needs settlers."

"Aye, but how can an active soldier farm the land?"

"As long as there are no hostilities, you have time to yourself. Even with the Cherokee troubles in South Carolina, you had lots of time to work with Papa."

"I believe you're serious."

"Quite, but—we don't need to decide now," she said in what she hoped was a casual voice. "I could inquire about grants, though—sometime."

"From Herrera?"

"Oh, I don't know. Someone. Perhaps even Major Ogilvie himself."

"Not until I'm well enough to return to the regiment. Or . . . be drafted, or whatever it is awaits me now. Anyway, it's a man's place to do that. If I think well of the idea later, I'll take care of it."

She settled more comfortably on the ground beside him, laid her cheek against his shoulder, and felt his arm slip around her. Better to let matters rest for now. Even though she hadn't gone so far as to mention his leaving the military, he'd been more receptive to looking into the possibility of a grant than she'd dared hope.

"I was just thinking about poor Cameron," David said. "Being fastened in stocks rubs a man sore in more ways than the gouges on his wrists and legs."

"Oh, David, I don't know which seemed worse for him—the terrible heat or the terrible humiliation. I wanted so to wipe his face with a cool cloth—sweat was streaming into his eyes. His wrists locked in fast." She sighed. "Poor Ann's beside herself with worry, I'm sure. Were I in her place I don't think I could bear it, David! Should I walk back to the fort and try to find her? Bring her here with us until James is free again?"

"No. Stay with me. I'm—acting braver than I feel about all this." He got up abruptly. "There. You see how selfish I am? Forgive me. I'm sure Ann does need you. Everyone needs you."

She allowed him to pull her to her feet. "Then should I go now?"

"Yes, now, love. Bring her here. I swear I hadn't given a thought to the good Ann." David kissed her. "If you happen to pass James again, tell him—tell him I'm thinking about him. And, please, if you get a chance, with *anyone,* put in a good word for the man."

Maria had walked no more than three blocks up Marine Street when she saw Ann Cameron hurrying toward her.

"I know, Ann," she called, hurrying, too. "I know, I've heard."

In view of some Spanish children playing in the street, she embraced her friend. "I went by to speak to James."

"They let you? Oh, Maria, I tried to talk to him—his wife, mind you—the soldiers forbade it! New guards I'd never seen before. How did you manage?"

"By slowly walking back and forth in front of him and speaking carefully over my shoulder. I was stopped once, too, but I pretended I had an errand on the other side of the Square, then came back and spoke to him again. James answered me while staring at the ground. His only thoughts are of you, Ann. But you must *not* try to see him again. Things will only go harder for him."

"His poor legs and arms clamped between those splintery boards—in full view of everybody!" She burst into tears. "James, my good, kind James, who's never hurt anyone in all his life unless ordered!"

Maria led her to one side, away from the children. "Ann, you're coming home with me. I was on my way to get you. David's better. He'll welcome seeing you."

"But does he know about James?"

"Yes, I've told him. It was a ghastly blow for him, too, learning about the Royals, but he handled it rather well, I thought. Very well, for a man who's been so ill."

"Maria Fenwick, you should have heard my James! I declare, I'll die if he has to spend the night in those stocks, but oh, I was so proud of him!" Ann marched along, her head high, recounting the scene. "I was proud of the way he shouted his outrage! 'A man gives his heart and his life to his regiment,' he said. 'He kills and he fights and he suffers for loyalty to it, but he doesn't see it snatched away before his eyes without a tussle, sir!' And, Maria, he was shouting all this right at that starchy new Major Ogilvie, mind you! 'A man,' James went on, 'if he is a man, doesn't give up such loyalty on a whim!' And when he used that word *whim* was when Ogilvie's face got red and he bellowed out

orders to throw my sweet, strong, peaceful James in the stocks!"

"You must be proud, Ann. Really proud."

"I am. As proud as ever in my life. But, oh, Maria, our husbands are *not* going to like serving under Major Ogilvie one bit. He added insult to injury by ordering a member of James' own company to take him off to the Square. This Ogilvie is a rooster-necked, scrawny-faced beast without a heart!"

Maria took Ann's arm. "Ann, listen to me. I've already planted a seed in David's mind about applying for a land grant. He didn't altogether reject it. Why doesn't James do the same?"

Ann shrieked, "Fastened in stocks?"

"No, be quiet. Please try to think straight. He won't be kept there even tonight, I'm sure."

"But what you don't believe is that this Major Ogilvie has no feelings!"

"I do believe it, but—"

"He just understands figures and battalions and companies and weapons and rations. Why, he's already cut our rations! I didn't tell you that, did I? Cut our rations, and he only took over late yesterday."

Maria stopped walking. "Ann, listen to me. If you value our friendship, you'll do as I say now. We'll talk later. I've just had an idea. Go straight down to the end of this street and turn right. The first cottage, the only one with a thatched roof on the north side of St. Francis Street. Go stay with David and wait for me."

Ann shuddered. "By that evil monastery on St. Francis Street? Are all those crosses and monks still there?"

"Yes, but they won't bite. Please go, Ann. Now. I have something to do. I've just had an idea about how to help James." She kissed her friend's cheek. "Run on. Talk to David, but don't upset him too much. You look after my husband and I'll try to find some way to help yours."

Maria had no idea where she might locate Luciano de Herrera or Jesse Fish, but there was just a chance that either man's influence could help, and after all, they were her only prestigious friends.

6

Relieved that David would not be alone while she was gone, Maria walked rapidly along the Bay and then over to the land-gate street, now renamed St. George, in the direction of the Herrera house. Without Ann on her way there, Maria might have had trouble concentrating on her own mission; but David was devoted to Ann and was sure to respond to her need of comfort. And consoling her would nourish his own courage.

Maria herself had been so stunned when Herrera told her the disconcerting news about David's regiment that she had neglected to ask any further questions. So far, both men had courteously kept her informed concerning events at Government House about which she would otherwise have been ignorant. Both men felt—and she certainly agreed—that the transition had, so far, been surprisingly peaceful. Not only were the Spanish people being forced to give up their homes, but their food supply had decreased, and the very sight of British officials in charge of the city which had been theirs for so long might well have touched off civil revolt. According to Herrera, some three thousand Spaniards were living in the city at the time of the abrupt change-over, almost all the men in the pay of Charles III, King of Spain. Only a few families had sailed for Cuba. Aside from the six army wives and the British military, everyone in town but Jesse Fish was Spanish, and he, of course, was far more a part of Spanish rule than of English. Or was he? In any event, Fish felt that the uneasy peace had prevailed because both Acting Spanish Governor Don Melchor Felieú and Captain Hedges had accommodated each other in every possible way. Felieú had vowed to remain at his post, departing the colony only when the last of his fellow Spaniards left. There was no doubt that his presence had helped. Heaven knew, Captain Hedges' way had always been conciliation, but if Ann Cameron was right, life under Major Francis Ogilvie

could be a different matter. Desperately the colony needed an appointed British governor.

Maria weighed all these things as she hurried up St. George Street. What mattered now was finding help for poor James Cameron, and her best, her only chance of doing that was through Fish or Herrera, or both. Surely Ogilvie knew that, in order to maintain calm in the city, he would need to grant favors to both these prominent men, so highly regarded by the remaining Spanish. Both Fish and Herrera might welcome an early chance of testing their influence with the new British officials as they began arriving at Government House. If anyone, she reasoned, could influence Ogilvie, these men could. Between them they controlled the procurement of two absolute necessities for settling the new British colony—horses and houses. Since Herrera had no way of knowing how close she and David had been to James Cameron, perhaps it was not surprising that he had not offered his help. It was no secret that men frequently preferred to be asked anyway, and that was exactly what she intended to do.

At the entrance to the Herrera house, she found herself hoping that Jesse Fish would be there. Maria had already learned that Fish stayed with the Herrera family when business detained him overnight in the city.

She had just reached for the bell rope when she heard the door open onto the inside loggia, and Jesse Fish himself unlatched the street gate for her.

"I saw you coming," he said pleasantly.

"Mr. Fish, I'm so glad you're here!"

"You flatter me, Mrs. Fenwick. Please come in. This is my second home. A great convenience as well as a comfort." He held the gate and then the door as she preceded him. "I was reared in this house, you might say. Learned Spanish here. The Walton company paid for my keep. The Herreras are my family, you know."

"No, I didn't." Maria glanced around the well-furnished, spacious parlor. "You lived here until you moved to your own place on Anastasia Island?"

"I did. From the time I was a boy of twelve. Luciano and I are like brothers. I'm several years his senior, but he has a mind I still struggle to keep up with. And I'd kiss the ground under his sister Antonia's feet. His father, Don Sebastián, is my parent, too." He motioned toward a cushioned, handsomely carved chair.

Seated, Maria decided she would go straight to the point. "I'm grateful for your warm welcome, sir, because I need your help. One of our best friends, Private James Cameron, is in the stocks. Unjustly. He's ordinarily a quiet, obedient soldier, I can assure you, but he simply lost control of himself when he learned that the Royal First Regiment would soon be swallowed up in Major Ogilvie's Ninth. I'm assuming you've already met Major Ogilvie."

"Briefly. He's only just arrived. There was a short, semisocial gathering at Government House today."

"And—was Don Luciano invited?"

Fish smiled. "There's very little you miss, isn't there? No, I'm sorry to say he wasn't. A decided mistake on Ogilvie's part, too."

"I see." She sat straight in her chair. "You and I are not the kind who waste words. Can you help? Might there be some leverage used with Major Ogilvie to free James Cameron? His wife is at my home undoubtedly weeping her heart out at this minute." She paused. "*Is* your influence strong enough to put in a good word for our friend? I promise I won't forget the kindness."

Fish studied the bare tabby floor. "I doubt that anyone would find it easy to sway Major Ogilvie. At least, that's my first impression of the man."

"So I've heard. He's what other Europeans call a condescending Englishman."

Fish nodded. "You already know quite a lot."

"Not enough."

"Well, I'll tell you why I've sized him up as—difficult, without much inclination toward compromise. During the first moments of the meeting today, he read aloud—as though to convince us—the written statement from General Amherst, in command, as I'm sure you know, of all the British forces on the continent."

Maria nodded.

"The statement informed us that it is the King's pleasure that Ogilvie properly exert his authority to punish all such persons as shall disregard His Majesty's orders. If your friend Cameron objected, then I'm sure that Ogilvie, with his literal mind, felt he was merely exerting proper authority."

"But it wasn't proper! It was unjust, cruel. This man's military record is flawless. He's the kind of foot soldier His Majesty needs so desperately. The colony needs him." She snorted contempt. "Oh, I'm sure he meant to be making James an example for the others—but we're wasting words, Mr. Fish. Do you think you can help me?"

"I can try, dear lady, but I promise nothing. One moves slowly, as I'm certain you know, in asking favors. One weighs the end result of having asked, so to speak."

She smiled. "I didn't bother doing that with you, did I?"

"The rule doesn't necessarily apply between friends."

"I hope I will never impose upon your kindness, sir, but there are several reasons—two at least—why I don't feel I am imposing. One, I know you have a vested interest in the ultimate sale of St. Augustine property. It's in your interest to help this man. The Camerons have money from the spoils divided in Havana. They can't look for a house until he's out of stocks. Two, until an English governor is appointed and has arrived, Ogilvie is in charge of the government. He will surely need favors from you."

Fish leaned back in his chair. "I appreciate your common sense, Mrs. Fenwick. And you have my word for it that I'll wait upon Major Ogilvie this afternoon." His eyes studied her intently. "Our mutual understanding can be of inestimable value to us both in the years ahead, I'm sure. Now, may I be of any further service?"

"I must get back to my husband and Mrs. Cameron, but since I so fortunately found you here, I do have another question or two. With the change in military command, will soldiers, in your opinion, still be eligible for land grants? As long as Major Ogilvie is in charge, will his interests lie in keeping the military occupied with army duties, or did you find him interested in settling the colony? I realize it's early to ask."

"It is, and I have no firm answers. Only my opinion. He strikes me as a rather typical military man, bound by regulations and an inflated

sense of his own authority. Of course, the British soldiers are, as of now, eligible for land grants, so long as they are in or near the city."

Maria smiled what she hoped was her most appealing smile. "Your opinion is valuable to me. You see . . . I need someone to talk with."

"I am indeed flattered."

"With peace and this new regiment just arrived, wouldn't you think it might be easier for a man presently in the military to obtain a discharge when his term of duty is ended?"

"That's an interesting question."

"And one I'll beg you to keep confidential."

"You and your husband know far more about the British military than I, dear lady, but my opinion would be that it might well be a rather good time for obtaining a discharge." Fish gave her a quizzical look. "You've made me very curious."

Maria stood up, as did Fish. Ignoring his last comment, she said, "I don't suppose you have any late word concerning the arrival of the Spanish agent, Puente? My husband and I are satisfied with the cottage and want to buy it. He plans extensive renovations."

"I regret that I have no word whatever."

"Well, the money *is* waiting."

At the door, bowing over her hand, he held it for a long moment, then said simply, "You're the—most unusual lady I've ever had the pleasure of meeting, Mrs. Fenwick."

Her low laugh was intended to disarm. "Well, then, in that case, I'll feel free to ask one more favor. I'm a professional midwife, and if I do say so, a rather good one. I want work here in St. Augustine. I'd be grateful for your recommendation, should you learn of the need for my services."

She left the house and walked out onto the loggia.

Fish followed her. "Luciano told me, and it was welcome news indeed. Alas, I'm a lonely man with no hope of either a wife or a child, but the colony will need settlers and soon. I can think of no more effective way to convince a prominent South Carolinian or Georgian that he should settle here than to be told of the excellent service you offer." He frowned. "In fact, Luciano's recently widowed sister, our blessed young Antonia Pérez, is nearing her time right

now. I doubt that the family will forsake the old Spanish woman who's presided, however brutally in my opinion, at Herrera births for two generations, but I pray so—especially now that I know of your skills." He bowed again. "You may count on me. There isn't a doctor in the whole city at the moment, except for the British army surgeon. And only the one ancient and quite ignorant midwife."

On her way home, Maria cut confidently across the Square to where the stocks stood outside the guardhouse. She slowed her step as she passed James Cameron and, in a loud whisper, gave him the directions to her house and assured him that Ann would be waiting for him there.

David, Maria, and Ann were just sitting down to supper when James knocked on the door of the St. Francis Street house—a free man.

Throughout the meager meal of corn bread, salt pork, and tomatoes, Maria said almost nothing. She waited on the others, rejoicing with Ann that her husband had been released but equally happy with the visible proof that her hunch about Jesse Fish was right. He was a major cog of influence in St. Augustine. There could be no doubt that, with his help, the Fenwicks were going to take their own place of prominence in the town.

7

On a mild, hazy, late September afternoon, David sat alone in a corner of the garden chipping at a pile of old coquina blocks with which he intended to build their chimney. Hating the thought of Maria cooking in a smoky kitchen, he had tried to convince her that the

kitchen chimney should be built first, but she would have none of it.

"Cooking is a thing I do because it has to be done and I'm your wife," she'd argued. "I take every shortcut. I'm in my kitchen as little as possible. What I want is a parlor chimney where I can sit beside my husband—and love!"

He smiled. He hadn't thought a woman otherwise as practical as Maria was apt to be as romantic as Maria. Such seeming contradictions in this woman who filled his world appealed to him. All that had ever been required of him when a difficult decision arose was a full discussion with her—seldom a problem for either of them—and then, should they not see eye to eye, to follow her lead in the matter. He did not do this out of weakness; David knew that about himself. He simply recognized that, nine times out of ten, Maria's decisions were more prudent than his. It had nothing to do with his manliness. As with his pride in her professional life, agreeing with her was no threat. He had his contributions to make to their marriage and she hers. The reason most men chose to boss their wives, as he saw it, was because they had not married women whose opinions they could trust. Following Maria's advice on a practical matter in no way diminished him, because in other areas of their relationship she followed his.

No one knew better than David that it was he who had taught her how to play. He was still trying to show her that following God meant joy, not frustration. Her normal high spirits, her musical laughter had attracted him to her from the beginning, but he soon learned that a lonely childhood and the early death of her vivacious mother had thwarted her ability to make games of the small events of everyday life. Her heart had embraced his own without hesitation or reserve, but it had required time for her to learn his quick Irish humor and rather mercurial mood changes. David's way had always been to jest first about a problem; then, if that didn't work, to turn serious as a last resort. Not that he took life's true solemnities lightly. There had always been an underlying reverence in his love for Maria, for God, for the King, and for the regiment, but to David's mind, when a man could laugh, by all means laugh. More than that, if a reason for a game or a joke or a smile could be invented, that should be done, too.

Maria had gradually learned to share his games and humor, and he had enjoyed watching her learn. The good Lord knew that David Fenwick had learned aplenty from her. They were created for each other, needed each other equally, and David liked it that way. He was glad there wasn't a domineering bone in his body, since he knew he was not a weak man. He was an instinctive man. Maria was the thoughtful one of the two, and that was fine, since he could be trusted always to give her joy and laughter and total devotion. He loved Maria Evans as she was, and glory be, she had shown no more sign of changing him than he had of changing her.

Even though physically he was still not himself, there was strength in his almost perpetual good cheer, and he knew it. There was strength in her good judgment and ambitions for their future, and he knew that. He counted on their separate contributions to each day.

His arm was beginning to ache from the monotonous chipping, and he was restless without her. Until his illness, the only times he was not restless without Maria were the hours spent on duty. Otherwise, he seldom missed male company; he preferred every hour possible alone with Maria. Heaven knew they'd had few enough. It didn't seem logical, he supposed, but he was contented even to learn St. Augustine through Maria's eyes. After all, penned up behind their garden wall as he had been most of the time since their arrival, he'd had no other means of knowing the city or what went on in it.

David suspected that once a duly appointed governor arrived, the city could well be the fertile ground from which his wife's dreams for their future could grow. If the truth were known, as long as he continued to drill and instruct his men well, deserving their obedience and trust, and as long as he had Maria, he wished for little more from life. Still, her ambitions intrigued him, and certainly she'd shown no signs of being careless with what funds they had; her managerial abilities ranked high in his estimation. Being a good soldier for pay was far more satisfying to David than managing the money once he'd earned it.

He was not at all bothered that they had no children and was, in fact, relieved that Maria had not made a fuss about it. He hoped she was being truthful when she vowed that he was enough for her, too.

A son or a daughter would make a man proud, but he doubted that he could be any prouder than he was now as the man Maria Evans Fenwick loved.

He picked up an armful of cleaned stones and laid them end to end to form a new row in the stack, ready for the day when he would feel strong enough to start building the chimney. Of course, the thatched roof would have to be torn off and replaced with shingles, but he had no doubt that he'd be able to lay a fire by the time the nights grew chilly. His stamina increased with the passing of every day.

Even though Maria was just inside the cottage working, too, he missed her. Usually she came out to check on him every half hour or so. Well, undoubtedly she was making good progress with her sewing, and he'd promised to let her work in peace until she was at a stopping place. His new uniform, just arrived, with the identifying coat of the Ninth Regiment—red-faced yellow with square lace—did become him, in spite of the weight he'd lost. Nothing would do Maria but that she must make herself a new outfit to match what she called his splendor. He'd much rather have had her in the garden, but her industry amused him, and in his way he backed her determination that they both make a good impression in the city.

He picked up a stone and began chipping again. A man married to a woman like Maria can't help but get ahead, he mused. Life was like that with her. She'd been one of the big reasons he'd fought so well in Havana. Not that he'd ever underestimated himself as a soldier, but no matter what he did, keeping in stride with her invigorated him, and he surprised even himself by continuing to enjoy it.

More and more often he found himself thinking about that land grant she'd suggested. Why not? He would undoubtedly have thought of it himself once he'd gone abroad more in the city. James Cameron had asked if being married to an outstanding woman like Maria didn't lessen a man's self-esteem. David had laughed. Without her to fill his horizon, he surely would have broken under the long confinement from the fever. And certainly he would have had a far harder time adjusting to the idea that he was no longer a member of His Majesty's Royal First Regiment of Foot. Maria left little room for self-pity or rebellion. She was at once a jolt of brandy and a gentle caress.

Perhaps best of all, he trusted her.

Still confined at home, away from his new regiment, David felt suspended between two worlds. He'd not even met the much-criticized Major Ogilvie to whom he'd be obliged to give obedience once he was back on duty. But today was not the day for dread of Ogilvie or anything else. He seldom indulged in dread anyway, especially when he was feeling so much healthier in his body. He laid aside his mallet and chisel. The important thing was that he no longer felt suspended between life and death. He was going to feel like himself any day now—vigorous and ready for whatever life in St. Augustine brought—with Maria.

Weary of the monotonous work, he stood up, yawned, and started for the kitchen just as a horse galloped up and stopped in front of the house. Then there was a loud, rapid knock and Maria's quick footsteps. For a moment, he listened to the unintelligible murmur of her voice in urgent conversation with a man. *Herrera.*

Not pausing to think why, David retreated swiftly, out of hearing, back to his corner of the garden by the stack of coquina blocks. A frown, so intense it made his forehead ache, creased his brow. Why didn't I just go in and speak to the man? he demanded. Why? I know him, too. He picked up the mallet and shattered a perfectly sound block with a fierce blow—an idiotic waste! But what could Herrera want with Maria? Why hadn't she called to her husband to join them? Didn't the grand man know a woman had her work to do?

David's frown eased. Those were silly questions. There was no reason on God's earth why he need feel either angry or uncertain. He had never been jealous of Maria. Why now?

Before he could collect himself and stride into the house like a man, Maria came running out the back door and across the yard.

"David, it's happened! There's a baby to deliver. Don Luciano's young sister. Her husband died just before we got here. She's not only still in grief, the poor girl's been tortured all day and half of last night by some ignorant Spanish midwife!"

He said nothing, but stood looking at her in a kind of embarrassed relief.

"David, what is it? I said I'd come—and there's no time to lose. I have to go *now*. The girl could die."

"Are you asking my permission, love?"

"No! I mean—well, yes."

He laughed. "I thought you'd given your word." But this was no time for teasing. He took her in his arms and held her hard for a moment, then whispered, "Go, by all means. But what about medicines—oils? Do you have any?"

"A few I've managed to keep. Don Luciano or Mr. Fish, who's there, too, can ride to the apothecary if I need anything else." She kissed him. "There's meat to fry and a pot of greens. Be all right, please? I don't know when I'll be back."

"Don't worry about me," he said warmly. "And God go with you, my Maria. I'll be waiting."

In the street, Herrera helped Maria mount his horse, then swung up behind her. She could feel his arms firmly as he held the reins, steadying her during the hard, fast gallop out St. Francis Street and up St. George. She noticed people gaping at them as they thundered along the narrow sand lanes, but from what Herrera had told her, nothing mattered now but haste.

Nearly there, he spoke for the first time. "Señora? You will save my sister's life? The baby, too, of course—but please—my sister's life?"

"I'll try," she answered, clinging for her own life to the horse's coarse mane, breathing a prayer for patience and wisdom—success—after having been away from her work for so many months. Already, she suspected that the old midwife had been trying to force the child, terrorizing Don Luciano's sister, whose pain would be unbearable by now.

"Is the other midwife still there?"

"No! She is gone. I sent her from the house."

Neither spoke again until Herrera opened the door into his sister's room.

Kneeling beside the rumpled, blood-streaked bed, a neighbor woman bathed the face of young Antonia Pérez and tried to restrain her. The girl was crying out, struggling to get out of the bed, an effort

to escape the pain by leaving the scene of it. Maria knew the tendency well.

She hurried over, motioned the neighbor away, and began her examination. Sensing that Luciano still stood in the doorway, she ordered him out, the neighbor, too, and closed the door. By some means the writhing, weeping young woman must be quieted. When and if Maria needed help, she could call.

Only a few by-waters had begun to dribble from Antonia's body. The blood streaks had been caused by strain and panic and probably by unmerciful, premature tearing of membranes which held the baby. She would not tire the girl further by asking, but felt certain the other midwife had been holding Antonia on her lap, trying to force the child down. Too soon, Maria saw in a moment. Much too soon.

"Do you speak English at all, Antonia?" she asked in a quiet voice. Antonia nodded.

"Good. We'll do fine then. You see, my dear, it just isn't your time yet."

The girl moaned. "*Dios mío . . .*"

"I can tell you've been forced. Don't worry, you won't be again. I promise. Your labor pains will continue to come—that's natural. But no more forcing. What you need now is rest. And I'm going to help you. Nature is with us, not against us. We're going to work with nature—not fight it, you see?"

Still terrified, the girl tossed her dark head from side to side on the tear-drenched pillow. "I . . . can . . . bear. . . no more."

"That's exactly right. No more now. I'm right here and I'll be right here helping you to get quiet, to rest. To . . . rest."

Maria poured oil of sweet almonds into her hands and began bathing Antonia's body—the distended abdomen, gently, slowly— the shoulders and neck, breasts, arms, legs. The young woman had not cried out again, but she still sobbed, exhausted, her body jerking as though some evil hand tugged at a cord controlling it.

"Rest and quiet, not pressure. Pressure is bad. We're not adding to the pain, we're lessening it. With this sweet-smelling oil over your body and peace in your heart and mind. Confidence in your heart and in your mind and in the bright, happy promise of the beautiful

child you'll hold in your arms soon. Peace, Antonia . . . rest and peace and confidence."

Almost imperceptibly at first, Maria sensed more than felt the spasms lessen. The legs became easier to lift and massage, grew softer, the muscles more pliable. The legs and the arms. The baby was still alive. As her hands slid over the big abdomen, Maria could feel movement. The child was alive and Antonia was alive, and for now, with the body tensions easing, all was well. The girl's breathing still came in gasps, but the sobbing had almost stopped.

Labor came normally now, the body heaving forward in a natural way, but between the pains, Antonia rested.

Now and then, from downstairs, Maria could hear Herrera speaking anxiously—to the servants, she supposed, or to the aging father. Only Don Luciano, Antonia, and their father were left of the family in the big house. Her heart ached for the girl, so newly widowed; too much of too many kinds of pain for one sensitive, frail human being to endure. Maria longed for success with this birth as she continued the deliberate comforting massage, her hands moving slowly to preserve strength in her own arms in view of what might lie ahead, as well as to quiet her patient.

It had been more than a year since she'd helped a new life into this strangest of all worlds, and minute by minute, now that the pains seemed a bit more frequent, she began to turn her mind toward what she knew of the God who created human life in the first place and conceived this agonizing means of bringing it into being. God, never an overpowering presence for Maria as she went about ordering her own days, had never failed to become almost startlingly real each time she gave herself, body and mind, to the delivery of a child, to the giving of solace and faith to a pain-racked mother. Feeling herself now somehow more than ever an instrument of God to the suffering and grief of this pretty young woman, her own faith firmed . . . faith in the fact that by some means—no matter where she found the baby when she searched, or in what position—this time she would succeed. The prominent, once large Herrera family was dwindling. Luciano was

not married, Antonia's husband was dead. The baby would be cherished. Luciano had begged that she save his sister's life, too, and with all her might, Maria would try to save them both.

After a while, calmer in both her mind and her body, Antonia confirmed Maria's suspicions: the old Spanish midwife had indeed hauled the girl from the bed onto her lap and had spent much of the night pushing and shoving against the swollen belly; had also torn at the tender fluid-filled membranes. The tear, Maria found to her enormous relief, was not deep. In a moment, the neck of the womb, made slippery now and less taut after applications of oil of almonds and a whole beaten egg, admitted Maria's fingers, well anointed, then her hand. Antonia had only sighed sharply. She had not cried out.

It was not quite time, but neither was it too soon to fix the child's position in her mind. Her fingers relaxed, Maria moved them only enough to determine that what she could feel was hard and of equal roundness—the baby's head. She breathed a prayer of gratitude. Unless the child thrashed about further and twisted itself in its struggle to enter the world, Antonia, in spite of her night of torture and maltreatment, could have a natural birth. Dear God, let it be. Let it be . . . in nature's time, and normal.

Once more, Maria was experiencing the freedom, the near exaltation of surrendering herself to a Power even greater than the miracle of the life which she and the young mother desperately willed. A Power both tender and fierce. . . .

"We will find a way to thank you, Señora Fenwick," Don Luciano said at dawn, as he helped her dismount before her own house. "I refuse to believe you will not agree to payment, once you have rested. Once you begin to understand what you have done for the house of Herrera."

Maria smiled wearily. "I *don't want* any money for this case, Don Luciano. And I'm too exhausted for an argument. Right now, the only thing that's important to me is to satisfy myself that my husband is all right."

He bent above her hand and kissed it. The sky was streaked with pink, she noticed, as she watched him ride off. It was good—working again.

She let herself in the street door, undressed slowly, and crawled into bed beside a sleeping David. He stirred, spoke her name drowsily, comfortably, as though she'd been right there all night. Then still not really awake, he drew her head over onto his shoulder in the dear, familiar way.

He was all right. She slept.

8

Although six more shiploads of Spaniards had sailed for Havana during the bright month of October, Maria was called to attend three births. Word of her skill had spread in the city, thanks to Don Luciano and Antonia, so that even Spanish women who feared to accept the services of a Protestant Englishwoman had sent for her. None had been easy births. All three women had insisted upon the priest's being in the room to pray for their souls because of Maria's presence with them. There had been one failure, and it was not Maria's fault. The baby was dead in the womb when she reached the house, but she'd managed to remove it and the mother lived. Her growing reputation was an odd one. Spanish women feared her religion, and yet, as she walked the St. Augustine streets, she could feel dark eyes upon her, both fearful and admiring, as though she were a witch.

David was much stronger these days and had been back on part-time duty at the fort for nearly two weeks. The men who had been ill with Havana fever were returning one by one to light duty now, and

no more had died, but she felt, in spite of David's cheerfulness, that nothing was the same for him in the new regiment. With all her heart, Maria wanted him to ask for a discharge when his term of duty ended in December, but she kept quiet. It must be David's decision, and these interim days until he could go back on full-time duty seemed hard enough. He had said nothing by way of complaint about Ogilvie, but David seldom complained. Still, she knew his silence sometimes meant that he was worried. He would never put it into words, but he seemed to believe that if a man couldn't say something cheerful, he should be quiet. She had respected his silence on the subject of his military duties and had tried only to keep a light heart as she sent him off each day, hoping that he wouldn't tire himself during his free hours by working too hard on their chimney.

By November, the chimney was finished, and the stack of cream-colored, freshly split cypress shingles bought from Fish with her latest fee was diminishing in the corner of the garden. David had begun replacing the thatch last week on the main roof of the cottage and it seemed that his spirits improved as every new shingle went down. A hopeful rumor was abroad that seemed to cheer him. Scottish General James Grant, revered and beloved by both soldiers and colonists from his leadership during the Cherokee wars in South Carolina, was being considered as the first British governor of East Florida.

If only it turned out to be true that Grant was to be their governor, everyone's spirits would rise, but now even those rumors were in short supply. Uneventful day followed uneventful day as though the entire colony waited, as indeed it did, for the end of this awkward period with only a high-handed military despot in charge. Maria had written twice to her father, but had no assurance that the letters reached him, since even a makeshift postal system waited for the arrival of the new governor. It was just as well, she supposed, that potential colonists had not yet begun visiting the city in numbers, because its prospects were dull until a civilian government could be set up. If more had come, surely Ogilvie's lack of grace and warmth would have turned them away. Herrera had told her that even those Spanish officials still in the city complained bitterly about

the poor table Ogilvie set on the rare occasions when he'd had no choice but to entertain them.

As the empty, somewhat anxious days dragged along, two more shiploads of Spaniards left, but only two British artisans settled in St. Augustine. Maria had had no more births, and the run-down little town grew more and more desolate. She might have become depressed except for her unwavering faith in the future, but it would help—oh, how it would help—if some word about the new governor would come from London. She no longer worried that David might have a recurrence of the fever, but as well as he seemed and as proud of the new roof—nearly finished now—he teased less and, for David, was often silent.

Early in November, Maria managed to persuade a Spanish housewife to sell her ten chickens. The chickens became a source of amusement, clucking and skittering about the garden. One little brown hen which insisted upon laying her almost daily egg in the kitchen in Maria's favorite iron pot, David named Have To. They enjoyed breakfast more than ever under the orange trees, not only because Have To made them laugh, but because David had built two sturdy wooden chairs for the yard.

As much as she disliked housework and shopping, a trip to the nearby market broke the monotony of her days, especially if she happened to meet Ann, looking also for fresh vegetables or fruit to break the monotony of dried beef and potato soup.

"Oh, Maria, I just don't think we're going to like living here at all!" Ann babbled one morning about the middle of November. "I've tried, especially now that James and I are in a house—even though it's with two other couples. I've really tried liking St. Augustine, but I'm just about to give up! Look at this dried-up produce."

"Stop grumbling," Maria snapped, searching through a thin pile of stringy turnip greens. "This is to be expected. We're going through a bad period and we simply have to live through it." She tossed the greens back and turned away.

"But we haven't found a thing to buy! Aren't you taking home anything, Maria?"

"No."

Ann hurried along beside her as she headed once more for the Square, where notices were posted at what the British now called Payne's Corner.

"Oh, Maria, are we going back there again? You know that notice board will be as empty as ever. I haven't caught the slightest rumor that a new governor has even been appointed! Much less that it's going to be that smart, kind, good-natured General Grant."

Then, in sight of the notice board, they began to run. At the same moment, they had both seen the white sheets of paper—four of them—four long sheets fastened with flour-and-water wafers to the board. Three off-duty soldiers, strangers, stood staring at the board, frowning.

The two friends merely nodded to the men, and Maria began reading in silence.

After a moment, Ann shrieked, "Maria tell me! You know I can't read! Is it going to be General Grant?"

"Yes," Maria breathed. "Yes, thank God it is."

"Oh, how I wish I could tell James," Ann said, jumping up and down. "How can we wait to tell our husbands, Maria? They'll both be on duty at the fort until after noon. I just know how it will help James knowing this. He trusts General Grant's judgment so much. I think he'll even agree to applying for a land grant, Maria. I really do. Honestly, I really, really do."

"Sh!" The last thing she wanted was for the three strange soldiers to learn of their plan for their husbands. Especially soldiers they didn't know. Soldiers gossiped more than Ann did.

The men had been eying them, Maria knew, but she couldn't figure out quite why.

Then one of them tipped his cap and said, "General Grant is it, ma'am?"

"Yes," Maria answered, curtly enough, she hoped, not to encourage conversation.

"We can't none of us read, ma'am," the soldier said. "Would you mind reading it to us?"

"All of this? I—I really don't have the time."

"Oh, that's all right," he said smiling. "Don't make much difference anyway what it all says, so long as General Grant's coming. Does it say when?"

"I—don't think so," Maria answered, scanning the long Proclamation. "No. There's no date."

"Sooner or later, I guess," the soldier said, taking his friends' arms as they strolled away.

"Oh, Maria, I just can't believe James and I might really get out of that old tumbledown house on St. George Street cooped up with those other quarreling couples! If General Grant's our governor, we will!"

"What does a governor have to do with the fact that you simply haven't gone out looking for a house of your own?"

"But, with the King so far away, it's a governor's place to see that the people have what they need."

"Nonsense." Maria sighed then and smiled into Ann's pretty, earnest face. "In a way you're right, I suppose, and General Grant will help many things. Many things. But you could have a house right now, the same as David and I have, if you weren't so dependent on the King and James."

"But have you forgotten my real reason for not hunting a house? Our plan to get our husbands out of the army? I told you I didn't think it was wise buying or even renting a house of our own when maybe I might soon have James persuaded to ask for his discharge and apply for a grant! Why, who knows? The Camerons might end up with an enormous plantation—away from St. Augustine. Do you think you and David will stay in the city?"

"I most certainly do think so. I intend to feed and clothe us by delivering babies. Fine chance I'd have of doing that out in the country somewhere."

"Oh. Well, I guess James and I won't leave the city either, in that case. I couldn't bear not seeing you."

Concentrating on understanding the legal wording of the lengthy Proclamation, dated October 7, 1763, Maria hadn't heard much of what Ann rattled on about. David would be hurrying home from the fort to work on their house and might not see the notice. She wanted the gist of it well in her mind so that she could tell him right off.

First of all, the British Government had decided to divide the territory known as Florida into two colonies, East and West Florida. Pensacola would be the seat of government for West Florida and, of course, St. Augustine for the eastern colony. Prospective settlers were to be drawn in as rapidly as possible, and by way of encouraging this, the Proclamation declared that the usual colonial civil governments would be set up immediately upon the arrival of the two governors.

"Maria, do you find it difficult to understand?"

"I'll have no trouble if you don't interrupt."

"Oh, I'm sorry, but I'm so excited I can't think. I'm going on up to the fort. Maybe I'll run into James. I simply can't wait to tell him about General Grant."

"Good idea, Ann." She patted her friend's shoulder, said good-bye, and resumed her reading.

There was more about the two other northern colonies which had just been granted to Britain—Quebec and Nova Scotia—but her colony, East Florida, was what mattered. She skimmed a passage containing the names of prominent Georgians such as William Knox, who had made one contribution or another concerning reports on various aspects of East Florida, then let her eyes move rapidly down the long sheet of paper until she found the name Grant again. Ah! This part would interest David. General Grant was already standing up for his new colony, though still far away in London.

In fact, it seemed he'd already won a victory for them. A victory concerned with boundary lines. At first, so far as she could make out, the British Board of Trade had recommended that the northern boundary of East Florida run from the mouth of the St. Johns River on the Atlantic coast west to the Flint River. The line would then run south to the mouth of the Flint, on the Gulf Coast. Under this recommendation, the old debatable land between the St. Johns and the Altamaha Rivers—about which Maria had heard all her life— would be annexed to the Georgia colony. Unwilling to accept this, General Grant had protested strongly in a memorandum in which he argued that such a plan would give Georgia the most valuable part of the territory ceded by Spain and would cause East Florida to seem a most trivial return for Havana. Good logic, Maria thought.

All that would be left, Grant contended, would be a barren, broken sandbank—which the land had already been called as a province. He further reasoned that colonists would surely not settle such a land and that the colony would then be only a burden to the mother country. Grant had wisely insisted upon the St. Marys River as the northern boundary, and he had won.

In high spirits, she unlocked the cottage door and called to David. There was no answer. She searched the backyard, scattering the chickens—even climbed his ladder, thinking that perhaps he'd come home early and begun work on the far side of the roof over their parlor. He was not there.

Inside the house, she found his note scrawled on the back of what appeared to be a short letter. The note from David read: "Came home to change my shirt and shave. My Captain arranged an interview for me with Major Ogilvie. Shall we accept the regal invitation on the reverse side of this paper? I'm not much inclined, but I'll agree if you like. I love you. David."

Quickly, she turned over the sheet of paper. "Will Sergeant and Mrs. David Fenwick honor us with their presence at supper in the house of Herrera on Tuesday next? Doña Antonia, Don Jesse Fish, and I will anticipate the pleasure of your company. We have an important matter for discussion. My father, Don Sebastián, may feel too unwell to be present, but he, too, welcomes you." The message was signed with the graceful signature of Luciano de Herrera.

Her emotions tumbling over each other, Maria sank down to think on the new cushion she'd made for the old high-backed wooden settle. Their first invitation to the home of a prominent family pleased her enormously, and David had agreed to go. But underlying her excitement was alarm—perplexity, at least, over David's reason for the sudden, mysterious visit to Ogilvie. Why did he go? It could not have been routine regimental business, or he would not have come all the way home to change.

Did she dare hope that within himself he had actually decided upon leaving the military? Was he calling on Ogilvie to request a discharge? For the first time in their married life, David had

remained silent on a subject which so surely concerned them both, and she had, with enormous difficulty, not again even mentioned her dream of a land grant. Both of them waiting, she'd tried to convince herself, for some word as to who would be the new governor.

She knew there was no way she could avoid imagining his meeting with Ogilvie. If only she could have told David first about the Proclamation. But, of course, he'd see it—would pass right by the public notice board on his way to Government House! She laughed at herself.

Nothing to do but wait.

Yes, there was something. She could wring the neck of that one hen which had never laid a single egg and make chicken and dumplings for him.

By midafternoon, the sky was shrouded in gray, low-hanging clouds, and a steady, hard rain was falling. David would be soaked walking home, she thought, as she scurried about setting pails and pots to catch water streaming from the leaks in the unfinished section of the parlor roof. If only he'd agreed to begin shingling over her kitchen, but he had been eager to do the part that showed from the street first. But now he'd have to get at this part of the roof, she realized, as she sopped up water from her new cushions. The settle had become their favorite place to sit together at night, but not this night—in such dampness, the cushions wouldn't dry in two days. Oh, well, they could always go to bed early.

The fragrance of the chicken simmering in the pot filled the little house as Maria waited—poorly, as usual. Where was he? She'd been home for nearly three hours. Why was she unable to practice the same kind of patience in her daily round that she had learned to practice as a midwife? Who could answer that outside of God Himself? And where was He when she worried about David?

Back in her damp, smoky kitchen, she seasoned and tasted the rich chicken broth, got out flour, and began the dumplings. They were just about ready to drop in the pot when a splash of water, evidently trapped in the remaining thatch, fell somewhere in the parlor.

She went back there and down on her knees, and started mopping up the puddle on the old stone floor. She was still not sorry she'd let him do this part of the roof first; a leaking roof was a small matter, and she'd long made a habit of giving in on small things. But now, with the greatest of effort, she'd been giving in on a very large thing—not permitting herself to press David in any way to ask for his discharge; leaving the decision entirely up to him.

If he had decided as she hoped, what on earth could be keeping him? But suppose he had decided, against her hopes, to stay on in the army. What would she do? She was still mopping, her mind going in circles, when she heard his key in the street door. Breathlessly, she dried her hands and ran to meet him.

He kissed her; then, without a word, ignoring the half-mopped puddle and the aroma from the kitchen as well, he walked directly to their bed alcove. Still silent, he began to take off his uniform slowly, deliberately, as though he performed a ritual. Usually, he jerked it off and flung it at the nearest peg. Now, the damp red-and-yellow coat was straightened out carefully for folding when it was dry.

The tight breeches came off next, one slow movement following another. They, too, were hung for folding. Every move had an air of finality. Then, standing in nothing but his white shirt, he smiled the most forlorn smile she'd ever seen on his sensitive face.

There was no need for questions. Maria knew what he'd done.

Pulling on his old work breeches, he whispered hoarsely, "It's over. I'll have my discharge."

She started toward him, then stopped, for once unable to think of anything to comfort him.

"That man, Ogilvie, decided it for me really. You were right about him."

She crossed the room quickly and held him against her as though her own body could make him secure again.

"I'm out, Maria. I hope it makes you happy. Except for guard-house duty until December, I'm no longer a soldier." Gently, he disengaged her arms, removed his damp shirt and reached for a

clean, patched one. "I hope you're right about that land grant. Ogilvie says that as a civilian I'll have to wait until General Grant gets here. I saw the notice. Grant is coming."

"I know, David. I saw it, too." For some reason, she was still without comment on his news.

"There's a lot yet to be done on our roof—the whole house needs plenty of work—but I hope the governor comes soon. I do want the grant, but a man has to have work—every day, you know." Again, he tried a smile. "Even with a capable wife like you."

"You. . . didn't do it . . . just for me, did you?"

"No." His response came quickly and surely. "No. I'm glad if it pleases you, but I did it for myself, too. Maybe it's time for a new start all around. The French are off the continent entirely. There's peace now. Anyway, Major Francis Ogilvie is not a man I could serve unreservedly."

"Why, David? What struck you so wrong about him?"

"Don't ask a lot of questions, wife. I'm not sure anything's wrong with the man except that he's a—a wooden soldier. A stolid boor. I could never respect him."

Maria said nothing.

"One of the finest, most humane men who ever served the King is coming to be our governor," David went on. "A real administrator as well as a soldier. I took time to read the whole Proclamation before I went to Government House. Ogilvie not only kept me waiting for two hours, he didn't seem one bit enthusiastic about the general's appointment. I got the feeling he'll see Grant as usurping his own authority. That settled it for me."

He sat down slowly on the side of the bed, but went right on talking as though he needed now to end the long silence where his own career was concerned.

"Of course, it's never mattered that a soldier doesn't take to his commanding officer, but—" He looked up at her, his face heartbreakingly vulnerable. "Aw, why struggle for a reason—for anything? It's settled. I'll be out of the regiment Saturday, the tenth of December. You'll welcome the new year, 1764, in the company of a civilian husband. Now, could we let that be—the end of the talk?"

"The absolute end," she said.

She took his arm and led him into the parlor to a big, wide-armed rawhide chair. "Sorry, the roof leaked all over our cushions. But, sir—I have a surprise. I didn't know at the time exactly why we'd be celebrating, but for your supper—chicken and dumplings!"

9

The following Tuesday afternoon, Maria, wearing the new willow-green bodice and skirt she had made, and David, in his freshly brushed uniform, walked the last block to the Herrera house admiring each other unrestrainedly.

"If you think I'm beautiful," she laughed, "you should see yourself!"

"Enjoy me while you may, wife. This could well be my first and last social appearance in uniform. Two weeks and five days, and the world will bow to us as plain Mister and Mrs. Fenwick."

"Just so long as we're bowed to," she replied, hugging his arm.

Maria had never been so proud of him. Never one to ponder what might have been or nurse a disappointment, David was far cheerier than she'd dreamed he could be at leaving the military. Any wife might expect days or weeks of brooding on the part of a husband whose adult life had been epitomized by that traditional uniform. She'd prepare herself just the same for some moody days, once the discharge became a reality. After all, that uniform had been a part of David's self for more than fifteen years—since he was a boy of nineteen. Losing the pride in wearing his buttons and lace could still diminish him in his own eyes, but she had no

intention of letting such a future probability dampen their spirits tonight. Now that David was well again, there was a reason to hope that St. Augustine was giving him new dreams, too—as it had given her. New dreams for a totally different kind of life; new ambitions to live at the top of the heap instead of at the middle. She smiled inwardly. If anyone had told her a few months ago that David would have gone willingly to eat at the home of a Spanish family, she would have scoffed.

How good and free and joyful a thing it is to be his wife, she thought, as he rang the ornate iron bell above the Herrera loggia entrance. There was no doubt that David's resentment of Fish and Herrera had been real at first. Lack of it, under the circumstances, would have been unnatural, but he had righted himself, admitted grudging admiration for both gentlemen, and seemingly let go of the wariness she'd sensed in him at every mention of their names. Just today, he'd even suggested that he might consult with one of them before applying for a land grant.

After what seemed a long wait, Don Luciano welcomed them— but with a reserve that puzzled Maria until she recognized the sadness she had seen in him once before. He was graceful and courteous, but she could tell that David, too, sensed a difference—not toward them; within himself. She ventured to hope Antonia was all right—and the baby.

"Sí, señora, thanks to you and your good services, my sister and the child are well. And you are both welcome to our home." The same sorrow was in his usually warm and resonant voice.

The meal in the lamp-lit, low-ceilinged Herrera dining room was served by a big but soft-spoken black servant, whose broad face reflected the family's tension—whatever it was. In the absence of his father, Don Sebastián, Luciano sat at the head of the heavily carved table with Maria on his right and David on his left. Jesse Fish was at the foot, and beside Maria sat young Doña Antonia Pérez, who still appeared frail from the ordeal of her son's birth. She was exceedingly pleasant but shy—especially with Maria. This was not unusual. A

sensitive young woman, after her first child, was almost always more or less embarrassed when next she saw her midwife. Certainly it was rare, Maria thought, sympathizing with the girl, to see one's midwife socially at dinner.

"I know you don't cook your own meals as I do, Doña Antonia," Maria said, attempting to draw her into conversation, "but you must know how this delicious larded grouse is prepared. I'd like the secret."

"I would be happy to tell you all I know, Señora Fenwick, but that is little about its preparation." Antonia smiled at Luciano. "The grouse is so delicious because my brother is the hunter."

As the meal progressed, Maria's every comment to Antonia seemed somehow diverted to Luciano. Obviously she adored him. Her praise of him for the quality of the grouse had launched Don Luciano and David into a discussion of hunting in the province. Maria glowed at her husband and Herrera, happy for the harmony between them; they would need this warmhearted, influential gentleman, but her pleasure was not all so practical. She was now convinced that Don Luciano was truly their friend, who somehow also needed them.

Jesse Fish, seemingly eager for talk with Maria, had just begun telling her about his orange grove on Anastasia Island and of his success in exporting the fruit when the loggia bell clanged.

Motioning Antonia to follow and without waiting for a servant, Don Luciano excused himself as though he'd been expecting the bell. In a moment a burst of Spanish, agonized, tearful, could be heard plainly from the loggia.

Alone at the table with Jesse Fish, neither Maria nor David made any comment. Fish listened for a full minute, then shook his head sadly.

"You don't understand what's being said out there, of course, but I daresay the tone of it tells you something of the continuing tragic visits to this house these days." He sighed heavily. "One by one, at whatever hour voyages can be arranged, the Spanish families come to say farewell to their old friends and neighbors. As I'm sure you know, one shipload has already gone this month.

These people at the door leave tomorrow on the last ship to sail until mid-December."

Maria and David exchanged glances. They had heard of the sailing tomorrow, but now it seemed a personal sorrow. The Spanish exodus was finally gathering momentum, and Maria felt a twinge of shame that she'd hoped for it so often in the past.

She noticed that Fish's mouth trembled. "None of this is easy for me, either," he said.

To Maria's pleasure, David offered, "I understand that you grew up as a boy in this house."

"I did. It's the only home and the Herreras are the only family I've known since the age of twelve."

Maria found herself wondering why they'd been invited during such a sad time. She and David didn't belong here tonight. They were outsiders—British outsiders. "Please don't let our being here keep you from seeing your friends, Mr. Fish."

David said, "Perhaps we should go, Maria."

Fish lifted his hand. "Not at all. Life goes on. You are part of that future those of us who will stay must share. The callers are members of Antonia's husband's family—the Pérezes. I recognize their voices. I said goodbye to them earlier today. But don't feel ill at ease. You are both most welcome guests—needed guests for Luciano and Antonia, especially tonight. In fact, it was hard for Don Sebastián to remain upstairs. He is most eager to know you both, but Luciano convinced him that seeing the Pérez family again would be too taxing."

"He's ill?" David asked.

"Not really, but heartbroken, and growing older."

After a silence, Fish spoke as though to himself. "Our friends have been leaving now for more than eight months. A few left in April before you arrived. They'll all be gone soon."

"I've heard that the Spanish governor, Felieú, has been far more cooperative than the British expected," David said.

"Yes, being only an acting governor is never easy, Sergeant. The people all but worshiped their late governor, Alonso de Cárdenas. You may not know this, but on the same boat with the Pérez family

tomorrow, will go the bones of Governor Cárdenas, dug up yesterday from the Catholic Campo Santo."

Taking their late governor's bones! Why did that strike Maria as the most poignant thing of all? What had happened to her once unfeeling British heart—unfeeling where any Spaniard was concerned? David said nothing, but she was doubly touched that, judging from the look on his mobile face, he was as affected as she was.

The emotion-filled moment was broken by the return of Don Luciano and his sister. Antonia's cheeks were wet from weeping. Luciano assisting, she slipped back into her chair without a word. He then took his place again at the head of the table.

"We do beg your pardon," he said. "These are difficult times. Antonia just said goodbye to her sister-in-law—her best friend from childhood—Felicia Pérez. She leaves tomorrow with the rest of the family."

Silence hung in the handsome room, broken only by occasional footfalls and passing voices heard through the open windows and the ticking somewhere of a clock.

It was nearly dark. The big black servant slipped in quietly to light another lamp and remove plates. Maria noticed that Luciano and Antonia had scarcely touched their food. She observed also that the present silence, though sad, was no longer uncomfortable; she felt it binding their hearts, perhaps in a way nothing else could have done so swiftly. She looked across at David. The moment was helping him, too, she could tell—helping him think of the Herrera family and Fish as friends.

"I have been remiss not to remember to tell you," Don Luciano said, breaking the silence, "that my father, Don Sebastián, sends regrets because he is unable to dine with us. The sadness of the departure of our neighbors has drained him." The quick smile flashed. He got to his feet, glass in hand. "But we are here; and now I must propose a toast. To the good health, happiness, and prosperity—to the long life—of our honored guests, Sergeant and Mrs. David Fenwick."

Before David could respond, they heard shuffling footsteps and a wooden cane on the stone floor of the loggia. An old man coughed.

"Luciano," Antonia said, "it's Father! He's come down the dark stairs alone!"

Don Sebastián de Herrera, frail and aging, stood in the doorway. He leaned with both hands on a cane, but Maria thought she'd never seen more strength than she saw in the lined features of the man who stood surveying the room, the guests, and the table as though he first had to be certain that all was in order in his house. Then he bowed. The same quick charm that in his son stopped hearts lighted the older face.

Luciano went to him. "*Padre,* may I present to you our honored guests, Sergeant and Mrs. David Fenwick. *Amigos,* my father, Don Sebastián de Herrera."

David and Fish remained standing as the older man made his way around the table to where Maria sat. He bowed to her and, in a voice choked with feeling, said, "*Gracias, señora. Muchísimas gracias.*" Tears filled his eyes, he seemed unaware of them. "I am a man of poor *inglés,* but of great gratitude. A man humble before you, señora, for all the days of my life. Your skill give to me—the life of my daughter and of our *niño.* Though the reward we— decided for you is too small, I will be pleased to hear from your lips that you did accept it—from the hearts of each Herrera and from Jesse Fish, who is also—my son."

Turning to Luciano, Sebastián demanded, "She—is glad with her reward—with our small token of thanks? I could not wait longer to know!"

The younger Herrera reddened. "I'm afraid we have not yet told her, *Padre.* You see, the Pérez family came, and"—he laughed softly—"well, we simply have not yet told the señora."

Maria felt her own face redden. What did Don Sebastián mean, the reward? She stole a glance at David, who appeared as puzzled as she, and as surprised.

As soon as Luciano had pulled up a chair for himself, relinquishing his own to his father, Jesse Fish cleared his throat and, looking directly at Maria, began what was obviously a planned speech.

"Mrs. Fenwick, it is my deep pleasure to inform you that the Herrera family and I are decided upon a modest means of expressing our gratitude to you because our beloved Antonia sits at this table with us tonight, and her son, little Sebastián, sleeps peacefully in his cradle."

Maria shot another quick glance at David, then kept her eyes fixed on Jesse Fish.

"The expression of our thanks decided upon is indeed small, señora, compared to our joy in the child, but soon a transaction will take place by which we will transfer to the name of you and your husband the deed to one thousand acres of good high land, its buildings, dock, and adjoining marsh, owned presently by the family and me. The thousand acres lies some twenty miles north of St. Augustine, between Guano Creek and the North River. Once a British governor arrives and establishes a civil government in the province, the property transfer will be made."

"It—it is not only productive land, señora," Luciano said, as excited and hopeful as a boy, "it is also beautiful to see—as you more than deserve."

Maria studied her tightly clasped hands, her heart pounding. She dared not look at anyone. But in the seemingly endless moment in which they all stood waiting, it came to her that to look at Don Sebastián would somehow be less difficult. Slowly, she raised her eyes to the old man's face and tried to form some words of acknowledgment. Nothing came, but she could not take her gaze away from the almost childlike expression of happiness in the faded eyes. He nodded encouragement. She tried again to say something—anything—to end the silence.

"I—can't think of—the appropriate words," she whispered. Then, "David—help me!"

Don Luciano laughed. "I did not expect to live to see the day when you would be at a loss for words, señora."

"David—*please?*"

"It—it is a very large gift," he said stiffly. "Perhaps too large."

Maria's mouth went dry. Her thoughts raced toward him, her eyes pleaded. No, David! You've come so far with these people—

don't back away now! Don't be proud. We need the land. We need it, David. Help me, help me.

David looked at no one, the inner struggle plain in his eyes glistening in the lamplight.

Then, the slow, familiar smile came, the green eyes softened, and in a tight, husky voice he said, "My tongue is tied, too, wife. I've no doubt you deserve the generous gift of land—and I know how you must feel—but, all that comes to me to say, now that I've thought a bit, is that—it's a gift from God, too. By His own timing."

Maria sank back against the high chair. David, it seemed, had not finished. She looked up at him, still almost afraid to believe that his smile, full of goodwill, meant that he was going to agree.

"It—the land—is received with grateful hearts as from all of you, but from God, too," he went on. "You see, I, well, it so happens that I have just asked for my discharge from the British army. I'm free to cultivate the land!"

Stunned, Maria listened to the murmur of happy congratulations, some of the words in Spanish as though the family congratulated itself, too, that the gift had been accepted.

"Come now, Señora Fenwick," Luciano said pleasantly. "You still appear stricken, not glad! We would like to hear you accept our gift of gratitude yourself."

She stole another look at David. His face showed no strain. The smile was his easy one, almost the teasing smile. He had, oh, he had safely crossed a bridge.

"I do apologize for my hesitation," she said. "You've just taken me so by surprise, and—your generosity is beyond my belief—yet." David was still smiling indulgently. "So *much* is beyond my belief. All of you, including my husband, have made it possible for me to—accept with deep joy." Then, suddenly flooded with relief, she gave her low, vibrant laugh. "Can't you tell?" Both hands extended toward them all, she repeated: "Don Sebastián, Mr. Fish, Don Luciano, Antonia, David? Can't you *tell?*"

Luciano chuckled. "*Sí*, we can tell. Your face shows such radiance, Doña Maria!"

"*Doña?*" A half frown formed, then vanished. She lifted her head. Then, overwhelmed by the honor he had paid her, she exclaimed, "Why, of course! The wife of a landowner should be called Doña, shouldn't she?"

Luciano offered horses for their trip home. David refused. "We need the walk, sir."

And indeed they had walked along, their hands tightly clasped, for more than half the way, without a word.

"A cat's got your tongue, Maria."

"Yours, too."

"Aye. I doubt I believe it, yet."

"David?"

"Hmm?"

"I'm so proud of you. I'm so grateful to you."

"Whatever for?"

"You know perfectly well."

"Because I was finally able to swallow my pride so that my wife could accept a gift of a thousand acres of land?"

"I was afraid—for a moment."

"So was I. I surprised myself. Then, it was as though I—crossed over a bridge."

She stopped walking to stare at him in the darkness. "David, do you know I thought those very words—there at the table—when I saw your expression change? Do we dare get any closer?"

His laughter was bouyant as he took her arm to walk on. "Say, Maria—will we visit the new land soon? Do you think it appropriate?"

"Oh, David, David, I don't know! I'm too happy to think that far ahead. All I can think about now is—I'm so proud of you!"

"Sweet-soundin' words, love. Say them again. Are you really proud of *me?*"

"Prouder than I've been at any time in all our long two years of history together!"

David laughed. "Then pity me! How proud d'ye think I am of *you?*"

10

By January 9 of the new year, 1764, the Spanish exodus, which had begun some three months before the Fenwicks arrived, was finally ending. On January 8, a sloop bearing fifteen families and their posessions sailed almost without notice. The next day, with only a few British watching, the Camerons and the Fenwicks among them, seven more vessels were loaded, and the last departing Spaniards, citizen, soldier, and monk, were gone. Standing in the ship's launch for the entire distance from the wharf to his schooner, Acting Governor Melchor Felieú did not glance back once toward the city. Only eight Spaniards, Herrera and Manuel Solána among them, remained, a few with families.

Bundled against the cold wind off the water, the Fenwicks and the Camerons, sitting together on the seawall, witnessed the departure in near silence. Even Ann said little. Maria, in spite of her optimism for the future now that she and David would soon own a thousand acres of land, struggled with conflicting emotions. The miracle of the Fish-Herrera gift surely opened the future for them, and yet, watching the last sail vanish beyond the shoreline of Jesse Fish's Anastasia Island, she could not ignore the symbols of uncertainty. Those Spanish families squeezed on board the inadequate vessels had once felt secure in their St. Augustine houses, on land granted them by their king or bought by their own hard labor and planning. They, too, had dreamed dreams for their children, their children's children, themselves.

David got slowly to his feet. "Well, it all belongs to us now."

"I hope so, dearest," Maria answered. "I hope so."

"Why, whatever do you mean? The whole of East Florida belongs to us now! Doesn't it, James?" Ann's voice chirped, but without its usual gaiety, and she clung to her husband.

"Yes, of course, it all belongs to King George the Third now." James smiled his rueful, quiet smile. "We belong to him, too, so everything should be all right for us."

They parted without their usual bantering, Ann and James walking slowly north along the waterfront, Maria and David south. The sky flamed from the sunset; the cold west wind whipped Maria's long skirts as they walked along the sandy street. Even with David beside her, Maria felt a kind of nameless anxiety.

The monastery, empty now, the last monk gone, bulked in shadow against the glowing sky. St. Francis Street was deserted. No one else lived in their block. Only the two of them in the newly roofed little house beside its garden. The fireplace chimney and roof were finished; night after night she and David had settled down before their fire, and night after night she noted with joy that the chimney drew so well they could scarcely smell the aroma of pungent fat pine and oak crackling on the hearth.

They would spend this evening together, side by side on Maria's cushions tied onto the old Gonzáles settle, David singing his Irish songs, the two dreaming their now familiar dreams of how good life would be once Governor James Grant reached the little city. Then why was she feeling dread instead of anticipation? There was no rhyme or reason for anything but celebration now that the province was free of the Spanish at last and, best of all, now that David was no longer a soldier.

James and Ann had looked at houses, but so far, cautious, practical James had not agreed to rent one. He had point-blank refused to ask for a military discharge. The Camerons were still staying with two other couples on the second floor of a large and drafty old house on St. George Street near the fort. Poor Ann, so eager and full of fanciful hope, had never learned how to manage James at all. Like almost every other woman Maria had known, Ann complained to women friends but went right on keeping her thoughts from James, following like a kitten. James wouldn't hurt anyone intentionally, but neither was he aware of his wife's need for small happinesses and dignity.

Quite the opposite from her own husband, Maria told herself, as he unlocked their street door. David was surprisingly content as a civilian, and certainly he spent his every waking hour surrounding her with consideration. He sang more than ever and still seemed as excited as she with their gift of good high land. He had even written

her father in Charles Town for a book or two on agriculture.

In the same letter, sent by the hand of Mr. James Moultrie, David had urged Papa to visit them as soon as possible. Mr. Moultrie, of the prominent and wealthy South Carolina family, had a special respect for that fine carpenter, Richard Evans, who had through the years made several handsome pieces of furniture for the Moultrie house; and since Papa fully reciprocated, David had even asked Mr. Moultrie to use his influence on Papa to accept the invitation. Maria would not have felt so confident about asking the same thing of haughty Dr. John Moultrie, even though in Charles Town she had attended both brothers' wives in childbirth. The two Moultries had come south with five other of Charles Town's prominent businessmen to inspect the Florida colony.

David had brought home one day an extra bedstead in fairly good condition—bought from a British soldier, although it had undoubtedly been stolen from a Spaniard's house. Maria had never stopped being shocked and humiliated that gangs of British soldiers vandalized almost every dwelling as soon as the poor families sailed away to Havana. David, more philosophical, assured her that he had done no wrong by purchasing the bed. They had room for her father now, with a real bed in addition to their own.

Surely they would hear from Papa soon. Ann's grapevine told her that Dr. Robert Catherwood and some others from Charles Town had already decided that they would move down. Papa knew Catherwood, too. There was every reason to hope for a letter, and surely no reason at all for this persistent feeling of dread, which was not dispelled even after David had started a cheerful blaze and lit all the lamps in the parlor.

For their supper, which they ate before the fire, Maria served bowls of hot vegetable soup and fresh-baked bread. It should have been a perfect evening.

"I've tried two good Irish tales, three songs, more kisses than you can count, we've had an excellent supper, and still you're not yourself, Maria."

"It's nothing, really," she said, forcing a smile. "I'm ashamed. I can't put my finger on anything that's wrong; I just—"

He stopped her with another kiss. "There's only one thing to do," he whispered. "I'll take you to bed and love you until the bad wee folk let go yer spirit."

David had fallen sound asleep curled against her when Maria heard the clang of what must be the town bell ringing for a fire. At least, there could be no other reason for the bell to ring that time of night. She leaped from bed, ran in her nightdress out into the garden, and saw, to the north, angry flames flaring against the black sky. She screamed for David.

In a moment, he was beside her, urging her to get back into the house out of the cold. "The wind's up still higher, love," he pleaded. "You're shivering—you'll catch your death and besides, what can we do way down here at the south end of the city?"

Their palm and orange trees writhed in the driving wind, and sparks from the embers of their own fire blew about in wild patterns against the sky to the south.

"It looks bad in the dark, but it's likely not a big fire, Maria," David said, keeping his voice calm. "You're shaking like a leaf!"

"It *is* a big fire, David," she gasped. "It will be a big fire—wait and see. City fires always spread! Look!"

A blast of flames shot into the air as she stared transfixed. True, there was only one column of smoke so far, but her eyes followed the vagrant shower of fiery flakes above the dark streets and houses . . . she was ten years old again. It was two in the afternoon, and she was clinging fiercely to her father out in the street before their Charles Town house. A bakeshop on Broad Street had caught fire first, then the house next to it and another and another. Bells clanged and men ran through the streets readying the fire wagons and shouting warnings. Within minutes, the city seemed about to shatter with the bedlam of alarms of all kinds.

The child Maria, far too long-legged, tried to climb up into her father's arms to safety. The wind roared, and the burning buildings roared and exploded. Waves of flame were driven with such awful swiftness, nothing could check them. All afternoon and into the evening she had huddled, terrified and alone—her

88

father had ordered her to stay inside the Queen Street house while he helped fight the inferno which raged long after darkness fell. Finally dynamite had been set off to slow the spreading sea of destruction.

Maria's terror was reborn this night, as she clung to David in their safe garden in St. Augustine. "I'm sure it's the old house where Ann and James live!" she insisted.

"Maria! There's no way you can know that."

"Oh, but I do know it. Ann's house burned to the ground when we were children." She broke away from David and ran inside. "Ann's house is burning again," she shouted back to him. "We've got to go up there—now! Hurry!"

Without taking off her night shift, she began to put on petticoats and a bodice.

David raced into the house and caught her arms. "Maria, listen to me! This isn't like you! What can we do up there? There's a fort full of soldiers to fight whatever blaze that is. We'd best stay right here—out of the way!"

She jerked free of him, threw her cloak around her shoulders, and ran out of the house and halfway up Marine Street toward the Square before he caught up with her, his regimental coat over nothing but his nightshirt and breeches.

The sky was no longer angry; only a white cloud of smoke rose from where the red flames had been. Maria sank down in the sandy street, weak from the ordeal of her panic. Without a word, David knelt beside her and took her in his arms. Finally, he helped her to her feet, and they started slowly home.

When they had walked almost back to St. Francis Street, she found the silence too much to bear.

"David," she said in a small, strained voice. "David, I'm so humiliated. I—I should have told you long ago, that—I lose all control of myself when fire breaks out!" She forced a brittle laugh. "Now you know where I'm—weak as water."

His arm tightened about her. "I was wondering if there was a single weak streak in you, love. I swear, it's almost a relief."

"Is it?"

"Aye. But terror isn't truly a weakness. Terror is—terror. Your father told me about the fire that burned half of Charles Town when you were young. He told me about how it had long haunted you."

Inside the house, David brewed strong tea and brought it to her where she sat huddled. "Now, look at us—how close and cozy we are," he said as he settled with his own cup beside her. "Here we are, closer than ever because you needed me in a new way. You see? God in His wisdom wastes nothing. Nothing whatever, Maria. Not even fear."

"No, I suppose not. David?"

"Hmm?"

"Where did you learn so much about God?"

He laughed softly. "I didn't know I'd learned so much about Him."

"But you have. It's as though you and—and God were friends."

"Aye."

"But where did you happen onto—thinking about Him as—a real Person?"

"Out in a leaking boat on the lough back in Ireland one day, when I was no more than ten. The Scriptures declare that He has all the hairs of our heads numbered. If attention like that isn't personal, what is?" He pulled her to him. "Maria, God's behind all the *good* wee folk. He's dependable in every way."

"Then, are you the same as praying when you talk to your gentle bush? To its Creator?"

"Aye. The same as." He peered into her empty cup. "More tea?"

"No. I'm sleepy now. Aren't you?"

He set down his cup, took her face in his hands. "Not too sleepy to see that I'm holding the most beautiful face firelight ever shone upon. Smile? That's better. Thankful?"

She nodded.

"No two people ever had more reasons than we to be thankful. Go on, tell me just some of our reasons."

"I'm too sleepy, David."

"Just one, then?"

She kissed him. "All right—and it's the main one. You're well again. You're my strong husband again and we're alone in our own

house—and we own a thousand acres of land—and Papa may be visiting us soon. That's more than one."

He'd been counting on his fingers. "And?"

She laughed. "The city didn't burn."

"And?"

"David, we've got to get to sleep!"

"You forgot the very most important reason of all to give thanks, love . . . my pride is injured."

"You don't look injured. What did I forget?"

"Guess?"

"Tell me."

"I love you more than ever."

11

By midmorning the next day, Jesse Fish stood in the chill, gusty street outside waiting for a response to his ring.

Handsome bell the young man's hung, he thought, not at all puzzled that he continued to think of both Fenwicks as much younger than himself. The reason seemed plain. Happiness gave them the look and behavior of youth. Both, he was certain, were in their early thirties. Fish was thirty-nine. He felt older. Loneliness aged a man, but it also kept him concentrated on business. He believed the Fenwicks to be enterprising folk, especially Mrs. Fenwick, and he was certain that she would be interested in his proposition.

He could hear David chopping wood in the backyard and was pleased when Maria greeted him warmly, showed him to a chair by the fire, and left to make tea. Fish thought he'd never seen a more

cheerful room, or a more handsome woman. The Fenwicks made a striking couple—he fair and boyish, usually smiling; his dark-haired wife poised, always in control of herself, and so vital she brought alive the very atmosphere around her. And she never seemed to waste words, everything she said meant something, created the way for a definite response, almost demanded it. He would give up everything he owned for a woman like Maria Fenwick.

The *chunk-chunk* of the ax out back stopped, and he could hear the rattle of crockery and the murmur of their voices, soft and intimate from the kitchen, as Fenwick dumped wood for cooking.

I hope the man knows how blessed he is, Fish thought, getting to his feet when Maria returned with Mrs. Gonzáles' old majolica teapot and a tray of cups and saucers.

He and Maria commented on the unusually chilly weather and last night's fire on St. George Street.

"My husband has already been up there this morning," she said, with an embarrassed smile. "I'm afraid I felt some panic last night, thinking it might be the house where our friends the Camerons are staying." She poured scalding water from the heavy pot which hung over the fire and set the tea aside to steep. "We're terribly relieved that it was an empty house that burned."

Young Fenwick strode briskly into the room, his cheeks glowing from the exercise at the woodpile in the cold wind. He greeted Fish and then, with a concerned glance at Maria, said he'd never seen his wife so upset about anything. "As for me, I was glad to see that nothing caught fire on either side of the house that burned," he added.

Fish smiled wryly. "You should have seen those British troops working their bucket brigade last night to put it out. I happened to be staying in town and went to the scene. I had to chuckle. They've ripped most of our houses apart for firewood up to now. Last night they were all heroes."

"That's human nature, Mr. Fish," Maria said. "But something tells me you didn't drop by just to discuss the fire."

Fish smiled. "You're right, Mrs. Fenwick. I have an offer to make. As your husband knows, the house on St. George Street near the Square burned to the ground. One of the few with a chimney. Nothing

but the chimney standing in the rubble this morning. I owned that house." He turned to David. "You've impressed us all, Fenwick, with the work you've done here. I'm prepared to offer the property to you at a good price—the chimney, what lumber you can salvage, and the lot. Governor Grant will surely arrive on our shore one of these days. British settlers will begin to come in numbers. With your skill, you could build a small frame house on that lot and own what will surely be a valuable resale property. Does it interest you?"

Fish could read interest on Fenwick's face, all right, but he noted that the young man looked first to be sure that his wife shared his interest.

Then he asked cautiously, "How much?"

"I'll sell you the lot—fifty feet by seventy—and whatever you can salvage of the house for seventy-five pounds."

Without a beat, Maria Fenwick said, "We might consider fifty, Mr. Fish."

He bowed slightly. He'd expected fifty. "Then—are we in agreement?"

"Before we discuss it further," she said, "we both wonder how it happens that you're free to sell that property but not this one before the Spanish agent returns. We do plan to stay on here. We'll farm on the thousand acres you and Don Luciano gave us, but live in town."

"Because I owned it outright, your husband can buy the burned-out property now, out of his Havana spoils. Then, once the British settlers come, you, Mrs. Fenwick, through the practice of your profession, will have ample income for the purchase of this place here. I expect my friend Puente back in the spring. And I might add, Fenwick, with you out of the military, now seems a propitious time to interest you in developing something either for rent or for resale."

Mrs. Fenwick's expression told him nothing, and Fenwick was plainly waiting for her to speak first. There was an odd gleam in his eye that Fish could not interpret, although he had little doubt that the man liked his proposition.

When Mrs. Fenwick continued to look thoughtfully at the floor, Fish filled the silence. "I realize this is sudden and that you'll need to talk it over between you. When Puente comes, I

anticipate no problem in settling the deal for this house here and at a reasonable fee. In fact, we will let your rent apply on the purchase price. The poor Spanish are more or less beggars in the sale of their St. Augustine holdings. Their choices are limited." His features softened. "I've already talked too much, but I feel I want to tell you this—if you turn me down on the St. George Street lot, I don't intend offering it for such a ridiculously low price to anyone else."

He saw them exchange glances; then Fenwick asked, looking at him curiously, "And how does that happen, sir?"

"I've become attached to you both," Fish said simply. "More than that, I care about the future of the city. Prosperous settlers benefit everyone. You are a settler now, Fenwick, and it's my honest opinion that you'll turn a nice profit by having a small new house ready to sell when the families begin coming down from South Carolina and Georgia. I see no reason why you and your able wife won't become influential residents. There's no quicker path to influence, you know, than owning property."

Mrs. Fenwick stood up, unmistakably closing the interview. "You've been most considerate, sir, but we do need to talk—alone." She gave him her hand. "You have our word that we'll be in touch with you as soon as we've made up our minds."

When David returned from seeing Fish out, Maria ran to him, grabbed his hands, and began to dance him around the room.

"David! We're on our way—do you realize that? We've begun! Really begun."

He pulled her down on the bench beside him, laughing. "On our way, are we! Judging from your grand performance, I could easy believe we're almost there! I'd an idea what you were up to, but it's plain to me you're the trader in the family, so I mostly kept mum and enjoyed the show."

Maria was still glowing. "That's business for you, David. I think I trust Jesse Fish, but he's the one real businessman left in the city, and I don't intend to let him outsmart us."

"I take it we're buying the burned-out property, then."

"Of course we're buying it. And he's right. By the time Puente comes, I can pay for this house myself. We'll have enough left of your Havana money over the purchase price of the new property for materials and to live on for a while. There'll be more settlers coming, and I'll have many more calls for my services. We won't be one bit short of cash. You'll build a good house on St. George Street, we'll sell it, and—" She frowned, her excitement abating. "David, am I running ahead of you?"

"What do you think, love?"

Maria took a good look at her husband and saw the same gleam in his eye that had puzzled Fish. She said wonderingly, "I do believe you understand me better than I understand myself."

They closed the deal for the St. George Street lot early in February, and David, succumbing to Maria's insistence that he start the new house before building her kitchen chimney, worked hard throughout the month of February clearing rubble and gathering materials. She missed him at home, but sang at her work because she'd never seen him happier. Daily, she prepared lunch for them, took it to the St. George Street lot, and had a picnic with him. Of course, a new house going up caused talk and excitement in the town and there were days when David found it hard to get his work done because so many men stopped by with questions. Since the Spanish agent, Puente, still had not come, he regularly referred all inquiries about houses to Jesse Fish.

"Nine times out of ten they've already had an unsuccessful interview with poor Ogilvie," he told Maria. "The man means well, but I doubt that he's spent a day learning the city's properties. His mind has room for nothing other than ammunition storage and drills."

There had been no word yet from Maria's father, but David reassured her that one day a gentleman would walk up at the St. George Street site and hand him a letter from Richard Evans. Men came every week or so from Charles Town.

In mid-March, on a clear, spring-green morning, the letter came, but not as David had expected. Maria, in the midst of scouring a badly burned pot with the good scrubber David had made from dried gourd fibers, hurried to open the street door to an insistent

knock. There, in clothing more elegant and expensive than any she'd seen since she left Charles Town, stood the other Moultrie brother—imposing Dr. John.

"Dr. Moultrie! What a pleasant surprise," she said, wiping her wet hands on the back of her top petticoat—out of sight, she hoped.

"I had a bit of trouble finding you, Mrs. Fenwick," he said, in his most urbane manner. "I trust I'm not intruding."

"Not at all, sir. Won't you come inside? I'm happier than I can tell you seeing someone from Charles Town."

She seated him in their most comfortable chair and offered tea, which he refused.

"My time in St. Augustine is limited. I have an appointment in half an hour with a gentleman named Fish."

"Oh, yes, he's a friend of ours."

Moultrie seemed surprised. "Is he indeed? Well, with so few civilians in the city, I suppose you do get to know one another."

Inwardly, Maria bristled. John Moultrie would naturally be surprised at finding a Charles Town midwife and her husband, a mere ex-soldier, friends of an important northern mercantile company's representative. She found herself suppressing a smile. If Dr. Moultrie stayed around St. Augustine long, he'd learn a few things. To any British citizen, the city was new and offered an open chance to reform the social structure.

"How's Mr. James Moultrie?" she asked after a cool silence.

"Splendid, thank you. He was to accompany me, but business detained him. We—we're both considering moving here, you know."

"No, of course I didn't know, Dr. Moultrie. We've had so little word from Charles Town during the change of government."

Moultrie was searching his pockets. "My brother had in his possession a letter for you . . ."

Maria's heart pounded. Papa!

"He planned to deliver it himself. It's from your father, I believe. They—uh—are somewhat acquainted as a result of your father's work, I understand. Ah, here it is." He handed her a thin letter bearing her father's seal.

"You couldn't give me anything that would make me happier, sir. You see, I've had no word from my father since we came here so many months ago."

Moultrie stood up. "Well, splendid. You'll want to read it, of course. I'll be on my way. It's been pleasant, Mrs. Fenwick."

She saw him to the door, the long-awaited letter burning her apron pocket. "I am deeply grateful to you, sir. I'm aware of how busy you must be. This personal delivery of my father's letter is appreciated."

It suited her to be as urbane as he. At least, he had been gracious to bring the letter himself, and if he planned to settle in the city, she'd better watch her *p*'s and *q*'s. Undoubtedly, a man of his class, wealth, and culture would become a St. Augustine leader.

She locked the door after him and hurried through the house and out into the back garden, where she could read her letter in the sunshine.

<div align="right">

10 March, 1764
Charles Town, South Carolina
Queen Street

</div>

My dearest Maria and David,

I wish I had followed my instincts to write a bit each day over the past months until a way to send a letter was found. Your father is getting old (60 last week) and prone to procrastinate. Now, I am short of time since my friend, Mr. James Moultrie, waits for me in our parlor. My days, my weeks and months have been good in that I have kept my health and worked every day. More and more, I am turning to the making of furniture and find it rewarding both to my purse and my understanding of human nature. I work, of course, for the very wealthy and socially prominent and still believe Mr. James Moultrie to be one of the rare and truly modest men in his class. I have also added the estimable gentleman Mr. William Drayton to my list of clients. He has benefited me greatly by the loan of many fascinating books from his enormous library.

I am writing words, when I know you must be eager for news. There is little. Business continues good in town with seemingly

more ships than ever plying the trade waters between Charles Town and London. Of course, your father misses you, and the temptation to visit you soon is great, but I am committed to many cabinets and chairs and tables for the next year and so feel it is best that I wait until you both are more settled in St. Augustine. I have heard rumors that some sort of postal system will be established, and so we will not feel as distant from one another. I am proud of you, David, for your understanding of my daughter's desire to have you all to herself and out of the military. My confidence in your judgment assures me that you would not have made such a sacrifice had you not been interested also in becoming a successful civilian settler in His Majesty's new Florida colony. I must end this. It is good that you are both nearby, at least, nearer than Havana. And my love for you, and my pride in you knows no bounds. My next letter will be of a more newsworthy nature.

Yr loving father,
Richard Evans

Tears streamed down Maria's face as she sat holding the blessed letter. Papa was still the same. Kind, intelligent, gentle, and concise. A real thinker, a reader of books few would expect a man to read who worked with his hands. Best of all, he was well. She'd hoped, of course, that he'd be visiting them soon, but she should have known that reserved, cautious Richard Evans would do nothing so impulsive as that.

She leaned back in the sturdy garden chair David had built and closed her eyes. Did Papa every so often stop to plumb the depths of a secret place as she did? As she was sure David did?

She opened her eyes. The sun lay in long, clean streaks across their garden, which burgeoned now from his careful tending, with bright new buds swelling with life, a sprouting vegetable garden, young, shining leaves on their orange trees, where a few fragrant blossoms opened to the pale, clear, green air. She looked and thought a moment. The spring air did have a fresh green cast, more a green feel than a color, but green. She hugged her father's letter to her and

sighed. Could a woman ask for more of life? Papa all right, a good house made better by David's dear, capable hands, enough to eat, and—best of all—the morning and evening sound of gunfire from the fort meaning only a signal, not death. She let her gaze move across the bright-dark shadows and sun slashes of their garden behind the sheltering wall. They had lived in the St. Francis Street cottage not quite eight months, but Maria was at home. Familiar and at home. She closed her eyes again and floated on a transforming current of peace that joined the cottage garden and the deeps of her own green and secret place, where all things came clear. The inner and the outer worlds of Maria Evans were, for this day, good . . . and one.

She looked at her mother's gold watch. She had been dreaming in the garden for nearly an hour and would have to hurry with David's lunch. He'd hired some help because he was raising the roof beam on their new frame house on St. George Street this morning. The work today would be hard. He'd be starved by the time she got there.

She refolded her father's letter, tucked it in her bodice for fear she'd forget to take it along, and danced her way into the kitchen, both arms swaying high over her head, long skirts swirling, glad to her fingertips and her toes to be alive.

Outside the privacy of her home, she walked more sedately up St. George Street, swinging her lunch basket, and crossed the lane that led to the Marina, reminding herself that she must go on up to the market on her way home. It was Wednesday, and the fish would be fresh caught. David had come to expect a good fried fish and corn cakes for his supper on Wednesdays. His praise of her cooking banished most of the dislike she'd always had for anything domestic. That fried fish could taste exactly the same week after week, but this evening, David would swear, his green eyes glowing, that it tasted better than last.

Well, maybe I am improving, she thought, as she squinted against the spring sun for a glimpse of the superstructure of David's new house. He'd done it! She could see the roof beam in place. Almost running now, she began to wave in the direction of the knot of men gathered in the street in front of the new building. David would be among them, all standing there admiring the new roof beam.

She turned her ankle slightly on a pine cone lying in the sandy street and slowed her pace just a little. No sense in falling flat on your face with joy in order to arrive with a lunch full of sand.

A man broke away from the group gathered in front of the new house and ran toward her. David? No. Not David. A light-skinned black man was loping toward her.

"No, ma'am. No! Don' go no closer, ma'am," he gasped.

Maria froze. "What—did you say?"

"I said don' go no closer. They's been a bad accident."

She grabbed the man's sweating arm. "Someone's hurt?"

"Bad."

"Who is it? Stop gaping and tell me!"

"A—a man got—killed, ma'am. You better stay back."

Maria broke past him. Pushing through the cluster of men, she saw James Cameron hurry toward her, his face twisted with anguish.

"James!"

"Maria . . ."

He stopped her forcibly and held her so hard her arms hurt. "Maria! You can't go up there!"

She could see a figure now sprawled on the ground. With a wrench, she jerked herself free and fell to her knees in the sandy dirt beside David.

"No!" she screamed. "David, *no!*" Then, gathering the limp body into her arms, she began to rock him. His head fell loosely to one side, and she saw blood soaking the tawny curls on his neck.

"Musta' broke his neck. Backwards, ma'am," someone mumbled. "He fell backwards. Hit his head on those bricks."

"Get the doctor—the new doctor," she ordered. "Don't just stand there! James Cameron, you're David's friend—get Dr. Catherwood! He came yesterday—we've got to get the doctor here quickly!"

"Maria, listen to me! No use getting a doctor for David. You know that."

"*James, help us!*"

Her cry sounded far off. James probably didn't hear.

"*James!*"

The distance widened, and deep, deep blackness flowed over her.

Part Two

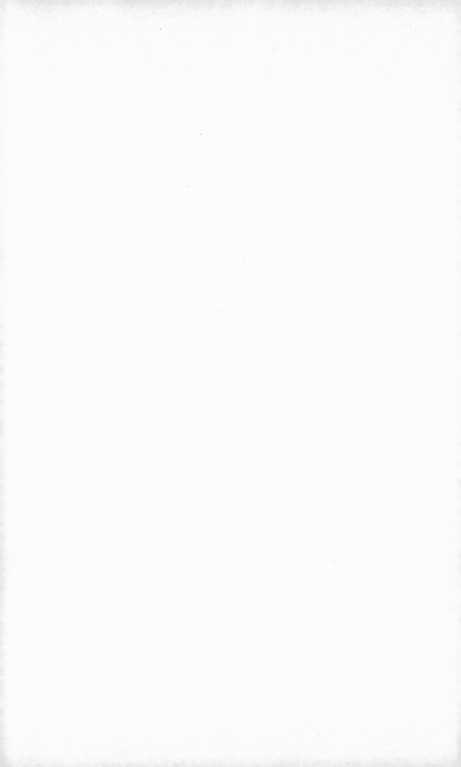

12

I "I was wondering, Ann, what day this is."

Maria spoke in an expressionless voice from David's rawhide chair, where she had sat hour after hour, day after day—not by a window, nor by a door, but in the very middle of the shadowy parlor, the most sheltered place she could find. The thought of conversation with anyone except Ann Cameron was more than she could bear. There in the darkest part of the house was some safety, at least, when the few friends she'd made kept ringing the gate bell. Since the day they buried David, she had seen or spoken to no one but Ann, who had been unselfishly willing to leave her own husband and move into the St. Francis Street cottage. Guilt at keeping the Camerons apart had begun to gnaw at the edges of Maria's grief. Ann must soon go home.

"Did you hear me, Ann? I was wondering what day this is."

The scraping sound of a palmetto broom over the stone floor stopped abruptly, and Ann hurried to kneel by Maria's chair. "No, Maria dear, I'm sorry! I was making such a racket with that broom, I guess. But—today is Thursday, April the seventh. How wonderful that you finally asked me!" Ann took her hand. "Don't you see that your asking is a very hopeful sign?"

"Is it?"

"Yes, it most certainly is," Ann's words tumbled on. "You see, what I mean is that Don Luciano said I should let him know the very first time you inquired what day it is or what time it is, because he and Mr. Fish felt sure that would be a most hopeful day for you!"

Maria turned her face away, ashamed for her friend to see tears streaming once more down her cheeks. Ann had endured sleepless nights, too, she knew. The house was small. There was no possibility that Ann had not suffered through the uncontrollable sobbing which more often than not had been the reason that Maria herself came awake. Tears flowed even out of the brief, nightmare spasms of sleep. In every layer of her mind, asleep or awake, she fought to believe that David still lived, laughing and teasing, telling his Irish tales, singing, whistling at his work—kissing her.

"Is it all right if I tell Don Luciano you asked?"

Maria sighed heavily. "I suppose so. He's been here every day, hasn't he?"

"Every single day! And Mr. Fish, too. They both think so highly of you."

Over and over Ann had told her how well folk thought of her, and it was like salt in her wound. Without David to think the very world of her, what did she care what anyone else thought of her? David's accident—she had not yet managed the word *death*—had scattered to the winds everything she had ever been in all the thirty-four years of her life. That self was buried and no one could think anything of a self that no longer existed.

Ann tried once more. "Mr. Fish said also for me to tell you when I thought it wise that the Spanish agent, Don Elixio de la Puente, is here from Havana. That means property can be transferred—bought and sold. Now, I guess."

Maria's laugh was metallic. "Fish is a businessman through and through, isn't he? After we paid him for the St. George Street property out of David's Havana money, there was some left for developing that never got done. I suppose he'd like me to put it down on this house instead."

"Oh, I think you're just as wrong as you can be! That wasn't what he meant at all. He said now he and Don Luciano can draw up the papers with Señor Puente so that you will own that thousand acres of good high land on the North River."

Maria closed her eyes a moment. "Oh, Ann, I'm so ashamed."

"Ashamed? What on earth for?"

"Jesse Fish has been nothing but patient and kind. I—I just swing from one emotion to another. I don't want to grow bitter. I truly don't."

"Maria, dear Maria," Ann said, soothing her, embracing her, "you won't get bitter. Not you. You're just not the kind of person to get bitter. Please give yourself time."

"Dear God, how much time is needed?"

"A lot, I'm sure. It's only been about three weeks! I don't think we can expect even God to wave a magic wand over our heads and cause such—ghastly pain to go away. I really don't think so, Maria. I'm proud of you for the way you've been. Few women ever love as you loved David. I can't think what I'd do without James! I know I'd go around fainting, to keep from facing one minute alone."

"I—fainted, too, when I saw that—that blood in his hair—and knew that he would never be able to stand up and speak to me again." Her head nodded slowly, self-accusingly, up and down, up and down. "Oh, I fainted, too, Ann. I don't know yet who brought me back here. I've never thought to ask. Your James, I suppose."

"No. James took care of David. Don Luciano and I brought you home in his carriage. He helped you into the house as tenderly as though you were an injured little girl."

Maria looked at her, puzzled. "I—do half remember the motion of a carriage. But, Ann, I didn't know you and Don Luciano were with me."

"Shock does dreadful things to us, Maria. How could anyone have a worse shock than the one you had? But do you realize that you haven't talked to me like this since I've been here?"

"Poor Ann."

"Don't poor Ann me! I'm just—so happy to have you talking now." After a long moment, Ann said slowly, "Maria, David is—still alive, *somewhere*."

Maria turned away again. "No! Don't tell me that—ever! It doesn't do any good because I can't find him!" She spread her hands helplessly. "I've tried—I've tried so hard. I'm—so accustomed to knowing

exactly where he is—and I can't find him, do you hear? If—he'd just answer me once, just once, so I'd know he's all right—"

The weeping began again, strangling her words. She fled to the alcove and threw herself across the bed, only dimly aware that faithful Ann, not knowing what else to do, had gone back to sweeping.

Jesse Fish had stayed in town at the Herrera house since the arrival of Don Elixio de la Puente, who was also quartered there. For nearly a week, the two men had spent the daylight hours drafting a map of the city and a listing of all the Spanish-owned properties, setting prices at a little above what they expected to get. A handful of new settlers had come, but more than two hundred houses still stood vacant. The impetuous, impatient Puente was discouraged.

Jesse Fish laid down his glasses and smiled across the Herrera dining table, where their map and listings were spread. "The British have come now, Don Elixio," he said calmly. "You'll have to get accustomed to their restraint. They don't buy the first property they see."

"I am aware of that, Don Jesse, but are we to have no wealthy Englishmen to purchase property in the city? Señor Henry Laurens, the two Moultrie brothers, Señor Juan Ainslie, and Señor Juan Holmes—all have indicated their desire to own land—but not city houses. The outlying land they will, of course, get free from British Governor Grant, should he ever decide to honor the province with his presence. Free, except for the purchase of the required number of slaves to cultivate it. How are we to make profitable deals for the Spanish families who own town houses when Englishmen prefer large free land grants outside the city walls?"

Fish nodded. "I know, I know. It seems that way now, but most of these men will settle in town houses, given time. Governor Grant will appoint a Council. Every man you mentioned will expect to be on it. They'll need quarters in town. Patience has always been the key to comfortable living in St. Augustine, *amigo mío*. It will ever be."

"But there is a limit to our time! Only eight months remain until all Spanish properties must be sold! If not, the Spanish owners in Havana and elsewhere have lost their equities. I cannot tolerate that humiliation, too."

"There will be a way," Fish said.

"What way?"

"I firmly believe we'll make fifty or sixty good city sales within the next few months. I know, for example, that both Moultries want good town houses."

"Then why do they not buy them?"

"Our asking prices are too high. Their soldiers have done extensive damage to most of the properties, as you know, and they estimate the cost of the houses according to their present state of disrepair."

"That is highly unjust!"

"Perhaps, but that's the way it is." Fish turned the map so that Puente could see the lot on which Fish placed his quill. "Here, near the old monastery on St. Francis Street, for instance, is one property I'm sure we'll sell—perhaps soon. A widow lives there now."

"Ah, sí. Doña Maria Fenwick. Don Luciano's dear friend."

"And mine, I hope. Her husband met a tragic death or they'd have bought the house when you first arrived last week. I—haven't had the heart to confront her with business yet. Her grief is devastating. They were the happiest of people."

Puente smoothed his neat dark mustache thoughtfully. "So I am told. Sorrow is sorrow among people of all nations, no? I know of this woman. She is to receive the valuable thousand acres you own with Herrera on North River for saving Antonia's life. You see? I am informed."

"Any day now, we're hoping she'll talk to us—to Luciano or to me. We want you to handle the change of title to the property, since it is Spanish-owned land."

"Sí. I am willing, of course, but not until I attempt to convince you both that your generosity has got the better of your common sense. One thousand acres of good high land is a ridiculous fee for a midwife!"

107

"For Antonia's life? And little Sebastián's?"

Puente shrugged. "The land is in the name of Don Jesse Fish and Don Luciano. It is your decision to make."

"That's right. And we've made it—from the fullness of our hearts. You wait, Don Elixio, until you know this lady. She's far more than any man's idea of a mere midwife."

Puente walked around the table and whacked Fish on the shoulder with the back of his hand. "If I am to believe you and Don Luciano, she is some manner of—queen!"

"No," Fish said slowly. "No. She's a very human woman. Highly intelligent, ambitious, but sensitive, too. And—"

"And very beautiful, if Herrera is any judge of beauty." He laughed. "And if he is not, then who is a judge?"

Fish did not smile. "I'm sorry I can't join in your mocking mood, *amigo*. Doña Maria's grief . . . is also mine. I understand what you're saying, but the thought of her—alone in the cottage where they were so happy—dries up my laughter."

"*Perdóneme*. I meant no offense. But the husband has been dead now for nearly a month. Do you not think she will talk to us soon?" He tapped the map with slender, nervous fingers. "We do not have all the time in the world, Don Jesse. One property after another we must sell—in a steady, day in and day out manner! I am fully responsible to His Majesty. I cannot allow sentiment to slow my work. Her sadness is a pity, but so is the destitute state of my countrymen who have been forced to give up the houses where they, too, loved and were filled with happiness and grief."

"*Comprendo*," Fish said, his face more enigmatic than usual. "I do understand our problem, and that the responsibility is mainly in your hands. But if I am to help you—and I believe you need me under the circumstances of my British birth and connections here—I insist that you leave the closing of the St. Francis Street sale entirely to me."

Puente sat down and tipped back in his chair. He studied Fish for a moment, then said, "You are right, of course. I do have need of you. And we will—wait upon Doña Maria Fenwick's pleasure. But, you will forgive me, sir, if I tell you that I did not expect to hear such

tenderhearted sympathies from a man of your professional reputa-
tion." He raised his hand. "No, no, no! No offense. I do not chide. I
merely express my—uh—complete surprise."

April became May, and Ann, at Maria's insistence, agreed that
next week she might go back to the quarters she shared with James.
The moment had to come, Maria knew, when she must face her first
night alone in the cottage. She was beginning to want to have it
behind her. More often each day, she had wondered about seeing the
dawn on that first morning after she'd managed one night by herself.
Fleetingly the thought had come, then lingered: the very light of it
seeming to suggest some small solace akin to hope. If that first dawn
were a bright one, then perhaps . . . no! Ablaze with color or hung
with lowering clouds, dawn could never be the old dawn again. Still,
the thought returned, lingered a bit longer. Then, after several days
of this, Maria had told Ann, "I am ready to be alone."

"Of course, I want to get back to James," her friend had said, "but
James and I love you. You come first, until you're yourself again."

At every casual mention that the day might come when she
would be herself again, she tried to remember how she had been
when life, not death, had filled the hours. It was as though she,
Maria, sat to one side watching, knowing exactly what Ann
meant, what Ann was trying to do for her. She even pitied her
friend, especially at those moments when she felt Ann longing to
prod her—the hunched, grieving woman, who seemed often to
drift far away even from her own being. Then the turgid flood of
grief would rush back, and her one hope lay in the knowledge
that by some means, in order to go on, she must become an
entirely different person from the one who had loved David. The
sorrowing woman who still refused to see friends when they
called could never enter into the life of the new colony, could
never again practice her profession—could not even return home
to be her father's daughter.

At last the morning came when James was to bring supplies for
Maria and take Ann home. Still fussing about with her bundles,

pretending that she was not quite finished, Ann had, Maria knew, been packed and waiting for more than an hour.

Their talk at breakfast had been stilted and polite, almost as though they were not old friends who had shared the most intimate suffering. That fact seemed almost a barrier today. Maria felt sorry for Ann, and her recent habit of sitting as though to one side, watching them both, obsessed her. At least, she thought, when Ann leaves, the obsession might be broken. She felt herself diminished by this strange sense of being two persons at once. If only she could face her own, only self alone, perhaps some nameless event or action would rouse her into living again. This made little sense, but she tried to count on it.

She wished James would get there. Poor Ann. There seemed now nothing left for them to say to each other.

When at last the gate bell clanged, Maria jumped to her feet. "That must be James now."

"Maria! Are *you* going to let him in yourself?"

She took a few brisk steps toward the door, then stopped. Seeing James, actually talking to him meant that she would have to ask the questions which had tormented her all these weeks. Had James himself bathed David's body? Had he got all the blood out of his hair? Had David's neck been broken, as she vaguely remembered someone saying? There had been color in his face still when she'd been holding him there in the street; she had thought at first that he *must* be alive. As well, perhaps, that she had fainted before the color faded and a gray, dead memory became her last picture of him.

"Maria? I—I'd be so proud if *you* let James in." Ann's voice sounded almost daring.

"No. No—you let him in, Ann." She lifted her head, her body rigid. "I'll—speak to him, of course. But—you go."

Ann embraced her and ran to unlatch the gate.

Still rooted in the middle of the floor, Maria clenched and unclenched her hands, all but holding her breath. The thought of making talk with James had struck a deeper terror. She stamped her foot in anger. If she could be civil with anyone in the whole world, if she could ever make sense in any conversation again, it

would be with David's friend, kind, quiet James Cameron.

A full minute dragged by before she heard Ann's chirping outside the house door. A full minute in which she knew that Ann had been feeling the welcome pressure of her husband's arms about her.

Some terrible time of nameless reckoning had come. There was something urgent for Maria to do at once and she was filled with fear of it. It's only James, she thought. Why should I fear James? And what is it that I must do? James was suddenly an outsider, since day by day Ann had melded more deeply into the atmosphere of grief in the house. In seconds James, the outsider, would walk through the door and she would have to do something before he did. *What?* She pressed her fingers against her eyes, still swollen from last night's tears. James would come bearing all the provisions he could carry and she would thank him, of course, but there was something else required of her *before* he appeared. Something to be faced. To be put into words.

She sucked in all the air her lungs would hold and let it out jerkily.

"I'm—a widow," she whispered hoarsely. "I'm a—*widow*."

James had brought more supplies than she needed. Methodically, she'd put them away—flour in the fine wooden bin David had made, half a sugar loaf in a tinned canister away from the dampness, potatoes in a dark corner of the small back room with a dirt floor, alongside the slab of salt-packed beef. It was cold in there; the potatoes wouldn't sprout so soon. At noon, she forced down a cup of strong tea. Its bitterness stimulated her a little, and when the late afternoon shadows began lengthening across the back garden, she got up from David's chair in the center of the dim parlor and walked deliberately outside. For the first time—just for the sake of being there—she was back where they had played and laughed, where David had worked. Until now she had almost fled to and from the woodpile, the privy, the well. Stiffly, she walked up and down, forcing herself to look at their two empty chairs under the orange trees. She made her hand touch the budding

branches of the stubby little fig, David's gentle bush. She did not cry.

Back in the parlor once more, she sat down.

Perhaps she should make a list of painful things to be done and then do them. At the top of the list would be tonight: the first night alone in the cottage without him. In all her thirty-four years she had never been alone at night. There was no need to write that down. Tonight would come.

Ann had left a pot of potato soup. She should eat, but that meant she would have to swallow. The silence was so thick in the house, she felt as though she breathed silence and not air. She hadn't wound her mother's gold watch in days, and the clock had stopped ticking. Poor Ann, who'd tried so hard, would feel terrible that she'd forgotten to wind the clock. What did the hour matter? The night was on its way and she had no strength for it. Only dread.

Right now, this minute through which she labored, Maria could not imagine how Ann had got on her nerves at times. She'd give anything she owned to hear her friend prattle about almost any subject on earth.

A cart bumped and squeaked outside in the street, but she heard no horses. At the window, welcoming the interruption, she could see that two soldiers pulled the cart loaded with lumber in the direction of the deserted monastery on the corner. Was it true that they were beginning to fix it up for a barracks for British soldiers? Ann had mentioned something about such plans. The thought brought a kind of relief. At least, there would be the sound of human voices again in the empty street.

She watched the cart approach from the direction of Charlotte Street, the two soldiers bent under the strain of their load. It was still fairly light outside. Lighter than in her parlor. They would not be able to see her, but she could see them—living, breathing human beings, a small brush with daily life. She recognized neither man. Undoubtedly, they had come with Ogilvie in the Ninth Regiment, but they would both know about David's accident. She stifled the impulse for a word with them. Most likely they were decent enough fellows. On the other hand, everyone knew that she was alone now. They would have

discussed it in the Square at the guardhouse. The soldiers in St. Augustine were bored, and gossip was their most colorful pastime, aside from drinking. It wouldn't surprise her that one of these nameless men even knew of David's spoils from Havana and that the remainder of the money was hidden in her house. Cold sweat broke across her forehead. James had said there had been no pay for the army in weeks. Who could stop the two soldiers from returning tonight to rob her? Seldom a night passed without a robbery in the city, and there had been more than a dozen murders since the British arrived.

Maria jumped back from the window as the cart rolled directly past. To the dark dread of this night was added a new burden . . . the primitive fear of what could happen to her alone. For the first time in her life, she was starkly afraid.

The cart lumbered out of sight and out of hearing. She sat down again in David's chair and waited—for nothing.

13

An hour or maybe far less than an hour passed before she got up and lit one of the Gonzáles oil lamps. David had made a good supply of wicks. More than enough to light her darkness all summer and into the fall.

The lamp had just flared when the gate bell was tapped softly, so softly she was not sure she'd heard the ring. Then it rang again, stopping her heart. The soldiers had seen her after all! Seen her—alone in the house.

She took three steps toward the door, then back to the chair. The bell clanged more loudly. Whoever was out there had surely seen her

in the lamplight through the curtainless window, could shoot her easily from the street. David's sword! She ran to the fireplace, took down the sword and then blew out the lamp. The bell rang again. Slowly, feeling her way through the semidarkness, she opened the door into the garden. Two figures stood outside the spindle gate. A man and a woman.

"Doña Maria?" A Spanish woman's voice, young, hesitant.

Weak with relief, she fumbled with the gate latch, unlocked it finally as heavy footsteps hurried away, and there in the gathering darkness stood Don Luciano's sister, Antonia, alone.

For a long moment, neither woman spoke. Then Antonia said, with a small, shy smile, "If you do not want me to come into your house, I will understand."

"I—I'm sorry to be rude, staring this way. It's just that—I thought I saw a man, too."

"My brother, Luciano. We do not want to intrude. Once you opened the house door, he hurried back to Marine Street, where we left our horses."

"I see."

"Luciano wants you to know that he does not expect to come in."

"Well, I—I—" Maria looked at the long, heavy sword in her hand. "I suppose you're wondering why I came to the door—armed?"

"No, I do not wonder. I know. You are afraid."

"Yes." Her voice sounded matter-of-fact. "Please do come in, Doña Antonia."

"Will I be of help to you?"

"What?" She frowned. Not at Antonia, at herself for finding it so hard to talk to this gentle girl. "Yes!" Suddenly she fought back the impulse to grab Antonia's arm and pull her inside. "Yes. I—want you to come in and—talk to me, please."

Back in the parlor, Maria, hurrying to hang the sword in its place and to relight the lamp, did not notice until she finished that Antonia had sat down on David's end of their cushioned bench. Not wanting to appear discourteous by asking her guest to move, she stood, the burning spile still in her hand, looking, not at Antonia, but at the bench

itself. Until now, through all the weeks he had been gone, she had not permitted her eyes to linger on its looming, worn presence in the room. It was Ann who had taken the cushions into the yard to sun. She could tell Ann that it was too soon for her even to look at the bench where they had been so happy together night after night before David's handsome fireplace, but she was embarrassed now with Antonia, whose brown, sympathetic eyes had been following her every move.

"You will sit here beside me, Doña Maria?"

Maria looked at the flowered cushion where Antonia's slender hand lay, inviting her to sit down. Then slowly, numbly, she moved toward it, perching on the edge, her back ramrod straight.

"Your brother, Don Luciano," Maria said, her voice husky, "he will return to see you home?"

"Oh, he's waiting for me—with the horses. Neither he nor my father will permit me on the streets alone at night."

"He's waiting out there in the dark—just waiting?"

"*Sí*. He is the best of brothers. He wanted me to come to you. I have thought of you so often, but tonight, because he knew your friend Señora Cameron had gone, there was no rest for Luciano until he brought me to you."

"I see." She tried a little laugh. "News travels fast in the city, doesn't it?"

There was a brief silence, then Antonia said, "This—impossible night will pass, Doña Maria."

"Yes. Yes, I suppose it will."

"I did not have to spend such a night alone in an empty house where Diego—my husband—and I were happy, and so I do not expect you to believe entirely in my understanding of what you face." She reached to touch Maria's hand. "But this I can offer you. Tonight will be no worse than the other nights have been—without him."

Maria looked at her helplessly. "It—won't be?"

"No. You have already lived through the worst night. The first night in an empty bed is past. That is what I came to offer to you. I wish I had more."

Her eyes fixed on an irregular crack in the stone floor, Maria said, "But every night has seemed the worst."

"*Sí*. Again, I hesitate to speak to you. Aware that I have—my husband's child to listen for in the night. All thanks to you. All thanks to you, I still have my own life."

She noticed that Antonia's fingers twisted nervously. "And do you really thank me for that?"

"From my heart."

"Because of the child?"

"To be sure, but dare I also say I thank you that I, too, am living? Do not try to answer that. And, I beg you to know that I have never been more nervous than now, attempting to—comfort you at a time when all words of comfort might appear to you as—rusty hooks jerked into—your heart. I am not bold, Doña Maria. It is only that we are—your friends. Your—helpless friends."

The girl's soft voice poured over the pain like soothing oil. Maria did not answer, but she wanted her to go on.

"The sun will turn the water below it and the sky in which it hangs another special color just for tomorrow morning. It will be different from the color of any other morning—if rose, a new shade of rose. If gold, a new gold. Never the same. There will be newness again. Newness that does not shut away the memories which were glad, but newness that belongs only to you. A new thing in the sky and in the water and in the very grass under your feet. *Your* newness."

Maria saw that the delicate, olive-skinned hands lay quiet now in Antonia's lap.

"The pain, I am sure, in one form or another will never end. I was slow, but I have accepted that now. As will you. But you must give yourself time. There is no pain worse, but God knows how much we can bear."

Maria thought of the mental and bodily agony which she had watched this slip of a girl endure when her son was born into the dark midst of her own grief. It was impossible to think her glib. She was acquainted with pain. No one could doubt that.

"The pain does not leave, but it is mercifully worn away a little each day. Oh, I have not known of the wearing away at times. Only

when some fresh newness comes." She took Maria's hand now. "Do you hear me at all? I am not good with your language, but do you hear me from my heart, Doña Maria? It is the giving of these new things that is of God. New events in the town, new lives you will save, new skies, new thoughts, new dreams." Her voice pleaded for Maria's attention. "Does your heart listen to me—and does it understand me? I was a widow but a few weeks when you came like an angel to my baby and me. Your coming was a newness. You were—you are—a blessed newness to me!"

A faint smile on her face, Maria said, "What you are saying is that—living goes on."

"But not forever in desperation! In—growth, perhaps, of the spirit, where the deeper the sorrow cuts in, the more joy one hopes some day will take its place."

"Joy?"

"Joy. Do I blaspheme to use the word this night?"

Maria sighed heavily. "No. No, you don't. The word just—surprised me, I guess. *He* was—my joy."

"*Sí.*"

They sat for a long time in silence, Maria scarcely aware that a wind had risen, causing shadows to dance across David's new whitewashed ceiling. Joy. The shape of the word had always danced in her mind, as her heart had danced with each sight of his golden, laughing beauty. Joy.

"Joy is the word to cling to," Antonia was saying, as though her gentle spirit had dipped into the secret place of Maria's thoughts. "I do not know joy yet, either—aside from my *niño,* I mean to say. I—thought we might cling to the promise of it—together."

"What . . . is . . . joy?"

"I do not know, other than perhaps it is God in—the marrow of our bones."

Maria stiffened. "God—could have kept him from falling!"

"*Sí.* God can do anything." The soft voice was steady. "But He did not, for some reason of His own. As he did not heal Diego's fever. He—took him to Himself, instead."

"Is that enough for you, Antonia?"

"God is enough."

"God and your child and your brother and your father and servants in the house with you!"

After a pause, Antonia said, "Bitterness is natural, too, some of the time. Do not hate yourself for being bitter. It is part of the pain, but I beg you, do not let it linger. Even though you are alone."

Maria had heard enough. "Forgive me. I've been rude, not to have offered you refreshment of some kind. I—could brew tea."

"I did not come for tea. I came for—you. To promise you—joy again some day."

"To—*promise* me joy?"

Antonia sat, too, now, on the edge of the couch, her dark eyes seeming to look into Maria's very soul. "Yes. Doña Maria, listen to me through one more—clumsy speech. Do you know how it is—working one's way through a tangled skein of yarn or to the end of a long row of stitches when one is too tired—even to try? Surely you have watched countless women labor their way through the agonies of—bearing a child. The end seems never to come. But it does come. Long nights—end. One must likewise labor one's way through grief. Do not sit here alone in this empty house—without motion. You do have friends. One day, there will be—not a return of the old joy, but the beginning of a new joy. I work toward my own—every day. One day I will find it."

"How—can you know this—so young?"

"God, I suppose." She stood up. "Now, I must go."

Maria stood, too. "I will find a way to thank you for coming," she said, her voice remote. "Maybe some day I'll understand—about your God—my husband's God." She straightened her shoulders. "I hope you'll not be offended, but I'm afraid my way is to depend on myself for this—newness. One thing I know. Never, never again will I open myself to—such pain."

Antonia looked startled and then anxious, as she, too, stood. "Not for one minute did I mean that, Doña Maria—that you will ever love so much again!"

"Then what did you mean?"

"I do not know. I only know that in me is—the promise of joy. And the promise is strong enough so that I dare to promise it for you, too." Then she added, "The idea of loving is—as impossible to me still as it is to you!"

"Thank you for saying that." They stood, but neither moved toward the door. "Now, I really must invite your brother to come inside for at least a greeting. I've refused to see him or Mr. Fish for weeks."

Antonia reached toward her. "Not tonight. My heart prompted me to come so that you could be only yourself with another woman who lives through the same pain. You could not be yourself with even so kind a man as Luciano."

"How old are you, Doña Antonia?"

"Twenty-three, nearly twenty-four."

"I'm ashamed to say I'm ten years your senior. I don't act it, do I?" After a long pause, she said, "How can I ever show my gratitude?"

Antonia reached up to kiss her on the cheek. "Only do not forget—I am here, if you need me. This night will pass. All the long nights will pass. One morning you will find—a new small joy."

14

The empty days and agonizing nights of the first summer without David were eased somewhat by frequent letters to her father and a journey by water in the company of Herrera and Fish to the thousand acres of land between Guano Creek and North River.

Standing with her two friends in the weed-choked front yard of the solidly built but empty cottage overlooking the river and the

marshes, she had struggled to show them a pleasure she could not feel. The high land was better and more beautiful than she'd dared dream it would be, but seeing it without David suddenly brought back her overwhelming sense of loss, fresh and piercing. He had never seen it, and this was to have been their place to repair and cultivate—their timber to cut and sell. How he would have responded to the wild beauty of the blue water and the green, green trees—talking trees and gentle bushes—so many gentle bushes!

No one spoke as the three stood gazing out over the water to the plumy line of pines and palms on the far side of North River. In the other direction beyond Guano Creek lay the Atlantic Ocean—neither visible. Finally, Jesse Fish, in a voice so quiet it was almost a whisper, said, "It is our hope that the beauty of this place will help heal your heart, Doña Maria."

"Heal?" The word had no meaning. "Heal, Mr. Fish? Yes. I pray—in time—it will." She looked from one to the other. "You are both good men. I'm grateful . . . more grateful now than ever."

After Luciano offered to handle details, it was agreed that she would cut fifty acres of timber near Guano Creek to be sold at once to the British Government for cash. Their business discussions provided a welcome escape into practicalities as they ate a picnic lunch on the wide porch, but Maria felt enormous relief when they boarded Fish's boat for the trip back. She could mark off one more difficult ordeal as finished. Done. She had seen their land—without him. Visiting the property could never again be this painful, and her determination to drive ahead, to become another person—one who could never be as hurt again—was confirmed. Maria Evans would become known in the East Florida colony as one of its most influential settlers, her life centered around one goal—spiraling success.

That night she wrote at length to her father and offered to correspond with any Charles Town people who might be interested in moving down. Because Indian raids had slackened, at least for the time, the mails were moving more quickly between St. Augustine and Charles Town. The latest letter from Papa had

reached her in less than two weeks, even by the dangerous overland route.

In July, she had delivered two babies—children of the Ainslie and Holmes families—both down from Charles Town. Again, she had experienced the old certainty and strength within herself as she'd worked over the young mothers, had again felt the strange Presence which came to her at no other time. On the nights following the two deliveries, she'd slept more soundly than on any night since David went away.

By August, Maria had made up her mind. She would not buy the St. Francis Street cottage. She had, she felt, done her best to live there alone, but David so filled the rooms of the little house that his presence kept the agony alive. At times, when the sun went down, she was sure she could not bear it for even one more night. There would never be another house she could love as she'd loved this one, but she would be able to leave it because flickering even now at the edges of her mind was the thought that some day, once she'd achieved eminence and once she'd learned better how to live without him, she just might buy the house and enlarge it to her own taste—add a handsome second story.

It would not be easy to tell Jesse Fish that she was now no longer interested in purchasing it. Fish had been so patient, but since she planned to ask him to find another property in the north end of the city, she supposed his quizzical eyes would light up as they always seemed to do when real estate was discussed. Though alone, he seemed rather contented, she thought, even though his only fulfillment lay in turning a good deal for a piece of property. In fact, because of this it became easier after a while for Maria to speak more confidentially to him than to anyone else—especially to Ann or Antonia, who simply did not understand her determination never to put herself in a position where she could know heartbreak again. In Maria's opinion, Ann had never learned to use her mind; had never dared think that a woman had the same right as a man to reason and make decisions. As for Antonia's faith that joy would somehow return, Maria admired her for that but

did not admire her willingness to sit passively by and wait for it to happen.

Maria was able to trade for material gain and prestige all hope of finding love again because love had gone with David. Daily, she told herself that she was starting her life as a widow on solid if joyless ground. With such a protective shell accumulating around her heart, she could, like Jesse Fish, aim all her energies at getting ahead.

Governor Grant was due soon, and colonists from Charles Town—the Moultries, Dr. Catherwood, Messrs. Holmes and Ainslie, William Drayton, if he decided to come, too—would all certainly be appointed to Grant's Council. The source of her future influence lay in these men, since all were already aware of her professional reputation in Charles Town.

Unlike David, she had never looked for—nor found—outward signs from God, and such answers as she found within, she credited to her intuition. One day, soon after Grant arrived, she would simply know when she was to move away from the cottage and then she would act. For her, there had always been release in action, and when the time was right, the release would come again.

On August 29, a cloudy, humid day, Maria went with Fish and Herrera to the wharf at the foot of the Square and watched Governor Grant's sloop, *Ferret*, weigh anchor at the St. Augustine bar. Only the firing of the salute guns at the fort broke the summer silence of the nearly empty little city. The men of the Ninth Regiment, standing at attention with Major Ogilvie, made up most of the assemblage available to greet the long-awaited governor. Clustered nearby in little knots stood the pitifully few new English settlers, the handful of remaining Spaniards, several Negroes, and two or three dozen curious Indians.

A pilot boat brought the corpulent but sprightly James Grant ashore, and three cheers from the regiment temporarily drowned applause from the tiny crowd. Maria and her friends watched the Scottish governor and his travel-worn entourage walk across the

Square toward Government House. All was again quiet.

"I'm due to meet the new governor as part of a welcoming committee, as soon as he's had time to freshen up a bit," Fish said without enthusiasm. "You also, Luciano?"

Herrera shrugged and shook his head.

Fish took Maria's hand. "Leaving you, dear lady, is not a matter of preference."

Maria and Don Luciano watched Fish's quick, precise steps as he walked away. Gulls wheeled overhead and settled again on the wharf pilings as though nothing unusual had occurred. A stray dog sniffed at Herrera's boots. A pair of mockingbirds, gray-white wings flashing, hovered above a stack of casks, then chased off, singing. A small boy's voice shrilled and another answered. Then Herrera laughed.

"Is something funny, Don Luciano? If so, I've missed it."

"Not funny, perhaps—just flat. I cannot help remembering the excitement and festivities attending the arrival of a new Spanish governor in the days of my youth. The city was in a state of celebration for days. But this!" He shook his head. "I do not envy Don Jesse his invitation to the stodgy little welcoming ceremonies. Unfortunate Governor Grant."

Maria gave him a confident smile. "You wait, sir. You'll find nothing unfortunate about the man a few months from now."

"The best governor cannot succeed without settlers."

"There'll be settlers. Some of the most prominent men in Charles Town will come. Grant's well known there. The city will prosper, and what's more, those of us who live here will know what's going on at Government House. His Excellency is an affable, fair-minded gentleman."

"Spoken like a true British subject," he said.

"That's what I happen to be." She held out her hand. "Well, I must go home and write to my father of the governor's arrival."

"I may walk with you?"

"If you like."

After they had gone some distance down Marine Street, Herrera said, "I am sorry for Don Jesse. The man would far rather be in my place at this moment—with you."

"Oh?"

"Do not tell me that you have not long known that he is hopelessly enamored of you! He has said nothing to you?"

"Not one word."

"And if he did?"

"I would simply trust his friendship then, as I always have."

"And do you trust my friendship, too?"

She laughed. Laughter came easily with this man. "Oh, yes! I must say I've never given a thought to doubting *you*."

Instead of a bantering response, he fell silent until they reached her gate. Still without a word, he unlatched the gate, touched her elbow politely as they stepped inside the garden.

"I can manage the house door myself, thank you," she said. "But don't forget, you and Mr. Fish have promised to keep me informed of every new event at Government House, now that its occupant is finally there."

Luciano turned her toward him, kissed her tenderly, then let himself out the gate without another word.

How long Maria stood motionless in the garden she could not have told. Then abruptly, she unlocked the house door, slammed it, and wiped her mouth hard with the back of her hand.

"David," she cried aloud. "David, I'm afraid! I wasn't—I was getting over being afraid without you. Now, I'm afraid again!"

For her supper, she had only tea and biscuit, then went early to bed. The clock in the parlor struck three before she could check her wildly circling thoughts. So much depended upon her relationship with both Fish and Herrera. If only there were someone, somewhere, to help her keep things exactly as they were, but there was no one except herself to do it. "I want those men to go on—just being my friends. I need them. I need them both."

At last, she drifted fitfully off to sleep, repeating over and over again, "David . . . pray for me. Tell your God . . . I need help. I dare not be worried or nervous. I . . . *won't* be."

124

15

After a few more influential settlers had come from South Carolina and Georgia—enough to make up a Council, at least—Governor Grant felt that October 31 was the appropriate time for his official inauguration. Maria attended with Fish, Herrera, and Ann Cameron. Ann's bubbling pride in her husband, James, chosen as one of the soldiers who fired the Volley of Joy, helped lighten the solemnity of the occasion, so that even Don Luciano, usually so bored with what he called drab British pomp, had seemed to enjoy himself.

Maria had told no one, certainly not Ann, that Herrera had kissed her, nor that he had insisted that Jesse Fish was also in love with her. For the most part, she kept to herself her continuing grief for David, consciously separating her memories from her search for a new life. Scarcely a night passed without tears, but why talk about it? What could anyone do?

Through the cooperation of Jesse Fish, a young Georgian and his wife were now settled as tenant farmers in the cottage at North River, and Maria used part of the three hundred pounds from the sale of her timber there to buy the required number of slaves to cultivate the large holding. Her timber was mostly brought to St. Augustine by the British for the repair of official buildings on the Square. Some of it went to St. Francis Street for the new addition to the barracks, now in the planning stage. In spite of free land grants to be given out to new settlers, few had come, and of those who had moved down, interest in the available Spanish real estate had remained negligible. Don Elixio de la Puente, with just forty-five days remaining when monies for the sales of these properties could still be sent to their former Spanish owners, had tired of trying to dispose of them and returned to Havana. But an unusual transaction took place before he sailed: most of the remaining city houses and lots were turned over by Puente to Jesse Fish for a ridiculously small sum.

"And that is my present predicament," Fish told Herrera one morning early in 1765, well after the treaty date had expired.

The two friends sat, cigars in hand, over Fish's accounts in the parlor of the Herrera house.

"Predicament?" Don Luciano asked, raising a quizzical eyebrow. "I'd say it is a bonanza, *amigo*. With the time long past when all monies must be returned to Cuba, you will be the sole judge of their value as well as your own fee for selling them." He shrugged. "A splendid opportunity for you to grow rich."

"I won't object to that, of course. But I'll need your help as always, Luciano. You know I think on a grand scale—have little or no gift for figures." His black eyes twinkled. "I'll want the records kept straight. You and I are then in this together, eh?"

Herrera laughed. "So that I share a portion of the guilt you will feel when the properties do not—uh—bring exactly what their Spanish owners expect. *Muy bien.* Together." The men shook hands. "If Puente had not sold them to you, they would have reverted to the British Crown. We are too Spanish for that, no? Who will know if I personally see to payment of *some* of the money to my countrymen in Havana? You alone will decide the amount, but the poor devils will be fortunate now to get anything. You have saved the houses and lots from the British King. Beyond that, only we will know."

The men sat smoking for a while, each deep in his thoughts. Then Herrera said, "In the case of the sale of the St. Francis Street cottage to Doña Maria, we will show every leniency, *sí?*"

Fish gave him a knowing look. Plainly, Luciano loved Maria Fenwick, too. Plainly, if either man succeeded in winning her, it would be Luciano de Herrera. "Yes," Fish said. "Yes, by all means. In fact, I plan to charge her so little, there will be no profit for me whatever. All monies from that house will go back to my friends, the Gonzáles family."

"And what will happen should the Gonzáles family let it be known in Havana that they have received more than another might receive in the future?"

"We think of that later."

Herrera extinguished his cigar and stood up.

126

"You're going some place, Luciano?"

"*Sí, amigo.* I am off to pay a friendly visit to Doña Maria. I go every day and so do you. Do not pretend otherwise."

Fish stood, too. "This time I go first."

"Oh?"

"At the lady's request. She sent a message this morning by her friend, Mrs. Cameron. Doña Maria asked to see me."

"Interesting. Has she made up her mind at last about the property?"

"I hope so. If not, I have another interested party—the new paymaster to the regiments. A Captain Joseph Peavett."

"*Muy bien.* If the lady sent for you, then by all means *go, hermano.*" The smile flashed. "I can wait."

"Rather pleasant for February, isn't it, Mr. Fish? But I'll gladly light a fire if you're chilly." Maria sat quietly in David's big rawhide chair.

"I'm comfortable, thank you—and curious as to why you sent for me."

"To apologize, for one reason. I've been very slow making up my mind about this house. I've done my best. I couldn't seem to hurry. I've decided now. You've been more than patient. But I . . . can't stay in this house. I feel I've given myself enough time. It will be a year next month." She paused. "The decision to leave here . . . has not been easy."

"My heart has ached for you throughout the past year. It still does."

"Is my decision a dreadful disappointment? And the Gonzáles family—I've grown quite close to them—sleeping in their bed, eating at their table."

"The Gonzáles family will get their money. You see, there is a new gentleman in town, a Captain Joseph Peavett, who already has his eye on this place. I awaited your pleasure, of course."

Her own dream of owning and remodeling it some day—once she'd learned how to live without David—gave her pause. Quickly, she put the dream aside, forced a smile, and said, "It—it's rather a blow—imagining someone else being here. Does Captain Peavett have a family? If so, I'd think he'd have to enlarge the cottage."

"No. He's a bachelor, I assume. Like me." He reached into his coat pocket and took out a folded sheet of paper. "By the way, I've

brought the names you requested. Every member of the governor's new Council."

Maria took the list and scanned it. "Oh, thank you. This is really splendid. My father knows almost all these gentlemen. Actually, I've served at the birth of some of their children—the Moultrie brothers, Mr. John Dunnett, Mr. David Yeats. I believe the only name I don't know, in fact, is Mr. James Box of Savannah."

"Box comes well recommended," Fish said. "He's to be the colony's first Attorney General."

"So I see." She refolded the list and placed it in a small drawer in the lamp stand. "I don't think I need to explain this to you, but when I say my father knows these men, I merely mean that he's met them—or knows them by reputation. He's worked for some of them." Then, rather mockingly, she added, "You see, my father is a carpenter and furniture maker. An enormously skilled craftsman, but *not* one of these—mm—gentlemen."

"We understand each other, Doña Maria," Fish said intensely. "It's my fond hope that—the understanding may continue." He quickly resumed his enigmatic manner, his eyes avoiding hers. "Some of the social patterns of Charles Town will, of course, carry over down here, but you and I will have the advantage of having been here first—before the new settlers. St. Augustine has always been a garrison town where knowing the ropes matters at least as much as class distinction. In some instances, more."

Maria, pleased at his wisdom, was also relieved to notice that his voice had resumed its matter-of-fact tone.

Fish crossed his thin legs. "Now then, in what part of the city would you like to locate?"

"As far from St. Francis Street as possible. I'll never stop . . . missing my husband, no matter where I live. I've accepted that. But I've also accepted the fact that I must begin to build a new life in a house without memories. Do you have something at the north end of town?"

"Yes, yes, I have," he said slowly. "But before we go into that, what of the half-finished house your husband was building? Will you complete that?"

"Certainly, but I could never live in it."

"I understand."

"I'd appreciate your suggestions for a good builder—and of course, I'll want you to handle the sale of it."

He nodded agreement.

"Now, what do you have for me to live in?"

"One place comes to mind," he said, tapping the tips of his dry, slender fingers together. "On what is now called Charlotte Street between the Street of the Old Treasury and Hypolita. A six-roomed two-storied coquina house. In need of a cleaning and a coat of paint inside and out, but the roof's in good repair, the windows all glazed. There is one fireplace in the parlor, and another can be opened in the bedroom above—the room I'd think you would choose to occupy."

"What about the kitchen? I've had my fill of an inside stove with its abominable smoke."

"Oh, the kitchen is a detached building to the rear. You can easily build in a fireplace and do away with the Spanish stove, but surely you won't be doing your own cooking there, will you?"

"No. I'll buy one or two servants, but I wouldn't want my cook's eyes to burn the way mine have here." Her low, melodic laugh gave him the pleasure it always did.

"Well, I see no problems with this house, provided you like it, of course. I'll be glad to make inquiries about servants for you, too, if you like. I heard just yesterday of a good young Indian woman. Supposed to be rather artful in the kitchen. She was the property of Governor Felieú. He sold her when he left to Don Manuel Solána, who, as you know, has chosen to stay in the city rather than give up his properties."

"The purchase price of the house, should I like it?"

"For you—and I'll ask you to keep this confidential—two hundred and fifty pounds."

"Then, will you show it to me tomorrow? I have an interview with Governor Grant at one o'clock. You could meet me at Government House about one thirty and we can leave from there."

Fish rose to go, an admiring half smile on his face. "An appointment with his Excellency, eh?"

"Is that so surprising?"

"You know perfectly well it is—for a lady. But, of course, not for one lady—Doña Maria Fenwick."

"Don't you think Grant will be interested in informing prospective settlers of the services of an excellent midwife in St. Augustine?"

At the gate, Fish bowed over her hand. "You are indeed enterprising."

"I hope your captain—what's his name, Peavett?—will be happy here." She looked about the garden. "I'll hate leaving. It won't be easy."

"I'm sure it won't be, but if it's any comfort to you, Joseph Peavett is an extremely high type of officer and gentleman. He'll take excellent care of the place."

"I'm glad to hear that. Part of my heart will stay. I have tried, Mr. Fish, but I know I'm going to be ill if I don't begin soon to fill my life with something that pushes me forward—not back—and I can't do it here."

The next day, promptly at one o'clock, Maria was admitted to Governor Grant's second-floor office. Her first face-to-face glimpse of that sophisticated though rotund gentleman put her at ease, even while he was pulling his enormous girth out of the chair, greeting her with a warm, full-faced smile.

"You do me honor, Mrs. Fenwick," he said, gesturing toward a high-backed chair near his desk. "Your reputation has preceded you—your splendid reputation, I might add."

"Thank you, Excellency. I'm woman enough to be curious. Who spoke of me?"

"Oh, more than one member of my Council, madam." He rubbed his cherubic chin thoughtfully. "Let me see, as I recall the first to bring your name to my attention was my Chief Justice, Mr. James Moultrie. The man had much to say in your behalf."

"Knowing Justice Moultrie, I'm not surprised. He's a gracious person."

"Then, I believe Mr. Ainslie and Mr. Holmes were the next to proclaim your praises."

"I've had the honor of attending both their wives since they've settled in St. Augustine."

130

"Even Dr. John Moultrie, like his brother, spoke well of you." Grant chuckled easily, his whole torso moving up and down. "And when that critical and brilliant gentleman manages a good word for anyone other than himself, the praise must indeed be deserved." He leaned toward her confidentially. "I want you to know I've already made use of your name and your fine capabilities, dear lady."

"Oh?"

"Only this morning, and then not for the first time. You see, I've written a number of letters to the other southern colonies, urging responsible folk to join us here in this glorious and healthful land of East Florida." He laughed. "At least, I hope I'm making it sound 'glorious.' One of our shining attributes which I've offered prospective colonists is the enormous advantage of your excellent services as mid-wife. With the new King's Road under way into Georgia, I predict our Florida family will grow—and you will be assisting in a most important way. Now, then, I trust you do not object to what I've done."

Maria, obviously pleased by his long speech, stood and extended her hand. "On the contrary, your Excellency, I'm grateful. You've done exactly what I came to request of you. I won't keep you longer from your duties."

On his feet, the Governor bowed gracefully and took her hand in both of his. "I admire ambition, Mrs. Fenwick. I detest those who are content to leave well enough alone. Well enough can always be improved upon—don't you agree?"

"I most certainly do agree, sir."

"Good day, Mrs. Fenwick. Do come again."

"Good day, Excellency. With your permission, I probably shall."

When Jesse Fish joined her in the courtyard, she felt a wave of the old excitement for living as she walked rapidly beside him up Charlotte Street toward the house he'd described—a house she thought she knew and had rather admired. But the wave of excitement was not for the house. Its ordinary shape—three moderate-sized rooms and a loggia on the ground floor, three above under a gabled roof—did not inspire immediate affection as had the cottage, and that was all right. The sense of excitement and adventure had come from the stimulating interview

with Grant and the news that even "critical" Dr. John Moultrie had already put in a good word in her behalf with the governor.

After a thorough inspection upstairs and down, the two stood talking in the street.

"I'm pleased that you like it," Fish said, as they began to walk south again toward the cottage. "The property is a good buy."

"It will do very nicely. What I need now is a place to eat, sleep, handle my accounts, and entertain occasionally. I don't expect to become attached to it. I do thank you for all you've done."

"I'm honored when you're pleased," he said. "You'll find my recommendation for the builder to finish your husband's work on the St. George Street house a good one, too, I believe." For a time he was silent, then said, "Your interview with Grant was successful, I observe. You had the look of a cautious cat who had just happened upon a nest of newborn mice when you came down those steps at Government House."

Maria laughed. "I felt like that, Don Jesse. I still do. Governor Grant could not have been more gracious—or more cooperative. I'm—almost hopeful again."

As the remainder of the short St. Augustine winter passed into spring and summer, Maria's days were busier than any since David's death. She not only retained the builder whom Fish had recommended to complete work on David's house, she hired two free Negroes to paint her Charlotte Street residence—white, inside and out. The only sad event was the unexpected death of her favorite Moultrie brother, James, the Chief Justice of the governor's Council, on August 6. She had lost a potentially helpful ally in a high position in the city, but her father had written that William Drayton was definitely moving to St. Augustine, and Maria's prediction that Grant would appoint him Chief Justice in Moultrie's place came true. Drayton was, if possible, even more influential, certainly more aggressive, and he, too, had always been extremely kind to her father back in Charles Town. She didn't like him as well, but what mattered now was the value of his connections in town.

Packing the few belongings accumulated on St. Francis Street would require little time or attention. Her old energy was returning. Shopping the city for cooking utensils, dishes, linens, and tableware was accomplished in only a few days. During the interim, while her new Charlotte Street house was being repaired and painted, she'd presided at the births of three British children—one the son of James Dunnett, a Council member who had paid her so well she was certain that Grant's enthusiasm for her work had prompted Dunnett to call her. All three births went smoothly, and the combined fees covered the work on the new house.

By mid-November, the painful task of disposing of David's clothing was behind her, and on the same day as the arrival of the new English rector, the Reverend John Forbes, she left the cottage and moved into her comfortable home at the north end of the city.

Even then no one knew that Maria was able to leave the cottage on St. Francis Street only because of her dream. Some day, some much later day, when she was stronger and older and more accustomed to life without David, she fully intended to move back and make the cottage a grand house.

16

The end of 1765, Maria was well settled into her Charlotte Street house, although her parlor and one or two other rooms lacked sufficient furniture, and would until she could earn enough money to pay for the quality pieces she wanted. Her full attention and all her available cash had been lavished on suitable furnishings for her

new room upstairs and for a comfortable bedroom for Papa, for the time when—if ever—she could persuade him to visit. She had written that it was ready and waiting for him.

The new experience of at last having a good servant gave her the most pleasure of all; expanded her self-esteem and her sense of well-being. The Evans family of Charles Town had never even thought of a servant. Her parents, and then Maria and her father, had done all the domestic chores because there'd never been enough money for help. Money for Maria's tutor had come before anything else.

Surely Long Stem, the slender, graceful, silent Indian woman whom Jesse Fish had found for her, must be one of the most efficient servants in town. Of course, it took some doing to learn Long Stem's ways. Maria had never had any close contact with an Indian, but Long Stem matched her lovely name, and after a time, Maria learned that the young woman's silences meant only that she was a full-blooded Indian and not that she was surly. It would have helped pass some of the long, lonely hours had Long Stem shared the English love of conversation, but Maria had no real complaints. The house was kept in perfect order, her meals, especially considering the occasional shortages in town, were deliciously prepared, and it was gratifying to sit down to her dinner and be served. When Maria could catch Long Stem's eye the girl smiled back, her even teeth flashing white in her dark oval face. There would be no problem whatever with entertaining guests now and then; at Government House, Long Stem had been well trained.

Maria Evans Fenwick's bearing grew more assured than ever as she went about the city. She had been right. The only way of life possible without David was to plan and work at her own success and prestige. A good address, a well-trained servant helped. The obsession to become an independently wealthy woman in the new colony grew daily. With part of the proceeds from the sale of David's house, she bought another good small property on Marine Street, which she rented. At the right time, if she chose, she could sell that at a nice profit as more settlers came down. Strengthening her resolve to succeed was the ever-stronger vow never to love

again. In her own way, she would keep her perfect life with David—intact, alive, and secret.

New settlers were not coming down in droves, as hoped, but they were coming and soldiers were also beginning to buy houses in town. Fish's quick sale of David's St. George Street house to John Moore, victualer for the regiment, had solidified her goal for personal independence. Through Fish and Herrera, and because of her widening reputation in the city as a midwife, she came to know more and more people of importance. She had even met the eccentric, brilliant Surveyor General, William Gerard De Brahm, after delivering his daughter's infant son. Jennie Mulcaster was married to Frederick George Mulcaster, the likable young man who was said by the town gossips to be the natural brother of King George III. Whether or not this was true, it was a fact that Mulcaster was a trained surveyor who assisted his father-in-law in surveying and mapping the colony.

She also saw to it that the new rector, the Reverend John Forbes, became aware of her professional competence; and through him calls for her services increased. Ambitious, conscientious, and one of the busiest men in town, John Forbes personally conducted Maria on a tour of his newly completed Anglican "church"—the repaired second floor of what had been the old Spanish Bishop's Palace on the Square; claimed, as was so much of St. Augustine, by Jesse Fish.

Neither Fish nor Herrera, in spite of their continuing kindness to her, had shown further signs of infatuation. That was exactly as Maria wanted it. She needed them as she needed young Reverend Forbes, whom she found a bit stuffy and somewhat overawed with his new work; she needed and wanted every man she knew—but *only* as her friend. She intended to see to it that she became so respected in the colony that, even should another midwife appear on the scene, it would make little or no difference in her standing.

Alone in her room at night, she felt herself to be growing more mature, less and less vulnerable to whatever might occur in the future. But the times of helpless, childlike weeping and despair, though less frequent, had not ended.

Late that spring a letter came from her father, and although she had meant to do some marketing, Maria hurried home so that she could read it in the privacy of her room. The packet of folded, sealed pages was the thickest she'd received. Word from him was always a delight and a comfort, even though of late he'd been going on almost ridiculously, she thought, about the new Stamp Act, which seemed to be causing much talk and resistance in Charles Town. Surely, along with his everlasting politics, this letter would contain some word about when he was coming down. He'd been building a new store and hadn't yet seen his way clear to come. "I mean to spend a while with you, daughter, when I do visit, so you and I must both be patient," he had written last month.

Calling to Long Stem that she'd be ready for her noon meal soon, Maria hurried upstairs to her room, broke her father's neat seal, and unfolded the letter.

9 May, 1766
Charles Town

My Dearest Daughter, Maria,

Your latest rec'd last week gladdened my heart, although it gives me some concern that you have shown so little interest in the local rebellion here over the heinous Stamp Act of last year. It has occurred to me, however, that since East Florida's value is mainly military and the colony entirely dependent upon the King and Parliament for support, slight attention might have been paid there to the rank injustice of the Act. South Carolina, as you know, is a commercial colony. The Act let loose demons here, although, I understand, in a much more cautious manner than in the northern colonies. Before I attempt an explanation of some of what has occurred, let me say that I plan to be there with you no later than July of this year—less than two months from this date, at which time I will inform you fully concerning the repercussions of the Stamp Act inflicted so unjustly upon the American colonies.

In her joy that he was coming, Maria said aloud: "All right, Papa. All right. I'll listen, I promise—if you'll only come." She read quickly on to the end of the letter.

The Lord be praised, because of resistance by both British merchants and colonial officials—and the people as a whole—the hateful Act has now been repealed. They were taxing us, they claimed in London, in order to pay for larger military protection against the French, who, as you know, have finally been run off the continent. Had the drastic Act not been wiped out through our efforts, Americans would have been taxed for the very air they breathed. We expect some tax, of course, but not without representation in Parliament. We have none, and so those demons of resistance have been unleashed for more than a year. Englishmen are born free and are not to be taxed except by their own consent. So reads the British constitution. We even closed our ports in protest, and right at the time of rice harvest. You must have been missing a few items down there because of the embargo, but Charles Town has been an exciting place to live and so I am sure that you can understand my perplexity that you have commented almost not at all upon the goings on. You surely have a stamp distributor there, but evidently unnoticed. We hung ours in effigy on a gallows forty feet high in the center of town.

Do not despair of me. I am sure when I am there, you will understand why your old father has become a Son of Liberty. Our beloved Lutheran pastor has been run out of town for his patriotic stand for liberty, but before he left, he urged me to visit you and I will. Nothing can shake my loyalty to George III, but I am convinced that once I make clear the underhandedness of Parliament, you will stand with me. I will write again when I know my actual arrival date, but until then, I am as I have always been, your adoring Father,

Richard Evans

Maria sat for a long time, thinking. Of course, there'd been talk in St. Augustine of the impudence of the South Carolina colonists who had the nerve to object to British taxes, but except for her father's infrequent letters on the subject, she had paid little attention. The entire episode had, in St. Augustine, seemed remote and passing. Naturally, they had a stamp distributor, a dull, sallow fellow named Thomas Grahme, who, if he hadn't been appointed by the Crown, would have been run out of town—not because he represented the new Stamp Act but because he had run up so many bad debts in the city.

She sat frowning, a bit worried because Papa had allowed himself to be caught up in the inflammatory movement, but she smiled, too, because at his age he'd had the courage and the strength to stand up for what he believed. Oh, well, the Stamp Act flurry was over, and what mattered was that Papa was coming at last.

Long Stem called her to eat, and as the Indian girl served beef and vegetable stew, Maria began to tell her all she planned in preparation for her father's visit, even though it was still two months away.

"Of course, I'll hire someone to help you, Long Stem, but I'll want all the windows washed and lemon oil rubbed into the new furniture I bought for his room until he can see himself in it. And oh, don't you think it would be a splendid idea if you made a new counterpane for his bed? I think I'd like a heavy, fringed cotton twill in an indigo blue. What do you think?"

The girl stood watching Maria's face, the usual noncommittal expression on her own. Then, after a silence in which Long Stem never seemed to feel uneasy, she said, "You smile. More."

"Hmm? Oh, yes, I'm very happy. It's been such a long time since I've seen my father. He and I were as close as two peas in a pod once." She waited. Nothing more from Long Stem. "Well, what about a new counterpane?"

A rare, infectious grin lighted Long Stem's almost boyish features. "You keep smile, Mrs. Fenwick."

"Yes. Is—it all that strange? Am I so glum most of the time?"

The girl shook her head. "You buy cloth. I sew, and sewing make smile go on. Long Stem work. House will shine. Your father want to stay with us. Then Long Stem never hear you weep out your heart in the night—again."

On the bright morning of July 10, Jesse Fish and Luciano de Herrera called for Maria to escort her to the waterfront at least an hour before her father's boat could be expected to reach the bar. Both men glowed because she was glowing and made extravagant plans for honoring Richard Evans during his visit.

"The first privilege will be mine," Luciano said. "My father and my sister will have it no other way."

"Of course, it has nothing whatever to do with your own wishes," Fish said in a resigned voice. "But I'll agree, provided I'm invited. Then it will be my turn, Doña Maria. It will be my pleasure to have you and your father as house guests for an extended stay on Anastasia Island at El Vergel. In fact, Governor Grant has already agreed to come, too, while you're there."

Maria beamed. "You're both good," she said simply. "You're both such good men. My two faithful friends."

Richard Evans could see Maria waiting on the wharf with two men as the pilot boat brought him ashore. The men—one of them a Spaniard—appeared to be gentlemen of means, and after warm greetings and introductions, the older man found conversation easy as Fish and Herrera carried his luggage to his daughter's house. He found nothing to dislike in either man, but he was relieved when they said good-bye without coming in.

He thoroughly enjoyed his first meal alone with Maria and warmly complimented her Indian, Long Stem, on the delicious dinner of fish, roast of beef, lima beans, and greens, with cream cake for dessert.

Later, in her parlor, tea in hand, he examined his own feelings. He had never felt so happy or so sad. Happy for her success, her comfortable home, and that they were actually together in the same room again. But seeing her alone brought back a rush of grief for his

son-in-law, whom he had loved. And brought back grief for Maria's mother because Maria was so like her.

"You're quiet, Papa," Maria said, refilling his cup. "It's natural, I guess . . . David isn't—with us anymore."

"Only God knows why a young man with his life ahead of him should die—while an old man like me goes on." He filled his pipe thoughtfully in silence—the deep, close silence he and Maria had always been able to share. When the pipe was lighted from a spile she brought him, he smoked a moment and then said, "I wish I could have died in David's place. For your sake."

"He—didn't suffer. I can be thankful for that."

"Will you marry again, daughter?"

"Never!"

"Never is a long time."

"You didn't."

"No, I didn't. I couldn't seem to bring myself to it, somehow. But—I pray you find someone who can provide for you."

"Papa, I forbid you to speak of it again. Please!"

He smiled a little. "I'm glad you added the 'please,' " he said, then fell to studying her face. She seemed, perhaps, slightly more mature, but her tragic loss had not noticeably aged her. A strong-planed, open countenance, wide-set eyes—her mother's eyes, the color of violets—a nearly perfect mouth, not too large, not too small. A beauty by any man's standards, unless he preferred a clinging vine or a moss rose easily stepped on. Ambitious, a will of her own. And David Fenwick had been just right for her—never threatened by her free nature or accomplishments, but reinforcing these assets with his appreciation; upstanding yet easygoing; full of laughter and the joy of living and yet a loyal and conscientious soldier—as no doubt he would have made a conscientious landowner, in partnership with his wife. No wonder, he mused, she shudders at the thought of tying herself to another man, but she should some day. She should. She seemed determined to live in St. Augustine, and it was not good for a lady to be alone in a garrison town. Her father would not live forever, and

especially since the deep, new roots of friendship and camaraderie he'd formed back in Charles Town—roots grown out of the Stamp Act rebellion—he doubted that he could ever be contented in a military colony totally beholden to the King and the men in London. So far, Richard Evans had managed not to bring up the subject of the rebellion, had felt that best on their first night together, but he did intend to be sure that his daughter had a firm grasp of the facts in the controversy. The present lull in the trouble was only temporary.

Maria broke the long silence. "Tell me more about the Sons of Liberty, Papa. I know you're dying to talk about it."

He smiled. She was still able to read his thoughts the same as she'd always done. "I thought we'd stay off the subject for tonight anyway," he said.

"No. Go on. Then, I've a lot to tell you about this doggedly loyal little colony of East Florida."

Evans tapped ashes from his pipe and cleared his throat. "Well, daughter, you've always had an open mind about issues. I've been proud of that in you. But it does trouble me that you seem not to take seriously our resistance to being taxed without any representation in Parliament. It is important to your old father that you understand why I believe as I do. Is that childish of me?"

Maria laughed her low, beautiful laugh. "Of course not. And I do have an open mind. In fact, it's so open I no longer have any illusions about governments in general. Or that people have a voice in their government."

"Oh, but people do have a voice! Englishmen do. Will you hear me out?"

"Yes—if you're not too tired from your voyage."

"Do I look or act tired?"

"Frankly, no. I've already told you how well you look. And distinguished. You could pass for a dignitary, with that straight bearing and patrician nose. Your hair's gray only where it becomes you. You really don't seem any older, Papa." He was smiling. "Don't you believe me?"

He reached to pat her knee. "I've always believed you, Maria."

"Then take my word for it that I want you to talk—all you need to—about your cause of liberty. If I've acted unconcerned, it's only because we have been unconcerned here."

"But surely there's been talk, especially now that the King's Road is well along and prospective settlers are coming down to look you over."

"There's been talk, yes. But—how can I say this? We're such a new colony. The Spanish have been gone such a short time, it's just—well, in view of the way they were treated by their monarch—it's more rewarding than ever to be subjects of the King of England. I enjoy being surrounded again only by Englishmen. Especially after Havana."

His voice was teasing. "Maria Evans, you're not surrounded only by Englishmen. I've already seen at least one Spaniard who looked as though he'd like to surround you exclusively!"

She didn't join in his little joke as he'd expected. Instead, she said quite solemnly, "Yes. Yes, Don Luciano is in love with me. So is Mr. Fish, although he's never mentioned it. And—Papa, I, really wish they were not."

"They appear to be gentlemen."

"They are. And I desperately need their friendship."

"Obviously you have it, daughter."

"I have, and that's the thin line I tread. I must keep the friendship. It isn't easy under the circumstances—sometimes."

He nodded. "If any woman can do it, you can. Tell me about them. They're both in business here now?"

She told him all she actually knew about Fish and Herrera. About the strange circumstance of the young Fish having been reared by a Spanish family, the seemingly immutable closeness of the two men now—even where she was concerned. "There is gossip that they're both—somewhat wily," she added. "That Jesse Fish, by some means, through Herrera, made an illegal or at least questionable contract with a Spanish agent named Puente—some such thing having to do with real estate in town. I've tried not to listen to the gossip. Mostly, of course, I hear it from Ann Cameron."

Richard Evans nodded, smiling. "Good little Ann—always so interested in everyone around her."

Maria laughed. "Oh, Papa—you know perfectly well her tongue's loose at both ends! Not maliciously, though. Ann is my real friend, but she does get on my nerves about Fish and Herrera. This is something she got hold of in the past week or so, and I don't want to hear it. Both men have been excessively generous and patient and understanding with me."

After a long moment, Richard Evans said, almost to himself: "I would not want you to marry either man."

"Heavens! I've no intention of doing such a thing. You did seem to like them well enough, though."

"I don't know them. I liked them all right. They're your friends. For a first meeting, that was all I needed to know."

"Papa, that was a very peculiar thing you said."

"That I wouldn't want to see you married to either man?"

"Yes."

"I don't see what's peculiar about it."

She laughed. "You still don't waste any words, do you?"

"Should I?"

"No." She got up to hug him. "I love you exactly the way you are. And I'm so glad you're here—oh, I'm so happy you're here with me!"

Taking one of her hands, he said, "You know, I think I'll hold my tirade about the Stamp Act for another time, if that's all right with you. Perhaps there's nothing more to say anyway. Men stood shoulder to shoulder—men of the Mechanics Guild and men of prestige in the town—as did our politicians who went to the Stamp Act Congress. We won. The infernal thing is gone. And—I'm here with my beloved daughter."

"Papa?"

"Hmm?"

"Wouldn't it be—wonderful if we could be really sure that David and Mama know we're together tonight?"

"They do know, Maria," he said softly. "And if you don't yet have assurance of that—I pity you."

She was standing now, facing the empty fireplace, her back to him. He could see her body stiffen. "Well, I don't know it. David—David is—just *gone*. That's all I know."

"Faith is a personal thing, daughter. I'd give you mine if I could. It comforts me. In fact, it's kept me alive since your mother left us."

She whirled suddenly, a forced, cheerful smile on her lovely face. "What solemn talk! This is no way to say our first good night! Forgive me?"

"For what?"

"For—bringing it up. For not being braver than I am. It's just that—no one here knew David well enough to love him as you and I did. I've—I've been—quite alone." She kissed his wide, high forehead, a habit since childhood. "Time for bed, and wait till you see what Long Stem's fixing us for breakfast tomorrow! Your favorite—battercakes and molasses."

17

Jesse Fish sat alone sipping a second cup of coffee, served him on his veranda at El Vergel on Anastasia Island. It was an overcast, late summer morning. The house was dim and still, the dust heavy on the green leaves of his orange groves. After four glorious days in which laughter, light, sumptuous meals, and good conversation had filled the rooms of his house, the guests were now gone. He was alone again as he had seemed to be for most of his forty-two years.

Growing up in the Herrera household, he'd felt included in the once large, warm family, but not really a part of it. He had always

144

felt alone. After yesterday's late departure of Doña Maria Fenwick and her father, the sense of isolation was almost unbearable—newer, sharper.

Her low, musical laughter and the sight of her lovely form moving from room to room of his own spacious house had filled his heart; had seemed literally to light his home. Fish had been so drawn to her restrained, intelligent father that he'd dared do what he never expected to do—he had spoken of his love for Maria and had asked Richard Evans' help in persuading her to marry him. The conversation between the two men, which had occurred night before last after she had retired, had not ended poorly. He felt that Evans held him in high regard, but he had bluntly refused to intercede.

"It's plain that you don't know my daughter, Mr. Fish," he had said in his firm voice. "I could talk in your behalf all the way to my grave, but if Maria did not feel inclined to marry you, she'd never do it. The girl's mind is entirely her own."

Jesse Fish drained his coffee cup and set it down. His intentions were settled. Maria Fenwick was the woman he wanted, but if she continued treating him merely as a valued friend once he'd approached her directly, he was going to find someone else. The loneliness had lasted too long. It was withering his deepest instincts. This large and fine house had not been built for one person. It was clear to him at last that, as much as he wanted more wealth and influence, he wanted children and a woman to love and understand him.

Now that London was supplying the needs of St. Augustine, his work with the Walton mercantile firm had ended; nevertheless, he was richer than ever. He claimed all of Anastasia Island and had been able to purchase one hundred and eighty-five buildings and lots in the city for the meager sum of 6,169 pesos. He also claimed several church properties, although Grant was surely going to give him a fight over those. There was no doubt that the plunge he had taken, even for such a small sum, had been risky. But with the cunning of Luciano, he'd manage a good profit one of these days

when more settlers came. Any woman should find him a desirable husband, but Maria Fenwick was not just any woman, and it was she whom he wanted to marry.

True, the population was still too sparse for Grant to call an election. Unlike other British colonies, East Florida still did not have an elected Assembly. The governor was wooing settlers, though, and wary as Fish was of Grant, he respected both his talents and the problems he faced. Word was out in the town that he was finding it difficult to deal with Major Ogilvie and the Surveyor General, De Brahm. Only a saint could avoid trouble with both men, and Grant was no saint. But his Excellency was making some progress. He had, at least, persuaded the cantankerous De Brahm to settle in St. Augustine, and Fish had sold him the fine house on St. George Street adjoining Government House Gardens.

John Stuart, who worked closely with the governor as Superintendent of Indian Affairs, also bought a house from Fish to occupy during his frequent visits to the colony. The government had even provided Grant with his own schooner so that ample gifts could be sent at all times to the Indians in the area. There was no doubt that his Excellency knew how to run the government here, which had always included handling Indians. Grant also knew how to apply his great personal charm and diplomacy among his officials. Countless arguments had already been settled because James Grant entertained the contesters so royally at his own table that they had little choice but to behave civilly toward each other. The two new schoolmasters who had arrived only last year would surely help attract more settlers. The city would fill up one day, as would Fish's reserves, and then he would speak to Maria.

Jesse Fish's thoughts went to his new friend—at least, a man he hoped would be his friend—Captain Joseph Peavett, who had just purchased the St. Francis Street property. He liked Peavett, sensed in him some of the same banked fires of passion and ambition which Fish himself owned to. Captain Peavett was perhaps a

146

year or so past forty-five, mature and levelheaded, an extraordinarily good conversationalist, and obviously—as regimental paymaster—a reliable man of business. Perhaps he'd invite Peavett to spend a few days with him at El Vergel. He needed another close friend besides Luciano, who, Fish was convinced, loved Maria, too.

The gentle St. Augustine autumn passed swiftly for Maria. She had not only been occupied with repairs on her small Marine Street house, she was called upon to deliver seven babies. All but one lived.

"Don't expect much talk from me, Don Luciano," she said wearily when she found him waiting in the street following the futile delivery. "I feel the tragedy deeply because it was a Spanish baby—the child of your friend. One of your few countrymen to stay. The family's sympathy for my failure made me feel still worse."

Luciano held her arm as they walked slowly toward Charlotte Street. "You did your best," he said.

"I always do my best. Sometimes that isn't enough. It must be very late. It's so dark."

"Sí. Nine o'clock. Doña Maria, why is it that you care more because the family are friends of mine?"

"That's a foolish question."

Standing before her house, Luciano looked up at a lighted window on the second floor. "Your father has not retired."

"He's probably reading. The man devours books. Fortunately, I just received several from Charles Town. Along with them the *South Carolina Gazette*. He may not even hear me." She sighed. "Good night, Don Luciano. I do thank you for waiting for me. I wish I had done better."

"May I come in for a moment?"

"Not tonight. I'm too exhausted. Please understand. My father and I will have you to dinner soon."

Abruptly he grasped her by the shoulders and said, his face close to hers, "Do not worry. I am not going to ask you to marry me—not ever. I am not the kind of man who marries. But you

must tell me why you are so careful with me. Why is it so strange that I need to know that you . . . find me a little more than . . . your friend?"

Before she could answer, he took her in his arms and kissed her—not tenderly this time—with the passion of a man who could not help himself.

"Maria, Maria," he whispered, kissing her eyes and hair. "Maria, *mi querida,* you—kissed me in return! You kissed me!"

She pulled away and fumbled for her key in the big pocket of her skirt. "If this spoils our friendship," she gasped, "I swear, Don Luciano, I'll never forgive myself!"

He took the key and opened the loggia door, laughing.

"I'm glad you find it funny."

"Not funny, Doña Maria—intriguing! And I promise you, the friendship will be only stronger. I just needed to know—you see?"

"I can't imagine why I did it," she said matter-of-factly. "So, there's nothing to know."

Maria climbed the outside stairway, dazed and humiliated. She *had* kissed him, and she was again afraid. Not afraid because she kissed him. She would never allow herself to be tempted like that again. Never. The fear, no matter what he had said to reassure her, was for their friendship—their all-important friendship. She not only needed his influence in the city, she needed Luciano himself. David's lightheartedness still haunted her dreams at night, and Luciano's gaiety, his quick laughter, were like faint, merry echoes which now and then eased her pain a little.

She unlocked the upstairs door quietly, for once hoping her father would not call her to join him. She was bone tired.

As she tiptoed toward her own room, his door swung open. "Ah, there you are! A successful time of it, daughter?"

"No, Papa. The baby died."

"I'm more than sorry, my dear. You look in need of companion-ship. Come in and sit down with me. A good talk will take your mind off what happened."

His voice was so eager, his face in the lamplight so full of affection, she could only smile weakly back at him. "All right. But not for long. I'm tired all the way through."

He seated her in his chair and perched on the bed. He'd come to the door with his newspaper in hand, and she could tell he was controlling himself for her sake over something he'd just read.

"You've been reading, I see," she said disinterestedly.

"Indeed I have." He smacked his copy of the *Gazette* with the back of one hand. "You remember the Charles Town editor, Peter Timothy—always pretty plainspoken, but there's more trouble afoot—such an unjust new act of Parliament that old Peter's more irate than plainspoken this time. Let me read what he says, Maria. Listen. 'This paper reported first in South Carolina, the initial actions against the repressive Stamp Act. Once again we are forced to print the news concerning another potentially repressive move by Parliament called the Declaratory Act.' "

"Papa, please. Can't we just talk?"

"You'll sleep better with your mind on what I'm reading. Listen to this, Maria. 'We understand that certain British officials considered the repeal of the Stamp Act to have been a show of weakness by Parliament. Therefore, to placate those officials, the ominous Declaratory Act is upon us. This Act states categorically that in all cases whatsoever, *Parliament has the right to legislate for the colonies.*' "

"What does that mean, Papa?"

"Wait a minute, I'm coming to the kernel of it all. 'South Carolinians believe in local government. Our elected Assembly must be subordinate to no power on earth. From now on, resistance to British authority has become a genuine option. It would surprise no one that British officials suspect us of conspiring to rid ourselves of their control. Certainly, even the most loyal subjects among us here in America, deem it likely that the mother country is attempting to enslave us. We close by quoting Charles Town's outstanding delegate to the Stamp Act Congress, Christopher Gadsden, who said: "At this time there should be no New England men, no New Yorkers, no Virginians, but all of us Americans." ' "

He waited for her comment. She said nothing.

"Well, daughter? What do you think of that?"

"Honestly, it's so far-fetched, I don't know what to think. I'm—too tired—to think."

He went to her. "And I'm a beast forcing you to listen. But when I leave here, Maria, I will need to know that you have some idea of the state of things outside East Florida."

She sat up. "You're not leaving!"

"Yes, soon. I want to be busy again. Anyway, it's your turn to visit me. The change will do you good. Give you a real feel of the trouble up there."

Maria sighed wearily. "Papa, I've listened to you. Now, you listen to me. I'd enjoy a visit home. I really would. But there's something you, too, must understand. This is my city now. It once belonged to David and me. It's mine now. I'm building a life here, and your daughter means to become an influential, prosperous citizen of St. Augustine. I've only just begun. I couldn't possibly leave anytime soon—even to please you. Besides, I think you—and plainspeaking Peter Timothy—are exaggerating things all out of proportion. There are too many loyal subjects in South Carolina for serious trouble with the King."

"That's where you're wrong, daughter. I don't know of a single disloyal subject in the entire colony, but we *are* British subjects, conditioned to true liberty under our British constitution. Things may quiet down, but I can promise you that during the Stamp Act crisis, the colonies to the north of us were on the brink of armed rebellion."

Maria looked at him for a tender moment, kissed his calloused hand, and said in a voice she hoped was not too casual, "You'd better put such farfetched ideas out of your mind, calm down, and get some sleep yourself. I must." Then, "Papa, you're not leaving right away, are you?"

"A week, perhaps. I know you think I'm an excitable old man, but Maria, as the Scriptures say, 'I hear a sound of going in the tops of the mulberry trees.' Hear it all the way from South Carolina. I want to be there—whatever happens—with my American friends."

18

Aside from an occasional uneasiness that Spanish fishing vessels loitering near the Keys might mean trouble with the Spaniards and perhaps the Creeks, life moved along in a routine way throughout the rest of the year 1766. Luciano assured Maria each time she inquired that Spain meant no harm to the new British province. He also jibed good-naturedly that Governor Grant needed to keep the peace within his own Council—and between himself and the quarrelsome Surveyor General, De Brahm, rather than worry about the Spanish fishing vessels. For her part, Maria found William Gerard De Brahm a fascinating man—surely a brilliant one—but her respect for Grant ran so deep that, in the recurring confrontations, her sympathies were aligned on the side of the governor, who should, she felt, have unchallenged authority.

Anyway, she had her hands full looking after her own affairs. In letters to her father, hoping to allay his fears for her safety, she went on reminding him that, unlike South Carolina, East Florida was at peace. "Our people," she wrote, "are willing to abide by the laws of Parliament, and our sole objective is to get ahead in the daily round. If only you would move here with me, you would find your old age peaceful." Papa remained firm in what he called his "patriot" sympathies.

Early in 1767, she wrote of the arrival of Dr. Andrew Turnbull, a Scotsman of fine appearance, bold ideas, and means, who at once got into Grant's good graces with the grandeur of his proposal for colonizing a large area some seventy-five miles south of St. Augustine at Mosquito Inlet, a new colony to be called New Smyrna after the city where his Greek wife had been born.

Maria, of course, wished that the new settlement were nearer St. Augustine so that she could serve the women among the

hundreds of indentured Greeks, Italians, and Minorcans whom Turnbull was bringing to work his new land grant. But the whole ambitious plan had so gladdened the heart of Governor Grant that she, too, was glad for Turnbull's ingenuity. Anything that strengthened the East Florida colony as a whole strengthened her own future.

Turnbull, accompanied by his beautiful Greek wife, was granted the two-storied house across St. Francis Street from the cottage—the fine place Maria had so admired on her first day in town. The acquisition of the house was questionable, since Jesse Fish claimed that he owned it, but the royal governor had simply declared it the property of the King of England and granted it to the new colonist, Andrew Turnbull. The grant churned up a fresh wave of gossip that Fish had acquired all his St. Augustine holdings by some illegal means. Maria kept still. She liked Dr. Turnbull, and Jesse Fish was her friend. She also meant to remain in the governor's favor. The gossip went nastily against Fish, but as Maria saw it, he stood to be ruined financially if property which he felt he owned could be granted arbitrarily by the Crown.

St. Francis Street, with the Turnbulls renovating their large home and long-delayed military remodeling of the old monastery still in progress, was no longer the quiet, empty lane she remembered. The work had been unbelievably slow, but St. Augustine would one day provide ample housing for its growing number of troops. The garrison city, formerly a home to only part of the Southern Brigade, was scheduled to replace Pensacola as the brigade's main station and headquarters.

More and more frequently during 1767 and 1768, Maria was a guest at the governor's fancy-dress balls, always escorted by both Don Luciano and Jesse Fish. Fish had introduced her to Captain Joseph Peavett, who had bought—but did not yet occupy—the house on St. Francis Street. He was a big man with a prominent nose and an accomplished dancer, for all his size; she had danced with him two or three times. She had the impression that Fish in his restrained way, deeply admired this new friend of his.

Letters from her father came often; he was well, thank heaven, but his mind these days, especially as the months moved toward the end of the year 1768, was entirely filled with the trouble between South Carolina and Parliament. His latest letter, received in October, had run on for pages about what he called "another hateful act"—the Townshend Act, by which duties were to be collected upon all glass, lead, paint, paper, and tea imported into America. The Massachusetts colony, early in the year, had circulated a sizzling letter among the other colonies urging joint action to oppose the Act, and now, according to Papa, British troops had moved into Boston to maintain order and support royal authority.

Alone in her room at night, she worried about her father and yet felt helpless to disengage him from what could, she supposed, become a serious colonial rebellion. They had always left each other free; she respected him totally. Her strong will had come down to her through Papa. There was nothing she could do but worry—and hope he'd come to his senses—or that, by some means, the controversy could be brought under control. Here in St. Augustine such turmoil still seemed remote.

Over the months, Maria dreamed at times that she lived in the little house on St. Francis Street with David, now standing empty and forlorn. Usually, with effort, she managed to push back those painful dreams by diving headlong into work on her meticulous records as soon as she got dressed in the mornings. But in the half-sleep moments just at dawn on a chilly spring morning in 1769—she would remember the year, because this dream stood alone among all the others—she had seen herself back in the cottage with David, and this time with them was a tawny-haired little boy—David's son. The child she had never given him.

Her eyes wide open, she stared up at the beams of the low white ceiling, unable to move because the dream was still so real. After a few minutes, tears flowing unchecked down her face, she leaped from bed and stood looking out at the gradually lightening sky. A vivid reddish glow widened along the horizon over Matanzas Bay, and in the still dark-blue dome above it hung a

sickle moon, beside it the morning star. The beauty was as intense as her pain. She felt she might faint with a new, strange, unfamiliar longing. True, she had expected one day to give David a child, but he had so filled her hours that her longing for the feel of a baby of her own in her arms had never surfaced before this starkly beautiful, hopeless morning. Through the five years since David's death, she had known sorrow only for *him*.

Roughly, she jerked off her night shift and began to bathe in icy water. If Long Stem heard her and brought hot water, she'd send her away. Anger mingled with her odd new grief. She felt angry enough to punish herself with the splashes of cold water. Something had to bring her to her senses. She *had no child* of David's—she would never have one.

Half dressed, she hurried again to the window. Perhaps the magical moon and its companion star would be gone. In the space of those few minutes, their strangely enchanting positions in the sky had become symbols. Symbols of all she would never experience. The sun was mounting rapidly, washing night blue from the sky, but the thin moon and the star still hung, almost defiantly whiter—not brighter—whiter than before. Somehow contradictory, out of place in the sunrise. She watched, motionless, as the heavens paled. The moon and the star only whitened until, still glowing, they became a blue-white part of the sky itself. She trembled. Was she still dreaming? Or had she awakened a lunatic? Were the moon and its star etched against the sunrise an ordinary happening that she had simply missed seeing before? Or were they a sign of something horrible yet to come? What else could come? David was dead.

She hooked on the bodice of her lavender-striped day dress. Its firmness seemed to give outward resistance to the unexpected pain that continued to rage within her. Then she began to pull on petticoats. Being dressed and ready for the work of the day would surely help wipe out the dream. Who could trust or even pay any mind to what happened in the mystery world of sleep?

She brushed her heavy brown hair, fastened it close to her head, and put on the lawn mobcap with amber velvet ribbons. Staring at

her own stricken, drawn face in the looking glass which sat on the newly purchased chest of drawers, she felt old and alone. Forsaken. Forsaken by David. And by her own child.

A rapid knock on her door sounded like a cannonade.

"Long Stem?"

"Long Stem," the Indian girl replied in an excited voice. "Visitor downstairs."

"A visitor at this hour?"

"Mr. Jesse Fish."

"I apologize for coming so early," Fish said as they took chairs in her parlor, "but my mission is urgent. I'll come right to the point. I'm—leaving for the New York colony tomorrow."

"Well," Maria said, surprised yet somewhat relieved by the interruption. "Is that good or bad news? We'll miss you, of course, but—"

"Perhaps it's neither good nor bad," he said, his voice unusually nervous. "Business, of course, but also my first visit back to the place of my birth since I came here at the age of twelve."

"You certainly sound mysterious. Am I supposed to pursue my curiosity? I am curious, you know."

"I'd hoped you would be." Sitting very erect in his chair, his hands folded on his lap, Fish went on. "You see, I've decided to get married. I don't have to tell you what I have to offer—or what I don't have to offer a woman. You already know both my attributes and my shortcomings. Doña Maria, I want more than anything on the face of God's earth to marry—you. If you won't have me, I intend to find a bride in New York."

"Well, I must say you've taken me unawares." She laughed uneasily. "I'm sure it shows on my face."

"I feel I've proved my intentions toward you. I've admired you—in fact, I've loved you—since our first meeting. You've known, of course."

"Yes. And I've been honored and—complimented, Mr. Fish." After a pause, she said, "But I can't help wondering why you've waited until the day before your departure to tell me."

"I wish I could explain. I can't. The older I grow, the less I seem to know myself. I've decided it's because I'm alone too much with my own thoughts. I'm lost in them—and they're empty thoughts." He leaned slightly toward her. "Doña Maria, you . . . wouldn't need to love me in return. Just seeing you walk through the rooms of my house would be enough. Talking to you about the things I've never been able to share with another soul. I'm a restrained man. I assure you I'm no . . . animal. I need companionship. I promise you would never find me forcing my attentions upon you—never."

In spite of her deep attachment to Jesse Fish, the idea of marrying him revolted her, but along with the revulsion came pity— genuine compassion for this soft-spoken, gentle man proposing to her in an almost sorrowful manner. Her goal of becoming one of St. Augustine's wealthiest women could be reached at this very moment with one affirmative nod of her head. The thought fled as swiftly as it had come, and she said slowly, carefully, "I've grown to be—very fond of you, sir. To depend upon you. But my regard for you is too deep for me to be anything but honest now."

"Your answer is no."

"My answer is no—but with gratitude."

He reached for his tricorn on a nearby table. "I see. Then, I'll bid you goodbye for a while. I'm not certain how long I'll stay away, but I plan to return with a wife. I want you to know, however, that even if I find her greatly to my liking, it's somehow important to me that you never forget that it is you, above all other women, whom I love."

"You—leave me very little to say, Mr. Fish."

He raised a hand. "Don't try. There is one more thing. You're acquainted with Captain Peavett, the purchaser of your St. Francis Street cottage?"

"Yes, we've met at Government House. A skillful dancer. Why do you ask?"

"The man has come to be one of my close friends. He's the only person who knows of my feelings toward you."

"You—told Captain Peavett?"

Fish nodded. "Only Captain Peavett. Luciano didn't need to be told. In fact, Peavett knows of my visit here this morning and its purpose. He knows I've tried to befriend you, guide you in a business way. You've made quite an impression on the man. I've taken the liberty of asking him to give you any counsel you might need during my absence."

Maria's laugh was puzzled, though not at all unkind. "Indeed!"

"I trust you're pleased with the arrangement."

"I should be flattered, I suppose. Perhaps, to an extent, I am, but I also feel a bit like a piece of real estate being deeded from one gentleman to another!"

Fish remained solemn. "If I've hurt Captain Peavett's chances with you by telling you this, I've done him a great injustice."

She stared at him incredulously. "Captain Peavett's *chances?* Captain Peavett has sought no chances with me! Not that I would be interested if he did—in spite of his sudden prominence in the city and his unmistakable charm."

Fish got to his feet. "My dear lady, Don Luciano de Herrera will never marry you or any other woman."

Maria, even more dumbfounded, sank back in her chair. "Mr. Fish, if I have anything to say about it, he'll never marry me, at least." Then, wanting to end the awkward interview, she, too, got up. "You have indeed been lost in your own thoughts, sir. And I choose to forget most of what you've said. I'll just wish you well on your journey—in every way."

He bowed over her hand, but did not kiss it. "Thank you. I find you—a very great lady always. I hope I haven't insulted you."

"You've surprised me, goodness knows, but you haven't insulted me. As usual, you've been honest. I'll return the favor by assuring you that I and all my affairs will be in good hands during your absence—*mine.* Goodbye, Mr. Fish. Safe journey."

When Jesse Fish had gone on his lonely way, Maria stood for a while, her hands still flat against the door she had just closed after him. This good if strange man had inadvertently done her another real favor: the disturbing dream had receded. She could have her breakfast now and get to work on the accounts.

19

During the next six months, Maria delivered eight children, among them, in February, the first son of the Reverend John Forbes and in early June Ann Cameron's firstborn, a girl. She would not permit any payment from James Cameron, but fees from the other deliveries brought enough cash for the remaining furniture needed in her Charlotte Street house and final repairs on the Marine Street property.

While the hot, moist summer hung over the city, there was little entertaining done, but in autumn the social tempo quickened. On a late October evening, wearing a jade-green silk ball gown with matching stole and slippers, a wisp of lace in the coil of her thick shining hair, Maria strolled on the arm of Luciano de Herrera through the twilight across the Square toward Government House.

"I hear the governor's band tuning up already," she said.

"Without doubt his Excellency is tuning himself, too. The man could not survive without his fancy-dress balls, no?"

"He told me last week that he'd written to the South Carolina royal governor to insist that there is no such gaiety as ours in any other American colony." Maria laughed lightheartedly. "Tonight, I believe him."

They spoke and nodded to other prominent couples strolling across the Square toward the brightly lighted Government House. Then Luciano said, "It is fortunate for me that we have a bit of gaiety in St. Augustine, since I am now your sole escort."

"Have you heard anything at all from Mr. Fish?"

"Not a word. Which leads me to suspect the old fox has found a wife."

"I hope so. Oh, I hope he has."

"You are glad, too, then, that I am your only escort, Doña Maria?"

"You're gallant enough," she said teasingly, "but not exactly subtle."

He laughed, then grew serious. "It is odd at times to be the only Spaniard among so many Englishmen—except, of course, when Don Manuel Solána agrees to attend the governor's soirées. Only Don Manuel in all the city has the courage to refuse such an invitation."

"Would you like to refuse?"

"Never."

"Now and then I feel you and I are segregated from the others, no matter how charming their welcome appears."

"Because I am Spanish?"

"Yes. But also because, as the widow of a sergeant and the daughter of a carpenter, I wouldn't even be invited if I didn't own property."

"Does that disturb you?"

"Not one bit. I have a good time with you, but my goals are not social. They're monetary." She laughed her beautiful laugh. "My father is amused, too, that his daughter moves in the society of the Moultries, the Draytons, the Catherwoods, the Holmeses—and now, the elegant and cavalier Dr. Turnbull. I wonder if he's had any more riots among his colonists at New Smyrna?"

Luciano shrugged. "Who knows? One hard overseer named Cutter is said to have brought on the first troubles. The colony must be primitive at best. How Turnbull expects a thousand strangers to be peaceful together under such conditions, I do not know."

Maria changed the subject. "I wonder if Captain Joseph Peavett, Mr. Fish's friend, will be here tonight?"

"I saw him back in the city this morning from a journey to North River. If he believes you will attend the ball—sí. Captain Peavett will be here in all his forceful glory."

In the courtyard of Government House, their talk was drowned by the noise of gathering guests and music, so that Maria almost shouted, "Whatever do you mean—his 'forceful glory'?"

"Has a more handsome, energetic man graced our city than the bronzed Captain Peavett with the nose of the eagle? Do not tell me you have not noticed, because I will call you a beautiful liar!"

Maria and Luciano danced the first minuet together without conversing. They were familiar now and at ease socially. I'm fond of

him, she thought, as he touched her hand lightly in the forward balance step, and such a comfortable fondness it is. Like the brother I never had. Her most reassuring thought was that in the three or so years since their one passionate kiss, he had never tried it again. And still their good times went on. There was no explaining it and no need to try. If he had been restraining himself with her, she could not detect it. If he had meant nothing by the kisses, she didn't mind in the least. He had made two things clear: he was never going to marry and he was her friend. A woman in her position could ask for nothing more. She needed an escort; attending the elaborate social functions in the city was important to realizing her ambitions, but a romantic encounter was the last thing she wanted. Her heart could never again open to any other man. Don Luciano left her free, and she liked him for it.

The dance ended, and over the applause and talk and laughter, she heard her name called. The governor, lavishly uniformed, was approaching.

"Good evening, Mrs. Fenwick! I'm honored that you came." He bowed. "And you, Don Luciano. Such a handsome couple graces my ballroom. Are you enjoying yourselves?"

They assured him that they were, Maria curtsying, Luciano bowing deeply, but since Grant was an almost perpetual talker, little needed to be said in reply to his greeting.

"I hope you are finding the evening pleasant, because I predict the social life in our city will grow ever more lively. The Turnbulls must be the next to be honored. The good doctor has already agreed to serve on my Council. What a dynamic gentleman he is! I blink at his bold ideas, his sweeping plans for his new colony. In fact, I fear he's brought too many people for perpetual harmony at New Smyrna, but we shall see. Perhaps he can control his overseers so there'll be no more riots. I've already asked that he serve also as Secretary of the Council and Clerk of the Crown and Common Pleas. The man declares, alas, that he's too busy to accept all my appointments, but he will sit on the Council when he's in the city. So, you see, entertainments are in order. Much merry entertainment!"

"*Sí*," Don Luciano said.

"Of course," Maria said and was about to add that she would be happy to know Dr. Andrew Turnbull and his lovely Greek wife better, but Grant went right on.

"Now, tell me what you both hear from our traveler, Mr. Jesse Fish."

"Not a word, Excellency," Luciano said. "I suspect he has found a bride."

"Bride? I'd have sworn that Fish belonged to our club of carefree bachelors, Don Luciano! Well, if that's what he wants, I hope he's been successful." He chuckled, his girth shaking. "We need settlers, you know. And speaking of newcomers, I've just received word that Captain Joseph Peavett will apply for a grant on North River, adjoining your property, Mrs. Fenwick." Grant scanned the candlelit ballroom. "Don't see Peavett yet. He sent apologies for being late, but assurance that he'll he here. Some business to attend to, it seems. The man lets nothing come before business. Admirable trait! Well, before I move on to my other guests, I must tell you also that there will be still another celebration here at Government House when Brigadier General Frederick Haldimand arrives in town. Commander-in-chief, you know, of His Majesty's Southern Brigade now."

They acknowledged the news with proper comments.

About to turn away, Grant stopped, looked at Luciano with a quizzical eye and asked, "Were you already aware of that, Don Luciano?"

Herrera smiled knowingly. "Yes, sir. I was."

When Grant had gone, Maria demanded to know how Luciano knew about Haldimand and why the governor had asked.

He smiled, shrugged and said nothing.

"Why do you have to be so mysterious?"

"Why do you have to be so curious?" His dark eyes cut in the direction of the entrance to the ballroom. "Why not turn your curiosity toward the doorway? See who arrives."

Captain Joseph Peavett was alone—tall, imposing, his well-cut uniform still somehow giving the appearance of genteel ruggedness,

as though he would be as much at ease on a hunting trip as here in the entrance of an ornate ballroom. He stood looking about for a time, nodding courteously at acquaintances. Then he spied Maria and headed straight for her.

"Shall I move away?" Luciano asked.

"Don't you dare!"

"Good evening, Mrs. Fenwick, Don Luciano. I was unavoidably detained, and since I've already missed some of the ball, I decided to find the lady with whom I would most enjoy a dance." He offered Maria his arm. "With your permission, sir? And yours, dear lady?"

A gavotte had already begun, and Peavett expertly led her into the quick four-four rhythm. Big men, she knew, were often light on their feet. Peavett was the lightest of all, she believed. A head taller than she, he exuded confidence, not only in his dancing, but in the very tone of his deep, rich voice.

"I can't tell you how relieved I am to find you here, Mrs. Fenwick."

"Thank you, Captain. I understand from his Excellency that you've been to North River."

Smiling broadly, he said, "How flattering to have been discussed by the governor—and by you."

Maria thought he sounded no more flattered than he'd sounded relieved that she was there. Merely pleased in both instances. He appeared to be somewhat older than Maria, yet his heavy, muscular body moved with the agility of Herrera's—he was a better dancer, if the truth were told.

"And did the governor sound encouraging where my chances for the North River grant are concerned? I assume he told you I've applied for one."

"He did indeed. I'm sure you'll get it, Captain. He seemed highly pleased with the whole idea. I own property there, too, you know."

"Yes. I do know."

They danced to the end of the music, and Peavett guided her through the crowd to the edge of the floor on the opposite side from where Don Luciano waited.

"Oh, I see now," Peavett said smiling down at her, "that Don Luciano is over there."

"And will you take me back to him, please?"

"As soon as you've promised to let me call on you at your home. When may I come?"

She bridled a bit inwardly at his presumption that she was going to say yes, then she heard herself laugh invitingly. "I believe I'm free next Tuesday, sir. Will you come for tea?"

He bowed over her hand. "I'm as certain as I can be that I have something of interest to discuss with you, Mrs. Fenwick."

"Indeed."

Her response was feeble and she knew it.

"Indeed," he repeated after her, taking her arm and moving her deftly back to where Luciano stood.

Once Peavett had gone, Herrera's lack of curiosity irked her. "Aren't you even going to ask if I enjoyed my dance with the captain?"

"I could tell from watching."

"Do you know something else?"

"Should I?"

"That man is so—so self-assured, he reminds me of—myself!"

Summoned in the middle of the following Monday night to assist at the birth of Honoria Clarke's child, Maria found herself struggling, not with the birth, which was blessedly a normal one, but with her own impatience. Mr. Clarke had sent for her too soon, and since it was against professional principles to rush a woman in labor, she had no choice but to sit and wait while the pains and the labor increased.

At two in the afternoon on Tuesday, knowing that the baby could never be delivered in time for her to keep her appointment with Captain Peavett, she sent one of the Clarke children with a message postponing their tea.

"I'm—so sorry, Mrs. Fenwick," Honoria Clarke kept repeating. "I'm sorry—to take so long."

"You're having a very natural birth, Mrs. Clarke. You're not taking too long at all."

"I couldn't help hearing what you said to—my son. I know—you had an engagement."

"Yes, I did. But nothing at all is important now except that you and I bring a healthy baby. And we will. We will."

It was dark, nearly eight o'clock, when Maria reached her house. Too tired to search for the key in her midwife's satchel, she rang the loggia bell and leaned against the gatepost to wait for Long Stem.

The house door and then the gate opened, and there, smiling, stood Joseph Peavett, a candle in his hand. "Welcome home, Mrs. Fenwick. Your good servant has tea waiting. And supper, if you haven't already eaten."

Maria stared at him, thinking what a mess she must look—her skirt wrinkled, her hair disheveled. "Tea must be cold by now, Captain," she said, allowing him to admit her to her own house. "You received no message from me?"

"Oh, yes. I got your message, but since I'm leaving on an inspection trip to the New Smyrna colony early tomorrow, I waited. Are you annoyed with me?"

She tossed aside her satchel, let him remove her wrap and sank into a chair. "No. Just exhausted. And—messy, as you can see. But that can't be helped."

"Were you successful?"

She nodded. "A daughter to the Clarkes."

He poured scalding water into the teapot from the kettle that Long Stem had hanging above the small fire and sat down.

Maria laughed. "I feel as though I'm visiting you, Captain."

"And I"—he laughed, too—"feel quite at home here, Mrs. Fenwick."

"I find this house comfortable," she said. "A bit large for one person, but I needed room for my father's visits—although he's only been here once. My father and I are close. I wish I could persuade him to move down permanently."

She was chattering. Why on earth did she feel a need to make small talk with a gentleman who had surely come on some sort of

business? She should just wait courteously for him to bring up whatever it was that was so important.

When it was ready, Maria poured the tea, handed a cup to the captain, and sat on the edge of her chair, gratefully sipping her own. She could not remember sensing silent strength in a man as she sensed it now in Joseph Peavett, and yet, when he spoke, it was gently and with grace. A most appealing man in all ways. Still, she felt peculiarly ill at ease—an unfamiliar sensation.

Well, she thought, setting down her cup, this is my house and I'm tired. I even sent him word not to come today. The least he can do is get to the point of his visit.

"You have something to discuss with me, Captain Peavett?"

"I do indeed. A business matter for which I apologize, in view of what you've just been through. You see, I've now been assured that I do qualify for that land grant on North River. There is only one piece of property between my land and yours—mine, too, lies between the river and Guano Creek, a bit to the west. The intervening land can be had by a grant. Your thousand acres are already productive, well stocked with both animals and Negroes—and a tenant farmer. I believe you'd qualify for that additional piece between our two holdings. Why not petition the governor for those five or six hundred acres, permit me to buy half of it from you, and go into the timbering business with me?"

Maria rubbed her forehead. "I'm frowning, I know. It's just that—"

"That I appear to be rushing you? I assure you I'm not. I simply don't mince words. And time, as I see it, is of the essence here. Perhaps you've already heard the rumor that his Excellency is considering a leave of absence from our colony."

She sat straight in her chair. "No! Why?"

"His health, I believe. A chronic bilious condition."

Maria laughed again and said quickly, "I'm not making fun. His Excellency has no more loyal resident than I. But he does eat far too much rich food."

"And wine flows too freely at his affairs. Oh, not too freely to accomplish what he sets out to do, I suppose." Peavett leaned

comfortably back in his chair, obviously amused. "I was there one night when he refused to stop the serving of both mousse and wine until he'd brought peace between William Drayton and John Moultrie—no mean feat. And of course, the wine and the mousse were delicious."

What a pleasant, good-humored man, this Peavett, she thought.

"You see," he went on, "my plan for us is this. Although I'm on the river, too, the water's not quite so deep at my landing. We could share the cost of a new dock, combine our timber sales, and do a brisk and profitable business." He stood, looking down at her warmly.

"Of course, I expect no decision now. I merely wanted to plant the seed before my journey tomorrow. I must let you get some rest. Will you think about it seriously?"

Maria stood, too. "Yes, I will. On the face of it, I'm interested. But I'll need to ask a few questions and consider the answers carefully."

"I sincerely hope you'll investigate me thoroughly."

"I didn't mean I questioned you—not with your position and standing in the army."

Peavett smiled a little. "Nevertheless, I'd be pleased to have you see Frederick Mulcaster. He's known me since he was a boy in London. From a highly connected British family. Close to the King himself." His open, ruddy face broke into a wider grin. "Are you about to ask me if indeed Mulcaster is the illegitimate brother of the King?"

"No. I like him, whoever he is. You'll discover that I did not get my total share of so-called womanly curiosity, Captain."

"I hope to discover much more about you. I do not speak facetiously."

"I doubt that you speak facetiously very often," she said.

"You're perceptive, too, I see."

She started toward the door. "And tired, if you don't mind."

"Forgive me. I have stayed too long. I should return from New Smyrna within a month or so—in late November or early December. I'm going, frankly, because of my new friendship with Turnbull."

"As I mentioned, I already like your idea of applying for that grant," she said. "You see, I wasn't aware that the piece of land between

our properties was available. I *will* have to consider carefully the idea of a joint venture, though. You'll have my answer when you return."

"Good enough. Then I won't worry about it while I'm away. You make me feel very confident, Mrs. Fenwick."

She held out her hand. "Are you ever any other way, Captain?"

20

Early the next day, Maria was dressed and downstairs in time to see Long Stem blowing her daily puff of smoke toward the sun in greeting. The girl turned, smiling, when she heard Maria.

"Long Stem glad for you this day as for the sun, Mrs. Fenwick."

"Thank you, I'm glad for you, too—every day."

"Long Stem glad for the liberty to smoke pipe never allowed a woman in my tribe."

Maria stood beside her at the back door. "Do you—get lonely here with me?"

Long Stem nodded, then brightened. "But light will be lifting on this house from now on."

"It will be? Why?"

"Captain Peavett."

"Oh?"

"Captain Peavett bring more light than Mr. Fish."

Maria laughed. "Poor Mr. Fish. I don't know why I say 'poor Mr. Fish.' He must be having a marvelous time in the north, he's staying so long."

"Captain Peavett bring good fortune to this house."

"Really?"

Long Stem looked again at the sun she'd just welcomed. "You do not get well without your husband—after nearly six years."

Maria waited a moment before answering. "No. I—don't get well. I don't expect I will. Ever."

"His spirit here to heal you. You no believe that."

"I'm afraid I don't. Now, serve my tea, please? I have an appointment with Governor Grant this morning."

The governor, glad for such a pleasant interruption in his official routine, received her at once, his fat, pixie face beaming. He liked this woman. The way his digestion had plagued him lately, it was going to be soothing to hold conference with Mrs. Fenwick, whom he had always found as sensible to talk to as she was lovely to look at.

After he'd seated her, he offered a glass of claret, which she refused. Grant poured a small amount for himself and sat sipping it. "Good for the stomach, my physical gentleman declares. Isn't that delightful? Splendid medicine, although I'm not sure I agree with Dr. Catherwood that a disease distresses my stomach. I've simply had a stomach *full* of that bad-tempered De Brahm!"

"He is a capable man, though, isn't he?"

"Confound it, yes. But I declare to you, dear lady, that I would recover completely if only there were a way to be rid of him. I'd appoint his son-in-law, Mulcaster, in his place if I had a chance. De Brahm is an appalling man!" He drained his drop of wine. "But, how rude of me to belabor you with my problems of state. I'm at your service, Mrs. Fenwick."

He sat studying her as she told him from the beginning how she came into possession of the North River property and what Captain Peavett had suggested. Grant already knew that Fish and Herrera had given her the thousand acres in gratitude for having saved the lives of an Herrera mother and child. During that portion of her story, he concentrated on the woman herself. A carpenter's daughter, John Moultrie had told him. She was more than that. More, too, than merely

a superior midwife whose services helped him settle the colony.

He smiled to himself: Who had ever heard of a beautiful midwife? While she did not meet his taste for lush, Rubenesque beauty, her almost perfectly proportioned face and figure surely accounted for her so attracting the gentlemen of the city. She was, in herself, a personage, strong and clear-minded. Oddly, for such a spirited woman, she still grieved, he'd been told, for her husband, killed in some manner of tragic accident several years back. Perhaps her sorrow, so artfully concealed, accounted for a part of her attraction.

"You see, Excellency," she was saying, "there is a strip of land some five or six hundred acres in all which separates my property from the grant for which Captain Peavett has just applied."

The governor nodded attentively. "I've studied the map of the area—an excellent one, I'm sorry to admit—done by the prickly De Brahm. Peavett saw to it that I made a thorough examination of the survey before he applied for his grant. A studious and careful gentleman. I more than welcome the captain to our colony."

"I came today, sir," she said, "because Captain Peavett told me that you may be leaving. I do hope he's wrong."

"Alas, my physical gentleman is urging me to a sea voyage. Confound it, if he were an astute physical gentleman, he'd find a way to rid me of De Brahm instead!" He nodded his big head. "It is true—I have considered a leave, although I'm so tied to my infant colony, Mrs. Fenwick, that I shall stall as long as possible. There will be ample time to handle your request for a grant of that North River land." His eyes danced. "You *were* about to apply for a grant of that piece of land, weren't you?"

Grant thought he'd never heard a more melodious laugh.

"Yes, Excellency, I'm applying as of right now. Does your time permit this morning?"

He clapped his hands for a secretary. "My time is yours, madam."

"There is one additional favor I'd like to ask. The fact that I'm applying for this grant does not mean I've made up my mind to go into business with Captain Peavett. When he returns from New

Smyrna, should you see him first, I'd like your promise of confidence about my application."

Grant's bushy eyebrows twitched. "You have questions about the captain's integrity?"

"The paymaster to the regiments?" She laughed again. "But I'm a lone woman. And very cautious about signing my name without giving myself plenty of time to think."

From Government House, Maria went to the house of the Herreras. Don Luciano saw her coming up St. George Street and hurried from the window to answer her ring.

"I think you know by now," she said, after telling him of Peavett's proposal, "that I will ultimately decide for myself. But I would very much like your opinion."

Herrera had only half listened as they settled for talk in his parlor. His own thoughts were in such turmoil since his latest letter from Havana that talk of Joseph Peavett seemed an intrusion. Looking at her, more desirable than ever in vibrant blue, a mobcap with ribbons of the same color deepening her blue-violet eyes, he could think only that in a matter of hours he would be forced to sail away from St. Augustine—where he could no longer even look at her. He would, of course, have to tell her about Fish. And so, he thought, why not put off more talk of the business with Peavett by telling her now?

"I am honored, Doña Maria," he said, "that you have come to me for my opinion of Captain Peavett. You see, I had not spoken to Don Jesse Fish yesterday for five minutes before he inquired after his new friend, Peavett. He puts high stakes in the man."

She did not disappoint him. The woman he loved was as dumbfounded as he'd hoped. "Jesse Fish—is *back?*"

Herrera smiled slyly. "For a week now. He is a captive on Anastasia Island."

"Don Luciano, I'm in no mood for jokes. How could his return be kept a secret for a whole week?"

"Simple. He left the ship from Charles Town at the bar and went by boat directly to his island—with his sixteen-year-old captor!"

170

"Stop talking in riddles!"

"*Muy bien.* I will tell you. Our old friend, Don Jesse, is married to a redheaded child of Satan named Sarah, who I predict will be the ruin of the man unless by some means he comes to his senses. He had good sense once. It is gone—*perdido.* The girl wasted no more than ten minutes before she got Fish out of the room and was about the business of seducing me."

He knew his news had shocked her, and he watched her regain her composure as quickly as only Maria Fenwick could.

"I'm sure you're enjoying every minute of this," she said in a quiet voice, "but I'm not. And if you insist upon being jocular and—and coarse about this matter, instead of giving me a straightforward answer—we'll just change the subject. I'm sure Mr. Fish will tell me all about his new bride himself. In his own time."

Luciano laughed. "Then you are a victim of false hope, *amiga.* He is no longer a gentleman of freedom to see his friends. I tell you he is a captive. A man in the prison of his own home with a tiny tyrant who rules his every thought. She would not even permit him to return with me on business to the city!"

"In heaven's name, why not?"

"Her new gowns purchased in Charles Town have not yet arrived. Fish can go nowhere without her, and she will not be seen until the gowns are here." He could feel her eyes studying him.

"Don Luciano, is it really true that Mr. Fish did not once communicate with you during all these months he's been gone?"

"Why do you ask that question?"

"Because it just isn't reasonable that he wouldn't."

"But you have not asked until now."

"That's no answer."

He shrugged. "You heard me tell many persons including the governor that I had not heard. Do you accuse me of a lie?"

"Don't be silly. I just can't imagine Jesse Fish surviving all that time without reports on his real estate here."

"He knew the properties were in my good hands."

Luciano could see her deciding to drop the subject.

"I wonder if he saw my father in Charles Town?"

"Your father has not written of a visit?"

"Why *are* you being so cagy? No, I've had no mail at all from my father for—too long." Her face saddened. "All this liberty business in South Carolina has apparently put up a barrier between us. Not of my doing. I simply refuse to mention it in my letters to him."

This seemed to him a good time to test her a little. "Perhaps there is reason for the resistance in his colony. Don Jesse is convinced that the Crown of England is being high-handed with its American possessions."

"What in the world convinced *him* of that?"

"The New York colony, where he had the misfortune to find his sixteen-year-old hoyden, is even more rebellious than South Carolina." Mention of the rebellion and her father had so saddened her that he knew he must not tease her anymore. "I will tell you. Don Jesse did see your father. They talked a long time of the patriot trouble. Your father is deeply involved in it, *amiga*. With him, it is not mere talk. Forgive me. To bring you anxiety is never my intention."

She drew a deep breath and looked steadily into his eyes. "I—didn't come here to discuss my father—or Jesse Fish, for that matter. I wanted to know whether you would advise me to join Captain Peavett in the transactions of the land and timber."

"I have no interest in Captain Peavett, land, or timber."

She jumped to her feet. "Why *are* you being so difficult?"

On his feet, too, he whispered hoarsely, against his will, "Doña Maria, I've never loved you as much as in this minute!" With a sharp groan of anguish, he took her in his arms and held her to him. "*Querida,* oh, *querida*—if only—" His strong sense of duty forced him to break off, but he tightened his arms about her.

"If only—what?" she gasped. "Something is very wrong. Can't you—tell me?"

He let her go abruptly. "No," he said, turning away. "No, I cannot tell—even you." The half laugh was not convincing. "I am as much a captive—as Don Jesse."

"What a strange thing to say!"

"Everything is strange, Doña Maria. Strange and true."

"True?"

He managed a crooked smile. "You ask what I think of Captain Peavett's business proposal? A pox on his business proposal! You see, I—sail to Havana tomorrow, and as sure as a gun is made of iron, this great man of business will become your escort!"

She walked slowly home. She knew she had showed her shock at the news of Fish—as Don Luciano had meant her to—but by some means, she had left the house without betraying her further shock that Luciano was going away so suddenly without having told her of his plans. What had kept her from pressing him for an explanation was as much a mystery as that she'd continued to value and encourage his friendship, knowing how he felt about her. Was it actually possible to know how this laughing, sometimes passionate, sometimes too casual man felt in his own heart? Why had he vowed never to marry? Was he simply not the marrying kind? Really? She had seldom faced any of these questions before. Needing his influence in the city, his gaiety, his companionship, she had permitted her own needs to dispel any thoughts of him more serious than an occasional fear that his feelings for her might get out of hand.

Why was he going to Havana so suddenly? Why, indeed, had she felt reluctant to ask? Had she imagined that in telling her of Fish's sympathies for the rebelling colonies Luciano had shown sympathy of his own? Of course, every Spaniard was born with a hatred for the British Crown. Luciano could easily be fond of Grant personally and still wish ill to George III. So could Fish.

She would miss Don Luciano. The fact of his leaving already lay heavy. Her affection for him was as real as any she knew, and in spite of his desperate embrace today, he had, in some troublesome way, seemed to shut her out. In fact, that was probably what had restrained her from further questions.

She walked faster. The small garden back of her Charlotte Street house, cloistered and private behind its coquina wall, had

come to be her place to think. For a winter day, the sun was warm. She would go there and, in the depths of her own green and secret place, make her own decision on Peavett and North River.

"You're a woman alone," she said aloud as she turned her key in the latch. "Even Papa seems far away."

Except for several visits either from Ann or to the Cameron household, to share in Ann's delight in her five-month-old baby—a pretty, healthy little girl named Nancy—Maria found November a long, dreary month. But she awakened one December morning before Christmas astonished by a sense of her old buoyancy. She had felt cut off from the life of the city, with Luciano gone and Fish still imprisoned on his island. Even Ann's gossip—collected these days on her outings with the baby—was inconsequential. Ann had, of course, heard that Grant was considering a leave of absence. The seeming threat from Spanish fishing boats seen loitering in the Keys several years ago had vanished as mysteriously as it had begun. Dr. Andrew Turnbull had come to town for a Council meeting and, at Captain Peavett's request, stopped by to report that Peavett would stay at New Smyrna three or four weeks longer. Maria experienced a moment of disappointment, but Turnbull seemed not to notice. He was overflowing with news of his flourishing colony.

She had delivered only two babies in the past several weeks. Time had lain heavy on her hands, but this morning was different. For no reason, except that her indecision about Joseph Peavett's business proposition had resolved itself, she felt more hope than she'd felt in months. If Peavett returned still interested in their joint business venture, she was ready. The spirited feeling was a confirmation that she had made the right decision. Only the waiting period until he came back to the city appeared difficult.

The buoyant mood lasted into the new year—until the next letter from her father.

8 January, 1770
Charles Town

My Dearest Maria,

I am well and keeping busy both with my work and with our Mechanics Non-Importation Association. I am active in the Progressive Party formed under the leadership of planters and merchants, convinced as we all are, that England has made laws injurious to business. Our Non-Importation Embargo worked well. Imports from Great Britain dropped by more than 50%. Our only drawback was that unlike the period of the hated Stamp Act five years ago, the British economy was improved, and so our efforts bore less influence than hoped. Still, Non-Importation saved South Carolinians more than £300,000 in payments to London. Lord North has now taken the late Townshend's place at the exchequer, and we learn by our spies abroad that he has brought about the repeal of the unfair Townshend Act. As I'm sure you know, our ports are again open to British trade.

As I have written the above, dearest daughter, I have been troubled, knowing of your disinterest or downright objection to my views. Your letters have changed and it grieves my old heart. You have kept so mum on the issue of Liberty, that the general tone of your letters has changed from love to duty. Do I complain without reason due to my advancing age? Or does your allegiance to the East Florida colony—a puppet colony—stand between us?

Maria let the letter drop to her lap. Tears filled her eyes. Distance is the culprit! If only Papa would move here, she told herself, he'd come to his senses and see not only that I love him as much as ever but that he is a victim of northern propaganda about the King.

She laid aside the letter and began to pace her parlor. If he were in St. Augustine, he'd see that true progress could be made only by obedience to the Crown. The total military strength of St. Augustine had now increased to 641 men. It was still being said that the ever-expanding barracks would be completed "any day"—including

another "extra" building to house even more troops. The city was growing. Almost three thousand people lived in East Florida now, counting the fourteen hundred at New Smyrna. Brigadier General Haldimand had arrived to make St. Augustine his headquarters, and one of his first orders was to remodel the old Indian church on the outskirts of town to be used as a military hospital. Only De Brahm, as cantankerous as ever, persisted in giving Governor Grant undue trouble these days—by refusing to take orders except from Whitehall.

With Fish married, Luciano in Cuba, and Peavett at New Smyrna, Maria had chosen not to attend with anyone else, but his Excellency had given three separate entertainments in Haldimand's honor. Social life in the city would, she knew, never interest her father; still, it was an indication of progress in the new colony. She must find a way to persuade him to move down, at least to come for a lengthy visit.

For more than an hour, she crumpled page after page of a letter she seemed unable to compose. Perhaps she was trying to reason with him too much. Perhaps, now that he was getting old, an outright plea would work best, though pleading with her father about anything would be a new experience. She didn't plead well with anyone, but she would try once more.

A fresh sheet of paper before her, she dipped her quill again. Before she had written two lines, she heard Long Stem's voice at the front of the house. For Long Stem, the voice was excited.

In a moment, Captain Joseph Peavett entered her parlor.

After tea, he abruptly cut short his review of conditions at New Smyrna and leaned toward her.

"That's enough of either the hardships or the progress of Dr. Turnbull's colony—I find I don't want to wait another moment for your answer, Mrs. Fenwick. Are you going into business with me?"

She nodded. "I am, Captain."

His eyes lit up, but he kept his voice even. "Splendid. What a happy return you've given me! There is only one way in which it could be improved. Governor Grant is entertaining tonight. It seems, by some means, he's managed to rid himself of the Surveyor General, De Brahm.

Mulcaster has just been appointed in his place. There may be no public announcement, but I'm sure that's the cause for the celebration. I've been invited. Will you do me the honor of going with me?"

"Why, yes, Captain. I haven't been anywhere interesting in weeks. I'd love to go."

In Maria's parlor that night when the ball was over, she and Peavett made plans for a trip to their properties on the North River to inspect the potential docking facilities on her land.

"For the sake of appearances," Maria said, "and since he will be our new provincial surveyor, why not ask that nice Mr. Mulcaster and his wife to go with us? Also since he's an old friend of yours. I'm sure my farmer can make room for us all."

Peavett's face, more tanned than ever since his trip to New Smyrna, glowed. "What an eminently suitable suggestion! If I'm wise, I'll begin at once consulting you on every possible occasion, dear lady." His smile deepened. "And about every matter."

Maria went upstairs that night—heart quiet, head clear—and, with no effort whatever, wrote the letter to Papa.

21

During the year 1770, Maria and Peavett made several pleasant trips in the company of the Mulcasters to the property between North River and Guano Creek and observed with excitement the completion of the new dock. Then, at the end of the year—on the very day Papa was to arrive—Maria was called

urgently to the home of Jesse Fish on Anastasia Island to preside at the birth of his first child.

Since his return to East Florida more than a year ago, she had not once seen Fish privately. At Government House functions, she had spoken with him only in polite conversation during a minuet. He had aged, and his bright, dark eyes darted constantly after the over-dressed figure of his child wife, Sarah, who laughed too loudly, flirted unmercifully, and addressed her husband as though he were a servant. In all her forty years, Maria could not remember disliking anyone as she disliked Sarah Fish. The thought of being shut in a room with her during the birth of the child was repugnant. But sitting beside Peavett in his boat en route to Anastasia Island, she vowed to do her best, as she always did, and to concentrate, as she worked, only on the years of friendship which Jesse Fish had shown her.

Shaken and drawn, Fish welcomed them at the spacious front door of his home, El Vergel, and took Maria directly upstairs to Sarah's room. "Should you need more help, Doña Maria, just step out here in the hallway and call to me." He withdrew his hand from the doorknob to touch her arm briefly. "My wife is—a mere child," he whispered. "Try to save both my children, please."

Wondering grimly if the baby were really Fish's and if anyone would ever know for certain, Maria entered the darkened room. Since her arrival in the city, the red-haired, garrulous girl had refused to let Fish escort her to St. Augustine except for fancy-dress affairs at Government House, where, of course, she would not have been invited had it not been for her influential husband. Otherwise, according to Ann Cameron, Sarah visited the city alone for clandestine meetings with soldiers. Maria felt no shame for wondering about the identity of the baby's father.

"You don't like me, I know," Sarah said in greeting. "But from what I hear, you do like your fees. My foolish old husband is very generous. Attend me. You won't be sorry."

"Your husband has already proved his kindness and generosity, Mrs. Fish," Maria said firmly, reaching for a bolster at the foot of the bed. "Are you frightened?"

Even in her pain, the girl laughed. "Of you?"

"No. Of having your first child." Maria answered her own question: "I can see you're not." She adjusted the bolster and ordered her patient to kneel on it.

"I thought kneeling—was only for—difficult births," Sarah said sarcastically, her pain obviously increasing. "You're not—having any trouble with—me. I'm—more a woman than anyone thinks!"

"Just the same, you will kneel as I tell you. For your husband's sake, I want our work—eased. Spread your legs."

Sarah screamed. "It's coming already!" Then she gasped, "I might not have needed you—at all!"

Quickly, Maria examined her and to her horror felt, then saw the baby's arm come down and out. With relief, she observed that the arm was not swollen and was of a pink, healthy color. She placed one finger into the child's hand. Her finger was gripped. The infant was alive. Before Maria could begin to massage the distended abdomen or attempt to turn the child, a sudden throw seized Sarah, she screamed again, and the baby boy and the afterbirth tumbled out together!

Without being told, the girl rolled over on her back, lay catching her breath for a few minutes, then smirked, "Good night, Mrs. Fenwick. My servant knows how to bathe a newborn infant. I—really didn't need you at all."

"Maria, I'm afraid you offended our friend, Fish, last night," Joseph Peavett said as they were being rowed back to St. Augustine the next morning. "He wanted to reward you handsomely. I honestly don't think the man believed his childless life would ever end. We'd talked at length, you know, before he went north. Before—you rejected him."

Maria turned in her seat to stare at him. "He told you—oh, I remember. That was when he tried to put me and my affairs in your charge . . . you and he discussed me as though I were a piece of property. For your information, I'm not."

Joseph laughed. "You don't need to tell me that! But Jesse Fish was truly concerned about your well-being, as you know. Do you suppose your father will be waiting for us at your house?"

Joseph Peavett was a skillful diplomat. At times, she could feel him managing her responses. But she had a little more to say about

Fish and was going to say it. "As for rewarding me, Jesse Fish was such a friend to me when I was a stranger in this city I could never repay him. What I have just done—that this was all I could do—makes me rather sad." But then she smiled at him. "Now to answer your question"—she raised her eyebrows—"yes, I do suppose my father will be at my house—my father the rebel."

Unruffled, he smiled back. "I'm reserving opinion on that subject. In fact I anticipate long talks with Richard Evans. We need firsthand, undistorted information down here concerning the events to the north."

"I think 'events' are waning," she said confidently. "Father hasn't said much in the last two letters. The Liberty Boys are undoubtedly losing their fire."

"I'm not so sure."

"I am. Otherwise, I don't think Papa would be here now. But he is here—or should be—and oh, Joseph, I'm like a child at seeing him again!"

Peavett laid his big, brown hand over hers. "I'm hoping he'll stay with us permanently. I have a strong feeling that he and I are going to be friends."

"You'll come for dinner tonight, won't you?"

"I was hoping for an invitation."

"Oh, yes, you are invited! I'm counting on you with Papa. Haven't you guessed?"

They reached the city wharf at midmorning. Insisting that he had urgent business and could not stay for the noon meal, Peavett took Maria home, hoping at least to meet the father. Instead, they found a note informing Maria that Richard Evans was taking his midday meal with Grant's Chief Justice, William Drayton. As they sat down in her parlor, Peavett watched Maria's expression change from disappointment to admiration.

"Joseph, if you don't know, I can't explain to you how amazing this is! My father is a *carpenter*. He's worked for most of the Draytons off and on back home in Charles Town—but to dine with one! Papa's always been such a reserved man. Content to be the best

craftsman in town, never caring a whit for social prestige. How on earth do you suppose he met Drayton here already? You and I were only gone overnight!"

"I'd never voice this to anyone else, but I've suspected St. Augustine's Drayton of rebel sympathies for weeks," Joseph said in a casual voice. "Perhaps the two men had a meeting set up. The unrest at the north brings about strange bedfellows."

"What makes you think the Chief Justice of the Council is not loyal?"

"I didn't say he wasn't loyal. Your father's loyal, too. Drayton's agitation over the fact that Grant has never called an Assembly election has no bearing on loyalty. The English constitution decrees that every colony should have an Assembly. West Florida's had one for over four years. Justice Drayton's a student of Blackstone. He's a lawyer's lawyer through and through. He knows the constitution and is of the legal bent of mind which thrives on exactness and controversy. He's right, too. We are overdue for an Assembly."

"Why do you suppose we don't have an election?"

Joseph shrugged. "The unrest to the north has generally been fermented by members of the elected Assemblies. Things are going along pretty well here. Grant has enough shrewdness to handle even strong-minded men like Drayton and Moultrie. If he didn't, those two gentlemen would be at each other's throats. Moultrie is as much against an Assembly as Drayton is for it, and to this extent his reasoning is similar to Grant's—that East Florida can't complain of taxation without representation in Parliament because we aren't expected to be self-supporting. The boat here is fairly steady. Why rock it?"

"But, Joseph, what about the other colonies? Oh, the uprisings are minor, to now—except for what Papa's Liberty Boys are calling a massacre in Boston. But who knows what provoked those British troops to fire on that band of ruffians up there? Why can't Americans tend to their personal business, Joseph, and let the King take care of us all?"

Joseph liked everything about this woman. She was correct. If every colonist tended to his own affairs, things would surely right

themselves. British law had been proved by the centuries. What benefited the mother country ultimately benefited her children everywhere in the far-flung empire.

"I may be self-absorbed," she went on, "but it seems to me that any society is to be judged by the success of its members. If you and I succeed in our private business dealings, won't the colony benefit? Do we have to nose into government?"

He laughed softly, getting to his feet. "I think your father is the man for this discussion. He'll be back soon, surely. You two need some time alone."

"I'm suddenly not sure I'm—ready for a conversation alone with my father."

"Nonsense. Just try to keep him off the subject of the resistance for a while until you're comfortable with each other again."

He'd so seldom seen Maria uncertain about anything, her rueful smile charmed him.

The long years of closeness and deep affection between Maria and her father bridged any awkwardness she might have feared in their meeting. All through the afternoon, the talk went well, mostly about old times. Papa was older. Otherwise he seemed little changed, his voice still firm and quiet, his infrequent smile as reassuring as ever. With effort, she refrained from asking how and why he had dined with Drayton so soon after his arrival. She talked at length about her good fortune in still having Long Stem, of the plans she and Joseph Peavett had for their joint venture on the North River. She made no bones whatever about her dislike for Jesse Fish's Sarah, went into detail describing the fancy-dress balls, and talked a little too much, she sensed, about how well loved the East Florida royal governor was among the colonists.

For the most part her father listened attentively. Then he said, "Your governor is undoubtedly a charming, diplomatic gentleman, but—he's leaving you."

"Justice Drayton told you that?"

He nodded. "Grant's had his leave for six months or more. Seems love for the colony has forced him to disobey his doctor. Drayton

predicts the man will be gone by the fall of 1771—or sooner."

A little annoyed that her father already knew more about his Excellency than she, Maria snapped, "I suppose Drayton's delighted."

"Not at all. "Why should you say a thing like that, daughter?"

"Oh, his constant agitation for an elected Assembly."

"Has nothing to do with agitation. Has only to do with British law. Drayton's a loyal subject demanding constitutional rights for the colony."

"I know, I know. But until lately, we've had so few settlers—how could we have held an election? So few men of property to run for an Assembly."

"Except for the Indians and Negroes, East Florida's almost solidly British now, though. It's time, Maria."

"Papa, why can't colonists tend to their own affairs and trust His Majesty to look after us? I was just saying that to Captain Peavett when we got back from the island today."

"And does he agree with you?"

"He seems as determined to succeed here as I am."

"You see quite a lot of Peavett, don't you?"

"As I told you, we're in business together."

"And has he asked you to marry him?"

"No, he has not!" She felt her face flush. "He's—very good company and I enjoy being with him. Nothing more."

"Well, all right. Don't get excited. Drayton tells me your friend Herrera is in Cuba."

"Yes. He left quite suddenly. I miss him."

"Is he the reason Peavett hasn't asked you to marry him?"

"Papa, I never knew you to be so nosy!"

"You're all I've got, daughter. But I apologize. We've always left each other free, and I mean to now, if I can. I'm glad Peavett's coming tonight. Eager to meet him. He's well respected, I understand. One of the few men not trying to run the government."

They sat in silence for a few minutes. Then her father asked, "How are you, Maria? Inside? You almost never mention David in your letters."

Her eyes filled with tears.

"I see," Papa said softly. "Still bad, eh? I shouldn't have brought up his name. But well, being here with you again . . ." His voice trailed off. "I loved the boy like my own son."

That night, after the evening meal, a pleasant one, with Joseph at his most cordial, Maria was called to a delivery—one of the servant girls at Dr. Andrew Turnbull's town house on St. Francis Street. Not only did she hate leaving Papa, but every trip to the old familiar street where the cottage stood—the home now of Joseph Peavett—was painful. In fact, she still avoided the street when possible. As usual, Peavett offered to go with her—wait, or return at any hour she anticipated being finished. Tonight, she refused. In the years since she'd moved away, she had never walked down St. Francis Street without an escort. Strangely, unexpectedly, she found herself wanting to—even though it was dark. Besides, it had become very important to her for Peavett and her father to get acquainted.

"It's early. I'm not afraid, Joseph," she said when Peavett saw her out the loggia door. "Dr. Turnbull's servant says the girl's almost ready and that Dr. Turnbull will see me home."

"Very well," he said. "I would like a visit with your father. But in case Turnbull isn't free to bring you home, send for me. I'll be right across the street at my place later on."

The birth was troublesome. The young woman needed at least two hours before Maria could do more than make her comfortable.

"Regrettably, we've sent for you too soon, Mrs. Fenwick," Turnbull said, adjusting his jacket with what Maria thought a rather arrogant hunching of his straight shoulders; a gesture repeated until one had to notice the excellent cut of the coat. "Servants tend to get excited at a time like this," he went on. "But I've wanted to speak with you anyway."

He seated her and stood rocking on his heels, his tapering fingers settling the deep wave in his dark hair. "My wife will join us here in a moment, but first this. As you undoubtedly know, our needs at my New Smyrna colony are many. None more urgent than the need for a well-trained midwife. Would you consider training someone? I'll pay you well."

184

The idea appealed at once to Maria, but before she could respond, Mrs. Turnbull, tall, buxom, and beautiful, her nearly haughty appearance in sharp contrast to the sweetness of her speech—cultivated English, with a slight Greek accent—came bearing a polished silver tray with tea.

"We are deeply sorry for the long wait, Mrs. Fenwick," she said, placing the tray on a low table. "Perhaps a cup of hot tea will help. And, of course, I overheard my husband's request of you. Please comply! Our need for a midwife is severe."

"I'm interested," Maria said, as Mrs. Turnbull poured her tea. "In fact, I think I know the very young woman to train. My patient tonight."

Looking from the doctor to Maria, Mrs. Turnbull gave her beguiling smile. "A coincidence!"

"Indeed," Turnbull said. "And why is she your choice?"

"The girl shows now, even in her pain, a professional interest in all I've done for her so far. I like her. She seems poised. She should work out well. I can begin to train her the minute she's recovered from the birth of her own child."

It was after midnight when Maria was ready for Turnbull to escort her home. At her gate, he thanked her again, placed a hundred-pound note in her hand—more than enough to cover both the birth and the girl's training—and said good night.

Her father's light still burned in his room on the second floor. She knocked.

"I'm too tired to talk, Papa, but I wanted to apologize for being so late."

He kissed her on the forehead. "You're an important woman in this city, daughter."

"I'm going to be some day."

"Too tired to sit down a minute?" he asked.

"Yes. I really am."

"Well, I still want to say one thing—I hope you'll marry Joseph Peavett."

"Papa!"

"He's the right one. He understands you. Knows even that the time has come for you to visit him in the cottage, where you lived with David. Peavett's a fine man. He loves you with the love of a mature heart."

She forced an uneasy laugh. "He certainly never mentions it."

"He's not only mature—he's wise. Good night, daughter."

"Goodnight, Papa."

Weary as she was, Maria sat down at her small writing desk and took out a sheet of paper. Desperately, she needed to articulate what had become—this night, even before Papa spoke of it—a deep, searing truth. There was no one to tell, so she wrote it out: "I will never love anyone as I loved David—as I still love him—but how long *will* Joseph wait to ask me to become his wife? If Papa's right, if Joseph does love me, *what is he waiting for?* Surely not for me to behave like a schoolgirl. I'm a forty-year-old widow and I am lonely—I am lonely."

She read the words over and over, then carefully tore the paper into tiny pieces.

22

For five months, her father stayed with her in St. Augustine, and Maria began to hope that he might move down. Peavett thought not.

"Something far deeper than your father ever mentions will take him back to the South Carolina colony, Maria," Joseph said. "And when he goes, I lose a friend. Richard Evans and I don't always see eye to eye, but not since the death of my brother in London a decade ago have I felt such comfort in a friendship."

Did Joseph Peavett need comfort, too? She had never connected need of any kind with this strong man. He wasn't exactly merry—certainly not with David's infectious merriment—and yet his pleasant strength soothed her, gave her a sense of security she had needed ever since David went away.

She had not yet set foot inside the cottage on St. Francis Street, but more and more frequently the thought came that she must do it soon. Before moving in, Joseph had, she understood, repaired the cottage carefully and added a tabby patio to the rear. She was grateful that he had not yet insisted that she come, but one word of urging would help make up her mind. She would have to see it eventually, and at times she found herself almost impatient with Joseph's enduring patience. Papa had visited there often, but had said little about the house except to praise David's roof.

David . . . had she dreamed him? Did the actual music of his laughter, which she seemed still to hear at times, spring from some deep sleep in which she had moved about the city ever since he went away? Did the successful, strong-willed, poised Maria Evans Fenwick go about her busy life in a dream? Or was time out of joint? Did David know he had been gone for seven years?

Early in June of 1771, just before the elaborate farewell parties began for Governor Grant, her father went back to Charles Town without any further advice to his daughter concerning her personal life. He did say with his small, wry smile that she and Joseph had better extend themselves a bit in their efforts to get along with John Moultrie, whom Grant had appointed to act as lieutenant governor in his absence.

"Dr. John's brother, James, was a warmhearted, fair man," Papa said. "He's dead. Dr. John may feel his oats as acting governor. You'll both do well to keep that in mind. Of course, I'm sure Grant will keep in close touch with the colony while he's abroad, but—" He thought for a moment. "Things do change across that distance of three thousand miles of ocean, Maria. That's a part of the big American problem. What may seem fair and just at a meeting of

the Board of Trade in London often turns sour before the action reaches our shores. So far away, Grant could lose touch, too."

One of the grandest affairs to be given at Government House during the early summer was the fancy-dress ball to welcome the wealthy Fatio family to the colony. Maria, of course, went with Joseph.

"Too bad," he said, as they moved sedately across the polished floor, "that Major Small's Band of Musick had to leave with General Haldimand. The Fatios appear to be the caliber of folk who deserve the best in entertainment."

"Joseph, does it concern you that Haldimand was ordered back to Pensacola?"

He laughed easily. "I'm always concerned when there's threat of an attack from the Spanish. Even in West Florida. By the way, my dear, any word from your Spaniard, Don Luciano?"

"Nothing. He's been gone a long time, too."

They moved apart in the pattern of the dance, and Peavett, resplendent in his silver-trimmed regimental coat, bowed to her. "Does this concern you?"

"I'm fond of Don Luciano. I don't miss him as much now that I know you, if that's what you mean."

They danced in silence for a complete turn of the floor, then Maria asked, "Did you see the perfectly exquisite furniture and the crates of linen and silver and books they moved into the elegant house Francis Philip Fatio purchased on the Bay?"

"No, I was handling my military payroll that afternoon. I do find them an extremely impressive couple. Any man rich enough to charter his own ship from England will certainly become a power in our struggling little colony. I understand he's already been granted one gigantic piece of land."

"Oh? Where?"

"North and west of the city on the St. Johns. He's Swiss, you know. Calling it New Switzerland, I believe. I hope he cultivates the land. Too many of our grantees are just wealthy. They don't plant."

The dance was coming to an end. Maria smiled at him. "Aren't we being boringly proper, sir?"

"I'll change to a more interesting subject. Will you have dinner at my place tomorrow? I think we need to be together away from all this social bedlam. Anyway, Maria, it's time you made yourself go into the St. Francis Street house again, don't you agree?"

The sun was dropping in a coral glow of cumulus clouds when he called for her the next evening. From the fort, they heard the big guns fire, marking the evening hour. A lonely, echoing sound, yet reassuring. An almost welcome intrusion into her chaotic emotions. Dread of entering the cottage again for the first time twisted oddly among darting, contradictory thoughts of the tall, gracious man who strode along beside her. She both fought and welcomed the peace his powerful presence gave her. She had never tended to such dependence upon anyone, and yet a kind of rest came upon her each time she thought of being able to leave at least some of her problems in Joseph's capable hands. She'd heard all her life that once a woman had been happily married, she could never again be content by herself. The whole idea had seemed preposterous. Now, she wasn't at all sure.

Except for tea or dinner at her house, with Long Stem watching over them, she and Joseph had seldom been alone. Their trips to the joint holdings at North River were always in the company of the young Mulcasters, who joined in their genial and interesting conversations, which might be mostly between Joseph and Frederick, about old times in London, or might be Maria and Joseph discussing some new plan for increasing their timber operation. On their latest trip, the talk had been of Joseph's idea for planting indigo.

Almost from the start, she and Joseph had shared their deepest fears and hopes for the growth of the colony, and of course, they had danced and danced. Sharp, bittersweet memories of David teaching her an Irish reel or wild jig in no way darkened her pleasure in Joseph's company or in his cultivated dancing. Shared passion with Joseph had never entered her mind. It was the calm, safe, adequate feeling he gave her which she needed, not his body. The meeting of

their minds both stimulated and rested her. That was miracle enough, and she was grateful.

In sight of the steep, hipped roof—each shingle fitted into place by David's young, slender fingers—her heart twisted with pain.

Determined not to spoil the evening for Joseph, she said casually, "You'll have a truly quiet street soon. They've begun to paint the new barracks, I see."

"I may oversleep mornings if those men with hammers and saws ever really finish over there." He chuckled. "We do need the housing, though, and it will be convenient for me. I can just cross the street to the barracks when they queue up for their pay."

They were both quiet as he unlocked the garden gate—still David's big lock, the key his hands had touched. Joseph had upholstered the Gonzáleses' old wooden settle in a ribbon-striped linen, but it still stood in the same place before David's hearth. She made herself sit down on it exactly where she'd always sat. There was fresh paint on all the trim, and the shutters hung perfectly. Of course, she had never seen the big wing chair—Queen Anne— with masculine proportions, but the house seemed little changed.

Peavett's one servant, a stoical black man, brought a mellow golden wine. Joseph, deliberately, she thought, did not sit beside her on the settle, but took the big chair. He appeared to be thinking clearly on two levels: hers and his. He said nothing about her old life here, but she knew he was aware of what she was going through, while at the same time determined to see to it that the evening be *his* evening, too. He would be reasonable in all ways and realistic. The man was the most reasonable person she'd ever known and totally ready to accept life as it was, in all its beautiful and stark realities.

She sipped the wine and felt less agitated inside, a bit more passive as the memories came in waves of pain and ebbed away.

After a long moment, he said, "I know this is hard for you, Maria, but being here is, I think, necessary. You and I are living."

"Yes. You and I are—living, Joseph." She could hear the servant in the small detached kitchen Peavett had built in David's garden out back.

190

"Would you like to see the garden before it's entirely dark? I've done quite a little work out there."

"No!" Then, more calmly, "No, thank you. Another time—for that, if you don't mind."

"Of course. Do you ever wonder if you'll love again, Maria?"

In spite of the evenness of his voice, the question startled her. "I—I don't know. Not in the—young, free way I loved David, I'm sure. I'm not young anymore. I turned forty-one a few days ago."

"And you're unlike any other woman on earth."

"Nonsense."

"Not at all. Except for my wife, Margaret, I've never known another woman to volunteer her age."

She stared at him. "Your—*wife?*"

"You didn't know, did you? I thought not. In fact, I've told no one about Margaret but your father." He smiled easily. "I might have known he'd keep my confidence."

Shaken with suspense to hear about a woman she'd never dreamed existed, Maria casually made a light comment about her father's perpetual respect for everyone's privacy.

"I told your father," Joseph went on, "because I wanted to. I needed to. I'm ready to tell you now, because I feel our—friendship will be strengthened if we can both—talk about them to each other."

"Your wife's dead?"

"Yes. For longer than Sergeant Fenwick. Over ten years. She was just your age when she left me. Forty-one. Young enough and old enough to be—near perfect."

"Near perfect? Joseph, what does that mean to you?"

After a long time, he spoke slowly and thoughtfully, in what seemed suddenly an older voice. "Margaret was as—unlike you as I am obviously unlike David. A delicate, small-boned little lady with honey-colored wavy hair and light blue eyes. A quick, fertile brain—but unlike yours, her mind never led; it merely followed mine. And she had a delicious sense of humor. We played at keeping house, I always thought, like two children. That was all her doing."

"Did she have to teach you to be—lighthearted?"

He nodded. "The same as Sergeant Fenwick taught you, I'd wager." Leaning toward her, he added, "I'm glad you're as you are, though, Maria."

"Why?"

"Do I need to put that in words?"

"No."

"Then I won't try."

The servant was moving about the room now, placing a savory-smelling roast of venison on the small dining table, set between the parlor and the bedroom alcove.

Joseph stood up. "Well, it's time, I see, for our first dinner together in my home."

"Yes."

She took his arm and let him escort her to the table.

"It is better, now that we can share them both, isn't it?"

Maria nodded, but said nothing more than a few polite words as the black man served their food.

During the meal and all the way back to her house on Charlotte Street, Peavett kept the conversation on an impersonal level. He told her of the formation of the new Vice Admiralty Court just before the governor's departure and then, at her loggia gate, said, "If my predictions are correct, dear lady, you and I will have some interesting tidbits to exchange now that Lieutenant Governor Moultrie is in charge of us here." When she didn't respond, he asked, "Want to know my prediction for the first explosive event?"

Although right now she hardly cared tuppence for his prediction, she said, "Yes. Yes, I'd love to know, Joseph."

"Unless I'm mightily mistaken, this issue of an elected Assembly will wind up with Moultrie refusing to consider it—far less tactfully than Grant ever did—and Chief Justice Drayton resigning from the Council in furious protest. Shall we make a wager?"

"If you like."

"Dinner again at my house if he does not resign. Dinner at your house if he does."

An hour or so later, dressed for bed, Maria sat by her window overlooking the dark garden. From somewhere in the shadows below, she heard the plaintive call of a chuck-will's-widow. Aloud, to herself, she said, "I do believe I'm—jealous of Joseph Peavett's 'near perfect' dead wife!"

Almost three years ago, Maria had delivered James Grant Forbes, the first son born to the English rector, and now, on a cloudy October day, she had just presided at the birth of a second son. Downstairs at the Forbes home, she was met by solemn, intense Reverend Forbes.

"My deepest gratitude to you, Mrs. Fenwick," he said. "Your fee will be sent to you directly. And I have a message for you—two in fact."

"Oh?"

"One from Captain Peavett which I don't quite understand. I assume you will. He'll be at your house, it seems, for dinner tonight because this morning Chief Justice William Drayton resigned from the Council. Do you make any sense of that?"

Despite her weariness, Maria found some enjoyment in answering the question accurately without admitting to the rector that Captain Peavett and she had made a wager. "Yes. Captain Peavett correctly predicted the resignation. Dinner at my house is his reward for being right."

"Well," the rector said carefully, "since Governor Grant felt strongly about delaying an elected Assembly, I have to agree with Moultrie in continuing the delay."

"I was sure you would. The other message?"

"Don Luciano de Herrera is waiting for you now on my loggia."

"He's back? What a pleasant surprise! Thank you, Reverend Forbes. That's really welcome news." She held out her hand. "Your wife will be fine in no time. She had an easy birth."

"I'd see you home, Mrs. Fenwick, but Herrera insists that's why he's here."

On the loggia, Luciano took her hand eagerly and talked fast and furiously about how much he'd missed seeing her, but he did not seem in his usual high spirits.

"I've missed you, too," she said, walking beside him up the street. "But why didn't you tell me you'd be gone so long? Two years!"

He shrugged. "I did not know."

"Well, what were you doing in Havana all that time?"

"Business."

"Secret business?"

He flashed his old smile. "My business."

"I know," she teased. "You're a spy."

He said nothing.

"Did you hear me? I think you're a spy for Spain—maybe. With you it's hard to tell. Of course, it could have been you who helped diminish the recent danger of a Spanish attack on Pensacola. Have you missed us all here so much you discovered a hidden British loyalty?"

Still he did not respond.

"I am only teasing, you know. Did I offend you?"

"No. You could not. It has been a long time with no sight of you. A struggle against—being a captive."

"A captive?"

"Of circumstances. More than anything on this earth, I want to ask you to become my wife. Yet I cannot."

"Why?"

He laughed now. "Would you agree if I were free to ask?"

"No. I don't love you that way, but I do love you. And I don't believe for a minute that you really love me either—except as your sister and friend. You've let your imagination run riot while you've been away. Don't do that. Don't be untrue to what you really feel. I need you to be my easy friend again. There's so much to tell you about what's happened in the colony."

"I know what has happened in the colony. I am interested only in you."

"Luciano, do you know that this very morning Drayton—"

"Resigned from the Council. So the lieutenant Excellency is without a Chief Justice. *Sí.* Turnbull resigned, too."

"Turnbull? Are you sure?"

"Who has proposed marriage to you in my absence?"

"No one."

"I do not believe you. Captain Peavett has been your constant escort." He laughed again. "I *am* a spy."

"Oh, it's good to have you back. You help me take myself and everything else less seriously."

"That is the trouble. You never take me seriously."

"I don't want to. I want to enjoy you." They had reached her house, and in spite of her delight in seeing Herrera again, a wave of tiredness swept over her. "I was at the Forbeses' almost eight hours. Will you forgive me if I don't invite you in?"

"Of course. I will come to dinner tonight."

Remembering the wager with Joseph, Maria said, "I'm sorry. I have a dinner guest tonight."

"Captain Peavett?"

"Yes, Captain Peavett. You should go to Jesse Fish anyway, your first day home. The poor man hasn't been to the city since you left! Not even to a Government House social event."

"There have not been many since Grant departed, no?"

"You do know everything, don't you?"

"You call me a spy. But I need intelligence as to whether or not you are in love with Captain Peavett." Before she could answer, he unlatched the gate and held it open for her. "Do not answer my question. I find I do not want to know the answer. Not now, Maria. Perhaps not ever."

During the final weeks of 1771, Maria went often to the Herrera house. The household was filled with the joy of Luciano's return. The devotion between father and son had always moved her, and she felt more and more drawn to gentle Antonia, who encouraged Maria to come not only for the pleasure of her company but especially so that the family would all speak English for the sake of young Sebastián. The child was now eight—lively and quick to learn.

Although Luciano did not seem to expect to take her to social functions, he attended, and they always danced at least once together. Antonia appeared to be thriving on what was evidently

her first fling in St. Augustine society, escorted on each occasion by her brother.

Outwardly, life moved along uneventfully, with only the usual dissent and friction among members of the Council. Now and then, Peavett would tell Maria of a secret meeting held in a tavern and attended by Drayton's friends, who, with Joseph, chafed more and more under the high-handed authority of Lieutenant Governor Moultrie and his allies on the Council. Neither Turnbull's nor Drayton's resignation had been accepted by the Crown, and both were back on the Council again, agitating still for a free Englishman's right to an elected Assembly. Moultrie and his faction continued to see in the agitation overtones of behavior that matched the vox populi rebellion in the colonies to the north.

The lieutenant governor, proud of his own profitable plantation, Belle Viste, commended Maria and Joseph on the productivity of their joint properties on North River. Joseph had certainly been sound in his judgment about planting indigo. The most impressive export by far that year had been indigo, and Maria and Joseph made their largest profit to date.

The Spanish hospital in the center of town was now reconstructed as a courthouse and jail, and Peavett learned late in the year that the old Spanish Bishop's Palace was to be turned into a British statehouse.

Moultrie stood firm on postponing the Assembly election, but for the few prominent citizens not actively involved in government, such as Peavett and Maria, life settled into a kind of easy rhythm.

"Too easy," Joseph said one December evening as they walked through the Square to inspect the work done that day on the statehouse. "Strikes me at times, Maria, as though we might be experiencing the quiet before the storm."

"I suppose you mean the northern colonies."

"You haven't told me any news of your father lately."

"He's fine, working hard. Always sends you his best. His letters have been brief."

"I don't think he trusts us anymore with his rebel news."

"Joseph, I'm certain that's all under control by now. It just takes time for a thing like that to die down."

196

"It's easy for us to be oblivious down here in our safe loyalties. Our Drayton's brother up in Charles Town—William *Henry* Drayton—is evidently still one of the staunchest advocates of what they're calling 'liberty.' I hear the same about Henry Laurens, too. I just don't feel as becalmed as you seem to feel, my dear." He sighed. "I hope I can stay out of it—all of it."

"You will, won't you? You will stay out of it?"

He gave her a warm smile. "I'm certainly not at home with politicians—or politics. Just with military men and lovely ladies."

They were standing together under a large, ancient live oak in full view of Government House, the wharf, and the somewhat crowded Square. As usual, Maria enjoyed their conversation; felt content being with Joseph.

"I wonder if there is another woman in all the seventeen British colonies who can converse about affairs of state as you do, Maria? Will you—do me the honor of becoming Mrs. Joseph Peavett?"

She had been idly watching a mockingbird flip about on the highest piece of statehouse scaffolding. For a stunned moment, she kept her eyes on the bird. Then he flew away, his gray and white wings stroking the air in half circles. She looked at Joseph. "You—want to marry me, sir, so we can have more time to discuss affairs of state?"

That was not at all what she meant to say, but for the life of her she could think of nothing else. Her ironic question hung there, causing her to feel she had been tactless. Still, after all this time, he'd certainly chosen a peculiar way to propose!

Without another word, he took her arm and led her rapidly away from the Square and down the Bay front toward his St. Francis Street house.

After hurrying along in silence for more than a block, he said, "I'm sorry, my dear. I was unforgivably awkward. I had my speech all composed, too. Please, don't say anything until we're inside my house except that you forgive me."

"I forgive you, Joseph."

Inside the cottage, he took her gently in his arms and held her, then led her to the old, familiar Gonzáles settle and dropped down beside her.

"I know you can never love me as more than your best friend, Maria."

"How do you know that?"

"Because you've had more than enough time to let me know it, were it true. I—I'm not even sure how many ways I love you. I only know I don't want to live any longer in separate houses. I want you with me. Maria? Will it be too hard, living here in this cottage with me?"

"I don't know. Would we have to? I own two other houses. We have the North River property. We could build our own place there."

"Suppose we did—what about your profession? Wouldn't you have to sacrifice your practice if we lived up there in the wilderness?"

"Oh, Joseph—yes, I would! And of course I won't—you're right. I couldn't leave St. Augustine."

"I thought not, my dear. Your wonderful service to the families of this city is one of the things I love about you." He took one of her hands, almost hiding it in his. "This is a valuable piece of land here. I have a dream. I've had it for more than a year. I want to make this little cottage into a fine, two-storied house for you. Not with your money. With mine. I would never, could never be a domineering husband to a woman like you. I *want* the good pride I feel in your singular accomplishments. But I am a man. I do need to provide our home right here on St. Francis Street. Out of my own resources. That is, if you'll agree."

Silence with Joseph had never been awkward. She said nothing for a long time, then slowly, her body, her mind, her heart settled into the only complete quiet she'd experienced since David went away. And a sense of wonder filled her that she and Joseph each had a dream for this house. She leaned her head back on the old settle and began to talk to Joseph about her own long-ago dream of returning here some day—some distant day, when she was sure, at last, that she could live in the house without David.

"And has that day come, Maria? Can you live here without him—with me?"

"Yes, Joseph. Yes. I'm sure I can."

Part Three

23

The wedding date was set with the Reverend John Forbes for 27 January 1772. Maria and Joseph would live in the ample Charlotte Street house until the extensive remodeling on the cottage could be completed.

They sat together, early in their wedding month, before a cheerful fire in her parlor. All of life was tranquil and good. Maria was not counting the days until this marriage as she'd done so long ago with David, but she was counting on Joseph Peavett; counting heavily on his steadfastness, his good sense, his rare ability to be with her—truly with her—in the silence. She was still her own woman. With Joseph, she always would be. The kind of freedom he gave had to do with the freedom and certainty that they belonged together at this time in both their lives. Maria, at forty-one, was eleven years younger than he, but she had never been aware of the difference in their ages. In the prime of his maturity, Joseph had the happy faculty of conveying his acceptance of her as his equal and his partner—without condescension or pretense.

What she needed now was what she had in Joseph. He was not beautiful to look upon as David had been, but he was undeniably handsome in his own way, and she enjoyed looking at him, especially now, with the firelight shadowing his strong features. He joked often about his nose. Maria rather liked it. His forehead was wide, his face full and otherwise well featured, more than balancing the prominent nose. It adds a complimentary distinction to his profile, she decided.

He smiled at her. She returned the smile.

"I'd give a lot to know your thoughts," he said.

"Your cocked hat won't fit any longer if I tell you. But I will. I was thinking that I like very much the way you look."

"I not only like the way you look, Maria, I like the way you *are*." He fell silent for a moment. "And do you think you will like the sound of your name as Mrs. Joseph Peavett?"

"Yes. I like it fine."

He sighed. "Mrs. Joseph Peavett, you give me beauty, warmth, superb conversation. The only thing I'll have to watch is that I don't become too satisfied with your company to the exclusion of every other friend." He looked at her for a long time. "You're my best friend."

"And I intend to be, for the remainder of our lives."

"By the way, my dear, how does a visit to the Turnbull mansion at New Smyrna appeal to you as a wedding trip? He's made a lot of improvements since I've seen it. Now that the twenty-mile stretch of the King's Road is finished down that way, we could go that far by carriage. I could send ahead for a boat to take us the remaining fifty miles or so."

"I think that sounds ideal, Joseph. We can look over that property you've been wanting for such a long time."

Joseph smiled again. "Do you realize most ladies would accuse me of being unromantic to suggest combining a little business with pleasure?"

"Not this lady." She laughed. "You might as well know it now—in one way I'll always be independent, ambitious Maria Evans. In fact, I've always thought of myself as Maria Evans—even married to David."

"I already knew that. Knew it the first time we met." Then, on a more serious note, "Have you always been—alone in that way, Maria Evans? Sufficient unto yourself?"

She nodded. "Even as a child."

"No close friends back in Charles Town?"

"None closer than Ann Cameron—we grew up as neighbors, and she's a dear, good person. But as for thinking for herself . . ." She chuckled, then gave him a penetrating, warm look. "Joseph, I

did mean it, though, when I said I'd be your best friend. Always."

" 'Till death do us part'?"

" 'Till death do us part.' "

"Which brings us back to our wedding trip and New Smyrna. Turnbull has given us an invitation."

"Oh, I think we should go down. I'd like to see the colony—and I'd also like to travel the King's Road. Undoubtedly those wooden causeways and bridges over the marshes and salt creeks will increase the value of property there. Now would be the time to ask for a grant."

Joseph shook his head. "I have a hunch our social visit to Turnbull's colony won't help our cause with Lieutenant Governor Moultrie. The two men are at each other's throats, and Moultrie has to pass on land applications until Grant gets back. Do you think the governor means to come back?"

"We have his word for it. You and I have never had reason to doubt his word, have we?"

"None whatever. But considering his recent inheritance of the family estate at Ballindalloch, I wonder if he will want to return to all the divisiveness in our colony. It's worsened without his diplomacy. The bad blood between Turnbull and Drayton on the one hand and Moultrie and his faction on the other is poisoning the government."

"That isn't going to get any better, either, Joseph. Turnbull wanted to be lieutenant governor. The fact that Moultrie doesn't agree to an elected Assembly isn't all of it. My theory is that Turnbull simply hates the man who got the position he wanted. Add that to the Turnbull-Drayton clamor for an elected Assembly and you have trouble up ahead for a good long time—whether or not Grant comes back."

Peavett's earlier smile became a delighted laugh. "There can't be another man in all the world whose wife combines brains and beauty like the wife I'm getting."

After their marriage in the old Spanish church, now renamed St. Peter's, Maria and Joseph began talks with William Watson, the best builder in town, concerning the remodeling of the St. Francis Street cottage.

"I want it all clear, Watson," Joseph said, "before we leave, exactly what my wife expects this humble little house to become. Within reason, there's no limit."

On the day before their departure, Maria gave detailed, final instructions to Mr. Watson, relieved that she would not be there to see the brutal ripping away of David's roof to make room for the second story they were adding. Up and down the garden she walked—Peavett and Watson in tow—pointing out the architectural features of her dream for the house, each feature already familiar. Joseph's eyes sparkled as she filled in the details of his own dream. In her mind's eye, she could see it finished—the aging coquina walls of the first floor patched and painted a soft pink, the second story lifting in gray-green clapboards to a new, gabled roof—with two chimneys instead of the one David had built; a second-floor balcony overhanging her garden, with a view out over the waters of Matanzas Bay.

"There is one thing I insist upon, Mr. Watson," she said. "When the loggia archways are constructed across the rear of the house, I want you personally to make certain nothing happens to that stubby little fig tree growing back there."

"That won't be easy to guarantee," Joseph said.

"But you must guarantee it, Mr. Watson."

When Watson had gone, Maria said, "Joseph, I know you think I'm unreasonable about the fig tree. May I tell you why?"

"You don't need to."

"I know that. I want to. That tree was David's gentle bush. Do you know what a gentle bush is?"

"I think I do—haven't I told you I had an Irish grandmother?— a bush or tree not planted by the hand of man."

"Thank you for knowing. Thank you for making so much possible. I've dreamed and dreamed about all this. About doing it myself some day." She took his hand. "But now that it's about to happen, I—I somehow don't see how I could ever have lived here again—without you." She looked up at David's roof. "Being here with you is—redeeming so much for me. I do thank you."

In a fine carriage Peavett had bought from William Drayton especially for the occasion, he and Maria set out down the King's Road toward Dr. Andrew Turnbull's New Smyrna colony. It was mid-February. The weather was cold but sunny, and after a night's rest at the tiny tavern at the end of the twenty-mile stretch of road, they found that Turnbull had sent his own sailing boat to take them safely to the colony situated in the area which had been known for years as Mosquitoes.

"We picked the right time to come, Maria," he said as they sat together on a backless bench on the small deck in the sun. "I've been to New Smyrna during the summer, you know. It's well named—Mosquitoes. Staying in Turnbull's house, I had as much protection from them as possible, but my heart ached for the poor devils—the settlers—trying to rest from their backbreaking labors in those flimsy, insect-infested palmetto huts. I'd never take you down here except in winter."

"I wonder what we'll really find, Joseph? Do you suppose we'll have a chance to learn what conditions are—or will the doctor show us only what he wants us to see?"

"I thought you were one of Turnbull's supporters. That's just a guess on my part, of course," he laughed. "But you're always charming to him."

"I like him as a person, if that's what you mean. So did Governor Grant. Heaven knows he did everything in his power to help out with the new colony, but he made no bones about telling Don Luciano and me one night at a ball that Turnbull brought too many people. That he did not take proper precautions to see to their provisions. Those rumors that they may be starving right now can't all be smoke and no fire, can they?"

"Well, you and I will try to take some walks on our own and see what's what. Do you know, Maria, they say the carpentry in that mansion of Turnbull's cost two hundred and seventy pounds?"

"If the colonists are starving in the face of—even that one fact—there could be another revolt."

"Are you hinting at something you haven't told me?" Joseph asked.

"No. And I could be dead wrong about how the colonists are treated. There are always two sides. As I remember, Luciano had heard that first uprising was really against an overseer. And they'd been there only a short time—slavish work, bad living conditions—the mosquitoes alone could have caused it, of course."

"There's the human element, too," he said. "That crowd of people came from Greece, Italy, Minorca—all strangers to one another. Mediterranean pepperheads, some of them, I'm sure."

Maria thought a moment. "Indentured people are almost like slaves, aren't they?"

"Yes, my dear, they are."

She moved closer to him on the straight wooden bench. One of the two sailors smiled. Joseph waved in salute.

"Joseph?"

"Hmm?"

"I do thrive on our—independent involvement in East Florida, don't you?"

"Independent involvement?"

"Well, except for our loyalty to George the Third, you and I have both kept ourselves independent—quite independent. We have friends on both sides of most issues. That's good. It leaves us owing no one anything." She patted his hand. "I like being independently involved—with you, Joseph. I like it more and more."

Maria marveled at the primitive beauty as their boat sailed past the little green islands of the Mosquito Inlet at the point where the Hillsborough River, running northward, paralleled the ocean and met the shining waters of the Halifax, flowing south. The country around the Inlet was low, but the west bank of the Hillsborough rose to what appeared to be lush high land.

"Could we have picked a more beautiful spot?" Joseph asked.

"No! But—look."

She pointed to the shelly bluff at the foot of which the palmetto shacks of the colonists huddled together in a clearing. "I know we're going to have a wonderful visit, but I can't help feeling there's more suffering than we know in all this natural beauty. There is a

kind of darkness in those flimsy dwellings. I'm glad we're together—very glad."

Their room at Turnbull's palatial home on a high bluff away from the settlement was finer than either had ever slept in, the view of marsh and trees and river from their windows spectacular. The doctor's consideration of their newly wedded state was made plain immediately upon their arrival.

"Mrs. Turnbull and I fully expect you two to want ample time alone," he said in his heartiest manner. "Your meals can be served—especially breakfast, if you prefer—right in your room. We're honored that you've chosen to spend such an important occasion with us, and so your wishes will be our commands."

After breakfast on the morning of their fifth day as Turnbull's guests, the Peavetts sat side by side on a plum damask love seat before the windows that overlooked the Hillsborough River and the marshes. Not one rickety, bug-infested colonist's hut was to be seen—only the water glistening in the sunrise, which, in its progress, had shaded the rippling surface from deep rose at dawn to violet to morning-sky blue. Beauty and the rich, potentially productive high land were all they saw, but Maria grew more and more curious to know how the indentured colonists themselves lived—and said so.

"You make me think of my mother now and then," Joseph said.

"I do? You've never told me about her at all."

"Is that right? You don't resemble her—she hadn't your fine looks; Mother was a plain lady. But she was a thinker—and a worrier. She didn't fret unnecessarily any more than you do, but she did sense approaching trouble, and she persisted until her feelings were put to rest by one means or another."

"Tell me more about her."

"Well, she was a most intelligent woman—like you. Interested far beyond other women in affairs of government, both local and in London. We lived in Tunbridge Wells, a small village in the south of England—my father kept a store, and no man—except

me—ever had a wife better suited to his business. My father died speaking of his pride in her. She had true style—even in her plainness. I remember the last night of my father's life. One of the things he said to me, if not the very last, was, 'Your mother, son, is not like other women. She can wear her storekeeper's apron with such a flair no fashionable lady at the King's Court can outlook her!' "

"What a wonderful memory of your father, too, Joseph!"

"Yes."

"Are you like him?"

"I'd like to think I am."

A flock of white egrets sailed up and out over the marshes and vanished into the now white sunlight glinting off the river.

After the birds were out of sight, Maria said, "Don't you think it's strange that in five days Dr. Turnbull has not even suggested showing us around the settlement?"

He pulled her to him, laughing. "This very day, wife of mine, I'll *ask* to be shown every foot of the colony."

"I just want to know your opinion of why he hasn't offered."

"I don't have any," he said pleasantly. "I simply think the man is trying to give us a carefree visit—with time alone. I wonder, actually, if you and I need to concern ourselves one way or another with how he runs this place. Remember our 'independent involvement' you mentioned? We know the crops here are successful. You were with me the day the brigantine, *George,* sailed from St. Augustine last year with over two thousand pounds of New Smyrna indigo aboard. I think these poor people expected hard work. It took time to settle them down in the beginning. I imagine things are running as smoothly as could be hoped for these days. But I won't mind asking for a tour. I'm sure Turnbull will agree. The man has real enthusiasm for his noble experiment."

"Why on earth do you use the word 'noble'? He's in a purely profit-making venture."

Joseph turned her face toward him and gave her a quizzical smile. "Since when does my wife object to profit making?"

"I don't. I just don't feel there's anything noble involved."

"Ignoble?"

She smiled, too. "No. And the doctor is a charming host. We could not be treated more royally."

"Don't worry your lovely head about how the settlers are treated. It's a cruel life by any measure, although they were undoubtedly expecting the promised land. They come from a sweet climate at least ten parallels farther north. To be set down in our low, swampy, subtropical country must be devastating. They have to blame someone for their troubles. Naturally they blame the man who brought them."

Maria said nothing.

"You heard Turnbull say last night at dinner that he encourages them to fish in their spare time and that many families have great quantities of dried fish in their huts."

"I hope that's true, Joseph."

After the noon meal, Turnbull invited them to see the colony. Speaking as though the idea had just occurred to him, the doctor ordered horses and two body servants to ride along.

"We won't, of course, bother to ride to the actual settlement," Turnbull said as they began walking the horses down the sandy road that led from the new stables. "Some wooden houses have been built since you were here, Peavett, but there's a dreary sameness about it all. I want you to see my indigo fields. They're being prepared now for spring planting and most of all I want to show you both my splendid new irrigation system."

"I want to see how the people live," Maria said to Joseph in a low voice.

He placed a finger over his lips. Then, to Turnbull he called, "We'll follow your lead, Doctor."

For almost two hours they rode across the flat land, forded small creeks, and cut along the dry marshes following the miles of irrigation ditches, which Turnbull explained were Egyptian in origin and had so far made it possible for New Smyrna to escape the killing droughts that had ruined so many East Florida harvests.

Turnbull rode slightly ahead, straight in the saddle, his rich baritone voice carrying tirelessly back to them on the somewhat windy day, always boastful of his colony's accomplishments. Joseph complimented him as they passed the impressive coquina-lined irrigation canals and seemed to be enjoying himself, but Maria felt the ride would never end.

"When you've seen one of these ditches, you've seen them all," she whispered to Joseph. "Let's go back."

"Doctor, my wife is growing a bit tired," Joseph called. "Will we be turning around soon?"

"We're already circling back in a general direction," Turnbull said pleasantly, trotting his horse to where Maria had by now halted hers. "But I did want you, Captain, to see the vast acreage already cleared. Why not wait for us here, Mrs. Peavett? One of the servants will wait with you. Your husband and I won't be gone more than half an hour." He turned to Joseph. "I can also show you the lay of the land grant you like. It's in plain view from my indigo fields."

Joseph gave Maria a beseeching look. She nodded agreement and smiled in her most charming manner at Turnbull. "Of course, I'll wait for you, gentlemen. It's just that I haven't ridden in so long. Take your time."

Joseph turned twice to wave his gratitude as he and Turnbull rode off, and Maria, with the skinny, crippled servant's help, dismounted and settled herself under an ancient, dying oak to rest. Without a word, the dark-skinned young man brought her water and biscuits, then squatted on the far side of the tree.

Relieved to be alone where she could think without having to make conversation, she drank, nibbled on a biscuit, and leaned her head against the great, rough trunk. Undoubtedly the crippled young man was one of Turnbull's colonists who probably spoke little English, if any. She felt an urge to question him about the treatment of the colonists, but decided against it. Anyone who met Turnbull socially would find him an attractive, gracious gentleman, however boring his long spiels about the canals. In her heart, she hoped her disturbing, lingering fears that he did

mistreat his people were groundless. As groundless as she suspected Joseph felt they were. Heaven knew the King needed settlers. Turnbull had brought by far the largest group to date, and it was possible that even the primitive life at New Smyrna was better than what these peasant farmers had known in the old country, even if they had come from a better climate. Whatever the condition of the palmetto huts down at the settlement, crawling with the same bugs she and David had battled, the huts couldn't leak more than the Havana barn the young Fenwicks had shared—or harbor healthier rats. I need some of Joseph's level-headedness, she told herself. My feelings about an ominous undercurrent here are probably without cause.

She closed her eyes. It is being a lovely trip. The Turnbulls could not be more hospitable. I do like Mrs. Turnbull—especially her charming accent. I think I rather envy her. The way she speaks seems to give her every word a kind of romantic ring of truth. Maria smiled to herself. I'll apologize to Joseph for being worrisome.

After the noise and clatter of St. Augustine, the wilderness silence was welcome, the winter sun warm on her face. Even the gulls wheeling above the rivers cried softly. A white-throated sparrow's unmistakably sincere call brought another smile. Those little birds always seem to be trying so hard, she mused.

And then her body froze as a man's repeated screams shattered the air, and she heard the sickening thuds—of a beating somewhere nearby. A heavy piece of wood bashing against a human body. She jumped to her feet as the screams broke off into hoarse shrieks of anguish—frenzied and then fading to an animal whimper as wood splintered and another man cursed in English.

She ran around the big tree to where the crippled servant sat motionless, his terror-filled eyes staring. "What was that?" she demanded. "Someone's being beaten! It's nearby—what's over there?" She pointed in the opposite direction from the trail Joseph and Turnbull had taken.

Still sitting on the ground, the frightened young man mumbled in a thick accent, "South field, señora."

211

She heard a sustained, tortured groan and then silence.

The little white-throated sparrow sang again.

"What's happened? I demand that you tell me anything you know! Someone has—just been horribly beaten!"

The servant only nodded.

Maria walked straight up to him. "Did you hear me? I demand to know. I've never heard anything so brutal! *Was* that—one man— beating another?"

Again the nod, the dark eyes still staring in terror.

"Who might have done it?"

He shook his head slowly.

"An overseer?"

"*Si.*"

"With—Dr. Turnbull's permission?"

Now the young man looked at her as he got awkwardly to his feet. Deliberately, it appeared, he flattened himself against the big tree, opened his mouth to speak, then shut it tight.

"You were about to tell me something. You can, you know. I am—on your side. Please tell me what you just decided not to say." She waited.

Pointing to his crippled legs, he finally began to talk to her. Under the flat, hopeless voice there was a hint of eagerness as though he'd waited a long time for this chance. Maria's concern had freed him. In his broken English, he told her—demonstrating with his puny body propped against the tree—of his own beating the day he had been crippled. Tied to just such a tree with ropes, his legs had been beaten with an ax handle until the bones cracked. An overseer named Bruce had done it because another overseer named Louis Sauche had refused to Turnbull's face. Sauche was himself punished for refusing, but Dr. Turnbull's orders had been carried out.

"But *why*? What had you done to deserve such a beating?"

"Sick. Not able—in my body—to work the fields."

"They beat you for being ill?"

He nodded. "All work—so many hours a day—or whip. Or worse than whip."

She began, "What do you mean, worse than—" when she heard the approaching gallop of the returning horses.

Quickly, she turned to the young servant. "Sit down," she ordered, "and act for now as though everything is all right. You have my word—I'll say nothing of what you told me. Nothing at all."

She also sat down, beside the water and biscuits, leaned her head back against the tree, and closed her eyes.

When the men rode up, she tried making pleasantries, tried listening to their talk about the indigo fields and the land grant Joseph now wanted more than ever, but in a moment Joseph knew something was wrong.

"Maria, you're white as a ghost!"

She looked from one to the other for a long time, then heard herself say, "A man—I could hear a man being—beaten. . ." She pointed. "Over there, Joseph. Over there. Dr. Turnbull, he surely needs help."

His face contorted by anger, Turnbull motioned to the two body servants, and without a word, wheeled his horse and galloped off with them in the direction she'd pointed.

Standing alone under the big tree, Joseph took her in his arms and held her for a long time without asking questions. Finally, he said hoarsely, "Maria, if you're right—if the man was beaten—it must have been a private quarrel between two colonists. Or at the very worst, an overseer taking more power into his own hands than Turnbull allows. He's a fine gentleman, my dear. I'm—so sorry you had to be nearby when it happened—but you must be reasonable."

Slowly, she pulled herself free of his arms. "Have I—said one word against Dr. Turnbull, Joseph?"

"No. No, I guess you haven't. I—was just remembering what you said this morning. And, Maria, I do believe the doctor does the very best he can."

Turnbull appeared deeply concerned over the beating, even saddened, but he asked the Peavetts to make no mention of it to his wife. "I protect her when possible," he said. "I do find it hard, at times, to control my overseers."

Even though Maria's tensions did not lessen, they stayed on until the end of February because she knew Joseph wanted to. It was not much more than another week, and she managed not to mention once how impatient she was to go home. Not only had she been unable to shake off the effects of hearing the beating and the crippled servant's story, but she was eager to examine the progress on their St. Francis Street house. Surely David's roof had been torn away by now, and she needed the diversion of supervising the remainder of the changes.

She could hardly believe they had been away just two weeks when at last Joseph said he thought they'd visited long enough, and she set about packing their belongings. Her husband seemed satisfied that he'd made the right decision about the Mosquitoes land. He was going to apply for the grant if he found he could purchase enough Negroes to qualify for free land, and Turnbull promised to visit them on his next trip to the city to discuss a joint timbering operation should the land be granted.

Joseph seemed utterly content. I'm going to be content, too, Maria vowed to herself as they bumped along toward home over the twenty-mile stretch of the King's Road. I'm going to stop concerning myself about things over which I have no control. At my age, one should begin to think more of contentment, to seek it out. Not to add unnecessary burdens.

With Joseph Peavett, she knew the search would be good.

Spring and summer of 1772 found the affairs of the East Florida colony going reasonably smoothly. There had been no word from Grant as to his return, but Lieutenant Governor Moultrie, in spite of continuing bickering on his Council over the lack of an elected Assembly, was doing a diligent job of running the colony. It had been Moultrie who pushed through the completion of the twenty-mile stretch of the King's Road toward the New Smyrna colony—an asset to Turnbull's settlement—but not enough of an asset to change the doctor's strong dislike for John Moultrie. The entire Turnbull-Drayton faction had made it plain

long ago that nothing Moultrie could do would please them. Maria and Joseph discussed the problem often, but most of their talk and their interest these days lay in the progress of their St. Francis Street house. William Watson, the contractor, was proving his reputed skills.

"It's a pleasure, Mrs. Peavett," he frequently told Maria, "to do business with a woman of your taste and knowledge of building. I don't hope to find such an agreeable lady any time soon again."

"You have my father to thank for what I know of building, Mr. Watson. And my husband for my agreeable disposition."

Don Luciano dropped by often to see the nearly square two-storied house take shape and seemed his old, easy, carefree self, but even he had almost no news of Jesse Fish, still in seclusion on his island.

For Maria, one small, but important dream had to do with the look of the garden, once the carpenters and bricklayers had gone. The garden must give her the feeling of her own deep, inner place. Must also be beautiful enough for David. She enjoyed designing the neat frame which would hold David's somewhat battered gentle bush upright against the back wall of the new arched loggia. In the garden itself, she wanted no blooming plants—no riot of flowers—only as many shades of green as the sandy Florida soil would grow.

Joseph was often away from their temporary Charlotte Street home. He not only handled most of their business dealings, leaving her free to concentrate on the final stages of the house on St. Francis Street, he had begun doing their marketing, too, simply because he enjoyed it. Maria had ample time alone, always a necessity to her. It helped her match Joseph's even moods and to complain less on the days when he entertained his noisy officer friends in their parlor.

On the first day of November, 1772, their new furniture—ordered from both Charles Town and London—arrived in St. Augustine, amazingly on the same ship. Joseph had ordered the schooner from London to pick up the Charles Town pieces Papa had made for them, but neither had truly hoped for such good fortune.

The finished house and its garden were ready at the end of the month and, with the help of a handful of off-duty soldiers who thought the world and all of Captain Joseph Peavett, they moved in.

Maria Evans had come home.

24

Through the winter, spring, and early summer of 1773, Maria and Joseph, still excited about being in their spacious and lovely remodeled home, mainly settled down to enjoying their good life. Aside from a hardening resistance to Moultrie among his enemies, led by Drayton and Turnbull, little happened in the affairs of the city to divert the Peavetts from the stimulating pursuit of success for themselves. Because of their shared interest in the goings on at Government House—especially as it had to do with the building of their own fortunes—they spent hours talking it all out, trying out this and that theory about the continuing conflict over the question of an elected Assembly. But since this question had not yet affected them personally, their talk remained objective. One day Maria would argue for an Assembly, the next she would take Moultrie's side while Joseph took Drayton and Turnbull's.

The Proclamation by His Majesty which Maria had read in the Square with Ann ten years ago had not been entirely fulfilled. No one could argue that. East Florida was to have been governed exactly as the other British colonies. It had not been. It was not now. The aristocratic Moultrie and the Council, all appointed from among the traditional ruling class, still made every decision for all the people. The diligence with which Moultrie handled the colony, all the way

from military protection to the trade problems with the Indians, seemed in no way to appease his opponents, who followed Drayton and Turnbull in agitation for an Assembly elected from the middle class. Still, average persons, so long as nothing threatened their placid city, were apathetic about the controversy.

There was more talk, though, at Government House social functions concerning the uniquely American opposition to the Crown developing among the other colonies along the coast. With improved mails, more newspapers were coming into St. Augustine. The city was no longer sealed off from the deepening unrest to the north. As the summer progressed, this so-called "American" consciousness appeared to Maria and Joseph to be outright defiance against any new royal decree from abroad.

"Why, Joseph? Why is it that even without an Assembly, our colony is still not on its high horse like the neighboring colonies? Thank God it isn't, but why do you suppose that's true?"

"We're new, my dear. Our roots aren't down in America yet. Of course, I think Drayton and Turnbull and the others have ample reason to press for an Assembly. It is the right of a British subject to be represented. Moultrie and Grant, I suppose, have had a valid argument against an Assembly, too. Only lately have we had enough people here to elect a public body. These things take time. As far as I can see, you and I have no reason yet to be particularly alarmed that we're ruled only by the influential among us. This may not be the farsighted view, but I confess I'd rather be here where Loyalists remain firm than to be in South Carolina, living in the ferment up there with your father."

"Papa's always been so conservative and cautious, I still have trouble picturing him actually involved with the resistance." She laughed a little. "I admit I don't doubt that he is. And maybe, if we were there paying the taxes they pay, we'd be with him."

"Perhaps. Perhaps, too, there's more of the northern type of agitation right here than you or I suspect. Did you ever think of that?"

"No, except when I hear those stupid rumors about Drayton and Turnbull being rebel sympathizers. But just wait until Governor Grant comes back, and you'll see them all settle down."

"*If* he permits an elected Assembly."

She sighed. "Well, anyway, they seem to have turned their thoughts to a few other things in Charles Town. Papa's last letter said the library now has a museum, too. And business must be good because there's talk of forming a chamber of commerce."

Joseph, preferring to deal with James Grant, had decided to wait to apply for his New Smyrna land until the governor returned. He had not yet managed to buy enough Negroes to qualify, and there seemed no hurry.

But on August 4, the slow-paced days were abruptly interrupted. On the notice board at Payne's Corner, there appeared the startling announcement that Lieutenant Governor Moultrie had been informed that His Majesty had appointed a new governor, Patrick Tonyn. As Joseph had surmised, the responsibilities of Grant's new wealth and estate at home outweighed any obligation he felt to resume the sticky problems of the still thinly settled "infant colony."

The news was a blow to everyone—to Moultrie and his Council friends, the Reverend Forbes and Dr. Catherwood—as much as to the Drayton-Turnbull faction. All had counted heavily on the intelligence of Grant, the men on each side believing that, once he returned, he would handle the Assembly problem their way. Few knew anything about the new governor, Patrick Tonyn, except that he was Irish, married, and a military man. Almost overnight, the complacent citizenry of St. Augustine grew restless and anxious. Gossip at Payne's Corner and in the Square became apprehensive. The spirit of rebellion in the northern colonies was spreading now among all classes, and almost to a man, the townspeople had counted on Grant's affable nature and diplomatic skills to keep the East Florida colony on an even keel. He was the only official, they believed, who could handle whatever might come to them. The anxiety which had been submerged in passive waiting for Grant's return surfaced now and would surely grow, since the new governor—whatever he was like—would not arrive until some time early next year.

To make matters worse, before any definite word of Governor Tonyn's sailing date reached the colony, they were squarely faced with the danger of an immediate Indian attack.

"A major threat of war," Joseph called it. "Moultrie himself told me."

Maria had lived in the little garrison city for more than a decade, had grown accustomed to Indians in the narrow streets bartering hides and vegetables or visiting Government House to collect their regular gifts and bribes, and had almost forgotten what it had been to fear Indian attack in her childhood back in Charles Town. "Maybe they won't actually attack us," she said. "It's the Georgia colony that keeps betraying them. What does John Stuart think? As Superintendent of Indian Affairs, he should know."

"He thinks we should be ready. Moultrie said Agent Stuart just left his home in Charles Town and came through Georgia on his way here."

"But it *is* Georgia Governor Wright who double-crosses the Creeks, Joseph. Whatever folk think of Moultrie, he's done well with them."

The East Florida Council met four times during early February, 1774, for a discussion of the colony's weak defenses, and issued a proclamation on the fifteenth forbidding any further trade with the Creeks. During its fourth meeting, the Council drafted a letter to the local commanding officer requesting detachments for the St. Johns River and an inspection of the condition of the tiny fort at Picolata. All the high officers stationed in St. Augustine disliked Lieutenant Governor Moultrie, but they were loyal officers. His requests were carried out, and a troop of rangers was formed at the same time arms were distributed to all sections of the colony.

Then, after weeks of siege preparations, the threat died as quickly as it had been born, and no one ever had an explanation for it. The city sighed with relief, and the wait went on for word of the arrival of the new governor.

"No white man will ever understand the red man's mind," Joseph said one night when he came upstairs after a talk with a handful of officers who had stopped by for a visit.

"What now?" Maria asked, sitting up in their handsome new four-poster mahogany bed.

"I've just learned that the Oconee king will be on hand with great pleasure for the inauguration of our new governor!"

"Joseph, I've made up my mind to something. I've complained for the last time about so many noisy visits from your officer friends. Never again. I can see how very important it is for you to be kept up on everything. We need to stay informed. Why don't we open a small tavern downstairs? We can easily afford a man to run it for us. After all, there are five rooms down there, and we have all the rooms we need up here except the dining room. The officers eat and drink every time they come—why shouldn't they pay for it?"

He had been undressing as they talked. Now, he stood in his nightshirt looking at her with such an expression of love and admiration, she began to laugh.

"I'd like a painting of you—just like that, Joseph!"

In two long strides he crossed to the bed and pulled her close. "Maria, oh, Maria, you are a wonderful woman! Did I mention to you that I'd been thinking about opening a small tavern downstairs? I'm sure I didn't. Never dreamed you'd agree."

She looked up at him, laughing. "Why wouldn't I agree? I like to make money as much as you do, you know."

At the end of February, Maria sat at her desk in the small ante-room at the top of the stairs, reading a letter from Papa just brought by one of the soldiers. It was dated 2 December of last year! Nearly three months ago. With almost no preliminary greeting, her father went right into the latest, disturbing news from Charles Town:

> The Virginia colony is leading the way in our quest for Liberty. Early last year, in March, as I recall, the Virginia House of Burgesses appointed a Provincial Committee of Correspondence to keep in touch with sister colonies in our mutual time of trouble. South Carolina followed suit. All but Pennsylvania have such committees. We are coming together in a

most encouraging way. How I long for some word that East Florida may some day wake up and join our struggle. If not, and if one more dastardly Parliamentary act further inflames our leaders, you, my beloved daughter, could be cut off from me. I detest the thought, but there could be war. There will always be war when reason departs. Reason has departed our government abroad. Word has just reached us here that to provide relief for the powerful East India Company, the government at Whitehall is about to allow the company a drawback of the tea duty in England, so that full duty will be paid by the poor colonists. I predict that none of the thirteen will comply without protest. The first such shipment is due here this week. You will undoubtedly hear of it before you can receive another letter from me, but I will keep you posted as best I can.

How I wish I could speak to you face to face, and to your illustrious husband. Do write me of events there and tell me that you are both well and prospering in these difficult times.

Yr loving father,
Richard Evans

She sat for a long time with the letter spread on her desk. Dear Papa—still involved with the rebellion as though he were not a man of nearly seventy! I should be glad, she thought, that he is well enough to be so aroused, however misguidedly. At least, I suppose I should be glad.

She refolded the letter, put it carefully away, and went slowly downstairs and out into her garden. The sun poured streams of pale, gold winter light down through the orange and nut trees, spreading leaf and branch patterns on the brown grass. When spring came, the garden would be nearly as she had dreamed it—cloistered, shaded, green. A place for contentment. There seemed little more she could want, but her father's letter—the spirit in it—had stirred an old drive in her, an almost forgotten compulsion to be swept off her feet by something dazzling, engrossing—or, more accurately, to sweep over

some situation herself, a conqueror. She laughed. How young of me. But I feel young!

Life with Joseph was almost too trouble-free. His command of himself and of their affairs became increasingly evident, and yet in every way that a man and woman could be equal, they were. He was going to leave the military soon in order to give more time to their investments—a decision he had not finally made before asking her how she felt about it. She had heartily approved, both for the reasons he gave and because of her fundamental—and comfort-able—respect for his judgment. She did consider briefly whether he would have followed that judgment even had she not approved. But she needn't worry about that; their values were so close as to be uncanny sometimes.

For no particular reason, Don Luciano de Herrera flashed into her mind. It had been more than a fortnight since he'd paid them a visit, and then he'd seemed preoccupied, the conversation almost strained. He had made one or two veiled remarks that made Maria feel as though there were dark, mysterious events forming some-where in the world of government that could affect them all. Events about which she and Joseph did not know.

What did Luciano actually do with his time these days? Of course, he handled Fish's real estate. Tragic Jesse Fish! Was he really a prisoner of his vixen wife, or was he just too humiliated by her boisterous behavior in the city to show his face? Maria could talk freely with Joseph about anything that crossed her mind, but out of the unexpected restlessness today, she found herself wishing for the old exchanges with Fish and Herrera. Was it merely her imagination suggesting to her that Don Luciano was involved in some secret Spanish negotiations or schemes? He had stayed such a long time in Havana without any explanation.

The picture of faraway gentlemen in white wigs bending over tables spread with maps—in England, in Spain, in the northern colonies—heightened her feeling of foreboding. All persons—even influential ones like herself and Joseph—were pawns in the intrigues of these officials, whose quixotic schemes ignored

people and their hunger and sorrow and tears and need to be safe. Pawns. Papa surely felt himself to be a pawn of the Crown and the men at Whitehall. Governments were necessary in the affairs of men, of course. Officials contended that human nature could not be trusted to govern itself, yet Maria Evans felt that she could be trusted. And Joseph.

Seated in one of David's old garden chairs, she looked up at the height of her fine house, its elegant roof line splendid against the pearly sky. A surge of pride in her own achievement coursed through her. She had made a dream come true. She, with her good, discerning husband, owned the one property she'd wanted in the entire city. Maria Evans was, in all ways, a success—and she had not been born to it. Would not more folk succeed if they were left to their own devices—not treated as pawns of some remote government?

She smiled, then frowned. "I sound like Papa," she said aloud.

What kind of action *would* the northern colonies take when that East India tea came into their ports? Life without tea for an Englishman was like a body without blood. Surely they wouldn't refuse it. She sighed. Well, at least, they'd heard that the new governor of East Florida was en route. He'd sailed into what were undoubtedly rough seas last December 22. February was over, but she was sure they couldn't expect him for another week or more.

She heard Joseph call her from inside. "Maria? Maria!"

"I'm in the garden, Joseph." She held out her hands to greet him. "How was the marketing today? Did you find anything fresh?"

"A few things. Some nice large shrimp—string beans and good yellow sweet potatoes." Plainly, there was something on his mind besides marketing. "Maria, I've some rather disturbing news. It seems several shipments of tea were permitted to be sent directly to the northern colonies with all taxes due. The East India Company had requested it of the Crown and—"

"I know, dear. Father's letter today told me all about it. He's expecting trouble."

"They've already got trouble. When was his letter dated?"

"Early in December. Almost three months ago."

"I'm not surprised it took so long. Ships were rerouted in anticipation of just what Parliament did about the tea. My dear, they're going to close the port of Boston!"

"Whatever for?"

"When this shipment of tea reached there, the rebels—dressed, I hear, as Indians—boarded the British ships and dumped the whole lot into the water!"

"Why, Joseph, that's outright defiance of the King."

"So—the port of Boston is to be closed."

"Papa said tea was expected in Charles Town, too—I wonder what happened there?"

"I'm coming to that. The Charles Town folk acted with a bit more restraint, but they've made their point. The tea is still intact, but stored in warehouses. It won't be drunk."

She took a deep breath. "I don't know what to say! And Joseph— I'm worried. Papa says there could be war—but surely not over tea!"

"I doubt it will come to that, but Parliament is cracking down. They've already passed what they're calling the Coercive Acts. There's another one due to be passed against the Massachusetts colony, depriving the people there of most of their chartered rights and greatly increasing the royal governor's powers. Still another act will force persons accused of capital crimes to be tried in England. This will all breed trouble. I don't like any of it—from either side of the fence."

Joseph, seated now in a chair beside her, put his head back and closed his eyes. For a long time neither spoke. Then Maria said, "I don't like any of it either, but, Joseph Peavett—I like *you.*"

He raised his head, a half grin on his broad, good face. "Thank you, ma'am. But what brought that about? Why do you like me this minute—in particular?"

"Now that you're going to be out of the army, you seem to be almost as—neutral in all this as I feel I am."

Events in St. Augustine over the past year seemed trivial compared to the chaos building in the northern colonies. The Grand

Jury had presented minor complaints that, in spite of Moultrie's efforts, the colony was not well fortified and that there were too many tippling houses in town kept without licenses—typical small-city problems. But by the time Tonyn arrived in March, the shadow of the gathering trouble to the north had fallen across the loyal East Florida colony, and the Grand Jury presentments sounded of small importance. No one doubted that a new governor had been appointed because of the approaching fires of rebellion—raging too hot and too nearby for the colony to be trusted to any but the strongest hands.

From the day of Patrick Tonyn's arrival, in spite of his exhaustion from the long, arduous sea voyage, few doubted that he would use firm measures in running the colony. His sturdy, tall body and hard-featured, almost expressionless face did not breed affection, as had Grant's; yet, except for the Drayton-Turnbull faction, who resented him from the start, most citizens respected his royal authority.

Tonyn's first impressions of the colony must have been mixed. He'd been informed of the division on the Council and, except for what struck Joseph as unbecoming subservience to Moultrie, appeared to greet each Council member with a stone countenance, indicating no promise of favors toward anyone. Fort St. Mark was certainly in need of extensive repairs, as was the governor's mansion. Ordnance was lacking and ammunition was scarce, but perhaps worst of all, since news of the defiance in Boston, the morale of the people seemed low. Maybe it was these conditions that caused Governor Tonyn to plan such auspicious installation ceremonies. After all, Maria and Joseph reasoned, it was the royal governor's job to build the colonists' confidence in British sovereignty and to reaffirm the Empire's prestige in a public way.

Maria had never seen so many Indians at once as were in town for the lavish event. And as usual, when honors were being bestowed, it was Chief Cowkeeper who gave a talk, on behalf of his Creek nation.

"Tonyn may do well," Joseph said, after they'd watched the elaborate ceremonies in the Square and started home. "I hope he does do

well, but I also hope he's been told enough about the city's need for harmony on the Council."

"He knows Moultrie's side of it, anyway," Maria said with a touch of sarcasm.

"That's exactly what disturbs me. If he continues to take Moultrie's word entirely about Drayton and Turnbull and their friends, he'll have only a one-sided view. An awkward position from which to govern."

Maria linked her arm in Joseph's as they strolled along the Bay. "I don't care what the gossips say, I do not think William Drayton and Dr. Turnbull, however headstrong both men are, have one shred of disloyalty in them. Joseph, the Councilmen are all reputable, intelligent, grown men! Why can't they stop acting like boys? I think even the Reverend John Forbes is taking sides—Moultrie's—and so, of course, Tonyn's. You'd think the rector of our Church would have some maturity of judgment, wouldn't you?"

Joseph laughed. "That would be ideal, but you know Forbes as well as I. His bread is going to be buttered on the Tonyn-Moultrie side."

They had reached their gate. "We're home," he said. "Let's go inside and have a good cup of strong English tea and just be together. What do you say to that?"

Maria smiled at him. "After all that pomp and circumstance, I'd like that very much, Captain Peavett."

While the problems of too many tippling places, too few guns, and too few soldiers vied with personality rivalry on the St. Augustine Council, events reached the boiling point in the colonies to the north. At the end of May, the Virginia House of Burgesses adopted resolutions calling for a congress of the colonies and sent copies to other Assemblies. None arrived in St. Augustine, of course, because there still was no hint that there would be an elected Assembly any time soon. As a result of the Virginia resolution, the First Continental Congress convened at Philadelphia with all resisting colonies except Georgia represented. There, a Declaration

of Rights and Grievances was hammered out among the divergent personalities at the Congress, and in October, the delegates adopted the Non-Importation Association resolution providing for non-importation of English goods after December 1.

Early in 1775, in one last effort toward peace, the colonies presented a plan for conciliation. Parliament rejected it. Lord North, still advocating reason in London, was also rejected.

Maria's father had been right. The lines were drawn for war.

25

On a quiet, soft June night in 1775, Maria and Joseph dined with the Turnbulls in their impressive town house across St. Francis Street. As usual, Maria enjoyed talking with Mrs. Turnbull when the ladies remained behind, sending the two men off to have brandy and their pipes in the parlor. But she felt she couldn't wait to be home again to learn from Joseph, once they were alone, exactly what he and the doctor had discussed with such concentration.

The Turnbulls, she knew, came to the city only when the Council met or when Turnbull's business required it, but the tone of their host's voice indicated that more than business was on his mind. Joseph seemed merely to respond briefly now and then, so far as Maria could tell, but Turnbull's staccato talk went on and on as though he were making every effort to convince.

Once the Peavetts reached home, she waited only until they were upstairs, out of hearing of the few officers still lounging in the front-room tavern, before she inquired about the conversation.

"Turnbull was bent on convincing me that it was a bad day for us all when the new governor came," Joseph began, a bit reluctantly. "He declares that Tonyn and his wife personally beat their slaves until the cries have been heard across the Square and that the Turnbulls have no intention of ever again attending a function at Government House."

"I've heard ugly rumors about those slaves, but I'd want to know for myself, Joseph. Do you mean the Turnbulls will snub the Tonyns because of the rumors?"

"It's more than that. It seems Turnbull knew Mrs. Tonyn back in Scotland years ago. Says he can't permit his wife to associate with her socially."

"Did he give you a reason?"

"Only that the woman is 'frumpy and mentally deranged.' That's about all, Maria. Let's go to bed."

"We'll do no such thing until you've told me everything he said."

Joseph frowned. "Just a lot of gossip and criticism of his Excellency for entertaining so little and so poorly. According to the doctor, Tonyn's sent most of his Negroes to his plantation—had to borrow some from Moultrie in order to give a small dinner last night for poor John Stuart."

"Why refer to a powerful Indian agent as poor?"

"Maria, I'm tired."

"You're keeping something from me, aren't you?"

Joseph sank into a comfortable chair and sighed deeply.

"I very much dislike being overprotected," she said.

He smiled. "I know. All right—John Stuart was run out of Charles Town, Maria, in order to escape being tarred and feathered. Accused by some patriots—friends of your father's, I must tell you— of not conducting Indian affairs for the good of the people. Seems Stuart's Indians are taking too many scalps. Inspiring white Royalists to do the same."

She sat down on the bed. "Do you believe that? I know Indians take scalps, but do you believe Englishmen would tar and feather— or actually scalp—other Englishmen? Would they even permit such a thing to happen?"

"I might as well tell you the whole thing. You're not being totally realistic about the trouble to the north, Maria. Because Turnbull and

Drayton are still pressing for an Assembly, Tonyn has openly, publicly, accused them both of being traitors, in sympathy with the South Carolina rebels. Some of the trouble is at last reaching us here."

Maria stared at him.

"It's not pretty, my dear," he said. "None of it."

"I know Drayton's brother, William *Henry*, is one of the leaders in Papa's movement up there—but does Governor Tonyn have any real grounds for calling our Drayton here a traitor?"

Patiently, too patiently for her racing thoughts, Joseph explained to her that since the problems in the northern colonies usually began in the elected Assemblies, to Tonyn's autocratic mind anyone in East Florida who urged a general election could rightly be accused of treason. "I might as well tell you, too, Maria, that your father's Liberty Boys have cut us off from the other thirteen colonies."

"Cut us off?"

"All trade. Probably all communication."

"But Charles Town's our main source of everything we need!"

He nodded. "I won't be surprised if mail is affected, too. According to Turnbull, we're all going to have to watch our step."

They sat in heavy silence. Finally, Maria asked, "What do *you* think, Joseph?"

"One thing I know—it is the right of every Englishman to be duly represented by an Assembly. An elected Assembly. God knows I'm no traitor to the King, but I am an Englishman—and I'm in favor of an Assembly where I'll have a voice." He looked at her with so much feeling, she thought she might weep.

"Joseph—I don't think I could—bear not hearing from Papa!" She stood up. "I'm sure in time the Assembly question will be settled." Her voice was unsteady, but she plunged on. "I don't like Tonyn either, but perhaps our dislike of the man is because he isn't Grant. At any rate, you and I must attend to one thing and one thing only—our own affairs. If Drayton and Turnbull go on defying his Excellency, he'll ruin them."

"Turnbull quite agrees. Even thinks Tonyn wants the end of the New Smyrna colony—just for spite."

"The doctor's as extreme as his Excellency!"

"I don't know about that."

"But the New Smyrna colony is producing well now. With supplies stopped from Charles Town, the governor would have to be insane to think of such a thing!"

"I—don't know."

"Stop saying you don't know and listen to me, Joseph. You and I are not going to become embroiled in this local squabble! It will pass. We will go on as before. The governor has simply allowed himself to be swayed by Moultrie's hatred for both Turnbull and Drayton. It shows weakness of character, but that's no concern of ours."

"Maria, I think it is."

"Why?"

"Because we live here."

"And we'll go right on living here—in our own world—minding our own business. When we do have an election, I know you'll be asked to offer for a seat on the Assembly. It's inevitable with your prestige and holdings. You must keep your mind open to both sides of this stupid local dispute. It *is* local, Joseph, and it will pass."

He got up slowly and put his arm around her. "I know you're upset because of the danger your father has got himself into, my dear. I can do nothing about that but—be with you in your anxiety. That trouble is *not* local." She had buried her face in the heavy embroidery of his formal coat. "Look at me, Maria, and listen to what I'm saying. Our life here means—even more to me now than it means to you."

Without raising her head, she whispered, "Don't talk nonsense."

"I'm not. You see, I know you feel genuine respect and affection for me, but my feelings for you no longer stop there—I simply keep on loving you more deeply all the time. And I value what feeling you have for me so much that I have no intention whatever of making a single move that might affect what we have together—if I can help it. We'll go on the same for as long as events permit. That's all I can promise."

Her face still buried in his shoulder, Maria closed her eyes tightly. Too many issues had arisen tonight; this was not the time for discussing the ways they loved each other. And then it came to her: that was not all he had been saying. What did he mean, "That's all I can promise"?

"Joseph? Are you frightened—about events?"

"I don't know. We're a long way from Virginia. I'm sure we'll be all right."

Maria looked up at him. "Why did you mention Virginia? Is there something you haven't told me?"

"Turnbull says Headquarters at the north have ordered more detachments from our Fourteenth Regiment to pack up tonight. They leave us tomorrow for the Virginia colony. Royal Governor Dunmore needs help up there."

"But what about our safety here?"

Still holding her in his arms, he said, "I don't look for a patriot attack on us. South Carolinians are less hotheaded than Virginians and Georgia is still reasonably loyal. Maria?" He loosened his arms and sat on the bed, pulling her gently down beside him. "We'll be all right, you know. It means so much that we have each other." His eyes asked a question. He wanted her.

She put her hands on his shoulders, smiled into his questioning eyes, and kissed him on his big nose. Then she said seriously, "It means a very great deal, Joseph—of course."

Joseph's lovemaking last night had been unusually tender, and Maria had been amply satisfied, but she had not slept right away. She did not want their relationship to change. She needed the security of his love—but his love as it had always been, not an adoration she could not match.

At breakfast, his manner seemed the same as ever, and she felt much relieved.

Today, though, she felt an irresistible need to talk sense with someone more objective. Herrera had always been able to help her put things in perspective. As a Spaniard in the midst of the British-American trouble, he came easily by the kind of objectivity Maria meant to hold to. Not a worrying woman, she merely wanted to see events clearly and without passion.

Leaving Joseph at work on their North River accounts, she hurried up St. George Street toward the Herrera house. She had just reached the Square when from the Bay front came the sound of marching. The already undersized Fourteenth, knapsacks and blanket rolls heavy on

their backs, red coats bright in the June sunshine, filed down to the wharf, where a schooner would take them to the colony of Virginia. She knew, even though Joseph had gone into no detail, how poorly fortified their departure would leave the city.

As she neared the Herrera house, she could hear fifes and drums strike up in the quiet morning as the soldiers neared the city wharf. Her heart pounded with the drums, but not with spirit—with fear for Papa, who in his latest letter had all but called himself a rebel.

At the Herrera gate, she rang the handsome old bell and waited, hoping that Luciano might greet her himself, but as soon as she heard the inside door close softly, she knew it would not be Luciano. The light footsteps across the stone pavement of the loggia were unmistakably Antonia's.

"Doña Maria!" the younger woman exclaimed. "Oh, it is so good that you are here. Please to come inside at once."

In the cool, shadowy parlor, Maria went naturally to her favorite chair. "Can you forgive me that it's been so long since my last visit, Antonia?"

"Oh, *sí!* You are prominent and growing more so in the city— and too busy to visit me. I do not expect it, but I welcome you. I will get tea."

"No. I can't stay long enough for that. I still have marketing to do for our noon meal. Is Don Luciano not here?"

"Luciano and Don Jesse sailed yesterday for Havana."

Maria made no effort to hide her shock. "I hope there's nothing wrong—I mean, with your family in Havana."

Antonia perched on the edge of a chair opposite, her whole body tense. "Doña Maria, I worry about so much these days! Could you not stay for a few minutes to talk?"

"Only a few minutes. What do you worry about in particular?"

"I am bewildered by so much. My poor father is bewildered, too. Luciano tries to be the same—but there is too much on his mind which he will not say to us. To either of us. I do not expect him to confide in me, his sister, but it is difficult for my father." She spread her hands in a helpless gesture. "I cannot say why he is gone to Havana—I do not know. I know only that after a visit to the house of Don Manuel Solána,

he sent a servant to fetch Don Jesse Fish and—at a time no ship was expected—a ship arrived and took them both away to Havana."

"Did he say nothing to your father to explain their quick departure?"

"Only some business. He also warned me to stay off the streets and—to send for you and Captain Peavett if there was trouble."

"What kind of trouble?"

"I do not know."

"Did he give you any idea of how long they'll be away?"

"None. I know only what I have told you, Doña Maria. We can do nothing but—wait."

At the market Maria picked up eggs, fresh lima beans, and a fish and walked briskly home to Joseph. She was anxious to share with him the news of Luciano's sudden departure; it would alleviate her shock. Still relieved that Joseph had behaved so normally this morning, she thought how good it was to be hurrying home to a wise, considerate husband.

He was waiting in the downstairs parlor. Without putting down her market basket, she kissed him, then said, "I'd better get these to Long Stem if my husband's to have his noon meal." Halfway to the back of the house, she stopped. "Joseph—do you suppose Spain still has its greedy eyes on our colony?"

"What in the world are you talking about? Where have you been this morning, Mrs. Peavett?"

"Marketing, of course—and I also went by the Herrera house. Luciano and Jesse left yesterday—with no warning to anyone—for Havana."

"Even the family doesn't know why they went?"

"No. Luciano said—business. That's all."

"Well, maybe that is all. He and Fish thrive on it, you know. Look here, Maria, let's not jump to conclusions about anything. Spain seems to be mostly ignoring us these days. At the pace events move, I've decided to put it all aside for the time being. Can't you do that? We've at least got a governor here now, such as he is. There isn't a Council in a single British colony without dissension. I have

you—you have me. That's a beautiful fish. Can't we just be together and enjoy our meal and forget all the intrigue for a while?"

She smiled halfheartedly. "Yes, Joseph. Of course we can. If you'll tell me—if you'll please tell me how to stop worrying about my father."

"As much as you love him, I doubt there is a way."

"If there's a God does He care anymore about us down here than governments care?"

"I don't know, my dear, I just don't know."

26

About the time the oranges in her garden were at their best, Maria stood at a market stall picking over some winter squash. Her head ached from another night of worry about her father, but Joseph, due back soon from North River, loved squash with oranges and sausages, and she found herself doing everything possible to show her gratitude for his kindness and understanding over the past anxious months.

For days, even weeks at a time, life seemed so nearly normal in St. Augustine—cut off in the main from the rebelling colonies—that she would find herself feeling almost contented again. Then, as the year turned into 1776, the news worsened, and so did her days and nights. Yesterday, she had presided at an unusually tragic birth. Mother and child had both died. With Joseph away, she felt sad, cross, exhausted, and unnaturally nervous. She was not amused when, at the market, two hands were laid over her eyes from behind.

Ann Cameron, she thought. No one but Ann would do such a childish thing.

"I'll bet you can't guess who it is, Maria Peavett!"

Maria gently disengaged the small, work-roughened hands and turned to embrace her friend.

"Oh, Maria," Ann wailed, "it's been so long since I've seen you! How are you? And Captain Peavett? Do you still like the changes he made for you in the St. Francis Street house? Doesn't it seem forever since I stayed with you in the cottage there?"

Maria's smile faded. "Yes, Ann. It does seem—forever."

"Oh, dear, I can see I shouldn't have brought that up."

"Why not? I have a good life now. The best I could have."

"Have you? Is that really true? I heard the other day that you and Captain Peavett are almost never seen together anymore."

"*What?*"

"That you're both so busy—you with your work, him managing all your properties, and officers and soldiers streaming in and out of your tavern. Are you really all right, Maria? I've missed you dreadfully. Of course, I'm busy, too, even more so since James is finally out of the military, and you have no idea how much work there is in taking care of a husband and a busy-fingered little girl of six going on seven. Still—I have missed you. You look as beautiful as ever—but tired, Maria."

"Why not come home with me right now? I'm ashamed of how long it's been since I visited you. Joseph won't be back from our North River place until late this afternoon. I'm free—unless I get an emergency call. Say yes, Ann."

Tears welled in Ann's eyes. "Oh, thank you! A visit would be wonderful. James' cooper shop is right in our house. He's very good with Nancy. I'd love to come. You're so famous in town now, I'm—well, I guess I'm honored. Isn't that funny?"

"It most certainly is."

Long Stem, pleased that Maria had brought a guest, served them crab soup, thick slices of fresh bread which Maria had picked up at the bakery, and pumpkin pudding. When the table had been cleared

and Long Stem was busy in the washhouse out back, the two friends settled in the parlor before a crackling fire.

"Maria," Ann began at once, "tell me the truth. Are you as happy as you pretend to be? Truly?"

"I'm too glad to see you again to be annoyed by such a ridiculous question. Where did you get the idea that I'm pretending?"

"Well—you and Joseph aren't seen together the way you used to be. People are talking, that's all."

"Give it some thought, Ann. How many places could we be seen together with Government House dark almost every night? With so much dissension in town half the Council is snubbing the other half? You know as well as I that there's been almost no entertaining."

"Well, don't bridle up at me for asking! I'm your oldest friend. I can scotch rumors, you know. And—I know how you loved David. If anybody on earth knows, Maria, I do. Don't I have a right to care that you're happy now?"

"Yes, of course you have the right."

"I don't gossip about you, Maria. I just listen."

"Well, then, listen to me now. You say you remember how I loved David. Then you know David was the love of my life. I could never love another man the way I loved David. But Joseph and I are a well-matched, devoted couple—we're deeply fond of each other, we like and respect each other, and we enjoy each other. We are together every night—right upstairs in our rooms. We talk, we play chess, we play checkers, we talk . . . yes, we talk quite a lot. My husband is the most interesting conversationalist ever."

"Oh." Ann was looking somewhat crestfallen.

"Perhaps we're close because we have so many interests in common. We're especially interested in East Florida land—buying it, making it work for us. At any rate, we're busy and contented." She reached to pat Ann's knee, smiling teasingly. "I've seldom seen you so disappointed."

"That's cruel! I want you to be—happy."

"I'm not sure *what* you want, Ann. Happy as I was with David? That or nothing? Surely you know better than that. Besides"—she laughed briefly—"I'm forty-five years old."

Ann giggled, and shuddered a little. "I know—I'm forty-three." Then she frowned. "You don't laugh much anymore, though."

Maria could feel her exhaustion catching up with her. "You said yourself I looked tired. I am." She had no intention of saying anything about her worries over Papa. "And I lost a mother and child—both—yesterday. That would take the laughter—and the heart—out of anybody . . . but don't worry, Ann. I have not given up laughing. Joseph and I can even joke over politics—as interested as we are in the issues."

"I'm not bright enough to talk politics with James. He's only interested in making casks and tubs now anyway, but he does vow that there's going to be a war in the other colonies." Ann took a breath. "Maria? Are you ever sorry you didn't marry Don Luciano?"

"No."

"He made you laugh a lot, though. And you have such a beautiful laugh—like music, I always thought. Do you think Don Luciano is a spy?"

"Ann!"

"I overheard two men in James' shop yesterday, and they declared he went sneaking off to Havana on some kind of shifty business. James agreed that Don Luciano might very well be in cahoots with Americans who are acting so disloyal right now. Did you hear that there were actually two battles up north?"

"Yes. One at Concord and one at Lexington in New England. But I don't want to hear another word against Don Luciano. Do you hear me, Ann?"

"I mostly just 'hear.' Honest, I really don't gossip with much of anybody but you, and you know how long it's been since we did. Do you think there's going to be a big war?"

Maria sighed. "Who knows that? There could be, I'm sure. There's never been any way for mere people to know what their governments might do."

"But it isn't the government! It's the people who have taken it into their heads that they're not free. We knew some of these same people in Charles Town—friends and acquaintances of ours who are ready to fight good British soldiers like James and David used to be!"

Ann sat up straight. "Now, why didn't I think of this before? I see it all as plain as the nose on your face, Maria! You're not unhappy with Captain Peavett—just as you say—you're worried about your father up there with all those rebels!"

Maria only nodded, hoping Ann would hop to another subject.

"Oh, I think you'd better bring him down here with us right away, don't you? Get him out of the reach of those rebels. I heard these same men yesterday say that a man named Thomas Browne—a big landowner in the Carolina back country—had to run for his life or be killed in cold blood! Have you heard about Thomas Browne? He just got in town here yesterday morning. He wears a bandana around his head, Maria, to hide the scars where three pieces of his scalp have been slashed away, and he also has maybe two or three toes missing from where they held his feet to the fire! They tarred and feathered him, too—just for being loyal to the King!"

Maria wanted her off the subject, but not wishing to be rude, she said, "I hadn't heard about Thomas Browne, but I know Mr. John Stuart had to flee for his life right from Charles Town. There isn't much you and I can do about it, though."

"I suppose not. They say this Thomas Browne is young and handsome, too, and filled with vengeance now—offering his services to Governor Tonyn to help protect us here. I think Browne's supposed to be very smart or something in a military way."

Maria didn't respond, and after only a beat, Ann raced on.

"Did you know Jesse Fish slipped off to Havana, too? And do you know people are saying that his wife drove him until he's peculiar in his mind now? Even that he's in cahoots along with Don Luciano with those awful rebels? Do you think Chief Justice Drayton and Dr. Turnbull are traitors, too?"

Maria sank back into her chair. "Ann, we're in enough trouble these days. The last thing we need is groundless gossip."

"But how can you help hearing things when so many people—rich and poor—are coming down here from even as far away as Virginia to get away from those rebels? And they've all got terribly sad stories. My goodness, Maria, there's got to be talk! You and Captain Peavett can read newspapers from Charles Town and places, but most of us can't

read. Don't we have to talk? How else can we find out anything?"

The friends sat for a while in silence, Ann squirming in her chair. Finally, with a frown so deep between her eyes that it crinkled her turned-up nose, Ann blurted: "Maria, there's something else they're saying, too. I tried—I really tried not to tell you, but I've heard three people say that your father is one of—those rebel people!"

Maria got to her feet, her face stern. "It's a lie," she said coolly. "A malicious lie. And I'll expect you to put a stop to the story at once. Is that clear?"

Joseph returned late from North River so tired that he went to bed and to sleep immediately after their evening meal. Alone at her desk in her small upstairs office, Maria sat staring at the blank sheet of paper before her. Lying to Ann to protect Papa could not end the danger to herself and Joseph if the rumors persisted. For some freak reason, Ann had missed the gossip in town that Governor Tonyn was censoring all mail that passed between Charles Town and St. Augustine—probably even family mail. In view of the Drayton brothers—one on each side of the trouble— his Excellency surely was reading family mail. Maria longed for word of her father, but one personal letter, unless he told her nothing of what was going on in Charles Town, could end what good graces she and Joseph enjoyed at Government House. Only written declarations of loyalty to the King satisfied Tonyn these days. Such a declaration would, she knew, never come from Richard Evans. Even to protect her.

She had laid out the sheet of paper with the idea of finding a way to tell Papa to be careful how he wrote for a while longer. The page lay blank, the quill beside it. Refugees were indeed coming now by land and water from Charles Town, but almost no one left St. Augustine for the north anymore. To send Papa a message by some trusted person was the only way. How? By whom?

Desperately she needed a good night's rest. Sleep seemed as far away and as impossible as finding peace about her father. How could any woman be expected to sleep anyway—with her husband snoring like a grizzly bear?

At breakfast next morning she made little effort to be cheerful. The baffled look on Joseph's face sealed her more deeply into her own troubled thoughts.

"Maria," he said at last, "this very morning I intend to do something about easing your anxiety over your father."

She gave him a cold glance. "What can you do?"

"I can stop by Government House and use what influence I have as a good colonist."

"The governor will suspect something about Papa."

"I'll take that chance. I'll say I've come to apply now for that land we've had our eye on this side of New Smyrna. With refugees flowing into our colony from the north, good, rich high land is going to be scarce, and we should own the tract. I'll hope to sound him out on the mails without his knowing how important it is." He reached across the table to touch her hand. "I've had more than I can bear, my dear, watching you suffer over the old gentleman's safety."

"Do you think you *should* take the chance? Ann Cameron said people are already calling Papa a rebel. It can ruin us, Joseph."

"That's a risk I'm willing to take. If you can write to him, warn him in some way, it will ease your mind. My opinion is that Tonyn makes a special effort through his intelligence web to intercept only letters from men known to be involved in the trouble. In an offhand way, I'll try to make it clear that your father is too old to be up to any real mischief."

"But Joseph, you hate lying!"

"Most people do." He got up from the table, folded his napkin carefully and went to her. "He's my father, too, Maria. We're in everything that happens, good or bad, together. Don't forget that."

The first few minutes of Joseph's interview with Governor Tonyn were almost more than he could believe. Tonyn received him well enough, but before the pleasantries were ended the door burst open, and in came Tonyn's short, thick Scottish wife, a dust cloth and palmetto broom under her fat arm.

She grunted and sighed, dragging heavy furniture here and there across the bare wooden floor, and swept furiously with the stiff

broom—all without one word of apology. She did nod a curt greeting before she began, but until her husband objected in an offhand, irritable voice, she said nothing.

"It's complaints, is it?" She asked without turning from her work. "I dinna ken when ya think the room's going to dust and sweep itself, Patrick. You sendin' the niggers off to your precious plantation. Go on about your business. You won't bother me."

A little embarrassed, but not much, Joseph thought, the governor obeyed his wife and their talk went on. The New Smyrna grant was agreed to at once—too quickly, because what Joseph had to say next was certainly not to be said in the midst of the woman's raised dust and din. At last the governor grew annoyed and, when Peavett continued to stall the conversation, the big, expressionless Irishman rose to his feet and bellowed for his wife to get out and to get out now.

She peered at him over her shoulder as she swept up a large pile of clutter—dead wasps, sand, and ashes—shrugged, collected her implements, and left.

"You're surprised, I suppose, to find my wife at such work," Tonyn said absently. "Funds are short. Servants are not worth their pay. Slaves are animals."

Better to ignore it, Joseph thought, and went right to the purpose of his visit. "If you can spare a few more minutes, Excellency, I have a special request. My wife has not heard from her aging father in Charles Town for months. Mind you, we're both aware that you must stay on guard about all communications. You're doing a highly commendable work to protect us as you have. But Mrs. Peavett is extremely worried about her father—an old man, aged seventy. Surely, he can't be suspect."

Joseph had never lied easily. He concentrated now on keeping his gaze firmly on the governor's almost blank eyes.

"I've heard no rumors that your wife is disloyal," Tonyn said. "I see no reason why she's not heard—unless, of course, her father is ill or dead." Then, without warning or apparent reason, the governor's voice, normally flat and toneless, began to rise. Spots of color stained his angular cheeks. The small eyes snapped. "As royal governor of this province, I have every right to protect it from the traitorous

rebels to the north! It is for me to decide which letters are to be intercepted. But I'm not inhuman, Peavett!"

"Oh, we count on that, Excellency. Both my wife and I know something of the extent of the demands upon you these days." He stood. "I have no further intention of detaining you now, but if you could give me the name of a trusted person who might hand carry a letter from Mrs. Peavett—"

Tonyn slapped his desk. "You know *nothing* of what I face, sir! Sit down." It was a command. "Sit down and listen to what I have to say. There are few—almost none—who have any idea of the life I lead. I *am* a human being, Peavett. And my very blood flows with loyalty to the King."

"None of us doubts that, sir."

"Your implication that I'd withhold personal mail proves that the rumors I've heard about your visits to the traitor Turnbull are true!"

"Now, just a minute, Excellency, we're social acquaintances of the Turnbulls, that's all. When he's in the city, he's my neighbor across the street."

"Forget the madman, Turnbull! Do you realize, Peavett, that single-handed I could have prevented the shameful conduct of those wild men in Charles Town who had the temerity to store that good British tea in warehouses back in 1773? Had that tea been shipped here to my province, it would have been accepted without question! Charles Town would have accepted it then—from me. East Floridians have *never* complained about His Majesty's tax. The tea could have been shipped from us to the South Carolina colony without incident! The now boiling southern revolution could have been prevented by me—had I been consulted first!"

Joseph stared at him. "I—I'm afraid I don't follow you."

"Then hear me! With the exception of Drayton and Turnbull and their plaster-image cronies, East Florida is loyal! Our people grumble a bit, but not about paying their just tax. Had our province been used as the intermediary, there would be no southern conflict now!" Tonyn leaned back in his chair as though a deed had been done. "That, sir, is just one of the burdens I bear. With veritable ease, I could have prevented much of what is happening."

Joseph blinked and rubbed his large nose, stalling again—this time in order to think of a response to this improbable tirade. Improbable and, considering his purpose this morning, irrelevant. There was a grain of truth in what Tonyn had said, he supposed, but all based on hindsight. The governor was under far more strain than he'd suspected. "Well, that's certainly a provocative idea, Excellency," Joseph said carefully. "In years to come, historians might well have called such an original move—uh—strategic."

"Oh, I wrote of the error in judgment to Lord Dartmouth, president of the Board of Trade. My thinking *will* be recorded in the history of our chaotic time." He sat up. "Now, because I was not permitted to help, the fires of war burn at our very borders."

"Is there a new threat, sir?"

"Every day dawns a new threat! Detachments are ordered to Virginia, to South Carolina, to Georgia—and the source of these detachments? St. Augustine! To our detriment. Bringing still another burden down upon my shoulders. By some means, from behind the palmettos and pine trees and scrub oaks and sand dunes, I must, by magic, recruit local replacements. How am I to train them even if I succeed, without arms and munitions and officers?" He leaned forward. "Let me tell you of another brilliant maneuver. This one accomplished. Unorthodox, to be sure, but one I wish you'd speak about in the city when the occasion arises. So determined am I to protect the colony under my care, that I met with the Creek headmen in secret, lavished gifts upon them, and asked them to fight with us against the Georgia rebels!"

Joseph, longing to end the rambling interview, still felt he must be courteous. "And will they?"

"Without much enthusiasm, but they did agree." He struck the desk again. "And then, the vile Georgians played right into my hands. My Indians were strengthened at once in their resolve to help us because those bloody Georgian dogs attacked them on their way back to their villages that very day and took every last ounce of gunpowder and every ball I'd given them!" Tonyn leaned back in triumph. "Now, the Creeks are convinced to a man that I was right about Georgian treachery. There will be fewer scalps left in the

future on traitorous cracker heads. There will be Indian burnings of their farms and their plantations and their timber. You see, Captain, I have a score to settle—a galling one. From now on, I intend to spare nothing to avoid a repetition of the kind of shame heaped upon me when that gunpowder was stolen by rebels from our ship, the *Betsy,* right under the barrels of our guns at Fort St. Mark!"

"I see."

"What do you see, Peavett? That you have a governor who means no ill whatever to any East Florida colonist who shows by his actions that loyal blood flows in his veins?"

"Why, yes, sir. Yes, indeed."

"Good. You're an influential man in town, Captain. To thank me for my vigilance in your behalf, you need only to spread the word of my endeavors in behalf of the colony." He folded his hands and looked directly at Joseph. "Now then, I still need more recruits. My eye is on the settlers at New Smyrna. I should hope you'd keep that in mind when you begin to cultivate your new land there. Fair enough?"

"I don't quite know what I could do, Governor, to influence the Minorcans and Greeks in Turnbull's colony, but I will certainly not hesitate to praise your dedication when the occasion arises. I'm sure Dr. Turnbull needs all his settlers, though."

Tonyn almost smiled "*If* the colony at New Smyrna is still in existence when you next go down."

Joseph dared not show his surprise and horror at what appeared to be an outright threat to destroy Turnbull's settlement.

"I should be gratified to count on you, Captain." Tonyn went on. "It seems at times that my only influential friends in the province are Moultrie, Dr. Catherwood, Yeats, and the rector, John Forbes. The latter, by the way, is a blessing to us. A man of enormous spirituality and fairness of mind."

Joseph must let that pass, too, since he and Maria felt Forbes to be more ambitious and self-serving than spiritual. He had come here for Maria's peace of mind. He would try once more to settle the matter of the letters and then get out as soon as possible.

"Sir," he began, "the contractor, Mr. Watson, is making a short trip to Charles Town on business. Do I have your permission to

ask Watson to hand-deliver a letter from my wife to her father?"

Tonyn looked at him for an awkward moment, the look perplexing to Joseph. At last, the governor said in an almost pitiable voice, "I'd be grateful for even half a dozen more colonists as considerate as you, Peavett. Perhaps you do understand something of my problems. After all, you showed me the courtesy of asking my consent. By all means, give the letter to Watson. I'm sure he'll be glad to deliver it."

"I'm grateful to you, Joseph," Maria said when he'd told her the strange and mystifying details of his interview. "But I don't want us getting involved with any—not *any*—of these government intrigues. Please don't misunderstand what I'm saying. I know you approached his Excellency just for me—to give me some peace of mind. I love you for it, too. It's just that we've kept clear so far. The letter will be ready for Mr. Watson tonight." Her frown wrinkle deepened. "I wonder if you should actually accept that grant at New Smyrna."

"I don't see how accepting another grant for which I qualify will embroil us in a government intrigue."

"Perhaps not. But what on earth did Tonyn mean when he implied that New Smyrna might vanish?"

"He hates Turnbull. Honestly thinks he's a traitor."

"But we couldn't even visit our grant down there without contact with the doctor. I'm nervous, Joseph. The governor is in a position to wipe out any man in the colony if he chooses. I'm nervous. And that's so unusual for me, I don't know how to handle it."

"Then I'll tell you. Right after we eat, go upstairs and rest."

"What will you do? I thought we were going marketing together. We haven't a thing in the house for tonight."

He laughed. "After that wild interview with his Excellency, I need a brisk walk. I'll go alone."

"Joseph, will you promise me not to see any more of either Drayton or Turnbull—or the governor when you can avoid it?"

"Dear, you *are* terribly apprehensive, aren't you?"

"Tonyn doesn't in any way suspect Papa, does he?"

"My dear, my dear. Trust me. I told him only that your father is very old and very close to you. Too old to be suspect."

She made herself smile. "All right. I believe you." In his arms, she laid her head against his chest. "Dear, dear Joseph—you are a good man."

27

When Watson returned from Charles Town a few weeks later, he brought a short note from Maria's father which struck fresh terror in her heart:

20 January, 1776
Charles Town

My Beloved Daughter,

The long silence has been as difficult for me as for you, but these are dangerous times. I am well and still able to work part of each day at my trade. Beyond that, I feel strongly, due to your precarious position there, that I should not write more now or in the future. I assure you both of my continuing devotion and pray that you can accept the new truth that we may never see one another again. May God in His mercy protect us all. I trust you will find the seal upon this letter unbroken, and so can breathe more easily.

Your devoted father,
Richard Evans

With each rereading, Maria grew more terrified, her mind struggling to take in the fact of an all-out war among Englishmen so fierce that, especially in view of her father's advanced age, she might never see him again. She and David and the others had gone willingly into the war that raged between England and Spain, but civil war in which Englishmen killed and tortured Englishmen was more than she could accept. Surely both sides had built their disagreement all out of proportion. By some means, there would have to be a reconciliation. By some means, Maria Evans would keep her head and not give in to panic. If only she could talk face to face with Papa. He was old now and surely not as sharp in mind as he'd always been. But her father was only one of thousands of rebelling colonists, and the horrible truth was that most of the northern agitators were not old—they were young or middle-aged men in their prime. Men like Henry Laurens, Christopher Gadsden, Thomas Heyward, and William Henry Drayton were also fanning the fires of rebellion. None of it made sense, and if Papa had not become embroiled in it, she supposed her anxieties would have been far less.

After all, the influx of refugees from Charles Town and Savannah was exactly what the East Florida colony needed. Because of it, her own profession was steadily growing. Right and left Joseph was buying and selling small properties to the refugees, and along with all their other holdings the Peavetts now owned the two thousand fertile acres that adjoined the New Smyrna colony. Joseph had barely managed to find enough Negroes to qualify for the grant because of Tonyn's push to recruit laborers of all kinds—black, Indian, and white—slave and free. Turnbull, of course, was making every effort to block Tonyn's recruiting efforts among his laborers at New Smyrna, but nothing could shake Maria's conviction that no matter how New Smyrna's vast indigo exports benefited East Florida, Governor Tonyn, if it meant he could ruin Turnbull, would not let up. Reason had vanished from the local scene, so that she was forced to keep reminding herself that the dissension was just that—local—and would have little or no effect on the building of the Peavett fortune.

In the privacy of their rooms at night, Maria and Joseph admitted to each other that their sympathies ran toward Drayton and Turnbull, the two gentlemen now suspected by the governor of treason—of direct connections with the rebel cause. At Maria's insistence, the Peavetts kept their sympathies secret, even from Drayton and Turnbull. As of now, she had managed to persuade Joseph to stay out of it. In order to appear entirely neutral, she would, by sheer willpower, manage to keep most of her heartbreak over Papa to herself.

A handful of officers had stayed so late one night eating and drinking and complaining about the two hundred raw German recruits due in town soon that the next morning Maria and Joseph rested beyond their usual rising time.

"You know, Maria," he said, stretching his long arms above his head, "sometimes I think we should close out our tavern. We don't need the extra money anymore. What do you think?"

She yawned before answering. "That's your decision, but frankly I'd be relieved. I thought they'd never leave last night."

The officers who frequented Peavett's tavern were changing so rapidly now as new regiments came and then were shipped off at a few days' notice to augment British forces to the north, they formed few attachments anyway. The loud talk and laughter continued to annoy her, and she could have wholeheartedly shared in the decision on the tavern, but she had deliberately deferred to Joseph in this relatively unimportant matter. She was counting on her strategy to help keep him thinking that their neutrality was as much his decision as hers—if not more so.

In a moment, he slipped his thick, muscular arm under her head and pulled her to him. "Perhaps I'd just like more time alone in our house with you, Maria."

"That would be nice, dear," she said, lying quietly in bed. "But is the tavern all that's brought on this thoughtful mood first thing in the morning?"

He hugged her. "No. The tavern gets on my nerves at times—I may close it down—but there is something else on my mind."

She waited.

"I ran into Chief Justice Drayton yesterday. Only—he was no longer Chief Justice. The poor man has been suspended from the Council—dismissed outright from his post."

Maria sat up. "And you waited all this time to tell me? Why?"

"I honestly don't know. There's no use trying to make up a reason. I just didn't tell you, that's all."

So much for her strategy, she thought ruefully—there was nothing more important than to keep Joseph out of any secret involvement with the Drayton-Turnbull affair. Her impulse now was to question him closely. She restrained it.

"Aren't you going to fuss at me?"

"No." She kept her voice quiet. "Our strongest bond has always been respect for each other as human beings. I am spoiled, of course, by your confidence in me about everything."

She liked the feel of his hand smoothing her hair.

"And I don't intend to stop spoiling you ever, my dear," he said.

"Joseph, what were the charges against Drayton this time?"

"The man was too upset to tell me in detail. He did say they were trumped-up charges, which I certainly believe. The charge that turned the trick with the Council was simply a fresh accusation by his Excellency that Drayton was in direct communication with his rebel brother in Charles Town." Joseph sighed. "Oh, Maria, a man has to pick his way through every day if he's to be safe in this town now. It's like tramping the woods in snake season."

After a moment, she said, "Joseph—I do trust you to keep us unentangled."

When he remained silent, she sat up in the bed and looked directly at him. "You haven't told me everything, have you?"

"There's a secret meeting next week at Wood's Tavern. A meeting of those of us who feel with Drayton and Turnbull that it's long past time the East Florida colony had an elected Assembly."

Again, she managed to keep her voice even. "You're going?"

"Yes. I'm going."

"I—see."

"The noose is tightening on both men. In our position in town, I see no plausible way I can refuse to go without appearing to be

entirely on the governor's side of the trouble. You might as well know that even if I could avoid going, I'd be at the meeting anyway. Drayton and Turnbull are hotheaded, arrogant men, but on the issue of an Assembly, they're right. I expect my just dues as a British subject, too. *Our* just dues. We're entitled to an elected Assembly."

A chill ran over Maria. "All right—but dearest, I want your promise to do and say as little as possible at the meeting. You and I could be ruined by all of this. If you love me—you'll be more than careful."

At the appointed time on the morning of February 27, Joseph reached Wood's Tavern at the north end of the city, just as Robert Bisset, James Penman, and Spencer Man arrived. They merely nodded to one another and entered the low-ceilinged, white-plastered tavern in near silence. Abraham Marshall, James Moncrief, and Francis Philip Fatio were already seated at the heavy, well-scrubbed wooden table to the right as Joseph took his place with the others at a slightly larger table. Men continued to file into the small room until, seated and standing about the walls, some seventy-five were present. Dr. Andrew Turnbull, who would chair the meeting, sat in the center of the room, busily poring over a sheaf of papers on his lap. He did not look up until the shuffling of boots and low-voiced greetings had subsided.

"Gentlemen," he said, his usually sonorous voice kept low, fingers settling the wave in his hair, "it is no secret to any of you that such a meeting as this in a city as small as ours during these days of bad blood and suspicion would be labeled by many as outright subversion."

"Hear, hear," the men muttered, also in low voices.

"To allay such possible accusation, we will first of all draft a loyalty address to the King in which we declare that we will studiously avoid every connection with or support of the persons engaged in rebellion against His Majesty."

Joseph felt the tension mount and eyes turn to ex-Chief Justice Drayton, in contact, they all suspected, with his brother in Charles Town. Joseph kept quiet. If he signed, it would mean that Maria could not write to her father—even in an emergency—until the

trouble was over. Nevertheless, if he acted on his true convictions, he would have to sign.

"We must draft such a statement notwithstanding those very great distresses which many of us now feel both from want of contact with loved ones," Turnbull went on, "and from want of those needed supplies from the colonies to the north. I also recommend that we add that, to the utmost of our weak abilities, we will always be ready and willing to manifest our loyalty to His Majesty's government here and to Parliament." The doctor peered over his glasses at the men. "Do I hear voices of agreement?"

"Aye, aye," resounded in the small room. Joseph remained silent.

Then Francis Philip Fatio got to his feet, his thin, patrician features solemn. "I sense agreement with your recommendation, Dr. Turnbull, but if I might add a further suggestion, I should be honored."

"With your high standing among us, Mr. Fatio," James Penman said, "I feel I can speak for the meeting—we would welcome your suggestion."

Turnbull nodded assent.

"It seems to me," Fatio said, "that we should take it upon ourselves to add, in conclusion, our deepest and most heartfelt wish for a speedy and happy reunion of all British colonies with the mother country."

"Aye" and "Hear" could be heard from everyone present and as Fatio took his seat again, a round of applause broke out which, for secrecy's sake, Turnbull had to silence.

The agreement, with the addition of Fatio's sentence, was quickly passed around the room. With a flourish, Turnbull signed, even for his New Smyrna colonists. Only Joseph hesitated.

Turnbull's voice was tense, impatient. "Peavett? We're waiting."

His face drained of color, his mind on Maria's grief over her father, Joseph slowly wrote his name.

When this was done, Wood and his servant set mugs of ale before the men, and they took up the important topic—the true reason for the meeting—their strong objections to the dismissal of William Drayton from the Council. Robert Bisset was asked to read a document in answer to Governor Tonyn's charges against the ex-Chief Justice, and after a heated discussion, it was unanimously

decided that the suspension was unjustified. The next step was to draw up an address to Drayton assuring him of their warm feelings and confidence. There was no doubt in Joseph's mind that the Chief Justice had been unfairly treated. Neither he nor Maria felt that William Drayton had conducted himself in a more independent manner than many other loyal colonists of influence. Still, Peavett's name on the loyalty oath attached to high praise for Drayton made him uneasy. He had acted according to his convictions, but he would remain uneasy until he knew how upset Maria was going to be.

The only controversy in the meeting came during the discussion as to how the commendation for Drayton would be delivered to the King. The normal path would be through the governor. A few men grew angry and left when the majority voted that only a copy would be given to Tonyn, while the original would be taken directly to London by Turnbull himself.

"I'll agree to that," Joseph said, "but how will you get the governor's permission to leave the colony, Doctor?"

Turnbull's dark eyes narrowed. In reply, he only smiled.

The meeting was adjourned.

At their noon meal, Maria, after listening to Joseph's report of the secret session, ate in silence.

"Aren't you going to say something, my dear? Could I have done otherwise than sign both the loyalty oath and the statement of our confidence in Drayton?"

She did not look up but said, "You did what you had to do."

"Then what's wrong, Maria? I was vastly relieved that I was not among the six men chosen to present the copy to his Excellency. I thought you'd be pleased by that."

"I am. You were fortunate." She glanced at him, and the anxiety in his good, open face forced her to add: "I am pleased. And since you were actually there, you did what you had to do. What you didn't have to do, Joseph, was attend the meeting in the first place!"

He laid down his fork and sat staring at his half-finished food. "The last thing on earth I ever want is to displease you, but I—did have to go."

"I know!" Her voice was unintentionally sharp. She felt no anger toward her husband. Only fear of the consequences of taking sides on such a dangerous issue. "You simply don't seem to understand that our future in the colony—our standing with that volatile man at Government House—is more important to me than anything else on earth! I'm cut off from my father now—maybe forever. All I have that matters—except you, Joseph, of course—is what you and I *own*. And what more we may acquire."

Joseph looked at her fondly. "You surely have me," he said, smiling, "and I have the cleverest wife in the colony."

"That's as may be," she said, her face scarcely softening. "You have a busy one, anyway. I've a baby due sometime today. Dorothy Moore's second."

They got up from the table and stood looking at each other for a moment; then Joseph embraced her. "I'll be there waiting to bring you home, dearest Maria, if you'll tell me about when you think you'll be ready."

"I could be finished by nine tonight, if Dorothy has another easy time of it. I'll send one of the Moore servants when I have a better idea." Wanting peace between them before she left, she took his face in both her hands and kissed his ample nose. "But, please, no checkers when I do get home. I'll be too tired for games."

On a blustery, cloud-driven day late in March, Andrew Turnbull exploded his devastating plan to Joseph in short, choppy sentences. Both stood on the corner of St. Francis and the Bay, holding their tricorns on their heads, Turnbull's voice raised, Joseph straining to hear over the wind. He said little because what Turnbull told him left him almost speechless. The doctor's first stunning declaration had been that he and Drayton had decided that Governor Tonyn had to be removed from office!

"Poor Drayton fled for his nerves to my place at New Smyrna. It was there we came to our decision. I can understand your shock, Peavett, and I ask only one small favor from you. We need to inform someone here of our intentions in case of shipwreck. Drayton and I are going to London ourselves. The mission is so secret, I have not

even told my wife. We've chosen you and you alone to keep our whereabouts quiet. Are you willing? I often stay here longer than planned. In the meantime, Mrs. Turnbull won't worry."

"Doctor, I know for a fact that the governor is watching you both like a hawk. What about your permission to leave the colony? He'll never grant it."

"That is our problem, sir. And we'll handle it. Lord Germain in London will know of my fate should anything happen on the voyage. My wife can contact him through the Board of Trade." He held up his hand. "No more questions, Peavett. Both Drayton and I trust you entirely." He smiled slightly. "Not necessarily your loyalty to us, your judgment in all matters."

With that, Dr. Andrew Turnbull strode away toward the wharf where a ship for London lay at anchor.

Joseph stood, still clutching his hat, and tried to think. It had seemed a small favor—merely that he inform the man's wife where he could be found in case of shipwreck. Permission to leave the colony on that ship, he knew, had been granted to a nephew of Turnbull's, but how in the world did both Drayton and Turnbull expect to sail, too?

He walked slowly toward home. Inside, out of the wind, he'd decide how much to tell Maria. In the four years of their married life, he'd never thought of keeping anything from her for long. But lately, she'd appeared almost cross at his slightest involvement in any of the city's problems, almost cool when he showed interest in the growing trouble between his friends, Drayton and Turnbull, and the governor. He would have to think long and carefully before telling her that he knew anything—anything at all—about Turnbull's latest scheme to be rid of Tonyn. Maria, out of the goodness of her heart, was delivering the infant of a poor refugee widow from the South Carolina colony. There would be time to think alone before she returned.

He let himself in the house and climbed the steep stairs to the second-floor living quarters, his tread heavy and slow. He felt strangely tired for midmorning and far older than his fifty-seven years.

"Maria," he said softly into the empty rooms. "Maria, I love you more—far more than my own life."

In the big upstairs parlor, he sank into a chair, tossing his tricorn on the table beside him. His head felt dizzy, and he was surprisingly short of breath for such a small amount of activity. She would be busy for at least two more hours. No one needed him or expected him. Time to rest awhile, to let his head clear, and then he'd decide how much to tell her of what Turnbull planned.

He listened to the clock tick away one minute, then two, three, four . . . five . . . his head did not clear. He gripped the arms of the chair to steady himself in the room, which had begun to rock crazily. The clock ticked faster, the minutes sliding away from him, washing before them the whole foolish storm in his mind—Turnbull, Drayton, the governor, his need to decide what to tell Maria. A sharp, stiff feather pricked his brain and his world began to burn up in a flash of pain as swift as lightning and as hot.

He grasped his head in both hands and cried out, then slid easily, slowly, without discomfort, from the chair to the floor, meaning to call for Maria, but only able to think her name.

28

Day after day through the strange, chaotic months of the summer and early fall of 1776, Maria struggled to find even a few minutes alone—away from nursing Joseph—to quiet herself. Every time he had been bathed, shaved, or fed since what stern, professional Dr. Catherwood called his "slight apoplectic stroke," Maria had done it, refusing all offers of help. Her real world had seemed to fall to one side, leaving only chamber pots and lather and soapy

cloths and the ache in her arms and back from hours of massaging Joseph's cramping legs. Though the stroke had affected only one leg, inactivity caused cramps in both. After three or four firm confrontations with Catherwood, the doctor had at last agreed to take away his hideous leeches and stop bleeding Joseph.

By late fall, she actually felt that under her care she and her husband were making progress together. As many times a day as he agreed to go through with the ordeal, she would exercise his partially paralyzed right arm, bending it slowly but firmly, back and forth at the elbow, kneading the almost helpless muscles. The arm and then the limp right leg. The initial paralysis in arm and leg was lessening. With enormous effort he could move them both. Tears ran down his cheeks and wet the pillow as she worked over him. He was deeply grateful and tried with all his strength to help. Except for the use of a wrong word here and there, Maria felt certain that his speech and fine mind had not been permanently affected.

As housekeeper, Long Stem had become more indispensable than ever, and she was now allowed to take over Joseph's tedious exercises whenever Maria was called to deliver a baby.

"Captain Peavett so good a man, we get him well again," the soft-spoken Indian woman said over and over, the rare smile lighting her features. "Your hands upon his withered arm work magic. His love for you is deep and steady as a river."

As the year progressed, more and more refugees poured into St. Augustine and with them two midwives, who somewhat lightened her work load, although the wealthy in town still demanded Maria Peavett.

By November Joseph could, with her help, walk across their bedroom, dragging his right foot with each step. She clapped her hands in praise, but sometimes tears would be running down his face by the time she managed to get him safely back to bed.

"I—did it," he said, smiling the now crooked smile, the corner of his mouth still drooping from the paralysis. "I did it, but, oh, Maria, do you think I'll—ever be able to walk down the street again?"

"Of course you will! I've never heard such foolish talk."

"I'd give anything I own to be able to—dance you home again." He had meant to say "walk." "I worry every time you have a case. All the strangers in town. No one should ever take—walking down a street for granted."

The year had been hard for them both, but harder for Maria in a way she could never let him know. In the agony of the perpetual need to motivate him, to keep him believing that he would recover—in the deadening routine in which she passed her hours and days and nights—she was losing touch with herself. Sheer strength of will drove her through the leaden days. There was no time to read, no time to visit friends, no time to be alone in the deep places of her being where her strength once lay. As sure as she dared pick up a book, thinking Joseph was asleep, he would call—with a strange, almost keening tone to his voice— "Ma-reee-ah!" At times it chilled her blood. But he *had* walked across their room and back, and although his right arm groping to embrace her felt awkward and flabby, at least it was no longer immobile. By mutual agreement, she stayed on his left. That way he could hold her as strongly as needed for support and give her an occasional hug into the bargain.

Her personal goals, once the moving force in her own life, now seemed wasted. Every ounce of energy was thrown into achieving one thing—getting Joseph downstairs for dinner by Christmas Day. Their first floor was still a public place. He had put off closing the tavern before the stroke, and Maria had left it open; now more than ever, Joseph, a lifelong army man in his interests, needed news from the outside. The officers, especially brash young Colonel Thomas Browne, kept the military news coming. Browne, the former Carolina landowner who had fled after being tortured, tarred and feathered, and who now commanded Tonyn's East Florida Rangers, made frequent visits to the tavern and to Joseph's room upstairs.

The so-called patriots were in control of both South Carolina and Georgia, and indeed, last summer the rebelling colonies had

issued what they ridiculously labeled a Declaration of Independence from the mother country. Rebel leaders Sam Adams and John Hancock had been burned in effigy on the Square in St. Augustine.

There was real fear in St. Augustine now, especially while rebel Colonel Lachlan McIntosh's militia occupied the land between the St. Marys and the St. Johns rivers, inflicting all manner of bestiality upon East Florida colonists and their properties.

True, in the early fall, St. Augustine Regulars, reinforced now by Browne's Rangers and several hundred of Tonyn's Indians, had repulsed one attack on the northern border of East Florida by McIntosh's militia. But with the rampaging rebels in control of both Savannah and Charles Town, no St. Augustine resident in his right mind felt safe.

About a month ago, Browne had started bringing newly arrived Colonel Augustine Prévost, now the ranking British officer in the south, to visit Joseph. Maria was grateful to Browne, even though the man disturbed her. After all, the focus of his very life seemed turned toward the destruction of Papa's patriots by whatever means. Understandable, she supposed, if the stories were true that they had burned his feet and partially scalped him, but in spite of Joseph's thirst for news, she found herself wishing that the news could come from some source other than Browne. Prévost's visits upset her, too—not only because he and Browne argued so fiercely about control of the St. Augustine forces, but because plainly both men upset Joseph. She still saw few signs of damage to her husband's mind from the stroke, but his emotions were strained to the breaking point by his feeling of uselessness, and she longed for a visit from Jesse or Luciano—both of whom Joseph trusted. Both were still away.

To Maria, the one redeeming aspect of Joseph's illness was his forced removal from the troubled affairs of the city. Both Drayton and Turnbull were still in London, and of course Tonyn had gone on seething with anger at their departure without his permission. The two conspiring friends had simply gone on board to bid

Turnbull's nephew good-bye and sailed right off with him! Others who had attended the secret meeting at Wood's Tavern were now being openly called the "traitorous creatures of Drayton and Turnbull" by the governor and his faction. At least, Joseph was escaping that.

If God were still in His heaven, He knew that Maria Evans did not have American sympathies. Nor did Joseph. But in her most truthful moments—the brief moments grabbed at every opportunity to be alone in her garden—she had to admit that her British sympathies were none too strong either; she returned again and again to her long-held belief that the flesh-and-blood men who actually governed did not really care a whit for the people whose lives they uprooted—whose servants they were sworn to be. She had never forgotten the suffering on the faces of the Spanish people all those years ago. Their government had literally torn apart their lives and dreams. They had all believed St. Augustine to be their permanent home. Certainly the new United States government, with its cocky Declaration of Independence and its violence, cared only for itself.

Joseph seemed a little better, enough so that her days went along without crises, growing only more monotonous. In her own thoughts, she found less and less hope for a return to normal life. Dr. Catherwood had said that a stroke victim could reach a kind of plateau and exist on it—not live, Maria thought—for years on end. She felt increasingly alone; there was no one to turn to in these bitter times but herself.

With Long Stem's help, she did manage to get Joseph downstairs for Christmas dinner, but the effort of getting him back up the steep, narrow steps was too much. To herself, she vowed not to try it again. She found Joseph weeping several times in the next few days, and when she asked why, he would not or could not give her a reason, but she guessed that he had sensed her decision.

The holiday season passed, and the new year, 1777, brought word that William Drayton was back in town from London. In fact,

he had been back since Christmas without the Peavetts' knowledge. They were shut away almost as though in prison. But at least, news of Drayton's return had given them something to discuss, and when Maria learned that, on orders from Whitehall, Drayton had been reinstated as Chief Justice, they had a laugh together picturing the governor's fury. Turnbull was still in London, bending every effort, they were sure, to have Governor Patrick Tonyn removed from office. Even with Turnbull still away, the cleavage in the city remained sharp, because Chief Justice Drayton had simply resumed his duties without so much as a courtesy call on Governor Tonyn.

With eight-year-old Nancy now at school, Ann Cameron had come alone at least twice a week through all the months since Joseph's stroke, and although her intentions were the best, the visits were beginning to be a harassment to Maria. Always fond of pert, talkative little Ann, Joseph had, in his illness, taken a strange turn against her.

"I don't care about the news she brings," he all but shouted at Maria one cold, dark February day. "I don't care, I don't care, I don't care!"

"But Joseph, can't you tell me why?"

"The woman's tongue never stops wagging, and when I don't answer as quickly as she thinks I should, she wags the harder. Sometimes I can't get my answer into words. Keep her away from me, Maria. Keep her away!"

Except for the new quirk about Ann, her husband seemed no worse. Maria determined when Ann next came to make one gentle try at discouraging her. If she were a praying woman, she surely would have called on divine help when, three days later, she heard Ann chattering away at Long Stem from downstairs.

"You promised me," Joseph said anxiously. "Maria, you promised me you'd get rid of her—she's here again!" He caught hold of her hand. "Don't let her come up here, please!"

"All right, all right, Joseph. I'll go right down and send her away."

She had just reached the door when he called to her softly. "Maria—I'm sorry." His eyes hoped for her forbearance.

She went back and kissed him. "It's all right, dear, truly. Just don't worry."

By the time she reached the foot of the stairs, someone else was at the door. Not ringing the gate bell—knocking, loudly and urgently on the street door.

"Good morning, Maria," Ann piped cheerfully. "Now, I wonder who that could be? Do you want me to go?"

"No. No, thank you. Long Stem will answer it. I want you to come out in the garden with me. I need to talk to you."

"Let me warn you, it's cold out there, but I'll go. I only come to help you, Maria, in any way I can."

"I know."

Ann, still bundled in her cloak, and Maria, in a heavy shawl, sat down in David's chairs.

"What's happened? You look so funny, Maria."

"I feel funny having to say what I must say, Ann. No one's been a better friend to me than you, but—Joseph, in his nervous state, has asked that you not come so often. At least, not to see him."

Ann blinked her wide eyes a time or two and then said, "It's—because I talk too much, isn't it?"

"Yes."

A totally childlike smile spread across Ann's face. "And here I thought I was helping by bringing him news of the town. You just never know, do you?"

"Not with a stroke patient. I've had to close the tavern. Suddenly Joseph couldn't stand the voices."

Quick tears filled Ann's eyes. "I'll miss seeing you, Maria."

"You know I'll miss you. You're—all I have left of my old friends." She reached for Ann's hand. "How can I thank you for—for not being hurt and angry with me?"

"Oh, I'm hurt, but I'd never be angry with you." She lowered her voice almost to a whisper. "But—two of your old friends are back, Maria. Don Luciano and Jesse Fish came back last week! Of course, you won't be seeing Mr. Fish, I'm sure, not with that brazen hussy of a wife. But Don Luciano will come to visit you. Especially when he knows you can't leave the house much anymore."

Maria frowned. "Last week? Luciano got back last week—and he hasn't let me know at all?"

"I'm sure he's heard about Captain Peavett. Maybe he thought he'd be in the way." She laughed weakly. "Everybody doesn't come blundering in the way I do."

"No. They certainly don't. I can go for days and see no one but Joseph and Long Stem."

"Before I go, there's one other thing that's happened. The whole town's overrun with Minorcans from New Smyrna!"

"What?"

"Well, I forgot to tell you, but it's been all over town for the past few weeks that his Excellency is out to ruin Dr. Turnbull's colony and that the settlers down there were sending messages back and forth to these awful patriot rebels asking for help, and—"

"Help from what?"

"Turnbull's people are supposed to be starving and getting terrible beatings and all that. It's been all over town that the governor wants them in our army! And it seems to me that since they've run away up here from Turnbull's colony, that's where they should be—in the British army. I guess Governor Patrick Tonyn won that battle, don't you?"

"Yes," Maria said solemnly. "It would seem so. Poor Dr. Turnbull."

"Do you really like him?"

"Not particularly anymore. I just hate to see any dream go up in smoke."

Long Stem appeared on the back loggia. "Mrs. Peavett?"

"What is it now?"

"At the door," the Indian woman pointed. "Six people—in rags. They beg for food. The woman sobs—the children cry."

"Who are they?"

"Minorcan. From New Smyrna colony. Only the woman speaks Spanish-English. She demands food."

From upstairs Joseph began the plaintive, wailing call that caused Maria to stiffen with dread. "By all means, give them food—all they need."

When Long Stem left silently, Maria turned to Ann, and over Joseph's continuing wail, she said in a strained voice, "Listen to him, Ann. Do you see why I can't have—visitors anymore?"

"Yes, It's horrible. It's just horrible, Maria, and I don't know how I can stand it for you! I want so much to help!"

"I know. And the best thing you can do now is—go. Or maybe help Long Stem with—those people. I must see to Joseph. His poor leg must be hurting again. He won't let Long Stem rub it anymore. Only me. Goodbye, dear Ann. This will end somehow—some day."

Because she refused steadfastly to treat Joseph as a helpless person, Maria told him carefully about the Minorcans, but sat on his bed as she talked so that she could watch him closely, expecting that he might burst into tears. He had begun to weep more often; it weakened him, and one of her most taxing duties was to find ways of bringing him out of it. This time, he didn't shed one tear, but lay propped on his pillows, his head shaking from side to side, out of control, as he murmured, "Poor Turnbull, poor Turnbull, poor Turnbull."

Gently, Maria took his face in her hands and stopped the compulsive movement. Then he began another of his recent habits: "Mark my word," he mumbled, "mark my word, mark my word, mark my word."

"I do, Joseph," she said quietly. "I always do. But about what this time?"

"Mark my word about Governor Tonyn. The man won't stop until he's ruined both Drayton and Turnbull. Mark my word, Maria. Oh, I know Drayton's been reinstated on the Council as Chief Justice and Turnbull's still in London, but mark my word, mark my word."

"Would you like to get up for a nice walk around the room?"

"Not now. I'm—very heavy in my heart over these men. Very worried about them." His head began to shake again. "Just—very worried about everything."

Once more, she steadied his head.

"Mark my word, Maria, nothing will ever be the same again. Take Ann Cameron. She used to come here often. Has she deserted us, too?"

Maria said nothing. She would have no trouble explaining to Ann. Better, she'd learned, to wait until he spoke again. Too often, in her determination to help him, she had only made things worse. She smoothed back his thinning hair and waited.

"I'm just very worried about Ann. I'm just very worried about my wife. Cut off from all her friends—Don Luciano, Jesse Fish, Ann Cameron, Turnbull, Drayton, their wives, Mulcaster—poor Mulcaster, his wife's dead. Poor Maria."

"Oh, but Joseph, dear, Ann Cameron was here just now, and she had some good news. Fish and Herrera are back in town!"

Tears filled his eyes now and flowed down his cheeks. "Poor Jesse Fish . . . poor Jesse Fish."

"I know, but maybe things will he different for him now that he's been away so long."

"Herrera's deserted us, too. Poor Maria. Mark my word, they don't come—any of them now—because of me."

29

Maria sent word to both Luciano and Ann that a visit would be welcome. Ann accepted the renewed welcome as she'd accepted the rejection, but she waited for Maria's nod before going up to Joseph—about half the times she came. Sometimes she helped Long Stem with a minor task or two while Maria was with Joseph.

Herrera did not come for an entire week. Then, one afternoon in early March, he appeared—as courteous as ever, but, Maria thought, peculiarly subdued. He continued to visit Joseph once or twice a month, declaring that he was simply too busy to come oftener. Each time Maria went to the gate with him, he hurried off without a sign of the old closeness. He paid duty calls on a very sick man—nothing more. Once she tried to discuss the affairs of the colony with him, but only once. With a firmness she'd never seen before, Luciano insisted that she had too much on her mind with a bedridden husband to trouble herself even with an all-out war to the north.

Daily, as the weeks dragged by through spring and summer and into fall, her nerves grew more ragged. Shut away from the life of the city—her life—she disciplined herself through the daily round of nursing Joseph, of keeping his spirits as high as possible. That she no longer believed he would get well in no way diverted her attempts to encourage him. More and more often, he had no control over his bodily functions, so that along with the repeated massages, she was now changing his linens as many as three or four times a day. The time came when she finally—and thankfully—let Ann help her upstairs now and then.

With the aid of a Minorcan boy named Pablo whom Maria had hired from among the New Smyrna colonists, Long Stem managed the household. Maria began to miss the income from the tavern. She had not had time to deliver a baby all year. Except for sporadic money from the North River land—sporadic because Joseph no longer managed it—rent from the Charlotte Street and Marine Street houses provided her only cash. Wealth did not necessarily mean income.

Late in 1777, the city—crowded with Turnbull's colonists clustered in hovels at the north end of town and by still more British refugees, plus the entire Sixtieth Regiment—was gripped by panic. Rebel forces had once more attacked the colony from the north, and this time scouts and a few soldiers had pushed as far south as the St. Johns River—some had even crossed it at

Cowford—before Browne's Rangers and Prévost's Regulars stopped them. The thought of the patriots so far south frightened everyone in town—Maria most of all. She slept almost none for nightmares in which rebel-set fires, burning across the flimsy little garrison city, engulfed the St. Francis Street house with Joseph helpless in his bed.

Sensing her underlying fear, her husband grew more agitated with the passing of each day, and Maria stopped the visits of both Colonel Browne and Prévost, now a general. Browne was plainly jealous of Prévost's promotion, and their visits upset Joseph beyond what she would allow. Joseph appeared to have better use of his partially paralyzed arm and leg, but he cried all too easily, and most of the time he sat staring into space, eating only enough to keep a bird alive. The blockade at Charles Town had caused their food supply to dwindle so that Long Stem could no longer prepare his favorite meals. No wonder he didn't eat. Even Maria found the steady diet of boiled or fried *yomine,* as Long Stem called it, fish, and what vegetables the town gardens could produce hard to swallow.

As 1777 neared its end with no further trouble to the north, she gradually allowed herself to hope that perhaps in St. Augustine, at least, the people were going to be safe from the war. A few more ships of the British navy patrolled the waters about the city, and Tonyn seemed reasonably satisfied that he now had enough troops and ordnance to protect them. Little news filtered down from Georgia or South Carolina—certainly not to Maria's ears—but battles were still raging in the northern colonies, and in London, Britain remained firm and unyielding.

When the German mercenaries had been hired to help beat back the Americans, it had only inflamed them. The patriots in the rebelling colonies—she would never learn to call them the United States—were more vicious, according to rumor, than the Indians had ever been. Men in South Carolina and Georgia whose only crime was loyalty to the King had suffered the incredible loss of sections of their scalps—a small section for each offense—

whacked away a piece at a time. Like Colonel Browne, they were tarred and feathered for no more reason than to be proud that they were British. The continent had gone mad with violence on both sides—hatred and torture and bloodshed inflicted by Englishmen upon Englishmen!

Under her anxiety for Joseph and the hardships of daily life in St. Augustine, fear for her father's safety raged like a fever, allowing no rest. There had been no word from Papa now for nearly two years. For all Maria knew, he was dead.

In rain or hot sun, on the days when Ann came to be with Joseph—or now and then, when Long Stem insisted—Maria had trudged to the recently opened Panton and Leslie store on the Bay at Treasury Street, hoping, since the trickle of mail came in there, for a letter with some news of her father. None came, but she had made a new friend—the young Scot, John Leslie, with whom she could talk without feeling his suspicion of her interest in an old man who called himself a patriot.

Don Luciano still visited Joseph, but he seemed older, more burdened with a nameless problem; at times, she thought, disturbed. But as usual, he pretended that he hadn't a care in the world beyond the failing health of his own father. He had for some time been handling the rental of her Charlotte Street house—and had, she suspected, because cash was so short, paid the rent on occasion from his own pocket. But there was a change in him—she felt ill at ease in his presence—and so she turned to John Leslie for the small moments of stimulating conversation which she so missed now that she was virtually a prisoner in her own house. Leslie's near sardonic humor, his Scottish burr, his objectivity, pleased her. Like Maria, he seemed to mistrust all governments and accepted the inevitability of frequent compromise and intrigue.

He soon knew, of course, what her interest in the mail was, and one day he said, "You're a fine lady, Mrs. Peavett, and I'd miss your visits here at the store, but tell me, now, do you really expect a letter from your father? Do you truly think he'd chance it—these days? That anyone else up there would chance it?"

Tears stung her eyes. She had spoken of Papa to no one else in many months. Joseph appeared to have forgotten that she had a father. At this moment, she could have hugged the young Scot for even this scrap of concern. She blurted out the question she'd longed to ask.

"Oh, Mr. Leslie, isn't there someone—just one person—who could be trusted with a letter from me? Someone with a heart, who could put aside his or her loyalties long enough to do that? My father and I have not written to each other for almost two years, but I—I can't carry that load any longer. I'm sure it's no secret by now at Government House that—that my father's a patriot. I'm so desperate, I think I'd trust you with the information anyway at this point. I don't want to write to him about the war—I just want to be sure he's all right!"

"I know, Mrs. Peavett. I've known about Richard Evans' views ever since I came to town. I also know—of your unusual closeness to him."

"How did you know—about my father and me?"

"Herrera."

"Oh. John—you're so young, I hope you won't mind if I call you by your first name." She smiled briefly. "In fact, I'd like it very much if you'd call me—Maria. At my age it must sound silly, but— I'd like it."

"I'm honored, Maria." After a pause, he added, "Have you considered that no news of your father might mean that—he's no longer living?"

"A thousand times! There are days when I'm quite sure he's— gone. I'd just like to know!"

Leslie nodded. "I'll find out if you promise not to ask me to tell you how I did it."

"Thank you. I do promise. You see, John, I can endure a lot of difficult things, but I'm not at all good at—waiting. At not knowing. I wonder every day about women whose soldier husbands are fighting so far from home—how they manage. I once had a soldier husband, but I was fortunate enough to have gone to war with him. I knew how he was." She gave Leslie her hand. "Please find out about my father."

"I will. Just as soon as possible. I agree there's nothing worse than waiting—not knowing. And you have more than enough here to burden you, Maria. Count on me."

It was nearly Christmas again, but this year Maria had no heart for it, although she made cheery speeches to Joseph all through the month of December about the fine, improvised Christmas feast they'd have in spite of the food shortage—at lease one chicken, or a wild goose, should Don Luciano have time to hunt; a held-over plum pudding and of course Long Stem's *yomine*. Some days Joseph could enter a little into her plans, and today he seemed to try.

"You know, Maria, I once liked hominy." He tried to laugh, but only the now-familiar gasping whine came out—repeated little shrill sounds, like an animal in pain.

"It's nourishing, at least," she said. As so often, the effort of keeping his spirits up was draining hers.

"Maria," he said, breaking off his laugh, "send for Drayton. It's been so long since a man of influence visited me. Mark my word, it's the way—I am. They dread me, but get Drayton. I need to see my old friend, Drayton."

"I think that's a marvelous idea! I'll send the boy Pablo, right away. It shouldn't take him long if he hurries. Just to the edge of town."

Within two hours, Drayton was there, and much to Maria's relief, her husband asked to be left alone with him. When the Chief Justice came downstairs at last, he was as gallant as ever with her, but his face was drawn, his eyes old.

"I'll carry the picture of your once handsome husband as he is now—to my grave, Mrs. Peavett," he said. "Seeing him has made my own heavy burdens seem light. I marvel at your endurance."

She said goodbye and hurried up to Joseph. He was sitting in his favorite chair, motionless, staring.

"Did you have a nice visit, dear?" she asked, pretending not to notice the unusually distressed look on his pale, bony face.

His head began to shake from side to side. "Sad. Sad. Drayton just signed papers for the sale of Oak Park, his beloved plantation."

On a heavy sigh, his head still moving, he said, "Oak Park. How the man loved it."

Maria held his head until it stopped shaking. "But why did he sell the plantation, Joseph?"

"He's ruined. He still came to see me, an old friend, but he's ruined. Tonyn's won. Drayton's suspended again from the Council. He's leaving before the governor's had a chance to announce it. Bully for him! I'm glad for that much, but it's—worse than death for a man, Maria. Lots of things are—worse than a man's death would be."

To encourage Joseph to keep talking, she sat down beside him and began to massage his withered arm, marveling that he could still perceive truth so clearly. "Do you suppose Dr. Turnbull will ever come back to East Florida now?"

"He's back," Joseph answered weakly. "At New Smyrna. He'll be the next. Drayton shed tears over his friend. Ruined, too. Worse than death, Maria. Mark my word, a lot of things are worse than—death."

"Where will the Chief Justice go?"

"Charles Town. Back home."

"As a Loyalist?"

"Who knows that? As himself—a beaten man. Turnbull, too, mark my word."

Most days, Joseph's peculiar habit of using that phrase, "Mark my word," irritated her. Today, she was glad when he used it because it gave him a kind of pathetic authority, and he had grown so uncertain about everything in his world.

He was mumbling now so that she had to lean close or miss his words.

"Poor Turnbull will feel so alone if he tries to return to the city— so alone without his friend Drayton."

Alarmed at how faint he looked suddenly, she asked if he'd like tea or a little brandy.

He tried to smile, but did not look at her, his blank eyes staring straight ahead at the wall.

"Which, Joseph? Tea or brandy?"

His body convulsed slightly, but he went on staring, straining now to speak—one corner of his mouth moving almost imperceptibly. Then slowly, his emaciated, big-boned body appeared to be shrinking in upon itself. He grew rigid.

Maria jumped to her feet. "Joseph!" At the head of the stairs, she shouted, "Long Stem, send for Dr. Catherwood at once!"

Christmas Day came and went; 1778 arrived, almost without her notice. Hour after hour, day after day, she sat by Joseph's bed waiting for some small change. Dr. Catherwood had bled him again profusely. This time she had no choice but to agree, because the doctor threatened never to return if his orders were not carried out. But Maria had made up her mind that if Catherwood bled Joseph once more, she would dismiss him and send for Dr. Andrew Turnbull, in seclusion at his beautiful home in the deserted New Smyrna colony, half afraid, she was sure, to set foot in the city. Every foray at the northern border had been blamed by Tonyn on the doctor's conniving with the rebel Americans. His Excellency, driven to rid himself of his last dangerous influential enemy in the colony, was spreading the word of Turnbull's imagined treason by every means short of a posted notice on the board at Payne's Corner.

Maria had heard vague rumors that the hated new United States had drawn Articles of Confederation which were being sent to the various rebelling states for ratification. France was now actively in the fighting on their side, and there was so much hot talk that Spain was entering the war, too, on behalf of the Americans that she intended to visit Don Luciano the first day she felt free to leave Joseph. Maria had always suspected that Spain had never lost interest in regaining the Floridas. Anyway, she longed for some word of Jesse Fish and even one talk with Herrera that might reassure her of his friendship. He had not been to visit since Joseph's latest stroke—no one had come but Ann. Maria understood why. Seeing her once strong-bodied, dignified husband as a shrunken, twisted, helpless invalid was too painful. For nearly two months, she had not

felt alive. She had existed, cut off from every interest outside that house. The other midwives, little by little, were taking over her profession, but she refused to leave Joseph. Even in his pitiable state, he was all she had left.

Two months had passed since Leslie promised to find out about Papa. She clung to her belief that John Leslie was the kind of man who would let her know as soon as he himself heard anything.

After Joseph's second seizure, she had, of course, lost track of all news of border skirmishes that might have taken place. Tonyn, Prévost, and Browne, she supposed, were still arguing among themselves about whether Tonyn or Prévost should have full command of the military. So long as the fighting was kept from the city gates, she had no interest anyway. Every ounce of energy was consumed by Joseph from the moment she awoke in the morning until she fell fitfully to sleep at night. Against Long Stem's pleas that she would get more rest in a bed alone, she still slept beside her husband, afraid that he might need her and she would not hear from the next room. Both his legs lay limp and inert now—the right paralyzed, the left devoid of all strength— but the pain in them, whether real or imaginary, was at times so excruciating that he cried out for help. She bathed him, cut his nails, shaved his dry, shrunken face, and carried the heavy stone bedpan when she detected his need, but she was still continuously changing the bed. Dr. Catherwood only shook his head and shrugged when she asked if there was any chance that Joseph might improve. At least, the bleeding remedy had been stopped. No matter what the doctors believed, as long as the blood was being drained from his body, Maria knew he could regain no strength.

About mid-April, on hand for her regular visit that week, Ann Cameron took matters in her own hands when she saw the great, dark circles and the deep lines of weariness etched into Maria's normally expressive face.

"I've had all of this I can stand," Ann declared. "It's usually you who tells me what to do, Maria, but today I'm telling you. I'm

ordering you to leave this house and stay away all afternoon! Even a strong woman like you can stand just so much. Nancy will be in school all afternoon; I'll be right here, and the servants know where to reach Dr. Catherwood—now scoot! Do you hear me?"

Dressed in a new, bright, full-skirted, fashionable sprigged cotton with flaring cuffs—she'd had it made before Joseph's illness and never worn it—Maria walked slowly up the Bay front, wondering where to go. She would do some marketing before returning home, but for her own sake on this her first afternoon away from the house since the second stroke, she longed for diverting conversation, and so found herself headed for the Panton and Leslie store. If John Leslie had received any news of Papa, he would have let her know long ago, but the young Scotsman was her best—perhaps her only—choice, and she did enjoy talking with him, as he appeared to enjoy her.

She straightened her shoulders, swept her skirts up out of the dust, and walked faster.

John Leslie showed no surprise when she entered his office, even though he'd heard, of course, that she'd been spending every hour at her husband's bedside, shut away from all that interested her so intensely. Undoubtedly what a woman needed on what he thought might be her first day out was someone to listen, perhaps a laugh or two—the latest gossip. He greeted her warmly but easily, and led her to a chair beside his desk in the privacy of his office behind the warehouse. Her tight, tense smile revealed everything. He wished with all his heart for better news of her father. At least he would give her a good visit before he told her.

"I hope I'm not keeping you from something important, John," she began. "You see, I'm a bit short on conversation at my house these days. One Indian, one Minorcan, and—my husband." She laughed and seemed to relax a little. "Is there anything exciting—or funny to tell me?"

"Not much. I suppose you've heard that Turnbull is leaving too, now."

"No! My husband predicted it—but I hadn't heard."

"As soon as he can sell his city house. He was here yesterday. Says he'll drop by to say good-bye to Captain Peavett."

Maria caught her breath. "Oh, I hope he doesn't! Mr. Drayton's visit—well, it's hard to explain Captain Peavett's condition." As though deciding not to try, she went on. "Of course, I don't blame Dr. Turnbull for wanting to escape our royal governor. You haven't been here as long as I have, John, but Tonyn's hatred for the man has been frightening to watch over the years. A purely personal vendetta, in my opinion."

Leslie thought she looked revived. He wondered how long it had been since she'd had an interesting exchange with another human being. She'd managed, according to Catherwood, to teach her husband how to mouth a word or two since the latest stroke, although he seemed unable to say anything but "Yes" when he meant "No" and "Where?" when he meant "Why?" One thing Leslie knew, now that he'd seen her—he was not going to tell her about her father today unless she asked point-blank.

"What of the fighting, John? Really, I'm starved for news!"

He leaned back in his chair. "Well, let me see. Generally, the fighting goes well for us, but you probably already know that young Lafayette arrived from France last year bent on saving the new, noble United States single-handed if Washington fails. And Beaumarchais, the French playwright, is also about to bankrupt himself in his efforts to give financial aid to the new nation."

"How can you, an Englishman, call it a new nation?"

He laughed. "It's not hard. Try it out. And—let me see—a further piece of news from dear old England has it that Lord North presented another plan for conciliating the quarrelsome colonies to Parliament. The man keeps trying. Want to make a wager that they'll reject it?"

Her beautiful, weary face had grown solemn. She looked away from him, and he was just as glad. The pain in her eyes was unbearable.

"I tried, John. I honestly tried just to pay you a visit—to talk. I'm not as strong as I used to be. I can't manage." Her work-worn hands

were squeezed so tightly in her lap the bones showed white. "My father—I did try not to ask. I—don't suppose you've heard anything?"

Leslie sat quite still for a moment, then went to her. "I have heard, Maria," he said softly. "I wish I hadn't—but I have. Yesterday. He's dead. Your father's been dead for over a year."

"I see." Her words came as from a distance—far beyond the office. Slowly, she gathered her skirts about her and stood up facing him. "Thank you."

"I'll walk you home. Better yet, I can get my carriage."

"No. I'll want time alone. I'm all right." She tried a smile. "I—just needed—to know. I won't have to—worry about him anymore, will I?"

"No," he said, and added, "You may be the most courageous lady I've ever known, Maria. I wish I . . ." His words trailed off.

Offering him her hand, she said, "You're a good friend, John. I knew no one else who could have helped. Please don't worry. You see, long ago—many years ago now—I learned how to live with the most hideous grief." Her chin lifted. He thought he knew what she had looked like when she was young. "I'm far better off—knowing, at last. Waiting is worse—not to know is worse."

Without another word, she turned and walked out of his office, her head high, her wide shoulders straight.

"I—love her," John Leslie said aloud when the door had closed. "Not the way a man loves a woman. The way a man might love—a goddess."

Outside in the clear, spring sunshine, Maria started home along the waterfront, her legs like wooden things over which she had little control. She would have to tell Joseph that Papa was gone. Ann would be there. She would have to tell her, too, once she reached the house. She could face neither of them yet. On impulse, she retraced her steps to Treasury Street and headed for the Herrera house on St. George. John Leslie would have let her talk, she knew, for as long as she needed, but now her need was for an older, tried friend.

Don Luciano, red-eyed and sad, answered her ring himself.

"You have come at the right time to comfort me," he said brokenly. "My father—died this morning."

Inside the house, they clasped hands briefly and he motioned her to a chair. Instead of sitting down, Maria rushed into his arms, weeping helplessly. For a long moment, they clung together.

Then, one hand firmly against his cheek, Maria looked at him. "I'm sorry, Don Luciano. You must know how sorry I am."

"*Sí*. You loved him, too. Everyone loved him."

"Antonia? Should I go to her?"

"Later. It is I who need you now. I am not strong enough for this. *Mi padre* was old—rich in years—but one never expects the death of a—a beloved parent. Stay with me a little time?"

She sat down. "Of course. Ann Cameron is with Joseph. I can stay an hour or so if you need me."

"He died—peacefully. With my sister holding his hand."

Tears flowed unchecked down Maria's face.

"You weep, too, *amiga,* but do not. My father's life was full and content, marred only by the departure of our people and the early death of my mother. He is at peace."

"I weep for you, Luciano. And for myself."

He looked at her intently. "Did you come today for my help?"

Maria's first impulse was not to tell him that her father was dead, too—to leave him unburdened, at least for the moment. It would not be false if she told her old friend that she had come only in need of his company; in need of some small release from these days through which she struggled. That today she felt that she could not endure another moment of her life as it was with Joseph—as he was. The words would not come. Sitting up very straight in her chair, she heard herself say: "My father is dead, too. Mr. Leslie found out yesterday. At least, you know how your father died. I—did come to you for help. Now, we can comfort each other. I don't have to wonder how you feel right now—I know."

When she had gone, Luciano stood alone and grim-faced in the shadowy parlor of his father's house. War and the demands of war

did not pause for a man's grief or for the grief of a friend. There was work to do. He had dispatched a servant with instructions for the finest coffin. The dead body of his father, bathed and dressed by Antonia herself, rested on the bed upstairs. Gentle, saintly Father Pedro Camps, the Minorcans' priest, would be returning soon, but work must come first.

Luciano could no longer delay writing the intelligence report to Havana. The Spanish fishing boat, ostensibly in St. Augustine for thread and net-mending, could not be kept waiting. After all, only hours were required to repair nets. Nets torn intentionally so that the small boat's Captain Chapúz would be allowed to dock at the town wharf.

On board the fishing boat had been presents for Luciano from Havana—sent, as always, by the Bishop, who acted as liaison between Spanish officials and Herrera, their spy in British East Florida. Don Sebastián had died this morning while Luciano was at the wharf receiving his gifts in which the secret Spanish orders came hidden—a barrel of Málaga wine, two earthen jugs of oil, three jars of Sweets of Limoncillos, three boxes of guava paste, and six sombreros of palm leaf, which the governor general had "been told are esteemed in that country." The smuggled note ended with the words: "You will receive these friendly gifts, I know, as proof of my affection and trust and in sign of how I have esteemed the latest news which you communicated to us here through the Lord Bishop. We await word on future events which may pertain to the governments of Charles Town and Savannah—and of course St. Augustine." The short letter was as always unsigned.

No one in the city had better opportunities than Herrera for obtaining secret intelligence. His family had been respected residents of St. Augustine since the 1600s, and even the city's attention to his father's death would further divert suspicion. Luciano, at Tonyn's personal request, would accept the sympathies of the government tonight and would go out of his way to thank his Excellency in his most gracious manner. By the same token, believing both Drayton and Turnbull to be of American leanings, Luciano had made a point

of extending his deepest regrets to them when they left the city. In his position as intelligence link to Spain, he had learned to show the warmest regard for men of all persuasions on the local scene. If his intelligence was to be of any use to his own beloved King Charles III, Don Luciano de Herrera must continue to be equally well liked by both factions—yet intimate with none.

Not even with Doña Maria.

In his room, he sat down to cover two items as clearly and as concisely as possible. Not only would Captain Josef Chapúz be growing anxious; Antonia needed her brother and her brother needed her.

He dipped a quill and swiftly wrote of the three British naval vessels now patrolling the waters around St. Augustine and of the command of the military forces, including Browne's Rangers, which had finally fallen to General Augustine Prévost, Governor Tonyn having relented at last under pressure from abroad. The second item concerned a newspaper article about the American, Sam Adams, who declared that "nature designs that we, the United States, should have both Floridas."

Keenly aware of Spain's similar intentions, Luciano wrote: "I am in total agreement with His Majesty's opinion that such eagerness on the part of the new United States can be surely manipulated to Spanish advantage. In fact, should Spain support the American revolution in a still more important way, the greedy desires of such men as Adams could be used well to persuade American forces to help Spain reconquer West Florida and, if heaven wills, my colony here." Before sealing his report, he wrote an addendum: "The British Sixtieth Regiment of Foot is strong in the city now and the fort has been well repaired with additions of second-floor rooms."

After tucking the report into the folds of a new British blanket purchased yesterday from John Leslie as a gift for the Lord Bishop, he carefully wrapped the bundle in burlap, tied it securely with rope, and hurried to the wharf. There would be no problem, he knew, with the British port officer, who had become Luciano's good friend. And why wouldn't they be friends? The Spaniard had spent

an hour or more every afternoon for months making jokes and playing mumblety-peg with the port officer's lame little son.

When the package was safely in the hands of Captain Chapúz, Luciano was torn, as he knew he would be, by the longing to hurry to St. Francis Street. Maria's tortured face had hovered above the writing of the messages to the Lord Bishop. Beautiful Maria, so stricken, so pitiably alone in her grief. He forced himself to walk quickly back to St. George Street. His own father lay dead upstairs, and his place as the only remaining Herrera son was beside the dead body of the man whose Spanish blood ran hotly in his own veins.

Ann left before Maria summoned courage to tell Joseph that her father was gone. Meaning to resist the news by saying "No!" Joseph had, instead, said "Yes!" and then wept like a child, lost and desperate.

When she had quieted him, Maria stood by the window over-looking the narrow, littered street. By some means, for Joseph's sake, she must live out these days of her fresh sorrow with a composed spirit. He was too weak and too helpless for grief. Don Luciano now had his own grief to bear, as did Antonia. Maria did not know John Leslie well enough to burden him. She understood that Jesse Fish's own life was full of misery and that he was more frail than ever. Fish had liked her father and had seemed especially fond of Joseph. But any shock he might feel at her father's death, she thought, would be nothing to his shock if he could see his old friend, Captain Joseph Peavett, now. In any case, there was no reason to think Jesse would ever come.

The sky outside was high and blue, but her own horizon was gray and flat, as unrelieved, as the sky over the Bay on a rainy winter morning. Grimly, she set herself to plod through the days.

At the close of 1778, word came that Savannah had fallen to the British. That was some relief. But by the end of the next year, Spain openly entered the war on the side of the impudent United States—Papa's friends—and lost no time in attacking West Florida so successfully that General Bernardo de Gálvez claimed it all except the city of Pensacola. Still, Don Luciano continued to assure her

that he knew of no plan to attack St. Augustine. When Charles Town fell to the British, too, in April of 1780, Maria worried less. After all, with neighboring Georgia and now South Carolina back in His Majesty's hands, no matter how hard her days, she could at least feel safe from rebel attack for the first time since the fighting began.

Dr. Catherwood said repeatedly that Joseph, especially with the care she gave him, could live on and on. Day after day, week after week, month after futile month would turn into year after futile year, and Maria Evans would grow old alone in her fine house on St. Francis Street—entombed and safe in her carefully accumulated wealth of land and possessions.

The same year that the British recaptured Charles Town, Holland declared war on England. The British King, she thought, also stands alone in the world.

Maria dreamed one night of David and awoke in tears.

30

By late Spring of 1780, older residents as well as the Loyalist refugees crowded into every available house and, under the palmetto roofs of improvised shelters, lived in constant fear of an attack by Spain. After the capture of West Florida by Bernardo de Gálvez, there seemed no plausible reason why he would not move next against East Florida, but Maria lived cut off from almost all military news. James Cameron, who had joined Browne's Rangers, was fighting somewhere in South Carolina, so that even Ann knew little of what was taking place.

Worse still, all Ann could talk about was her premonition that James was going to die. "He will die this time, Maria. I know it. I try to hide it from Nancy—after all, she's only eleven—but we haven't heard a word in months. I just know James is in terrible, terrible danger!"

"We all are, if Governor Tonyn is right about the Spanish threat. But life is hard enough without borrowing trouble. Luciano says Spain is not going to attack us here. I choose to believe him. That helps me sleep better at night."

Regardless of the Spanish danger, East Florida still seemed the safest place for loyal Englishmen. For two years things had been quiet there. Because of this and the departure of the governor's despised enemies, Drayton and Turnbull, even the Council was peaceful. Finally, no longer threatened, Tonyn relented and called for an election; at last there would be an Assembly. Protestant adult males owning fifty acres would be permitted to vote for Assemblymen who owned at least five hundred acres.

But before the election could be held, the people—especially those down from Charles Town—were annoyed and disconcerted by the arrival of a shipload of South Carolina's most prominent gentlemen—American rebels all—as British prisoners of war.

"You won't believe me when I tell you who they are, Maria," Ann said on her next visit, her eyes big as saucers. "Fine, upright gentlemen—from families we've known about since we were children! You won't believe me, but I saw them being marched across the Square to the old statehouse—British prisoners, Maria, *our* prisoners! I don't think it's dawned on me before that gentlemen like these could be rebels. Do you want me to tell you who's up there—in jail—right now?"

"Of course I want you to tell me."

"All right, listen. Thomas Heyward, Jr., William Johnson, the Reverend John Lewis, Arthur Middleton, John Moultrie's own brother Alexander, Josiah Smith and the newspaper publisher, Peter Timothy—and that's not all—both Mr. Hugh and Mr. Edward Rutledge, and maybe the worst yet—General Christopher Gadsden himself!"

Maria couldn't believe her ears. These were not only among the most outstanding men in Charles Town—they were men her father had loved and followed. Because it insured her own safety in St. Augustine, she had felt relief when both Savannah and Charles Town had been recaptured by the British. Now she was swept by a new, sharp grief—grief for those men who were obviously enemies of the King. Men whom she had grown up respecting.

Having been through the capture of Havana with David, she knew that when prominent men in a conquered town were taken prisoners of war by the British, they were allowed to make parole; to give their word to remain in or near their own homes, free to go about their daily lives but confined on their honor to certain boundaries. No matter how distorted their political views, these Charles Town men were honorable. Not one would have broken his parole. For the British to have arbitrarily torn them from their families and homes to imprison them in a strange place did not sound at all like His Majesty.

"I know it doesn't make sense, Maria," Ann insisted, "but I told you I saw them with my own eyes when they were marched off that ship. They're allowed the freedom of the area around the Square, but imagine gentlemen like the Rutledges and that nice, kind, smart Mr. Thomas Heyward—in prison at that old statehouse! I know how amazed you are, because I had a hard time believing it when I saw it with my own eyes."

"Well, that's exactly what I intend to do. This afternoon, while you're here with Joseph." She turned to the small parlor looking glass to tuck in graying strands of hair.

"Joseph is the same," she said over her shoulder. "You can help me get him up in his chair before I go. He'll sit there until I'm back. Do try to make him talk some, though. Don't do all of it, please." She sighed. "I've tried so hard on his speech."

At Don Luciano's gate, she waited for an answer to her ring. If anyone in the city had access to the new prisoners in order to give them favors of one kind or another, it would be Luciano, who

managed always to ingratiate himself with all factions. Lately, he'd seemed more his old self, more buoyant, the familiar smile flashing again. Maria thought him even more striking-looking now that his hair, like hers, had begun to gray at the temples.

The gate opened and he greeted her, beaming. "Come inside at once," he said. "The sight of you is like an answer to prayer. You have been so much on my mind. You see, I have a brilliant idea. You are so confined at your house by poor Captain Peavett, you must need funds. Do not pretend. The other midwives have stolen your income, and so I will purchase your Charlotte Street house—for cash money if you will permit me."

Seated in the parlor, she took a deep breath and laughed.

"Ah, how good it is to hear the music of your laughter again!"

"You've overwhelmed me! But yes, Luciano, I do need cash. I hadn't thought of selling the Charlotte Street property, and yet, why not? Unless your interest in it is purely charitable."

"It is not. I will never live in a house with you. Very much, I want to live in a house where you once ate and slept."

"You *are* impossible, but very dear to me. All right, have the papers prepared. I agree. And since I'm so out of touch with property values in the city, I'll even let you set the purchase price." After a pause, she went on. "I really came for another favor, though."

Then she told him the reason for her visit. He listened, assured her that he could help and within half an hour, she was seated across from Thomas Heyward, Jr., in a small room on the first floor of the statehouse on the Square.

Maria remembered Heyward from some eighteen or twenty years ago when he had been an attractive young man in his twenties, and it was not until this war-worn, graying stranger smiled that she recognized him. Now in his middle forties, she reckoned, he pretended, at least, to remember her—but more significant to her were the tears which sprang to his eyes when she mentioned Papa's name.

"I loved him almost like a father," Heyward said. "Up until the night of his death, he never missed an Association meeting. He stood on street corners passing out bulletins, he knocked on doors,

he cheered us on continually. He was one of our nobler patriots. His very being thrived on the blessed cause of liberty, Mrs. Peavett. A man of spirit! That spirit came here to prison with every man who was dragged from his bed on that ghastly night a month ago and herded into the stinking ship that brought us here. I'll never forget Richard Evans. And I thank God that he lived to learn about our Declaration of Independence. It meant more than life to him."

Maria studied the rough board floor of the tiny room. "I'm sure you know that I didn't share my father's—beliefs, but he was dearer to me than anyone left on earth." The visit was limited to ten minutes. She hurried on. "There is one thing I desperately need to know. How did he die? What took my father's life? Did he suffer a long illness? Did he die alone?"

"So far as we know, he died in his sleep. A neighbor found him—there in his bed, a peaceful expression on his face. Evidently his heart."

Maria thanked him, said goodbye, and walked rapidly around the side of the statehouse toward the Square, where Don Luciano waited. She had just turned the corner of the building into a narrow path when a boy of twelve or thirteen came careening toward her, his arms full of bundles stacked so high he blindly knocked her against the side of the building spilling his bundles.

"Look where you're going, boy," she said in a cross voice.

And then she saw his face under a shock of black, curly hair. He was perspiring, and two curls stuck to his high forehead, but the smiling face sent such an unexpected wave of pleasure over her, she found herself smiling back at him.

"I do beg your pardon, ma'am," he gasped, his blue eyes alight with what struck her—foolishly, she supposed—as a kind of unearthly joy. The news of Papa had reopened her grief; she had yet to feel fully the relief of learning that he had not suffered. How could she even think of the word *joy*? All the same, the boy's face shone with it as he stood to one side of the narrow passage, pushing the fallen bundles into a heap so she could pass.

She hurried on through the passage. Then she turned to look after him. He was still watching her, his face full of light. He

waved one grimy hand in a kind of salute. Maria waved back.

Luciano was waiting in the Square, and before she told him about how her father had died, she asked, "Did you see a boy with his arms loaded with bundles run into the path beside the statehouse just now?"

"*Sí*. He is young Juan Eduardo Tate. Everyone knows him."

"Luciano, I've never seen such a boy! Who are his parents?"

"He has none. An orphan. He is a mystery. So bright, so well-spoken, he is rumored to be well-born. He reads every book he can find. You yourself, heard him speak perfect, educated English. Still, he came early this year with an ignorant back-country couple from South Carolina. The man showed no interest in Juan Eduardo after the woman died. The boy is alone now, sharing a room with three other children in the house of a Minorcan near the land gate. He is very vague about his own parents. He seems only to want to make his new friends happy—to give joy and help and comfort." Luciano paused. "I've been thinking of offering him a home with me. He is irresistible."

So Luciano, too, had felt that joy. "Yes," she said, deep in thought. "Yes, he most certainly is—irresistible. And I'm sorry to deprive you of him, but I've just decided that I want him. Please go on, Luciano, if you have business. I'm going back to find young John Edward Tate and take him home with me to stay—if he'll have me. I've just lost the boy Pablo. I need young Tate. He's so—unusual, I think I might need him in more ways than the help his strong back can be to me."

Luciano smiled. "Of course. Your need is far greater than mine. I hope he agrees. Just don't waste your wits trying to find out all about his background. He seems content only to live each day—to prefer it that way. The lad is, the Minorcans believe, an invader from a better world. Superstition, of course."

Sitting on the edge of one of her straight parlor chairs later that day, John Edward Tate said, "I waved to you after nearly knocking you down, Mrs. Peavett, because of your beauty and—goodness. I saw them both in your face first thing. I'm honored to be wanted here in this fine house, but I couldn't leave Señora Nita. She took me into her house and treats me like her own son. Besides, I don't think

the poor prisoners—the gentlemen from Charles Town—can get along without me. I've been running errands for them. Trying to cheer them up.

He so disarmed her, Maria had trouble conversing with him. There was never a hint of what he might say next. The boy was simply so natural and seemingly so guileless, he kept her uneasily off guard, while at the same time giving her a kind of quiet, inner pleasure that she found hard to fathom.

"But it's up to Government House to see that the prisoners are cared for. At least their basic needs."

"Everybody needs a little more than that, though, don't you think? And some of those men didn't have a chance to bring along a servant. Of course, I've never had a servant, but when you're accustomed to one, I'm sure you don't know much about taking care of yourself." He squared his sturdy shoulders. "Between us, I believe those gentlemen when they tell me that they were unjustly accused of breaking their parole in Charles Town. I believe in justice, don't you?"

"Oh, yes. Yes, indeed I do," she said, unable to disagree.

"And I also believe those men are gentlemen of honor," the boy went on. "Did you know General Gadsden refused to make parole here? He did. He said if the British broke their word in Charles Town, he didn't intend to trust them here. Just think—a general in solitary confinement in a dungeon at the fort! Without even a candle for the night hours. Something must have gone wrong in Charles Town. I'm sure they all obeyed the rules of their parole, aren't you?"

"I'm afraid I have no inside information, John Edward. Which side of the rebellion do you believe in?"

"Neither side. I love all people the same."

Before Maria could think of anything further to say, Joseph called from upstairs, in the flat, familiar wail. She stood up.

"I'll have to go to my husband. Will you come back to see me, John Edward? I don't wonder the prisoners need you—you cheer me up, too."

One day he would come here to live—she was not going to take no for an answer indefinitely.

For more than a month, young Tate came every day at the same time. He chopped wood for Long Stem's kitchen fireplace and bathed Joseph with such tenderness and skill that Maria was embarrassed at having given him instructions. He knew instinctively how to handle—and charm—Joseph, who repeated the word "No" over and over in appreciation as John Edward's strong, expert hands massaged the wasting muscles in his useless legs. Maria, relieved of a good part of her daily physical exertion, found in herself a new patience with Joseph, a gift from the boy.

The whole atmosphere of the house brightened when he rang his familiar *ding-ding, ding-ding, ding-ding* at the garden gate. She gave him more and more responsibility, fed him well, bought him new clothes, and had the cobbler make him two new pairs of shoes, but he steadfastly refused her every offer of wages.

"God pays me well," he said with his radiant smile.

"And with what?"

"Love, Good Maria. That's the best exchange in the world. He gives love to me and I pass it along to you."

His new name for her—Good Maria—made her feel both special and undeserving. How, she wondered, had she survived the long, nerve-racking months—years—without him? How much longer could she endure his departure at sundown to go to sleep on a grass mat on the floor of a Minorcan hovel? Daily her longing grew for him to become a part of her household. He had become the son she never had.

More than that, in a way she did not even begin to understand, the blessed boy had given her a life that was bearable again. For one thing, with him there to be with Joseph in the afternoon, she could now spend more time in the shade of her garden alone. Slowly, barely perceptibly, she began to feel a small return of her old contentment. The kind of contentment she'd known before Joseph's strokes—taken for granted.

And it was the kind of contentment that seemed to override fear—the fear still gripping the city that at any moment the lookout stationed on Anastasia Island might sound the arrival of Gálvez'

Spanish fleet. Again and again Don Luciano assured her that St. Augustine was safe. Although she had no idea how he could be sure, most of the time she believed him. But what really saved her from fear was her deep conviction that one day she would have John Edward always in her home, a member of the family.

Late in the fall of 1781, the familiar jingle of the gate bell caused Maria to push aside her account ledger and hurry to greet John Edward.

His eyes were red from weeping, but he tried to smile. "My news today, Good Maria, is—" He broke off, his mouth quivering.

"You've been crying! Sit down and tell me," she said.

"Last night—last night—a soldier—raped and then murdered my friend, Señora Nita." A shudder escaped him.

"Murdered? The lady you live with?"

The boy sat slumped on a bench, staring straight ahead. "He killed her—my kind Señora Nita! She—she was all I had, except you and Captain Peavett." He looked up at Maria; his eyes brimmed over.

She held out her arms and he rushed into them, sobbing. When, after a while, the sobs subsided, she could feel long tremors persisting in his sturdy body. She sat on the bench and pulled him down beside her.

"How I wish I could have protected you from any violence, John Edward! At your age—"

"They tried to protect me—the others in the house—they took her away. But there was blood"—the horror returned to his eyes—"blood like when the Indian killed my mother. I saw that—I saw him kill my mother."

Maria concealed her shock. Sensing his need, she said again, "Tell me."

"Yes—with a white man's ax. And I heard the shot that killed my father. I was eight years old. Mostly I try not to remember, but sometimes—" He shuddered again; gripped her hand. "They were—like you, Good Maria. Gentle people." He forced a smile. "God took care

288

of me, though. I hid in a clump of myrtle trees. But before I got too hungry—after the Indians left—Mama Lucy found me."

"Mama Lucy? The lady who brought you to St. Augustine?"

He nodded. "Mama Lucy wasn't a fine-spoken lady like my mother and you. She had no schooling, but she was good." The smile came more freely now. "Mama Lucy loved God. She couldn't read, but"—he held up two grimy fingers side by side—"she and I were—like this. I used to read her Bible to her by the hour, from the time I was very little."

"She—died, too, didn't she? Just before you went to live with Señora Nita?"

"Yes. God took her—no more worries, no more beatings."

"Her husband beat her?"

"Yes. Over me. He—didn't want me around." For a long moment, the boy studied the stone floor. "Mama Lucy's fine now. So is—Señora Nita. They're with God today, both of them. And my parents." A look of wonder crossed his face. "Right in the presence of God. This minute."

Maria said softly, "Your faith is either perfect—or insane, son. Whichever it is, I'm glad you have it. Have you—believed like this—all your life?"

"Yes—for as long as I can remember. I'm not too old yet, you know. It—hasn't been very long, the way God counts time, since I was—with Him before. Before I was born to my mother and father, I was right with God, too. So were you. So was everybody."

She took a deep breath. "You're beyond me! Far beyond me. At any rate, I do so regret your new heartbreak, John Edward. But you'll live here with us now, won't you—at last?"

"Thank you—I would like to."

"When can you move in? I want you to pick out any room upstairs except the big bedroom."

He stared at her, unbelieving. "A room upstairs for *me*? I'd already decided to put my mat in the shed behind Long Stem's kitchen."

"Indeed you will not! You're not coming here to live as a servant. You're coming as—my son. Our son."

With the back of his hand he wiped the last tear away and sat beaming at her. "I have more news—the other made me forget. Pretty important news, too."

"Oh?"

"British General Cornwallis surrendered seven thousand men at a place called Yorktown in Virginia. My gentlemen at the statehouse jail just told me. They're shouting their heads half off with joy." The smile faded from his face. "I can't help thinking about the soldiers who got killed or hurt—but my gentlemen at the statehouse are singing a song Mr. Heyward made up to the tune of 'God Save the King.' Only they're singing 'God Save the Thirteen States—Thirteen United States!' "

"I—see."

"Sometimes I don't think you're on one side or the other, either, Good Maria. Down deep."

"Who knows—down deep?"

"Anyway, there's more. General Gálvez finally took Pensacola in a very bloody battle, and my gentlemen at the statehouse are sure the new United States will make some kind of deal with the Spanish so Spain will help them get both Floridas as states, too. It's all pretty mixed up, but I know you're interested in things like that, aren't you?"

"I certainly am. And that's not good news at all—to me."

"Well, I hope it stops the killing. I get just as sad thinking about the dead body of a young American patriot as I do about the dead body of a British Loyalist. I know that's the way God feels about it."

"Yes, I suppose He does," she said absently. The boy had startled her again with the vastness of his caring, and a bit more of the protective shell which she'd worked so hard to build around her heart, chipped away. "Did you bring your things with you? I want you to move right in."

The smile again, a bit sheepish this time. "I brought only the clothes I have on. I knew you wouldn't mind that I gave away the other nice things you bought me to a poor Minorcan boy with a bad cough. But I'll keep these clean. I'll wash them every night."

"You'll do no such thing. We'll get more. Now, let's go up and tell Captain Peavett that you're here to stay. He'll say 'No' a dozen times,

and that will mean he's as joyous inside as you've made me."

In the spring of 1783, word reached St. Augustine that the long, perplexing war was ending. Perhaps now, she thought, some kind of normality could be restored in the city. For more than seven years, St. Augustine's narrow, dusty streets had been thronged with regiments of arriving and departing soldiers—redcoated musketeers armed with their cumbersome Brown Besses, Scotsmen in plaid overalls and bonnets, German mercenaries with blue coats and frighteningly long bayonets. Governor Tonyn, she knew, would insist upon ample military protection for the town, but in spite of the lingering dread of a Spanish invasion, Maria felt enormous relief.

Theatrical productions were to be held with some regularity at the still unfinished statehouse now that the prisoners had gone. Maria had already bought tickets for herself and John Edward to attend *The Beaux' Stratagem* by George Farquhar, with the farce, *Barnaby Brittle,* tossed in for added entertainment. Because it was not considered decent for a woman to perform on a stage, the King's soldiers, to John Edward's delight, would play all the parts.

Before last year had ended, Luciano had brought her the news that the city was, as he had always claimed, safe. General Bernardo de Gálvez had turned his attention to the capture of the Bahamas instead.

Her friendship with Herrera, while still close, had grown to be almost too comfortable. Most of the time there was no sign whatever that he had ever been in love with her. Perhaps he isn't anymore, she told herself one afternoon alone in the garden in one of David's chairs. There does come a time when five years' difference in the ages of a man and woman stretches to seem far more—if the woman is the older. I'll be fifty-three in July. Luciano is still in his forties—and as handsome as ever. He'll come to me one day with the news that he's found a younger woman. She sighed. I'll be glad for him—and a little sorry for myself.

These thoughts of approaching age increasingly disturbed her when she was alone in her garden—often when not alone. Even when she was working with Joseph or hard at work on her accounts,

they intruded. She had never loved Luciano de Herrera enough to marry him, even if he'd asked, and yet she was undeniably glad that as yet he hadn't come with news of another woman.

Busy rubbing Joseph's legs one winter day, she smiled forlornly at the sight of her competent hands, shiny with oil, lifting and rolling the thin muscles. The once gracefully smooth hands she'd always secretly admired were now splotched with brown, the skin crinkled a little even under the sweet oil of almonds.

At least she could smile. Through all the years in St. Augustine she'd had all she'd really wanted or needed from Luciano—more in the way of friendship than many people ever had.

As Maria fully expected, John Leslie was elected to the East Florida Assembly. St. Augustine residents would now pay an internal tax, and in the first issue of the city's first newspaper, the *East Florida Gazette,* was a detailed account of the beginning achievements of Leslie and his fellow Assemblymen. She read it to Joseph.

However hard she tried with him, his speech since his second stroke had never amounted to more than a few words now and then, and he was still apt to say the opposite from what he meant. His clarity of mind seemed to vary, but he was often able to show her in other ways than words that he understood her—often enough so that she had long since made it a practice to assume his full understanding whenever she talked to him—or, in this case, read from the paper:

"Stray cattle in the streets will be impounded. . . . Privies must be cleaned at night when requested by the scavenger or beadle. . . . No one is to work on Sunday and the price and quality of bread will be strictly regulated at the town bakery."

Maria laughed aloud. Joseph smiled with the one side of his mouth he could still move. For such trivia as that, Drayton and Turnbull had fought to their ruin!

Her pleasure in their sharing of this ironic joke brought to Maria a sharp longing for one of their old two-sided, animated conversations, and a realization that she missed him—that indeed, she had missed him many times during the years since he was first stricken. The

extreme demands on her time and energy had kept her from allowing a full awareness of this to come to the surface. Before the coming of John Edward, she would simply not have been able to give in to it.

Although news of the Second Treaty of Paris did not reach St. Augustine until the end of 1783, the treaty, ending the war between the United States and Great Britain, had been signed September 3. It recognized at last that thirteen of the Crown's most valued colonies had broken entirely away and would henceforth conduct business in the world as an independent nation. Maria felt that she had lived through enough history—enough tragedy to see now more clearly than ever that the name of the government in which she happened to live mattered less and less. She clung still more firmly to her old belief that governments operated almost entirely without regard for the people unfortunate or fortunate enough to have been born in a certain place on the face of the earth. Whatever the government, the men who led it would, sooner or later—because they were men—be at war.

The gate bell clanged loudly the day before Christmas, and while Maria was hurrying to answer it, she could hear Ann Cameron screaming her name.

Weeping, Ann fell into her arms. "He's dead, Maria! James—is *dead!* I told you they'd kill James this time!" Nancy stood behind her, taller than her mother now, eyes brimming but quiet.

Half shaking and half embracing her friend to calm her, Maria said, "Listen to me. How do you know? Who told you?"

"Colonel Fuser himself came to my house. For nearly a year James was thought to be a Georgia prisoner of war. Now it's certain. He's dead! *Dead!* Kind, gentle James, who never hurt a living soul unless he was ordered to."

Maria's mind flew back to that long-ago-day—James in the stocks on the Square for objecting to the loss of his beloved First Regiment, sitting patiently in the hot sun, his hands and feet tight in the wooden braces—to David—to Ann and her scratchy broom after David's accident, sweeping Maria's empty cottage for want of something to say that would ease Maria's heart. She held Ann in

her arms now for a long time, one hand smoothing the thin little back, trying for words that wouldn't form and wouldn't help, she knew, if they did.

The bell clanged again, and Maria opened the door to Don Luciano. What a time for him to come, she thought, and decided to tell him at once about James Cameron, so that he could leave quickly for Ann and Nancy's sake. He did not go, but stood uncomfortably to one side of the parlor, his face drawn with sympathy, obviously waiting to talk with Maria.

"Nancy and I will be destitute, Maria," Ann went on as though Luciano were not in the room. "We're probably destitute right now! Our second little house is empty. The tenants went back to Charles Town yesterday." A fresh spasm of weeping choked off her words.

"Don Luciano," Maria said tensely, "could you—would you see me later, please?"

He walked toward the little group. "I would if I could, Doña Maria," he said softly. "I am as ill at ease with this tragedy as a man can be, but what I have to say, you should hear from me. Both of you. The news will come twisted from its flight around the city before it reaches you. I will go once I have told you."

Out of her swollen face, Ann looked at him wildly.

"Word of the entire treaty agreed upon in Paris did not reach the *Gazette* in time for publication in last week's edition."

Maria braced herself. "Yes, Luciano?"

"Great Britain has ceded East Florida back to Spain." He broke off, then began again. "I am also certain that your monarch will exert every effort as did mine so long ago—to make smooth the transfer of governments."

That night, lying in the big bed beside Joseph, whom she had not yet told, Maria saw as though it were yesterday the anxious, angry faces of the Spanish residents of St. Augustine twenty years ago, as they hurried in and out of their houses bearing the burden of their belongings and the burden of desertion by their King.

The sky was streaked with dawn before she finally slept, but her mind was made up. She and Joseph would not leave. For one thing, it might very well kill him to move him. For another, they would have to leave empty-handed, whereas—most importantly—she was certain that their property—if they stayed—would not be confiscated by the Spanish. Whatever they had to do to stay, even if it meant swearing allegiance to a new king, they would do. The colony would again need settlers. So deep was the hatred of Spain in the average Englishman, most of the people would go—only God knew where—but she and Joseph would stay.

Maria and Joseph and her beloved boy, John Edward Tate.

31

During the early weeks of 1784, the city had begun to empty. Even Ann was gone now—penniless and brave. Maria had stood alone on the wharf waving, tears streaming down her face, even after Ann and Nancy were no longer recognizable as they waved back from the small boat which took them out to the schooner anchored at the bar. What lay ahead of them in London, no one could foresee, but Ann so often afraid and helpless in the daily round, had gone with enormous courage, praying that relatives abroad would take them in. Maria longed to be able to guide Ann, to help her file her claim in London for her lost St. Augustine properties. Ann could not read and had never laid eyes on any of her living London kin.

Walking slowly back home, Maria had felt more alone than at any time in her life, but firm in her resolve to stay.

A few hundred British were still in the city, the wise ones, Maria felt, waiting, hoping as she hoped that, when new Spanish Governor Zéspedes arrived this summer, his countrymen would follow, resettle the colony, and pay decent prices for the abandoned houses. She hoped, but the hope was slim. Having watched the Spanish leave back in 1763 and having seen Jesse Fish grow wealthy from their real estate, she expected the same windfall to come now to Francis Fatio and her friend John Leslie, who were left to handle the possible sales of British property. It had been a relief to learn that John Leslie was staying. He and his partner, William Panton, who was already in Spanish West Florida in charge of a store there, appeared confident that they would be granted a monopoly on Spanish trade. Everyone knew that Spain was not capable of supplying the Indians with the high quality of goods to which they had been accustomed under British rule. Panton and Leslie had access to those goods through their New Providence firm in the Bahamas. In order to keep peace with the Indians, Governor Zéspedes would need both men as much as they needed him.

Joseph's eyes had shown his agreement when Maria told him that they would both eventually become Spanish subjects and Catholics. He had even managed his one-sided smile.

Spring buds began to swell on the winter-quiet trees, and Maria's interest in the upcoming change in governments grew, too. In spite of the monotony of her daily life, she went on experiencing a kind of excitement. She told Joseph everything she managed to learn.

One May morning, with John Edward's help, she lifted Joseph back into bed, turned him on his stomach, and began to rub the now sickening sweet oil of almonds into his back. It was a point of pride with her that Joseph had suffered almost no bedsores during the long years as an invalid—now unable to turn himself. Today, especially, she longed for a good talk with him. When John Edward went back downstairs to help Long Stem with the candle-making, she talked as she rubbed.

"Do you remember, Joseph, dear, that the British are leaving? That we now know the name of the new Spanish governor, Don

Manuel Zéspedes, and that he's in his sixties? That you and I are going to stay on in our comfortable house?"

She stopped rubbing to watch his head—too big now for the rest of his emaciated body. He responded by moving it in understanding. For a moment, she looked at the prominent artery above his temple still pulsating steadily, as it had day after day, night after night, week after exhausting week. His heart remained strong, too strong to release him from the cage of his useless body. The huge nose—a hooked bone now—was half-pressed into his pillow. Even after he was first stricken, she had often kissed him teasingly on that impressive nose. Only now and then could she still bring herself to do it.

"Luciano has already met the new governor's secretary, Don Carlos Howard," she went on. "Evidently he's a capable, slightly built, quite striking Irishman, a captain in the Spanish Hibernian Regiment. Howard was sent on ahead to make ready for Zéspedes' arrival. I'll wager that this Howard will be a big key in the transition, Joseph. Luciano says he speaks Spanish fluently." She could not tell how much Joseph was still following what she said. "Of course, Don Luciano is in seventh heaven because his people are coming back. But, you know, I wonder if they'll really come. You remember how hard it was to convince Englishmen that they should settle here. I sometimes doubt that we'd ever have had enough settlers if it hadn't been for Papa's revolution." She rubbed a while in silence. "I can't imagine what a shambles Government House must be, can you? After all, Tonyn has been living at his plantation most of the time for years. The night John Edward and I went to an entertainment at Government House, the roof leaked like a sieve—as I told you when we got home, I'm sure. Governor Zéspedes is going to have to get out a lot of buckets if it rains before he's had time to fix the roof." She sighed, straightened her back, and put the cork in the bottle of oil. Then she sat on the side of his bed and smoothed his balding head. "You're a wise man, Joseph, to agree to our staying. If Ann Cameron or anyone else is ever compensated for lost property, I'll be surprised. But you and I will go right on, in full possession of all we've worked so hard to acquire." She laughed a little. "The Peavetts will be among the few smart ones."

Maria was glad Joseph could not see her face. Her words belied her true feelings. It would be more than strange—unnatural—to be a Spanish subject—and a Catholic.

John Edward's friends the Minorcans stayed gladly. They spoke their own Spanish dialect and were already Catholic. They had suffered so much in New Smyrna that St. Augustine was a haven. Even those who had not yet managed decent city housing were at least free to live as they pleased—to manage their own destinies.

The Minorcans, in fact, made up the bulk of the population of the town when Zéspedes finally took over the reins of government on the afternoon of July 12, 1784. Maria, because John Edward was with Joseph, was able to attend the ceremonies with Don Luciano, whose face shone when Governor Tonyn formally handed over the fort to Don Manuel Zéspedes. Herrera's dark eyes followed Spain's white flag with the red cross of St. Andrew as it slowly and majestically rose to the top of the flagpole of the ancient stone structure which would once more be called the Castillo de San Marcos.

As she watched, Maria's own emotions were mixed, but her intention to stay on did not waver. She had, she reminded herself again, quite by accident been born British and Protestant. In all her fifty-four years, to be honest, she had never been fully convinced that either the English government or the Protestant God had bothered to any degree about Maria Evans. As long as she could keep her vast holdings together, she would take her chances on a new church and a new king.

The ceremonies ended, she and Luciano had begun to walk slowly toward her house when a soldier ran up with a message in Spanish for Luciano, who read it quickly and told Maria he was summoned by Zéspedes to Government House.

"You will forgive me, Doña Maria," he said apologetically. "It is a disappointment to leave you, but—" The dark eyes flashed and he laughed. "You see, I am free now to tell you my secret. For my loyalty and skills as a Spanish spy during your father's war, I am to be honored."

For a long moment, Maria stared at him; then she, too, began to laugh. "Ann Cameron swore to me once that you were a spy!"

He shrugged. "Does it matter now?"

"No. Governments have never stood between us, have they?"

When Don Luciano strode away across the Square, which she would now have to learn to call the Plaza, Maria felt more starkly alone. Not particularly concerned that Luciano had been a spy— just alone. She missed Ann. Who was left to Maria Evans? Her clever, expedient friend, John Leslie, whom she so seldom saw. Don Luciano—but now that his beloved King Charles III once more owned the province, she was sure to see less and less of him. If she were ever to be free to practice her profession again, it would be among Spanish women. Most of her old British clients were gone.

Undergirding her life—her future—was one person; her boy, John Edward, now sixteen, whom she had come to care about so deeply, to depend upon so steadily. Nearly a man, tall, his voice changing, he still seemed to live almost entirely for what he could do for others. He had friends all over the city; had kept up with the Minorcans, but remained these days primarily concerned with herself, Joseph, and Long Stem— his family. Many afternoons Joseph watched the doorway for the boy, at whose appearance even the gaunt invalid's face reflected the glow of joyous well-being that John Edward always seemed to radiate. He appeared to Maria as grateful as she that he was her son.

Slowly, she made her way down Marine Street. How filled with dread she would have been to walk again into that house—its very walls permeated with sickness—had she not known that John Edward Tate would be there waiting to cheer her. Twenty long years ago, Antonia had promised her a new small joy some day. John Edward had brought her joy indeed—new joy. True, it was not David's joy. If she let herself dwell on that, she might still cry—any time. Does a strong woman still mourn, after twenty years? If she loved, yes. Somehow, it helped that John Edward believed in David's God.

She looked across the glistening waters of Matanzas Bay toward Jesse Fish's island—his prison, they said, and that he was very feeble.

At least, she thought, I know he's there. She tried to imagine what her old friend's days must be like. Did he talk to his wife, Sarah? Was the son Maria had delivered growing up to be any solace to Fish? As best she could remember, the boy was in his teens by now.

She let herself in at the street door and, as usual, went directly up to Joseph's room. In the doorway, she stared at his empty bed—its linens stripped off. Then she looked at his chair. Joseph, who had not been out of the room in more than four years, was gone!

For a long, frozen moment she did not move or call out. Her husband was dead. There could be no other explanation for the empty room, the stripped bed. Her whole being felt numb. Beyond that—nothing. The tall, courtly man she'd married so long ago had really been gone for a long time. She had learned to live without him.

Maria was gripped briefly with the irony of the fact that she had been away from the house when, at last, he'd been allowed to die. One of her relatively few absences in all the years of caring for his every need, responding to his every look. In all the years until John Edward, every groan had commanded her to hurry, to run to him, to help him. She had become far more familiar with the cramping legs, the twisted back, the chafed buttocks than she could remember ever being acquainted with the depths of the man's being. The pleading, sunken eyes had haunted her restless nights. From deep sleep, she had heard his every whimper, the tremulous, almost quarrelsome wail: "Ma-reee-ah!" She had ached with his pain and grown tense with his frustration. There had been times when she had been cross with him, but God knew she had tried—if indeed there were a God who snatched away young, vibrant men like David and left old men to die more slowly than a tree with blight.

"I'm a—widow again," she murmured.

Then, as she turned to go back downstairs, she was struck with the peculiar unreality of this moment. Where was Joseph's body? Why had he been taken from his room?

She hurried across the parlor toward the garden, where she'd just caught the first sound of voices. Impossible, of course, but she could have sworn that she heard John Edward laugh! At the

loggia door, she stopped as though memory blocked her way.

From the far corner of the garden near David's orange trees, there floated the heart-stopping lilt of a young man singing an Irish song. Singing with such purity and tenderness and abandonment that she felt she might faint.

Strangely frightened, she took four or five steps back into the house, then forced herself to go straight across the loggia and into the garden to where she could see the orange grove.

Patches of soft, filtered, late-afternoon sunlight lay under the waving branches of the dark-leafed trees, casting their uneven, unearthly patterns on the grass. What she saw could not be real. What she heard could not be real.

David had been dead for twenty years, and yet the beauty of his voice and the beauty of his being filled her garden. The singing young man's hair was jet black, not tawny, but it curled in the way David's hair had curled, and the voice floated, half on song and half on hidden laughter . . . David's voice . . . David's kind of song . . . David's beauty and strength. When the young man stopped singing and turned to look at her, she felt David's joy.

Joseph was not dead. He was there, being entertained by the strange singer of songs. Joseph, in one of David's old chairs, with John Edward on the grass beside him, was almost smiling.

"Oh, there you are, Good Maria!" John Edward leaped to his feet and loped over to her. "Look—our surprise for you!" He grinned at her stricken face for a moment, then said, "It's all right—my friend carried him down."

She hurried to her husband. With enormous effort, he actually managed to lift the withered right arm an inch or so from his lap, and his left arm moved up as high as her waist before weakness forced it to drop.

"Joseph! You're outside!"

She could think of nothing else to say because, less than five minutes ago, she had accepted the relief of his death. Relief for them both. From habit, she smoothed his bald head and felt his dry, folded cheeks for fever.

"*He* brought Captain Peavett down those steep stairs," John Edward boasted, lightly punching his friend's strong forearm. "I really didn't help much. He just picked him up and carried him all the way down those stairs and out here to the garden!" The boy's own chest expanded. "Good Maria, this is my friend, Mr. John Hudson. We've known each other ever since he came to town two weeks ago. I met him on one of my visits back to the Minorcan quarters, almost next door to where I used to live. John Hudson, meet Captain Peavett's wife, my Good Maria."

"How do you do, Mr. Hudson," Maria heard herself say in a surprisingly controlled voice. "It's a—a miracle what you've just done for my husband. I haven't seen him—so happy in a long time. We're deeply grateful to you." Young Tate, as tall now as she, moved to stand proudly beside her. Nervously, she clutched his arm. "I suppose I really shouldn't be surprised to discover that John Edward has a miracle-working friend."

John Hudson, who had been looking at her so directly that her head swam, let his smile widen enough to expose the whitest, strongest teeth she'd ever seen, then bowed. "It's been my pleasure," he said, and his voice, lower pitched than David's but with the same Irish lilt, hummed through Maria's spirit like a golden cloud of bees. He went on, "I'll take the captain back upstairs any time you say."

"Oh, can you do that all alone? He's helpless. Our steps are very steep."

"I believe he's stronger than any man in town," John Edward said. "Don't worry."

"The captain's light as a bird, ma'am."

"But he's so helpless, I don't see how you brought him down!"

"Oh, Captain Peavett helped a lot, Good Maria," John Edward said. "After all, a man as strong as I've heard he was before he took sick can help a lot—even now."

Once more, her boy had come to her rescue. As though poor Joseph were deaf and too old to understand, she had spoken of him as though he were—the burden he had become. More times than she could remember, she had warned herself against doing

just that. Her heart reached toward John Edward in gratitude.

"You've come to our city at an—awkward time, Mr. Hudson," she said. "Two governors attempting to function side by side. Will you be staying?"

His laughter rippled like water. "Aye, if the Peavetts and John Edward are staying, then so am I. I confess I wandered in from Havana just to look the place over. I've seen all I need to see—right here in this garden. I'd like to visit the captain every day, if you'll permit me."

32

During the transition period the Spanish and British lived together as peaceably as could be hoped. Military backgrounds shared by the officials in charge on both sides supplied a common bond. Even Tonyn made an effort to get along with the aging Zéspedes. Tempestuous Thomas Browne, now the British Indian Superintendent, caused no problems and managed to hold back a threat of Indian war. Of course, Maria believed that no one was acting more nobly than the circumstances required. Good relations with Zéspedes meant fairer deals where abandoned British properties were concerned. Peace with Zéspedes' British counterpart, Governor Tonyn, would hasten the day when the Royal Spanish governor would be in complete charge of his new colony.

Tonyn, although he had not lived in the decaying Government House for years, suddenly surprised everyone by announcing a ball to be held there in honor of Spanish officials. John Edward

brought the news to Maria, and her first reaction was to laugh. With that leaking roof, if it rained the night of the ball, there would certainly be a ballroom full of dancers attired in soggy silks and brocades. But, in a way, she would give anything to attend. Social lines, drawn so sharply before Drayton and Turnbull had been driven from the colony, had blurred. She wondered if Governor Tonyn, with his two snobbish adversaries safely back in South Carolina, would bring his peculiar little Scottish wife to town for the ball. Would the Forbeses, the Catherwoods, the Holmeses, the Moultries be there? In only twenty-one years, British roots had gone deep into East Florida soil, but Maria felt sure the ex-Council members would all leave as soon as their complicated affairs could be settled. Ann would have known through her grapevine. The thought jarred often that, because Ann was illiterate, Maria would never even receive a letter from her. Perhaps Nancy would write sometime.

Captain Carlos Howard was a bachelor, so except for Zéspedes' wife and the wives and daughters of the few other Spanish high officials in town, there would be no prominent Spanish ladies present at the ball. Only five hundred Spanish soldiers were garrisoned in the city now and few officers. The huge, weather-stained ballroom would not be crowded. A lot could be learned of the latest political developments if one were there to circulate among the guests.

In another way, Maria realistically accepted the fact that she no longer had a place in St. Augustine society. She had attended parties with Fish and Luciano before her marriage to Joseph, but Captain Peavett, prominent citizen, had been her commanding entrée. She lay beside him the night she'd learned of the approaching ball, remembering . . . his smile, his well-formed, stately figure bowing to her in the minuet, his guiding her with more grace than any other gentleman on the floor. She remembered his formal civilian wardrobe, in the clothes press for years—the bottle-green, richly embroidered coat, the white, ruffled shirts, and the high-waisted silk breeches. They would hang on his skeletal body now.

Joseph snorted in his sleep, coughed the wracking, weak cough of an old, ill man. Maria, feeling her own years—suddenly fighting the desire to be young again—let the tears fall unheeded onto her pillow. Joseph resumed his snoring.

Even if Luciano asked her to attend the ball, she could not go without setting the town gossips humming. But he probably could not have invited her anyway. It was only proper for him to take Antonia, since the dance was in honor of the Spanish government.

"You're too old to be tormenting yourself like a schoolgirl," she chided in a harsh half whisper. "Go to sleep."

Sleep would not come. After two or three hours, she slipped quietly from bed and tiptoed out into the upstairs parlor, where there was a tall pier glass. Picking up a lamp left burning always outside Joseph's room, she shuffled in her bare feet across the parlor to the far wall, where the looking glass stood, and began surveying herself from every angle. The full nightdress hid her slightly thickened waist. Her breasts were still fairly firm, the wide shoulders only a little stooped. But when she lifted the lamp nearer her face, she cringed. Deep half circles puffed under the weary eyes. Eyes David had once called luminous. Wood-violet eyes. A brief, bitter smile deepened two etched lines at the corners of the generous mouth. She frowned, and the crease between her high arched brows sharpened. Her teeth, thank heaven, were still sound. Poor Ann had left snaggle-toothed. Maria lifted her chin in the old characteristic way. There would be at best some fine ladies at the upcoming ball dressed in elegant damask gowns with front teeth missing!

"Ma-reee-ah!"

At the pitiful wail her whole body sagged. Couldn't he sleep through this one hour and leave her to her own thoughts? As always, she hurried to him. His legs again. She threw back the cover and began the eternal massaging. At last, the circulation restored, he sighed heavily, drooled from the paralyzed side of his mouth, and went back to sleep. Maria replaced the lamp on its stand outside the door and crawled in again beside him, her body rigid. Even if John

Hudson did come every day to visit Joseph, she could and would ignore his bright, deep-set eyes, which seemed to follow her every movement around a room or the garden. John Edward had told her young Hudson was only twenty-six years old! How twisted had her mind become from these years of lonely bondage that she was pleased—even flattered—that John Hudson so much as noticed a woman more than twice his age?

She forced her eyes shut and willed sleep. Eventually it came. She dreamed again of David.

Wells, the printer, had left the province even before the Spanish occupation took place, so once more the city learned local news by word of mouth or by notices posted at Payne's Corner, which the Spanish were calling the Public Corner. Throughout 1784, there were frequent arrivals as Americans came from Georgia and South Carolina to settle British family-property claims before the arbitration board. There were more and more departures as more and more Loyalists continued to leave for Europe or New Providence—a few to Nova Scotia. Now and then word reached St. Augustine of the bustling activity at the St. Marys harbor, where Spanish troops kept arriving, their ships passing contingents of departing British soldiers. The last of the British garrison left on August 14 for Nassau, and later that month, Governor Manuel Zéspedes received his first diplomatic visitor from an American state. Enduring the oppressive heat and swarming insects, a man named William Pierce made the laborious journey through the swamps and lowlands from Savannah to bring personal greetings from Georgia Governor John Houstoun. In December, another well-to-do Georgian, Mr. John McQueen of Savannah, came—to look over the potential of the province under Spanish rule.

Aside from the tidbits brought to her by John Edward, Maria learned little of what was happening in her city. Hudson had not missed a day visiting the big house on St. Francis Street since he had first come in July, but except to vow that he fully intended to

become a Spanish subject and stay on, he showed little interest in events. Maria gradually began to lose her own. Thanks to the presence of her new son, she had, before Hudson came into her life, reconciled herself to the hard years with Joseph—days and nights of duty to the helpless man, to be endured stoically, with John Edward's help, one slowly dragging past another.

Then the boy had brought John Hudson, and she found herself literally counting the hours until his merry, carefree jingle sounded daily at the gate.

"Go out on the town, lovely Mrs. Peavett," he would say in the lilting Irish cadence that always caused her heart to beat faster. "John Edward and I will take care of everything for you! I've a song to sing for Captain Peavett and three new stories to tell." And then would come the laughter, to Maria, like good bells. "I like the old fellow, you know. I genuinely like him."

Hudson was attached to the Spanish garrison in some minor way, but how he lived she had no idea. Of course, he ate one meal a day with her, and Long Stem, who obviously adored him, outdid herself cooking delicious food. He still slept in a back room of a Minorcan house near the land gate, but beyond that, Maria had no notion of what Hudson's life was like away from her. He came each day to stimulate her own life. That was enough. Having lived for so long with the harshness of reality, she felt loath to ask many questions.

"You never sing a mournful song, John" she said one January day as he sat across from her beside the glowing brazier in the upstairs parlor. "Have you never been sad a day in your life?"

"If I have," he said, "I've forgotten it." Then with fetching inconsistency, his face darkened. "Yes. I've been sad. The day I left Waterford, my town in Ireland. The day I walked away from my river there and knew I'd never feel the thrill of a fish on my line again in those crystal waters. That day I knew great sadness." The smile returned. "Aye, I knew sadness for the space of about one hour's time! Since then, I have wandered the earth, being aware only of the day. The minute." He leaned toward her and touched her hand lightly. "This day, this minute I'm a happy man because

you're here, too." The smile became an easy, gentle laugh. "You see—I've found you—at last."

Night after night, as 1785 wore on, lying beside a snoring Joseph, she tried to decide what John Hudson had meant. "I've found you at last." She repeated the words over and over to herself, sometimes whispering them, at other times allowing them to dance through the shadows and the sunlight of her green and secret place. Daily, though, she found it easier to forget about her secret place, where most things had always come clear. She didn't feel like thinking. Whatever he had meant by saying that he had found her, he had given her so much more than she would ever be able to give him.

Still caring faithfully for Joseph's every need, the days were no longer dreary and predictable. For months now, John Hudson had been her secret lover—known only to herself. The words *secret lover* did not startle her anymore, and there would never be a reason for them to startle anyone else. That Maria Evans had a lover only in her mind and her heart could in no way hurt poor Joseph. Nor could it frighten John Hudson that an aging woman loved him. He completed her already, without guessing.

The town was full of Negroes—both slave and free—some illegally claimed by departing Englishmen, others with papers lost during the Revolution. John Edward had seen Maria's friend John Leslie, who reported that he and Francis Fatio were serving with enormous discomfort on the new board of arbitration in such matters, but Maria was no longer absorbed in the happenings of her town. Even the rumor that there was a last-ditch resistance spreading among British property owners in North Florida, who hoped to be permitted to remain on their land outside Spanish jurisdiction, failed to engage her. She had, in fact, scarcely listened to the rumor because her own holdings were in order and her decision to become a Spanish subject firm. By March, when the last loyal Englishman departed, she had convinced herself that, after all, she would mind very little living in a Spanish city.

One of these days, she must request Spanish protection for herself and Joseph. Repeatedly, she had asked John Hudson's advice as to how to go about becoming a Spanish subject, but he would only laugh and say, "Let them tell us!" teasing her that the important thing was that she become a Catholic so that they could then, in all propriety, walk together up the Bay of a Sunday morning to attend Mass.

His disregard for anything practical dismayed her at times, but only fleetingly. In a while she would visit John Leslie and find out exactly what was required for transferring allegiance. There were now three Johns in her life—John Edward, to show her the meaning of unselfish love; John Leslie, to deal with the hard facts of slow government transition; and John Hudson to make her heart sing.

In their different ways, especially within the glow of her memories and often these days within the bright frame of her dreams just before waking, the three brought David back.

"The Indians have been in town twice, Maria," Leslie said when she called at his office in December. "I have to admit that old Governor Zéspedes handles them well. Of course, he was helped at both of his Indian congresses by the inestimable virtues and clever brains of our two new parish priests."

"I'd heard that there were new priests here now."

"You mean to tell me their reverences have not called on the prospective converts on St. Francis Street?"

"Not yet. That's one reason I'm here, John. Joseph is far quieter in his mind since Mr. Hudson comes every day—and of course, because of young John Edward. But he does not improve. I need to know what's involved with our becoming both Roman Catholics and Spanish subjects."

Leslie laughed. "You didn't even flinch when you asked. I'm proud of you. Still, I've come to expect courage from you, Maria. No objections by your husband to the change-over?"

"No, John, he's become so docile. He can speak only a few words, and I'm the only one who really understands them, but he

looks at me with those—dim old eyes in such a sweet, submissive way, I—feel sometimes as though I'm his mother!"

"I've heard apoplectic people often turn mean. You're fortunate."

"I know."

Leslie selected a cigar from a heavily carved humidor, clipped the ends, and then laid it on his desk. "Well," he began in a businesslike voice, "all you need to do as far as I know, Maria, is pay a visit to his Excellency. At government's snail-pace, I doubt frankly that anything will be done soon. You'll be able to sign for the captain. I signed our pledge of obedience for Panton. He's permanently in Pensacola, you know. As for becoming Catholics, that wasn't required of us."

"And you only signed a pledge of obedience, did you?—not an oath of allegiance to the Spanish King?" An amused look crossed her face. "Of course, everyone in town doesn't own a trade monopoly."

"Neither do we—yet. But we're hopeful. Would you like me to see Governor Zéspedes for you?"

"No, thank you. I haven't met a governor yet who intimidated me." She stood to go. "While Mr. Hudson is with Joseph, I think I'll call on his Excellency right now, if he'll see me."

"Good luck." As he walked her through the warehouse to the front door, he asked, "By the way, where did you find this Hudson?"

"I didn't. My foster son brought him to me."

"I see."

"*What* do you see?"

"A still very beautiful lady who I'm sure will be wary of keeping her excellent reputation in the city entirely free from—flaws."

She laughed her low, musical laugh. "Don't worry, John. Mr. Hudson's devoted to my husband. And—young enough to be my son!"

"Helps you with the captain's care, does he?"

"More than anyone would ever believe."

"I doubt if most people would believe it, to be truthful. The man's something of a mystery in town. A much-discussed mystery, in fact. You know I'm no prude, but do be careful, Maria."

Walking briskly across the Plaza toward Government House, she tried for a moment to figure out what John Leslie might have meant.

310

Then she dismissed it. Of course a city with so few inhabitants gossiped about a breathtakingly striking young Irishman who had come out of nowhere. But no one had better say one critical word about John Hudson—at least, not in her presence.

That night, sitting beside Joseph on the bed, she told him in patient detail about her interview with Governor Manuel Zéspedes, who had treated her with genuine courtesy and had explained the procedure involved in their becoming Spanish subjects. So far as Zéspedes knew, the process would not take place in the foreseeable future. He had also promised to send both Father Thomas Hassett and Father Miguel O'Reilly soon to baptize the Peavetts in their home.

"I told the governor I wanted to be baptized here with you, dear," she said. "He felt it might be better if my baptism took place at the church, but I insisted. If it's to have any meaning for me at all, it will be because we're together."

Joseph smiled his crooked smile and laughed his hiccuping, old man's chortle. Then he pointed the forefinger of his left hand at her and shook his head to show his joy.

"We can't sign our oaths of allegiance to Spain until after our baptism. There seems to be no hurry with either. The governor was most kind, Joseph, and seemed genuinely pleased to have such a wealthy and influential man as you agreeing to stay in the colony."

For a long, painful moment, Joseph stared open-mouthed at her, the eye on the paralyzed side of his face round and gaping. Then, while she wished with all her heart that she could take back those last words, tears slipped down his cheeks. His mind at this moment, she feared, was painfully clear: in full view of the woman whose admiration he most wanted, he was suffering the irony of the idea that any governor might be pleased to have the broken ruin, Joseph Peavett, in his colony.

She smoothed his brow, but said nothing more. In a moment, Joseph pointed to her again. Maria understood. He was telling her that it was she whom his Excellency wanted.

The two rather young priests, solemn Father Hassett, stocky, the shape of an ample, well-fed paunch evident under his black

cassock, and tall, lean, sandy Father Miguel O'Reilly came the following month to baptize Maria, Joseph, and John Edward into the Roman Catholic faith. Don Luciano and Don Manuel Solána witnessed the simplified ceremony. John Hudson, who had asked, was present, too.

Maria's heart beat rapidly throughout the unintelligible Latin phrases, not because she experienced any particular spiritual state of grace—she understood none of it—but because in some elusive way, it would give her still another bond with Catholic John Hudson, who did not once look away from her throughout the sacrament.

Joseph was baptized first and rested against his pillows. A sweet spring breeze brushed Maria's face as Father Hassett laid his hand on her head in baptism. A drop or two of the holy oil dripped down her neck, but wishing to preserve the solemnity of the occasion for the priest's sake and for Joseph's, she let the oil drip. When the light pressure of the hand lifted, she was looking full at John Hudson. Let him think what he liked; under the protection of this one sacred moment, she would make no effort to hide her awesome desire.

The Latin words droned on, her eyes still locked with John's. Then Joseph began to gasp and choke for breath. Pushing in front of Father Hassett, she knelt quickly beside her husband and found his pulse so faint, she commanded John Edward to run for a doctor.

Before the boy could reach old Dr. Bernardo de la Madrid's house on the Plaza, Joseph had drawn one last, rattling breath and lay dead, the drops of holy oil still on his high, white forehead.

312

Part Four

33

The funeral mass, said in the stuffy, second-floor rooms of the old Bishop's Palace, which now served as the Catholic church, was in Latin, except for one verse of Scripture which Father Thomas Hassett quoted directly to Maria:

" 'Jesus said unto her, I am the resurrection and the life: he that believeth in me, though he were dead, yet shall he live. . . .' "

She had heard the words so often in the Lutheran church back in Charles Town and from the lips of the Reverend John Forbes, they had grown too familiar for meaning. In fact, the same words had angered her as a child when the minister spoke them over the wooden box that held the still body of her young mother. "Mama's dead," she'd cried out to Papa that night when they were ready for bed in the empty house on Queen Street. "Mama's so dead, she can't get up or anything! What made him say she's still living?"

Papa had taken her on his lap and told her in his gentle voice that Maria would understand some day when she was older. She felt too much relief for Joseph even to try to understand now. Relief for the Joseph her husband had become during those ten last, long years. But as the Latin droned on, she felt duty bound to devote her thoughts to him—better, perhaps, to the real Joseph, the fine person she had married and with whom she had once had such a good life. She closed her eyes so as to summon up that open, loving face, the whole handsome, vital person . . . but her imagination would not oblige her—the memory was too

insistent of the gaunt, beak-nosed, helpless invalid for whom she had spent herself unstintingly for so long. Hastily she opened her eyes, just as John Hudson, who had carefully seated her at the Mass between himself and John Edward, gave her hand a quick, reassuring squeeze.

Love for John Hudson consumed her.

Hudson gripped her arm as he supported her down the steep, wooden steps of the church and outside to the sunlit Plaza, where all those left in the city who had known him were gathered to pay their respects to Captain Joseph Peavett.

In the knot of people outside, bent, haggard, and shabby-looking, Maria glimpsed Jesse Fish, leaning heavily on the arm of Don Luciano. She nodded warmly to Herrera and hurried to Fish. He bowed, kissed her hand eagerly and smiled an almost toothless smile.

"I can't think of anyone I'd rather see here this morning than you, dear friend," she said with true affection. "It's been a very long time."

He nodded, unashamed or unaware of the tears which glistened behind his spectacles. "I still deplore anything that causes you pain, Doña Maria," he said, his voice slurred and old. "I hope you will accept my deepest sympathy. Captain Peavett, long ago, was my friend."

"Yes," she answered with a sad smile. "He was mine, too. As you've always been." To have inquired about Fish's health would have been cruel. The thought came that indeed, he, too, might have had at least a touch of apoplexy. It was all he could do to stand. What an effort it must have been to make the trip by boat from Anastasia Island. All she could think to say that was honest was that she hoped so much that he would visit her again some day. His little she-devil of a wife was, of course, nowhere to be seen. Maria did not mention her.

Throughout the meeting, John Hudson stood beside Maria. She introduced them and explained—perhaps overexplained to Jesse—how faithful Hudson had been to Joseph during the last year of his life.

Don Luciano had stood to one side as she and Fish talked. Now, he stepped up to steady Jesse, who had been squinting intently at John for a long, awkward moment without so much as acknowledging the introduction.

"Yes," Fish said. "I've heard about you, Mr. Hudson." He turned to Maria. "I'm no longer young, Doña Maria—older than my years—but I am still your friend. I would hope that you will take no step without consulting me. Please don't hesitate because I am no longer well. Don Luciano can fetch me to you, or you to me, at any time. My—feelings for you have not changed." And then he shook a trembling finger at her. "Be careful. Be exceedingly careful."

John Edward jogged on ahead to notify Long Stem of their arrival as Maria and Hudson drove slowly toward St. Francis Street in Joseph's old carriage.

"I could have walked, John."

"Of course you could have. You're the youngest woman I've ever known."

"I'm in no mood to be ridiculous."

"I am not being ridiculous. One thing you will learn is that I never mince words. I don't even need to know your age. You're young enough to me, but with the added excitement of maturity." Holding the reins lightly in his smooth, strong hands, he glanced at her and smiled the smile that turned her heart to water. "But I am being too bold today. This is our beloved captain's day. Shall we talk about him? I want to do nothing forever but what is right for you, Maria . . . forever, Maria."

Until this moment he had called her only Mrs. Peavett. His lilting voice caressed her name, his eyes directly upon her face. Her old face, she thought irrelevantly, the wrinkles showing out here in the sunlight, and then forced herself to respond in a casual voice.

"Forever is a long time, John."

For the distance of a city block, he drove the horses in silence, his eyes on the narrow lane ahead. Finally, he asked, "Will you still want me to come to your house now that you no longer need me?"

"I don't know what I'd do if you stopped coming!" The unguarded words obviously surprised her more than they had surprised John.

He looked at her again. "I'll come, then."

Maria, in black silk, sat beside him in suspended silence. The wrong words spoken now, she felt certain, could wreck the remaining years of her life. What she really wanted was for this warm, sunny man to spend all his days and nights in her house. No matter what anyone else said, she felt, *she knew* him to be unselfish and tender—reliable. Otherwise, why on earth would he have cared so for an ill, whining, old man whom he'd never known as the real Captain Joseph Peavett? John, she was certain, was lonely, in need of family life—a home, friends who would love him for himself.

"What may I do for you for the rest of the day, Maria?"

She gave him a grateful smile. "Just stay with John Edward and me."

At home, after they waved John Edward on his mission to the city stables with the carriage and horses, arm in arm, Maria and Hudson walked slowly through Maria's garden gate and around the house to the arched loggia.

"I love you, Maria," he said simply, his gaze direct and sweet. "I mean you only good."

Then he took her in his arms and kissed her gently on the mouth. She clung to him.

"Now then," he whispered, "I promise not to say that again for a long, long time. 'Twould not be proper with the captain so lately in his grave. I felt you needed to know." He held her at arm's length and smiled. "So, I have told you, and now we can conform to custom. No one needs to know but us for whatever time you say. No one but you and the boy and me seems to know that Captain Peavett has not truly been here for a long, long time."

He led her to one of David's chairs, his hand on her arm as possessive and certain as the look in his dark, melting eyes and the sure ring of his voice. "I expect nothing from you." He bowed. "I'm—simply at your service, lovely Maria."

318

The short, raw, rainy February days flew toward the close of winter as though they were the gold and green days of spring. Days filled with light for Maria, even when the sky above her garden hung low with clouds. John refused to move into her house as a nonpaying boarder, choosing, he said, to protect her reputation until enough time had passed for him to live there as her husband. There had been no moment of decision between them. He had not even asked her to become his wife. They had simply known. Not one day passed without his visit. She ate breakfast with John Edward and hurried through her accounts and the supervision of her household, listening through every minute for the merry jingle at her gate. Daily, in Hudson's arms, she took and returned his kisses, touched his face, his arms, his shoulders, reassuring herself that she had not dreamed him in the night just passed.

A year from Joseph's death, she felt, would be long enough to wait, now that only a handful of permanent English residents remained in the city. Say January 1787. She had seen neither Don Luciano nor Jesse Fish since the funeral, nor had she thought of calling on Antonia. John Hudson filled her days, her hours, her minutes. There could be no sorrow now that Joseph was at last freed from his wretched cage. There could now be no sorrow—no more sorrow anywhere in her world. She lived each day almost convinced that John Edward's God—David's God—Antonia's God had begun to pursue her heart with love instead of a command to endure. She felt yielded to a love so much higher than herself that there were times—especially during the long winter evenings before the fire when John sang to her—that she longed to know how to pray. Longed to understand the kind of prayer that reached into the very glory she had seen so often on David's face in the garden when the house was only a cottage. The clean, child glory she saw when John Edward—a young man of seventeen now—smiled.

The affairs of the still sparsely settled colony appeared to be going reasonably well. In spite of all the Indian problems involved

with the Panton and Leslie trade and the continuing agitation by the greedy Georgians, Governor Zéspedes did seem to be piloting a steadier ship of state than the erratic Tonyn. At least, so far as she knew. Because John Hudson showed no interest whatever in such matters, neither did she. His full, passionate attention was beamed upon her, upon bringing her the joy she'd lost so many years ago. The joy and the love and the youth. Why should she worry herself any longer with political developments? She owned more property than most East Florida colonists. After a lifetime of struggle amassing it, why should she bother now with the sordid intrigues at Government House? John had come. When the year was behind them, this shining year of 1786, he would become hers and she his forever.

An hour or so before John was due on a morning in late spring, Maria opened her gate to a solemn, subdued Don Luciano. Appearing uncharacteristically tense, he wasted no time in small talk.

"I have come at last, Doña Maria, without hope—but compelled after all the years of our friendship—to ask you to marry me."

If he had struck her, she could not have been more astonished. "I—don't know what to say. What in the world brought on such a question—at this late date?"

"May I sit down?"

"Of course. You surprised me so, I forgot my manners."

He followed her to the garden. "It has been no secret, my love for you, Doña Maria," he began. "For twenty-three years. But I was a Spanish spy, you a British subject. The agreement I entered into with my government forbade my marrying anyone but a Spanish lady. I—loved only an English lady. Also, you were not Catholic. I have waited, for your sake, these months since Captain Peavett's death." His face paled. "What is there that stands between us now—but the scoundrel, Hudson?"

Maria struggled with both anger and anxiety for Herrera. As he spoke, the color seemed to drain from his face and his voice thinned.

"Luciano! Are you—ill?"

"*Sí*. My sister worries. I lie to her. I do not lie to you. The doctor, Bernardo de la Madrid, is a wise man. My heart, he claims. *Sí*. My heart—is in need of you, Doña Maria. This Hudson, he will ruin you!"

She stared at him, feeling dizzy herself, and helpless, as though she had just been pushed from a high place and was falling headlong.

"Maria *mía*." His words were labored. "For so long we have been friends. Let me—save you from this foolish thing you plan!"

"How do you know what I plan?" That was not at all what needed to be said, but her mind had gone as dry as her mouth.

"The man has no standing in the city. For all the years we have been friends, I have watched you toil and save to acquire your excellent position here—your properties. If Hudson has worked one day in his short life, I would be surprised to learn of it!"

She got abruptly to her feet. "That's enough. That's more than enough!"

He looked for a long time at the greening grass of her garden, then began nodding his head slowly. "*Sí*. It is enough. Except for one thing."

"Well?"

"I will—go to my grave—loving you as deeply as a man can love a woman." He still sat slumped in the old chair. "I have loved you since the day you appeared at my father's house so long ago, to rent a horse."

A finch called somewhere in the garden. Once, twice, then three times, waiting between calls, deepening the silence that had moved in between them. The longer the silence lasted, the more difficult it was going to be, she knew, to respond. Her anger was subsiding. Luciano was only jealous of John and obviously not well. She searched desperately for the right words. The right words for them both. None came.

The bird called once more. Luciano looked directly at her for the first time since they'd entered the garden. He lifted one hand to preserve the silence, then got slowly to his feet and walked around the house out of her sight.

Still standing under the orange trees, she heard the gate close softly behind him.

That night, while she listened intently as John explained just how he wanted an upstairs room remodeled for his own use once they were married, the gate bell rang. He went to answer and returned in a moment, his face carefully guarded, showing no emotion whatever.

"I know this will be a blow to you, lovely Maria," he said gently, "but I'm here to—comfort you."

"What is it? What's happened, John?"

"An Herrera servant just brought word that Don Luciano died an hour ago—of heart seizure."

Resolutely, the next morning, Maria made herself walk the familiar distance from St. Francis Street to her old house on Charlotte Street, into which Luciano had moved with Antonia and her son in 1780. Young Sebastián must be about twenty-three; he was the first baby she had delivered in St. Augustine. Now he was married and in his own home.

"I can't do much for you," Maria said, after the two women embraced. "I'm—empty-handed. But I—came, Antonia."

The younger woman nodded her head numbly. "My brother, he loved you," she whispered.

"Did he tell you that?"

"He did not need to tell me. I have known for many years." Then, Antonia said, "He—did not suffer too much."

"Oh, thank you. I'm glad to hear that."

"A severe pain and the gasping for breath. But not so long a time."

"He visited me only yesterday."

"I know. He wanted to save you from—from any more heartache."

In the midst of her grief over Luciano, resentment as strong as acid seared Maria's mind. Obviously Luciano and Antonia had

discussed her upcoming marriage to John when she herself had told no one. How, *how* could two such close friends fail to understand that with John Hudson the sun had come up in her life for the first time in almost a quarter of a century? She had highly valued her life with Joseph before he was stricken—she still did—but then, she had never expected that the sun would truly rise for her again after David went away. Walking to the Herrera house, she had felt stabs of guilt for having neglected both Luciano and Antonia. After what Antonia said, the guilt was gone. She rose to go.

"I shouldn't have come. I did come with good intentions. I see it was a mistake." Her shoulders straightened and her chin lifted. "I'm sorry—about so much. I'm truly sorry."

That evening in the parlor, when she told John of her visit to Antonia, he laughed tenderly, very tenderly. "I can help you with that, too, Maria. You see, I understand why your friends disapprove of me."

"Nonsense."

"*Good* sense on their part. You've fallen in love with a madcap, poorly connected Irishman with no money—who is able only to return your love a thousandfold. There's no way mere friends could understand love like ours. Everyone—you must remember this, beloved—everyone is going to misunderstand. You and I are simply going to have to forgive them." He knelt beside her chair and took both her hands in his. "The kind of love we know passes not only the barriers of age, it passes the barriers of any human understanding. Except ours. Like me, you're Catholic now. We're supposed to have some sense of what true forgiveness means. And we must forgive them all, Maria." He forced her to look at him. "Antonia's was a painful, but small attack on me. After all, I'm in love with the most respected and successful lady in the colony. I've made her happy. Why wouldn't there be jealousy?"

"Jealousy?"

He laughed again, softly. "Of course. Was Herrera a happy man? Is Jesse Fish? Is Antonia happy? Is John Leslie? It's human

nature, love, to be jealous when a sky-splitting joy such as ours is looked at through lonely eyes. We must have only pity for all your friends."

"One thing I know. We *can* stay to ourselves."

"Of course. I just want you to be sure that none of it bothers me one whit. Listen to me, Maria . . ." He began to sing to her: "I know where I'm going and I know who's going with me. . . ."

Under the gaze of those dark, enfolding eyes, her hurt and indignation began to slip away. Perhaps he was a madcap. Of course, he had no money, no connections in the province. But he was surely far wiser than his twenty-seven years. Tonight, she had needed that wisdom. When once again, she needed him to be only young—a madcap—he would be. He pulled up a chair and stretched his supple body in it. Neither spoke. There was no more need for words.

Maria soon found herself thinking of all her friends without bitterness. The pain at losing Don Luciano flooded back over her. Although of late they'd seen little of each other, his death would, she knew, be unreal for a long time.

John reached to touch her wrist lightly. "Don't feel you have to talk, love," he said. "I touched you to remind you I'm here—with you in your sorrow."

"Don Luciano was part of my life—for twenty-three years. My dear friend. His sister's child was the first St. Augustine baby I delivered."

John said nothing.

Antonia's thin face, swollen from weeping, came before her. I was cruel, Maria thought. I must go again. I will make myself go again—after they bury Luciano—and do a better job of—expressing devotion, for her sake. But, she prodded herself, it is surely not fair to John to let the grief show so plainly now. I owe it to him to turn my thoughts back to our life together.

"Let's talk more about your private room," she said. "If we remodel it, that old desk and bed will look shabby. We'll have to buy all new furniture. I want you to have the handsomest desk in town!"

"Oh, I'd like that. But what will I do with a writing desk? Were I disposed to write letters, which I'm not, I should write them only to you. I'd much rather kiss you instead." He touched her gently again.

They did not wait the full year after all. On the last day of November 1786 she rode in Joseph's carriage between John and John Edward to the church in the old, ramshackle Bishop's Palace on the Plaza, and in the presence of no one but Father Hassett and the two witnesses, John Edward and Don Manuel Solána, Maria Evans Peavett became Maria Evans Hudson.

That night, lying beside him as he slept in the big bed, her body and heart satisfied for the first time in more years than she cared to count, she experienced a kind of certainty that defied even her understanding. The disapproval of her friends no longer troubled her, because the certainty she experienced did not come only from trust in John. It came from trust in the quality of her own love for him. She had been too young with David to realize that real love went on year after year concerning itself first and last for the loved one. At fifty-six, Maria Hudson had learned how to love fully. Her happiness for the years left to her would be measured not by how John made her feel, but by the extent to which she was able to give happiness and security to him.

Careful not to awaken him, she slipped an arm under his tousled head and pulled him onto her shoulder. With the strong will which had pushed her ahead all her life, she now closed her mind to the dread picture of a young, handsome man one day supporting a frail, faded old woman. When, in less than four years, she would reach her sixtieth birthday, John would still not be as old as she had been on that long-ago first day in St. Augustine. She took her contentment this night from the quality of her love for him and the almost certain knowledge that she would die first. Her death at some future time as an old woman could not then hurt John too deeply. And death could never hurt her again.

34

As to what was going on in the province, Maria knew only that Governor Zéspedes had gone with Father Miguel O'Reilly and Captain Carlos Howard on a tour of the province, to extend through winter into spring. A hardship, she'd thought absently, for his Excellency, a man well into his sixties, but Father O'Reilly and Captain Howard would, she knew, see to his every possible comfort, and it was important, she supposed, for the few settlers scattered about the colony to meet their governor.

Beyond that, her thoughts were far from the welfare of East Florida. She did think now and then that if Spanish settlers came, she might return some day to the practice of her own profession. She might act in an emergency even now, but a Spanish midwife had come from the Canary Islands, and until Maria again ran short of actual cash, she intended to spend her time with her new husband. They had decided against a wedding trip because life in the St. Francis Street house was so comfortably shut away from outside interference, there seemed no need to leave. Besides, it was good to be happy and carefree in the house where poor Joseph's suffering had so darkened the years. Except for time spent occasionally in his newly done room, the door closed, John seemed content just to be with her. She had found a gay, warmhearted companion for her days, and each night he slept beside her in the big bed in her room. She had insisted that they both needed new wardrobes, and so hours had been spent at fittings. His slightest wish was, to Maria, a command. A command that gave her more pleasure than even she could believe. When she asked, as she often did, if there was anything, *anything* he wanted of life that he lacked, he would take her in his arms and say, "Yes. Yes, beloved Maria. More years to be with you."

Summer was upon them. The days grew longer. The air, when there was no east wind, swarmed with insects. Flowers bloomed

now in their garden because John wanted them. That she had intentionally not planted flowers so that the garden would more clearly resemble her own nearly forgotten green and secret place no longer mattered. She seldom sought it out these days. She had found her certainty, as well as her stimulus, in the miracle of the presence of the young man who loved her so well. They spent less time outside in the heat of summer. John hated the flies and sand gnats even more than she, and because he found David's wooden chairs too hard and straight, she'd had them moved to one corner of the yard; on the days when they could sit out, they reclined in new padded chairs built to John's specifications by a carpenter on St. George Street.

Not often, but now and then, she spent an evening alone with John Edward. John had only to hint that he felt like a mug or two of cider and the company of his men friends from the old days, and she would urge him to go, wanting always for him to be free.

"I've learned this much at least about love—your favorite subject," she said one evening as she and John Edward sat side by side on the balcony off her upstairs parlor. "I mean to leave John free. I love him enough to see to that."

Looking out from the balcony over the waters of Matanzas Bay to Jesse Fish's Anastasia Island, John Edward did not answer or turn his head.

"Cat got your tongue, dear? Is anything wrong?"

Long palm fronds cast waving shadows across the normally happy face of the young man she loved as though he were her own son. He turned in his chair to lay a comforting hand on her arm. "I'm sorry, Good Maria. There's something on my mind and I'm—going to tell you. I'm just trying to find the right words."

"We've never had to be careful with each other."

He nodded, took a deep breath and said, "John—uh, John—"

"What about John?"

"I'm only telling you this because he's my friend and he made me promise I would. John—has a debt."

"A debt?"

"Yes."

"Well, why on earth didn't he tell me?"

The boy shrugged. "I—guess he was ashamed."

"Oh, I don't believe that. He and I are too comfortable with each other for him to be ashamed to tell me anything!"

John Edward thought a minute. "Well, you know how it is—sometimes when a man's in love with a woman—aw, you know what I mean, don't you? After all, he didn't have a peso when he married you. That's hard on a man."

"I know." She sighed. "You're being wise—as usual. Wiser than I. Son, tell me the truth. Have I harmed him by—by being too generous? I don't feel I'm giving to him. Everything I own is his, too—and yours. I've never seen any of that stubborn male pride in John. He's always received so graciously. If he needs money now, he knows he only has to tell me. Have you any idea why he needs it?"

"He's been—gambling."

"I see. Well, I expect him to have a good time when he's out with his friends at night. Surely he couldn't be gambling much. There's so little money in town. Actually, we have more than most, but for months now, I've taken yard goods as rent from Mr. Arbuthnot, the tailor. I don't worry my head any more, thank heaven, about the happenings at Government House, but everyone knows that even the governor can scarcely get enough cash from Havana to pay the soldiers, let alone the carpenters and stonemasons working on the fort. There just isn't much money in the province, so aren't you making a mountain out of a molehill? What money John needs, of course, he may have, but it just couldn't be much."

John Edward hung his head. "He—didn't gamble for cash. He put up one of your houses. He lost it."

She sank back into her chair. "Do you know which house?"

"The little one—on Cuna Street."

"Where Mr. Arbuthnot lives?"

"Yes, ma'am."

"Well, I'm too attached to the Arbuthnots to see them have to leave their home. They've both worked like dogs to build that little

business." She stood up. "I'll think of something. I certainly don't have that much extra cash. Thank you for telling me, but from now on, he *must* come to me. John must not burden you."

He got to his feet and put his arms around her. "Good Maria, nothing that has to do with helping you could ever be a burden to me. Besides, he's my friend. I brought him here."

"And no one could have done a more wonderful thing for me. I'm sure he—just had a little too much to drink that night."

"Yes, ma'am. I hope that's all it was."

"Son, I want you to love me, but not so much that you ever forget to love John Hudson, too. He needs us. We're all he has."

Maria was sitting up waiting when John came home, long after midnight. She could hear him bump the wall beside the narrow stairs, his booted feet feeling uncertainly for the treads, but he was singing softly to himself. He stood leaning against the doorway of their room, then ran to kneel at her feet, his head in her lap. "Forgive me, Good Maria. I'm late."

"Yes. But you're here." There was so much emotion in her voice, it trembled a little, like an old woman's voice. "Did you have a good time with your friends?"

He nodded his head, his face still hidden in her lap.

She laughed. "Is that all you can do? Nod your head? Who was at the tavern?"

"Nobody you'd know," he answered, his voice muffled in the folds of her dressing gown.

She took a deep breath. "John Edward told me about the Arbuthnot house. I'll—have to do something to save it for them. Tomorrow, after we've had a good night's sleep, we'll think of a way to keep the house."

Slowly, he raised his head and looked straight into her eyes. "Did you know I'm married to the most wonderful woman in the whole wide world?"

"I know you're married to *me*. Now, out of your clothes and into bed with you."

In his arms, she struggled to suppress the impulse to scold about the gambling. He was kissing her tenderly, as sensitive to her body as ever.

"John! There's something I must say to you . . ."

"I love you, Maria," he breathed. "Let me show you—how much!"

"No! I—need to talk to you!" His caresses grew passionate, his hands moving downward over her yielding, trembling thighs. "John Hudson! Listen to me . . ."

"What is it, Maria?" He breathed the words between kisses. "What is it you want, lovely Maria? What is it, my love?"

When she had given him everything her mind and body and heart could give, they both slept.

She awoke the next morning, John beside her, still asleep, one arm thrown across her. She stirred, tried to disengage his arm. He tightened his grip.

"John, it's time for me to get up. I have work to do on the accounts this morning."

"Sh!"

"You sleep if you like, but—"

"Shh!"

Suddenly he opened his eyes and smiled at her like the sun coming up all roseate over the Bay.

"Fooled you, didn't I? You see? I wasn't so sound asleep." He sat up. "Now then, so you'll know, love, that I merely had a wholesome time last night with my friends—that I didn't gamble, that I'm a solid, responsible husband, I intend to help you with those accounts this morning!" Then he took her in his arms. "*After* I've had about six kisses, that is."

He bounded out of bed and went to his own room to bathe and dress—earlier and with more gusto than she'd ever seen before. Bathing herself from the large handsome porcelain bowl Joseph had selected especially for her, Maria could not help smiling. She smiled and kept smiling as she dressed for the day in one of her new summer cotton dresses—yellow-and-blue striped, with flouncy cuffs

at her wrists. John was singing at the top of his voice in the next room, and surely, because he splashed so vigorously, Long Stem would have to mop the floor.

After a big breakfast of mullet roe and rice, they worked together over their accounts for the remainder of the morning. Her delight that he was voluntarily helping her, showing an unexpected aptitude with figures, caused her to postpone any mention of the Arbuthnot house. Her way was to go directly to the heart of any matter, but being in love changed a woman.

At last she laid down her quill, closed the ledger, and sat looking at the dark, handsome head still bent above a full sheet of entries. Her husband was suddenly showing such acumen, such rapid comprehension of their vast holdings, she wondered how wealthy they might become if he possessed one shred of Joseph's ambition to acquire more wealth. Such ambition would soon put an end to their carefree lives, though. Maria didn't want that. She and Joseph had devoted their every waking hour to managing their possessions, to keeping track of newly available lands and houses as they came and went on the market. Joseph's prestige in the city—and, of course, hers—had made it possible to acquire land grants which would, she was certain, be unavailable to a young stranger like John Hudson.

Her eyes caressed the lines of his freshly combed, shoulder-length hair swept back from the perfect forehead and tied with a black ribbon. His finely boned hands held the quill with grace as he transferred one long column of figures to a second clean page. Even the slight frown drew her. It matched the deep cleft in his wide chin. Beautiful was the word that came always to her mind with John, as it had with David. The whole of John Hudson now beautiful and familiar. A stranger? Yes, to most of the city. Almost a stranger to her last night, but today he was her own dear, familiar husband—and would be until the day when her life would end.

All though their happy working time, she'd put off bringing up the gambling debt. If only she'd dreamed that John had

gambled away the Arbuthnot house! She heard light, rapid foot-steps on the stairs and looked up to see John Edward in the doorway of her second-floor office. The sight of the boy drew her cruelly back to reality—to what she must do without any more delay. As clearly as if he were saying the words, she read his language from his face: he looked a question, eyebrows raised, seeming to infer her no, and took on an expression of extreme commiseration at the task still ahead of her. Then he turned and went softly back downstairs.

John had not looked up from his figures. Whether her boy had merely wanted to show his sympathy or had felt she might need a reminder, it worked. She had indeed been on the verge of trying to think of a plausible reason to go on postponing any mention of the gambling debt. How could John Edward know her so well?

"John," she said in a strained voice. "I'm so pleased that you're helping me, but we have to find a way to save the Arbuthnot house! Do you have an idea?"

He sighed contentedly, as though the entire matter had nothing whatever to do with him personally, tipped back on the legs of the straight chair in which he sat and mused, "Yes, yes, I have an idea. While I was going through the assets on your North River property—"

"On *our* North River property."

"Right, love. It occurred to me that we don't need all those Negroes we have up there. We could sell off—"

"No! That's one thing we absolutely will not do. I do not sell any of my people. They're not only our most valuable assets; I know them all. I refuse to sell even one of them."

"Then how about the seventeen who work Captain Peavett's Pablo Creek plantation?"

"No. We sell none of our people. None who work—anywhere."

He scowled, but only momentarily. "Then how about that ten acres adjoining the large tract on the outskirts of the city? It's just lying there, bringing in no money."

"You've really boned up on our holdings this morning, haven't you? Who would buy it? John Leslie?"

"Perhaps. Or one of my Minorcan friends. An ambitious woman named Señora Ysabel Perpal, who lives in the old De Brahm place next to Government House, might well be interested in some farmland near town. She already owns several acres out that way."

"Can she afford it?"

"I think she can. This is quite a lady. Minorcans aren't all palmetto cutters, you know, no matter what your British aristocrats thought. Ysabel might like the idea very much. Shall I inquire?"

"You know her well enough to call her by her first name?"

He laughed. "I lived with the Minorcans, don't forget, love. Until you rescued me and set me down here in your palace."

Maria thought that quite unfunny. "All right. I'll see John Leslie today and ask him to appraise both the ten acres and the Arbuthnot house."

He laid his hand over hers. "I'll never do it again, Maria, I promise."

She suddenly felt old and unsure. "All right. I believe you. I— have to believe you."

In Leslie's office that afternoon, partly because she wanted an unpleasant matter behind her and partly because she was embarrassed at not having seen him in so long, Maria opened their conversation abruptly.

"I need a favor," she began, hoping to keep her voice even. "In going over my accounts today, I was reminded of that ten acre tract west of the city."

Leslie, watching her closely, nodded. "I know the land."

"Could you give me an idea of its value on the Spanish market? It's of no earthly use to me."

"I'd appraise it at roughly a hundred and twenty *pesos*." He waited, his eyes still on her, then said, "That should just about buy back the Arbuthnot house."

Maria jerked herself straight in her chair, but said nothing.

"I saw no reason to continue the little charade," Leslie went on. "We're friends. At least, I hope we're still friends. I detest charades.

So do you. It isn't like you to come here with a cock-and-bull story about that land being of no use to you." He leaned, almost wearily, she thought, back in his chair. "This kind of thing won't go on, will it? You are going to hold a tighter rein on your new husband's gambling habit, aren't you? You see, Maria, I honestly don't think I could endure it if what you and Captain Peavett worked so hard to accumulate should be—"

"That's enough! I didn't come here to be insulted or to have my husband insulted."

Leslie waited, then said quietly, "The man means trouble, my friend. Trouble for you, for your future, for this town. I'm aware that I've probably just ended a friendship which I shall value always, but I'd be no friend if I kept still. The Arbuthnot house is only the beginning of your troubles."

"I don't frighten easily, John Leslie," she managed to say. "That one loss is all there is and I demand here and now that you believe me *and* apologize!"

"I can apologize far more easily than I can believe you."

"Have I ever lacked integrity?"

"Never. That's what breaks all our hearts—those of us who hold you in such high regard."

"Who else knows, John? If you are my friend, you'll tell me all you know of this—preposterous false gossip!"

"Maria, I happen to know it isn't false."

"But—who else is aware of it?" She heard an unfamiliar, shrill edge to her voice.

"Jesse Fish, for one. He knew way over on his island."

"I suppose that hussy of a wife told him!"

"I imagine she did. She and your husband know the same stripe of people. Fish didn't say. The old man did make a trip over here to talk to me about it. To be sure it's true."

Maria was so near tears, she scarcely trusted herself to speak, but driven to explain, she threw herself on the mercy of her friend. "John, please listen to me. I know how people talk because I married a man so much younger that I am. I've tried to put the talk

out of my mind and sometimes I've managed, but I *know* they think he married me only for my money. That's not true. I don't understand it any more than you do, but John Hudson loves me. It's a mystery—a miracle, but he does. He—simply made a— youthful mistake with the dice. He's promised it will never happen again. I believe him. If you knew how good and kind he really is. Oh, he shows only his devil-may-care side to most people, but I know him. He took care of Joseph as though he were his own father! Keep an open mind toward him, please. Visit us and get to know him. Don't judge him, I beg you, on hearsay. He's a great-hearted, happy-natured person who would do anything on earth for a friend. John Edward said the Minorcans love him. Now that he lives in a fine house on St. Francis Street, he still visits his old friends—every week. He and John Edward often go together. Take gifts to them—fruit from our trees, jellies, even meat and sugar and rice. He's a foolish child, but he's good. Won't you, for friendship's sake, not prejudge him?"

Leslie ran a hand through his thin hair. "You make a strong case for him, I must say."

"Have you any proof whatever that he's done anything else wrong? Is there any other reason except his lack of—of judgment that causes you to speak of him as you have? To pity me as you so obviously do?"

"No. To be honest, there's nothing else. So, I apologize." He leaned toward her. "I suppose I should tell you where I learned about your loss of the Arbuthnot house. You see, I happened to be in the same tavern the night your husband laid his bet. I watched it happen. He was drunk. Quite drunk."

"Of course, he had to be! John, he *is* young. Fun-loving and young. That's one reason I married him. After the years of confine-ment with poor Joseph—I needed to laugh again. Do you understand that?"

He nodded. "You're managing to make me feel like a ha'penny, and I probably deserve it."

"To whom does he owe this debt?"

"A new man in town. A Georgia cracker. Maria, let me buy that ten acres. We can settle it right now."

"Frankly, I thought you might offer once you understood, but I want my husband to learn from this. He thinks a friend of his will want to buy it. He's with her now. If possible, I'd like him to get himself out of the mess."

"All right, but if that fails, just let me know."

Maria stood. "Thank you for everything—especially for your understanding of—my position in all this. You see, I *am* the one who's receiving from this marriage. I married him for what he *is* to me—because I love him in every way a woman can love. Already, he's given me far, far more than I'll ever be able to give him."

35

For the remainder of 1787 and into the spring of 1788, Maria's days were idyllic. John had sold the ten-acre tract to the enterprising Minorcan, Ysabel Perpal, the gambling debt was paid, and the tailor, Arbuthnot, still lived and worked in the Cuna Street house. Partly because of their extensive holdings, she supposed, but also because Zéspedes had begun a campaign to persuade her to return to her profession "for the well-being of the colony," she and John had been invited to several functions at Government House. Whatever the reason, she enjoyed herself as much as she ever had at a ball, in spite of the fact that she now grew a little winded when she danced too long without pause.

"Does it embarrass you that I can't quite keep up, darling?" she asked one night when they returned home from the most lavish ball the governor had given to date. "I do still dance well—while I'm dancing, don't I?"

"More than that, love," he answered, pulling his nightshirt over his head, "you're by far the most beautiful."

"Nonsense. At my age?"

"Because of your age!" He drew her down beside him, where he sat on the bed. "Maria Hudson, listen and heed what I have to say because I don't intend to repeat myself. I would never be invited to Government House without you. The only genuine pride in me is that you are my wife." His face was open and childlike. "I don't see much reason to go over and over a thing, but you know as well as I that in all my thirty years, I've wasted my time, what talents I have. I've accomplished only one important thing in my entire life—I succeeded in getting you to marry me. For always, I will be humbled by that." The disarming smile flashed. "I even think that maybe one day I'll turn into a true gentleman. Did I conduct myself in a proper fashion tonight?"

As she thought he had been both proper and charming, her answer came eagerly. "Yes. Oh, yes, beloved. I was proud to be Mrs. John Hudson."

He settled himself more comfortably beside her on the bed and began swinging his legs. "Maria, do you know I was a little scared the first time we went together to Government House?"

"As handsome as you are? I can't imagine why."

He was holding both bare feet out in front of him now, examining his straight, slender toes. "Oh, I dunno. Yes, I do know. You're the most respected lady in town. The best known, the most admired. The most gossiped about because you married a no-good lad like me." Drawing his legs up onto the bed, he crossed them under him and looked straight into her eyes. "Help me, Maria. Don't be satisfied with me as I am. Teach me how to be a wise, mature, acceptable gentleman."

"John, I wouldn't change one thing about you—"

Without warning, he pulled her forcibly down onto the bed beside him and arranged her head just the way he wanted it on his shoulder, so that her face was pressed into his neck. "There now, I can talk more easily when you're not looking at me. I know I'm handsome. The living image of my no-good Irish father. I've noticed, don't think I haven't, that you've never pried into my family. My father was the handsomest man in Waterford, Ireland, and the biggest sot. He beat my little mother regularly, but she loved him—and I never forgave her for loving him because I hated him from the time I was old enough to know he was my father! My mother was a weak saint. Unlike you. You're not a saint and I'm glad for that, and you're strong. I need you to be strong." He was silent for a time, then went on. "Do you know something? The only good, saintly, loving person who was ever drawn to me in my whole life is our John Edward. I don't know why I'm so fond of him except that he loves me just as I am and with all his heart. Our boy really is a kind of saint—I sensed that right off. Because of my mother, I know a saint when I see one. He's a saint, and still I don't think the less of him or consider him at all weak. God knows I don't aspire to sainthood, but for you, now, for the first time in my life, I want to be accepted—trusted. I want St. Augustinians to think me worthy, at least, of your little finger."

He drew her closer, but she knew he was in no mood to make love to her tonight. She was glad. This was a new kind of closeness growing between them. What he had just told her required no response. He was like that. Seldom touchy. Never demanding. Her husband was her sweet young friend—both man and child. Two minutes, or perhaps three, passed in deep silence, then he whispered: "Maria?"

"Yes, my dearest?"

"Could we just drift off to sleep—like this? Close and quiet?"

She yawned contentedly. "I am asleep, my dearest."

They laughed.

One early summer day, Maria finally paid a visit to Antonia. This time it was not difficult. She found the younger woman

hospitable and willing to forgive not only Maria's burst of defensive temper because Antonia had criticized John, but the long months of neglect as well. From then on, with almost embarrassing gratitude, Antonia accepted every invitation to visit the Hudsons. As with John Leslie, Maria felt that Antonia was also beginning to understand her young husband.

"I spoke with Don Manuel Solána," Antonia said after the three had finished dinner on a hot, humid July evening. "He urged me to convince you, Doña Maria, that you are needed desperately in the city as a midwife. For one thing, his own wife is soon to have her second child, and they are frightened—she nearly died with her first, thanks to the crude ministrations of the old woman who officiated. One of our family friends did die—the midwife was the same old woman. Both mother and child would live now had you been there."

Maria winced inwardly. Lately she had turned down call after call, justifying her refusals by the fact that she had served her time in the difficult profession, was growing old, and needed now to be free of responsibility.

"That's a great compliment, Antonia," she said carefully, "But no one can be sure they both might not have died, no matter who was in attendance."

John, whose mind had seemed miles from their woman talk, sat up brightly. "But, Maria—Doña Antonia is right! I've just decided I've been selfish long enough." He beamed his smile at them. "You're needed, love. Antonia is giving good advice. Anyone needs to be needed—even you. You see, I haven't told you, but Father Hassett himself came to me weeks ago, thinking I was the sole reason you refused to resume your 'true work'—his exact words. It seems you're a tradition in this city—never mind how long it's been. Maria Hudson is needed. I'm in favor of it."

"But, John, you didn't tell me Father Hassett had spoken to you."

"Of course not. I was humiliated that he blamed me." The smile was turned now to Antonia. "You see, I'm so much less than my wife," he went on, "I try to hide all my deficiencies—especially from her."

"He's teasing," Maria said uneasily. "I will think it over, I promise. Since Joseph died, I've thought now and then of returning to my profession, but—oh, I admit I've enjoyed sleeping all night every night, without being aroused by either my poor dear invalid in pain or a mother in labor."

Later, after John had seen Antonia home, he said with a solemn look, "Don't refuse because of me, Maria. I promise to be right there waiting to protect you on your way home through the dark streets— just as Captain Peavett used to."

"How did you know that?"

"It's part of your history in this city, my eminent darling. As I said, you're a tradition."

Maria's decision to return to work was partly owing to the approaching time of her old friend Manuel Solána's wife, and sure enough, her first call came from Solána himself. Doña Maria Mestre Solána, his second wife, was a young Minorcan. Solána was filled with gratitude that this time she would, with Maria's skill, be spared another close brush with death.

But walking beside John toward the Solána home, Maria felt nervous and uneasy. "I'm out of practice, John. And the Solánas are prominent in the city. They were Luciano's close friends, and Antonia's so fond of them. You will be waiting for me, won't you?"

He gripped her arm comfortingly. "Don't worry, love, I'll be waiting—in the parlor. Don Manuel has promised to send a servant in plenty of time for me to get there."

In the loggia of the Solána house, he kissed her tenderly on the forehead and left. Maria hurried to the gate for an instant to watch him stride gracefully up St. George Street. She had assumed that he would go back home, but of course, she told herself, the poor boy had endless time to kill before he could return for her. Heaven knew he'd done all a man could do to help her in the surprisingly difficult task of reentering her old profession. He had not only encouraged her—this morning, he'd made two running trips to the apothecary for sweet oil of almonds—

the very scent of which brought an all too vivid memory of Joseph's aching legs—and for cordial powders. She had smiled at John when he left her, but she found that she was nervous and uncertain without him.

The awareness that she was somehow apart from him swept over her. Even her knees felt weak as she followed Don Manuel Solána up the outside stairway. As always, she insisted upon entering her patient's room alone.

Solána's wife lay in a heap on the tumbled bed, her eyes wide with fear. Reason enough for the fear, Maria knew.

Maria spoke so firmly and gently that her own assurance began to flow back. She had not, after all, forgotten the bright agony of this moment of pain and mystery. Her hands moved deftly over the big abdomen, her instincts certain, as though the years away from her practice had never existed. The examination, as always, filled her with wonder. She thought again of God. Nothing had changed. The steadying Presence began to fill the room, and this time the Presence did not seem strange or confined only to this moment when a new life was about to enter the world. A fleeting, grateful thought of John Edward came, and some of the awesome responsibility of the task at hand shifted to John Edward's God. A faint smile on her face, she mixed and administered a plain, milky clyster, relieving the mother's pain a bit, communicating her own quiet confidence.

For three hours, the strong, capable hands worked slowly, carefully. There was, she soon realized, need to turn the baby within the womb. Speaking words of encouragement and faith in the fact of the life about to come into being, gently, without a single outcry from the mother, Maria brought down the tiny head.

It had all gone well, far better than she'd dared hope. While the woman rested a moment, a thought illumined Maria's mind like a flash of lightning over a summer sea: From now on, would the Presence of John Edward's God—of David's God—be there if she felt need? Beyond a moment like this? If she called to Him, would He really come?

341

She bathed the infant girl, laid her in the mother's arms, and stepped out of the room to give Manuel Solána the good news and to ask that he send a servant for her husband. Back quickly in her patient's room, cleaning up, she heard a door bang shut. By the time she finished preparing mother and child for the father's visit, dear John would be there. As she worked, her heart lifted, and much of the weariness dropped away. She could do anything, endure anything, extend herself to any painful length if, at the end of it all, John Hudson was waiting.

A hanging iron lantern cast shadows across the tree-sheltered loggia of the Solána house as she reached the bottom step of the outside stairway. Her eyes searched the semidarkness.

"Good Maria?"

Her heart pounded. "John Edward?"

"Yes. I—I came to take you home."

She hurried to him. "But—where's John? He isn't ill, is he?"

"No."

"Then where *is* he?"

Her boy laid his hand on her arm. "I don't know, Good Maria. I haven't seen him since he left the house with you."

"I—thought I'd—just stop by the tavern for a round with my friends. Kill the hours while you were—working. Be home in plenty of time. I—stayed too long, Maria!" John's voice slurred in boyish anger. "*I told you I'm weak!* I told you, but you didn't believe me. Now, I'm—so ashamed. I'll never, never do it again, love. I promise. I guess I suddenly felt like—a nothin'. You'll be in demand again all over the city—after tonight. My friend Ysabel Perpal's daughter's having a baby. They'll want you." He looked up at her for the first time since he'd begun the tearful explanation. "I'll be there when you need me again, Maria. I swear to you—on my rosary, I swear to you, this will never happen again!"

On the stormy November night when she handed Juana's new son to the child's eager grandmother, Ysabel Perpal, Maria knew that

John would not be waiting. At the foot of the stairs this time, she looked for John Edward; and it was John Edward she saw. His lantern held high so that she could immediately recognize him, his eyes spoke admiration and comfort. He had remembered to bring her cloak against the rain.

She went to him. "I knew it would be you."

Over the next months, she delivered seven more children. Each time her foster son came for her. Each time, her husband begged forgiveness. Each time, she forgave him. But on an exceptionally chilly night for late spring, she reached the end of her endurance.

"I'm finished with it all, John," she said, sitting straight in her chair before the fire he'd just built. "I've delivered my last child. I can't live with this estrangement any longer. Or this worry over you! I didn't really want to go back to my work. You persuaded me. You were wrong. There isn't—obviously, there can't be—anyone or anything in my life but you."

Long legs stretched toward the fire, he stared morosely at the stone hearth.

"Look at me, John." He kept his eyes down. "Well, all right, then—don't. But one thing is very clear, and it's final. You need me more than anyone else does. That's enough for me. You wouldn't have been running to that tavern every time my back was turned if I'd been home where I wanted to be."

"You're cross."

"Not with you. With myself. You meant well, persuading me to go back to work. We've made good use of the money. It's true, I do need to be needed. But—you need me most. You're lost without me. Now I know."

For what seemed an interminable time, while she sat tensely waiting, he said nothing. Maria began to weep softly, hating herself for it, longing for him to take her in his arms. He did not.

Regaining her control, she asked, "What *can* I—do for you? There's no way I can avoid—being almost fifty-nine, but you're all I have outside of John Edward! What can I do to help you?"

His face, which had been so young and miserable, at once broke into an irrepressible smile. "Let's get out of the city for a while!"

"What?"

"Let's go—oh, let's go live for a long time on the North River land! Just you and me. I've never even seen our land up there. Isn't there an empty old shack we can stay in?"

"Oh, there's our cottage—built for Joseph and me—it was always ready for us. Sometimes we took guests. I don't know what condition it's in now, of course."

"Don't worry about that—you've never seen my carpentering, Maria—I'm a craftsman! I'll repair the place and you can give the orders."

"That's exactly what I'm sick of doing—giving orders, cajoling! Don't you have enough sense to know that?"

"You're even more beautiful when you're angry."

"Right now I don't care whether I'm beautiful or not."

"You worked too hard on those accounts today after the long delivery yesterday, love. You're tired. How were the accounts? I haven't seen them lately. Are we making lots of money at North River? Isn't it past time that the owners inspected the place?"

If she lived to be a hundred, there would be no way she would ever be able to anticipate him. Surrendering to utter weariness, she sank into the chair. With effort, she collected her wits enough to say, "Yes. We're making money up there. Our timber's bringing good profits in the West Indies. At least, along with everyone else in town, we're piling up credits with the Spanish government." It was true, she reminded herself, that she and John had never seen the North River land together. If one of his very own ideas worked out to good advantage, it might help. "All right," she said. "We'll go. Would you like to buy a boat for us to make the trip? It sounds as though you want to stay awhile. In that case, we shouldn't borrow one."

He brightened. "First thing tomorrow morning! In fact, I've had my eye on a fine little yawl. Almost new. Shipshape." His arms were around her now. "I love you," he said. "And just wait till you see the magic I work with a hammer and saw. I'm Erin's best!"

36

The next morning, groggy from oversleeping, John hurried through breakfast, kissed Maria, and left to buy his boat. Biting wind off Matanzas Bay brought him fully alert as he hurried up the waterfront toward the tavern owned by Ysabel Perpal's son, Juan. The first step in his scheme had worked. Maria had agreed rather quickly and graciously, he felt, considering how he must have surprised her. She loved him; he counted on that. It annoyed him, though, when she spoke of being old. A woman as smart as Maria should realize that her age was one of her main attractions. Well enough to spend a night in the straw with a tittering young filly, but when a man's future was at stake, he needed a woman with some subtlety and experience. And means. He needed her strength, too. Heaven knew, he'd played his own weak mother for a fool all through his boyhood. Maneuvering his sensible wife was different. He thought often of how he might be damaging Maria. He'd seldom, if ever, thought about the effect of his pranks and schemes on his mother.

He was deceiving Maria now, of course, but he'd make up for it in the end. He knew exactly how to make her happy, so a bit of trickery now to prevent future trouble for them both was only practical. He wasn't exactly ashamed that his mounting debts were forcing them out of the city for the time being. Every man he knew gambled some. One day he would win, and she would be proud. The only problem lay in keeping her ignorant of the latest debts. The noose would tighten if he stayed in St. Augustine. The property between North River and Guano Creek lay twenty safe miles away. Safe for them both until a solution came to him.

He swung casually astraddle the wooden stool at his favorite table in the tavern and waited for the Minorcan, Perpal, to appear. There would be no need to send for him. At the approach of anyone who owed him money, Juan had eyes in the back of his head.

In a moment, tall, hawkish, unsmiling Juan Perpal slid onto the stool opposite. "You got the money?"

"Plenty to buy your yawl, Juan. And I have forming in my fertile brain the perfect stratagem for eventually paying off every peso I owe you."

"I want the debts paid first."

"My good fellow," John said, "wouldn't you like to make a fine profit on your yawl, too? Come now, you're greedier than that. To be truthful, unless you sell me the boat, you'll probably never get the money I owe you."

"I'll get it, Hudson. I'll petition the governor."

"Aw, don't be a fool, Juan. That's a long-drawn-out procedure." He leaned toward Perpal confidentially. "Can't you trust me—just one more time?"

"You want the boat to make escape."

"No, no, no. I want the boat to take my wife on a profitable little trip during which I will find a way to deliver every peso due you when we return." John smiled. "You know how prominent my wife is in the colony. We own too much property for you to lose money on a few paltry debts."

"*I* own the property unless the money is in my hand."

"Even if my plan fails, do you think for one minute that an honorable woman like my wife would refuse to pay?"

Juan Perpal thought a moment, rubbing his dark, stubbly chin. "How much you give me for the yawl?"

"Fifty pesos."

"I sell it for seventy-five." He held out his hand.

John laughed and dug into his pocket. "Sold."

After counting the money carefully, Perpal peered at him. "You get enough from her to pay up all your debts to other people? And you pay me first? Before the others?"

"A promise. After all, you extended me more credit, didn't you?"

"*Sí.* I was a donkey."

"Nonsense. You'll find out how trust is rewarded. You see, Juan, my plan is to sell some slaves or a few acres of the North River tract. There must be well over two thousand acres up there! Beautiful,

high land, standing with all kinds of timber. How could there be a better risk than me?"

Perpal did not change expression. "Who has cash to buy land in Florida now? The British are gone, do you forget that?"

"Not all of them. John Leslie worships the ground my wife walks on. He'll buy it in a minute if she asks him to."

"The government owes Leslie much money. How can he buy land without money?"

John got up. "You'll see. Isn't it better, far better for two good Catholics to settle their affairs like brothers? Have the Minorcans had a better friend than John Hudson—ever?"

"Friendship does not pay debts."

John made him shake hands. "You've just robbed me for that boat, Juan. For now, we're even. I'll see you when we get back to the city."

For their voyage up the North River, the stormy March weather seemed suspended. It was a calm, sunny day with just enough wind filling the sails. John Edward, in spite of Maria's urging, did not go, nor did Long Stem, and once she and John had arrived and were settled into the sturdy cottage, she was relieved. Her husband had never been more attentive. The little house did need some repairing, and John was soon busy with the tenant farmer's carpentry tools. She marveled at his skill.

"How my father would admire your new shelves!" she said one morning as they ate the breakfast she'd prepared—biscuits, fried ham, *yomine* cooked the way Long Stem cooked it, boiled and then browned in the ham skillet. Maria rather enjoyed cooking again, and John's appetite was complimentary indeed.

"Do you really think your father would have approved of me, Maria? Not many do."

"I love you," she said. "That would be enough for Papa."

"But I mean—as a man."

"I told you, he'd be boasting about your skills as a carpenter."

The too familiar pain of defending John—even to himself— flared again. His serious, self-demeaning moments troubled her; left her so little to say. He was right. Few people in St. Augustine thought

highly of him, but twenty miles of marsh and river separated them from everyone in the city who gave them both discomfort. They were safe. Shut away alone and safe. Even the farmer's house and the Negroes' quarters were more than two miles away.

Lingering over coffee, her eyes feasted on the variety of greens in the rim of forest not fifty feet from the kitchen window: dark-leafed live oaks mingling their wide, thick branches with the bright, spring green of sweet gums and new pine growth—the yellow-bronze pollen drifting on air currents, warblers hovering everywhere. "Let's stay here forever, John. I'm dreaming, I know, but don't you wish we could?"

He gave her a melting smile. "This minute—right now—is better than any I've ever known. Enjoy it, dear Maria. We don't have to give one thought to the city or anybody in it, all day. Today is what we have, love—and in it, I intend not only to love you well but to build a bedside table for your books and your cup of water."

"Why didn't you tell me long ago that you were so good with your hands?"

He shrugged. "Why didn't you tell me you could cook? Anyway, would it be suitable for the prominent Maria Evans to have married a mere craftsman?"

"Maria Evans' father was a craftsman, I'm proud to say."

"We've only been here three weeks. Maybe we can't stay forever—but promise me we can stay for months," he said.

"Darling John, the accounts are past due now!"

"Who cares about accounts and debts in this—green and secret place?"

For an exhilarating moment, she felt impelled to reveal her delight that by some mystical chance he had happened upon her private name for her private place. But even as he asked quickly, "What are you thinking?" she changed her mind. Even with David, Maria Evans had never tried to share her most private being. How could she?—it would no longer be private.

Before she could answer John, he said with a light shrug and a smile, "Never mind," and went back to describing his plans for her table. Relieved, she still wondered: Was he really so sensitive to her? Or just lacking in curiosity? It didn't matter.

The more intense, dazzling light of late April found them still there, Maria boldly, merrily postponing their return to the city.

"I feel absolutely daring," she said as the two walked hand in hand through the woods by the river one late afternoon. "Do you?"

"Oh, I'm a daring man. Didn't I have the courage to ask you to marry me?"

"You did, thank goodness. Look!" She stooped to pick him a cluster of blue butterfly peas growing beside the pine-straw path.

With one motion, he took the flowers, slipped his arms around her, and kissed her long and tenderly. "Maria?"

"What is it, darling boy?"

"Will you always love me?"

"Until my heart stops beating—even after that, if John Edward turns out to be right about his God."

"Even if I turn out to be a—a worse problem to you some day?"

She freed herself from his arms and stepped back to look at him. "You're no problem to me, and I want that straight. I've never lived by what other people say or think. You've stopped gambling. You love me. How could you be a problem—ever?" She grew somber. "If there's a problem, John, it will be yours—when I'm an old, helpless woman "

He returned her gaze for a time, then touched the silver at her temples. "I need your wisdom—your maturity." Then he laughed his carefree laugh and spread his arms as though to embrace all the beauty around them. "Everything I have is—what you are, glorious Maria. I'm content—content, content, *content*—to live under such a lovely shadow!"

She laughed, a little self-consciously. They began the walk back toward the house through the sun-streaked tangle of new-leafed grapevines and smilax that spiraled through the myrtles and gums and palms.

During their blissful, closed-away time here, they'd covered together almost every foot of her thousand-acre gift from Jesse Fish and the Herreras, as well as Joseph's adjoining property. Had spent hours under a large, favorite oak tree by the river. Maria had been so long in the city, so busy with the events of her own life, of

John's, that her inner green and secret place had dimmed, had slipped away, almost too deep for reaching. Here in the quiet, arching green, she was newly aware of it, as though it were waiting for her to find it again. Perhaps tonight, when John had fallen asleep beside her . . .

That every responsible friend she had in the city thought her a fool for marrying John Hudson she had never doubted—especially after the death of a man like Joseph. But she had simply managed by rising above what they thought, by blotting it out, pushing it to one side out of her way. By refusing to face what she'd done in the old, searching manner—in the green and secret place where all things came clear. She had loved John, wanted him, and married him without once thinking it through. Perhaps she no longer needed to test herself. Perhaps this was one of the freedoms of growing older. No matter, she thought, as they came in sight of their cottage. For nearly three years—except for a few times—the pleasure of John had held. There was, at this late date, little to fear. Wasn't he walking beside her now, allowing her the freedom of her own thoughts without misunderstanding? Didn't she feel complete—complete in this silent wilderness moment as he held back hoops of briars for her to pass and steadied her over fallen logs, clearing the path for her feet?

At the cottage door, which John had painted fresh green to match the spring, he turned her to him. "I'd like you to agree to something, Maria," he said softly.

"Anything, darling."

"Could we, from now on, call this place—New Waterford?"

Her eyes filled with tears. "You were born in—Waterford, weren't you?" She tried the name. "New Waterford . . . New Waterford."

"I know I'm a sentimental man, but you see, I've been—born here, too. I feel that way, Maria—here with you. As though I had been born under our big oak down by the river."

With a happy smile, she opened the door for him, swinging it wide. "Welcome to New Waterford, beloved boy. Welcome to New Waterford!"

Abruptly, he gripped her shoulders. "Maria! Let's stay here. Let's never go back to the city! I feel so safe here—no trouble. There could

350

never be any trouble at my New Waterford." His laugh was mirthless. "There—isn't even a tavern!"

She looked closely at him in the gathering shadows. "John, are you—afraid to go back? Afraid of what might happen? Tell me the truth. We can't stay here, you know. People who own houses and land are never free to do exactly as they please. But you don't need to be afraid—not of anything, dearest. Not of anything. Not so long as I live."

He kissed her forehead lightly. "I was only teasing. At least, we don't have to go back tonight, do we?"

John had just fallen asleep when she heard the soft, quick knock on the cottage door. Maria sat up in bed, then reached for her dressing gown. John did not stir.

The knock was repeated.

"Who's there?" she called, pulling on her gown as she hurried, by bright moonlight, to the parlor. "Who's there?"

"John Edward, Good Maria."

Quietly, so as not to wake her husband, she unlatched the door and stepped onto the porch. They hugged affectionately; then she demanded to know why he'd come.

"I was getting worried about you, for one thing, but the main reason is the baby due to the wife of Don Mariano de la Rocque, the City Engineer. The governor himself sent me in his boat to bring you back to deliver the baby. Also, Mr. Leslie says he has to see you right away—as soon as you arrive."

The night was mild, but Maria shivered and drew the long gown about her. "I'll go, of course," she said in a hollow voice. "Especially since his Excellency wants it. But, do you know why John Leslie is in such a hurry to see me?"

"He didn't say, but—Good Maria?"

"What is it?"

"Leslie thinks you'd better not bring John with you when you come."

By the ghostly moon's light, she stared at the young man's blurred white face. "Leave—my husband *here?*"

"That's what he said."

She could feel the hard, thick pounding of her heart. "I'll—decide about that," she said icily. "Come on in, son. John's already asleep. You can fix a pallet in the parlor."

Inside the little house, he put one arm around her sagging shoulders. "Don't forget, I'm twenty-one now," he whispered. "I can look after you. John won't need to know what Leslie said. You won't be gone long."

One small lamp burned in the kitchen, off the room where they stood. It threw enough light for her to see that John Edward was giving her his reassuring smile.

"I'll tell you what we'll do first thing in the morning," he said. "Leave it to me to convince him that he might just as well wait here for you. That way, you won't have to lie awake tonight wondering how to tell him."

"He—does love it here."

"Can you get some sleep now, Good Maria?"

She managed a smile. "I'll try." Then she hugged him again, hard, gratefully. "I'm glad you're here. I—didn't know it, but I needed you. Whatever would I do without you?"

37

John agreed—almost too quickly, Maria thought—to stay behind at New Waterford. She should have been relieved, but his willingness disturbed her.

In spite of the good sailing weather and the beauty of the marshes and stands of wind-twisted scrub oak and pine that bordered North

River as they moved silently back toward the city in the governor's boat—in spite of John Edward's cheerful talk and the courtesy of the small crew—Maria worried every mile of the way.

At home at last, after the slow day of sailing, Long Stem turned back Maria's bed, vast and empty without John. The Indian woman, pleased to see her mistress, promised her favorite breakfast of soft eggs and biscuits and preserves, but Maria did not sleep until the sky streaked with dawn, and then only for an anxious hour or so. Nor did she eat more than a few bites of the carefully served breakfast.

By nine o'clock, she was dressed and on her way to Leslie's office. She was not troubled by the prospect of delivering the Rocque baby. Barring complications, that could be finished soon. Even if she stayed in town briefly to observe both mother and child, she could be back with John within ten days. There was, of course, a sense of satisfaction that the governor himself had felt that no one else could properly deliver the new infant of the city's influential Engineer. Still, she remembered no time in her life when such a cloud of worry had smothered her. Leslie would not have sent for her unless something dreadful was wrong. The Hudsons owed only a few household debts. Debts that would have been paid had she not stayed away so long—that she would certainly pay before returning to New Waterford. The trouble could have no bearing on her business affairs, but what besides business would concern John Leslie?

I don't walk as rapidly as I once did, she thought wearily. But she had reached the Plaza. Only a short distance yet to go.

For the first time, she dreaded seeing her Scottish friend.

John Leslie seated her across from him, on the opposite side of his desk in the back office—the familiar arrangement in which they had talked so often. He did not appear nervous; rather, she thought, overly solicitous, too kind, too careful of her.

"I hope you enjoyed your stay at North River, Maria."

"It's undoubtedly one of the most beautiful places anywhere around." She stopped gripping the arms of the chair and leaned

toward him. "We've never needed small talk. What's wrong? I scarcely slept a wink last night."

"Quite a lot wrong, I regret to say. And if there is a God, only He knows how I despise being the one to tell you. Your husband is in deep trouble."

Maria closed her eyes, but said nothing.

"He's ruined you. In your saner moments, you must have known he would. The man's a hopeless gambler. This is not hearsay. Governor Zéspedes, who feels more sympathy for you than I dared expect, called me to his office—showed me the stack of petitions from your creditors." Leslie held one hand six inches or so from the top of his desk. "A stack that high. Many writs of execution already among them. His Excellency, in view of the enormity of what is owing, had no choice but to issue the writs. There are also many promissory notes in varying amounts—signed by John Hudson."

She could feel the pulse thumping in her throat, the burning in her face. High, harsh waves of humiliation tossed her nauseously. But the fear was worse. She had never known fear like this.

"It's just as well you do like the North River place. Barring a miracle, that's where you'll be living once this is over. Unless I miss my guess, Hudson will be expelled from the city." Leslie's face contorted with pity. "You do know how I—loathe all this."

She nodded. "How much—will I lose, John?" She heard her voice quaver.

Leslie sighed. "I've figured and refigured. The appraisals on your holdings have been disappointingly low in the present market. Owing, of course, to lack of settlers and ready money in the colony."

"Then, I'll arrange for some new appraisers!" Her voice was suddenly her own. Not strong, but her own.

"I've thought of that. It's possible, but not very realistic to expect much improvement."

Maria took a deep breath. It did not help.

For a long time, the two friends sat in silence. Then Leslie said, "He'll have to come back to the city. I wanted to tell you alone—but he'll

have to come back. I understand he also bought a new boat for the trip."

"That was my idea, and I know it's paid for!"

"Good. Selling that will cover one of his smaller notes."

"Why does he have to come back? Why can't I settle it?"

"It's the law. They'll go for him—arrest him—if he doesn't return of his own free will."

"I see." She straightened her shoulders. "There's—no chance I'll—lose my home on St. Francis Street, is there?"

Leslie nodded, avoiding her eyes. "I see no other way. It's your most valuable piece of city property."

"But—it's my home! I live there . . ."

He jumped to his feet. "Maria, Maria, this is as hard for me as though I were losing my own fortune. I'll do everything in my power to help you—everything. But one favor, please. Keep that young whelp out of my sight! You don't deserve any of this—not any of it. I will not be accountable for my actions, even to you, if I have to look at that pretty face of his—ever again!" He was shouting.

The small office reeled. Feeling faint, Maria gripped the arms of the chair again and prayed wildly for help to right herself. Fainting in John Leslie's office would only cause more talk. Then hot, defensive anger swept over her. The same anger she'd felt toward Leslie when he'd attacked her husband before. The same anger she'd felt toward Antonia. Protective, tough anger that was going to hold her steady. She would not faint. No matter what her husband had done, she would hear no one—*no one* attack him! She stood up.

"Thank you," she said coolly. "I'm grateful, but I see you and I cannot discuss this further. I'll get a lawyer."

Leslie had regained control—his voice was quiet now, almost gentle. "There is no lawyer in the city, Maria. You know that. But I've taken the liberty of sending for Don Louis Fatio. He's read law. He's as respected as any man in the colony. I think he'll take the case."

"You—force me to more gratitude." Her chin lifted. "I'm leaving now. If you've sent for him, I suppose Mr. Fatio is at his father's place on the Bay."

Leslie nodded. "Waiting for you."

Her lengthy interview with sedate, precise Louis Fatio went better. She had never known him well, which made her tormented emotions easier to control.

"Your husband will have to return to the city, Mrs. Hudson," he said, as he saw her to the door. "I wish there were some easier way to handle matters. There isn't. I suggest that you remain here and send for him at once."

"I prefer to go to him—explain it all."

Fatio's dark eyes were understanding, but there was firmness in his voice. "I'm sure, once you've thought this through, you'll decide to do all in your power to show proof that these debts will be met."

Maria flared. "I don't need to think it through! I'm a woman of honor, Mr. Fatio."

"Then, you must stay in town as a visible show of that honor. It's imperative, since the property is all in your name, too."

Outside, under the blazing sun, the long walk alone back to her house on St. Francis Street loomed endless. She had no strength for it. By now, everyone in the city—everyone she would meet—would know what John had done. Her prominence and the years of ugly gossip about him would guarantee that. Her legs trembled as she started up the Bay. Her back and head ached. No breeze stirred. A mosquito bit her sharply on the neck, and she began to weep helplessly as she walked.

Then came a sudden, fantastic wish that Joseph—the Joseph who had been her partner in all her concerns—were here to advise her.

A week later, while Maria was delivering the Rocque infant, young Tate brought John back to St. Augustine. The baby delivered, Don Mariano de la Rocque himself had escorted her home through the dark streets at one in the morning, assuring her in his faulty English that Governor Manuel Zéspedes would show every possible leniency toward her in her trouble. He added, of course, as had everyone, that such leniency would be in deference to her position in the city, not in deference to her husband.

356

As she fumbled with her key, the door to her house swung open and John Edward embraced her.

"Good Maria! You're home. Was it a success?"

She nodded, clinging to him. Then she pulled herself free. "Is—he here?"

"Yes. Upstairs—shut in his own room."

"Asleep?"

"Who knows?" John Edward's voice held no hint of sarcasm. Only abiding understanding and acceptance of the heartbreaking man she'd married.

Slowly, one leaden step after another, she climbed the steep stairway and knocked on John's door. There was no response beyond the muffled sound of his sobbing. She tried the door. It was unlocked. For a long time, she stood inside the room looking down at the pathetic man-child. His face was buried in a heap of pillows. The lean, wide shoulders heaved convulsively.

"John! Oh, John . . ."

For perhaps half an hour—at least she thought she'd heard the clock strike from downstairs—she sat on the narrow bed beside him, smoothing the dark, tousled head, massaging his bare shoulders and back.

"I don't know how," she said at last, "but I'll find a way to get us out of all this." He had stopped sobbing, but he said nothing. His face was still buried in the pillows. "You said you wanted to live at New Waterford anyway, John," Maria went on. "We may have to do that now. But—not without a *fight*."

There had been no fight in her—only fear and anger—until she spoke the word. Slowly, the will to survive energized her body, her mind, until her very being tingled with determination. "Did you hear me, John? We'll fight! We won't lie down and let it crush the life out of us. Will you help me? Answer me, John!"

He turned heavily in the bed so that she could see his swollen face. Then he said hoarsely, "The only thing I can do, Maria, is to act like—the whipped pup I am. That's all I can do. That's all that would make *them* happy!"

"That isn't true, but we don't need to say any more tonight. Will you sleep here, or with me?"

In silence, he crawled out of the bed, followed her into the large room they shared, and without a word, lay down beside her, his head on her shoulder. In no time, he was asleep.

For the first time in her life, she felt trapped by the turbulence and unreliability of her own shifting emotions. One moment she knew herself equal to any disaster, the next she was paralyzed by fear. For over a week, neither she nor John left the house. John Edward or Long Stem did all the marketing. Maria slept little, but John, alternately petulant and cocky in his own defense, slept like a baby. The mornings of that shut-away, stifling week were spent over the account ledgers— John working with her—his slender fingers filling page after page with figures, adding up asset after asset, proving, he swore, that John Leslie and Fatio were dead wrong.

"We're far from wiped out," he declared. "I see us losing only a few hundred acres of Captain Peavett's land and four small houses—look."

Only a few hundred acres and four small houses! What good could it possibly do to falsify the figures? He was not only dishonest in his estimates—he was cruel. Affectionate, yes. This did not waver. He pouted, he cursed, he beamed his Irish smile and she could accept all that. But once she'd faced his capacity for cruelty, Maria could not wipe it out of her mind. That trait, she now saw, he'd kept hidden from her and probably from himself. A subtle kind of cruelty which was such a part of his nature that even he could not see it or believe he possessed it. But not once did he flare at *her.* His bursts of anger blazed toward John Leslie, who had told her in the first place, toward Don Louis Fatio, Governor Zéspedes, his creditors. Part of the cruelty lay in his remaining invariably loving with Maria, as though he had mounted a crusade to slay the whole city in *her* behalf. For hours at a time, he acted as though he were bent on rescuing her by falsifying the very accounts which she or anyone else could comprehend at a glance.

As the days wore on, she found herself wondering with detachment what had happened to the weeping lad who vowed that the only

way he could fight was to act like a whipped puppy. The defeated attitude had vanished so completely that she might only have dreamed it.

Maria heard herself sigh often. She felt discarded, isolated. She clung like a drowning woman to the flimsy hope that by the sheer weight of her prestige in the city, she would find a way out of the disaster. Let John strut up and down and harangue about the whole rotten mess. Let him cheat on his columns of figures. She could live with his quick mood changes. The mystery was that she still cared about him beyond her own understanding. It was not easy, but she could manage life with John far more easily than she could face the thought of her own painful humiliation the first time she found the courage to venture out again into the city. From the age of thirty-three, she had bent her every effort to building the reputation she now held. Joseph had been right—there *were* things far worse than death. Her heart ached over John, but it was her pride that suffered most now.

Three more days passed; then Maria was summoned to come alone at once to the office of the governor. Word was sent by John Edward, who, with his never-failing wisdom, told her in private.

"Go today, Good Maria. Don't wait. Don't put it off."

"I'm going right away," she said. What could his Excellency want with her? She was swept by a new wave of incredulity. "Oh—how did it all come to this?"

"I don't know." He thought a moment. "God does know. Is that—any comfort to you?"

"No. God made John the way he is in the first place!"

Governor Manuel Zéspedes, now in his seventieth year, gray and balding, rose and bowed as she entered his office. "You do me great honor, Doña Maria."

She sat rigidly in the high, carved chair, her hands clenched in her lap. "Needless to say, your summons has made me anxious, Excellency. A woman is seldom called here."

He smiled warmly, nodding his understanding. "It is my hope that the festive mood abroad in the city, building toward our celebration of the coronation of King Charles the Fourth, will not

increase your nervousness. I do not overlook that a woman with your present burdens could well find the festivities an irritant. It will be my last and best St. Augustine day. I have called you here to to tell you that a new governor will replace me next year. If matters move as slowly as usual, the ultimate solution of your husband's trouble will come at the hands of the new young governor. Don Juan Nepomuceno de Quesada is his name."

Maria sat motionless. John Edward had told her of the planned fiesta—but to lose kindly, wise Governor Zéspedes was unthinkable.

He sat now, fingering the embossed lid of his silver inkwell, raising and lowering it with light, tapping clicks. "I will, of course, apprise the new governor of everything," he said. "To so reassure you is one reason for this interview. I did not want you to learn of my departure from someone unable to give you that reassurance." He paused. "I—have another reason to summon you here. The public auction at which all your city properties will be sold will, at my order, be delayed until after the coronation fiesta in honor of the new King. I felt that would be the least painful way for you."

The ringing in her ears was deafening. No one had mentioned one word about a public auction! She struggled to take it in. Her houses, her lands—her way of life—her standing in the city—sold at public outcry? Not once had it crossed her mind that time would not be allowed for her to sell off the holdings herself and pay the debts with some measure of dignity.

Sensing her shock, Zéspedes said, "The creditors do not agree to wait for slow, piece-by-piece sales which could take years. I had hoped for a delay, but I have been forced by the size of the debts to order the public outcry."

In that moment, another surge of cleansing anger energized her. "Our attorney, Don Louis Fatio, has assured me that there is no law against my arranging for other appraisals—even requesting and receiving an extension of time for payment as much as five years or more." In spite of efforts to control it, her voice rose haughtily. "I have the cash now, Excellency, to pay off my husband's smaller promissory notes. I am not a poor woman, you know. I do demand my rights. And

I am entitled to time to work things out." When Zéspedes sat sadly shaking his head, the strident tone left her voice. "Excellency, I beg of you, since you respect me enough to give me this advance warning, can't you, won't you permit a little more time? Three months? Two?"

Courteously, his sad eyes avoided hers. He looked down at the bare wooden floor of his office, but he went on shaking his head.

"But, with just a little time, I could work out many of the debts at my profession, sir! I'll accept every case, however small the fee, if you'll only agree. You yourself thought highly enough of me to send for me to deliver Don Mariano de la Rocque's child! Most of my fees are not small. I will sign any kind of paper you say guaranteeing that every fee for the remainder of my days will go to pay my husband's debts!"

He had stopped shaking his head, was only studying her now. Maria took some small hope and plunged on. "In fact, I'm sure the whole indebtedness doesn't exceed two thousand pesos! In less than five years, especially if settlers come, I can work off those debts with my own hands!" She leaned toward him. "I nearly collapsed at first, but now, I intend to keep my home on St. Francis Street, Governor. I will fight to keep that much, at least. After all, two thousand pesos is not an impossible amount."

Zéspedes came slowly around his desk to stand beside her. "The sum is twice as much as you think, señora. It is more than four thousand pesos. I cannot stop the action of the law. The monies are owed. They will be paid, and the St. Francis Street property is your most valuable asset. It is valued at seven hundred pesos. The other city holdings, plus the land left you by Captain Peavett, do not suffice."

Maria was on her feet, too, now. "Why, my home is one of the finest in the city! I wouldn't think of letting it go for under nine hundred pesos—even a thousand!"

He rapped a signal on the desk with his knuckles. "You deal with Spanish law, not British." A rear door opened and Captain Carlos Howard appeared. "Show Mrs. Hudson out, Captain, please. We have quite finished our interview." To Maria, Zéspedes said firmly, "The papers on this matter have been sent to Havana for review. In the meantime, you will see to it that your husband makes no attempt

to sell any of your properties—or to leave the city. If he does, I will have him arrested and thrown into the Castillo. Further, it is my painful duty to inform you that the public auction *will* take place shortly after the coronation fiesta."

Exactly one month after the celebration, the dreaded auction took place. The day following, shut in the house with John as she had been through the ordeal, a messenger from the governor brought a note of temporary hope: thanks, she supposed, to pity or respect for her long-held standing in the city, Zéspedes had relented a little. He would permit her to live in her house for another year. In fact, the St. Francis Street property had not yet been placed at auction. She and John could stay on there until after the arrival of new Governor Juan Quesada, expected at midsummer of the year 1790.

That she could live in Joseph's fine house for another year helped, but Maria reacted little when the governor's message arrived. John was elated.

"We will not lose this home, love," he declared enthusiastically. "I promise you that—I promise it."

"I'd give anything to believe you."

"But, we have time now—time we should have had before they snatched away our other properties just to spite me!" He knelt beside her in the parlor. "I'll get work! You know how good I am with my hands. You said so yourself at New Waterford! I'll get work as a carpenter and have my wages attached—every peso—and save our home!"

Maria looked at him, then laughed bitterly. "You would have to work—with pay—every day for three years to earn the remaining thousand or more pesos. There isn't that much work in the city, and who really gets paid in cash anymore? Not even the carpenters at Government House. It's a—foolish thought, John. It won't work. There isn't that much time."

He stood to his full height, looking down at her with such sudden, hard arrogance, she could only stare back.

"Then, the only way is to sell our people," he said. "The other land's gone. We don't need them all at New Waterford. Just twenty-five

slaves, Maria, and I'd be free! Do you care more about those black brutes and wenches than you care about me?"

She slapped him so hard he lost his balance and fell backward against a table. A candlestand crashed to the floor. Slowly, he got to his feet, his mouth twisted, his eyes showing the deepest hurt of all.

A choking sound came from Maria's throat. "You made me do that!"

Swaying a little, he rubbed his cheek, turned, and headed for the row of wall pegs where he kept his tricorn.

"No, John, don't go out. I'm—really not a—frightened old woman!"

At the looking glass, he settled the hat in place at a jaunty angle. "John, please—I beg you not to go!"

He strode out the street door and slammed it without looking back.

At midnight he returned, half drunk and contrite—explaining at length that he knew full well that they did need all their people, now that their only future income had to be made at New Waterford.

Looking up at him as he stood uncertainly beside their bed, Maria spoke not one word.

38

Because it took so long for papers to be reviewed in Havana and returned to Government House in St. Augustine and because their attorney, Don Louis Fatio, lived so far from the city, there was a lull in the harassing meetings in which John was badgered with queries concerning the remaining indebtedness. The lull lasted until after Zéspedes left the colony and new, young

Governor Juan Quesada arrived in July of 1790. Maria did not meet again with Zéspedes. There had been no reason. His refusal to honor her pleas for delay and leniency, though courteous, had been firm. She and John were now at the mercy of an unknown new royal governor, who would undoubtedly be occupied for the first few months of his tenure with learning the procedures of government.

Eventually, Maria knew, she would have to apologize to John Leslie, toward whom she'd shown such anger months ago. Leslie, she hoped, would have forgotten at least some of her fury. After all, he had married in the interim and had surely not been concentrating on his troublesome old friend, Maria Hudson.

During the anxious waiting period, John, when he was not being sweet, was cocky and arrogant—his sole defense, she now realized, against the constantly thrumming fear in the depths of his being. They had begun to talk idly about nonessentials, a habit which had always annoyed Maria. And yet time alone only heightened for her the agony of the seemingly certain loss of the St. Francis Street house. New appraisals obtained by Don Louis Fatio had helped a little, but not enough. The revised appraisals now showed an increase of no more than two hundred pesos in the estimated value of Maria's remaining city property, including her home. One thousand was needed. Ultimately, a part of the New Waterford land would go, too.

After having hidden for so many months from the townspeople, suddenly and without explanation John had begun, almost brashly, to enjoy going out again. He insisted upon doing all the marketing. Maria permitted it because nowhere in her once resilient nature could she find the courage to be seen. She spent every day at home, moving crazily between the two selves which now seemed to struggle within her, both without direction. The one, a suffering older woman, brought down by her own bad judgment, sick unto death of herself, ashamed, hating failure more than anyone she'd ever known, yet wallowing in it. The other, a woman somehow still youthful—still youthful enough in her heart and in

her body to go on wanting love from the incredible young man who had brought on her ruin.

She found herself avoiding time alone with John Edward even more carefully than she avoided time alone with herself. The boy's devotion-filled, penetrating eyes appeared now and then in her dreams, the same knowing, waiting look she saw in unguarded moments during waking hours. It was as though he watched her, waiting. Waiting for her to—do what? If possible, through all the trouble, he had been even kinder, gentler, more cheerful. His love for her and his loyalty were all the more proved through every hour of every day in that not once did either that love or that loyalty exclude John. He still laughed at her husband's stories and sang songs with him to help pass the long evening hours. Not one word of condemnation had passed his lips. Not one. Long Stem had said her piece one morning and from then on had only glared at John in silence. But young John Edward Tate had gone on being his friend— as much as anyone was allowed to be the friend of such an unpredictable and tortured man.

Maria could have asked no more of her son than he had been giving. In her most selfish moments, she could not have asked as much as he gave. But by late summer, he had begun to irritate her. My tattered nerves, she thought, nothing more. He's the only truly good person in the whole household! Surely, he'd done nothing to upset her—but even during the long hours in which he studied to be a surveyor, he was waiting. It grated on her unmercifully. If only he'd find a nice young girl and fall in love, Maria could then hope, at least, that those eyes would stop their protective watching of her every move. If she weren't shut away from morning to night, she'd find a wife for him, and for herself some relief from the burden of his strange concentration upon her.

It's probably all in my tangled imagination, she told herself one morning as she sat alone in the garden trying not to think of anything. Trying and, as usual, failing. If John Edward means to confront me with something, heaven knows he's had ample chance to do it. He knows how much I love him. He's always felt perfectly free with me—

from the day he bumped into me beside the statehouse. If he is waiting to confront me with my sins and my bad judgment for loving John Hudson, surely he'd come right out with it—ask to see me alone.

"Well, I don't want to be alone with him!" Since the trouble began, she had caught herself speaking aloud, to no one in particular. "And I know why I don't! He'll prattle on about how I should have faith in God. The last thing I want to hear *now*. Faith in God is all right, I suppose, for a young person like John Edward, safe and secure in my house." The words brought a bitter laugh. "*My* house, for the moment. He's as safe and secure as I am, at least. He knows I'd never, never send him away. Wherever I'm forced to go, he'll go, too. He's almost finished with his surveyor's training; he'll have work he likes." She sighed, as she did so often these days. "It's fine for him to float through these dreadful months in the company of his mythical God . . . with that soft-brown, irresistible tenderness in his eyes . . ."

She jerked herself up out of one of David's old chairs in the far corner of the garden, where she'd begun to sit when John was out, and began to pace the brick walkway back and forth, back and forth. A small breeze, cool, probing, touched her face. She stopped and stood looking at David's gentle bush—the once stubby little fig tree—now grown wide and full, its broad leaves lush, its divided, sprawling gray trunks thick and sturdy.

"David?" She whispered his name, tentative, reaching. "David? Are you here? Are you . . . *anywhere,* David?"

"I'm here, Good Maria."

Startled, she turned to face John Edward, a small tray in his hand on which were a saucer of Long Stem's bread pudding and a glass of milk.

"You ate almost nothing for breakfast," he said, his voice quite casual. "I thought you might be hungry."

"I am! But not for food." The words surprised her. She had certainly not meant to say them. "Just put it down somewhere. Thank you." She tossed an embarrassed glance at David's gentle bush. "I must be getting old, talking to myself like that. Tell me, what have you been up to this morning?"

"Oh, I made a long list of provisions for New Waterford. I'll send them up this afternoon. Then I put new stain on the street door and replaced the windowpane those drunk soldiers cracked the other night." He sat the tray down on her fern-covered stone water filter. "What are you hungry for, Good Maria? I've been waiting a long time to hear you say those very words."

She was suddenly so tired, there was nothing to do but walk back to David's chair and sink into it. In a moment, John Edward followed slowly. Neither spoke for a while, the boy waiting again.

"I can't imagine what made me say such a thing!"

"I can."

"I suppose you can." There was an edge to her voice.

"Have I made you more miserable?"

"I don't know. *I don't know!* I only know we must not talk like this. I'm not up to it. Not now. Not ever."

He sat down cross-legged on the grass beside her. He said nothing, but in spite of herself, Maria went on.

"I don't know myself anymore at all, son. I did once. I knew Maria Evans better than most people ever know themselves. I prided myself on that." She tried a laugh. It was hollow. "I—prided myself on most everything, in fact. It's as though I've—broken into pieces. I honestly think I must have been held together for all the years of my life by my pride. I'm scattered in little pieces now, because I— don't have—an ounce of pride left."

"Oh, that's good. That's very good."

A bitter expression crossed her face. "What's good about it?"

"Everything. Pride's a terrible stumbling block to knowing yourself. Especially if it's been what held you together."

"For heaven's sake, don't preach! I know you've been waiting, lurking around the house for just this moment when you can tell me that if I'll only put my trust in God, all John's miserable debts will go away!"

He laughed gently. "Never in a million years would I say a thing like that!"

"Why not?"

"Because it wouldn't be true."

"Oh."

"Jesus trusted the Father with all His heart. They crucified Him. Nailed Him to a cross."

"What on earth does that have to do with—anything?"

"I just didn't want you to think I believe that God spoils any of us by keeping all trouble away. He certainly didn't keep my mother and father from being killed by Indians."

"Then—" She shook her head. "You're saying—" But he was going right on.

"That's past, you know that. You and I have today. My parents are with God. I only brought it up to explain that God sees things the way they really are. My mother and father were fine, warm-hearted people, but the Indians thought of them as enemies. God understood why they killed my parents, and He didn't stop them. He knew the Indians as they were; He understood them. The way He understood the people who killed Jesus."

"Son, I don't follow you! I—I just don't follow you!"

"I know."

"*What* do you know?"

"That you can't follow what I'm saying."

"Then why in the world don't you hush? Go in the house and get busy. I'm sure there's something that needs to be done!"

"Yes, ma'am. There's a lot. But none of it is as important as you are—this minute."

"Why this minute?"

"Because you're more open to God's love right now than you've ever been in all the time we've been together."

"You're acting as though I'm—ten years old! As though I'm a helpless child or—or an equally helpless old woman! I'm neither. Turning sixty does not change one thing. Not one thing." She sighed. "These ghastly days, nothing changes—anything." When he didn't respond, she goaded him. "What right have you to speak to me as though you were God Almighty?"

"None."

"Then I wish you'd stop talking as though you know me better than I know myself."

"Maybe I do, but that isn't the point. You're tired, Good Maria. Tired and—defeated all the way through. That's wrong. When we're defeated it causes God real pain. You're blaming yourself for something you did that may have been unwise, but it wasn't *bad*. There's nothing bad about loving. You meant well when you married John. If ever a woman loved a man, you loved him. Even now. You just need to know where to turn."

She heard her heart pounding; surely he could hear it, too. "So? So I spoiled John! So—I'm an old fool. I've been told that. There's no need to repeat it."

"I don't think I need to tell you that you're twisting the meaning of what I said. I don't think you meant to, either. The only bad thing is—still believing, so stubbornly, that *you* can save either John—or yourself."

"I don't believe that anymore!" She was spitting out the words. "I don't believe—anything anymore!"

"I know."

"No, you don't know, and I want you to go. Go on, get out of this garden! Out of my sight!"

He got slowly up from the ground and started for the house. "All right," he called to her from the loggia, where he'd picked up the tray. "But I'll be back."

Maria sat staring after him, unwanted tears streaming down her cheeks. Tears of self-hatred and loss—and of panic. Her son's departure from the garden had left her so stiflingly alone that she felt she might be dying. Dying could well be like this—a headlong, terror-filled plunge into—nothing. Her heart called out, cried out, John Edward! David! Someone—help me! Silence closed in around her and a lone wren shouted. She waited. An orange thumped to the ground from a tree somewhere behind her. Silence. The wren shouted twice again, mocking her. Mocking her darkness, her wrenching sense of being lost.

The tears dried on her face and no more fell. Still she waited. Her boy had said he'd come back. Where was he? For weeks, months,

she had avoided such a talk with him, and now her life—her only hope of ever surfacing from this drowning moment—hung on his return. "I am lost," she said aloud. "Did John Edward tell me that? I don't remember that he did. I'm lost—from myself. I don't know myself—my real self—like this."

A door closed softly off the loggia. John Edward was coming back. No one else closed a door so softly.

"I thought I'd read to you awhile," he said, his smile as sunny as ever. "Even if you send me away again, I thought I would."

She reached toward him. He grasped her hand in his warm one.

"Thank you, son. Thank you for coming back."

Then she noticed that the book he carried was her father's old Bible. It had been in John Edward's room ever since he'd come to live with her. She took a sharp breath and exhaled slowly—the repeated, now familiar sound of her own resignation. "If it will please you, go on, read your book to me."

Her body slumped deep into David's weathered chair. She closed her eyes. "You're all I have to depend upon. Read. I'm listening." Again she sighed. "I'm listening . . ."

" 'O Lord, thou hast searched me and known me. Thou knowest my downsitting and mine uprising, thou understandest my thought afar off. Thou compassest my path and my lying down and art acquainted with all my ways. For there is not a word in my tongue, but, lo, O Lord, thou knowest it altogether. Thou hast beset me behind and before, and laid thine hand upon me. Such knowledge is too wonderful for me; it is high, I cannot attain unto it.' "

The beautiful words stopped.

"Go on, please!"

He cleared his throat a little and began again, slowly, measuring every word. " 'Whither shall I go from thy spirit? or whither shall I flee from thy presence? If I ascend up into heaven, thou art there: if I make my bed in hell, behold, thou art there.' "

Her eyes still closed, Maria said hoarsely, "Did I ever tell you that I've—felt the Presence of God every time I've brought a new life into this—ugly world?"

"No. He loves you so much, though, I'm not surprised."

She made a breathy, disdainful sound. "I've often wondered why otherwise He made Himself so scarce! I've needed help at other times, too."

"I guess maybe you knew about needing Him most at those times when two lives were in your hands."

"Maybe. But it's been strange. Very strange."

"You're the best midwife anywhere, but you knew how much you needed Him when a baby was about to be born. I think really wise people know when they need help because they know themselves. Maybe you only—knew yourself then."

His insights never failed to surprise her. "If I'm not too addled and full of years to follow you, I think that might be true. Is that—all of whatever it is you're reading?"

"No. There's more. Are you getting tired?"

She shook her head, gestured for him to go on.

" 'If I take the wings of the morning, and dwell in the uttermost parts of the sea; Even there shall thy hand lead me, and thy right hand shall hold me.' "

Her heavy, broken voice interrupted, "Oh, son, I *need* someone—*someone* to lead me. To hold me. You know that, don't you?"

"Good Maria," he said lovingly, "I've been waiting to hear that, too."

She opened her eyes. "But what causes me to feel so helpless now? I've had trouble before. I could always stride ahead—even of myself—finding a path on my own. I've done that for over half a century! Even when my first husband died—the worst time of all. Even then, I managed in time to see a small flicker of light up ahead. A path that led—somewhere. I can't see ahead now at all. Not—one step."

He began again to read in his low, calm voice: " 'If I say, Surely the darkness shall cover me; even the night shall be light about me. Yea, the darkness hideth not from thee; but the night shineth as the day: the darkness and the light are both alike to thee.' "

She leaned forward. "That's simply too good to be true! Beautiful, the way you read it, but it creates—a sadness in me. I

can't bear any more sadness. Don't you see I can't—bear any more?"

"Just a few lines more? Please?"

She fell back in the chair again. "All right. All right."

"I won't read the whole Psalm—just this—'My substance was not hid from thee when I was made in secret and curiously wrought in the lowest parts of the earth. Thine eyes did see my substance, yet being unperfect; and in thy book all my members were written, which in continuance were fashioned, when as yet there was none of them! How precious also are thy thoughts unto me, O God! How great is the sum of them! If I should count them, they are more in number than the sand: when I am awake, I am still with thee.' "

A soft, pervasive silence moved across the garden, enveloping her.

"Could that—possibly be true?" Her question seemed to move away from the boy—out beyond them both. He said nothing. Somehow the question gave her a good feeling—much to be desired. She repeated it. "Could—that possibly be—true?"

After what seemed a long time and no time at all, she heard John Edward ask, "If I read just a little more, Good Maria, will you say the words after me? That's the way you'll find out how true it is, I'm pretty sure."

She nodded. "All right. All right."

" 'Search me, O God, and know my heart: try me and know my thoughts . . .' "

"Search me, O God," she said in a voice not her own. "Search me, O God, and know my heart. Try me and know my thoughts."

He continued: " 'And see if there be any wicked way in me, and lead me in the way everlasting.' "

Looking at David's gentle bush, she repeated the words, ". . . if there be any wicked way in me . . . *lead me in the way everlasting.*"

There was still scarcely a sound in the garden, its grassy floor mottled now with shifting, noontime light and shadows.

"Will—faith in God work, son? Will it—really work—for me?"

He gave her his smile. Everything from the boy had always been a gift. "I guess you'll just have to try it the next time you feel—lost, Good Maria, and find out."

39

Over the next weeks, without explanation, John Hudson reversed himself yet again and began spending as much time away from his wife as possible. Her changed manner lately had done more to increase his guilt than had the remaining debts. Being with Maria back when she'd wept often or lost her temper over what he'd done had been far easier. Oh, she still bossed him as though he were twelve and not thirty-two and still defended him, he knew, on the rare occasions when she spoke with an outsider. He had no doubt that the woman loved him as much as ever, but something had changed in her—it made him want to get away from the house. She accepted his attentions as before—and yet not quite as before. There was a disturbing difference, and the mystery behind it bothered him more than the change itself.

For a period, right after she found out about his enormous debts, her courage had seemed to crumble. He'd almost despised her for that because it had been her rocklike courage that had drawn him to her in the first place. A man had a right to courage in the woman who loved him, especially when his own needs were so enormous. So why be frightened at her new surge of courage now? Why be disturbed that she seemed almost—peaceful?

Well, he was on his way to the Plaza this bright day to get away from her for a while, at least. The change in her—the new, almost awesome quiet and strength he'd noticed in the past month—instead of helping, had shut him out. He had no strength of his own. He'd counted on hers, but lately he felt vulnerable and naked. Still, gamblers, he supposed, did not really need courage; they only needed daring and the knack of sealing off everything beyond the next moment of exhilarating risk.

He walked slowly, idly; no one was expecting him. He was merely on his daily trip to the Plaza, to the Public Corner, hoping

that no further bad news would be posted there against him. Today, he admitted, he felt all alone in the world. More so than usual. Alone and afraid. Maria was still his wife, would still be waiting for him in the fine house of which he'd been so proud, but her strange, patient distance these days taunted him beyond endurance. He was convinced that she no longer needed him. She loved him—as her troublesome child, perhaps, but—the conviction galled that she no longer needed him as a husband.

He kicked at a shell on the sandy roadbed of Marine Street, cursing his luck. If I'd not been caught just when I was, I could have won it all back and more, he thought for the hundredth time. There was no doubt he felt a victim of his creditors, of the haughty new governor. He scoffed at all their stupidity. How his creditors could be so dim-witted as to think they'd lose even one peso, he could not imagine. If there had ever been a good bet, it was John Hudson. They had all conspired against him, treated him like dirt under their feet. The only person who'd never done that to him in all his thirty-two years, in fact, was Maria, who had made him, for a short time at least, feel like a gentleman.

Declaring himself a victim inevitably lightened his guilt. It lightened now still more when he told himself again that surely the sensible, prestigious woman was still in love with him. He walked faster, striding toward the Plaza, his head high, his shoulders back.

"Remember last night, fella," he said aloud and laughed. "Remember the old woman the way she was just last night!"

It helped. The intoxicating cockiness returned. The future looked better for the moment. He had been proud to live at the St. Francis Street house, would dread the sight of her heartbreak when she lost it, but if the truth were known, he much preferred New Waterford. She might well be her old self again there.

The closer he came to the Plaza, the more his mood lifted. Why be lonely or beaten when a woman like Maria still accepted him? He'd never demanded her respect—only the safe, secluded haven she offered. He felt better, more sure of himself.

In a moment, he actually began to whistle. The sun was bright, the coastal August sky high and blue, the breeze clean. For this day at least, why borrow trouble? After a quick stop at the notice board, he'd head for Perpal's tavern, where he'd be welcome, as always. Juan Perpal had his money from the sale of the Arbuthnot house. They were friends again. And anyway, men fell into debt every day. Money should not be taken all that seriously. Find it, lose it. What difference? Sing a song and live. Whistle a tune, be merry. The old woman had simply refused to do that, and maybe, instead of feeling beneath her, he should work on the idea of feeling sorry for her that she couldn't see life as he saw it. She could, in fact, learn a thing or two from her great friend, John Leslie. He liked Leslie. A man with his head on straight. After all, he'd owed Leslie five hundred pesos for more than two years. The man had never mentioned it—even to Maria, or John would certainly have heard about it.

He reset his tricorn at a more rakish angle and headed for the Public Corner. If the notice board was empty of any further mention of him, he would go straight to the tavern for a convivial afternoon.

Clustered around the notice board were three acquaintances, Spaniards with whom he'd gotten drunk a few times—Sebastián Berazaluze, vain and fat, Antonio Palma, skinny and nearsighted, and gossipy Pablo Cortina. Oh, well. Harmless, dull men. He nodded arrogantly to all three—a manner he assumed in public these days—and strode up to the board. The notice, and there was only one, was, as he might have guessed, written in Spanish! "Plague take the smug new governor," he mumbled.

John had watched from a distance as Don Juan Nepomuceno de Quesada came ashore over a month ago and had hated him on sight. Pale, pompous, yellow-haired, almost delicate. Yet a man of typical Spanish arrogance. Arrogance proved now by the posting of a notice for the public in a foreign language! No matter to the offensive new governor that dozens of British had decided to swear allegiance to his bloody monarch and stay in the city. Well, the act of swearing such allegiance would, when the time came to do it,

roll off John Hudson's back like water off a duck, but it did infuriate him that no English translation of the notice—whatever it said—had been posted. The more he stared at it, the more enraged he became.

In full view of the three Spaniards, he ripped down the single sheet of paper, snorted at the flowery signature of Juan Quesada, wiped the notice across his buttocks, and tossed it disdainfully to the ground.

The burst of horrified Spanish from the three men who had watched him do it enraged him still more—with a hot, blue flame of defiance—then a spurt of fear. For a moment, he glared at the men. They glared back, and one of them, Palma, pointing toward the edict still on the ground, said in broken English, "You have done a crime, Juan Hudson! We report you to his Excellency!"

"That is a warning," fat Berazaluze mouthed, also pointing a thick finger.

John shrugged, hooted with laughter, picked up the edict, and, spitting on the flour-and-water-paste wafer that had held it in place, stuck it back on the notice board by one corner.

"If any of you gentlemen has an extra wafer on you, I'll gladly post your precious Governor's edict more securely."

"We warn you," Cortina said darkly. "We will not lie about what we have seen here!"

John flipped his hand across his backside at the three men—the Spanish gesture of contempt which they all understood—and sauntered away toward the tavern.

He needed, after such a fit of temper and such a dreary encounter, to be a little happy again.

Later the same day, John Edward, too, saw the notice, asked an onlooker to translate it for him, and hurried home to tell Maria. The time had come, the edict declared, for all British subjects to appear at Government House before his Excellency, Juan Quesada, to take the oath of allegiance to Spain.

"Do you think it will make you sad, doing it, Good Maria?"

She smiled a little. "No. Not now. So much troubled water has run under the bridge, I don't think I'll mind. Except—oh, it is still so humiliating for me to appear in public! Will I ever, *ever* lose this—ghastly humiliation over what John has done?"

"Time is supposed to help a lot of things," he said. "Time and God."

"Yes. Yes."

"Remember how cross you used to be when I mentioned God?"

"I wish you'd forget the way I used to be." Then, with great affection, "Son, nothing seems quite as bad as it did, to be truthful. I'm stronger." They exchanged smiles. "It seems foolish to say it when I will undoubtedly still lose my home. But—since you read to me—nothing seems quite as dreadful. And I am stronger."

Two days later, at nine in the morning on Monday, the sixteenth of August, Maria stood between her husband and John Edward in the great hall at Government House and, with all the other British subjects who had chosen to stay, took an oath of fidelity and subjection to the Royal Laws, usages and customs of Spain. They swore to God and upon His Holy Cross.

Young, aesthetic-looking Governor Quesada administered the oath himself and, when it was over, walked solemnly and unsmilingly down the straggly line of new subjects, shaking each hand—until he reached John Hudson. Instead of grasping John's extended hand, Quesada snapped his fingers, and two guards appeared. They grabbed John by the arms and hurried him struggling out of the hall.

Maria started after him. John Edward restrained her and demanded to know the reason for Hudson's arrest.

"Criminal abuse of authority," Quesada snapped. "Criminal abuse of *my* authority! You will find your husband in stocks before the guardhouse, señora." He bowed slightly to Maria and walked out of the room.

For several minutes, the subdued crowd of newly sworn subjects stood in near silence, then, mumbling their astonishment, they began to drift away. Most of them were long-time British acquaintances, some were friends, but there was nothing to say.

"I'll take you right home Good Maria," John Edward whispered. "You may want to lie down."

She still stood, leaning heavily on John Edward, her mind again leaping the years back to the day she had walked up and down in front of poor James Cameron as he sat with his hands and legs fastened miserably in the stocks—his physical discomfort as nothing compared to the humiliation. Overcome with the memory, she sobbed uncontrollably.

"I'm going to my husband," she said, struggling to regain her poise. "Once I've seen him, maybe I can begin to sort things out. He's not in the military. Perhaps I'll be allowed to speak to him. I want *him* to tell me what he's done—this time."

Outside in the shimmering heat of the Square preferring to go alone, she sent John Edward home, and began to walk resolutely toward a small gathering of soldiers working in front of the guard-house—fastening John between the rough boards. A burst of bawdy laughter reached her. She winced, but kept moving steadily toward them. John had evidently done some scandalous new thing, but she was going to find out from him, and by the time she reached his side, by God's grace, she would be strong enough. Looking neither to the right nor to the left, she walked on, for the first time oblivious of the staring faces. Undoubtedly the people already knew what he'd done. News traveled faster than the wind in St. Augustine. The latest episode in the Maria Evans Hudson scandal. Well, let them look. Let them hum. No matter what they thought, she was going to John because he was still her responsibility.

The soldiers fell back when she approached. No one made any effort to prevent her speaking with John, who sat head down with his wrists and ankles locked securely between the splintery braces of the stocks.

For a long moment, she stood there. No one, no one on earth could do a worse thing to this proud young man who had brought her so much grief and so much happiness than to put him on public display in the city where he had already endured so much embarrassment and defeat.

"I'm here, John," she said.

"Hello, Maria," he answered, not looking at her. He laughed—a hard, ugly sound. "I guess you can see—I'm here, too."

"I came to be with you and to listen while you—*you* tell me exactly what happened. I want to know the truth—I need to know before I can make a single move to get you home. There must be some reason why you're under arrest, and before I hear it from anyone else, I want you to tell me—all of it."

He nodded. "The truth is that I've got so many enemies in this town, I'm the whipping boy for every pure-of-heart bastard in the whole city!"

"John! I won't hear such language, nor at this moment any self-pity. What I want is a full explanation."

He began slowly, half in guilt and half in arrogance, to tell her about his trip to the notice board. "I saw the edict, and of course I hurried over to see what it said. Maria, I've gone every day for weeks to see if they were trying to do anything worse to me! Well, it was posted so high up on the board, I couldn't even tell whether it was written in Spanish or in English. So, I reached up and pulled it down in order to read it. That's all."

"That's *all?* What did it say? Was it the notice calling us to swear allegiance today?"

He nodded. "But I had no way of knowing that then because that woman-faced, overbearing governor had posted it in Spanish!"

"Go on. Pulling down a notice in order to read it is not enough reason for you to be here in stocks. It's unlawful, I'm sure. But I doubt it's a crime."

"That's what I'm saying, Maria. It isn't!"

"We have no way to be sure about that right now. Just tell me every single thing you did. Was there anyone nearby who saw you?"

"Ha! That's the rub. Three of the stupidest, meanest little peasants in town watched me like hawks."

"Who were they?"

"Cortina, fat Berazaluze, and Palma. I despise 'em!"

"We're not discussing them, although I'm sure they did report you."

He made a hissing sound between his teeth.

"John, what did they have to report?"

Involuntarily, he tried to stretch out his hands in the open gesture she'd seen a thousand times when he proclaimed innocence. The thick, locked timbers caught his wrists.

"They had nothing to report of any consequence! Nothing at all. I tried to read the notice, saw it was in Spanish, licked the wafer and reached up to refasten it to the board. After that," he lied, "I went on my way." He was silent a moment, then added, "Oh, maybe the notice did flutter out of my hand in the wind. Yes, I think it did accidentally fall on the ground. I might have wiped off the dust it fell into on—on my shirt—before I put it back up." He looked directly at her. "Before God, Maria, that's the truth. All of it."

She took a deep breath. "You *are* before God, John."

Again forgetting the bruising boards clamping his arms, he winced in pain as he tried to reach for her. How often had he reached for her in the past, knowing that, with one touch from him, she would agree to whatever he asked. Would believe whatever he told her.

"I know I'm before God," he mumbled petulantly. "I'm a good Catholic, too, don't forget."

She moved a step closer. "All right. I'll find some way to get you out of that torturous contraption. That must come first. We can talk better at home." Then, for the first time, she touched him, touched the limp, helpless hand hanging from the stocks' crosstimbers. "I'm going straight to John Leslie's office for advice. He'll know if our attorney, Mr. Fatio, is in town today." Maria took a deep breath. There seemed to be no real air in the hot west wind. Then, she managed an encouraging smile. "John Leslie will at least be able to tell me the next step I should take. Try to be patient. I'll be back, I promise."

His expression was transformed. He beamed. He even made a joke as she walked away. "Don't worry, Maria," he called. "I'll be waiting for you!"

At the entrance to the Panton and Leslie office, she stopped. "No," she said aloud as though she addressed someone nearby. "I've just changed my mind. I'm not seeing Leslie. I'm going straight to the governor himself!" Her chin lifted. "I've lost that—crippling pride I used to have. I find I'm not one bit ashamed to plead, if necessary, for his Excellency's mercy! His mercy—for John. For us all."

Captain Carlos Howard, reserved in manner, admitted her to the familiar office. Governor Juan Quesada, his soft golden hair falling to the shoulders of his blue uniform, rose to greet her and motioned to a chair—the same chair where she'd sat before, pleading with Zéspedes the first time in John's behalf.

"Your Excellency," she began, "I've come to beg you to release my husband from the public humiliation of the stocks. Obviously, he's done something wrong—but he isn't a common criminal."

The enigmatic, rather effete young governor said nothing in response, leaving her suspended in the awkward silence. The only sound in the high-ceilinged room, aside from the gentle scraping of palm fronds beyond the open window, was the *tap-tap* of his fingernails on the desk. His penetrating eyes seemed to bore through her—surprisingly dark eyes for a man with such yellow hair, she thought irrelevantly.

"The whole thing has come as such a shock to me, Excellency, that I—scarcely know what to say, but—"

"Do you not think it was a shock to me? Think of me!" He clicked his nails once sharply. "The edict treated in such an obscene manner was *mine*."

"Of course, but my husband is not a bad man. He's impetuous, irresponsible, but I'm sure there was nothing—obscene. I beg you to give him a chance to tell you his side of the story! He's still very young."

"I know what happened at the Public Corner! There were three witnesses." He gave her a withering look. "The—*youth* of this man whom you chose to marry, señora, matters not to me."

Desperation clouded her mind momentarily. She had heard that Quesada was erratic, both gentle and hard as flint. At all times

unpredictable. He seemed now almost to despise her. Why? Had Zéspedes not told him of her prominence in the city? Of her services to the colony through the years? Of the property she had owned? She struggled to think clearly. The insulted official she faced obviously could not be reached by reason. And no matter in what direction her troubled mind darted, it crashed inevitably into the cul de sac of—something John had done! Her former value to the colony had now been wiped out—by John.

With little hope, she tried another tack. "But, Excellency, until an unfortunate stroke of bad luck, my husband was one of the largest property owners in town! A wealthy colonist."

Quesada's frail features broke into a smile. "So I have heard. All because he had the cunning to marry you. Such cunning will not be of influence upon me, señora."

Even in the heat of the musty room, her hands felt like ice and her head ached. She was failing John, and failure was so new to her, she had no idea how to handle it. By some means, she must get out, but how? What could she say to make her exit plausible? Some words—any words—to ease a little of the tension, so thick in the room it was like a noxious smoke. She stood, as did the governor at once, showing his eagerness to be rid of her.

She cleared her throat. "I—I beg you, Excellency. Once more, I plead with you—call upon the compassion of your Christian heart—please, *please* release him. I'll bring him here—you have my word—to explain. Surely a just man like yourself will at least listen to both sides of this dreadful affair!"

His eyes narrowed. "Your husband will be given a fair hearing. There is to be no injustice in the province so long as I am governor, but the last thing I would care to endure, señora, is an interview with this impudent man!" He spat the words in her face. "He has performed a depraved, filthy, abhorrent act—against my authority. The witnesses warned him that I would be told. He shrugged! Worse, he laughed!"

Steadying herself, she made one last, desperate attempt. "Do—do I not matter, Excellency? I have been a useful colonist for twenty-seven years!"

"So I have been told." He chopped his words. "I pity you. But it is not you with whom I deal in this matter."

Dear God, help me, she breathed. Help me think of something else! To Quesada, she said in a weak voice which she scarcely recognized as her own, "Isn't—there—*anything* I can do?"

"*Sí.* You can go to your house and leave your lawless husband to me!" Surprisingly, then, he walked from behind his desk and laid his hand almost gently on her arm. "Would it not be a relief to a woman of your age, Doña Maria, to have this man's stubborn will broken—once and for all? It is plain to everyone in the city—except you—that he is a poison!"

Her shoulders drooping. Maria turned and moved slowly toward the door that led to the outside stairs.

"Señora?"

She stopped, but did not turn back to him.

"Your husband will be released at sundown from the stocks. But you may not see him again today."

Turning to stare at Quesada, she said, "I promised."

He tossed back the long yellow hair. "That is not my concern. At sundown, I will order Juan Hudson to be taken to the Castillo de San Marcos. You will be given permission to visit him there tomorrow—and every day." The governor's voice turned abruptly confidential. "You must trust me, señora, to know what is best for the man."

When she emerged into the glare of the courtyard, John Edward ran to assist her.

"I've been waiting," he said. "I didn't go home. I've—kept you in sight. I thought you might need me."

He asked no questions. Her face told him everything. Holding her arm firmly, he began to lead her back across the Plaza.

"We'll have to go home another way," she said woodenly. "I've been ordered not to see John until tomorrow. He's to be thrown into the Castillo at sundown. I failed."

"You tried."

"But this time, I can't help him. His Excellency is—more unpredictable than John! I'm helpless this time. Helpless."

"Maybe that's good," John Edward said. "Maybe now God will have a chance—to help us all."

She stopped to look at him, a deep, perplexed frown on her still handsome face. I'm pushing her, he thought. How can I expect her to understand something so deep about God—so soon, with her mind so troubled? He smiled reassuringly and said nothing.

"You're really saying what everyone else has said, aren't you? You agree that I've made it *easy* for him—to ruin our lives."

"I'm glad you see it, too, now, Good Maria. Sometimes even God can't help us when we still feel able to help ourselves." He smiled at her again, hugged her to him, and began to lead her down a back street toward home.

"I don't need to lie down," she said when they reached the house. "I think I want to sit in one of David's chairs in the garden for a while."

"Tea?"

"No. I just want to be in the garden." Then, without a sign of pathos in her voice or on her face, she added quietly, "I'll lose my garden one of these days. I need to be in it all I can now."

"If John gets out of this present trouble about the edict, you still could sell at least part of New Waterford and save the house."

"Whether you believe me or not, son, I've given in to him for the last time. I think I've just realized what you were saying as we were walking home. I've been—John's god." She looked away. "It's all right about this house. It will be best anyway for both John and me—if he's ever out of this present mess—to leave the city. He seemed ever so much better at New Waterford."

Her fine mind and her broken heart had begun to work together—in God's presence. John Edward could count on that and leave her alone. He watched her move slowly through the parlor and out onto the back loggia. "I love you, Good Maria," he called. "I'll be in here studying, if you need me."

Outside in the garden, she could see rain clouds forming, and although there was no hint of a breeze, she felt a small, surprising

refreshment. For a long time, she stood leaning against a loggia pillar, struggling not to feel guilt because of the sudden odd quiet in her. Quesada had said John would be released from the stocks at sundown. She looked at her mother's gold watch on its chain about her neck. The sun would not begin to go down for two hours. How hot and cramped he must be, his head and arms attacked by flies and gnats which he could not brush off. No free hand to wipe the perspiration trickling down his face and neck. If the rain came, he would be drenched by sundown.

She remembered again Ann Cameron's long-ago hysteria when James endured these same torments. Ann . . . how long ago Ann seemed. How far away. For months after Ann left, Maria had been tortured with worry over her helpless little friend. Had Ann been able to draw any compensation from the Crown for the loss of her small St. Augustine holdings? Nancy would be twenty-one now. Was she looking after her mother? Was Ann growing old somewhere alone and in want?

How odd to be thinking of Ann Cameron with John in stocks! Her husband, John Hudson. Her *child*, John. Her troubled, trouble-making child.

She had humbled herself before the governor in a way she had not been forced to do even when John first brought about their financial ruin. And yet, in spite of feeling his agony at this moment, the humiliation did not run as deep . . . why? Am I growing accustomed to John as he truly is? she wondered. *How* is he—truly? The sigh came. "No longer truly my husband—not the man I tried to turn him into when we married," she said aloud in the soft, green silence. "Perhaps no longer my husband at all, except by law. And in God's sight. God? How *is* John—in Your sight?"

The thought lingered, then strayed. Odd. She was finding it hard to concentrate on John, as though he had become someone else's problem, no longer hers.

One hand lay idly on the wide, weathered board which David had shaped and fitted into place as an arm on the chair where she sat. She studied her hand—blue-veined, blotched with livery brown

spots—but still strong and well shaped, the finger joints as smooth as ever, no knots, no stiffness.

She was not old! She had nearly choked from panic and desperation in Quesada's office a while ago, but she did not feel old. Unchanged inside, in most ways, from the thirty-three-year-old woman who first explored the narrow, sandy, littered lanes of the ancient city on her first day there, with David waiting at the foul-smelling, flaking old fort. The cavernous, rat-infested place where John would spend this night. This night and how many more? And there was a terrible difference from David waiting: Maria could not get John out.

Still, her heart was filling with an unfamiliar, indefinable hope. There had been nothing in Quesada's manner today that had given her reason for the slightest shred of hope, and yet the hope had now been born—had here, in her garden, been handed to her—as though it were an eternal gift.

Her eyes moved, from the faint shadows resting beneath the orange grove, along the weathered wall cloaked in lush green ivy, across the brick walkway she and Joseph had designed, and along the grass to David's gentle bush. For the first time since she'd known she would lose her home, she was stabbed by the thought of leaving the once stubby little fig tree which she'd protected through the years. It could not be moved. Its roots, like hers, went deeply into this small piece of earth. There would be gentle bushes, of course, at New Waterford, but they had never belonged to David.

She sank deeper into the chair and rested her head. Her life lay in pieces all around her, and yet for such a long, quiet time, she had sat here much as any other St. Augustine woman might sit in her garden, woolgathering. Her thoughts leaping almost idly, her heart surprisingly still. There seemed no plausible way to help John, and yet the hope held. For him? Hope for his freedom? Or just some kind of hope for herself? She didn't know. There seemed to be no logic to it, but unless the wounds of the past year had driven her out of her mind, it was real.

A gentle breeze touched her cheek, and for the first time in months, with no effort at all, she was able to slip comfortably into the once familiar depths of her being . . . the hot, muggy afternoon faded. Had the fresh breeze done it? No matter. She felt the cool green—the green of her long-cherished green and secret place. The deep and secret place where all things had once come clear . . . today? Could they—would they—come clear on this day of black humiliation and helplessness? Even shame?

The green surrounded her, its unwavering light clean, its glooms luminous . . . her secret refuge so long gone, today so oddly familiar, as though she'd never been away. Odd. Odd being alone like this— alone in such familiar surroundings after the taxing, hectic years of living on the scarred surface of life. Familiar and odd.

Blessedly able again to be quietly alone, Maria began to wonder at the new dimension of comfort which in these moments had so unexpectedly invaded this tragic day.

"I am alone," she whispered, "in my green and secret place."

And then—for the first time, she knew she was not.

Was not alone. *Someone else was there.*

Why had it never struck her before that Someone else had been there all the time—waiting? A dim, diffused glow began to illuminate her inner horizon. Not bright; there was no glare. She closed her eyes. "O Lord, thou hast searched me and known me. . . . Thou understandest my thought afar off. . . ."

She had never known such peace. A kind of peace very near to— joy. The new joy Antonia had promised so long ago? For the first time in all these years she remembered that when she had asked Antonia, "What is joy?" Antonia had brought God into her answer somehow. "God within you"? That was the idea, she thought, but it wasn't quite right, or adequate.

A long time later, when she opened her eyes again, she saw the rain clouds passing away, the leaves on the orange trees darkening, the very air of the garden turning rose-coral. The glow of sundown.

Sundown.

John would be on his way to the dungeon.

40

Every day for a week, Maria walked to the Castillo. John prowled or sat in a heap in the only completely windowless cell in the fort. The same cell, John Edward had told her, where Charles Town's General Christopher Gadsden had been locked during the Revolution, without visitors or even a candle at night. Maria had scoffed at the idea of such punishment then. She believed it now.

At least, Quesada had granted her special permission for a daily twenty minutes with John, and in spite of the fact that a guard peered through the tiny square opening of the massive door, trying to eavesdrop on their every word, she had not missed a single day. Why the guard was ordered to stand there she couldn't imagine, except that John's episode at the Public Corner—whatever it had actually been—had so turned his Excellency against him that little of what Quesada did made sense. When she permitted herself to try to figure out why the incident had caused such severe punishment, her newfound joy wavered, but not for long.

Except for a time spent surveying for a lumbering crew at New Waterford, John Edward had gone to the Castillo with her, waiting always outside the dank, foul-smelling cell, since only Maria was permitted to visit John. Her husband's mood spiraled erratically from pathetic, tearful contrition to cold silence to flinty arrogance.

As the days wore on, the long, hot exhausting walks and the agonizing visits tortured her far more than she was willing to admit. Why, she found herself asking, did she go on visiting—a near stranger? On certain days, John did not even greet her when she walked into the dark, high-vaulted cell. At other times, he would charge at her on sight, demanding that she do something to help him.

One day in late August, she had used every ounce of will she posessed to keep from crying out in terror when he grabbed her violently and shook her. Crying out, she knew, would not help. She had remained silent. The most nerve-shattering days of all were those when he sat, hands hanging limply between his knees, saying nothing, not looking at her, spitting at a crack in the stone floor where she stood. By early September, each moment spent with him in the unrelieved gloom of the dismal cell seemed to stretch into a tormented eternity. The laughing, virile, attentive young man she had married was gone. The townspeople, John Edward had told her, were calling her husband mad, stark raving mad.

"They want him kept in there, Good Maria. They don't want him loose in the city. They think he's a hopeless case—a danger."

One minute she found herself almost in agreement. What if John were released suddenly; could she manage him at home? The next minute, her heart broke—again—for the weak, anguished young man who had seemed to give her back her own youth.

"John," she asked one day, "do you ever talk to God here alone?"

"Ha!"

"Answer me. During all the dragging hours, doesn't it ever come to your mind that He—might be here, too?"

He spat. "They send a priest once a week. My guess is the black devils don't want my soul on their consciences."

"Have you—told me the whole truth? Have you? *Did* you—wipe your backside with the governor's edict? You know perfectly well that's the filthiest, most impudent gesture of all. Did you do that?"

He strode toward her across the shadowy cell, his face distorted. "Now *you* will be my inquisitor, eh? You!"

"You need to get out of here! You need our life again, as it was. Maybe, just maybe there's a small chance that a full confession might get you a little leniency." Her voice broke. "I—can't stand these visits much longer! I don't know you anymore."

She braced for another explosion of fury. Instead, he walked away. She waited. Then, from across the room, his back to her, he said softly, "Poor Maria. Poor old woman!"

She felt faint. The air in John's dungeon, where no outside breeze ever blew, was hot and fetid, but she felt herself slipping away, unable to stop—slipping not from the oppressive lichen-caked cell but from John. He had finally spoken the truth; to him, she *was* a poor old woman. And at last—or was it only the first time she'd faced it?—she saw them both off to one side, as in a painting; as they really were. As they had been all along. An aging, determined, self-serving woman using her wealth and her position to buy what, in nature's wisdom, could never be. Her still active imagination had, to her, transformed this charming but unstable young man into—David. Without a nod at either reality or common sense, she had used her indomitable will to try to remake a wanderer, a lovable, scheming scoundrel, into her image of what she wanted him to be.

Maria steadied herself. She was not going to faint. She was merely sliding away from him, sliding, powerless and away—a woman sliding down a sand dune. At the bottom, though, if she could just hold on, would be the solid earth.

"Poor old woman," he repeated on a harsh laugh. "*Poor* old woman, as helpless to save herself as she is to save me!"

"I—tried."

"I wish you'd stop now." His voice was icy, his glance vacant. "Don't make another move toward me. I'll—help myself from now on. I'll get myself out of here."

"John!"

His arms were around her and he kissed her roughly. The odor of his body, so long unbathed, repulsed her, but she returned his kiss. A foolish old woman kissing a quite mad, unshaven, strange young man.

The great key turned in the lock and the door opened. A guard took Maria by the arm and led her away.

The sunrise, amethyst and golden on the white walls of her bedroom, blazed into full daylight before Maria gave up trying to sleep and sat stiffly on the side of her bed. The fear that had haunted

the night just past was as harsh and real in the morning sun.

Why the fear did not strike yesterday she could not have explained. Being with him had always caused her senses to criss-cross. Even though he had become a stranger yesterday—gone as though he had never been there—his presence had still somehow been able to cloud her mind. Of course. He meant to escape! The thought, in spite of her stark, new picture of them both, had brought the fresh fear. She had looked after him for so long, the idea that he would surely bungle an escape filled her with terror. Somehow, she would have to find a way to make him change his mind.

From downstairs, through her open window, she heard the gate bell. Maria reached for her dressing gown and waited. John Edward or Long Stem would surely be up.

In a moment she heard the gate latch open, then close. The low, tense murmur of voices—men's voices—reached her from the garden. Words she could not quite make out. Her whole body trembling, blood hammering in her head, she ran into her upstairs parlor and out onto the balcony which overhung the garden.

"He had a way with him, all right," she heard John Leslie say. "I doubt that anyone else could have persuaded a guard to let him exercise in the quarters just outside his cell. He tried to overpower the guard then and take his gun, but he was shot in the heart. He's dead—and I'll have to tell her."

Numbly, Maria turned and walked back into the upstairs parlor. She stood a moment, looking toward the room remodeled to his taste, then slowly she walked down the steep stairs and opened the door to the garden.

"I heard," she said. "I heard."

Leslie and John Edward stared at her. Neither spoke.

"Will they let me—bring my husband home now? You're both my dear friends. What do you think? Can I bring my husband home now?"

"I'm all right, son," she said to John Edward after Leslie left to handle the release of John's body. Then she looked at the boy, her

gaze steady. "I'm—all right. And—*he's* all right, too, now."

John Edward hugged her tenderly. "How wonderful to be sure of that, Good Maria. He's—on his way to a place where he might finally learn how to live. John had a great big need to live."

She patted the young man's arm, asked to be left alone, and walked around the corner of the house and straight to one of David's chairs. The word *waste* kept darting across her stunned mind and then, as quickly, it was canceled out. John could no longer waste himself, or be wasted.

For a long time, at least for what seemed a long time, she sat rubbing the grain in the arm of David's chair with her thumb. The garden was not quiet. Two wrens and a jay split the morning air with their calls. A heavy wagon rumbled and creaked down St. Francis Street, the horses snorting as they clopped past her gate. The wind was right so that she could hear the marching drums all the way from the Plaza. Long Stem was making a dreadful clatter in the kitchen at the rear of the property. No matter. There was silence, sustaining silence—and peace—within Maria Evans.

"Maria Evans." She spoke her name aloud. "I'm—Maria Evans again—and I'm alone. John will be coming home after a while, and I won't need to make that visit to his dungeon today—or ever again." Her eyes were dry.

Poor young John Hudson's troubles were over.

Through four often beautiful but nerve-racking years, she had tried—every hour of every day and night—to see to it somehow that the devastating young man was all right. Only God could now make sure of that. Her efforts were almost at an end.

By late morning they had brought him home, and she was once more busy taking care of him. With the help of Long Stem and John Edward, Maria bathed and dressed him in the new yellow waistcoat, gray breeches, and stylish jacket which she'd had tailored two weeks ago, hoping to cheer him if Quesada at last agreed to let him out of prison. His face, its healthy tan faded from the stay in prison, was further blanched by the pallor of death. But he looked peaceful, she thought. Peaceful at last.

When they had finished and John lay on the small bed in his own room upstairs, Maria was glad for immediate plans to carry out, so began explaining them to John Edward.

"First, arrange for a boat. Perhaps, under the circumstances, Juan Perpal, who took back John's fine little yawl on part of the debt, would rent it to us for long enough to take him home."

"Home?"

"Yes. I've never seen him as much at home as he was at New Waterford. I'm taking him back. I also want Father Thomas Hassett, if he will, to go with us, please. I know exactly where we'll bury John up there. While you're gone, I'll dress and be on my way to Government House. Alone, this time, son. His Excellency has papers for me to sign."

John Edward, as she expected, did not add to the burden of this bright-dark day by asking one single question concerning her sudden business at Government House. Maria was grateful. She was grateful, too, as she stepped out on St. Francis Street, for Long Stem's Indian habit of silence. Most servants would have been wailing and wringing their hands. The big house was quiet behind its sheltering wall—quiet and peaceful. John could rest while she was gone.

Walking up Marine Street along the Bay, memory took her back to the day she had first found this narrow, sandy, shell-strewn lane. She and Jesse Fish had met that day, right about here. She stopped a moment to let her gaze wander out across the shimmering waters toward Fish's island. How long it had been since they'd seen each other! Joseph's funeral, as she recalled. Poor Don Jesse, old and ill—not altogether sound in his mind, some said. Could she leave St. Augustine without at least sending a message to the man who had once been such a good friend to her? After her interview with Quesada, she would, of course, stop by John Leslie's office to say goodbye. He would see that her message reached Fish.

The sun was high now. She hurried toward Government House. The remainder of the afternoon would be spent packing

the few belongings she meant to take with her when she sailed for New Waterford with John. She could not yet think of the silent form upstairs as John's *body*. It was still John lying there, quietly sleeping.

She would leave Long Stem behind in charge of sending the rest of her things and would ask Leslie for one last favor—the shipment of her furniture to New Waterford.

Maria reached the Plaza, her mind entirely settled. A miracle of God. Except for the new peace, the new hope which so gradually had begun to invade her heart in the garden the afternoon John Edward had read from the Psalm, this would have been a day of thick, dark agony. Of abject failure. There was no explaining the peace holding firm in the depths of her green and secret place, even though she was still sorrowful and somewhat stunned. The peace had come with little or no effort. A gift.

At Government House, she quickened her step across the courtyard and entered the high door to request her interview with Juan Quesada.

"I regret to say, señora, that I am not free to call his Excellency. He's resting. One of his severe headaches." Captain Carlos Howard bowed. "I'm sure the governor would want me to extend his sympathy, as I extend mine."

"Thank you. But I'm leaving the city early tomorrow morning. There are papers for me to sign—as you probably know."

"I will get you the papers." The captain half turned away.

"Captain Howard," Maria said urgently, "I must meet with the governor now—only for a few minutes, but it must be now."

Howard bowed again and left the room, and within fifteen minutes Maria was seated once more in the high-backed chair before the governor. Perhaps, she thought, looking at his pale, pinched face, Howard had not lied about the severe headache. For whatever reason, Quesada appeared to be in pain. Maria tensed.

Sitting very straight in her chair, she said, "This will be our last interview, sir. My foster son and I leave tomorrow for my property at

North River, called New Waterford. My late husband gave it the name." She thought Quesada winced slightly, but no other expression crossed his face. "I've lost everything I owned in St. Augustine. I see no reason to stay on."

He appeared startled. "But señora, your professional services are sorely needed in the city. You will be missed. Is there no means by which I can change your mind?"

"None whatever," she said firmly. "I'll be sorry to leave my work, of course. But I'm not young anymore, and perhaps I've served long enough."

Without warning, the nervousness which had gripped her when the interview began was lessening. Quesada's evident reluctance to have her leave had been gratifying, more so than she would have expected. But her tenseness had lessened for another reason as well: the damp, close, musty air in the governor's office had—just for an instant—been dispelled by the remembered scents of the cool green rim of forest outside the window at New Waterford where she and John had eaten their happy meals. For a brief moment, she seemed to smell the black earth, carpeted with pine needles, felt more than saw the curve in the North River, its waters flowing as smooth as glass down from the rich adjoining land which Joseph had left her. All that remained now of what Joseph had left her.

Still sitting erect in the high-backed chair, the governor's eyes upon her, she relinquished within herself not only her brief, remaining, legal claim to the St. Francis Street house, but the property's place in her own heart. Giving up the house was almost a relief. Her long struggle was ending.

The cool green had come. And in the love of God, peace.

Laying John to rest under the big oak near the river would not be the tearing experience she had braced herself to endure. She would be doing the last tender, caring thing for him, and then she, too, could live a life of rest in the green place beside the river and the marshes they had loved together.

Quesada waited, his thin, nervous hands quiet for a change.

Maria cleared her throat. "My home will be entirely vacated within a few days, Excellency. Whatever is to be signed, I am here to take care of right now."

The young governor rubbed his forehead, then leaned toward her, his face showing the first real compassion she'd ever seen in it.

"It is awkward to say this," he began, "but only yesterday the decision reached me from Havana concerning the punishment due your—late husband for the crime committed in the Plaza against my authority. I thought I would tell you about it when you came to sign the papers—" He looked hesitant.

For a moment Maria felt overwhelmed again. "Now, Excellency? You want to tell me about it—now?"

"The sentence was not severe. It is not within my power to see within your thoughts, señora. Is it your wish to learn of the sentence?"

"I—I really don't know. I wasn't prepared to have you bring any of that up today."

"I did not expect to—today. But as you wish."

"Yes. Yes, I believe I'd like to know."

Quesada waited a moment, then said, "Don Juan Hudson was to be banished from St. Augustine to the distance of twenty miles—for a period of not less than four years."

For a long time she said nothing, her mind trying to absorb what he'd just said, the irony bitter and penetrating.

Then she spoke, her voice level. "Well, it so happens that New Waterford is a little more than twenty miles from the city, Excellency. We'll be complying in full."

After a long pause, he said softly, "I have never met a woman of—such character, señora."

She held out her hand. "The papers concerning my house, please?"

He reached into a drawer and took out a sheaf of documents. "Do you desire me to read them to you? They are written in Spanish."

"No, that won't be necessary. I know what's in them. I'm ready to sign."

Quesada pushed the papers across the desk, dipped a quill carefully, and handed it to her. In clean, slanting script, she wrote "Maria

Evans" in two places and returned the quill to its crystal stand.

For an awkward beat of silence, they sat there. Then Quesada said, just above a whisper, "You have been in the city for many years, señora. To leave must bring you still further grief."

When she stood, the governor stood also.

"Further grief? No, Excellency. I'm sure it makes little sense because I have lived a good and at times a happy life here. There is no way in which I could ever stop loving St. Augustine. It's been my city for too long."

Tears began to sting her eyes, and she lifted her chin slightly. "I have no intention of taking your time to explain, but I've finally found what I'd spent my St. Augustine years searching for—*peace*. Peace has somehow come to me without effort on my part, once I stopped trying so hard. Once my carefully built world began to—crumble about me."

Quesada looked at her, a deep, incredulous frown creasing his forehead. "Out of the tragedy of—your late husband's ruinous deeds, you have found *peace?*"

"Yes. You see—" She broke off suddenly, struck by the realization that she was talking to the wrong person. The papers were signed. She had no further business here. As rapidly as good manners permitted, she took her leave and began to walk up St. George Street. To Antonia.

It was Antonia whose understanding she wanted—Antonia whom she needed to tell that she had, at last, found peace. Love and gratitude—and remembrance—swept through her like a restoring breeze. In the stir and noise of the street, she could almost hear Antonia's quiet voice trying to convince her on that long-ago night at the cottage, with David so newly gone, that one day she would find—not only peace but joy. But she still could not remember Antonia's exact words about joy and God. She breathed a prayer that Antonia would recall them.

A block east of St. George, she turned into Charlotte Street, to the house that had been hers and then Luciano's and was now Antonia's alone. Whether or not Antonia was able to recall her own words, Maria thought, she owed it to Antonia to make it clear—as clear as quiet, settled water—that Maria Evans was, in spite of this

last stark tragedy, going to be all right. Luciano's sister had asked so little through the years, had tried to give so much.

At the door, the two women embraced without speaking, then walked arm in arm into the familiar parlor and sat down.

"You—have come to me in your sorrow," Antonia said. "I am glad."

"Yes. It—was as though I had no choice. I wanted, of course, to say goodbye, but—"

"Goodbye?"

"I'm taking my husband's body to North River. Tomorrow. I'll be staying. Everything is gone here." She learned forward almost eagerly. "Antonia, I haven't always been a considerate friend to you. It is you who never failed to consider me—in all ways. Will you listen now? Just let me talk to you?" Her words spilled out. "I know I should be shattered today. My husband's dead body lies on a bed back at the house—the beloved house which has just been taken from me forever. Part of me *is* shattered, but—do you remember the night so long ago when you came to the cottage on St. Francis Street to tell me that even though David was gone, I would one day find— a new joy?" She spread her hands in a helpless gesture. "Am I—absurd to mention the word *joy*—today?"

Antonia whispered, "No! No. I am listening, Doña Maria."

"Do you understand that I couldn't bear for you to speak to me of joy that night so many years ago? Whatever you said that brought God into it was so far beyond me, I rejected those words out of hand. And forgot them. And now I wish I knew, since—Antonia, I *have* a new joy inside me!"

Antonia smiled. "I think I said joy might be God—in the marrow of our bones."

Tears brimmed in Maria's eyes as she looked at her friend. Then she gave a half laugh—easy, with music in it, the way her laugh used to be. She let her head fall back against the high carved chair, her tense body relaxing. "That's it. That's it, Antonia. God—in the marrow of my bones. Thank you." Then, as though someone else were speaking, she seemed to be listening to the flow of her own words . . . quiet, definite, as steady as a river.

"You see, I've been trying all these years, ever since David's death, to find—something that would fill the empty place he left. The years with Captain Peavett before his fatal illness were good, but all through them, as through the years alone, I was trying to secure myself by hard work at my profession, by amassing property, by building my own influence in the colony—most of all, I tried to build an impenetrable wall around my heart. I even tried marriage to a lovable—but help-lessly weak—young man, young enough to be my son. I made a fool of myself in the end, but—Antonia, the empty place is filled now—with peace. Yes, and *joy*. An outright gift." She sighed. "I don't understand any of it, but who *does* understand the love of God?"

Antonia leaned forward to touch Maria's hand, but said nothing.

"Now? Quite willingly—*quite* willingly—almost with a kind of anticipation, I'm going to New Waterford to live free for whatever time is left me. And, dear friend, you're not to worry about me, because I won't expect to be happy every day. Just free. Not even trying to under-stand that I have, at long last, been given God's kind of joy."

Tears were on Antonia's face, but she was still smiling. "Doña Maria, you are wise to say that you will not expect always to be—happy. God's joy and human happiness are not the same. Happiness comes and goes—as a sunny day comes and goes. Real joy does not, cannot change, no matter what sorrow reaches us, because our secret is true—real joy *is* God in the marrow of our bones."

Afterword

Maria lived with John Edward and Long Stem at New Waterford in her newly found peace for almost two years, enjoying frequent visits by her old friends from St. Augustine, John Leslie and Father Thomas Hassett, both of whom were with her when she died on September 30, 1792, at the age of sixty-two.

No one can be sure where she is buried, but the best opinion is that she lies somewhere at New Waterford. The fertile and beautiful North River land which she owned is in the vicinity of what is now called South Ponte Vedra, visible in a line of lush green trees to the west as one drives along present route A1A by the ocean.

Her Charlotte Street house, where she lived as a widow after David died and for a time following her marriage to Joseph Peavett, may be seen from the street in St. Augustine. It has been admirably reconstructed, leased to the Southern Bell Telephone Company as business offices, and is now listed as the Luciano de Herrera House, 58 Charlotte Street.

The narrow, still quaint lanes of restored St. Augustine are, of course, the same streets Maria walked; the Square (now called the Plaza) is there, as is Government House, although little of the original building remains. But there is one place in the city today where Maria's presence is palpable—her beloved home on St. Francis Street, known for many years as The Oldest House. This ancient building, once Maria's and David's cottage, has been magnificently restored and is lovingly kept, as she would like it

kept, by the St. Augustine Historical Society. Because of its excellent restorations, any visit to St. Augustine today is a meaningful step back into the long history of our oldest city, but there is something special about walking into The Oldest House on St. Francis Street near the Bay and across the narrow lane from today's National Guard Armory—in Maria's time, the Franciscan monastery and military barracks. The painting on the jacket of this book was done from a photograph of Maria's garden and the house as she and Captain Peavett remodeled it so long ago. There were many alterations during the years, but I am convinced that the St. Augustine Historical Society has carefully returned it very much to the "look" Maria wanted it to have. If you're fortunate enough to visit The Oldest House, you will probably be welcomed by my warm friend, Virginia Solana, who, along with the other charming hostesses, will add immeasurably to your knowledge of the history of the property itself. Mr. Carver Harris and everyone connected with the St. Augustine Historical Society are to be commended for the labor of love and the zeal for historical accuracy which they have given in their restoration and continuing care of Maria's house.

Accounts of Joseph Peavett's vast holdings and his place in the society and history of East Florida are preserved at the St. Augustine Historical Society Library at 271 Charlotte Street—now my second home—but there is no marker to be found for Joseph, although it is probable that, since he was baptized Catholic before his death, he is buried, along with John Edward Tate, in old Campo Santo, now known as Tolomato Cemetery—not open to the public.

There is no record of where Maria's father, Richard Evans, was buried in Charleston, South Carolina. For my "picture" of the Queen Street home of the Evanses in this novel, I used the well-restored Thomas Elfe House on Queen Street, Charleston.

As with the writing of the three novels in my St. Simons trilogy and *Don Juan McQueen,* I am deeply indebted to countless persons whose help has ranged all the way from the purely technical and

historical to the love and encouragement necessary to the completion of a book such as this.

Maria is dedicated to one of my dearest friends, Nancy Goshorn—she of the dependable humor—whose unflagging faith in me and its pursuant effect cannot be expressed in words. She also traveled with me and helped with research. Nancy and her aunt are my mother's neighbors, and I have dedicated this book to Nancy, not only in gratitude for her devotion to Mother, but because she is among the few persons on earth who know when to laugh at me and when to take me seriously. One can ask no more of a friend.

Dena Snodgrass, Jacksonville's outstanding historian, has stayed merrily and encouragingly beside me in person, by letter, and by long-distance telephone. Dena has not only kept the relevant material coming; she was beside me on the front seat of my car when I made my very first visit to Charleston, South Carolina, in search of Maria's roots. It was Dena who introduced me to Mary Elizabeth Prior, then Director of the South Carolina Historical Society, who also gave most generously of her expertise and faith in what I was attempting to do. Capable Martha Matheny, the Library's archivist, was also of help to me.

Perhaps one of the most rewarding aspects of doing a book such as this is the cementing of what one knows will be lifelong relationships. Pat Wickman, of the St. Augustine Preservation Board, not only offered the full benefit of her finely honed mind and her knowledge of the old city where she was born, she dug and dug and filled pages with perceptive answers to my endless questions. When I am no longer at work on the history of Pat's hometown, she and I will go on being close.

There would have been no book about Maria Evans were it not for another valued friend and expert research historian, Eugenia Arana, of the St. Augustine Historical Society. In five minutes, at lunch one day during a trip to the oldest city, Eugenia Arana "gave" me *Maria*. Something nearly chemical occurs in an author's mind when the right story comes along. One simply knows. Through

every phase of the complicated research, from translation of Maria's Spanish Testamentary, to the precise location of her houses, to a better understanding of Maria's character, Eugenia Arana has been with me. She and Jackie Bearden, Administrative Assistant at the Library, have not only found an answer to my every question, they have cheered me on and have made possible even more accuracy than a novelist needs. Once more, Eugenia's knowledgeable husband, Luis Arana, Historian for the National Park Service at the Castillo de San Marcos, has, along with George Carroll, checked me in the always risky field of military history.

I thank the amiable Dr. J. Leitch Wright Jr., Professor of History, Florida State University in Tallahassee, for a long afternoon of counsel and for his excellent book, *Florida in The American Revolution.* My thanks also go to Elizabeth Rountree, Director, and to Marcia Hodges and Harriette Hammond of the Brunswick, Georgia, Public Library System; to James Ward of the *Florida Times-Union;* to Lilla Hawes, retired Director of the Georgia Historical Society Library in Savannah; to Luz Strong for certain Spanish translations; to John Griffin, now Director of Key West Preservation Board; to Dr. Overton G. (Tony) Ganong of the St. Augustine Preservation Board; to Albert Manucy of St. Augustine; to Jacqueline Solana of the St. Augustine Historical Society Library; to Commander Harry P. Hart, USMS Retired, of Jacksonville, Florida; to Frankie Walker, WFOY, St. Augustine; to Charles Robshaw, Park Technician, Castillo de San Marcos; and to Hayward L. Moore, M.D., of Brunswick, Georgia.

There would have been no way for me to handle Maria's difficult profession of midwifery without the expert and gracious assistance of Dr. Joseph I. Waring, Director of the Waring Historical Library at the Medical University of South Carolina in Charleston.

My house and my daily needs have been looked after in all ways by Ruby and John Wilson and Monroe and Lois Wilson. Six personal friends, Lorrie Carlson, Audry Blackburn, Frances Pitts, Theo Hotch, Clara Marie Gould, and Agnes Wishart Holt again shared themselves and remained interested throughout.

Evelyn Braddock of St. Augustine kept in close touch and seemed always to know when I had need of her expertise as a Florida naturalist. And of course, heart-deep thanks and love go to my mother and her neighbor, Mary Jane Goshorn, for believing in me and for their daily closeness in spite of distance.

It is futile to try to thank my housemate and fellow author, Joyce Blackburn, not only for creating the kind of atmosphere in which one could scarcely keep from writing *and* living, but for being my very best friend, and who again has done a superb job of preediting—the results of which make me sound far better. From the same part of my heart goes gratitude to Elsie Goodwillie, our beloved friend, who through still another book has deciphered my scribbles and done her usual excellent typescript without once losing patience.

Edward L. Burlingame, Editor-in-Chief of the Trade Division of J. B. Lippincott, and Peggy Cronlund, my creative and caring copy editor, along with all the others at the publishing house who contributed so much, have my love and my deepest thanks.

Finally, I am once more indebted to the name of Hartridge—this time, since my inestimable friend, the late historian Walter C. Hartridge, is gone—to his Susan and young Walter, for allowing me free use of Walter Hartridge's invaluable papers. Finding some of what I sorely needed in his files was like a confirmation from Walter himself, because he had, without my knowing, already done extensive work on the life and times of Maria Evans, whose story I have tried to tell.

Eugenia Price
St. Simons Island, Georgia

BOOKS BY EUGENIA PRICE

Fiction

St. Simons Trilogy
Lighthouse
New Moon Rising
The Beloved Invader

Savannah Quartet
Savannah
To See Your Face Again
Before the Darkness Falls
Stranger in Savannah

Florida Trilogy
Maria
Don Juan McQueen
Margaret's Story

Georgia Trilogy
Bright Captivity
Where Shadows Go
Beauty from Ashes

The Waiting Time

Nonfiction

Discoveries
The Burden Is Light
Never a Dull Moment
Early Will I Seek Thee
Share My Pleasant Stones
Woman to Woman
What Is God Like?
Beloved World
A Woman's Choice
Find Out for Yourself
God Speaks to Women Today
The Wider Place
Make Love Your Aim

Just As I Am
Learning to Live from the Gospels
The Unique World of Women
Learning to Live from the Acts
St. Simons Memoir
Leave Yourself Alone
Diary of a Novel
No Pat Answers
Getting Through the Night
What Really Matters
Another Day
At Home on St. Simons
Inside One Author's Heart

About the Author

Before making St. Simons Island her home, Eugenia Price, a native of Charleston, West Virginia, was a resident of Chicago with a highly successful career in the thriving area of radio soap-opera programming. The major networks eagerly sought her creative production talents and Price was well respected in the broadcasting world when her life took a marvelous and powerful turn. God began to use her extraordinary writing gifts to communicate her faith with others.

Price's earliest books—*Discoveries*, *The Burden Is Light*, and *Early Will I Seek Thee*—gained her enormous popularity as a speaker at religious groups across the nation and across all denominational lines. Her compelling message was not about doctrine, but about new birth. In rapid succession she wrote books dealing with Christian living, women's faith perspectives, and devotional themes. Her masterful rephrasing of the entire Bible, *Beloved World,* went through countless printings. Twenty-six highly personal nonfiction works and fourteen historical novels were ultimately released by the leading publishers of the day.

Eugenia Price died on May 28, 1996, and is buried at her beloved Christ Churchyard, Frederica, St. Simons Island. Following her death, the Eugenia Price/Joyce Blackburn Charitable Foundation was established with Blackburn, also a prolific writer, as president. The Foundation holds all publishing rights in perpetuity. Its sustaining purpose is to ensure the availability of this written legacy for future generations of readers.

About the Foundation

The Eugenia Price/Joyce K. Blackburn Charitable Foundation, Inc., was established to ensure the perpetuation of the accomplishments and commitments of the founders. The Foundation's primary work is the continuation of the literary legacy which has enriched the lives of millions of people. The work of the two authors includes fifty-seven titles that have been published in eighteen languages and printed in excess of fifty million copies worldwide. The Foundation intends to make available in print these Christian inspirational, historical fiction, juvenile, and biographical titles so that each new generation of readers may be enriched by the authors' combined works.

Price and Blackburn have long supported a wide variety of humanitarian, artistic, and preservation organizations. Proceeds from the Foundation will be used to fund grants, scholarships, and contributions to charitable groups. Specific programs which promote excellence in writing will be established. Under Foundation auspices, events and activities will be developed which perpetuate, promote, and celebrate the memory and achievements of these two beloved literary artists. The Foundation accepts tax-exempt donations which will fund its work. Contributions may be made to:

Eugenia Price/Joyce K. Blackburn Charitable Foundation, Inc.
c/o Eileen Humphlett, Executive Director
607 Bellemeade, St. Simons Island, Georgia 31522